Two Ro... to Wisdom?

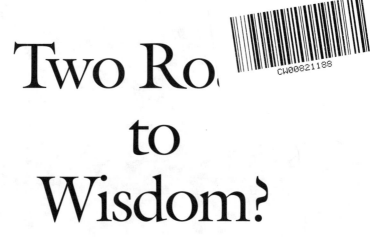

Chinese and Analytic Philosophical Traditions

Edited by
Bo Mou

With a Foreword by
Donald Davidson

Open Court
Chicago and La Salle, Illinois

Cover picture: *The Peach Blossom Spring* by Wen Zhengming (1524). From "Tao Yuan Bi Jing"/Private Collection/ The Bridgeman Art Library.

To order books from Open Court, call 1-800-815-2280.

Open Court Publishing Company is a division of Carus Publishing Company.

© 2001 by Carus Publishing Company

First printing 2001

Printed and bound in the United States of America.

Library of Congress Cataloging-in-Publication Data

Two roads to wisdom? : Chinese and analytic philosophical traditions / Edited by Bo Mou; foreword by Donald Davidson
 p. cm.
 Includes bibliographical references and index.
 ISBN 0–8126–9434–1 (pbk. : alk. paper)
 1. Philosophy, Comparative. 2. Philosophy. 3. Philosophy, Chinese.
 I. Title: Chinese and analytic philosophical traditions II. Mou, Bo, 1956–

 B799 .T96 2001
 181'.11—dc21 2001021929

Contents

Foreword

The analytic method in philosophy is employed by almost every philosopher from time to time and by just about no one all of the time. It is a method that starts with a question or a doubt and tries to find an answer or to resolve the doubt. This sets in train attempts to find reasons for or against theses that suggest themselves as answers to the questions or resolutions of the doubts. The analytic method can engage with ideas at any level and from whatever quarter or discipline or tradition. It provokes argument and when practiced with an open mind it engenders dialogue. At its best, dialogue creates mutual understanding, fresh insights, sympathy with past thinkers, and, occasionally, genuinely new ideas. But before there can be dialogue the parties must meet, as they do in this book.

We seldom stop to think how much, as philosophers, we share with other philosophers from other ages, other countries, other traditions. We tend to discover our common problems and interests as we read, teach, and travel. The discovery surprises us for, to begin with, minds are best compared by finding as many points of similarity as everyday patterns of action and reaction afford. But once this fitting of pattern to pattern is accomplished, the remaining differences loom out of proportion. This perhaps explains why a first exposure to a new tradition seems to reveal an unbridgeable gap. What experience shows, though, is that, as in other areas, differences are to be understood only as seen against a background of underlying agreement. The underlying agreement may be largely unspoken and unnoticed, but it is always available. Sometimes we need help in appreciating how philosophy builds on what we all know. No world views or conceptual schemes are truly incommensurable.

The present book provides a welcome opportunity for those of us steeped in Western philosophy to enlarge our appreciation of how much we have in common with the Chinese philosophical tradition, for it is this store of universal problems that can give point and interest to our divergences. It is all to the good that we should find and cultivate convergence on such general values as human rights, academic freedom, relief from the fear of hunger and of war, and the right to live under political systems of our own choosing. But we should not seek conformity in philosophy. On the contrary, in our intellectual work we should celebrate variety and do all we can to insure its survival.

We should not make the mistake of supposing that under ideal circumstances our institutions and our philosophical proclivities would or ought to become more alike. If anything, we should expect the opposite, and we should welcome it. We welcome understanding, and with it tolerance, but variety and difference is at the heart of philosophy.

DONALD DAVIDSON
June 2000

Acknowledgments

I would like to thank the authors for their valuable contributions, almost all of which are previously unpublished pieces written expressly for this volume, and for their patience and cooperation throughout the process of bringing this book into print; and Donald Davidson for writing a foreword that is succinct but rich in content. I am thankful to Nicholas Rescher and Lik Kuen Tong for their kind permission to reprint their recent essays here.

My concern with the issue of philosophical methodology in Chinese and comparative philosophies as well as in general philosophical pursuit was initially projected into coordinating, and participating in, a panel meeting of the Society of Asian and Comparative Philosophy at the Eastern Division 1996 meeting of the American Philosophical Association. I am grateful to Chad Hansen and Lik Kuen Tong for their kind support of the idea of a panel discussion of the methodological issue in a dialogue way and for their careful preparations for their engaging presentations on the issue; Henry Rosemont, Jr. for his constructive suggestions and his active plan to participate in the panel discussion as a speaker; and Xinyan Jiang for her earnest participation in the above panel as a commentator. All these contributed to the success of the panel discussion.

I am indebted to the following persons for their sincere support, valuable advice, substantial assistance or helpful information that I received in the process of preparing this volume: Chad Hansen whose always-*junzi*-attitude I admire, whether one agrees or disagrees with him on various academic issues; Kwong-loi Shun with whom I had many helpful discussions on relevant issues and who provided valuable help during my stay at UC Berkeley where this project was eventually completed; Adam Morton whose support and assistance came in need; David Hall from whom I received various helpful suggestions and whose effective completion of his contribution much ahead of time was no doubt a timely push to me; Robert Allinson whose professional advice on academic publication turned out to be very valuable; You-zheng Li, my former colleague at the Institute of Philosophy, the Chinese Academy of Social Sciences, with whom I had extensive and in-depth discussions of related philosophical issues; Mary Rorty who read an early version of my introduction and

viii

Acknowledgments

gave me helpful suggestions; and Bryan Van Norden whose relevant information always came to my aid.

I am thankful to our editors at Open Court, David Steele and Kerri Mommer, for their remarkable efficiency, timely assistance, and valued understanding.

Bo Mou
Albany, California
July 24, 2000

Note on Transcription

Because of its accuracy in transcribing actual pronunciation in Chinese common speech and its current wider use, the *pinyin* romanization system is employed in this volume for transliterating Chinese names or terms. However, those Chinese names or terms are left in their original romanizations (typically in the Wade-Giles system) in the following cases: (i) the titles of cited publications; and (ii) the names whose romanizations have been widely and conventionally accepted (such as "Confucius"). The titles of cited Chinese books and essays are given in their *pinyin* transcriptions with their paraphrases given in bracket parentheses. The following rule of thumb has been used in dealing with the order of the surname (family) name and given name in romanized Chinese names: (i) for the name of a historical figures in Chinese history, the surname appears first and the given name second (such as "Zhu Xi"); and (ii) otherwise, the given name appears first and the surname second.

TRANSCRIPTION CONVERSION TABLE

Wade-Giles	Pinyin		Wade-Giles	Pinyin
ai	ei		p	b
ch	zh		p'	p
ch'	ch		szu	si
	q		t	d
hs	x		t'	t
ien	ian		ts, tz	z
-ih	-i		ts', tz'	c
j	r		tzu	zi
k	g		ung	ong
k'	k		yu	you

Introduction

For a long time, Chinese philosophy and Western analytic philosophy, or Western philosophy in the analytic tradition, have been considered to be remote, irrelevant, or even opposed to each other. Many in each tradition have taken philosophical practice in the other tradition to have merely marginal value. For one thing, their reflective modes of thinking and methodological approaches are thought to be sharply contrasted. For another thing, it is also believed that the two philosophical traditions have been concerned with quite different issues. Both considerations point to a series of fundamental philosophical concerns, especially the issue of philosophical methodology. Now, however, as different cultural communities and ideological traditions become closer than ever, the desire to bridge the "gap" between different philosophical traditions and the concern with how they could learn from each other and jointly contribute to a common philosophical enterprise in a complementary way have become pressing in philosophical circles. These concerns are intrinsically linked to the issue of philosophical methodology because, to a large extent, the distinctive perspectives or visions on various issues of different philosophical traditions are related to distinct modes of thinking and/or methodologies. On the other hand, the issue of philosophical methodology has been a fundamental and perennial concern in philosophical reflections. It would be especially rewarding to approach the methodological issue from a broader perspective, beyond the boundary of any one philosophical tradition.

With those concerns, the theme of the current volume consists in three objectives which are closely related in this volume: (1) to investigate the issue of philosophical methodology through a comparative approach; (2) to promote dialogue and understanding among different philosophical traditions and among philosophers with different cultural backgrounds, philosophical trainings, and methodological approaches; (3) more specifically, to study how the two distinctive major philosophical traditions, Chinese philosophy and Western philosophy in the analytic tradition, can learn from each other and jointly contribute to our common philosophical enterprise in a complementary way, especially in connection with methodological guiding principles, perspectives, and instruments.

The key terms involved in the central concern of this volume, "philosophical methodology," "Chinese philosophy," "analytic philosophy," or "analytic methodology," need some preliminary minimal clarification. The term "philosophical methodology" is used here to denote a variety of methodological approaches in philosophical reflective pursuit; and it is meant to cover either various instrumental methods, or distinct methodological perspectives which (are intended to) look to different aspects of the object of study, or methodological guiding principles which are presupposed by philosophers in guiding or regulating how to apply methodological perspectives or instrumental methods. The phrase "Chinese philosophy" is used to cover various movements of philosophical thought in China from its classical period (the last few hundred years of the Zhou Dynasty, roughly mid-eleventh century to 249 B.C.) through the Qing Dynasty (1644–1912) and their contemporary developments. Studies of Chinese philosophy include its contemporary intellectual inquiries as well as its previous scholarship. The phrase "(Western) analytic philosophy" has been used in its narrow sense—meaning the contemporary analytic movement in the twentieth century in the West—or in its broad sense—meaning a mainstream Western philosophy in the analytic tradition from Socrates, Plato, and Aristotle via Descartes, British empiricism, and Kant to the contemporary analytic movement. The term "Western analytic philosophy" is used in its broad sense here, and what it denotes might as well be called "Western philosophy in the analytic tradition." Note that, besides indicating a historical connection between Western philosophy in such a tradition and some methodological approaches taken in this tradition, such phrases *per se* as "Western analytic philosophy" and "Western philosophy in the analytic tradition," used in the title and here, are not intended to imply that those methodological approaches are, intrinsically or conceptually, exclusively connected with Western philosophy. Indeed, the meaning of "analytic methodology" or "analytic methodological approach," among other terms, turns out to be what is at issue in this volume. With the preceding minimal clarification of the meaning of "philosophical methodology" in place, one might tentatively identify "analytic methodology" as a sweeping term referring to the characteristic methodological approach which has historically dominated in the Western analytic tradition. But the reader needs to be alert to what an individual author in this volume might mean by "analytic methodology."

With the fundamental but controversial character of the issues addressed, this anthology emphasizes its openness and serious critical nature without a pre-set orientation or inclination for or against any *ad hoc* methodological approach or orientation. With the distinct or even drastically different points of view presented by its contributors, this volume emphasizes a reflective dialogue among different views for the sake of understanding, further reflection, and philosophical progress. Su Shi, a Chinese poet in the Song Dynasty, once wrote: "One can't recognize what Lushan Mountain really looks like, exactly

because one places oneself in the midst of the mountain high."[1] The saying can be borrowed to capture the point of the critical and comparative approach which this anthology takes to fulfill its goals. Indeed, for that purpose, this anthology endeavors to make a balanced selection of the relevant representative approaches and to enable the central concern to be addressed from different angles. Though the direct focus of the volume is on the relation between Chinese and Western analytic philosophies in connection with philosophical methodology, the authors represent a wide spectrum of metaphilosophical or metamethodological attitudes in the current philosophical scene. This project is the result of an international cooperation and a global philosophical conversation in another sense: The authors come from different geographic regions with their different academic or cultural settings, such as the U.S., mainland China, Hong Kong, Taiwan, and the U.K. Moreover, all the contributed essays except two are previously unpublished pieces written for this volume; various original ideas presented here would significantly contribute to the scholarship concerning the issues addressed in this volume.

The sixteen authors' fifteen contributed essays are organized into four parts, which address the central concern of the volume from different angles but in an interconnected way:

Part I: Philosophy: Discipline and Methodology;

Part II: Chinese Philosophy and Philosophical Analysis (I): Methodological Perspectives;

Part III: Chinese Philosophy and Philosophical Analysis (II): Test Cases;

Part IV: Methodological Issues in Comparative Philosophy.

Note that, because of a close connection among these different parts and the comprehensive character of many of the articles here, the way to organize the entries is not exclusive. The reader might select her own order of reading for the sake of her own specific interest and concern. In the following, let me sketch my organizational strategy and outline how each part is relevant to the theme of this volume and its connection with other parts.

The first part presents a general, metaphilosophical discussion of philosophy as a discipline and its methodological features respectively from certain analytic points of view and from some other lines of thought in the Western tradition and Chinese sources. One consideration is this: The direct case–investigation in this volume is the relation between Chinese philosophy and Western philosophy in the analytic tradition in connection with philosophical methodology; one needs to have a fair understanding of analytic methodology and its contemporary orientations. In their contributions, Nicholas Rescher and Adam

1. See Su Shi's poem "Inscription on the Wall of *Xilinsi* Temple" (my translation).

Morton, two of the most active and productive contemporary analytic philosophers, give the reader a first-hand and updated understanding of contemporary analytic methodology and some of its variants. Rescher characterizes philosophy and its key methodological feature as rational conjecture based on systematic considerations, and he also emphasizes a harmonization of two basic ways of doing philosophy, rhetoric versus demonstration, which seem to be competing but are actually mutually supportive. In an engaging way, Robert Neville criticizes the Cartesian "doctrine of method" in the analytic tradition from some other lines, such as pragmatism and Confucianism; he then reexplains "analytic methodologies" broadly as disciplined argumentation and characterizes philosophical discipline as appropriating philosophical resources, engaging real issues, and proposing hypotheses and making cases for them. The pragmatic spirit and the real-issue concern have also been highlighted by some philosophers in the analytic tradition like Adam Morton. He characterizes philosophy as an engineering-like pursuit and suggests a pragmatic middle way between two competing dominant guiding lines, Quinian versus Strawsonian views, regarding the relation between apriori-constrained common sense and their truth-evidence-concerned theoretical counterpart. From a fundamental metaphysical point of view, Lik Kuen Tong challenges the "dogmatic substantialist" orientation of what he calls "the rationalist-analytic tradition;" in so doing, he systematically presents his Field-Being conception of philosophy, which characterizes philosophy as the human pursuit of *dao*-learning carried to the limits. The four essays in the first part provide the reader with a relatively balanced background as well as insights into how to think critically about the nature of philosophy and its various methodological features.

The essays in the second part directly address the issue of the relation between analytic methodology and (the studies of) Chinese philosophy through their general theoretical discussions of pros and cons. When giving critical examinations of both the analytic approach in the Western tradition and some representative methodological approaches in the Chinese tradition (in the classical or modern periods), each of the authors in this part suggests his own methodological approach to (the studies of) Chinese philosophy, or to general philosophy as well, in a more or less systematic fashion. Both Chung-yin Cheng and Shu-hsien Liu endeavor to integrate hermeneutic and analytic approaches to conduct the studies of Chinese philosophy and bring its valuable insights and visions into a world philosophy; but they make the point in their distinct ways. Cheng provides a systematic theoretic account of his onto-hermeneutic program and illustrates the explanatory force of this approach by sketching how it could treat Quine's philosophy of logic and language as its part and how it could overcome Gettier's Problem in epistemology. Liu illustrates his methodological points by examining the evolution of his own understanding of Chinese philosophy; in so doing, he stresses the methodological

significance of Cassirer-style hermeneutics and of the thesis of *li-yi-fen-shu* (one principle with its many manifestations) of Neo-Confucianism. Taking a pragmatic, historicist, and ethnocentric metamethodological approach, David Hall highlights some contrasting crucial problematic situations in the metanarratives of Chinese and Western analytic traditions (such as "continuity" versus "discreteness") and emphasizes conscious efforts by both parties to create the conditions of mutual appreciation and understanding. From a comprehensive semiotic perspective, You-zheng Li gives a critical examination of contemporary scholarship in the studies of Chinese philosophy; through examining the linguistic, conceptual, disciplinary, and cultural constitution of Chinese philosophy, he explains how an interdisciplinary semiotic approach would bring Chinese philosophy into a more constructive dialogue with Western thought. Note that, in the essays of this part, the very concept of analysis might be understood in a way beyond what philosophers in the analytic tradition usually take it to be; a more or less neutral term, "philosophical analysis" is thus used in the title of this part so as to more adequately cover what the authors intend to deliver.

In the third part, in contrast to the general theoretical pros and cons discussion in the last part, the issue of the relation between analytic methodology and the studies of Chinese philosophy is addressed in another way: Certain analytic strategies are in a broad sense presupposed and applied to some important issues in Chinese philosophy. Distinguishing metaphysical, epistemological, and moral transcendence and elaborating Daoist insights, Chad Hansen argues that moral transcendence in Chinese thought lies in the language of the moral community rather than epistemological transcendence. He characteristically uses a "linguistic" interpretative methodology on the analytic track that highlights the norm of use enshrined in social linguistic practice. In his discussion of self and self-cultivation, Kwong-loi Shun treats early Confucian thought as a coherent body of ideas and focuses on analyzing the interconnections of those relevant ideas; in so doing, he emphatically employs the method of conceptual and linguistic analysis to clarify and elaborate the meanings of those relevant key terms in the early Confucian text. Yiu-ming Fung addresses a quite tough issue: whether or not some central theses involving ultimate concerns, such as the unity of Heaven and humans, should and could be conceptually and logically analyzed. He endeavors to deconstruct what he considers the myths of New Confucianism from an analytic perspective and through several philosophically interesting thought experiments. These treatments, in this volume, are considered to be test cases for whether or not analytic strategy would significantly contribute to our understanding and studies of Chinese philosophy. If the authors' studies here do help us gain in-depth understanding of Chinese philosophy and contribute to philosophical investigation, that would be a convincing mark of the successful application of analytic strategy.

The essays in the fourth part focus on a series of related methodological issues in comparative philosophy, especially in connection with comparative studies of Chinese and Western philosophies. Robert Allinson's contribution focuses primarily on the issue of *how* to look at the nature and status of comparative philosophy. He endeavors to demystify comparative philosophy as a separate discipline apart from philosophy proper and to reconstruct comparative philosophy as integrative philosophy. Ji-yuan Yu's and Nicholas Bunnin's co-authored essay addresses the issue of whether or not there are some general methods by which to conduct comparative studies. The authors endeavor to show how Aristotle's three-step method of "Saving the Phenomena" (establishing the phenomena; analyzing the conflicts among them; and saving the truth contained in all the reputable opinions) can be usefully extended to the area of comparative philosophy. In his essay, Bryan Van Norden challenges Alasdair MacIntyre's thesis of incommensurability regarding different intellectual traditions and makes his points through a case analysis concerning Mencius's and Augustine's seemingly quite disparate explanations of human wrongdoing. My own contribution focuses on the structure of philosophical methodology in view of comparative philosophy through a metaphilosophical analysis of the status and functions of various dimensions of the methodological approach and their relations, illustrated by examining Socrates's and Confucius's cases. Note that the methodological issues addressed in this part and many of the authors' points here are not restricted to the comparative studies of Chinese and Western philosophies but, as a matter of fact, are related to any comparative investigation concerning distinct modes of thinking, methodological approaches, or points of view in different philosophical traditions or within (the complex array of different approaches of) the same tradition. In this way, many points made by the authors in this part have their general methodological import concerning philosophical pursuit.

As emphasized at the outset, all the contributors to this volume are engaged in a reflective dialogue. If it is understood in the fashion of the Socratic dialectic, this dialogue has yet to be completed. For, as Donald Davidson points out,

> there are two vital aspects of the Socratic dialectic which transcend the mere attempt to convict a pretender to knowledge of inconsistency. One is that both participants can hope to profit; the other is that unlike a written treatise, it represents a process which engenders change. . . . There can be a great difference between a dispute involving people who understand each other well, and an exchange in which achieving mutual understanding is a large part of the problem. But there is even greater chasm between an exchange viewed as a situation in which the participants have clear concepts whether or not they use the same words to express those concepts, and an exchange seen as a process in which the concepts themselves come into focus. A written discussion veils this distinction almost completely.

Writing reduces the number of active interpreters to one, the reader, thus elimi-
nating the interaction of minds in which words can be bent to new uses and ideas
progressively shaped.[2]

Davidson's point, if my understanding is right, is not to deny that philosophical
writings can be effectively involved in a philosophical dialogue but to high-
light one aspect of the spirit of the elenctic method: all the participants in a
dialogue, whether the authors or readers in this case, are expected to be open-
minded and sensitive to alternatives so as to progressively shape and refine
ideas. In this sense, the discussion in this volume is a beginning of a dialogue,
rather than its ending. It invites further interaction, reflection, and critique on
the readers' part as well as on the contributors' part.

Bo Mou
Albany, California

2. Donald Davidson, "Dialectic and Dialogue," in G. Preyer et al., eds., *Language, Mind and Epistemology* (Kluwer, 1994), 432.

PART ONE

PHILOSOPHY:
DISCIPLINE AND METHODOLOGY

Philosophical Methodology

Nicholas Rescher

1. Truth-Estimative Conjecture

Philosophers generally pursue their mission of grappling with those traditional "big questions" regarding ourselves, the world, and our place within its scheme of things by means of what is perhaps best characterized as *rational conjecture*. Conjecture comes into it because those questions arise most pressingly where the available information does not suffice—where they are not straightforwardly answerable in terms of what has already been established. What is needed here is an *ampliative* methodology of inquiry—one that is so in C. S. Peirce's sense of underwriting contentions whose assertoric content goes beyond the evidence in hand.[1] We need to do the very best we can to resolve questions that transcend accreted experience and outrun the reach of the information already at our disposal. It thus becomes necessary to have a way for obtaining the best available, the "rationally optimal," answers to our information-in-hand-transcending questions about how matters stand in the world. And experience-based conjecture—theorizing if you will—is the most promising available instrument for question-resolution in the face of imperfect information. It is a tool for use by finite intelligences, providing them not with the best *possible* answer (in some rarefied sense of this term), but with the best *available* answer, the putative best that one can manage to secure in the actually existing conditions in which we do and must conduct our epistemic labors.

Despite those guarding qualifications, the "best available" answer at issue here is intended in a rather strong sense. We want not just an "answer" of some sort, but a viable and acceptable answer—one to whose tenability we are willing to commit ourselves. The rational conjecture at issue is not to be a matter of *mere guesswork,* but one of *responsible estimation* in a strict sense of the term. It is not *just* an estimate of the true answer that we want, but an estimate

Reprinted with permission from Nicholas Rescher, *A System of Pragmatic Idealism*, vol. III: *Metaphilosophical Inquiries* (Princeton University Press, 1994), 36–58.

1. For Charles Sanders Peirce, "ampliative" reasoning is synthetic in that its conclusion goes beyond ("transcends") the information stipulated in the given premises (i.e., cannot be derived from them by logical processes of deduction alone), so that it "follows" from them only inconclusively. See C. Hartshorne and P. Weiss, eds., *Collected Papers*, vol. II (Cambridge, MA, 1931), sect's. 2.680 *et passim*.

that is sensible and defensible: *tenable*, in short. We may need to resort to more information than is actually given, but we do not want to make it up "out of thin air." The provision of reasonable warrant for rational assurance is the object of the enterprise.

In the information-deficient, enthymematic circumstances that prevail when questions must be resolved in the face of evidential underdetermination, we have and can have no logically airtight *guarantee* that the "best available" answer is actually true. Given that such truth-estimation involves transcending the information at hand, we know that rational inference cannot guarantee the truth of its products. (Indeed, if the history of human inquiry has taught us any one thing, it is the disastrous metainduction that the best estimate of the truth that we can make at any stage of the cognitive game all too frequently comes to be seen to be well off the mark with the wisdom of eventual hindsight.) Rational inquiry is a matter of doing no more—but also no less—than the best we can manage to realize in its prevailing epistemic circumstances. Nevertheless, the fact remains that the rationally indicated answer does in fact afford our most promising *estimate* of the true answer—that for whose acceptance as true the optimal overall case be constructed in the circumstances at hand.

The need for such an estimative approach is easy to see. After all, we humans live in a world not of our making where we have to do the best we can with the limited means at our disposal. We must recognize that there is no prospect of assessing the truth—or presumptive truth—of claims (be they philosophical or scientific) independently of the use of our imperfect mechanisms of inquiry and systematization. And here it is *estimation* that affords the best means for doing the job. We are not—and presumably will never be—in a position to stake a totally secure claim to the definitive truth regarding those great issues of philosophical interest. But we certainly can—and indeed must—do the best we can to achieve a reasonable *estimate* of the truth. We can and do *aim* at the truth in our inquiries even in circumstances where we cannot make failproof pretentions to its attainment, and where we have no alternative but to settle for the *best available estimate* of the truth of the matter—that estimate for which the best case can be made out according to the appropriate standards of rational cogency. And *systematization* in the context of the available background information is nothing other than the process for making out this rationally best case. It is thus rational conjecture based on systematic considerations that is the key method of philosophical inquiry, affording our best hope for obtaining promising answers to the questions that confront us.

2. The Problem of Data

It is informative and interesting to approach a philosophical text from the angle of the question of *authority*, and to ask ourselves, line by line and claim by claim: On what sort of basis can the author expect us to accept the assertion

at issue? Is it as a matter of scientific fact, of common sense—of "what every-body should realize," of accepting the assertion of some expert or authority, of intuitive self-evidence, of drawing a suitable conclusion from previously estab-lished facts, or just what? Ultimately, the issue of acceptability is always one of considerations we are expected to endorse or concede because of the plausibility of their *credentials*. And this has many ramifications.

Neither individually nor collectively do we humans begin our cognitive quest empty handed, with a tabula rasa. Be it as single individuals or as entire generations, we always start our inquiries—even in philosophy—with the benefit of a diversified cognitive heritage, falling heir to that great mass of information and misinformation that is the "accumulated wisdom" of our pre-decessors—or those among them to whom we choose to listen. What William James called our "funded experience" of the world's ways—of its nature and our place within it—constitute the *data* at philosophy's disposal in its endeavor to accomplish its question-resolving work. These "data" of philosophy include:

1. Commonsense beliefs, common knowledge, and what have been "the ordinary convictions of the plain man" since time immemorial;

2. The facts (or purported facts) afforded by the science of the day, the views of well-informed experts and authorities;

3. The lessons we derive from our dealings with the world in everyday life;

4. The received opinions that constitute the world view of the day; views that accord with the "spirit of the times" and the ambient convictions characteristic of one's cultural heritage;

5. Tradition, inherited lore, and traditionary wisdom (including religious tradition);

6. The "teachings of history" as best we can discern them.

No plausible source of information about the world and our place within it fails to bring grist to philosophy's mill. The whole range of the (purportedly) established "facts of experience" furnishes the extra-philosophical inputs for our philosophizing—the materials, as it were, for our philosophical reflec-tions.

All of philosophy's data deserve respect: common sense, tradition, general belief, accepted (i.e. well established) prior theorizing—the sum total of the different sectors of "our experience." They are all plausible, exerting some degree of cognitive pressure and having some claim upon us. They may not constitute irrefutably established knowledge, but nevertheless they do have some degree of merit and, given our cognitive situation, it would be very convenient if they turned out to be true. The philosopher cannot simply turn his back on these

data without further ado. Still, even considering all this, there is nothing sacred
and sacrosanct about the data. For, taken as a whole, the data are too much for
tenability—collectively they run into conflicts and contradictions. The long
and short of it is that the data of philosophy constitute a plethora of fact (or
purported fact) so ample as to threaten to sink any ship that carries so heavy a
cargo. For those data are by no means unproblematic. The constraint they put
upon us is not peremptory and absolute—they do not represent certainties to
which we must cling at all costs. What we owe to these data, in the final analysis,
is not *acceptance* but merely *respect*. Even the plainest of "plain facts" can be
questioned, as indeed some of them must be, seeing that, in the aggregate,
they are collectively inconsistent.

Philosophizing accordingly roots in contradiction—in conflicting belief-
tendencies. Philosophical problems arise in a cognitive setting, not wholly of
our making, that is rationally intolerable; the overall aggregate of contentions
we deem plausible involves us in logical inconsistencies. The cognitive situation
is always deeply problematic in its initial and presystemic state. The impetus
to philosophizing arises when we step back to look critically at what we know
(or *think* we know) about the world and try to make sense of it. We want an
account that can optimally accommodate the data—recognizing that it cannot,
in the end, accept them all at face value. Philosophy does not furnish us with
new ground-level facts; it endeavors to systematize, harmonize, and coordi-
nate the old into coherent structures in whose terms we can meaningfully
address our larger questions. The prime mover of philosophizing is the urge
to systemic adequacy—to achieving consistency, coherence, and rational or-
der within the framework of what we accept. Its work is a matter of the *disci-
plining* of our cognitive commitments in order to make overall sense of them—
to render them harmonious and coherent. And so the demands of rational
consistency come to the forefront.[2]

Two injunctions regarding the mission of rational inquiry set the stage for
philosophy:

- Answer the questions! Say enough to satisfy your need for
 information about things.

- Keep your commitments consistent! Don't say so much that some of
 your contentions are in conflict with others.

There is a tension between these two imperatives—between the factors of com-
mitment and consistency. We find ourselves in the discomfiting situation of
cognitive conflict, with different tendencies of thought pulling in divergent

2. This view of philosophy accords closely with the spirit of Aristotle's description of the
enterprise in the opening section of book beta of the *Metaphysics*, with its stress on the centrality
of apories.

directions. The task is to make sense of our discordant cognitive commitments and to impart coherence and unity to them insofar as possible.

Here, then, we come to one of the core issues of the domain. Philosophizing on any topic always moves through two stages. At first, there is a "presystemic" stage, where we confront a group of tentative commitments, all viewed as more or less acceptable, but which are collectively untenable because of their incompatibility. Subsequently, there comes a "systematizing" phase of facing up to the inconsistency of the raw material represented by the "data." And this becomes a matter of eliminative pruning and tidying up where our commitments have been curtailed to the point where consistency has been restored. Those "data" of philosophy are invariably the deliverances of fallible sources of information that afford misinformation as well, so that the process of getting our answers to fit with the data also involves smoothing out the data themselves.

The key task of philosophy is thus to impart systemic order into the manifold of relevant data; to render them coherent, harmonious, and, above all, consistent. One might, in fact, define philosophy as the rational systematization of our beliefs on the issues—the fundamentals of our understanding of the world and our place within it. We become involved in philosophy in our endeavor to make systematic sense of the extra-philosophical "facts"—when we try to answer those big questions by systematizing what we think we know about the world, pushing our "knowledge" to its ultimate conclusions and combining items usually kept in convenient separation. Philosophy is the policeman of thought, as it were, the agent for maintaining law and order in our cognitive endeavors. Its task is to render our "experience" (in the broadest sense of the term) cogent and intelligible.[3]

3. Why Not Simply "Live with Inconsistency"? The Imperative of Cognitive Rationality

The pursuit of rational coherence—consistency, compatibility, comprehensiveness—is the crux of philosophical method. But is this emphasis on structure, order, and logical elegance in fact justified? Is systematic coherence and consistency itself not simply the hobgoblin of small minds. Is it not a mere ornament—a dispensable luxury?

To Alice's insistence that "one can't believe impossible things," the White Queen replied: "I daresay you haven't had much practice. When I was your age, I always did it for half-an-hour a day. Why, sometimes I've believed as many as six impossible things before breakfast." But even with practice, the

3. These aspects of philosophizing are explored at greater length in the author's *The Strife of Systems* (Pittsburgh, 1985).

task is uncomfortable and unsatisfying. A profound commitment to the demands of rationality is a thread that runs through the whole fabric of our philosophizing; the dedication to consistency is the most fundamental imperative of reason. "Keep your commitments consistent" is philosophy's ruling injunction. We don't want just answers, but reasoned answers, defensible answers that square with what we are going to say in other contexts and on other occasions. And this means that we must go back and clean out the Augean stable of our cognitive inclinations, seeing that the commitment to rational coherence is a part of what makes philosophy the enterprise it is.

Yet is consistency itself something altogether fixed and definite? What of the fact that there are different systems of logic? Does this not open up the prospect that one thinker's inconsistency is another's compatibility? Perhaps so. But at this point we must be maximally strict. If even the most fastidious logician discerns problems, we must undertake to worry. In the interests of philosophical adequacy, the propositions we juxtapose must, like Caesar's wife, be above suspicion; if there is *any* plausible basis for charges of incompatibility in *any* viable system of logic, then adjustments are in order.

It must be emphasized that the impetus to rationality does not in any way prejudge the *outcome* of our theorizing. It may well turn out in the end that the "principle of noncontradiction" does not hold of the world; reality as best we can discern it may possibly turn out to be inconsistent. But what is presently at issue is not reality as such, but our *account* of it. Regardless of the world's consistency, our *theory* of it must be self-consistent if it is to merit serious consideration. And here it is important to recognize that thought need not necessarily share the features of its object. A sober study of inebriation is perfectly possible, as is a coherent characterization of the opinions of an incoherent thinker or a consistent characterization of an inconsistent system (where we insert another assertor—perhaps "the nature of things"—between ourselves and those "inconsistent facts"). A coherent theory of an inconsistent reality can perfectly well be contemplated.[4] A methodological insistence on consistency does not prejudge the ontological nature of the real; what is at issue is simply the consistency and coherence of our own deliberations. We might in the end be driven by rational considerations to accept the conclusion that reality is inconsistent, but this is no reason to cease striving for consistency in our *theory* of reality—at any rate until such time as a clear demonstration of the actual impossibility of reaching this goal becomes available.

After all, to endorse a discordant diversity of claims is in the end not to enrich one's position through a particularly generous policy of acceptance, but to impoverish it. To refuse to discriminate is to go empty handed, without answers to our questions. It is not a particularly elevated way of doing philos-

4. To be sure, its details must be wrapped in the intricacies of semantical theory. See Nicholas Rescher and Robert Brandom, *The Logic of Inconsistency* (Oxford, 1979).

ophy—but a way of not doing philosophy at all. For it evades the problems of the field, abandoning the traditional project of philosophy as rational problem solving. We are compelled to systematize our knowledge into a coherent whole by regimenting what we accept in the light of principles of rationality. Philosophizing is a work of reason; we want our problem resolutions to be backed by good reasons—reasons whose bearing will doubtless not be absolute and definitive but will, at any rate, be as compelling as is possible in the circumstances. Reasoning and argumentation are thus the life blood of philosophy. If we do not have a doctrine that is consistent and coherent, then we have nothing.

Of course, no rational guarantee can be issued in advance—prior to any furtherance of the enterprise itself—no categorical assurance that our philosophical efforts at systematizing our knowledge of the world is bound to succeed. The systematicity of our knowledge is (as we shall see) not something that can be guaranteed *a priori*, as having to obtain on the basis of the "general principles" of the matter. The parameters of harmonious systematicity—coherence, consistency, uniformity, and the rest—represent a family of *regulative ideals* towards whose realization our cognitive endeavors do and should strive. But this drive for systematicity is the operative expression of a governing ideal, and not something whose realization can be taken for granted as already certain and settled from the very outset. The extent to which our efforts at philosophy can manage to succeed in achieving the objectives at issue is always "something that remains to be seen"—in *this* regard replicating exactly the situation of natural science.

4. Systematicity and the Impetus to Coherence

Philosophizing is a matter of bringing question-answering commitments into alignment with the varied and often dissonant data of experience. But just how can such a process be expected to work?

The coherentist approach to rational substantiation proceeds by way of a network model that sees a cognitive system as a family of inter-related theses, not necessarily arranged in a *hierarchical* arrangement (as with an axiomatic system), but rather linked with one another by an *interlacing network* of connections. These interconnections are *confirmatory* in nature, but not necessarily *deductive* (since the providing of "good explanatory accounts" rather than "logically conclusive grounds" is ultimately involved).

A network system dispenses with one advantageous feature that characterizes Euclidean systems *par excellence*. Since everything in a deductive system hinges upon the axioms, these will be the only elements that require any independent support or verification. Once they are secured, all else is supported by them. The upshot is a substantial economy of operation: since everything pivots about the axioms, the bulk of our epistemological attention can be confined to

them. A network system, of course, lacks an axiomatic basis, and so lacks this convenient feature of having one delimited set of theses to carry the burden of the whole system upon its shoulders. On the network model, the process of justification need not proceed along a linear path. Its mode of justification is in general nonlinear, and can even proceed by way of (sufficiently large) cycles. Two very different conceptions of explanatory procedure are at issue. The Euclidean approach is geared to an underlying conception of fundamentality or logical dependency in the Aristotelian sense of *priority*, in terms of what is supposed to be "better understood." Its procedure is one of *reduction by derivation*: reducing derivative, "subservient" truths to their more fundamental "master" truths. By contrast, the network appeal is unreductive. Its motto is not "Explanation by derivation" but "Explanation by interrelation."

But even when its linkages operate along wholly deductive lines, a network model would still depart drastically from the geometric paradigm. For from the network standpoint, the classical Euclidean model imposes a drastic limitation in inflating what is at most a *local* feature of derivation from the underived (i.e. *locally* underived) into a *global* feature that endows the whole system with an axiomatic structure. What matters is that the network links theses in a complex pattern of relatedness by means of some (in principle variegated) modes of probative interconnections. The network theorist does not deny that a cognitive system must have a *structure* (how else could it be a system!). But it recognizes that this structure need not be of the form of a rank ordering — that it can provide for the more complex interrelationships that embody a reciprocity of involvement. It is no longer geared to the old hierarchical world picture that envisages a unidirectional flow of causality from fundamental to derivative orders of nature.

An important advantage of a network system over one that is axiomatic/deductive inheres in the former's accommodation of relatively self-contained subcycles. This absence of a rigidly linear hierarchical structure is a source of strength and security. In an axiomatic system a change anywhere ramifies into a change everywhere — the entire structure is affected when one of its supporting layers is removed. But with a network system that consists of an integrated organization of relatively self-sufficient components, certain of these components can be altered without dire repercussions for the whole.[5] C. S. Peirce observed this aspect of network systematization when he wrote:

> Philosophy ought to imitate the successful sciences in its methods, so far as to proceed only from tangible premises which can be subjected to careful scrutiny, and to trust rather to the multitude and variety of its arguments than to the con-

5. Compare Herbert Simon, "The Architecture of Complexity," *General Systems* 10 (1965): 63–76; reptd. in *The Sciences of the Artificial* (Cambridge, MA: MIT Press, 1989), 193–229.

clusiveness of any one. Its reasoning should not form a chain which is no stronger than its weakest link, but a cable whose fibres may be ever so slender, provided they are sufficiently numerous and intimately connected.[6]

On the network-model approach to the organization of information, there is no attempt to erect the whole structure on a foundation of basic elements, and no necessity to move along some unidirectional path—from the basic to the derivative, the simple to the complex, or the like. One may think here of the contrast between the essentially linear order of an expository book, especially a textbook, and the inherently network-style ordering of an entire library or an encyclopedia. Again, the contrast between a taxonomic science (like zoology or minerology) and a deductive science (like classical celestial mechanics) can also help to bring out the difference between the two styles of cognitive organizations.

One vivid illustration of the network approach to organizing information comes from textual interpretation and exegesis. Here there is no rigid, linear pattern to the sequence of consideration. The whole process is iterative and cyclical; one is constantly looking back to old points from new perspectives, using a process of feedback to bring new elucidations to bear retrospectively on preceding analyses. What determines correctness here is the matter of over-all fit, through which every element of the whole interlocks with some others. Nothing need be more fundamental or basic than anything else: there are no absolutely fixed pivot points about which all else revolves. One has achieved adequacy when—through a process that is continually both forward and backward looking—one has reached a juncture where everything stands in due mutual coordination with everything else. The key operative idea is that of *explanation through systematization*—i.e. solving the puzzle by "getting all the pieces to fit properly" so that a comprehensive picture emerges which "makes sense" by putting everything into place.

Network systematization is best approached in the light of a contrast between two profoundly different approaches to the cognitive enterprise which, for want of better choices, might be called the *expansive* and the *reductive*, respectively.[7]

The *expansive* strategy searches for a suitable basis of highly secure and unproblematically acceptable propositions that are acceptable as "true beyond reasonable doubt." Given such a carefully circumscribed and tightly controlled starter-set of secure propositions, one proceeds to move outwards ampliatively by making inferences from this secure starter set. The resulting picture is illustrated by display 1.

6. C. S. Peirce, *Collected Papers*, vol. V (Cambridge, MA, 1934), sect. 5.265.
7. Compare the author's treatment of data in *The Coherence Theory of Truth* (Oxford, 1973) and *Plausible Reasoning* (Assen, 1976), where the relevant issues are treated in considerable detail.

Display 1

THE EXPANSIVE APPROACH

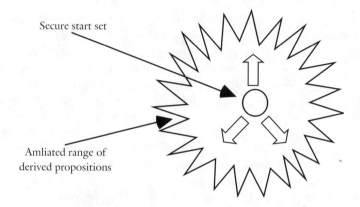

Secure start set

Amliated range of
derived propositions

We here proceed by moving expansively outward from the secure home base of an entirely unproblematic core. This is the classical foundationalist approach of mathematics. It will not do in philosophy. Here we must look elsewhere—to coherentism.

By contrast with the expansive approach of traditional foundationalism, the reductive strategy proceeds in exactly the opposite direction. It abandons the quest for an initial starter-set of secure and unproblematically acceptable truths. Instead its starting point is a relatively generous and undemanding quest for well-qualified candidates or prospects for truth. Thus at the outset, one does not require contentions that are certain and altogether qualified for recognition as genuine truths, but rather propositions that are no more than plausible, initially promising candidates for endorsement that exert an attraction on us at first view. Of course, not all of these inherently meritorious truth-candidates are to be endorsed or accepted as true, seeing that we recognize from the very outset that we cannot simply adopt the whole lot, because they are competing and conflicting—mutually contradictory. What we have to do is to impose a delimiting (and consistency-restoring) screening-out that separates the sheep from the goats until we are left with something that merits endorsement. And here we proceed by way of diminution or compression. As display 2 indicates, this approach reflects a coherentism that is the inverse of the expansive approach of traditional foundationalism. For the reductive approach proceeds by *narrowing* that over-ample range of plausible prospects for endorsement. The process is one of pruning and elimination by means of evaluations based on considerations of harmony and best fit—a reduction of overdeterminative data through the use of the parameters of systematization

Display 2

THE REDUCTIVE APPROACH

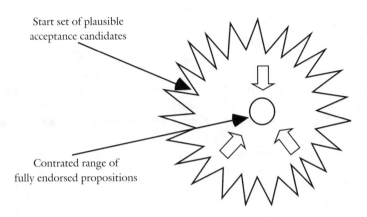

Start set of plausible
acceptance candidates

Contrated range of
fully endorsed propositions

as guides to plausibility. Using guideposts like simplicity, uniformity, regularity, analogy, and the like, we prime the data with a view to endowing the residually, retained data with as much order and harmony as is achievable in the circumstances. The coherence theory thus implements F. H. Bradley's dictum that *system* (i.e. systematicity) provides a test-criterion most appropriately fitted to serve as arbiter of truth.

As we have seen, it is the overdeterminative situation of a collective inconsistency of "the data" that characterizes the problem situation of philosophy, so that the coherentist methodology affords the most natural approach to the epistemology of the field. The process of deriving significant and consistent results from an inconsistent body of information is a key feature of the coherence theory of truth, which faces (rather than, with standard logic, evades) the question of what inferences can appropriately be drawn from an inconsistent body of information. The initial mass of inconsistent information are the data for applying the mechanism of coherence as a criterion of truth, and its product is a consistent system of acceptable truths. Such an approach assumes an entirely *inward* orientation: it does not seek to compare the truth candidates directly with "the facts" obtaining outside the epistemic context; rather, having gathered in as much information (and this will include also *misinformation*) about the facts as possible, it seeks to sift the true from the false *within* this body.

The coherentist approach unhesitatingly espouses the historic thesis that knowledge is "true, justified belief," construing this as tantamount to claiming that the known is that whose acceptance as true is adequately warranted *through an appropriate sort of systematization*. However, since the systematization at issue is viewed as being of the network type, the impact of the thesis is drastically

altered. For we now envisage a variant view of justification, one which radically reorients the thesis from the direction of the foundationalists' quest for an ultimate basis for knowledge as a quasi-axiomatic structure. Now "justified" comes to mean not "derived from basic (or axiomatic) knowledge," but rather "appropriately interconnected with the rest of what is known." Philosophizing thus consists in a rational rebuilding of the structure of our beliefs in the effort to do what we can to erect a solid and secure structure out of the ill resolved contents placed at our disposal by our initial restrictions to belief. On this approach, the validation of an item of knowledge—the rationalization of its inclusion alongside others within "the body of our knowledge"—proceeds by way of exhibiting its interrelationships with the rest: they must all be linked together in a connected, mutually supportive way (rather than having the form of an inferential structure built up upon a footing of rock-bottom axioms).

While the paradigm procedure for ampliative reasoning is *plausibilistic and inductive* (with a fall-back position to merely probabilistic inference in problem cases) the paradigm procedure for contraction is *dialectical argumentation*. To effect the necessary reductions we do not proceed via a single inferential chain, but through backing and filling along complex cycles of reasoning which criss-cross over the same ground from different angles of approach in their efforts to identify and eliminate the weak spots. The object of the exercise is to determine how smoothly and harmoniously a thesis can be enmeshed in the overall fabric of diverse and potentially discordant and competing contentions. We are now looking for the best candidates among competing alternatives—for that resolution for which, on balance, the strongest overall case can be made out. It is this second, reductive, approach that typifies the procedure of philosophy. Here, accordingly, it is not "the uniquely correct answer" but "the least problematic, most defensible position" that we seek. And the crux of our standard of acceptance lies, as we have seen, not with the issue of secure premisses but with the issue of sensible conclusions—results that fit most smoothly and harmoniously within our overall commitment to the manifold "data" at stake in philosophical matters.

One further important point should also be stressed in this connection. To someone accustomed to thinking in terms of a sharp contrast between organizing the information already in hand and an active inquiry aimed at extending it, the idea of a *systematization of conjecture with experience* may sound like a very conservative process. This impression would be quite incorrect. Inquiry—and philosophical inquiry above all—must not be construed to slight the dynamical aspect. And systematization itself is an instrument of inquiry—a tool for aligning question-resolving conjecture with the (of itself inadequate) data at hand. The factors of completeness, comprehensiveness, inclusiveness, unity, etc. are all crucial aspects of system, and the ampler the information-base, the ampler is the prospect for our systematization to attain them. The drive to system embodies an imperative to broaden the range of our experience, to

extend and expand the data-base from which our theoretical triangulations proceed. In the course of this process, it may well eventuate that our existing systematizations—however adequate they may seem at the time—are untenable and must be overthrown in the interest of constructing ampler and tighter systems. Philosophical systematization is emphatically not a blindly conservative process which only looks to what fits smoothly into heretofore established patterns, but one where the established patterns are themselves ever vulnerable and liable to be upset in the interests of devising a more comprehensive systematic framework.

5. On Validating First Principles

To be sure, rational inquiry meets with difficulties in this domain. All too clearly, the first principles from which our inquirers set out cannot be validated with reference to further considerations that are yet more basic. (This is so by hypothesis—if they could be established in this way, they would not be "first" or basic.) Little probative headway can thus be made by trying to provide any sort of "derivation" of these principles by recourse to premises in whose establishment these principles will themselves figure in their characteristic regulative role. And so, since first principles cannot be justified in terms of other, more fundamental premises, they must be justified in terms of their own consequences. Their validation requires a systemic approach. In particular, such principles must be able to *accommodate experience* in smooth attunement to the concrete interactions through which the world's realities make their impact upon us. It must thus be shown that if the principle is rejected then either (1) certain eminently desirable results will be lost, or (2) certain highly negative results will ensue. Accordingly, such principles can only be validated in terms of the unacceptable implications of their abandonment. In sum, first principles are to be judged by how smoothly they fit into the explanatory rationale of our experience with a view in particular to the question of how efficient an instrumentality they provide for the overall explanation and systematization of that experience. The crux here is that our first principles must not only meet the conditions of theoretical systematicity but must do so with reference to experience.

The dialectical process at issue may be clarified in a schematic way as follows. One begins with the presumptive "trial assumption" or "provisional hypothesis" of a certain cognitive mechanism—an instrumentality (process, method) for issue-resolution. One then proceeds to employ this instrumentality so as to determine a body of putative knowledge—an overall system. Thereupon, one deploys this knowledge to provide a rational accommodation for our "experience"—an information at large. Then, one *revises* the initial "trial assumption" (provisional hypotheses) with a view to the successes and failures of these applications. And then starts the process all over again at the first step. What is

at issue throughout is not just a merely *retrospective revalidation* in the theoretical order of justification, but an actual *revision or improvement* in the dialectical order of development, a cognitive upgrading of suppositions initially adopted on a tentative basis.

Reflection on this process makes it clear that if *this* is how the first principles of inquiry in question-resolution are legitimated, then the status of such principles is defeasible in the light of "the course of experience"—it becomes *a posteriori* and contingent. This circumstance is one whose importance cannot be overemphasized. It means that no particular formulation of a philosophical position—no explicitly stated substantive resolution to a philosophical problem—can be altogether adequate as it actually stands, without further explanation, qualification, and explanatory exposition. Further questions will always arise that need to be addressed in the larger scheme of things.

Descartes says that only physical things and intelligent beings exist. But what then of animals? Plato maintains that mathematical objects like shapes and numbers exist in a separate realm altogether apart from the material world. But how then can we embodied humans know them? Once a substantive philosophical thesis is formulated, further questions about its meaning, implications, bearing, and purport will always arise. As it stands, in its actual and overt formulation, the thesis is not complete, not quite correct, not altogether adequate to what needs to be said on the subject. Under the pressure of an ongoing readjustment to an ever-widening context of considerations, it admits of various alternative interpretations, constructions, elaborations; it presents further issues that must be resolved; it requires explanation, exposition, qualification. Taken just as it stands, without further elaboration, the exposition is not satisfactory: it leaves loose ends and admits of undermining objections.

In examining our first principles—and thus the philosophical theses that hinge upon them—we accordingly embark on a cyclic (and thus in theory non-terminating) process of elaboration and reformulation:

(re)formulation elaboration

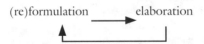

Such a dialectic of contention and elaborative explanation engenders in ever more fine-ground detail the inner commitments and involvements of the initial position that was the starting point of our endeavor to answer the philosophical question at issue. With any substantive philosophical issue, the intellectual game of problem-solving and issue resolution can thus be played at ever more elaborate levels of sophistication.

The ongoing elaboration of a philosophical position constitutes a process of expository development that brings its various aspects into clearer and sharper focus. The continuing development of conceptual machinery provides a process

of *ideational* magnification analogous to the process of perceptual magnification that accompanies the ongoing development of the physical machinery of microscopy. And there is no reason of principle why this process of ongoing elaboration and sophistication need ever stop; it can continue as long as our patience and energy and interest hold out. When we stop, it is because we are sufficiently wearied to rest content, and not because the project as such is completed.

It emerges on this perspective that the first principles that are basic to philosophical understanding are "first" (and ultimate questions "ultimate") only in the first instance or in the first analysis and not in the final instance and the final analysis. Their firstness represents but a single "moment" in the larger picture of the dialectic of legitimation. They do not mark the dead-end of a *ne plus ultra* that admits no further elaboration and substantiation. The question "Why these principles rather than something else?" is certainly *not* illegitimate here. It is something we cannot only ask but also answer, even if only provisionally and imperfectly, in terms of the complex dialectic afforded by the cyclic structure of legitimation as sketched above.

This approach indicates that philosophy should be seen as being, in the end, erected on a contingent and ultimately factual basis. Its determinative first principles and their correlative substantive doctrinal contentions are seen as defeasible and defensible: they can and need to be legitimated—a process that proceeds in the light of empirical considerations. Forming, as they do, an integral component of the cognitive methods that have evolved over the course of time, it can be said of them—as of other strictly methodological instrumentalities—that "*die Weltgeschichte ist das Weltgericht*," or, loosely translated, "The proof of the pudding is in the eating." (Recall too Hegel's penetrating dictum that metaphysics must follow experience and not precede it.)

These observations go no farther than to say that circumstances *could* arise in which even those very fundamental first principles that define for us the very idea of a philosophical category might have to be given up. But to concede the *possibility* is not—of course— to grant the likelihood—let alone the reality. Once entrenched, the principles at issue are so integral a component of *our* rationality that we ourselves cannot even conceive of *any* rationality that dispenses with them: we can readily conceive *that* they might have to be abandoned, but can scarcely conceive *how*. Thus to concede the in-principle defeasibility of these principles does nothing to undermine their indispensibility for us now, in the present state of the art in our inquiries.

6. The Test of Systematization

The flaws and failings that one can in principle encounter in philosophizing are many. There are flaws of issue-formulation (ignoring issues, distorting issues), in data management (inappropriately bestowing or denying credence, for example by "flying in the face of plain fact" or failing to reckon appropriately

with technical or scientific knowledge), in position construction (oversimplifying or overcomplicating one's resolutions of problems relative to the data—in the extreme case by actually contradicting oneself). Then too there are flaws of argumentation (in reasoning for one's conclusions or in refuting counter-argumentation), and flaws in dialectics (in giving too short a shrift to unpopular issues or assaulting one's opponents position only at their weakest spots without reckoning with their strengths). But all such flaws are, in the end, so many procedural failures within the setting of one large project: that of systematization. For the strength and weakness of a philosophical position comes down to the extent to which it is developed systematically in relation to the problems it confronts and to the rival alternative resolutions that it outweighs.

To obtain a clearer view of the underlying rationale for systematization as the instrument of truth-estimative conjecture in philosophy, let us glance back once more to the epistemological role of systematicity in its historical aspect. The historical point of departure here was the classical view that the principle of *adaequatio ad rem* is to be such construed as to mean that since reality is systematic, an adequate account of it will also be so. On this basis, philosophers long saw system as a crucial aspect of truth, stressing overall systematicity of "the truth," and holding that the totality of true theses must constitute a cohesive system. This classical approach viewed systematization as a two-step process: first determine the truths, and then systematize them. (Think of the analogy of building: first assemble the bricks, then build the wall.) With the tradition from Leibniz through Kant to Hegel, however, we come to a reversal of this approach. We now move beyond "*true → systematic*" to embrace the reverse transition "*systematic → true.*" Fit itself affords the criterion of rightness. From a *desideratum of the organization* of our body of (presumed) factual knowledge, systematicity accordingly came to be metamorphosed into *a qualifying test of membership*—a standard of facticity.[8] The effect of this Hegelian inversion of the traditional relationship of systematicity to truth is to establish "the claim of system as an arbiter of fact," to use F. H. Bradley's apt expression.

Beginning with the implication-thesis that what belongs to "our knowledge" can be systematized, we are to transpose it into the converse: If a proposition is smoothly co-systematizable with the whole of our (purported) knowledge , then it should be accepted as a part thereof.

From being a characteristic of "accepted knowledge" (as per the regulative idea that a body of knowledge-claims cannot properly qualify as such if it lacks a systematic articulation), systematicity is now transmuted into a testing standard of (presumptive) truth—an acceptability criterion. The key idea at issue is a transformation of systematicity from a framework for *organizing* knowledge into a mechanism for *determining* adequate knowledge-claims. Fit, attunement,

8. Compare F. H. Bradley, "On Truth and Coherence," in *Essays on Truth and Reality* (Oxford, 1914), 202–18.

and systematic connection thus become the determinative criteria for assessing the acceptability of claims, the monitors of cognitive adequacy.

This idea of systematicity as an *arbiter* of knowledge was implicit in Hegel himself, and developed by his followers, particularly those of the English Hegelian school inaugurated by T. H. Green. This Hegelian inversion leads to one of the central themes of the present discussion—the idea of using systematization as a control of substantive knowledge. F. H. Bradley put the matter as follows:

> The test [of truth] which I advocate is the idea of a whole of knowledge as wide and as consistent as may be. In speaking of system [as the standard of truth] I always mean the union of these two aspects [of coherence and comprehensiveness] . . . [which] are for me inseparably included in the idea of system. . . . Facts for it [i.e., my view] are true . . . just so far as they contribute to the order of experience. If by taking certain judgements . . . as true, I can get some system into my world, then these "facts" are so far true, and if by taking certain "facts" as errors I can order my experience better, than these "facts" are errors.[9]

The plausibility of such an approach is easy to see. Pilate's question is still relevant. How are we humans—imperfect mortals dwelling in this imperfect sublunary sphere—to determine where "the real truth" lies? The Recording Angel does not whisper it into our ears. (If he did, I doubt that we would understand him!) The consideration that we have no *direct* access to the truth regarding the *modus operandi* of the world we inhabit is perhaps the most fundamental fact of epistemology. We must recognize that there is no prospect of assessing the truth—or presumptive truth—of knowledge claims independently of our efforts at systematization in rational inquiry. The Hegelian idea of truth-assessment through systematization represents a determined and inherently attractive effort to adjust and accommodate to this fundamental fact.

On this approach, then—to which the present view of philosophizing as truth-estimative conjecture fully conforms—the assurance of inductively authorized contentions turns exactly on this issue of tightness of fit: of consilience, mutual interconnection, and systemic enmeshment. Systematicity becomes our test of truth, the guiding standard of the truth-estimation at issue in the process of "rational conjecture" that defines philosophizing. Our "picture of the real" is thus taken to emerge as an intellectual product achieved under the control of the idea that systematicity is a regulative principle for our theorizing. Here, evidentiation and systematicity are inextricably correlative.

To be sure, the line of approach at issue here has weakened the move from systematicity to truth somewhat. For its epistemological position moves from systematicity not to correctness itself, but rather to *the rational warrant of claims*

9. Bradley, "On Truth and Coherence," op. cit., 202–18; see 202–3 and 210.

to correctness. The operative transition is not from "systematic" to "correct," but rather from "systematic" to "rationally claimed to be correct." The role of systematicity is, in the first instance, epistemic (and only derivatively ontological). The "best available answer" at issue through the systematization of experience is so only in the sense of affording us the best available *estimate* of the truth that we can make in the circumstances—which, being the most we can possibly obtain, is (or should be) sufficient to content us.

7. Rhetoric vs. Demonstration: The Complexity of Systemic Justification

The fact is that philosophy cannot provide a rational explanation for *everything*, rationalizing all of its claims "all the way down." Sooner or later the process of explanation and rationalization must—to all appearances—come to a halt in the acceptance of unexplained explainers. David Hume, for example, wrote that the power of the imagination in collecting ideas and presenting them to consciousness is directed "by a kind of magical faculty in the soul, which, tho' it be most perfect in the greatest geniuses, and is properly what we call a genius, is however inexplicable by the utmost efforts of human understanding."[10] And in a similar view, Immanuel Kant proclaimed "how in a thinking subject *outer intuition*, namely that of space, with its filling in of shape and motion, is possible . . . is a question which no man can possibly answer" (*C. Pu. R.*, A 393). And again "the question . . . of how in general a communion of [interacting] substances is possible . . . is a question which . . . [one] will not hesitate to regard as likewise lying outside the field of all human knowledge" (ibid., B 428). Among seventeenth-century philosophers (Descartes, Berkely, Leibniz) such insolubilia were standardly laid at the door of God. Nor have the philosophers of a more recent time given up on characterizing certain facts as inexplicable.[11]

Now if we think of explanation as proceeding linearly, in the manner of logical derivation, by explaining A in terms of B which is in its turn explained in terms of C, and this in turn referred to D, then of course we must accept some inexplicable ultimate—unless we are to descend into an infinite regress. But if we are prepared to think of explanation as holistically systemic, then we can explain each of the group A, B, C, D, in terms of its being optimally attuned to all the rest in their collective wider context. And this means that we must accept some contentions *prospectively*—not because they rest on solid established grounds but because they lead to promising results—because they have

10. David Hume, *A Treatise of Human Nature*, ed. by L. A. Selby-Bigge (Oxford, 1967), 24.
11. The scientific intelligibility of nature, for example. See the discussion of this issue in the author's *The Riddle of Existence* (Langham, MD, 1987).

a certain systemic plausibility about them within the overall setting in which they figure.[12]

This fact that philosophical exposition cannot in the end operate satisfactorily in the linear manner of an axiom system proceeding from a starter-set of self-evident truths is reflected in the nature of philosophical exposition. There are two very different modes of writing philosophy. The one pivots on inferential expressions such as "because," "since," "therefore," "has the consequence that," "and so cannot," "must accordingly," and the like. The other bristles with adjectives of approbation or derogation—"evident," "sensible," "untenable," "absurd," "inappropriate," "unscientific," and comparable adverbs like "evidently," "obviously," "foolishly," etc. The former relies primarily on inference and argumentation to substantiate its claims, the latter primarily on the rhetoric of persuasion. The one seeks to secure the reader's (or auditor's) assent by reasoning, the other by an appeal to values and appraisals—and above all by an appeal to fittingness and consonance within the overall scheme of things. The one looks foundationally towards secure certainties, the other coherentially towards systemic fit with infirm but nevertheless respectable plausibilities. Like inferential reasoning, rhetoric too is a venture of justificatory systematization, albeit one of a rather different kind.

Consider the following passage from Nietzsche's *Genealogy of Morals* (with characterizations of approbation/derogation indicated by being italicized):

> It is in the sphere of contracts and legal obligations that the moral universe of guilt, conscience, and duty, (*"sacred" duty*) took its inception. Those beginnings were *liberally sprinkled with blood*, as are the beginnings of *everything great on earth*. (And may we not say that ethics has never lost its *reek of blood* and torture—not even in Kant, whose categorical imperative *smacks of cruelty*?) It was then that the *sinister knitting together* of the two ideas guilt and pain first occurred, which by now have become quite inextricable. Let us ask once more: in what sense could pain constitute repayment of a debt? In the sense that to make someone suffer was *a supreme pleasure*. To behold suffering gives pleasure, but to cause another to suffer affords an *even greater pleasure*. This *severe statement* expresses an old, powerful, *human, all too human sentiment*—though the monkeys too might endorse it, for it is reported that they heralded and preluded man in the devising of *bizarre cruelties*. There is no feast without cruelty, as man's entire history attests. Punishment, too, has its *festive features*.[13]

Not only is the passage replete with devices of evaluative (i.e. positive/negative)

12. This coherentist aspect of philosophical methodology will be dealt with in more detail in the next chapter.
13. Friedrich Nietzsche, *The Genealogy of Morals*, Essay II, Sect. 6.

characterizations, but observe too the total absence of inferential expressions. We are, clearly, *invited* to draw certain unstated evaluative conclusions. But the inference, "Man is by *nature* given to cruelty, and therefore cruelty—being a natural and congenial tendency of ours—is not something bad, something deserving condemnation," is left wholly implicit. This conclusion at which the discussion aims is hinted at but never stated, implied but never maintained. In consequence, reason can gain no fulcrum for pressing the plausible objection: "And why should something natural automatically be therefore good: why should the primitiveness of a sentiment or mode of behavior safeguard it against a negative evaluation?" By leaving the reader to his own conclusion-drawing devices, Nietzsche relieves himself of the labor of argumentation. Not troubling to formulate his position, he feels no need to give it *support*; he is quite content to *insinuate* it.

By contrast to the preceding Nietzsche passage, consider the following ideologically kindred passage from Hume's *Treatise* (with evaluative terms italicized and inferential terms capitalized):

> Now, SINCE the distinguishing impressions by which moral good or evil is known are nothing but particular pains or pleasures, IT FOLLOWS that in all inquiries concerning these moral distinctions IT WILL BE SUFFICIENT TO SHOW the principles which make us feel a satisfaction or uneasiness from the survey of any character, IN ORDER TO SATISFY US WHY the character is *laudable* or *blamable*. An action, or sentiment, or character, is *virtuous* or *vicious*; WHY? BECAUSE its view causes a pleasure or uneasiness of a particular kind. In giving a reason, THEREFORE, for the pleasure or uneasiness, we sufficiently explain the vice or virtue. To have the sense of virtue is nothing but to feel a satisfaction of a particular kind from the contemplation of a character. The very feeling constitutes our praise or admiration. We go no further; nor do we inquire into the cause of the satisfaction. WE DO NOT INFER a character to be *virtuous* BECAUSE it pleases; but in feeling that it pleases after such a particular manner we in effect feel that it is *virtuous*. The case is the same as in our judgments concerning all kinds of beauty, and tastes, and sensations. Our approbation is IMPLIED in the immediate pleasure they convey to us.[14]

While for Nietzsche cruelty is effectively a virtue only because people are held to be generally pleased by engaging in its practice, for Hume it is something negative only in that people are generally displeased by witnessing it. The positions differ but their ideological kinship is clear; both writers agree that cruelty is not something that is inherently bad as such—for them the pro- or con-reaction by people is all-determinative.

14. David Hume, *Treatise of Human Nature*, Bk. III, Pt. I, Sect. 2.

But what is also clear is that these kindred positions are advanced in very different ways. In the Nietzsche passage, the "argumentation ratio" of inferential to evaluative expressions is 0:12, in the Hume passage it is 9:6. Hume, in effect, seeks to *reason* his readers into agreement by a deduction from "plain facts"; Nietzsche seeks to *coax* them into it by an appeal to conceded suppositions and prejudgments.

Reflection on the contrast between the argumentative and the rhetorical modes of philosophical exposition leads to the realization that these two styles are congenial to rather different objectives. The demonstrative/argumentative (inferential) mode is efficient for securing a reader's assent to certain claims, to influencing one's *beliefs*. The rhetorical (evocative) mode is optimal for inducing a reader to adopt certain preferences, to shaping or influencing one's *priorities and evaluations*.

The *apodictic* (argumentative or probative) mode of philosophical exposition is by nature geared to enlisting the reader's assent to certain theses or theories. It is coordinated to a view of philosophy that sees the discipline in *information-oriented* terms, as preoccupied with the answering of certain questions: the solution of certain cognitive problems. It aims primarily to *convince* by way of reasoning.

By contrast, the rhetorical, *prohairetic* (preferential or evocative) mode of philosophical exposition is by nature geared to securing acceptance with respect to *evaluations*: to enlisting the reader's agreement to certain priorities or appraisals. It is preoccupied with evaluation, with forming—or reforming— our sensibilities with respect to the *value* and, above all, the *importance* of various items. It is bound up with a view of philosophy that sees the discipline in *axiological* terms, as an enterprise that has as its prime task the securing of certain evaluative determinations and the establishment of certain prizings and priorities. It aims primarily to *induce* people to an evaluative standpoint. It exerts its appeal not in reasoning from prior philosophical givens, but rather by rhetorical means that exert their impetus *directly* upon the cognitive values and sympathies that we have fixed on the basis of our experience of the world's ways.[15]

To exert rational pressure on a reader's sensibilities without using arguments that are themselves already value-invoking, one must appeal to the persuasive impetus of this person's body of experiences. Here too providing information can help—but only by way of influencing the sensibility, the reader's way of looking at things and appraising them through an appeal to things one already knows perfectly well. Accordingly, it is here that the rhetorical method comes into its own by enabling an exposition to appeal to— and if need be influence and modify—a reader's body of experiences in order

15. Compare Henry W. Johnstone, *Philosophy and Argument* (State College, PA; 1959).

to induce a suitable adjustment of evaluations. There are, of course, many ways to realize this sort of objective. A collection of suitably constituted illustrations and examples, a survey of selected historical episodes that serve as instructive case studies ("History teaching by examples"), or a vividly articulated fiction can all orient a reader's evaluative sentiments in a chosen direction—as the philosophical methodology of Ludwig Wittgenstein amply illustrates. And so, of course, can pure invective, if sufficiently clever in its articulation. What matters is that our agreement is elicited via the fact that something is rendered plausible and acceptable through its consonance with duly highlighted aspects of our experience—so that the course of our experience itself invites and elicits acceptance.

Since two distinct views of the mission of the enterprise are at issue with the demonstrative and evocative approaches to philosophy, any debate over the respective merits of the two modes of philosophical exposition is thereby inseparable from a dispute about the nature of philosophy. The quarrel is ultimately one of ownership: to whom does the discipline of philosophy properly belong, to the argumentative demonstrators or to the evocative rhetoricians?

This contest over the ownership of philosophy has been going on since the very inception of the subject. Among the pre-Socratics, the Milesians founded a "nature philosophy" addressed primarily at issues we should nowadays classify as scientific, while such thinkers as Xenophanes, Heraclitus, and Pythagoras took an evaluative—evocative and "literary"—approach to philosophy, illustrated by the following dictum which Kirk and Raven affiliate with Pythagoras:

> Life is like a festival; just as some come to the festival to compete, some to ply their trade, but the best people come as spectators, so in life slavish men go hunting for fame or gain, the philosophers for the truth.[16]

In nineteenth-century German philosophy, Hegel and his school typified the scientific/demonstrative approach, while the "postmoderns" who were their opponents—Schopenhauer, Kierkegaard, Nietzsche—all exemplify the axiological/rhetorical approach. In the twentieth century, the scientistic movement represented by logical positivism vociferously insisted on using the methodology of demonstration, while their anti-rationalistic opponents among the existentialists and also among the neo-Romantic theoreticians of Spain (preeminently including Unamuno and Ortega y Gasset) restored extensively to predominantly literary devices to promulgate their views—to such an extent that their demonstration-minded opponents sought to exile their work from philosophy into literature, journalism, or some such less "serious" mode of intellectual endeavor.

16. G. S. Kirk and J. E. Raven, *The Presocratic Philosophers* (Cambridge: Cambridge University Press, 1957), frag. 278.

In this connection we see as clearly as anywhere else the tendency among philosophers towards defining the entire subject in such a way that their own type of work is central to the enterprise and that their own favored methodology becomes definitive for the way in which work in the field should properly be done. The absence of that urbanity which enables one to see other people's ways of doing things as appropriate and (in *their* circumstances) acceptable is thus perhaps the most widespread and characteristic failing of practicing philosophers. But the fact remains that while individual *philosophers* generally have no alternative but to choose one particular mode of philosophizing as focus of their allegiance, *philosophy* as such has to accommodate both. Philosophy as such is broader than any one philosopher's philosophy.

The irony of the situation is that philosophers simply cannot dispense altogether with the methodology they affect to reject and despise. Even the most demonstration-minded philosopher cannot avoid entanglement in evaluation by rhetorical devices. For even the most rationalistic of thinkers cannot argue demonstratively for everything, "all the way down," so to speak. At some point a philosopher must invite assent through an appeal to sympathetic acquiescence based on experience as such. On the other hand, even the most sentimental philosopher cannot altogether avert argumentation. For a reliance on certain *standards* of assessment is inescapably present in those proffered evaluations, and this issue of appropriateness cannot be addressed satisfactorily without some recourse to reasons. Ironically then, the two modes of philosophy are locked into an uneasy but indissoluble union. While neither the logical (demonstrative) nor the rhetorical (evocative) school can feel altogether comfortable about using the methodology favored by the other, it lies in the rational structure of the situation that neither side can manage altogether to get on without it. The practice of philosophy is ultimately a matter of striving for a smooth systemic closure between the projections of reason and the data of experience—a harmonization in which the two modes of philosophizing come into mutually supportive overall harmonization.[17]

17. Some of the themes of this essay are developed more fully in the author's *Cognitive Systematization* (Oxford, 1979).

Methodology, Practices, and Discipline in Chinese and Western Philosophy

<div style="text-align:right">2</div>

Robert Cummings Neville

1. The Problem

The theme of this volume, Chinese philosophy and analytic methodology, is as creatively ambiguous as it is important. Its importance lies in promoting scholarly comparisons of Chinese and Western philosophies as background for integrating both into a larger world conversation of philosophy. The ambiguities have to do with what counts as Chinese philosophy and what counts as analytic methodology.

The problem from the Western side for what counts as Chinese philosophy is that philosophy might be defined so narrowly as to exclude all genres of Chinese thinking. Lawrence E. Cahoone, for instance, has written the subtlest book to date on the internal struggle of Western philosophy to fulfill its essential aim, which according to him is to know everything, at least abstractly, and to know that we know and why we know.[1] His point is not to laud the Western philosophic tradition. On the contrary, he shows that and how it fails in the work of its great late-modern defenders: Peirce, Nietzsche, Wittgenstein, Buchler, Derrida, and Rorty, and he makes no comments whatsoever on Chinese philosophy. If Chinese philosophies were to be registered on the grids of his rather analytic classifications of philosophical " . . , isms" and " . . . ologies," most would fall within the position he calls "nonfoundational realism." Nonfoundational realism, as he defines it, claims philosophical knowledge about the world but does not claim absolute self-reflexive certainty or comprehensiveness.[2] He argues that nonfoundational realism is untenable and hence he would not have a high regard for nonfoundational realist Chinese philosophies were he to regard them as philosophies at all. He might admit them as inquiries into "practice" or "aesthetics," but that is not philosophy for him. If "analytic argument" is construed according to something like Cahoone's

1. Lawrence E. Cahoone, *The Ends of Philosophy* (Albany: State University of New York Press, 1995), introduction, chap. 1, and *passim*.
2. Ibid., chap. 4.

reading of the history and nature of Western philosophy, then there is no problem comparing it to Chinese philosophy because none of the latter exists to be compared, at least not in the dominant, enduring, and still-evolving reflective traditions such as Daoism and Confucianism. Most Western philosophers who think the Chinese tradition has no philosophy are crude in comparison with Cahoone, defining philosophy as Socratic skeptical epistemology and having no tolerance for other modes of philosophic reflection.

Over against this narrow and exclusivistic reading of the nature of philosophy, it is well to recall that in their own Hellenistic time the Platonic and Aristotelian schools, and their competitors the Pythagoreans, Epicureans, Stoics, Cynics, and, a little later, the Neo-Platonists, functioned as what we today would call religions, or religious communities. Similarly, early Christianity was called a philosophy.[3] They were ways of life, sometimes gathered into organized communities, based on conceptions of the universe, nature, society, and human life that were articulated in powerful ways and defended over time against one another. Only some were Socratic in their form of philosophical inquiry (and only some were theistic, which means "religion" has a broader scope than theism). But they all involved reasoned conceptions of the important things in life, with both theoretical and practical implications, and they had ways of defending those conceptions and developing them over time. Great thinkers amended the schools, reconstructed their histories, and often successfully borrowed back and forth among the schools. If we keep in mind the social context of philosophy, what it means to have a living tradition of influences and correction, devoted to asking big questions in theory and practice, then clearly all the thinkers in Wing-tsit Chan's *Sourcebook in Chinese Philosophy*, as well as those in Radhakrishnan and Moore's *Source Book in Indian Philosophy,* are philosophers.[4] For purposes of this article, the Confucian tradition arising in China and moving to Korea, Japan, Southeast Asia, California, and Boston will be the main example of Chinese philosophy discussed.[5] The entire question of what counts as philosophy, and how the philosophies of

3. For an excellent sympathetic introduction to Greek philosophical schools as religious ways of life, see Pierre Hadot's *Philosophy as a Way of Life: Spiritual Exercises from Socrates to Foucault.* Edited with an introduction by Arnold I. Davidson, translated by Michael Chase (Oxford: Blackwell, 1995.) For more comprehensive studies, see *Classical Mediterranean Spirituality*, edited by A. H. Armstrong (New York: Crossroad, 1986), especially the essays by Arnstrong, Skemp, Atherton, Long, Pinsent, Dillon, Hadot, Saffrey, Kenney, Beierwaltes, Schroeder, Corrigan, and Manchester. On Christianity as a philosophy see, for instance, Helmut Koester's *History and Literature of Early Christianity* (New York: Walter de Gruyter, 1982), pp. 338 ff.

4. Wing-tsit Chan, trans. and ed., *A Sourcebook in Chinese Philosophy* (Princeton: Princeton University Press, 1963); Sarvepalli Radhakrishnan and Charles A. Moore, eds., *A Source Book in Indian Philosophy* (Princeton: Princeton University Press, 1958).

5. See my *Boston Confucianism* (Albany: State University of New York Press, 2000). The limitation of the discussion of Chinese philosophy to Confucianism derives from the limitation of my own expertise.

"different traditions" are connected, has been decisively transformed by Randall Collins who demonstrates its social bases and structures and lays out many of the causal lineaments of its global character.[6]

The other side of the ambiguity is what counts as "analytic methodology." If that phrase is interpreted in a strict and narrow sense to mean Anglo-American analytic philosophy, in *contrast* to Continental, pragmatic, Marxist, and process philosophy, then there are not many interesting comparisons between Chinese philosophy and analytic methodology.[7] Formal and informal logic, conceptual mapworking à la Strawson,[8] positivistic debunkery à la Ayer,[9] and ordinary language analysis à la the late Wittgenstein,[10] Austin,[11] and Searle,[12] can all be construed as methodologies, and as such there is little to commend them for interesting comparisons with Chinese philosophy. Nor, I think, is there much enduring virtue in them as methodologies, for reasons to be discussed below.

Those are all better construed, not as methodologies, but as philosophical positions generally sharing nominalism and an insistence on first-person empirical verification in ordinary untutored present consciousness.[13] As such, they can be grouped as various late outcomes of British empiricism in opposition to the various rejections of nominalism and the rejections of ordinary untutored present consciousness among their contemporaries, Peirce, Heidegger, Dewey, and Whitehead (not that those in the latter group agree with one another on many other matters).[14]

6. See his great work, *The Sociology of Philosophies: A Global Theory of Intellectual Change* (Cambridge: Harvard University Press, 1998). He lays out a sociological theory of philosophical creativity and influence, and integrates the philosophical traditions of the West with China, India, and the Islamic world.

7. Classic discussions of "analytic philosophy" in its early missionary days are J. O. Urmson's *Philosophical Analysis: Its Development between the Two World Wars* (Oxford: Clarendon Press, 1956) and A. J. Ayer's edited collection *Logical Positivism* (New York: Free Press, 1959), and his *Philosophy in the Twentieth Century* (New York: Random House, 1982).

8. See Peter Strawson, *Individuals: An Essay in Descriptive Metaphysics* (New York: Anchor, 1963).

9. See A. J. Ayer, *Language, Truth and Logic* (London: Golancz, 1936).

10. Ludwig Wittgenstein, *Philosophical Investigations,* translated by G. E. M. Anscombe (New York: Macmillan, 1953).

11. J. L. Austin, *Sense and Sensibilia,* reconstructed from the manscript notes by G. J. Warnock (New York: Oxford University Press, 1964).

12. John R. Searle, *Speech Acts: An Essay in the Philosophy of Language* (Cambridge: Cambridge University Press, 1969).

13. On the particular philosophical commitments of British empiricism, see John E. Smith's essays "John Dewey: Philosopher of Experience," in his *Reason and God* (New Haven: Yale University Press, 1961), and "Three Types and Two Dogmas of Empiricism," in his *Themes in American Philosophy: Purpose, Experience & Community* (New York: Harper & Row, 1970). For his sustained criticism of the British conception of empiricism, see his small book, *Religion and Empiricism* (Milwaukee: Marquette University Press, 1967). On the special theme of ahistorical present consciousness, see George R. Lucas, Jr., "Philosophy's Recovery of its History," in *The Recovery of Philosophy in America: Essays in Honor of John Edwin Smith*, edited by Thomas P. Kasulis and Robert Cummings Neville (Albany: State University of New York Press, 1997).

14. Charles Sanders Peirce, the founder of American pragmatism, believed that nominalism

Perhaps "analytic methodology" is best construed, not as referring to so-called "Anglo-American analytic philosophy," but as meaning only the general character of arguing positions closely from a variety of angles, being aware of dialectical differences, and prizing the precision that comes from making distinctions. In this sense Plato, Aristotle, and the other ancient philosophic schools are analytical, though with quite different styles of analysis. So are the Muslim philosophers influenced by Plato, Aristotle, and Plotinus.[15] So are the Christian and Jewish philosophers of the European medieval period. And so are the famous philosophers of European modernity; Pascal, Hegel, and Kierkegaard are as analytical in their own unique ways as Descartes, Spinoza, Leibniz, Hume, and Kant. In this generalized sense of arguing analytically, recognizing different genres of argument, there are many parallels with Chinese philosophy, for what they are worth. Zhuangzi has dialogues like Plato, and dramatic intent. The Mohists invented dull philosophic prose in China before Aristotle did in Greece. The Neo-Confucians were particularly fond of commentarial argument of the sort that would be recognized in medieval Europe and in discussions of the history of philosophy in the nineteenth and twentieth centuries. But these are the kinds of loose parallels we could hardly doubt would obtain between two great, imaginative, long, and interactive cultures such as the Chinese and European. How could it be otherwise?

2. Methodology as a Concern

This generalized construal of "analytic methodology" seems to lose an interesting concern, however. For, *methodology* in a far more specific sense has been a prominent theme in modern European philosophy. Indeed, the concern for methodology has been a foundational philosophical doctrine for that strain of modernity that led from Descartes through Kant to modernism/post-

was the root of all philosophical mistakes in European philosophy since the medieval period, and himself was a Scotistic realist. See *The Collected Papers of Charles Sanders Peirce*, edited by Charles Hartshorne and Paul Weiss, vol. 1 (Cambridge: Harvard University Press, 1931), pp. 1 ff.; see also John F. Boler's *Charles Peirce and Scholastic Realism* (Seattle: University of Washington Press, 1963). Peirce held that the concrete reality and intelligibility of any concrete particular thing derives from its general traits or habits expressed through time; see my general exposition of Peirce's system in *The Highroad around Modernism*, (Albany: State University of New York Press, 1992), chap. 1. Heidegger too defined individuality (*Dasein*) in terms of extensive temporal and spatial horizons. Dewey agreed with Peirce about nominalism and stressed the reality of habit, which is never completely contained within any particular expression. Whitehead developed the most elaborate realist metaphysics of the early twentieth century with an account of both realistic process and the eternity of forms; of the four, he is the closest to being a nominalist in the sense that actual things for him are only in the present. Yet Whitehead's conception of conscious experience is that it never is at a moment—a present moment is too short to be conscious of anything—but rather involves the integration across time of a specious present.

15. See, for instance, Syed Nomanul Haq's *Names: Natures and Things* (Boston: Kluwer, 1994), a study of the Neo-Platonic alchemist Jabir ibn Hayyan.

modernism.[16] The vague statement of the doctrine is that valid inquiry should be like a syllogism, starting from premises known to be true, proceeding by argument-forms known to be valid, to conclude with results that are thereby guaranteed by the path through which they were reached.

Descartes was, if not the inventor of the doctrine of method, at least the emblem of its originating importance for European Enlightenment thought, in his *Discourse on Method*. His *Meditations*, *Rules for the Direction of the Mind*, and even the *Optics* develop and defend that doctrine. The doctrine of method is complex but has the rough form of saying that, if a philosopher can work down to indubitable starting points, and move without introducing any connective tissue that is not thoroughly understood, it is possible to escape error entirely.[17]

In Descartes's case, there are two parts to the method. The first is working down to indubitable starting points which means analyzing the topic into simples. A simple is anything that can be understood all the way through, with no backside, as it were. The best examples are mathematical and logical principles.

Two metaphysical doctrines accompany this conception of attaining simples. One is that all reality is wholly positive and can be penetrated thoroughly in its positive character by what Descartes called the "light of reason" or the "light of nature": No backside or perspectivalism here, no darkside or internal nothingness, no dialectical negation—just positive things that are real in and as God makes them. The other doctrine is that such positive things can be taken apart from one another, separated in analysis, without changing their

16. For a more elaborate introduction to the idea that modernity, beginning with the European Renaissance, has many streams, only one of which is the Descartes-Kant-modernism/postmodernism line, see my *The Highroad around Modernism*, op. cit.

17. For the texts of the *Discourse on Method* and the *Meditations*, plus extraordinarily fine analyses of them by several writers, especially David Weissman, in Weissman's edited book, *Rene Descartes: Discourse on Method and Meditations on First Philosophy* (New Haven: Yale University Press, 1996). It might be helpful to quote the rules of method, from the *Discourse*, Weissman, p. 13:

> The first of these was to accept nothing as true which I did not clearly recognise to be so: this is to say, carefully to avoid precipitation and prejudice in judgments, and to accept in them nothing more than what was presented to my mind so clearly and distinctly that I could have no occasion to doubt it.
>
> The second was to divide up each of the difficulties which I examined into as many parts as possible, and as seemed requisite in order that it might be resolved in the best manner possible.
>
> The third was to carry on my reflections in due order, commencing with objects that were the most simple and easy to understand, in order to rise little by little, or by degrees, to knowledge of the most complex, assuming an order, even if a fictitious one, among those which do not follow a natural sequence relatively to one another.
>
> The last was in all cases to make enumerations so complete and reviews so general that I should be certain of having omitted nothing. (Haldane and Ross translation)

nature; nothing is internally defined by context or relations with other things such that changing contextual relations changes them. The modern notion of the "controlled experiment" depends on these two doctrines, and philosophers such as Hegel and Heidegger who strongly deny the doctrines are recognized as being hostile to science in the positivistic sense.

The other part of Descartes's method is to put the simples back together into the complex phenomena with which the method starts. Because it is the investigator that puts the simple parts back together, the only thing added to the simples, now themselves completely understood, derives from the will of the investigator. The investigator knows what is added because it all comes from the rational soul, not from any mystery in nature. Good investigation makes sure that every composition of simples by the will ought to be approved by the intuitive understanding first, so that the composition itself is made by simple steps. Error, for Descartes, consists in the will making judgments that the light of reason, knowing simple connections, does not inspect and improve. If the composition part of method is followed, with "constant summaries and reviews" to keep the whole argument in mind, then there is no chance for error to creep in, and science is built upon an indubitable foundation.[18]

Descartes's was not the only version of the doctrine of method. Hobbes (*The Leviathan*), Locke (*An Essay Concerning Human Understandint*), and Hume (*A Treatise on Human Nature*) favored sense data over intuitions as the indubitable simple starting points. Spinoza (*Ethics*) pushed intuitive geometrical reasoning farther than Descartes dreamed. Leibniz (*Discourse on Metaphysics*) disagreed with Descartes about God. Descartes thought God creates possibilities and hence could make any possible world; therefore, we need experimental science to determine which actual world God has made. Leibniz believed that God is constrained by both possibilities and goodness to create the best of all possible worlds; hence, for Leibniz the appeal to the aesthetics of argument was far more important than would have seemed reasonable to Descartes.[19] Having adopted the sense-data theory of simples, Hume crippled the second, compositional, part of Descartes's method by arguing that the will (or imagination) could composite anything it pleases out of the data, and hence nothing in mind gives a clue to what is real outside the mind save for the data. Even more drastic, Kant (*Critique of Pure Reason*) completely refigured Descartes's particular method so that science is guaranteed to give certain knowledge of the world if it follows the way of controlled experiments: Kant redefined the world as what science knows when it conducts controlled experiments. Rationalist intuitions and empirical sense data were rejected as adequate simples, in

18. I have analyzed Descartes's texts, with late-modern parallels, in *Recovery of the Measure* (Albany: State University of New York Press, 1989), chap. 2.

19. On this debate between Descartes and Leibniz, see my "Some Historical Problems about the Transcendence of God," in *The Journal of Religion* 47 (January 1967): 1–9.

Kant's scheme. What takes their place are categories of intellectual sensibility to which both objects and good thinking must be conformed; those categories define the form of the world and science fills in the content. However different from Descartes's particular method, Kant's is yet another example of the doctrine of method, namely, that if you can get to a certain starting point, and proceed without introducing mistakes, you can have certain knowledge at the end, a certainty guaranteed by the method.

The doctrine of method has had a predominant role in the history of modern European philosophy. Modernism, with its infamous foundationalism, dominated not only philosophy but the arts as well during the late nineteenth and most of the twentieth centuries. The logical positivists, with their concern not to be fooled by any nonsense, were modernists. So were the early and late Wittgenstein, the former in his assertion that where we cannot speak with "sense" (defined rather positivistically) we should be silent,[20] and the latter with his view that language games themselves are something like privileged simples. So was the phenomenologist, Edmund Husserl, whose *Crisis of the European Sciences* is a dirge for the failure of the modernist philosophic and scientific program.[21]

Yet the doctrine of method had its opponents. Hegel, in his criticism of Kant, said in effect that the doctrine of method knows too much. The kind of thinking that Descartes, and even more Kant, engaged in while defending their theories of method is something that does not fall within the method they allow. To know a boundary, Hegel said, means that you are already on the other side of it.[22] Hume's contemporaries and successor colleagues, the Scottish commonsense philosophers, also rejected the doctrine of method.[23] In essence their view was that knowing is not building upon a certain foundation but learning to correct your errors, with common sense providing what Dewey called the "funded wisdom of the race" that gives you adequate truth by and large. Peirce and Dewey picked up on this alternative to the doctrine of method, and hence to modernism and its denial postmodernism, although of course they knew nothing of those terms. Their philosophies, though often preoccupied with method, took method to be the process of correcting ongoing views,

20. See Wittgenstein's *Tractatus Logico-Philosophicus* (Londong: Routledge Kegan Paul, 1922), 6.53–6.54, 7.

21. See Edmund Husserl, *The Crisis of European Sciences and Transcendental Phenomenology*, translated with an introduction by David Carr (Evanston, Ill.: Northwestern University Press, 1970).

22. See G. W. F. Hegel's *Phenomenology of Mind*, translated by J. B. Baillie (2nd revised edition; London: George Allen and Unwin, 1931), preface.

23. See, for instance, Dugald Stewart's *Elements of the Philosophy of the Human Mind*, two volumes bound in one (Albany: E. and E. Hosford, 1822; vol. 1 originally 1792, vol. 2, 1813). Charles Peirce called his philosophy "critical commonsensism;" the "critical" part referred to Kant, interpreted nontranscendentally, and the "commonsensist" part referred to Stewart and Thomas Reid.

not a method for building a certain scientific edifice.[24] To put the point more strongly, if vaguely, for the Romantic, pragmatic, and process philosophies, the "results" of inquiry are to be judged by the cases that can be made for them as they are made vulnerable to testing, not by the process of inquiry that gives rise to them. On the contrary, the processes of inquiry are to be judged by their results. Therefore, if the "methods" of Anglo-American analytic philosophy are applicable only to small technical problems and fail to provide much wisdom about the great issues of life and or to engage the philosophic tradition, then those methods are wanting.[25]

If the comparative concern with Chinese philosophy is about the doctrine of method, that is a narrow concern. It would be like comparing Chinese philosophy with Western nominalism, with which the doctrine of method is closely allied. But suppose we contrast methodology in the sense of the doctrine of method with two related notions, philosophical practices and philosophical discipline.

3. Philosophical Practices

Philosophical practices are typical or habitual modes of presentation, argument, and life of the sort listed above. Written dialogues displaying debate with theses and objections are a common practice in Plato, Berkeley, Hume, and in modified ways in Kierkegaard. They are very common in Buddhist writing, both Chinese and Indo-Tibetan, and in writers such as Mencius and Zhuangzi. Zhuangzi rivals Plato in the artfulness of the dialogue, using the full power of the dramatic context as well as the verbal content of the argument. Prose essays in which positive theories are put forward with internal defense and criticism of alternative views are the primary philosophic practices of Aristotle, the Mohist writers, and Xunzi, as well as later writers such as Wangbi. Wangbi's work can also be considered a commentary, as can many of the writings of the Neo-Confucians on the Classics, and the later Neo-Confucians on the earlier Neo-Confucians. Qing Dynasty Confucianism was characterized by elaborate philological attention to the history of philosophic texts and the interpretation

24. See Peirce's essays, "Questions Concerning Certain Faculties Claimed for Man," "Some Consequences of Four Incapacities," "Pragmatism and Critical Common-Sensism," and "Consequences of Critical Common-Sensism," all in *The Collected Papers of Charles Sanders Peirce*, edited by Charles Hartshorne and Paul Weiss, vol. 5 (Cambridge: Harvard University Press, 1934). For Dewey, see, for instance, his *Reconstruction in Philosophy* (New York: Henry Holt, 1920).

25. See George Lucas's ingenious discussion of this in connection with Bertrand Russell's claim that Whitehead is muddleheaded and Whitehead's counterclaim that Russell is simpleminded, in *The Rehabilitation of Whitehead: An Analytic and Historical Assessment of Process Philosophy* (Albany: State University of New York Press, 1989), pp. 109 ff. I myself follow the pragmatic version of the rejection of the doctrine of method, and emphasize the vulnerability of all philosophic claims as hypotheses subject to test by argument and experience, including experiment. See, for instance, my *Recovery of the Measure*.

of philosophy as having a history. This anticipated a similar concern in European philosophy arising out of Hegel's approach to the philosophy of history and history of philosophy, and out of Jewish and Christian theologians' analysis of biblical texts.

Of course these and many other philosophical practices have analogies in both China and the West. With every analogy there are many disanalogies that should be pointed out. David L. Hall and Roger T. Ames have made very strong cases for the disanalogies in both philosophical practices and fundamental root metaphors between Chinese and Western thinking.[26] My concern here is not to trace out the analogies and disanalogies but to indicate the recurrence of a wide variety of philosophical practices in both China and the West, often with interesting parallels. The difference in philosophic practice between Spinoza and his near contemporary Wang Fu-zhi is not greater than that between Spinoza and Montaigne, another near contemporary, save in the fact that the Europeans had the same reference-set of antecedent texts.

The practices discussed so far mainly have been genres of philosophical writing. Philosophies need also to be understood more concretely as practices within social settings. Mention was made above of the fact that the ancient classical and Hellenistic philosophical schools were organized as religious communities replete with rituals and initiations. Even earlier, Confucianism was organized as a religious community mainly for learning and practicing ritual.[27] In addition to the organization of schools with a religious cast, philosophers in the ancient world gathered into what we would call proto-universities where different schools would be represented and different disciplines would be gathered along with philosophy. Plato's Academy and Aristotle's Lyceum are famous Greek examples, and the Ji-xia and Lanling academies of the same time are similar centers of learning.[28] Plato had once hoped that philosophy would be influential in the courts of political power, and established the Academy only after extreme disappointment in politics (he was sold into slavery!). Stoic philosophy was important for the Roman government for a brief period. If we count the philosophical aspects of Christianity and Islam, we can note the influence of Christian and Islamic philosophy during the medieval period in the courts of Europe and the Muslim world. Chinese philosophy has been much more deeply invested in determining political culture than Western philosophy, however. Confucius and Mencius wrote about

26. See their *Thinking through Confucius* (Albany: State University of New York Press, 1987), *Anticipating China* (Albany: State University of New York Press, 1995), and *Thinking From the Han* (Albany: State University of New York Press, 1998). But see also their *The Democracy of the Dead* (Chicago, Ill.: Open Court, 1999) which argues for the analogy between American pragmatism and Confucianism with regard to public debate and consensus formation.

27. See Robert Eno's *The Confucian Creation of Heaven* (Albany: State University of New York Press, 1990).

28. See Collins, pp. 142–46, for explicit comparisons and discussions of the relation of these Greek and Chinese academies to their political situations.

advising rulers, and the *Daodejing* is a manual for government. Confucians, Daoists, and Buddhists, as well as despised Legalists, have vied for favor at the Chinese court, and in some periods, especially the Han, have been actually instrumental in functioning as institutional philosophers. More often than not, however, the social context for Confucian thinkers especially has been that of being out of office, being exiled, being in official public retirement. The great Neo-Confucians Zhu Xi and Wang Yangming founded their teaching academies when they were pushed out of public life.[29] An ideal for Confucians, ever since Confucius himself, has been to be a scholar-official, an ideal no less powerful for the fact that circumstances often prevented its fulfillment. Nevertheless, from the twelfth century to the beginning of the twentieth, the civil service examination in China was a *philosophy* test.

In contemporary Western society, philosophers have sometimes played the role of what we now call "public intellectuals." One thinks of John Dewey, Bertrand Russell, Martin Heidegger, Ralf Dahrendorf, and Richard Rorty. But often these thinkers are rejected as philosophers by fellow philosophers precisely to the extent that they take part in public life. This is likely because, just to that extent, they move beyond the boundaries of philosophy as a discipline. Public intellectuals are those who define the contours of their thinking by the needs of the problems they address, not by the disciplines they bring to their inquiry. So public intellectuals are rarely pure enough for philosophers, or for social scientists or humanists for that matter. This guild-disapproval does not necessarily diminish their worth to the public conversation, however, although few people nowadays, philosophic or otherwise, would approve of the public stance of philosophers like Heidegger (a Nazi myth-maker).

The discussion of philosophical practices serves to show both the diversity of practices, and the fact that they are not distinguished particularly by separation into those of the West and those of China. The critical problem that arises in our own time is what forms of philosophical practice are appropriate. The nature of that problem can be sensed from a list of some of the issues to which philosophy needs to address itself in our world. Consider the following, arbitrary in a way, but also obvious.

The entanglement of world cultures. Although Samuel Huntington is extreme and oversimple in describing our situation as a "clash of civilizations,"[30] the realities of economics, global politics, and especially electronic communications require people to understand one another in terms of their background cultures,

29. For an interesting discussion of Zhu Xi and his political involvements, see Hoyt Cleveland Tillman's *Confucian Discourse and Chu Hsi's Ascendancy* (Honolulu: University of Hawaii Press, 1992).

30. See Samuel P. Huntington, *The Clash of Civilizations and the Remaking of World Order* (New York: Simon and Schuster, 1996).

including their philosophic cultures.[31] Therefore one great philosophic challenge for each of the world's philosophic cultures is to enrich its paideia so as to include understanding and interpretation of the others, eventually to enter into a global philosophic conversation inclusive of all cultural resources in philosophy. The project of this book addresses this issue directly.

Political thought for a global multicultural society. The world's philosophic cultures, in conversation, need to address questions of political authority and tolerance, including the distribution of power to manage economic and military affairs, in a world with many cultures. Western liberalism has a well-developed theory in several regards, but it itself is under attack from Western philosophy as well as from other philosophic cultures. A specific example is the debate over the differences between Chinese and Western liberal interpretations of human rights.[32]

Conceptions of the meaning and value of human life in a world understood according to the scale of modern science. A vast array of issues fall under this rubric, all arising from the destruction of "traditional" images of human meaning by the findings of modern science.

Development of conceptions of distributive justice for a global economy. Although most philosophic traditions have theories of distributive justice, nearly all assume distribution over an area to be ruled by a single government, not a world of global governments. Moreover, until the last century or two, too little was known about real economic causation for distributive justice to be a practical conception. Now we know something, because of advances in the social sciences, about how markets in one country affect life in another, and about what can be done to control these effects. The philosophic conversation needs to provide a normative account of this.

Ecological issues. Modern technologies have provided instruments for altering the human environment fast enough for it to be noticed, and science allows us to measure effects of technology that are far beyond the obvious, for instance, destruction of the ozone layer. Most philosophic cultures suppose that the problems of human life are to be worked out within the structures of a given environment. Recognition of the fact that human practices affect the environment means that new conceptions are required to understand how we are and ought to be "at home" in the environment.[33]

These are but a few of the issues to which philosophical understanding is relevant, and about which the world's philosophic (and religious) traditions

31. I have argued that "entanglement" is a more subtle metaphor than "clash," in *Boston Confucianism*.

32. See Wm. Theodore de Bary's *Asian Values and Human Rights* (Cambridge: Harvard University Press, 1998). Compare this with Hall and Ames's *The Democracy of the Dead*.

33. For a comparison of Confucian and Western philosophic views on this, see *Confucianism and Ecology: The Interrelation of Heaven, Earth, and Humans*, edited by Mary Evelyn Tucker and John Berthrong (Cambridge: Harvard University Press, 1998).

so far have little to say. Each has analogies from which to work, of course, but the question is just how far the analogies extend and where they are inappropriate. Moreover, the public for philosophic discourse requires making a case to anyone who has a philosophic interest, no matter what the philosophical culture of the thinker's background.

So what are the social practices appropriate for our global situation? I have three observations.

First, a principal, if not the principal, motivation for contemporary global philosophy engaged with the issues defining our world comes from religion, from the world's religions, from interreligious dialogue, and from religious activism. Contemporary religions have been at the forefront of coping with the entanglement of world cultures, urging political solutions to war and peace, imagining the place of the human in a world of vast scientific scale, coping with transnational injustice and oppression, and rethinking what it means to be at home on earth. In all the world's cultures except the European, philosophy is just the intellectual side of religious cultural life, and the practice of philosophy in religious communities is a natural and expected way. In European philosophy, there has been a skeptical alienation of some forms of philosophy from religious life, and philosophy has been defined very much in epistemological terms that are not friendly to religious commitment; the discussion of Cahoone at the beginning traced one form of this. In Europe and North America, philosophy has come to think of itself as a separate discipline from religious thinking, and often in somewhat hostile relations with religion. Accordingly, Western academic philosophy has been the most tardy of the world's philosophic traditions to define its roles in terms of problems of the sort listed above, save in the case of questioning human life relative to modern science, and thinking about global justice. But Western academic philosophy will just have to come along and learn to think about the big important issues, or it will die out within its academic base as trivial. At any rate, philosophical practices will and should be affected by religious practices.

Second, the locus if not always the motivation for the contemporary practice of engaged global philosophy will include the academy—universities and colleges. This will likely be its most important locus. The reason is that the academy, at least in the instance of philosophy in most places, is a neat balance of research and teaching where leisure is preserved for getting it right. Criticisms from peers and demands from students press philosophy departments to be honest, thorough, historically grounded, and relevant. Other fields within the academy have not been so lucky. Most of the sciences are pressured by government and business to give them what they want. The very irrelevance of philosophy and some of the other humanistic disciplines gives them the leisure to pay attention to getting it right. So far, philosophy is able to respond to the demands for relevance to the issues rather than relevance to some social group's special interests, although any discussion reflects the social biases of its participants.

The third observation is that philosophy needs to be in close interaction with other disciplines in order to address issues of the sort mentioned above. Obviously those include the natural and social sciences, and also the hermeneutical disciplines of history and criticism. All of these are to be found within the academy, and this is another reason why universities are likely to be the prime locus of philosophical conversations. Beyond "disciplines" in the academic sense, however, philosophy needs to be engaged with, learning from, and helping shape the various spheres of public life, including government and law, economics and production, cultural formation of communities, families, and persons, and religious practices. This is because, in the end, philosophy should not be defined as a guild with a special methodology but rather as the work of public intellect on the large issues of meaning and existence.

The vast extent of contemporary knowledge, however, makes impossible the ancient model of the philosopher as knowing everything important. Plato, Aristotle, Augustine, Confucius, Mencius, and Xunzi might well have known just about all kinds of elite knowledge for their day. Contemporary philosophers cannot know enough and therefore must think cooperatively with other "professionals." Philosophers are not alone in needing an interdisciplinary context: politicians too need economists, theologians, theater critics, and psychologists. Alfred North Whitehead pointed out the inevitability of philosophy operating in a field where the mastery of knowledge requires a plurality of professionals.[34] William Sullivan has analyzed the conflict internal to professionalism in thinking, namely, adherence to methodologies defining a guild and the engagement of issues that require more than that method, engagement often with a moral impulse.[35] So the practice of philosophy in the contemporary situation has to be situated in a multidisciplinary as well as multicultural context.

4. Philosophical Discipline

Surely the reader will have noticed the surreptitious introduction above of the notion that philosophy is a discipline, a profession. This needs analysis, for it surely is the real issue behind the problematic of "Chinese philosophy and analytic methodology." Can Chinese philosophers make cases for their basic claims being true, as Western philosophers have argued for their claims?

What is philosophic discipline? I suggest it is inquiry into philosophic issues involving three things. First, it is the study and appropriation of philosophic

34. See his *Science and the Modern World* (New York: Macmillan, 1925), chap. 13, "Requisites for Social Progress."

35. See William M. Sullivan, *Work and Integrity: The Crisis and Promise of Professionalism in America* (New York: HarperCollins, 1995). See also his earlier *Reconstructing Public Philosophy* (Berkeley: University of California Press, 1982) on the general topic of public philosophy or philosophy as the work of a public intellectual.

resources. These include previous philosophy and the other kinds of knowledge relevant for philosophic thinking. Second is the engagement of real issues. These can have a moral cast, as in the examples given above. But the real issues are matters of wonder, for philosophy, a matter of curiosity because something should be understood that is not. Moral issues are a subcase of these. Philosophy can engage the meaning of existence, or being, or why there is anything at all, with the same urgency as it engages the problem of conceiving of distributive justice in the days of the United Nations. Wonder and curiosity are among the defining characteristics of human concern. Third, philosophic discipline needs to propose hypotheses about how to understand the issues engaged, and then to make a case for those hypotheses. Usually making a case means showing that they are internally consistent and coherent and then making them vulnerable to correction regarding their adequacy and applicability.

All three parts of philosophic discipline are necessary, I believe. Without mastery and appropriation of the resources for philosophic thought, philosophy does not take advantage of the best that it can be, and remains amateurish. Therefore, much of philosophical education is devoted to getting oneself prepared through the appropriation of cognitive and perhaps spiritual resources. Philosophy does require a kind of guild-mastery.

Without engagement of the real issues, philosophy becomes intellectual history or a play of technical methods. Anglo-American academic philosophers are often accused of being only guild-masters, not real philosophers engaged with the issues that justify philosophic effort in the first place. This criticism is often overdrawn: great metaphysicians such as Paul Weiss and great political philosophers such as John Rawls have been academic philosophers.

Without formulating hypotheses and making cases for them, philosophy does not make claims as to the truth and defend those claims. Philosophy in China as well as the West goes beyond history-writing and aesthetic criticism by virtue of making good on claims to get the truth about its issues.

To call philosophic claims "hypotheses," of course, is to reflect the rhetoric of the pragmatic tradition.[36] Most philosophers never conceived of claims as hypotheses until that was spelled out in nineteenth- and twentieth-century pragmatism and process philosophy;[37] if they had known about those ideas, they probably would not have thought of their own views that way. But in retrospect, we can treat philosophic claims as hypotheses. So, for instance, the doctrine of method discussed above can be construed as an hypothesis for arriving at true conclusions, and the case for it assessed. Plato was rather explicit about considering his dialectic as a ladder of hypotheses. Aristotle dismissed

36. See the articles of Peirce cited above, as well as "The Fixation of Belief" and "How to Make Our Ideas Clear," both in *The Collected Papers of Charles Sanders Peirce*, vol. 5.

37. For process philosophy on the hypothetical nature of all philosophical claims, see Alfred North Whitehead's *Process and Reality* (Corrected edition by Donald Sherburne and David Griffin; New York: Free Press, 1978; original 1929), chap. 1.

dialectic as bad logic, and that itself can be treated as an hypothesis about logic, and assessed. Similarly, Confucius's views about humanity and ritual can be viewed as hypotheses about what ideals and courses of action to urge for the improvement of human life. Xunzi's views of nature or heaven can be treated as hypotheses about the natural context within which human direction and effort are to be understood, and so forth.

The chief significance of calling all philosophical views "hypotheses" is to point out that they are vulnerable to correction. Whether or not they would have thought of themselves as presenting hypotheses, every important philosopher's views have been vulnerable to correction. Sometimes that means merely the contradiction of them because they are not persuasive. But more usually it means the amendment and modification of them to be more nuanced, subtle, and articulate at getting around objections. In the long run, making a case for a philosophical hypothesis means making it so vulnerable to correction that it is responsive to every objection and has been modified so that nothing more can be said against it. To be vulnerable is to be correctable, and an hypothesis that has been thoroughly corrected has a good case. Only when something new comes up against it would its vulnerability again be tested and its fallibility displayed.[38]

Now it is apparent that a philosophy has good discipline when it can make a case for itself in the relevant public. What is a philosophy's public? It can only be those perspectives and other positions that can interact with it and have an interest in the outcome of the discussion to which it needs to make its case. Its public therefore is historically contingent.

Ancient Confucians had to make their cases in a public that included one another—for instance the followers of Mencius relating to those of Xunzi—and also the Mohists, Legalists, Daoists, and others. They did not have to make a case to the Platonists, Buddhists, Neo-Confucians, Cartesians, or Marxists. Contemporary Confucians do have a public that includes the whole of Chinese and Western philosophy, as well as that of India to which they have already responded somewhat through Buddhism. Similarly, Thomas Aquinas had a public including the Christian Platonists and Aristotelians as well as some of the great Muslim and Jewish philosophers, but not Zhu Xi or Kant; most twentieth-century Thomists, however, have been Kantians, and certain seventeenth-century Thomists such as Matteo Ricci would have liked to have included Zhu Xi in their philosophic public.

If judged by the standard of making a case for their philosophy as being true, in the context of their actual philosophical public, Chinese philosophers throughout history have been as disciplined or "analytical in methodology" as any Western philosopher. The title of Angus Graham's introduction to ancient Chinese philosophy, *Disputers of the Tao: Philosophical Argument in Ancient*

38. This is the main argument of my *Recovery of the Measure*.

China, accurately indicates that the philosophers argued their cases in a vigorously disputatious public.[39] The subsequent history of Chinese philosophy expanded its public to include Buddhists and others, down to the last two centuries in which it has engaged Western thought. The modes of argument have always been historically relative to the perspectives involved in the public at hand. As argued above, the genres of arguments have not been all that different from those used by Western philosophers in their own historical contexts. The content of the arguments has been quite different, especially in slant if not in topic.

In contemporary terms, the issue of Chinese philosophy and "analytic methodology," meaning good philosophic discipline, can be phrased in the terms laid out in the discussion of practice above. Do Chinese philosophies have something to contribute to the contemporary discussion of engaged issues, and can those philosophies be reconstructed so as to address the contemporary philosophic public? It seems obvious to me that the answer to this double question is vaguely yes, and that the case needs to be made for or against specific philosophic ideas in detail.[40]

Let me close this discussion with an example. The Confucian tradition from its founder onward has emphasized and elaborated the idea of ritual or propriety (*li*). On a superficial level this means court rituals or, what was the same thing in ancient China, religious rituals. More deeply, however, ritual meant convention, stylized meaningful gestures, movement, and language that presents the form of civilization. As Xunzi put it, ritual fills in the underdetermined natural capacities for movement, emotions, and thought that come with the human biological heritage. From styles of movement, of gestures, of making eye contact, of showing deferential respect to language, to forms of engagement, cooperation, and conflict resolution, down to the patterns of family life that make the procreative process into a civilizing process, that make cooperation on the hunt into friendship, that make the big clubs of leaders into public political processes, ritual is the complex dance that engages people together in sophisticated ways. By itself, ritual does not determine what people do within the ritual forms; but it makes the civilized activities possible. The Chinese critique of barbarians was not that they had the wrong ritual but that they had no effective ritual, or deformed and inadequate ritual. The Chinese knew there could be alternative conventions, for instance, other languages, forms of greeting, and court ceremonies. These all were to be judged by how well they effected civilized life, with rich family interactions, good friendships, and sound political processes. In fact, Confucius's critique of his own society

39. A.C. Graham, *Disputers of the Tao: Philosophical Argument in Ancient China* (La Salle, Ill.: Open Court, 1989).

40. Many specific proposals are discussed in my *Boston Confucianism*.

was that the rituals of the ancients had become deformed, and his revolutionary response was to teach rituals.

Now Western philosophy has had a much less exalted conception of ritual, with the Aristotelian distinction between the natural and the artificial already giving priority to nature over convention. The ancient Chinese believed in a trinity of Heaven, Earth, and the Human, and by the latter they meant the conventions that give human identity over and above natural biological endowment; for them, ritual completes the natural, fulfills it.[41] In the West, by contrast, the dominant moral tradition has been that of natural law, with the intent of getting behind convention to nature, the ends of which determine what conventions are moral. With the modern demise of teleological conceptions of nature that provide moral direction, the Western traditions of ethics have generally been subjectivistic, either transcendentally so as in Kant (*The Critique of Practical Reason*) or voluntaristic as in liberalism (John Locke, *Second Treatise on Government*, or John Rawls, *A Theory of Justice*) or Nietzsche (*The Will to Power*). Thus, Western moral and political thought has been tempted constantly by authoritarianism or relativism.

The Chinese tradition of ritual as the enabling dance of civilization has a great contribution to make to the world moral discussion. It makes moral judgment internal to ritual life and development rather than external. And it calls attention to the fact that many if not most moral problems are not about specific acts or specific goals but about the general ritual conditions within which people live. To at least this extent, then, the Chinese tradition's elaboration of ritual propriety opens a new way forward for Western philosophy as together the traditions deal with the important current issues. But how can the Chinese conception of ritual be tested so as to be affirmed as valid or true? To make the case is enormously complicated.

But consider that the Chinese conception of ritual can be reinterpreted within the language of American pragmatic semiotics. Peirce, for instance, called meaningful ideas "habits of thought" and "leading principles." These are general, like rituals, and public, involving a dance of many individuals in a society given significance by signs or ritual elements. Pragmatic semiotic theory provides an extraordinary new resource for developing the Chinese notion of ritual and making it widely applicable throughout late modern society.[42] At the same time, through pragmatism, Chinese philosophy is immediately linked

41. See the argument, for instance, in Xunzi's essay on *tian* (nature or heaven). It is book 17 in *Xunzi: A Translation and Study of the Complete Works* by John Knoblock, in three volumes (Stanford: Stanford University Press, 1988–94), in vol. 3. See the analysis of this essay in Edward F. Machle's *Nature and Heaven in the Xunzi: A Study of the Tian Lun* (Albany: State University of New York Press, 1993).

42. Peirce's semiotic theory is developed throughout volumes 1 and 2 of *The Collected Papers of Charles Sanders Peirce*, edited by Charles Hartshorne and Paul Weiss (Cambridge: Harvard University Press, 1931–1932).

with much of the history of Western philosophy. That the Chinese tradition of ritual can receive such reinforcement and enlargement through engaging a public that includes pragmatism is a very strong case in its favor.

The contemporary philosophic public, which determines what counts as good and adequate cases for a philosophic idea or position, includes both Chinese and Western traditions, indeed many traditions in each. The Chinese as well as the Western has a history of argumentation relative to the historically constituted publics within which the philosophers lived. The questions for contemporary definitions of "analytic methodology," where that means an appropriate discipline for being able to make truth claims, are to determine which philosophic perspectives constitute the public within which any philosophy needs to make its case, and then to determine which kinds of "analysis" or argumentation can address those perspectives.

Philosophy as Engineering

Adam Morton

Philosophy used to compare itself to mathematics. It aimed for certainty and proof, and an aristocratic oversight above the rest of knowledge. More recently philosophy has compared itself to science, or more accurately to a science. Philosophy is one discipline among others, aiming to find truths about the relations between thought and its objects, in a way that requires evidence from fallible sources, including evidence predigested by other sciences. I shall suggest a different comparison. Philosophy is like engineering. We are concerned above all with topics where theory and evidence are not in perfect agreement, and where practical needs force us to consider theories which we know cannot be exactly right. We accept these imperfect theories because we need some beliefs to guide us in practical matters. So along with the theories we need rules of thumb and various kinds of models.[1] We need a kind of first aid: what to do till the scientists arrives. In some cases they may never arrive.

Two consequences of this comparison are likely to be controversial. The need to accept beliefs on imperfect evidence may not seem consistent with actual philosophical practice, since we argue about every tiny detail and we subject even plausible suggestions to intense scrutiny. Moreover at the heart of the scrutiny there are often counterexamples—or examples that might or might not turn out to be counter—which need only be logically possible, or consistent with the best current science, in order to provide objections. And, second, the direction to practical purposes may seem far from the motivation of practicing philosophers, obsessed with truth, real and not approximate truth, for its own sake.

I think the appearances are misleading. "Will it work?" is as important to philosophy as "is it true?"—a special kind of "will it work?," though. The first task is to overcome the appearances. This is best done with examples.

Example One: Epistemology

One kind of epistemology has existed only since the time of Galileo. Since the early days of the scientific revolution European philosophers wrestled with a

1. I mean models in the sense of structured objects, representing the facts, which mediate between theories and data. See the introduction and articles in Margaret Morrison and Mary S. Morgan, *Models as Mediators* (Cambridge: Cambridge University Press, 1999).

particular interconnected set of issues, concerning the sources of knowledge, the relative roles of perception, reason, and traditional belief. These issues were animated by two realizations. First, that an understanding of the world had become possible, to be obtained by use of some mixture of experience, experiment, mathematics, free hypothesis-making, and common sense, which had never been available before. Second, that this new understanding threatened conflict with deeply entrenched beliefs, including those of religion. The depth and width of possible new knowledge and the seriousness of the threat to traditional belief were not clear.

A new project, with new opportunities and new dangers, needs a new set of rules for its participants. And a new vocabulary for stating these rules, and more generally for the commentary, praise, and criticism necessary to keep the project running. Any intellectual activity has such a vocabulary, so that we can then criticize and fine-tune our performance. Often it is a specialized vocabulary. For example, in chess playing we talk of strategies and traps and gambits. These vocabularies are not needed to take part in the activity; they are for talking about it, not doing it. But often we do it better if we talk about it. Someone could play brilliant chess without knowing about traps and gambits—they're different from the concepts of a king or of checkmate—but no one could discuss chess usefully without something like them. No one could discuss chess usefully with us, that is. There could be quite different vocabularies for talking about how to write winning computer chess programs, or even for talking about the game with people who approached it very differently from most of us. Whenever we can do things more or less successfully there is room for a vocabulary for discussing how things went and how to avoid their going badly.

In the case of early scientists the philosophical program of finding the right normative vocabulary for fine-tuning the project took the form of modifying an existing rhetoric. The rhetoric is the language for describing beliefs and the ways in which they are acquired—in modern language "rational," "reason for," "(un)substantiated," "evidence" and their kin—and the language for describing people and their belief-acquiring traits of mind—"hasty," "intelligent," "deluded," "gullible," and their kin. These play a role in everyday life in our efforts to assess the reliability of one another's beliefs. The project of modern epistemology, from Descartes to Popper, has been to adapt this regulatory vocabulary to provide a description of a set of practices which gives a good chance of achieving the promised knowledge and a vocabulary for making the metajudgments needed for regulating these practices. The project has produced no end of doctrines and problems. And it has been largely successful, in that as science has developed it has developed a regulative vocabulary adequate to its purposes, the language of data, hypothesis, explanation, evidence, and established knowledge. Professional and amateur epistemology have both played a role in this. Progress here is largely invisible—as is most philosophical

progress—as once a vocabulary is in place it seems the natural and inevitable way of describing its subject matter.

There is another source of the language and official problems of epistemology. That source is the debates among philosophers writing in Greek and Latin in late antiquity about knowledge, which we anachronistically assimilate to the modern epistemological project. In fact, the aim of the disputes among Stoics, Epicureans, and Peripatetics is essentially moral. The main question is how much we can presume know about the world, using the methods already available, not trying to describe any new methods. And this question is important not for its own sake but because it plays a part in disputes about the things one should rely on in one's life. Essentially, if you can know nothing about reality beyond your immediate experience there is no point to shaping your life around any beliefs concerning any such unknowables. It is an interesting question how much the vocabulary of these debates influenced the everyday regulative vocabulary of belief. (The answer could be: not at all.) In any case, by the time of the scientific revolution the terminology of ancient epistemology became one source for the language needed for framing a new and essentially different set of issues. Galileo's questions need a language, so that of Montaigne and Erasmus, deriving ultimately from Epicurus, Sextus, and Pyrrhus, is adapted.[2] Centuries later, we have difficulty seeing that the language could have any other focus.

Epistemology as the search for the right metadiscourse for science is now a large part of the philosophy of science. The issues are hard, important, and obviously practical. The aim is to keep an actual enterprise on the road, with one eye on the ideal and another on the facts about the limited human beings involved. But much contemporary philosophy is not closely connected to the philosophy of science. It is often not clear what the *point* of the enterprise is, besides saying intelligent things about issues, such as scepticism that have become part of the philosopher's job description. The result often illustrates or puts pressure on positions in the philosophy of language or the philosophy of mind. (And often there is a more visible point to these positions.) Recently there has been an interesting development of "virtue epistemology," which studies the traits of people which advance and hinder their epistemic projects. Virtue epistemology is concerned both with the traits that people actually exhibit, as described in terms of what we know about human psychology, and with our standard vocabulary for describing such traits. The practical point is pretty clear here. We need a regulatory discourse in our nonscientific belief-acquiring activities, and we so it helps to know what our actual metaepistemic discourse is, and how well it works. My own view is that virtue epistemology

2. See Michael Frede's introduction to Michael Frede and Gisela Striker, eds., *Rationality in Greek Thought* (Oxford: Oxford University Press, 1996), and Julia Annas, "Scepticism, Old and New" in that volume.

ought to focus on fine-tuning our set of epistemic virtues and vices. Are there traits which we take to be virtues which actually are not? Are there virtue-terms which would be more effectively deployed if their emphasis were changed? My own suggestion about the most promising focus for these concerns is our handling of our own finiteness. Do we have a useful vocabulary for describing how successful a person is in, for example, the rational response to her own particular kind and degree of irrationality?[3]

Example Two: The Philosophy of Mind

There are two rather different branches to the philosophy of mind. Both are shaped by the existence of what is now usually, perhaps unfortunately or mis-leadingly, called "folk psychology": the body of beliefs, intuitions, explanatory routines, and belief-forming procedures that we use in everyday life to understand one another. (So I could have just called it "the concepts of mind.") One branch of the subject then takes a semantic, external, angle on folk psychology. This asks what real facts folk psychology might be about, and whether it represents them accurately. So questions about mind and brain are central, but also what Thomas Nagel has called the mind-mind question, concerning the relation between folk psychology and the account of mind given by a not necessarily brain-centered scientific psychology. (To a very first approximation at the extremes are versions of dualism which say that the facts are just as folk psychology presents them, and eliminative materialism which says that the facts are so different that folk psychology has no real hold on them.)

The other branch takes a structural, internal, angle on folk psychology. It asks about the relations between the different folk psychological concepts, and about their roles in explaining actions. Belief, desire, will, memory, sensation, pleasure, anger, fear, remorse: the list goes on. Each of these concepts is puzzling in well-known ways; the links between them are puzzling; and the way that they interact to form the complex of ideas that lies at the heart of human life is still largely mysterious.

Neither angle excludes the other, of course, though most works in the philosophy of mind fall clearly into one branch or the other. In both cases our focus is on our ordinary mental concepts. From the external angle we ask questions about the whole set, with respect to another privileged set, those of neurology or cognitive psychology. From the internal angle we ask about particular concepts, usually expressing our accounts in terms of other commonsense psychological, descriptive, or normative concepts. Certainly the external angle

3. For a more detailed account of epistemology along these lines see my "Recent Work in Epistemology," *British Journal for the Philosophy of Science* 51 (2000). For virtue epistemology see Christopher Hookway "Epistemic Norms and Theoretical Deliberation," *Ratio* 12 (1999): 380–98, and Linda Zagzebski, *Virtues of the Mind* (Cambridge: Cambridge University Press, 1996).

suggests more drastic possibilities. Perhaps we ought to junk all talk of mind, perhaps we ought to operate with mental concepts as we would with useful but ultimately indefensible myths, perhaps we should try to formulate a hybrid mental/physical explanatory scheme. But if we take any of these possibilities seriously we are faced with detailed practical questions likely to snag on the fine grain of human life. How are we to instruct our children, amuse our friends, make our contracts, carry out all kinds of business, in the revised set of concepts? In the face of these it is easy to see the appeal of a quietism such as is found in the work of Davidson and some followers of Wittgenstein. The line is that mental and physical concepts are so different in conceptual style that they cannot be mixed. Assuming there is no way in which we can ignore the psychological altogether, this would seem to leave us no alternative but to go on folk-psychologizing as before, with however bad a conscience.[4]

There is an assumption here, though, about the relation between the external and the internal angle. Quietism assumes that if we are stuck with folk psychology we are stuck with folk psychology as it is and always has been. But in thinking this it is accepting an assumption also made by eliminativism. For it is very far from obvious that there is any such thing as a single unchanging folk psychology. Our everyday ideas about mind change and vary, under social, scientific, and moral pressure. If we decide that the facts about brain and cognition do not fit the presuppositions of our ordinary thinking about mind, then we are faced with an extremely engineering-ish problem. How are we to do justice to the facts as we understand them while still preserving a structure which allows us to serve the varied range of tasks for which we now deploy mental concepts? And the facts surely do not fit the presuppositions—the only question is the size of the discrepancies—so we are surely faced with these practical questions. And in their mole-like ways philosophers are slowly feeling out the fine-tunings and alternatives that we will need.

Example Three: The Philosophy of Language

The philosophy of language is the most abstract part of philosophy, the most rarefied, according to some the most central, nevertheless the part about whose philosophical character students and nonphilosophers most often have doubts. Like the philosophy of mind there is an outside and an inside angle. Looking at language from the outside we try to understand truth, reference, communication,

4. No short list could do justice to the variety of work in the philosophy of mind, but the issues discussed in this section are discussed in David Rosenthal's introduction to his collection *The Nature of Mind* (Oxford: Oxford University Press, 1991). The essays by Ryle, Strawson, Anscombe, Davidson, and Feyerabend in that collection are classics representing the variety of relevant views. Issues about folk psychology are well represented in the essays and introduction to Martin Davies and Tony Stone, eds., *Folk Psychology: The Theory of Mind Debate* (Oxford: Oxford University Press, 1995).

and various varieties of meaning, and try to see how these could have their origins in human conventions and rule-governed human practices. Looking at language from the inside we consider specific aspects of the languages we speak: quantifiers, names, demonstratives, vague predicates, natural kind terms. We try to understand how these relate to one another, and one by one we try to explain how it works, in terms of the others. The two angles are less separate than they are in the philosophy of mind. We try, for example, to understand whether there could be a language without vagueness or without demonstratives, and we wonder whether particular theories of truth apply more plausibly to languages exploiting some of these devices than those without them.

Some of the target concepts here clearly play a role in speakers' regulations of their linguistic activities: notably, meaning. We ask whether someone really meant what they said, whether a word was used with one meaning or another, or what the meaning of an unfamiliar word is. It is pretty doubtful that the implicit assumptions behind these regulative practices can be explained in terms of one single concept of meaning, and so one vital philosophical task is to separate out the different meanings of meaning. The articulated collection of concepts of sense and significance that a good philosophical analysis of meaning would produce, should be capable of supporting a sophisticated linguistic metadiscourse. For example, it should allow us to make a helpful separation between what words literally mean, what someone might reasonably be expected to have communicated with them on some occasion, and what the actual communicative intention was. It should allow us to do this better than our present vague talk of meaning. If not, it is not much of an analysis.

Other concepts in the philosophy of language play a central role in practices that relate language to other activities. Truth, for example, enters when we try to distinguish between norms, conventions, or aims that are targeted at some other moral or social purpose from those that aim at believing that p when p. For example it might be wrong to assert that p, or even to think that p, though the belief that p is in some sense justified. (Proposition p might be a fact about someone's private life, which you have no business discussing, indeed no honest reason even to be curious about, but, still, there is evidence for it.) If we try to explain this sense of "justified," in which a belief can be justified even though it would be wrong to put oneself in the way of holding it, we will inevitably have to say something like: beliefs are in this sense justified when they result from processes which typically result in true beliefs.

Truth is so basic and simple an idea that it is hard to see how a philosophical theory could propose an alternative to it. (But perhaps that is a remark simply about the limits of our, or my, imagination.) But there is a lot of room for variation in the concepts that surround and connect to it. Tarski's account of truth links the truth of whole sentences to the satisfaction of their component parts. ("there are cats" is true if and only if something satisfies "cats.") And by doing this it suggests that behind the concept of truth there are other

more fundamental concepts relating in more specific ways to the correspondence between words and world. One reason the concept of satisfaction is important is that it applies to the components of nonassertoric sentences, questions, and commands. It thus suggests that analogs of truth apply even when we would not normally say "is true." The command "Let there be cats" is obeyed if something comes to satisfy "cat," and then the question "Are there cats?" is answerable in the affirmative. So we can see a philosophical basis for a proposal that we call these true commands and questions.

Related to this, there are kinds and degrees of truth. There is truth in fiction, there may even be poetic truth; there is objective truth and truth that is the result of some convention about how we are to speak. It is not at all obvious what is the best and most coherent way of qualifying "true." One desideratum is keeping the relations between science and everyday belief clear (we may want to keep well apart claims that there is a real property of objects like *a* which *a* instantiates from claims that the rules of language allow a correct assertion of "*a* is P at t".) Another is allowing us to signal clearly the import of our communicative intentions (do we mean that p is literally true, or just that "p" would be an adequate way of capturing some of the consequences of the facts?). There are clearly many others. [5]

A General Pattern

Similar remarks could have been made about most other areas of philosophy. I have not discussed ethics and political philosophy because with them the corresponding conclusions hardly need argument. Moral and political concepts clearly form networks whose structures are hard to understand, but which we need to negotiate in order to live our practical lives. So there are two vital tasks. First there is the task of giving us the information we need about the structure as it is, in order to find our way about when using it. (So students in beginning ethics courses not only learn the differences between standard positions about the nature of The Moral; they also learn, for example, the difference between something's being a right action and someone's having a right to do it, or the difference between an act's being wrong and its being right to prevent someone doing it.) The second task is that of tweaking, modifying, or fine-tuning the structure so that it can do its job better. (So we have debates about whether our intuitions concerning when it is permissible to cause one death to prevent others show something essential about moral judgement or are just quirks of the way we happen to think now.[6]) Both of

5. For a general discussion of recent accounts of truth see Richard Kirkham, *Theories of Truth: A Critical Introduction* (Cambridge, MA: MIT Press, 1992). The issues of this section are closely related to the controversy over minimal theories of truth. See Paul Horwich, *Truth* (Oxford: Blackwell, 1990), and my review of Horwich, *Philosophical Books* 32 (1991): 231–33.
6. See the symposium between Frances M. Kamm and John Harris, "The Doctrine of Triple

these are very practical tasks, but neither can be carried out effectively without assumptions about the relevant facts, which determine whether and how a system of concepts can function. And neither can be carried out without assumptions about the structure of the system. We can in most cases only make the roughest of assumptions about either.

Here is a different way of putting it. Most philosophy is concerned with our box of conceptual tools. Sometimes it aims to sharpen tools already in the box, and sometimes it aims to add or subtract tools with an eye to the jobs to be done and the materials involved. This way of putting it has an advantage. It makes it no surprise that we are dealing with something at the same time very practical and very abstract. For the tools are *concepts*. They concern people's general patterns of thought, their use of implicit beliefs that cannot be mechanically expressed in available vocabulary, and their expectations that others will conform to general and often very subtle rules.

Patterns of thought, structures of concepts, cannot be read off the surface of what people say or how they react to particular cases. Suppose that there is a concept which if perfectly understood would lead to some simple conversational rule. (The concept might be "knowledge" and the rule might be that you can never say "she knows it but it is false.") It does not follow that every person who possesses the concept will adhere to the rule, and expect everyone else to. For in some contexts people will not recognize the rule as applying, in others they will take it to be overruled by another, in others they will aim at following it but will typically fail. ("I know" also tends to indicate confidence in truth, so we can easily fall into taking confidence as necessary for knowledge, so that we can sometimes speak as if confidence were also sufficient for knowledge.) So a conjecture that concepts related in a particular way lie behind the way we think and talk nearly always is indeed a conjecture, hard to verify and rarely exactly right. It is always an approximation to the complex relation between some abstract never perfectly instantiated idea and the improvisations that link it to actual practice. One does not do justice to performance without seeing competence behind it; one cannot represent competence other than as something very different from performance.

Digression: Concepts

I might seem to have argued my case at the price of buying a controversial theory. For I have argued in terms of *concepts* and the *beliefs* they allow us to have. Moreover, I have spoken of better concepts that allow us to have beliefs that are in various ways better. And I have talked of the structures in which

Effect," *Proceedings of the Aristotelian Society*, supp. vol. 74 (2000). Also relevant is Tamara Horowitz, "Philosophical Intuition and Psychological Theory," in Michael R. DePaul and William Ramsey, eds., *Rethinking Intuition* (Rowman & Littlefield, 1998), 142–60.

concepts are embedded. This sounds as if I am assuming that there are par-
ticular identifiable things called concepts such that there is a definite answer to
the question whether the concept one person has, and uses a word to express,
is the same as a concept used by another person. And while that assumption
would not be at all obviously false, it would be far from obviously true. Cer-
tainly many philosophers have reasons for disbelieving it. It would be hard to
reconcile with Quine's skepticism about meaning, for example. So it would be
a risky assumption to use in supporting a claim about the nature of philosophy.

In fact, I think what I am arguing is consistent with a wide range of views
about concepts and beliefs. I certainly need the following assumptions:
People assert and deny sentences of public languages, which can be true or
false. The truth or falsity of a sentence oftens depends on properties of the
words it contains, and the capacity to make true or false assertions depends on
capacities to use these words in specific ways. When people assert sentences
they cause one another to enter into states associated with these sentences,
and these are closely related to the states between which people move when
they think. Communication and thinking produce practical effects, and differ-
ent ways of communicating and thinking, producing different states of mind,
produce different practical effects. Some such states, and the use of sentences
associated with them, can have better practical effects than others. Some states
and sentences can be used to express truths that others can not.

I do need all these assumptions. But they are uncontroversial, within and
beyond philosophy. They could be accepted by someone who believed in con-
cepts and beliefs but individuated them extensionally, so that any two con-
cepts true of all the same things are identical. And everything I have argued is
consistent with this interpretation of concepts. The claims could even be
accepted, with a little rewording, by someone who denied that thought is in
any way conceptual. (The assumptions above do not use the words "concept"
or "belief.") For they are fundamentally claims about the activity of thinking,
and its capacity to be influenced by the way we use our words.[7]

Rounding-Off: Perverse Philosophical Self-Denial

Some of these issues come to a head when the philosophical question turns on
the relation between common sense and science. Then we can be crippled by
finding ourselves caught between two wrong pictures. The more dominant is
probably the one that comes from Quine. According to this view common
sense is just a theory, like any other, which may be a usable approximation to

7. For current work on concepts see Christopher Peacocke, *A Study of Concepts* (Cambridge,
MA: MIT Press, 1992); Andrew Woodfield, "Do Your Concepts Develop?" in Christopher
Hookway and Donald Peterson, eds., *Philosophy and Cognitive Science* (Cambridge: Cambridge
University Press, 1993); and Jerry Fodor, *Concepts: Where Cognitive Science Went Wrong* (New
York: Oxford University Press, 1998).

the truth and in fact may be more suited for everyday practical activities than the theories that we have more evidence to believe are actually true. This picture cripples us when we consider possible changes in common sense. If a philosopher is to argue for a change in view then she should argue for what we have more reason to believe, and thus for bringing the common sense theory nearer to the scientific one. Moreover most of the evidence is already in the hands of the scientists (be they physicists, psychologists, or statisticians), so that the role of philosophers is reduced to that of popularizers and mediators. Almost as inhibiting is the opposed influential view, the one that comes from Strawson. According to this view common sense is the source of its own distinctive concepts, on which it imposes a priori constraints. There is no disparity between science and common sense, on this view, because they are incommensurable. One task of the philosopher is to explore the a priori conditions that thinking must respect if it is to remain within the common sense framework. But it cannot stretch or reshape that framework.[8]

Applied to the most important interfaces between science and common sense, notably to ethics and to folk psychology, both these views are disastrous. The Quinian view suggests that we can only improve folk psychology by turning it into experimental psychology. And the Strawsonian view suggests that we cannot improve it without tampering with its essence, so that it is no longer commonsensical, no longer folk. On both views the idea of moral or folk-psychological progress seems to make no sense. My reasons for disagreeing with both views should be clear by now. Each focusses on a particular task, which is only a small part of what we can and should expect of philosophy. The Quinian ideal focusses on acquiring true beliefs, about nature, mind, and everyday life. The Strawsonian ideal focusses on understanding how we think now. Both focus on the concepts we actually have now. But we can also ask about concepts we could have, and routes we could take from here to there. When we ask about possible concepts we realize how little we know about actual ones. We realize that giving an up-to-date account of the physical world is in a way easier (after the physicists have done the hard work) than describing the structure of the concepts that either physicists or non-physicists appeal to in forming their beliefs. The difficulty of the descriptive task emerges when we address the practical aim of finding the best ways of expressing and managing what we currently believe, or of removing obstacles to things we would gain from believing. Then we find ourselves grateful for any partial understanding that allows us even a little bit of progress.[9]

8. See W. V. Quine, "Epistemology Naturalized," in *Ontological Relativity and Other Essays* (New York: Columbia University Press, 1969) and P. F. Strawson, *Individuals* (London: Methuen, 1959).

9. Nelson Goodman appreciated this point clearly in *Fact, Fiction, and Forecast* (Indianapolis: Bobbs-Merrill, 1955), when he urged us not to invent subtle justifications of induction in our ignorance of the patterns of inductive reasoning that we actually follow.

There are thus important consequences to saying that these central parts of philosophy are more like Engineering than like Science. While respecting considerations about what is true or supported by evidence their main focus is on the question "will it work?" In the case of ethics this suggests that we have two subjects, and it might sometimes help to keep them apart. The project of one of them, call it moral science, is to find the intellectually best supported positions about what we should do and what it means to say that that is what we should do. Taken like this, it is a very new project. As Derek Parfit points out, though humans have been formulating moral systems for millennia the idea of this project has been clear to only a few people during a few scattered moments of history.[10]

In contrast, the project of ethical engineering is to find systems of moral ideas that we can use to think through moral problems in the context of everyday life. We want to find theories, norms, ideals, and strategies, which will in practice lead us to satisfactory outcomes if numbers of us decide to try them. This project can be carried out without a profound or exact definition of what would be a satisfactory outcome. We simply need to be able to identify things that are less than perfect about the way we now act and think. And finding things that we now do badly is easy, though deep and helpful diagnoses of the sources of our troubles are not so easily had.

10. See section 154 of the concluding chapter of Derek Parfit, *Reasons and Persons* (Oxford: Oxford University Press, 1984).

The Art of Appropriation: Towards a Field-Being Conception of Philosophy

4

Lik Kuen Tong

1. Philosophy as *Dao*-Learning: The Supreme Art of Appropriation

Philosophy is the human pursuit of *dao*-learning carried to the limits. It is at the limits of our perspectivity that philosophical wisdom manifests.

What is *dao*-learning? And what do we mean by *dao*?

Dao means "the Way." *Dao* is the Way things *are*, the Way Being itself *is*. *Dao*-learning is a learning that is itself an occurrence in *Dao*, an activity that directs itself perspectively and transcendentally to the Way. It is not a science, but an art—the supreme art of appropriation.

Appropriation is an activity, which in directing itself the way it does, makes itself its own. It articulates itself in virtue of the form of its own becoming. Appropriation then is self-affirmation and self-definition. An activity in thus affirming and defining itself in its self-becoming does something most proper, right, and appropriate to itself: it gives itself its form, its ownness, its unique identity. But self-appropriation is inseparable from the appropriation of otherness. In affirming and defining itself in its self-becoming, an activity must execute or conduct itself appropriately in relation to the world, to its transcendental endowment as well as to its environmental heritage—to the other activities that collectively constitute the field complement of its being. The activity that says "I" can only do so by addressing itself to the "non-I." For the *I am* is only possible in connection with the *they are*.

We describe the art of appropriation as the "supreme art" because it is the art of all arts—the art that constitutes the innermost nature or essence of all activities. It is what the *Dao* itself is. For the Way things are, the Way Being itself is, is none other than the Way of activity. The *Dao* is activity itself.

Dao-learning then is not just any activity, an activity among activities. No, it is rather the inner activity that constitutes the very nature of activity itself.

Reprinted with permission from *International Journal for Field-Being* 1, no. 1 (2000).

Every particular type of activity has its own *dao*, the Way that particular type of activity appropriates itself. Thus the *dao* of carpentry is the Way the activity of carpentry appropriates itself, the *dao* of singing is the Way the singing activity appropriates itself, the *dao* of government is the Way the activity of governing appropriates itself, and so forth. Insofar as each particular type of activity is an instantiation of the supreme art of appropriation, there is a kind of *dao*-learning appropriate to the particular type of activity under consideration. The *dao*-learning of carpentry belongs properly to the activity of carpentry, just as the *dao*-learning of government goes properly with the activity of governing. The question now is, What then is the *dao*-learning in terms of which philosophy is defined, the *dao*-learning that is proper to the philosophical activity?

The answer to this question may be said to have both a transcendental and a horizonal sense. In the transcendental sense, philosophy as *dao*-learning is an activity that directs itself to the innermost nature of activity, to the art of appropriation as such which is inherent in all activities. This is what we mean by describing an activity as "transcendental." And philosophy, transcendentally understood, is necessarily a reflexive activity—an activity that folds or bends back upon itself. The self-appropriation of the philosophical activity occurs in the reflexivity of activity.

Now philosophy is not just a transcendental affair, but is also a horizonal affair. Every activity occurs within a horizon of activity, much like a ship sailing towards a horizon in an ocean. More exactly, we conceive the horizon of an activity as that which sets the dynamic stage of appropriation in its process of self-becoming. The horizon towards which an activity directs itself is a function of its situatedness in the dynamic order of things, its topological region, as we may call it, in the Great Ocean of Becoming. What distinguishes the philosophical activity from other types of activity lies not just in its transcendental character but also in its horizonal-topological conditionality. For while all particular activities appropriate themselves in their own situatedness, philosophical activity directs itself consciously and emphatically in its self-appropriation to the utmost limits. But just what is it that reveals itself at the horizonal limits? It is none other than the inmost nature of *Dao*, the supreme art of appropriation that reflexively and topologically consummates itself. The limits of *dao*-learning then constitute the point of intersection between the transcendental and the horizonal limits of activity. This is what we mean by the limits of perspectivity.

Hence philosophy, as we conceive it here, is a rather unique kind of activity, an activity that is transcendentally and horizonally immanent in all human activities. For any human activity is philosophical insofar as it is a pursuit of *dao*-learning carried to the limits. And at the limits of *dao*-learning there are no things as such, for everything in the universe has turned into a "thing-in-itself," an "instance of eternity," as we would characterize it, which is no longer merely this or that particular thing in separation from other things, but is Being itself

in its unique absoluteness as viewed from the standpoint of a field-topological region. The limits of *dao*-learning are the point at which particularity commands and embodies the truth of universality in the unique integrity of its own perspective. It is at the limits of our unique perspectivity that the wisdom of *dao*-learning gives rise to itself.

In Field-Being Philosophy (FBP), here presented both as a vision of life and reality and as a thought experiment, "Being" means the *One Being*, that is, the boundless plenum of activity that encompasses all and generates all. The Way is the Way of the One Being. Every perspective is a perspective of the One Being. *Dao*-learning is a learning that directs itself to the One Being. And what we mean by the supreme art of appropriation, the art of all arts, is none other than the *art* of the One Being. For the art of appropriation, we will recall, is the *art* of activity itself.

2. Truth, Reality, and the Good: The Three Worlds of Field-Being

In this postmodern age the term "One Being" certainly sounds strange and antiquarian to our ears. Insofar as the Western tradition is concerned, no great philosophers in the twentieth century embrace it. The notion of the One Being is found neither in Husserl, nor in Heidegger, nor in Dewey, nor in Whitehead, and certainly not in Wittgenstein. This is understandable in light of the fact that the oblivion of the One Being is precisely what characterizes the philosophical soul (at least in the West) of the modern era. But this oblivion, let us hasten to add, is not to be equated with the Heideggerian "forgetfulness of Being." Heidegger conceives Being exclusively in terms of the truth-process, the *aletheia* or unhiddenness of beings, and fails to fathom to the ultimate source and ground of the truth process itself. The notion of the One Being conceived as the ultimate reality is entertained neither by Heidegger nor by Whitehead. Both philosophers are fundamentally pluralistic thinkers. Just as in Heidegger, the One Being has been replaced by the truth process as the principle of significance, whereby the plurality of phenomenal beings become meaningfully disclosed, so in Whitehead the One Being turns into creativity as the principle of the reality process in virtue of which the plurality of actual entities (including God as a nontemporal actual entity) become dynamically consummated. To be sure, there is a kind of holism in their ontological or cosmological outlook—a unity of beings in Heidegger's world and a unity of actual entities in Whitehead's universe. But this holism or unity of Being remains for both thinkers a unity that is founded on a fundamental plurality: it is a unity *of* the fundamental plurality. Moreover, their holism is conceived one-sidedly either as a holism of significance underlying the plurality of meaning or a holism of work as the efficacy of power derived from the plurality of actualities. From the Field-Being standpoint, this one-sidedness needs to be

corrected. The unity of Being is as much a unity of significance as it is a unity of work. This unity is, to be sure, a unity of plurality, but it is a unity of plurality only because the plurality is the plurality *of* an underlying unity—that is, of the One Being that pervades all and gives rise to all.

That the unity of Being has its ultimate source in the One Being and that all unity of plurality is founded on an undivided wholeness, an underlying unity derived from the One Being is what we call the "Field Principle." The Field, as we understand it here, is the universal matrix of all existence: it is that wherein unity and plurality, the One Being and its diverse manifestations or emanations are diremptively trans-differentiated. FBP is, to be sure, a Radical Monism insofar as it affirms the reality of the One Being at the root of all things. But this monism is also a Universal Perspectivism that recognizes the uniqueness and reality of all things in virtue of the Field Principle. Every being or thing in the Field-Being universe has its own topological region of existence which is the same as the Field or universal matrix perceived from its own standpoint or perspective. My topological region is the Field for me, your topological region is the Field for you, and the topological region of a kangaroo or tree or star is the Field for each of them. But the Field for me and the Field for you are not two separate fields, but are the same universal matrix of existence in which both you and I (and the kangaroo or tree or star) are perspectively situated.

Now we call the universal matrix the "world of significance" to the extent it is unhidden or meaningfully disclosed to us, that is, experienced in the sense of being physically felt or conceptually understood in a certain way. The process wherein the world of significance is revealed is what we mean by the truth process. Let us observe immediately that there can be no unhiddenness apart from experience, or outside the perspectivity of percipient subject or energy. Since for us experience is both a physical and a conceptual matter, involving the perception of both physical and conceptual meanings, the truth process is not confined merely to the conceptual dimension, as Heidegger would have it. Anything is significant if it is physically felt or conceptually understood. But the world of significance is not separable from the "world of work," that is, the Field wherein facts and effects are continuously made or produced by virtue of the work or dispensation of power, that is, of matter-energy. Here, the term "matter-energy" is to be taken in a special sense, not to be identified with its usual signification in the physical sciences. "Matter-energy" is an abbreviation for vibrant energy and karmic matter, the latter referring to the accumulated effects or products of past actions. The appropriation of karmic matter by vibrant energy, which consists in the creative transformation of karmic matter through karmic labor, is what defines the meaning of subjectivity in Field-Being. The process of this creative transformation, which is the same as the process of becoming, is what we mean by the reality process, a dynamic movement marked by the cocoonization of power concrescence. What is cocoonized

is the emergent reality of a transfinite subject, a karmic laborer procuring self-transcendence in virtue of its primordial ingression in the karmic warp, the state of activity in the plenum defined by the limitation of the possible by the actual. (See section 7 below for more on the karmic warp.) This conception of subjectivity in terms of karmic labor and creative transformation implies the inseparability of the truth process and the reality process with the process of the good, wherein the universal matrix takes on a third dimension as the world of importance. Just as the world of significance is based on the articulation of meanings (both physical and conceptual) and the world of work arises from the configurations of matter-energy, so the good and the "world of importance" is the articulate totality of consummated rightness and values. The good is indeed the work of significance and the significance of work. In general, anything is good in proportion to its measure of rightness and importance to an appropriating subject or a community of appropriating subjects. While endorsing the universality of the good, we also emphasize the subjectivity and relativity of all values. For activity is in essence appropriation wherein truth, reality, and the good are inseparably intertwined.

Hence, the three worlds of Field-Being are not three separate worlds, but are distinguishable yet inseparable aspects of one world, the same Field or universal matrix of existence. There can be no consummation of rightness and values except in terms of the aesthetic complexity of experience, matter-energy, and meaning, the three intertwining components of aesthetic power which define the concept of substance in the Field-Being sense. This is to be sharply differentiated from the entitative conception of substance and power in traditional Western metaphysics. In Field-Being parlance, the substance of things is their aesthetic power which consists in the intertwining and interplayful complexity of experience, matter-energy, and meaning. Thus understood, aesthetic substance or power is the concrete medium of activity, the fundamental stuff out of which all things are made.

3. The Plenum of Field-Being: The Ultimate Activity as Field Potential and as Act

Field-Being Philosophy, then, is at heart an aesthetic and field-topological theory of activity. The term "aesthetic" here has two basic connotations: (a) the interplayful unity of experience, matter-energy, and meaning and (b) the art of appropriation underlying and constituting the interplayful complexity and process. This process is the process of the becoming of transfinite subjects, the emanating souls of aesthetic power, each of which is constituted and shaped by a unique diremptive transaction of field individuals and field orders. In the Field-Being scheme, all individuals, in the primary sense, are field individuals, and all orders field orders. Field orders are systems of strains which, replacing the conception of universals (including Platonic forms and Whiteheadian eternal

objects) in traditional metaphysics, are diremptive tensions in the Field constitutive of the pregiven formal conditions of becoming in the universal matrix. The form of a circular movement, for example, is the system of strains or diremptive tensions whose resolution is responsible for the circularity of the movement. And the form of perceiving an apple is the system of strains or diremptive tensions wherein the possibility of an apple perception is embedded. The articulate action thus responsible for the resolution of diremptive tensions is what defines a field individual. More exactly, a field individual is a process of power concrescence in the universal matrix whose resolution of diremptive tensions is achieved through a union of vibrant energy and karmic matter. Out of this dynamic union is the emergence of a transfinite subject under the concrescencing conditions of cocoonization. The resolution of diremptive tensions is an agency of karmic labor determined by the energetic and creative transformation of karmic matter. The life of a transfinite subject is the life of a karmic laborer.

The Field then is the universal matrix conceived as the womb of all field individuals and field orders (the particulars and universals in traditional Western metaphysics), the two primary types of existence in the plenum of Field-Being. When we think of the Field as the source of all possibilities and existence in articulate action, it is identified as the field potential. Since the field potential makes room for all particularity—all particular roles and functions—and, hence, cannot be identified with any particular roles or functions, it is the nothing that lies at the root of all things, that is, the "Radical Nothing." But the field potential, as Radical Nothing, is also referred to as the "Let-Be," the ultimate activity that is the articulate source and ground of all existence in the universe.

In the Field-Being scheme, to be or exist is to be an emergent from the Radical Nothing; a being or thing is what is let to be by the Let-Be. This Act of letting be of the Let-Be, the ultimate activity, is what we mean by diremption, or the process or movement whereby the many emerge from the One. The Act of the Let-Be is, in other words, what articulates the field potential which, functioning in the state of absolute purity and simplicity, is what we have termed the "Radical Nothing." The Let-Be as such is not the Radical Nothing, nor the Act of letting be, but is both and neither. The reality of the Let-Be is ultimately paradoxical!

This notion of the ultimate activity entertained in terms of the paradoxicality of the Radical Nothing and the Act is by no means novel in the history of philosophy. Indeed, it is what lies at the heart of the perennial-global metaphysical tradition. Here the term "metaphysical" must be understood in its primordial implications. The metaphysical is what lies beyond the physical, that is, beyond what has emerged from the Radical Nothing, as implied in the original, etymological root of the Greek *physis*, meaning "to rise, to emerge"— a meaning which has nothing to do with what we mean today by the term "physical." And just what lies beyond the physical, the emergents as such and

as a whole? It is none other than the ultimate activity in its Radical Nothingness, the source and ground of all existence (the Latin root of existence [*ex-sistere*] also means "to arise, to emerge"). Grasped in this primordial sense, metaphysics must be thought of as the conceptuality of the ultimate activity or the attempt to make sense of it. All great philosophical traditions in the world are metaphysical in their origins. The ultimate activity is called *arche* by the pre-Socratics, which finds its counterparts in the *Dao* of the *Daodejing* and in the *Brahman* of the Upanishads. Insofar as the *Daodejing* is concerned, the Radical Nothing is referred to as *wu*, whereas the Act is termed *you*. The paradoxicality of the *Dao* is the paradoxicality of *wu* and *you*. And what is the paradoxicality of *Brahman* in the Upanishads? Is it not in the distinction between the *nirguna Brahman* and the *saguna Brahman*, that is, between *Brahman* without qualities and *Brahman* with qualities, which correspond so closely to the distinction of *wu* and *you* in the *Daodejing*?

4. The Field Principle (I): Reflexion, Articulation, and Ontological Identity

Now the region of reality and thought that embraces the paradoxicality of the ultimate activity we call the "inner dynamics of the Let-Be." As such, it must be recognized as the perennial source of all metaphysics. In Field-Being, the conceptuality of this notion is captured by the Field Equation, symbolized by the notational schema Q.Q = Q.q, where Q stands for the Let-Be or ultimate activity, and q the diverse manifestations or emanations (field individuals and field orders), the *emanata* that have emanated or emerged from Q. (The letter Q [q] is chosen because the inner dynamics of the Let-Be is ultimately what is in question—what matters metaphysically and philosophically.)

The dot in the notational schema is capable of many interpretations, depending on how the symbols Q and q are conceived in relation to each other. We call the dot the "awesome field interface," inasmuch as it is that whereby all determinations (including all terms and distinctions) in the Field are trans-differentiated, that is, separated and yet held together, according to the requirement of the Field Principle. Thus, although both the field potential and the Act are designated by Q.Q on the left side of the equation, the dot will assume a different meaning in each case. If the ultimate activity is conceived in its absolute purity and simplicity, then the dot in Q.Q names the state of the Radical Nothing, the state of pure action. On the other hand, if the Let-Be is thought of in the diremptive movements of its Act, then the dot in question implies the articulate reflexivity of the ultimate activity, the state of articulate action. The Let-Be reflects, folds, or bends back upon itself in its Act of letting be wherein all that is let to be is articulated.

What is equated in the Field Equation, then, is the inner connection between two meanings of the Act, two moments of the diremptive field action, namely,

of field action in the sense of reflexion (Q.Q) and of field action in the sense of articulation (Q.q). Reflexion is articulation; articulation is reflexion: that is what the Field Equation indicates. What is stated in the notational schema is simply this: The Let-Be (Q) acts upon itself, all things in the universe (q) are let to be. This unity of Being expressed in terms of the diremptive identity of reflexion and articulation we call the "ontological identity." Let us reinstate the notational schema to set forth this first stipulation of the Field Principle:

Field Equation I Q.Q = Q.q (Ontological Identity)

The dot on the right side of the Field Equation is what expresses the general meaning of existence in Field-Being—that is, existence as a matter of articulation, manifestation and emanation. A thing or being is what is articulated in the Act of letting be; it is a manifestation of the field action, an emanation from the ultimate activity. Since field action is always a function of the inner dynamics, a dynamic relation of pure action and reflexive-articulate action, existence pertains to the diremptive affair of the ultimate activity. Existence is indeed diremption conceived on the side of things (q), of what has emerged in the diremptive field action. But what have emerged or emanated in the diremption of the ultimate activity, the *emanata* in the field action, are not things in the ordinary sense of the word. Strictly speaking, there are no things in the Field-Being universe. The universe in the Field-Being sense is not a collection of things in the sense of inert, substantial entities, but a plenum or continuum of activity. There is nothing outside this plenum: It has no otherness either without or within. There is no absolute time in which the plenum occurs, nor is there an absolute space in which the plenum is contained or situated. Time and space, like everything else in Field-Being, are a function or determination of activity, a role or state or character assumed or performed by the plenum. Thus time is the plenum performing the function of temporality, and space is the plenum assuming the role of spatiality. In short, in the Field-Being universe, there is nothing that we can think of or talk about which is not functional, that is, a function or determination of activity. Every concept is a concept of activity, and every word is a verb-word. In the primary sense, there is no time except as actional time, there is no space except as actional space, and there are no apples except as actional apples. In short, there is no difference between being and doing at all in the Field-Being scheme: being is doing, and doing being. For all is activity! All is activity!

5. Being as Nothing, as Becoming and as Thought: There Are No Opposites

Now if all is activity, then the traditional oppositions between being and nothing, being and becoming, and being and thought are no longer valid. In

the Field-Being continuum, there is nothing that is really nothing. What we have called the "Radical Nothing" is not truly a nothing: it refers to the quiescent state of the field potential or activity in its absolute purity and simplicity. The nothingness of the Radical Nothing remains a functional or role concept: for the function that is presupposed by all particular functions is still itself a function, the role that makes room for all particular roles is still itself a role. The seemingly negativistic or nihilistic language of nonbeing (*wu*) or emptiness (*sunyata*) so characteristic and distinctive of Asian philosophy, notably in the Daoist and the Buddhist traditions, has often been misunderstood. The truth is nonbeing and emptiness are not negativistic or nihilistic at all. On the contrary, they are among the most positive and affirmative of all terms or concepts—those that point to the Radical Nothing which, coiling at the root of the diremptive field action, is the transcendental source of all existence.

Similarly, since all is activity, there can be no contradiction at all between being and becoming, an antithesis that is almost synonymous with Western metaphysics. How can the two categories be contradictory if being is activity and becoming belongs to the very nature of activity? Is it not obvious that being is becoming, and becoming being? The antithesis between being and becoming so fundamental to Western metaphysics arises only when being is thought of in terms of something that is not activity. This it does in fact by absolutizing activity—by concentrating on those real or imagined aspects of activity that are most palatable to the taste of the discriminating intellect: namely, activity as absolute permanence, absolute unity, absolute definiteness, absolute completeness, absolute clarity, absolute impenetrability, and so on. Yes, all these characteristics are in some sense attributable to activity itself. But the point is—that is not all to the nature of activity. We cannot think of activity merely in terms of its absoluteness, for relativity, too, belongs equally to the essence of activity. For in the final analysis—a point to be made emphatically, the nature of activity is what is uniquely paradoxical: it is absolute and yet relative, permanent and yet forever changing, unitary and yet diverse, definite and yet lacking in definiteness, complete and yet incomplete, impenetrable and yet penetrating. This paradoxical nature resides in the inner dynamics of the Let-Be, the dynamic relation between pure action and articulate action in the transcendental constitution of the ultimate activity. The characteristics of absoluteness belong to the ultimate activity as pure action, whereas as articulate action the Let-Be is incurably relative. Under the influence of the Ego Principle, the inherent tendency of articulate action to perpetuate itself, the discriminating intellect tends to favor the absoluteness of activity because it owes its satisfaction to its conceptual graspability. Superficially, the discriminating intellect may appear to be driven by the desire for adventure in relativity, but it is at heart intolerant of all that is relative: it is in fact goaded implicitly towards its negation. For the discriminating intellect is itself an instrument for the despotism of the Ego Principle, the desire for absolute control.

Once again, if all is activity, how can being be opposed to thought? Is not thinking a form of activity? Whether one equates thinking with consciousness or, as in Field-Being, with experience in general, there can be no separation between being and thought. In the Field-Being scheme, all experience is in some sense cognitive: it is an immediate or mediated reception and transmission of information, a determination of significance in virtue of the aesthetic complexity of physical and conceptual meanings. In this general sense, the experience of dolphins is no less cognitive than the experience of human beings. Since experience is an integral part of power in constituting the aesthetic complexity of activity, the Cartesian dictum *cogito, ergo sum* is to be reversed in Field-Being. It is not that I think, therefore I am, but that I am, therefore I think. For I am nothing but a center of activity: I am my activity. In being I am given to thinking (in the amplified Field-Being sense), that is, to the cognitivity of experience that is an integral component of my power, my aesthetic complexity.

It should be clear by now that in the Field-Being scheme not only is there no contradiction between being and nothing, being and becoming, and being and thought, there is actually no contradiction or opposition between any pair of the traditional opposites. For in the unity of Being, that is, the plenum of activity in its undivided wholeness, there are only distinctions, but no real opposites. What is asserted in the Field Principle, which we may also call the "Ontological Principle" from the methodological standpoint, is a Radical Monism of activity wherein all distinctions and opposites are harmonized and united in the inner dynamics of the ultimate activity. This is the only type of monism, let us submit, that does not exclude relativity and diversity: in fact, it requires it. For in Field-Being Radical Monism and Radical Perspectivism are one and the same.

This fundamental harmony that lies at the heart of the One Being, the plenum of activity, is what in the *Yijing* tradition is called "*taihe*," the Great Harmony. In the realm of the Great Harmony, all roles and all concepts are distinct and yet equivalent; all words and discourses are meaningful and yet redundant or tautological. For in the final analysis, there are no things, no substantial entities, there is only activity—ultimately the activity that is both field potential and field action, both the Radical Nothing and the Act of letting be. That is what ultimately matters, what ultimately is in question, and ultimately what we can and do talk about.

6. The Field Principle (II):
The Surd or Ontological Difference

Critics of Field-Being are now impatient. Our way of talking about reality and the world does not seem to make much sense to them. For by "sense" they

mean common sense. Whether it be the common sense of the people from the streets or the privileged common sense of the trained philosophical specialist, what is common in the common sense is the prevailing cognition of the phenomenological consciousness, the consciousness that sustains our existence and ordinary activities and practices in the life-world. It is common sense to recognize that there are things, there are entities. What right does the Field-Being thinker have in countering this prevailing cognition of common sense? What justification is there in negating the wise and loudly pronounced judgment of the phenomenological consciousness? Is the Field-Being thinker given to fancy and extravagant speculation in making the bold assertion that there are no things, there are no entities? Is he or she at all responsible and serious? What exactly is the basis of his or her uncommon sense?

To begin with, the denial of things and entities in our ordinary experience may seem at first incomprehensible and extravagant. But what is being denied here must be properly understood. There are of course thing-like or entity-like phenomena like apples, trees, machines, animal bodies, and so on in our everyday experience of ourselves and the world. They present themselves as enduring individuals that sojourn for a while in the world of appearance. The point is that these thing-like phenomena are not themselves things, that is, not the way we ordinarily attribute to them, and certainly not the way substantialist philosophers would make them to be. What the Field-Being thinker denies in the commonsense or prevailing cognition of things is not the phenomena themselves, not even their thing-like or entity-like appearance as such, but the conceptual constructions of rigid identity we habitually attribute to them. What is being denied here in Field-Being is not the phenomena themselves but the conceptual attribution to these phenomena. To be more exact, what Field-Being denies is the existence and reality of substantial entities, things or beings that are supposed to be in themselves complete wholes—inert, separate, self-contained, and independent, each endowed with a rigid identity. But there are no things in themselves: there are no self-complete wholes. There is only the fluidity of activity, but not the rigid identity of substance. The universe is not a collection of substantial entities but a boundless continuum of activity that is forever fluid and incomplete. The plenum is not itself a digitum, nor analyzable into a collection of *digiti*. That, from the Field-Being standpoint, is what the truth is, what the One Being reveals to us.

In fine, what is being denied then is not the phenomenal world as such but its substantialization or enticization. The point is not only is the plenum not digitizable into substantial entitites or self-complete, self-contained wholes, the *digiti* in the substantialist universe, it is not even identifiable with the articulate totality of the *emanata*, represented by q in the Field Equation, which in Field-Being is what define the world, the emergent totality that is the original meaning of *physis*. The plenum is not a digitum, and is always greater than the

world. For the boundless continuum of activity which forms the One Being is in itself inexhaustible in its procreativity. This difference between the One Being and the beings, between the Let-Be and what is let to be, between the *arche* and the *physis*—or, more precisely in Field-Being terms, between the field potential and the *emanata* of the field potential, we call the "surd" or "ontological difference." This is the second stipulation of the Field Principle in which the unity of Being is understood as a lack of completeness or self-identity in terms of the difference between field action as such and an articulate totality of field action. If we let $\Sigma Q.q$ stand for the articulate totality of field action (totality of the *emanata*), then this second formulation of the Field Principle may be represented as follows:

Field Equation II: $Q.Q - \Sigma Q.q = $ Surd (Ontological Difference)

The term "surd," from the Latin *surdus*, is in its mathematical sense a mistransliteration into Latin of the Greek *alogos*, which means "irrational" or "speechless" (according to the Oxford Dictionary). The Surd is the *alogos*, the irrational factor in Being that renders us speechless because it defies rational explanation. But what does rational explanation mean? In the substantialist tradition of Western metaphysics, rationality is no more than the technical expression or product of substantiality: the essence of rational explanation consists precisely in the substantialization of Being, in turning the plenum into the intellectually graspable, calculable, and practically controllable world of the *digiti*. This digitalization of reality which culminates in its most triumphant expression as the invention of the computer has been foreseen in its nature and implications by some of the great minds of the twentieth century, including notably Bergson, Dewey, James, Whitehead, and Heidegger. But these great critics of substantialism in the contemporary West still fall short of what is ultimately expected of a Field-Being or nonsubstantialist thinker, namely, the acceptance and embracement of paradoxicality as the authentic philosophical attitude. In spite of their yearning for departure from analytic thought, they (perhaps with the exception of Bergson) remain anchored with at least one foot in the rationalist-analytic tradition.

Now by "rationalist-analytic tradition" we mean to include any mode of philosophical thought that insists on the primacy of the rational at the expense of the paradoxical. Since for Field-Being the realm of the paradoxical belongs only to the plenum, the One Being that is also the Great Ocean of Becoming, any philosopher who shies away from or refuses to recognize the plenum is by necessity a nonparadoxical thinker and belongs properly to the rationalist-analytic tradition. And any thinker who remains anchored in rationalist-analytic thought will find him/herself haunted by the ghost of substantialism with its inaudible enchanting voice, claiming: there are only things, only entities!

7. Substantialism as Profiling Delusion: The Ego Principle and the Karmic Warp

But there are no things, there are no entities. There is only activity! The so-called things or beings in our ordinary experience are really enduring centers of activity whose articulate action is what brings forth the presencing of persons, animals, trees, apples, chairs, rocks, winds, oceans, stars, planets, galaxies—in short, the innumerable variety of things in the phenomenal world. I am an enduring center of activity, and so are all the organs, issues, cells, molecules, atoms that compose my body as well as all the thoughts and desires and feelings and the other mental contents that compose my mind. Actually what we ordinarily identify as beings and things are not the enduring centers of activity as such but their surface phenomena produced by the effects of their articulate action. Thus an apple as perceived is the effect of the articulate action that presents the surface phenomenon we identify as an apple, a computer keyboard as perceived is the articulate action that produces the effect and surface phenomenon called a "keyboard," and an experienced hurricane is the effect and surface phenomenon of a hurricane-producing articulate action, and so on, and so on. In Field-Being thought, these surface phenomena of articulate activity are recognized as dynamic profiles, that is, more exactly put, aesthetic and trans-differential profiles of power concrescence. A dynamic profile is a moving film of reality, a perspective reflexion of the universal flux or matrix in action. It is described as aesthetic because the moving film is a configuration of the aesthetic complexity of experience, matter-energy, and meaning. And it is trans-differential because the profiling of power concrescence is consummated in and through the perpetual transaction of field individuals and field orders underlying and constituting the relational web of field action that is the universal matrix in flux. This action web of trans-differentiation, as we may call it, is the basis of the Great Flow, the Great Ocean of Becoming wherein all dynamic filmings or profilings occur. Just as the ripples and waves which rise and subside on the surface of an ocean are not the centers of action that produce them, so the emergent surface phenomena in the Great Ocean of Becoming are not identifiable with the articulate field action that generates them. The profiling field action that presents the perceived apple, for example, is actually an enormously complex event of power concrescence involving the participation of countless centers of activity converging for the time being on that region in the action web topologically indexed by the presencing of the perceived apple in question. The perceived apple is not itself a thing or substantial entity separable from the profiling field action. In itself, that is, abstracted from the field action, the perceived apple is a non-entity, a no-thing. As the Buddhists would say, the so-called things are in themselves empty, devoid of self-nature.

The attribution of thinghood or substantiality to the surface phenomena is thus the product of a profiling delusion, a mistaken identity brought about by the lure of definiteness and the inveterate disposition to grasp and to possess—the Ego Principle that is inherent in the nature of articulate activity. Every articulate action desires to perpetuate itself, that is, to continuously affirm itself in its own form of articulation. There is thus a will to power, as Nietzsche calls it, underlying each and every enduring center of articulate action. The enduring center is above all an ego center. It is indeed in virtue of the inherent Ego Principle or Will to Power that an enduring center derives its enduring character. The apparent stability, solidarity, and continuity of things are, in the final analysis, a function of the Ego Principle. Behind the uniformity of nature lies the Will to Power.

It is the Will to Power, which generally manifests itself as the will to grasp, to hold, and to control, that renders effective the lure of definiteness. In the presencing of an apple, for example, the percipient subject is habitually directed to the definite effects of the apple-articulating action rather than to the action itself. This withdrawal of the articulating act from the perception of the percipient subject is perfectly understandable inasmuch as the act of articulation is precisely that which cannot be grasped. What can be grasped in an articulation is not the articulating act itself but its form of articulation to the extent it is definitely presented in a perceived profile of its effects—the definite color, the definite shape, and the definite smell of the apple in appearance, for instance. The apparent character of the surface phenomenon, which is the combined profile of the articulated effects, depends partly on the perspectivity of the percipient subject. The apple that I perceived was not profiled the same way it was for you. And yet we both contributed to the articulate totality of the apple-presencing event in virtue of our own shares in the power concrescence that makes up the event—our own shares of the aesthetic complexity in the profiling of the underlying field action.

What is fundamentally at work in the power concrescence and profiling of articulate action is none other than the Ego Principle, the disposition, let us repeat, of an activity to perpetuate itself that is inherent in the nature of articulate action. It is the Ego Principle inherent in the center of activity which brings forth the surface apple phenomenon that is responsible for the endurance and continuity of the apple. The apple itself is nothing in abstraction from the enduring center of activity that articulates it. And the enduring center of activity in question is in no way separable from all the other centers of activity that have arisen in the plenum, in the Great Ocean of Becoming. For every center of activity is but a dynamic moment of the universal matrix, an aspect of an everlastingly self-reflecting, self-articulating, self-constituting, self-transforming, and self-profiling field action. The world as a dynamic and fluid articulate totality of field action is not to be digitized into a collection of substantial entities or

assembled into a machine made up of mechanical parts, however intriguing and orderly that substantial or mechanical assembly is.

How, then, does the Ego Principle operate in the substantialization of reality—in the truncation, bifurcation, and enticization of the plenum into a digitum? How does the Will to Power will itself in the mechanical profiling of nature? The answer is: The Ego Principle comports itself both objectively and subjectively through the Samsaric Cycle of the Karmic Warp. By "karmic warp" we mean the topological limitation of the possible by the actual, that is, karmic matter or the accumulated effects of past action. The Field or universal matrix understood as the realm of existence in the grips of the karmic warp we call "Samsara," the realm of warped possibilities. But the realm of warped possibilities is also the realm of karmic labor constitutive of the becoming and self-appropriation of transfinite subjects, the union of vibrant energy and karmic matter. It is a process marked by the perpetual recycling of power through the interpenetration of energy and matter. There is, on the one hand, the objectification of vibrant energy into karmic matter and, on the other, the revitalization of karmic matter in vibrant energy made possible by the perpetual enfoldment of consummated subjectivity. This recycling of matter-energy in the realm of the karmic warp is what we mean by the Samsaric Cycle. It is here that we find the inner meaning of the Ego Principle. The inherent tendency in articulate activity towards self-perpetuation is always subject to the influence of karmic matter. The Ego Principle is indeed what shapes the realization of warped possibilities. Now the operation of the Ego Principle is an objective affair insofar as the subjection of the Ego Principle to the karmic warp expresses a uniformity of nature, and it is subjective to the extent the Will to Power is karmic bound in determining the subjectivity and perspectivity of transfinite subjects. Karmic subjection is, in other words, the commonality of objective uniformity and subjective orientation.

8. Karmic Conformation: The Two Wings of Subjectivity

More exactly, karmic influence takes place subjectively in two opposite directions. It is fundamentally a function of two appropriational attitudes and dispositions under the impact of karmic matter that we may refer to, respectively, as the Will to Conform and the Will to Deviate from Conformation. Karmic conformation means solidarity and continuity with the past, which expresses itself in the desire to repeat the forms of definiteness articulated in karmic matter, in the consummated reality of past action. Karmic nonconformity, on the other hand, expresses an attitude and disposition in the opposite direction; it is the desire for freedom and independence from the past, from the karmic establishment in past action. These two wings of subjectivity, as we

may call them, may be combined in various ways in determining the disposi-
tional constitution of the subject, capable of being analyzed into different levels
and dimensions of attitudinal intensity and complexity. For the ease of
exposition, we shall arbitrarily refer to the Will to Conform as the right-side
wing, and the Will to Deviate from Conformation as the left-side wing. Thus
conceived, the dialectic interpolation of the two wings is what determines the
subjective operation of the ego center in activity. While Nietzsche tends to
emphasize the efficacy of the left-side wing, Field-Being restores it to its full-
fledged integrity: The Will to Power is a bipolar force, a two-winged reality.

But whether right-side or left-side, the Will to Power is a will to grasp, to
hold on to a form of definiteness so as to perpetuate it in one way or another.
This is the underlying motive force in the process of substantialization. Since
it is what makes possible the survival and growth of a life-form within the
samsaric sphere of the karmic warp, the Ego Principle is the principle of indi-
viduation in Field-Being. From this perspective, the substantialization of the
world is in an important sense necessary and inevitable. We need a substantial-
ized world in order to live.

But it is one thing to understand and recognize the practical necessity of
substantialization as an instrument of individuation for survival and control,
and another thing to be blinded by its delusive character in subscribing to the
reality of the truncated world. In Field-Being a distinction is made between
pragmatic substantialism and dogmatic substantialism as two fundamental
world outlooks, depending upon one's attitude towards the substantialization
of the world. Unlike the dogmatic substantialist, the pragmatic substantialist
does not view the truncated world as real, but only as an expedient construction.
The latter is cognizant of the truth, of Field-Being in its undivided wholeness:
he or she is at heart a nonsubstantialist in his or her intellectual commitment.

And the truth is, the Ego Principle is not the only force inherently opera-
tive in an enduring center of activity. For deeper than the Ego Principle which
is mostly at work at the superficial levels of articulate action is the Field Principle,
now understood as the Force that speaks on behalf of the unity of Being which
operates for the most part silently and unconsciously in the holistic center of
activity. It is in the holistic center of our being that we are inwardly connected
to the *Dao*, to the inner dynamics of the Let-Be. While the Ego Principle or the
Will to Power is disclosed to us through the prevailing cognition of phenom-
enological consciousness, the Field Principle or the Force is only revealed to us
in and through the intuitive veins and transfinite connections of meditative
consciousness, which will be cut off the moment they are enticized, the mo-
ment we attempt to grasp them. For the undivided reality of the *Dao* can only
be spontaneously intuited: it is precisely that which cannot be grasped.

The lure of definiteness loses its enchantment in the blissful quiescence of
meditative action. There one is reconnected through the intuitive springs to
the infinite reality of the *Dao*, to the inner dynamics between the Radical Nothing

and the Act in the field potential of the ultimate activity. This is the region wherein the Ego Principle itself is nourished and receives its creative vitality in the first place. For the Will to Power is itself grounded on the Field Principle as its principle of diremption and individuation. It represents an obligation of the Act to the Radical Nothing: The Will to Power arises from and is responsible to the Force.

This region of reality and thought wherein the connection between the Ego Principle and the Field Principle, between the Will to Power and the Force, is made or recognized is the realm of speculative consciousness. In speculative consciousness the truth and deception of phenomenological consciousness is examined and assessed under the illuminating light of meditative consciousness. This is the realm for the philosopher as a *dao*-learner, the realm of speculative philosophy in the Field-Being sense. It is in the realm of speculative consciousness that philosophy is the pursuit of *dao*-learning carried to the limits.

9. The Synthesis of Phenomenological Consciousness and Meditative Consciousness in Speculative Consciousness

Now *dao*-learning is, as we have stated at the beginning, an art, and not a science: it is the art of all arts, the supreme art of appropriation. It is in the realm of speculative consciousness in which the connection between phenomenological consciousness and meditative consciousness is established or re-established and rendered whole, that the real meaning and intention of the supreme art comes to the forefront of human cognition and in the reflexive transparency of its truth. For that in essence is what the *Dao* reveals itself to us. The Way *is* the supreme art of appropriation in truth, in reality, and in the good.

This notion of speculative philosophy as the pursuit and embodiment of the supreme art places Field-Being squarely in the perennial global-philosophical tradition and sets it apart from the substantialist straying from this tradition of Western metaphysics. What is primordial in the perennial global-philosophical wisdom is the fundamental intuition of Being in its undivided wholeness and the recognition of the paradoxical in the self-revelation of the ultimate reality. This is to be sharply distinguished from the rationalist-analytic outlook of the dominant substantialist strands of Western metaphysics which, in its truncated view of reality, has finally done away with the paradoxical. In the substantialist metaphysics an overinflated Ego Principle has usurped the reign of the Field Principle, the Will to Power has masqueraded as the Force. Heidegger was not without justification in calling Nietzsche the "last metaphysician."

Thus, in spite of the superficial resemblance between speculative philosophy in the Field-Being sense and the substantialist metaphysics that belongs to the Western rationalist-analytic tradition, there is really a world of difference

in their respective quests for truth, reality, and the good. The former is committed to the speculative harmonization of the Field Principle and the Ego Principle, whereas the latter resides precisely in the lacunae of their disconnection. As a seeker of truth, the speculative philosopher in Field-Being is a shepherd of the paradoxical, whereas the substantialist metaphysician aspires towards its ultimate possession through the elimination of paradoxicality. The speculative *dao*-learner as a master aesthetician rides along with the Great Flow, self-appropriating at ease in the Great Ocean of Becoming. By contrast, the substantialist metaphysician seeks to conquer the truncated world in a self-deluded oblivion of becoming, building his artificial kingdom upon enticized and digitized effects of the endurable. For Field-Being philosophy is primarily a life-form to live by, whereas in the substantialist tradition it must be looked upon as basically an instrument of control.

10. The New Metaphysics and the Appropriation of Karmic Labor

In order to preserve the primordial meaning of the metaphysical (the paradoxical ultimate reality that lies beyond *physis*), we shall call speculative philosophy in the Field-Being sense the "New Metaphysics." Conceived in this vein, the new metaphysician is at heart a meta-aesthetician, a practitioner of *dao*-learning or the art of appropriation to the limits. This conception of speculative philosophy as meta-aesthetics may now be further elaborated in terms of its relationship to the three worlds of Field-Being. First, meta-aesthetics assumes the role of meta-episteme when the pursuit of *dao*-learning is viewed in the light of the truth process or for the world of significance. Here, the supreme art of appropriation manifests itself as the art of making sense. Speculative philosophy, as meta-episteme, is indeed the art of making sense pursued to the limits. But the world of significance, as we have noted, is inseparable from the world of work, and the truth process from the reality process. When meta-aesthetics is viewed in the dimension of karmic reality as defined by the work of karmic labor, the art of appropriation turns into the art of meta-pragmatics, the general art of organized power which directs itself to the practical relation of the human life-form to its environmental or karmic heritage. The relationship between meta-episteme and meta-pragmatics then is the relationship between the activity of making sense and the activity directed to the practical use of power. This corresponds roughly to the traditional distinction between theory and practice in Western philosophy, although the distinction in the Field-Being context must be seen in the light of the opposition between substantialism and nonsubstantialism, and of the great emphasis placed on the notion of karmic heritage and karmic labor. Indeed, the characterization of the *dao*-learner as essentially a karmic laborer is distinctive of the Field-Being conception of the speculative philosopher.

For just as the truth process and the reality process are united in the process of the good wherein the realization of rightness and values is to be measured in terms of the creative transformation of karmic matter, so correspondingly the pursuits of meta-episteme and meta-pragmatics are to be envisioned in their aesthetic harmony in the practice of meta-ethics as the supreme art of appropriation in the world of importance. This is the ultimate and all-arounded calling of speculative philosophy, the calling of the meta-aesthetician as meta-ethicist, that is, as the artisan of rightness and values in the appropriation of karmic labor. It is indeed in the conception of the speculative philosopher as karmic laborer that truth and reality are united in the good, and that the inner connections between subjectivity, life, and existence are revealed in their transparent integrity.

In the Field-Being scheme, subjectivity, life, and existence are all defined in relation to the notion of karmic labor. First, karmic labor is the labor of all transfinite subjects who, as we have noted, owe their emergent being to the union of vibrant energy and karmic matter. The subjectivity of a transfinite subject is thus the subjectivity of a karmic laborer, which consists in the way it executes and comports itself in the energetic and creative process of karmic transformation. This process is the process of self-becoming wherein transfinite subjects consummate themselves in virtue of their respective cocoonization of power concrescence. Cocoonization is the process whereby an articulate activity transcends itself in its self-becoming in virtue of its own self-confinement and self-limitation. The butterfly that emerges from the cocoon is the same articulate activity that builds the cocoon. In building the cocoon and confining itself to it, the underlying action has brought about its own transcendence as an emergent self (the butterfly) in virtue of its own self-limitation. This inner connection between self-limitation and self-transcendence metaphorically expressed in the concept of cocoonization is, we submit, what life is all about. Hence, generally speaking, a life-form is a pattern of cocoonization, a conception which cuts across the ordinary, scientific conception of life in terms of the distinction between organic and inorganic matter. In the Field-Being conception, life-form belongs to all transfinite subjects and exists at all levels of matter-energy, organic or otherwise.

The meaning of existence in Field-Being may now be more sharply and properly determined. Existence, as we have indicated earlier, expresses the internal relation between Q and q, that is, between the Let-Be, the ultimate activity, and what is let to be, the *emanata*. Since the *emanata* consist primarily of field individuals (transfinite subjects) and field orders (systems of strains), whose transaction and trans-differentiation are what constitute the Field as the universal matrix in flux, to exist is to participate in the dynamic process of field action, and to play a role in the self-becoming and karmic labor of transfinite subjects. It is in and through their respective karmic labor that transfinite subjects become what they are. The reality of karmic labor is the reality of their

existence as *emanata* in the plenum of Field-Being. All *emanata* are field topo-
logically conditioned in the dynamic network of the universal matrix, in the
Great Web of trans-differentiation that bears the diremptive topology of field
action. The Great Web is an *Act* Wide Web, as we may also so characterize it,
inasmuch as it expresses trans-differentially the articulate totality wrought by
the all-encompassing and pervasive Act of the Let-Be. All karmic labor occurs
in the Act Wide Web and in a topological arena of the cocoonization of power
concrescence. And the mode of transfinite immersion in the web affair on the
part of karmic laborers is a matter of field-topological management, a function
of transcendental freedom and karmic necessity. This, in the final analysis, is
what karmic labor and transfinite subjectivity are all about. The story of self-
becoming is the story of web immersion.

11. The Field-Topological Conception of *Dasein*: A Critique of Heidegger

In the Field-Being vision, all transfinite subjects in the transcendental phase of
their existence emanate freely and spontaneously as pulsations of pure energy
from the Radical Nothing. Their emergent existence in the world begins at the
moment of fate marked by the transcendental ingression of pure energy in the
universal matrix in flux under the conditions of the karmic warp. This is the
primordial beginning of karmic labor at which point the fatefully fielded trans-
finite subject is given an address in the Great Web, the field address of its own
topological region. This owning of a field address and the occupation of a
topological region is what determines the concrete meaning of its transfinite
existence. The term transfinite implies the traversion of finitude from the tran-
scendental to the primordial, and from the primordial to the phenomenal phase
of articulate action. It is a movement or process of transition which leads from
the givenness of transcendental endowment to the givenness of environmen-
tal-karmic heritage. To adopt a term from Heidegger, we may call this con-
crete existence of a transfinite subject its "*Dasein*." The *Da* in the *Dasein* of a
transfinite subject is the place or locus of its Field-Being (*Sein*), namely, its
field address or topological region. The life of *Dasein* or transfinite existence
thus has the meaning of field-topological occupation. My *Dasein* is my field-
topological occupation, your *Dasein* is your field-topological occupation, and
the *Dasein* of a kangaroo is the kangaroo's field-topological occupation. All
transfinite subjects are unique by virtue of the uniqueness of their respective
field-topological occupations, each of which is not merely distinct in terms of
the distinctness of its life-form or the character of its cocoonization, but also
distinct in terms of the uniqueness of perspectivity from its own topological
standpoint. And yet the uniqueness of transfinite subjects is not incompatible
with their universal affinity. There is a commonality of field-topological occu-

pations shared by all transfinite subjects: namely, they are all karmic laborers essentially engaged in the energetic and creative transformation of karmic matter.

Needless to say, this conception of *Dasein* as field-topological occupation is quite different from the meaning of *Dasein* in Heidegger's philosophy. For Heidegger, *Dasein* belongs exclusively to human beings: only human beings are *Dasein*s. By contrast, there are in Field-Being as many *Dasein*s as there are transfinite subjects. Moreover, insofar as all transfinite subjects are essentially karmic laborers, the human *Dasein* is no more ontologically privileged, as it is for Heidegger, than the kangaroo or other nonhuman *Dasein*s. In fact, since every field-topological occupation is internally connected to each and every other field-topological occupation, as required by the Field Principle, one cannot give ontological privilege to one without conferring it to all the others. Every field-topological occupation is ontologically privileged in virtue of the uniqueness of its own perspectivity. For every *Dasein*, human or nonhuman, reflects in its own way the field-topological unity of Being from its own unique standpoint.

Thus, the opposition of *Dasein* and non-*Dasein* entities in the Heideggerian ontology, with the former given an exclusively privileged ontological status, is not acceptable to Field-Being. Relying solely on the efficacy of phenomenological consciousness, Heidegger fails to see or refuses to acknowledge that what he calls "entities" are not really entities, but are in themselves enduring centers of activity: they are *Dasein*s in their own right. Their enticization and substantialization in phenomenological consciousness is the consequence of our own profiling delusion, not the way they are in themselves. The hammer that we perceive and use as a seemingly inert object, a mere thing, is not the hammer in reality, but the hammer of our own construction, our own making. The truth is, the hammer that I work with is a pragmatic correlate of field action; it is the effect of a power concrescence involving both the hammer and myself as contributing centers of activity. The hammer enticized as a separate thing is just an abstraction from the enormous complexity of power concrescence—a shorthand in the pragmatic language of phenomenological consciousness.

Field-Being, then, does not speak of *Dasein*s and entities, but of human Daseins and nonhuman *Dasein*s. When we do speak of entities, they are to be thought of as abstractions, shorthands, or profiling delusions. Now the Heideggerians may counter at this point, that even if there are primarily only *Dasein*s in the Field-Being universe, still the fact remains that it is the human *Dasein*s who ask the question pertaining to the meaning of Being, and not the kangaroos. How can there be any ontological understanding of Being apart from the existence of human *Dasein*s?

Whether or not there are nonhuman *Dasein*s whose interrogation of Being resembles that of human *Dasein*s, we do want to emphatically submit that the truth process is not confined to human beings, as it is for Heidegger. The

unhiddenness of beings in their Being which for us is an aspect of the *Dao* is given in each and every form of transfinite experience and cognition. Every center of activity perceives, interprets, and appropriates itself to the *Dao* in its own way and within the experiential givenness of its own perspective. In Field-Being Philosophy, conception—and, therefore, understanding and knowledge—means organized information; a concept is a configuration of organized information. Our position here is that conception or understanding in this amplified sense is a capability inherent in all life-forms, an integral component in the aesthetic power and complexity of activity. Hence, we may say that every *Dasein*, human or nonhuman, has its own conception and understanding of Being.

But since all experience is the experience of a perspective, all conception and understanding is limited by the experiential givenness of its own perspectivity. It is simply a truism to say that the Being-understanding of a human *Dasein* is distinct from the Being-understanding of a nonhuman *Dasein*. And yet—this is fundamental to the Radical Perspectivism of Field-Being—all perspectives are perspectives of a commonality, that is, of the One Being that encompasses all and gives rise to all. This means that all beings are essentially interdependent and mutually constituted: they are ontological complements to each other. Just as every wave or ripple in an ocean is inseparable from every other wave or ripple or oceanic movement, but is just one aspect of the same underlying oceanic field action, so every human action or experience is but one side or moment of the universal matrix in the Great Ocean of Becoming. Thus the Being of nonhuman *Dasein*s does not depend one-sidedly on the Being-understanding of human *Dasein*s, as Heidegger's philosophy actually implies. On the contrary, since all *Dasein*s are ontological complements and mutually constituted in their Being, it is just as accurate to say that the Being of the human Dasein depends on the Being-understanding of the nonhuman *Dasein*s as to say the reverse. This is simply a restatement of the Field Principle as applied to the truth process.

12. *Dao*-Learning and the Unity of Field Apperception

The perception and understanding of the ontological interdependence of all *Dasein*s is an aspect of what we call the "Unity of Field Apperception." Field apperception is the unique perspectival apperception of field-topological reality belonging in various degrees of reflexivity to the experiential power of every transfinite subject. As such, the unity of field apperception is not, as formulated in Kant's transcendental analytic, a transcendental principle governing a self-enclosed and autonomous domain of human cognition, but is the unity of transfinite intersubjectivity which for Field-Being is the fountain spring of meta-episteme, the ultimate revelation of the universal consciousness. Just as the

reality process arises in the Field-Being continuum from the Great Warp, the womb of karmic matter and warped or karmicized possibilities in the universal matrix, so the plenum as the truth process reveals itself in the Great Mind or universal consciousness, that is, the universal matrix in its self-reflexive transparency. And just as the reality of a transfinite subject is an enfolded contour of the Great Warp in relation to its field-topological region, so the transfinite consciousness is a field-topological moment of the Great Mind or universal consciousness. The conception of mind as self-enclosed substance in the substantialist metaphysics is here completely abandoned.

Now once again we must not separate the truth process and the reality process from the process of the good. Indeed, it is in the process of the good that the truth and reality of Field-Being are united. For all articulate action is in essence appropriation, a matter of rightness and values. All beings in the Field-Being universe are field-topologically appropriated in the Great Web, in the universal matrix conceived as the all-encompassing horizon of transdifferentiation. In the Great Web, all rightness and values are feats of accomplishment arising from the internal demands of transfinite existence. These feats of accomplishment which constitute concretely the world of importance are appropriated transdifferentially in accordance with the internal connectivity of their respective topological regions. The good is the world of importance in its undivided wholeness, the appropriated articulate totality of all rightness and values. The *Dao* is the good transdifferentially understood.

The activity that we call "philosophy," the pursuit of *dao*-learning carried to the limits, may now be given a summary description. As meta-episteme, philosophy is a pursuit of significance, an activity of sense-making in the light of truth. As meta-pragmatics, it is a pursuit of efficacy in the reality process, an activity of making work by virtue of the aesthetic complexity of power. Finally, as meta-ethic, the philosophical activity is a pursuit of importance, an activity of making right in the undivided wholeness of the good. But making sense, making work, and making right are but different aspects of the same underlying activity, of *dao*-learning as meta-aesthetic, or the inner activity of appropriation that is the art of all arts.

This inner activity of appropriation is, moreover, the appropriation of karmic labor. In the appropriation of karmic labor, the philosopher as *dao*-learner is, like all other transfinite existents, perpetually engaged in field-topological management in which transcendental freedom is exercised under the weight of karmic necessity. It is here, in the field-topological harmony of transcendental freedom and karmic necessity, that the acme of transfinite subjectivity is to be sought in the unity of field apperception. It is here, too, at the limits of appropriation and apperception that the real meaning of the philosophical pursuit of *dao*-learning is to be understood.

We have earlier defined the unity of field apperception in terms of the ontological interdependence of *Daseins*, or as the unity of transfinite

intersubjectivity. But this is only a partial meaning of what we intend by the phrase. For by unity of field apperception we mean, more inclusively, the unity of the Great Mind or universal consciousness which is field action in its self-reflexive transparency. It is the Great Mind in us that apperceives, although its unity of field apperception is always deflected by the regional or local conditions of aesthetic complexity underlying the small minds of transfinite subjects, each of which is a field-topological moment of the universal consciousness. It is in the field-topological unity of field apperception that the three worlds of Field-Being intersect each other in the transfinite process of becoming. What is thus apperceived is a unity of truth, reality, and the good.

13. The Field Principle (III): Ontological Equivalence— The Thing-in-Itself as Instance of Eternity

The question remains: What exactly reveals itself in the field-topological unity of field apperception as the acme of transfinite subjectivity? Or, what is the meaning of *dao* at the limits of appropriation at which philosophical wisdom is said to manifest itself?

The answer is this: What reveals itself in the field-topological unity of field apperception and at the limits of appropriation is the thing-in-itself, or the unity of Being as an instance of eternity. This is the true meaning of *dao* that is the goal of the philosophical pursuit of *dao*-learning. To carry the pursuit of *dao*-learning to the limits is to seek to see things ultimately in the true light of *Dao* and to live authentically in the unity of field apperception. But what is the thing-in-itself? And what do we mean by an instance of eternity?

In the Field-Being sense, the thing-in-itself is not a thing, not a substantial entity. It is neither a Lockean "I-know-not-what" nor a Kantian limit of transcendental subjectivity. The thing-in-itself in Field-Being is simply the plenum itself as borne by the karmic labor of a transfinite subject in the moment of absoluteness, that is, the moment at which it consummates itself field-topologically in its self-becoming in virtue of its creative resolution of diremptive tensions. It is at the moment of absoluteness that the life of the karmic laborer turns into an instance of eternity through its unique procurement of transfinite integrity. It is also the point at which the awesome field interface that both separate and unite the Let-Be and what is let to be, the ultimate activity and the *emanata* in the process of diremption, has bequeathed to the world a niche of ownness. The third formulation of the Field Principle may now be presented as follows:

Field Equation III $\qquad (Qq)_i = (Qq)_j$ (Ontological Equivalence)

In this notational schema what is equated are two instances of eternity, designated respectively by $(Qq)_i$ and $(Qq)_j$, each being a perspective of the

unity of Being from the unique standpoint of their own topological region in the Field, represented, respectively, by the subscripts i and j, their field-topological index. What is implied in Field Equation III then is the ontological equivalence of any two perspectives of the plenum. Each perspective is a thing-in-itself or instance of eternity, as we have called it. Note that the awesome interface, represented by the dot in Q.q in Field Equations I and II, has disappeared. The bracket, signifying the niche of ownness that the awesome interface has given rise to replaces it in Field Equation III. What is enclosed in the bracket, Qq, is none other than activity in its paradoxicality, or, as we may put it, as a non-distinction-in-distinction: Q is and is not q, or q is and is not Q. This withdrawal of the awesome interface at the moment of absoluteness into a niche of ownness—a process we call "redemption"—is what marks the acme of transfinite subjectivity. This transfinite traversion of the way from diremption to redemption is in the *Daodejing* called "returning to the *Dao*." In returning to the *Dao* as an instance of eternity, the transfinite subject has reaped the reward of its karmic labor in procuring for itself a niche of ownness in the plenum. In the niche of ownness, pure unrealized transcendental freedom has become realized transfinite freedom. Here is the meaning of nirvana in the Field-Being sense, not as a state of freedom without karma (karmic labor and karmic necessity), whether or not that is at all possible, but as a state of freedom *by virtue of* karma. In this state of positive nirvana, as we would like to qualify it, the transcendental freedom of pure action has consummated itself in the transfinite freedom of articulate action. Hence, in the positive sense, nirvana is samsara, and samsara is nirvana, as the Heart Sutra puts it. For the attainment of nirvana is not outside the World, outside of the Samsaric Cycle, but in it.

14. Conclusion

What we have done in this essay is an attempt to lay bare in broad relief the Field-Being conceptual scheme and pinpoint the place of philosophy in it. Our exposition on this conceptuality is built on the fundamental intuition that all is activity and that the plenum of Being is diremptively an aesthetic and field-topological affair. This ontological theory centers round the explication of the Field Principle in terms of the three notions of ontological identity, ontological difference, and ontological equivalence as represented respectively by the three formulations of the Field Equation. This conceptual structure is further elaborated in terms of the opposition of the Ego Principle (the principle of individuation in Field-Being) to the Field Principle, and the Will to Power to the Force. This opposition, as we have seen, is the ontological basis for the opposition between substantialism and nonsubstantialism in thought. The central and unifying thread which cuts across this conceptual scheme is the theory of the becoming and self-appropriation of transfinite subjects or

karmic laborers understood both as life-forms and as *Dasein*s and in terms of, respectively, their cocoonization and field-topological occupation. It is in this elaborate conceptual framework that we attempt to understand the role and meaning of philosophy and its place in the Field-Being universe. The notion of philosophy, or more exactly, speculative philosophy, as the pursuit of *dao*-learning carried to the limits is here strategically entertained in relation to the inmost nature of activity and being, that is, as the supreme art and inner activity of appropriation. Our characterization of philosophy as the product of specu-lative consciousness wherein the connection between phenomenological and meditative consciousness is established or reestablished and rendered whole is crucial to the epistemic and methodological orientation of the Field-Being approach. For in contrast to the substantialist and rationalist-analytic tradition which relies primarily on the enticized experiences and presentations of phe-nomenological consciousness at the expense of meditative consciousness, the Field-Being approach is intended to correct this one-sidedness and embrace the middle way, the middle way of transdifferentiation between phenomeno-logical consciousness and meditative consciousness, and between substantialism and nonsubstantialism. Indeed, the synthesis of phenomenological and medi-tative consciousness in speculative consciousness is, from the Field-Being standpoint, precisely what distinguishes the unity of field apperception in the philosophical *dao*-learner. It is important to note that Field-Being does not declare war on substantialism and the rationalist-analytic tradition. On the contrary, it recognizes its value and importance and seeks to appropriate it critically both in the interest of truth and for the optimal creativity of value. The middle way, properly understood, is the way of the good.

Now the way of the good is only realizable in the world, in and through the Samsaric Cycle underlying the becoming and self-appropriation of transfi-nite subjects. In the projected sequels to this essay we shall look more closely into the reality of the Samsaric Cycle and the basic elements that compose the perspectivity of the human *Dasein*. Whether in care or in wonder, in enjoy-ment or in hope, the human *Dasein* as a karmic laborer and *dao*-learner must traverse the trinity of *Dao* from diremption to redemption in its becoming and self-appropriation. The trinity of *Dao* are the three realms of Field-Being, called, respectively, the "Act in its firstness," the "Act in its secondness," and the "Act in its thirdness," which constitute the path of diremptive movement for all transfinite subjects and *Dasein*s. From the transcendental arising to the mo-ment of fate (firstness), from the moment of fate to the moment of absolute-ness (secondness), and from the moment of absoluteness to the enfolded im-mortality (thirdness)—these phases of activity which define the trinity of *Dao* are what make up the wheel of the Samsaric Cycle. In traversing the trinity of *Dao*, the philosophical *dao*-learner will come to understand how the distribu-tion and redistribution of power or matter-energy is tied to the systems of meaning determined by the interplay of the Ego Principle and the Field

Principle, as well as the roles of the right-sided and left-sided appetitions in the formation of the motivational structure of his or her *Dasein* undertakings. But above all the philosophical *dao*-learner as a traverser of the trinity of *Dao* will inevitably come to face the Holiest of the Holy, which, symbolized in Field-Being as the rounded square of *taiji*, is the region of reality and thought wherein rationality and paradoxicality are equally appropriated and transcended. This is the region of thought reserved for meta-theology, the discipline of *dao*-learning that directs itself to the Field-Being of the Holy. In Field-Being thought, a distinction is made between the Holy of the Ego Principle and the Holy of the Field Principle. The confusion of these two senses of the Holy in the popular religious consciousness and the failure to recognize it in much of traditional religious thought is a major concern for the meta-theologian.

Meta-theology then is meta-aesthetics in search of the Holy, understood in the Field-Being sense. How meta-theology is related to the meta-epistemic quest for significance, the meta-ethical concern for rightness, and the meta-pragmatic predisposition to efficacy is a topic which lies beyond the scope of the present essay. We are also not in a position here to attack one of the most intriguing and challenging topics in the Field-Being conceptuality, namely, the conception of Space-Time as the field-topological horizon and interface of karmic labor. These and numerous other issues amidst the enormous onto-logical and methodological implications of the Field-Being scheme must be left for other occasions. Committed to his or her vision and yet ever flexible and responsible in his or her intellectual and spiritual experimentation, the Field-Being thinker delights in the adventures of thought.

PART TWO

CHINESE PHILOSOPHY AND
PHILIOSPHICAL ANALYSIS (I):
METHODOLOGICAL PERSPECTIVES

Onto-Hermeneutical Vision and Analytic Discourse: Interpretation and Reconstruction in Chinese Philosophy

Chung-ying Cheng

1. Analysis of Analytic Philosophy in the Western Tradition

In looking into the development of Western philosophy, we are struck by how a concern with reality becomes a concern with knowledge of reality and finally how a concern with knowledge of reality becomes a concern with a right method for seeking knowledge of reality. We see this development well exemplified in the history of Greek philosophy. In both Plato and Aristotle we see that the question of reality, the question of truth, and the question of definition and argument or proof are fully deployed in their writings. It is clear from these writings that a sense of logic and the analytic use of language are often guiding principles for their arguments and statements of conclusions, even though they are also clearly guided by an overall vision of what truth really is. From this fact we may say that analytic reason has begun with them and that they have laid the foundation for the future development of Western philosophy in an analytic and rational-argumentative framework. However, what makes this possible is often not brought to scholarly attention in today's studies of comparative philosophy. Yet it is important to ask this question not only for the purpose of comparing Greek or Western philosophy with Chinese or Eastern philosophy but for the purpose of seeking a deeper insight into how analytic reason is rooted.

To answer this question it is necessary to point out to the polemical nature of the Greek public and political life in Athens. It is in the fifth to fourth century B.C.E. that there is a popular need for intellectual wisdom and a response from the "wise men" (sophists) to attract his followers in the marketplace. This need to attract followers in the marketplace no doubt leads to a competition for truth and a promotion of efforts to use explicit language to demonstrate

that one does have an understanding of truth and that one can support one's argument with good reasons and produce evidence for one's truth in explicit and intelligible language. In other words there is a close affinity between *logos* and *lingua*. I believe that it is this background which leads to the birth of philosophy as an analytic and demonstrative or argumentative art of rhetoric and truth-seeking. This means that the development of analytic reason is premised on the public practical needs for clarification of truth and language.

We need to also note that in the Greek case even though analytical reason developed out of a public practical need in morality and politics, there is still an underlying paradigm of reality which would guide the coordination of analytic reason and practical reason. It is the paradigm of seeking truth as an independent, immutable, and eternal reality of perfection, which may be seen as rooted in the pre-Socratic tradition of the Eleatic School of Parmenides and the Gnostic-Mystical School of Pythagoras.

When we come to the modern period, we see that the development of analytic reason again takes place along with the development of practical reason: logic and philosophy are both born out of practical needs for power and the attention of the powerful. In both Descartes and Leibniz we see the strong urge to formulate a system of knowledge and a theory of truth which would enlighten the royalty and uplift the commoner. There is also a strong urge to reconstruct an image of God as glorified in the tradition of Christian faith in a rational system as guided by the Greek vision of truth. It might even be suggested that it is due to the inherent conflict between the Greek rational science and the Hebrew supra-rational faith that modern Western philosophy developed as an analytic discourse (in the form of treatises) and conceptual system so that it may lay out explicitly all possible arguments for supporting a polemical conclusion. This development inevitably has made both a political and a practical impact. But the most important result seems to be the advancement of modern science as an independent procedure and process of collective inquiry for knowledge of the external world. Thus we may say that philosophical thinking in the modern West is not merely a moral and religious concern but a technical and political matter of seeking both truth and power. In fact, we may see the twofold meaning of the term "practical reason": the moral practical reason and the technological practical reason. In both of these meanings philosophy plays a decisive role for the beginning of modernity of the West.

Specifically, modern Western philosophy begins with Descartes in his achieving a method or technique for acquiring applicable knowledge which underlay the development of science in the seventeenth and eighteenth centuries. This method as described in his *Discourse on Method* presents analytic reason as seeking clarity and distinction in conceptual analysis and referential reduction. It establishes philosophy as a discursive and logical discipline which requires analysis of concepts and language and construction of theories and systems of truth and knowledge based thereon for whatever purpose there is.

It would eventually become an instrument for expanding political power and securing economic development, creating a wide zest for power and wealth in the modern West.

The development of analytic reason in connection with science and technology is highly important for the development of modern Western philosophy. But one needs not forget that analytical reason thus understood has not totally forgotten its vision of the ultimate truth. Even after Kant's critique of rational metaphysics and rational theology there still remains a hidden ontological vision for most of the philosophers before Nietzsche: namely the ontological vision of an absolute reality to be referred to as God or the ultimate truth or the absolute spirit. But after Nietzsche such a vision is gradually lost as announced in his motto: "God is dead."

In light of the above, perhaps, we can reach an objective view on the rise of Western contemporary or twentieth-century analytic philosophy with regard to both its historical roots and its continuing practical needs for self-assertion and power. We can further list a few enhancement factors. First, we see that the development of modern mathematics and logic provides a better instrument for analysis in philosophical doctrine. But why did logic and mathematics develop in the first place? Again we cannot but mention the Greek idealism of perfect knowledge and the practical influence of science and technology. This helps to explain the rise of the logical positivism of Carnap and the Vienna Circle: the task of philosophy is defined as analyzing the language of science and attempting a logical reconstruction of our world views based on the paradigm of scientific knowledge.

In this connection we need to make a distinction between philosophical analysis and analytic philosophy. It is clear that Plato and Aristotle have already engaged in philosophical analysis of concepts and issues they consider conceptually essential and practically important in their times. The modern philosophers have done the same. But the so-called "analytic philosophy" is a unique twentieth-century product: it is a reflection of the scientific spirit in doing philosophical analysis which would involve the tasks of rejecting a major portion of traditional metaphysics or any metaphysical pre-understanding before analysis.[1]

Certainly if there is no other practical purpose than this (if analysis for scientific knowledge has a practical import at all), analytic philosophy would remain merely an effort to become a handmaid to positive science. The rise of modern social sciences to meet the need for critical understanding in moral, social, and political philosophy, however, shows that there is an important role for analytic reason to play: It is needed to analyze issues, conceptualize arguments, evaluate positions, and advocate policies and strategies in topics of

1. For a survey of issues in contemporary analytical philosophy, see P. F. Strawson, *Analysis and Metaphysics, An Introduction to Philosophy* (Oxford: Oxford University Press, 1992).

public affairs. It has also adapted itself to research on conflict resolution and the study of decision-making as regards public policies.

Hence, we may say that all recent development of social and moral philosophy in the West captured a third wave of development of analytical spirit and analytic reason after Plato and Descartes. This development was coming to see analysis as part of the construction of social knowledge and resolution of moral issues. This helps to make analysis a necessary tool for interpersonal understanding and social and cultural communication. Since the paradigm of the ultimate truth is lost after Nietzsche, it is interesting to observe that analytic philosophy could also be regarded as an implicit effort to search for a vision of truth and knowledge without the guidance of any traditional paradigm. Needless to say, physical science normally acts as a model and a paradigm of constructive knowledge and truth. But as physical science gradually loses its unity and determinateness as one sees in controversies over quantum mechanics, analytic philosophy moves into the final phase of postmodernity.

Instead of arguing for the cause of universal reason as the paradigm of modernity and enlightenment, analytic philosophy gradually transforms itself into a foundationless and goal-less pluralism of rationality. One sees that what prompts the transformation of modernity into postmodernity is precisely the loss of the paradigm of modern thinking, including the paradigm of theoretical reason. Because the paradigm of modernity and enlightenment failed to meet the needs of contemporary life and culture, there exists no real single paradigm for contemporary analytic philosophy. Therefore, we might even regard contemporary analytic philosophy as generally unanchored and devoid of direction. But this no doubt betrays a need for a new paradigm and thus makes the search for such a new paradigm even more serious and challenging.

The methodological importance of analytic philosophy cannot be underestimated. It has served to explicate, illuminate, differentiate, distinguish, and clarify a given position or argument or concept. Even though it could slide into piecemeal and isolated philosophical quarrels without making significant contribution, there is still no denial that it has brought our understanding of philosophical issues to a high level of clarity and precision. Perhaps we may say that logic, common sense, and modern science are the major components of contemporary analytic philosophy. But this is not to say that there could not be other new insights into reality or new discoveries of truth independent of analytic philosophy.

It is G. E. Moore who uses the analytic approach to refute idealism and reconstruct an ethics of goodness. Wittgenstein has shown how we should respect our uses of ordinary language in understanding and assessing a philosophical issue or even in using a name. Carnap has reconstructed the logic of confirmation and inductive probability even though he did not succeed in constructing a theory of reality from protocol sentences of observation. It is W. V. Quine, however, who has used the analytic method to its fullest extent: he has

debunked the traditional distinction between analytic and synthetic sentences and shows how one may identify the ontological content of our discourse. Even though he and his followers are unable to develop a full nominalistic/ extensionistic account of our common language use and modal logic, he has nevertheless successfully shown how our language was formed and what a logical structure it has. Finally, Quine has argued with acumen and persuasion how we may regard our knowledge as an organic totality with both internal indeterminacy of meaning and external relativity of truth. This led to his thesis on naturalized epistemology. These should suffice to show how an analytic approach to a traditional problem of philosophy not only can yield clarity but also can shed new light on our understanding of reality.

In light of the above, it appears that there is not just one analytic philosophy, instead there are many analytic philosophies. It is a mistake to think that the analytic methodology is simply a matter of applying logic and language. In fact, what is required in the analytical approach is both a preunderstanding of the subject matter and the theme for the analysis and an understanding of logic and language on different levels. Specifically speaking, the understanding of language is more challenging than understanding logic because it involves a presupposed semantic theory couched in a cultural and historical context. Hence, there is no uniformity of analytic methodology, there is only analytic understanding.

Saying so much for the justification of analytic philosophy, we have still to concede that analytic philosophy has not been able to resolve, dissolve, or answer all the metaphysical questions of being, knowledge, truth, and reality. It even cannot cope with the problems of self and human mind except presenting a reductionist and nonessentialist picture of human consciousness modeled after modern neurophysiology. It has not provided any systematic insight into human destiny or even human existence. It is partly based on these reasons that Richard Rorty has rejected analytic reason for its failure to enlighten, to edify, to discover, to create, or to change on a large scale.[2] But for me, this merely shows that analytic philosophy has yet to grow into maturity so that it may not remain at a positivist level nor confine its attention to the language model of a particular community and people such as English speakers. It means that it has to go beyond its concern with local contexts and extend its critical purview on cross-cultural and comparative issues and themes. For example, to speak of moral goodness, do we confine ourselves to texts of only Aristotle, Kant, and so on? Or should we also carefully consider Chinese philosophy which is a major tradition for works on morality and ethics?

The answer seems to be obvious. This suggests that we must see analytic philosophy as a form of analytic reason which has been put to a certain use in

2. See Richard Rorty, *Philosophy and the Mirror of Nature* (Princeton, NJ: Princeton University Press, 1979), final chapter.

a certain period of time. Analytic reason is best embedded as a methodology in a process of inquiry for meaningful analysis and creative discovery. It must not allow its methodological and instrumental nature to hinder its uses for achieving genuine insights in all important areas of human understanding. We must see analytic reason as an ingredient of the "whole reason" of the human understanding which includes practical reason (including the Habermasian communicative reason), aesthetic reason, and above all, ontological reason.[3] Its strength is to yield an analytic discourse for human understanding and human vision. Analytic discourse is a manner of organized and systematic conceptual discussion in commonsense language intended for critical response, communication, and understanding.

The sustaining development of analytic reason for producing an analytic discourse must be supported by the practical need of communication and requires attention to detail and precision in modern life. Because of this, analytic discourse as an embodiment of analytic reason serves a practical function and will last as long as we have visions of truth and reality.

2. Recognizing the Onto-Methodological Nature of Chinese Philosophy

The most distinctive feature of Chinese philosophy is that it is not so much concerned with logical, epistemological, and methodological issues. This is not to say that there is no logical thought or discussion on knowledge and method. As I have shown elsewhere,[4] in every major Classical School there is a logical position consisting in reflections on names, language, and reality. Specifically, the Neo-Mohists have actually developed and formulated fairly rigorous theories and explicit principles of logic and language highly comparable to Aristotle's writings on logic and analytics. It is interesting to ask what Chinese logic would be if there had been continuity of study and development from the Neo-Mohist times. In this connection it is instructive to wonder about the causes of the emergence of the Neo-Mohist logic in the Late Warring States Period and its being neglected in the Early Han Period.

Again I hold that it is the practical needs of the time which command the development of certain philosophical directions such as logical thought. This holds clearly for the development of the Neo-Mohist logic. The Warring States Mohist followers (called a "Neo-Mohists" in English) were under strong pres-

3. I have argued for the branching-out of various rationalities in the whole reason of humankind as a whole entity. Ontological reason is understood to refer to an overall and general understanding of reality as a whole. See my book *Zhishi yu Jiazhi* (*Knowledge and Value*) (Taipei: Linking Press, 1986), Foreword. Also see discussions in the later part of this essay. It should include both onto-cosmological reason and onto-hermeneutical reason.

4. See my essay "Logic and Language in Chinese Philosophy," a short version in *Journal of Chinese Philosophy* 13 (1986); a revised and extended version in *Handbook of Linguistics*.

sure to defend their Mohist philosophy of nondiscriminating love (*jian ai*) and rebut other schools of thought such as Confucianism and Daoism. One must remember that Mohism has been one of the most popular schools in Mozi's time along with Confucius and Yangzi. But by the time of the fourth century B.C.E. they are much overshadowed and under attack by both Confucianists and Daoists. As they did have the benefit of going through the overall debates on the issue of the relation of names to reality, it is natural for them to feel the urge to sort out types of inferences and references in the use of names and arguments in language. They have specifically concerned themselves with systematic definitions and explanations of key logical and epistemic terms and produced the Neo-Mohist Canons. Their research on mechanics and optics also shows that they are concerned with scientific knowledge and their technological applications. In this light their being able to develop a system of logic would not appear surprising. But the founding of the Han Empire and the subsequent ideologization of the Confucian Philosophy to the exclusion of other schools of thought makes a minor school like Neo-Mohists impossible to survive, not to say, develop or thrive, hence, the eclipsing of the logical trend in China in later times. Insofar as the imperial authority dominates the political scene throughout the twenty-four Chinese dynasties, the official Confucian ideology dominates the moral and intellectual studies, and consequently the incentive for Mohist logical studies and development of a full system of logic became muffled and died out.

One may thereby ask why there are no distinctive methodological and epistemological studies in Confucianism and Daoism. This issue, in fact, is a complex one, for this lack does not signify something negative, but instead it suggests something positive. It suggests the presence of a profound way of thinking. What is this profound way of thinking? It is the way of observing and experiencing a comprehensive reality in which everything finds a place and nothing is left over or alone. It takes a comprehensive observation and reflection to comprehend this comprehensive reality which is eventually named the Way (the *dao*).[5] It is important to note that both Confucius and Laozi make their views known under their respective understanding of the Way.

In the *Daodejing* we read the *dao* as something beyond description of language but which is nevertheless described as the creative process of formation and transformation of all things in the universe. In the *Analects* Confucius also speaks of the *dao* of morals and life. But we also know that Confucius refers to the heaven and the mandate of heaven in a metaphysical sense in his later life.[6]

5. See my essay "On *Guan* (Comprehensive Observation) as Onto-Hermeneutics," *Guoji Yixue Yanjiu* [*International Yijing Studies*] Issue 1 (1995): 156–203.

6. In recent discoveries of silk manuscripts of the *Yijing* we find that we can confirm Confucius's study of the *Yijing* and his direct contribution to the *Yizhuan* (philosophical commentaries on the *Yijing*).

It seems clear that both Laozi (if there is such a person) and Confucius harked back to an old tradition of the *dao*. Such a tradition exists since the formation of the book known as the *Yijing*. Hence, it is in the *Yijing* one would find the original insight into a comprehensive reality of the *dao* which becomes the source of the way of thinking for both Laozi and Confucius.

The philosophical significance of this notion of reality as the *dao* is threefold: First, from the ancient beginning of the *Yijing* Chinese thinkers make no bifurcational distinction between reality and appearance and regard incessant and constant change of all things as part and parcel of reality. The *dao* as the sustaining power of change but also as constancy of change emerges amidst the concrete changes of things. Hence, both change and nonchange are presented in reality as belonging to an organismic whole. Second, in this process it is also observed that the process of change is creative, polaristic, regenerative, recursive, reversive, transformative, coordinative, holographic, and harmonistic. Given all these features of change both cosmic and earthly patterns of formation of things are realized in various orders of things and there is no pattern which is not related to other patterns. Third, under comprehensive observation one can see that all changes could be said to start from the minutest beginning and grow into large-scale processes of differentiation of myriad things. On the one hand, this process is beyond description because it involves a potential infinity of possible developments and paths of change. It is a process of creative and unpredictable transformation called *shen*. On the other hand, the very traces of the cosmic change could be said to form a logical order of progression based on the multiplication of polarities of the *yin* and *yang* forces.

We may indeed regard this understanding of reality which presents the constancy and change of things as an organic unity as both ontological and cosmological. It is ontological because it directly presents what there is in terms of what is in change; it is cosmological because it also shows how the reality of cosmos could have developed as a creatively emergent order of individuated and interrelated things. I have referred to this understanding of reality as "onto-cosmological" because there is no separation between the ontological and cosmological, or between appearances and reality as in the Greek philosophy.[7]

If we can regard the *dao* as the comprehensive onto-cosmological reality as presented in the *Yijing* symbols and explicated in the Commentaries, then the *dao* is simply the way of change (*yi*) and transformation (*bian-hua*) as described above. Then we see that the *dao* is both describable in a logical sense and indescribable in an extralogical sense. The Daoist has taken in the indescribable aspect of the *dao*, whereas the Confucian has taken in the describable aspect of *dao*, which is also seen as representing the way of developing humanity and

7. We can see that later Western philosophers interpret appearances as projections of sense experiences, but for Plato appearances are still objective things which, however, are of a lesser degree of reality.

human society. Hence, the full picture of the *dao* is to be seen when we come to see the interdependence and underlying unity of Daoism and Confucianism in terms of their common source and common onto-cosmological vision.

The onto-cosmology of the *dao* generates the world of things in a continuous and sustaining process and it always preserves the underlying harmony of reality for the on-going differentiation and individuation of all things. All things are, therefore, not only related to the *dao* but related to each other in an ontogenerative sense of cosmic time. This also holds for our abilities of understanding and knowledge: we do know things for what they are in the process of their sustained growth and destined decline and our knowing is itself a genuine process in the world of reality and, hence, would be able to interact with things as they are becoming. Besides, our knowing as an open process does not simply involve believing, thinking, conjecturing, asserting, but also involves acting and doing things. Hence, knowing cannot be conceived as simply a mental act but must be also considered a bodily and personal action in an open-ended process of change. When we say that we know, what we know has to be tested in our conduct over a period of time and is subject to revision and transformation. From this point of view, there is no need to have an independent methodology to seek knowledge or to gain knowledge. Knowledge comes from the human mind's own engagement with the world and interaction with the world. As the world has different concrete situations so would knowledge as concrete engagements with situations and as concrete applications and practices over experiences.

Consequently, in Chinese philosophy there is no dualistic and dichotomous distinction between the object and subject, there is no abstraction of the object from the existing relationship between the subject and object as sustained by the onto-cosmological process of reality. Besides, no abstraction of method or methodology would even arise. This lack of methodological consciousness bespeaks an underlying continuum of subject and object interaction. It has the merit of allowing closer interaction between subject and object and this would be particularly meaningful in producing inter-human or inter-community harmony in morality and social activities. On the other hand, it must also be admitted that this lack of dichotomous separation between subject and object did not produce a sufficient distance necessary for objective and rational "cool" knowledge in the abstract and theoretical sense as one would find in modern sciences. It would not be conducive to a more objective evaluation of intellectual education in scientific knowledge and its consequences for planning purposes. Nevertheless, this is what the lack of methodological consciousness means in Chinese philosophy. It lacks methodological consciousness because it has something in its place, namely an onto-cosmological relevance and tension for achieving harmony between the human person and heaven as well as among people. In this sense we may perhaps speak of an onto-methodology and an onto-epistemology in Chinese philosophy.

Onto-methodology means that one comes to the notion of method from onto-cosmological experiences: A method hence would be a presentation of a procedure of operation or approach in recognition of a broad horizon of reality which is sometimes referred to as the realm of understanding and spiritual experience (the *jingjie*). As there is this constant engagement with the onto-cosmology of the *dao*, there is no need for a quest for an independent and rationalized methodology. This kind of quest has led to the methodological revolution of paradigms in Western philosophizing. The emergence of any major philosophy is preceded by a major methodological reflection and a methodological design or even an invention or discovery of new method. We may even regard the process of Western philosophy in its history as a series of paradigm revolutions in methodology, which in fact has continued to the present day. We see that even in a short period of three generations of German philosophers—Husserl, Heidegger, Gadamer—there are three distinctive methodological innovations: the phenomenological, the *Dasein*-analytical, and the hermeneutical. Similarly, we see that in another short period of three generations of American philosophers—Peirce, James, Dewey—there are three methodological renovations in the pragmatic method.

In the case of Chinese philosophy there are few explicit methodological revolutions in either the Confucian or the Daoist tradition. In the Neo-Confucian case, we see different masters of the *lixue* (Principle School) and *xinxue* (Mind School); each may have one's own view on how to cultivate one's virtues, but there is little which one can say about the methodology or method as a way of analysis or as a way of knowledge. There is, of course, the *gongfu* (efforts made in achieving a goal) for reaching various degrees of understanding, but *gongfu* is no method: it has to be exercised and practiced by each individual because it is not a pure intellectual skill but rather a willed effort and practice to pursue a worthwhile objective, which would give rise to a power of changing or transforming oneself. In the *Tong Shu* of Zhou Dun-yi, Zhou focuses on the virtue of truthfulness (*cheng*) as a method for justifying our knowledge or achieving sagehood (*sheng*). What is *cheng*? *Cheng* (truthfulness), according to Zhou Dunyi, is the source of power for cultivating oneself into becoming the sage and at the same time the source of the creative changes of heaven and earth. This then means that the human person can have direct experience of the truth and therefore disclose the common source of the reality of the world.

But *cheng* is not an emotional attitude nor a smart system of principles or procedures. It is instead a whole-heart and whole-mind effort made to reach fundamental understanding so that the true nature of human self and things in the world will be revealed. It is an effort which consists in ridding oneself of desires and prejudices and other preconceptions of mind so that the ultimate reality (nature) of onto-cosmological creativity will be reached and presented by itself. In this sense *cheng* is both centrality (*zhong*) and harmony (*he*) as

spoken of in the *Zhong Yong*. But it need not to be identified with a state of nothingness or total negation which one might see in Buddhist enlightenment. If we follow the idea of "Fulfilling the Innate Knowledge" *(zhi liangzhi)* of Wang Yang-ming, we would see *cheng* as the state where human existence finds its identity in the ultimate source of heaven-earth creativity and still be aware of its activity as part of the activity of common daily life. This is the state referred to as the unity of heaven and the human person *(tianren heyi)*. With this description, it is clear that *cheng* cannot be taken as a method or method-ology to be abstracted or separated from the onto-cosmological understanding itself. It requires one's direct confrontation with reality and one's efforts to cultivate oneself by emptying oneself of desires and "small knowledge" (à la Zhuangzi) and prejudices.

Not only can we speak of onto-methodology and onto-epistemology in Chinese philosophy, we can also speak of onto-ethics and onto-aesthetics in Chinese philosophy. In these latter areas it is clear that the good and the beauti-ful are not separated from our fundamental experiences of the ultimate reality of change and our knowledge or experiences of them must be subject to the checking and criticism of this onto-cosmological understanding. In fact, the various degrees of onto-cosmological understanding are themselves the values of ethics and aesthetics. For onto-ethics I have argued that the virtue ethics of Confucianism or Daoism is a good example of linking ethics to onto-cosmo-logical views of the human person and his actions.). Along this line, we may even speak of an onto-logic in Chinese philosophy. An onto-logic presents inner logical patterns of thinking disclosed in the onto-cosmological understanding. How hexagrams are formally related and how numbers assigned to the positions of the *yao*-lines acquires both logical and metaphysical meanings are good examples of onto-logic.[8] Similarly, we can speak of the onto-herme-neutics as a discipline which derives ways of interpretation in consideration of the total ontological or onto-cosmological understanding of the reality as truth. Of course, as a philosophical discipline onto-hermeneutics may develop any sort of onto-cosmological understanding and, hence, is not limited to Chinese philosophy. It could also incorporate analytic methodology as a way of mak-ing concepts precise and identifying issues for understanding and resolution.

In this connection, we may go back to my earlier point that analytic philos-ophy develops as an outcome of the intellectual need to cope with the scien-tific development and the practical need to meet the challenges of social development. Both these needs are now heavily present in contemporary Chinese philosophy. In fact, what China has faced in the past 150 years since

8. We may even attempt to define "possibility" and "necessity" in terms of the virtual situ-ations generated in the 2 to the *n*th power progression of the *yin-yang* forces on different ontic levels and thus construct a *Yijing*-based semantics of possible worlds. This would be also an instance of onto-logic. See also my article on the *wei* (positions) in the *Yijing*, "*Zhouyi* and Philosophy of *Wei* (Positions)," in *Extreme-Orient/ Extreme-Occident* 18 (1996):149–76.

the Opium War are wide challenges of scientific revolution and social revolution. Since these two revolutions did not happen in time to catch up with the West, it takes the brutality of the Western impact to plunge China into calamities. As a consequence, the Chinese tradition of culture and philosophy have to find a way to accommodate and absorb these catastrophic changes and challenges. There is no way and no justification to relinquish the tradition and blindly follow the West. No doubt the native tradition needs to renovate itself to meet the needs of change in both intellectual and practical life and to innovate ways for overcoming difficulties in both scientific and human development. First of all, it has to understand both the strengths and weaknesses of the Western tradition and recognize the crises and predicaments it has gone through and be aware of the core issues in its own development. On the other hand, it is absolutely crucial that one ascertain one's relative strengths and weaknesses in an open world of changes and transformations. It is in this light that I see the rise of contemporary Chinese philosophy not just as a necessary cultural response to the West but also as a signal for transformation of the human situation and human understanding.

In our analysis and reflection we have seen how the West arrives at a stage of losing onto-cosmological visions in their philosophical analysis, whereas the technique of analysis and logical thinking has reached a historic high development. It is only natural that the development of contemporary Chinese philosophy should appropriate and use the analytic technique for self-understanding and self-discovery so that the tradition could be brought to bear analytically on modern life and modern knowledge. But more important than this, analytic understanding and evaluation of Chinese onto-cosmological view and vision may have made a contribution toward both enrichment of human understanding of values and an uplifting and satisfying of the practical needs for understanding the human self and human life. Hence, it has the mission to forge the intellectual gap between the East and the West, and thus to bring a valued harmonization between the two traditions and a consequent practical harmony between the two worlds. In doing so it also fulfills the onto-cosmological vision of a world philosophy derived from the wisdom of both its Confucian and Daoist sages on comprehensive observation and comprehensive reflection.

3. Rational Reconstruction/Construction in Chinese Philosophy

Even though I have spoken of a general lack of specific methodological paradigms in the development of Chinese philosophy due to the predominance of the pervasive onto-cosmological understanding, there are still two implicit onto-methodological orientations in the development of Chinese philosophy which I will describe as follows.

First, there is the sense of comprehensive totality in which all things belong. According to this orientation, we cannot understand things independently of the contexts in which they could be identified and described. The contextual importance does not mean that there is no essence or nature to individual things and that all things are merely relations among all things. On the contrary, things have their relations because they are things. Things and relations are interdependent and therefore one has to understand things in terms of relations and relations in terms of things. Besides, things or persons are sources of activities and have their internal organizational autonomy which cannot be seen as simply elements of relations or the totality. Indeed, the totality constitutes a field or a region in which we see things move and develop and even change the given field or totality or open up to a new field or totality. But this is because each individual has its source rooted in the ultimate reality of the onto-cosmological reality.

This leads to the second onto-cosmological restraint or orientation: nothing is to be reduced to another thing. But this does not mean that one may not explain a thing in terms of its constituting elements and we should not look for more and more elementary parts and constituents. In fact, for a totalistic understanding we do need to analyze things in terms of their parts and constituents. But this does not entitle one to draw the conclusion that things are thus only understood in terms of their parts and constituents or to be treated as if they were their parts and constituents. On the contrary, the more atomistic our analysis becomes, the more we should beware that there exists the other aspect or polarity of reality where a thing must be understood by reference to a totalistic context to which it belongs onto-cosmogonically. This is an anti-reductionist proposition which does not necessarily negate reductionism, but which only treats reduction as a part of the program for understanding an object or a relation. In other words, we can achieve a reductionist analysis for the purpose of better understanding if we are also able to use it to restore or illuminate our conventional nonreductionist understanding.

Given these two onto-methodological propositions, we can now raise the question of how we make an analytic approach to the understanding and development of Chinese philosophy. In a sense the formulation of these two propositions already provides a basis for analysis of all the basic and secondary concepts, statements, views, and positions in Chinese philosophy. To say this is not to say that these propositions teach us how to do analysis in the technical sense. It is to say that they are required for doing analysis in a relevant and critical sense beyond using an analytic technique. To do analysis in a technical sense requires that we know the technique of definition, logical paraphrasing, and rational forms of arguments and inferences. But this would not automatically constitute an analysis of a given concept C or a given view V. In order to critically analyze C and V one needs to know and understand C and V in relevant ways and to do this is to ground C and V against certain background

principles or an understanding of reality as given in a theory or a tradition to which C or V belongs.

Of course, it is true that we may think of any background principles or understanding of reality without having anything to do with Chinese philosophy, then we would not have an analysis of C or V as a matter of Chinese philosophy, thus, the relevance of the two onto-methodological principles for the philosophical analysis of a C or V in Chinese philosophy. In a sense the two propositions given above define the most general features of Chinese philosophy: they outline a level of relevance for Chinese philosophy. With this understanding it seems clear that any concept or view in Chinese philosophy could be so related to the framework of Chinese philosophy.[9]

There is another way to make the same point: any concept or view in Chinese philosophy must already command and presume a certain level of understanding of its peculiarities and meanings which can only be derived from a pre-analytic understanding of some theory or philosophical tradition. Without this understanding no philosophical analysis of Chinese philosophy concepts and views could be possible. But how do we establish such a pre-analytic understanding? How do we know that our pre-analytic understanding is sufficient for making relevant and adequate analysis? These are difficult questions to answer, because there is no single way to establish a pre-analytic understanding which would be sufficient to guarantee a relevant and adequate analysis of a given Chinese concept or view. In the light of the above premises, it is no doubt necessary to have an understanding of Chinese philosophy as a whole so that we may be able to interpret and analyze Chinese philosophy as a part. This is not to deny that we should not open our eyes to see outstanding peculiarities of each C or V even in a context of looking for its relatedness to other concepts and views in the whole. Perhaps, we could then extend our requirements of these two basic Chinese methodological onto-cosmological insights into some universal normative principles, and see the tradition of Chinese philosophy and Western philosophy as both belonging to some unknown large whole and, hence, enjoying some underlying commonality. But to put these norms into practice it is still challenging to identify the common ground without ignoring the differences between them or without reducing differences to common features. Normally, we expect that there are common features among different things and there are differences among similar things.

9. It is indeed possible that we need to relate to the Chinese philosophical framework (as these two propositions can be so understood), then what will they relate to? They could relate to any view we may choose to hold. They may relate, for example, to a Greek tradition. Then the analysis of the Chinese philosophical concept and view may be still regarded to have a some minimum relevance for Chinese background, because it could be a matter of comparative study or it could be an expediency for articulating a given position, particularly if this analysis is set within the context of some theoretical controversies.

The point is to identify important (not facile) and significant common features and important differences.

In the case of East-West comparisons it is usually the case that we do not know the underlying totality or wholeness which holds the East and West as parts of an integrated or interrelated unitary system. Such a system (which we may refer to as world philosophy) is yet to be created, but to develop such a system we need comparison and dialogue, analysis and synthesis among different traditions or philosophers in a long process. Hence, we are begging the question in assuming we can first establish a world philosophy for the comparison and analysis of Chinese philosophy. A better approach is to recognize the differences before looking into the common ground and the ways of coordination and integration. This approach is important in light of the second onto-cosmological principle described above. The point is that in order to avoid falling into the trap of reductionism, we should identify peculiarities and particularities first before we attempt to establish the common ground for dialogue and even the possible fusion of horizons. Given this understanding of the extension of the first principle, a third principle or precondition for the adequate analysis of Chinese philosophy could be formulated as an auxiliary of the first one.

This third principle may not be founded until we have sufficient understanding of the differences between Chinese philosophy and Western philosophy, or to be more specific, to have sufficient understanding of differences between any C or V in Chinese philosophy and any comparable C' or V' in Western philosophy. With this recognition, then, any comparison or analysis of a Chinese C or V would have a useful start. This is, however, not to say that analysis and comparison cannot be made independently of this principle. It is to say that only after the warranted recognition of prior differences any discovery of commonality would be an important affair and any invention of commonality would be a creative achievement. Now the third onto-methodological principle can be stated as a generalization of the first two onto-cosmological insights in Chinese philosophy: there is a pervasive being holding both subject and object of knowledge together. This means that there is no dualistic separation between subject and object in knowledge or any other propositional attitudes of mind. But how to describe this nondualistic relation depends on our understanding of each C and V [10]

One can see that even though Western philosophy has a strong Platonic and Cartesian tradition of subject-object- and human person-God-dualism, there are counter-trends of anti-dualism in contemporary Western philosophy as represented by Bergson, Whitehead, James, and even Heidegger. It is impor-

10. But one has to be careful in understanding what has transpired in contemporary Western philosophy in applying the third insight.

tant to recognize various strains of the Western philosophy and particularly to recognize various strains within various strains of this tradition. For even within the new trends there could still exist Cartesian elements of absolute dualism. In more recent developments in analytic philosophy, for example, one can notice the strong movement toward an internalized realism based on the subject-object mutual determination.[11] This would provide an interesting background for the analysis of Chinese epistemology along with a rational reconstruction of the Chinese notion of knowing (*zhi*) in spite of our understanding of the earlier tradition of Cartesianism.

The above discussion suggests that the background understanding for an analytic approach to Chinese philosophy plays a crucial role in making the analytic approach to Chinese philosophy a fruitful enterprise, but how fruitful this enterprise is has to depend on how sufficient and how adequate one's background understanding is. There is no mechanical way to apply the analytic procedures in logic or language analysis to Chinese philosophy to generate a "Chinese analytic philosophy." In fact, there could not be any Chinese analytic philosophy without understanding Chinese philosophy in the first place. There could be no analysis without a pre-analytic background. The technique of analysis is merely a formal training, but apply this technique requires concrete understanding of the subject matter for analysis and concrete understanding of its contexts of genesis, use, and reference.

Apart from a requirement of pre-analytic understanding of the onto-cosmo-logical insights in Chinese philosophy together with a requirement of pre-analytic understanding of equally relevant metaphysical/ epistemological or methodological insights or constraints in Western philosophy on different levels and in different time periods, we need to confront the problem of language in any analytic study of Chinese philosophy. It is common knowledge that there are radical differences between Chinese language and English language in regard to both syntax and semantics. But more than that, one must also recognize that Chinese is a visual-based language, whereas English is a sound-based language, and as such there are philosophical implications. In visual-based languages the method of expression stresses concretion and direct presentation, whereas abstraction and mediation dominate in the use of sound-based languages such as English or any other Western language. But it is logically possible that both kinds of languages are virtually equivalent in being able to express the same ideas. But the so-called sameness of ideas is a matter of assertive understanding: as Quine has argued, there cannot even be the sameness of reference unless the two different terms are equally translatable into the same logical formula of first-order predicate logic.

11. One sees this in Hilary Putnam's publications on realism: *The Many Faces of Realism* (La Salle, IL: Open Court, 1987) and *Realism with a Human Face* (Cambridge: Harvard University Press, 1990). One can see from these two books and other essays by Putnam, there is a movement from the position of metaphysical or external realism to the position of internal realism.

There cannot be the sameness of sense because that would depend on the understanding of the person using the language. We would not know that one language such as Chinese would share the same meaning as another language such as English. It requires translation and translation requires again understanding of both the general use of the language and the particular use of the particular term or sentence to be translated. Hence, we come back to the same situation as in the case of making an analysis of a concept C or a view V in Chinese philosophy: We need background understanding of the pre-analytical philosophical tradition and their relevant individual contents. We need to establish a general sense of comparison and interpretation before we engage ourselves in a concrete analysis of a given C or V. Similarly, we need to know both languages well in order to represent the term of one language in terms of another language. Without such preparation, there cannot be adequate translation of a Chinese concept or term into an English concept or the interpretation of one Chinese view or position into a Western view or position.

We have also to admit that there is a large area of indeterminacy of meaning in translation and interpretation, but then there would be no reason to prefer one translation and interpretation over other translations and interpretations. This means that, even though the analysis of a native term conducted in a foreign language is subject to genuine semantical or even logical indeterminacy, with both our philosophical background understanding well-developed and our linguistic background understanding well-heeded, we would be able to reduce such indeterminacy of meaning and reference to a minimum.[12]

It is clear that both the philosophical (primarily onto-cosmological) and linguistic natures of Chinese philosophy constitute background constraints and even boundaries of our understanding of any concept or view falling into their scope as established by onto-cosmology of Chinese philosophy. Yet they do not determine the specific meaning or content of any given concept or view in Chinese philosophy. They are the determinables, not the determinates of Chinese philosophy. Given these determinates we are able to do analysis on a given C or V from Chinese philosophy for the purpose of making explicit and precise their meaning, significance, and importance or for the purpose of critical discussion relative to a philosophical issue or a philosophical dispute.

In connection with the former case, we may define the notion of rational reconstruction of a C or V in Chinese Philosophy as follows: A rational recon-

12. It is to be noticed that the way in which Chinese philosophy has been developed in the tradition reflects a total form of life as Wittgenstein would maintain. One cannot legitimately criticize the way in which Chinese philosophy has been articulated as not a way of philosophical articulation without betraying one's own philosophical prejudices. The fact is that Chinese philosophy has been conducted in the Chinese language and has observed its own way of expression within its culture which is different from the way of expression Western philosophers came to adopt within the culture of the West. Now we may say that the analytical approach requires a style of explicitness and precision in the way of expression and presentation whether in Chinese or English. This requirement marks the impact of modernity.

struction of a C or V is an explication of the meaning of C or V in accordance with well-established rules of logical analysis and argumentation without losing sight of the philosophical and linguistic constraints of its background under-standing. A rational reconstruction of a Chinese concept is therefore a combi-nation of both its underlying philosophical insight and the rational means of clear and full explanation and interpretation. If one lost the original philo-sophical insight, the meaning of the concept would be reduced or diverted or even distorted and the identity of the meaning of the concept would be lost; if we do not have sufficient ability to see this, analysis and argument would not reveal or disclose the insight in an appropriate modern linguistic and concep-tual context. This combination nevertheless is both organic and creative in that the true understanding of the concept would bring out its insight against its underlying background understanding in a rationally clear and communi-cable language. It is to give a new form and a new structure to the original understanding, and in doing so will bring out an insight into its possible inter-action with some contemporary Western concepts or views in a give-and-take process of mutual understanding and dialogical communication.

Consider how we rationally explain the notion of the *dao*. In the context of its use as a metaphysical concept, we have the statement of Laozi to deny that there could be any linguistic or conceptual representation of the *dao*. It is not a matter of adequacy of language for representation or predication, but a matter of the nature of the *dao* being such that it would transcend any effort to articu-late it, to pin it down, to define it, or to say things about it. Then the paradox is how do Laozi or we ever to speak of the *dao* at all? The answer to that is that we need open our eyes and feel from our whole person the presence of a vital force in things in the world and be aware how change and transformation of things betrays the presence of the vital force. On reflection and observation based on direct experience that an order emerges in a process of creative forma-tion and transformation of the 100,000 things. To understand the *dao* therefore requires one to know changes (as one reads from the *Yijing*) and to know the human person and other things in the world as a presence and as a process. It takes the whole person who is trying to understand to transform oneself into a position and state so that one may vividly experience the *dao*. Once one comes to experience the *dao*, one is in a position to speak of or to speak about the *dao* with the recognition that it cannot be really spoken of or spoken about. There is no contradiction here because we are speaking of two levels and two states in one word, the word *dao* as representing the experience of the person who speaks of the *dao*, and the word *dao* as intended to refer to the order and pro-cess in which the *dao* as experienced by the person represents.

Now given this double understanding, we are then able to explain the no-tion of the *dao* and our explanation can also be regarded as rational even though there is no intention to substitute this rational explanation for the reference and sense of the *dao* as it is intended in the texts of Laozi. This is, then, what I

mean by a rational reconstruction of the *dao*, which involves understanding the whole texts and contexts on both linguistic and meta-linguistic levels.

The above understanding of the *dao* obviously involves the understanding of the two onto-cosmological background principles as mentioned above. There need not be an appeal to mystic vision which cannot be explained or must repudiate a rational image. (I do not object to the use of mystic language when the occasion and context call for it, but in a philosophical discourse any claim of mystic experience could be projected on a rational plane and has its corresponding image, even though the rational image or its rational construction or reconstruction is no substitute for the so-called mystic vision or mystic experience. What is mystic about this is that it involves an irreducible unity of the whole person and the gestalt and ineffable quality of the experience of reality.) What precisely, then, is the rational reconstruction of the *dao* ? What is its rational image?

I believe that there are many portions of the *Daodejing* which already provide a rational reconstruction of the *dao*. In the first place, it is clear that the *dao* is an inexhaustible fountainhead of energy and the ultimate source of existence of everything. It is also the continuing sustaining force and vitality underlying all formations and transformations of things. In this sense it is the root (*gen*) of life of all things. The idea of oneness (*yi*) of the *dao* is also stressed for it is the oneness of the *dao* which gives rise to the twoness of the *yin* and *yang* which in turn gives rise to the threeness of all things. That *dao* is the single ultimate source of existence of all things also underlies the idea of life and production (*sheng*). Hence, it is clear that the *dao* is the single creative force which produces all things, which also maintains and sustains them. As the creation involves a process of generating the twoness, we can see how the forces of the masculine and the feminine (as symbols of the *yang* and the *yin*) come to play a formative and transformative role in the world-making of things. Namely we come to see that the *dao* functions as a creative process of polaristic differentiation. But in this process of differentiation the principle of singular individuation of the oneness of the *dao* is also pluralistically evidenced and maintained in all things. The oneness of the *dao* also gives rise to the idea of harmony (*he*) which is a state of mutual support among different and opposite things.

Finally, we also see the *dao* mentioned as the *wu* (the void). This is to be understood as the original reality of infinite creativity which becomes itself in giving forms to all things, for it brings forth and presents itself in the materialization of all things and all forms. It shows itself as a totality of what is formed and what is unformed and shows that what is formed is possible because there is the unformed. What is unformed and what is indeterminate in content and form is precisely what can be formed and determined and exists as its infinite and inexhaustive source. It is in this sense that it can be said to be void. In fact one may see that the *dao* is a self-voiding process for creating things in substance

because the *dao* is to give up oneself to become oneself. Not only is the *dao* is the self-voiding process of creative substantiation and differentiation, it is also a process involving the return and reversion of all things, because it has to maintain a balance and harmony among all created things so that necessity of return and reversion of all things are intrinsic to the processes of interaction among all things. Here we witness a full theory of the *yin-yang* exchange and interchange being unfolded in the texts of the *Daodejing* bearing the notion of the *dao*.

To put all these statements together is to produce a sayable and meaningful picture of the *dao* which is explained rationally in many words of the texts. Our analysis merely serves to bring the salient points out in a more coherent and interrelated manner, and this means that we are able to perform a rational reconstruction of the notion of the *dao* in an analytic discourse even though such a discourse is involved with dialectical and transcendent arguments bearing on the logical idea of negation and the metaphysical notion of the void. This only means that a rational reconstruction may still have to contain a dialectical description of interdependence and mutual implicativeness of concepts which however are not to be reduced to each other nor are to be subsumed into one concept without first having a thorough understanding of these concepts.

Here we also note that what is analyzed and dialectically described is not a given notion of the *dao* but the profound experience of the *dao* as presented in a ponderous and meaningful language by the author of the language who has the profound understanding of the *dao*. The way it is presented becomes an internal part of the meaning of what is presented and the presentation alludes to both the speaker whose vision and experience substantiate and bring life to the presentation of the *dao* as identified in a dialectical manner even when such identification is explicitly denied. For what is explicitly denied acquires an implicit presence in the negation and denial.

We may even venture to compare this analytical notion of the *dao* with that of the God in the Western philosophy and theology. We shall see that this comparison will bring both the notion of the *dao* and the notion of God to more clarity and more meaningful understanding. It is clear that in contrast with the *dao*, God has the image of the human personality and he is perfect in all aspects of power, virtue, knowledge, and existence. In this sense he is the source of all things, human beings, and all values. But unlike the *dao* he is thought of as making expectations, evaluations, and judgments which contain hopes for human salvation and fears for human condemnation. With this understanding of the God built on the paradigm of certain feelings of a human person, we can see that the way things and human beings are created, saved, or condemned, is very much different from the *dao*. Here we have an ethics of commandment, promises, contracts, expectation, punishment, salvation, or atonement, all based on a model of how a ruler would want his or her subjects

to behave. In a sense morality becomes a matter of being obligated to obey the way of God. God becomes a concept or a symbol for us to think of how we should be treated by an all-powerful and all-caring super-being. In this sense God is more abstract than the *dao* is, the *dao* which is more open to our comprehensive observation and deep reflection than God is.

Whereas we come to know the *dao* by all those objectively operational principles of world-formation and world-transformation, we can only come to know God by faith or authority or by a transcendent belief which no doubt is capable of forming a way of life and producing a norm of action. We may, of course, attribute to God all the characteristics of the *dao* and thereby make the God a *dao*-God. Similarly, we may also attribute to the *dao* the characteristics of God and therefore make the *dao* a God-*dao*. In either way we cannot reduce one to the other; hence, to understand them in terms of their own traditions and recognize their differences would be both the reason and the basis for the rational reconstruction of one or both.

There are two other kinds of rational reconstruction apart from the above: the rational reconstruction in Chinese philosophy of a notion or a view which does not exist explicitly but which could be inferred or constructed from the hidden resources of texts or contexts in Chinese philosophy so that it may critically respond to a modern or Western concept or view. In fact, we may start with a Western concept and work out a corresponding notion in the Chinese tradition which, although corresponding formally, needs not to have the same significance and content as the Western one. I have in mind the particular example of explaining the Western notion of justice in the Confucian text: What would be a Confucian theory of justice? I have explained the notion of justice in terms of both righteousness (*yi*) and benevolence (*ren*) so that one would find that in justice as fairness one must have considerations of others and a control of one's self-desires and following rules of propriety (as *ren* is explained by Confucius as "*keji fuli*").[13] In this interpretation actually I have enriched the notion of justice by suggesting that one needs feeling for others so that one can respect others and take others into consideration. I still call it a "rational reconstruction" because it is a rational way of improving the notion of justice and at the same time a creative way of presenting a novel concept or a novel meaning or view for the Chinese concept of *zhengyi*.

The second kind of rational reconstruction is the construction of a theory in answer to the theoretical dispute in a Western philosophical context. We know that from the Greek beginning there arose the dualistic account of the human person as a nonunified conjunction of spirit, mind, and body. In modern times Descartes accentuates the basic difference of mind and body to the

13. See my essay "Can We Do Justice to All Theories of Justice? Toward Integrating Classical and Modern Paradigms of Justice," in Ron Bontekoe and Marietta Stepaniants, eds., *Justice and Democracy: Cross-Cultural Perspectives* (Honolulu: University of Hawaii Press, 1997), 181–98.

extent that they are considered as two parallel processes of reality which in actuality would leave human mind and consciousness totally out of place. With the development of modern physics and biology it seems natural that the only way to treat mind and consciousness is to see it as reducible to brain activities and therefore as something no more than an epiphenomenon. Given this context it is of course significant to ask how Confucianism or how Daoism or Neo-Confucianism in Chinese philosophy would respond to such a Western analysis of the human person or the human mind.

Although we know that Chinese philosophers must have some important understanding of the relationship between mind and body in a human person, the Chinese focus however is more on how a unitary person with his or her mind and heart functions could live his or her full life and fulfill his or her nature and destiny in concrete practice which involves the activities of the human body. In order to participate in such a dispute it is, therefore, necessary to refocus the Chinese philosophical perspective, whether Confucian, Daoist, or Neo-Confucian, on the central issue of the unity of mind and body. One has to explicitly construct such a unity from the rich resources on Chinese views on unity of heaven and human beings, unity of inner and outer, the unity of knowledge and action, theory of human mind-body. There is, of course, no single way that we could develop such a theory. As philosophical issues can ramify, so there are many directions in which the Confucian, the Daoist, the Neo-Confucian, or even the Chan Buddhistic theories of self could be developed.[14]

The crucial point in developing such a theory is to see the relevance of the Chinese onto-cosmology in which human beings are generated as a supreme intelligence among all things but still retains its onto-cosmological substance/functions of *yin* and *yang* in a totality of organic unity. This suggests that there exists an inner *taiji*-type unity of vital force (*qi*) and its structural order in a person which accounts for the unity of the variety the natures of human mind and its functions. This reveals again the underlying ontological and cosmological differences between the separation of cosmology and ontology in the Western tradition on the one hand, and the nonseparation of the two in the Chinese philosophy. This also explains why the ultimate goal for a Western religious philosophy of the self is to extricate the mind and soul from the human person in order that it may return to its creator-God, whereas in Chinese philos-

14. It is interesting to note here that I myself have developed such theories on three occasions. On one occasion I have argued a theory of human nature in an effort to explicate the Heideggerian notion of *Dasein*. I have also developed a theory of selfhood with many facets to deal with the problem of self-cultivation and the problem of free will. This latter theory is important because the issue of free will as raised by Jesuits such as Matteo Ricci in their critique of Neo-Confucianism in the seventeenth century is both metaphysical and theological in nature. I have also argued against a radical nonessentialist or antiessentialist position on the Chinese notion of human nature in an article on a comprehensive theory of human nature.

ophy the ultimate goal for the self-cultivation is to realize the unity of the human person and heaven or to come to see one's true nature underlying all the attributions and eventuation of the self.

Given the above forms of rational reconstruction, it is still possible to distort and misrepresent reality in one's reconstruction or focal assertion, this is because people can misunderstand original meanings of Chinese terms or concepts. Similarly, one can also misunderstand and misrepresent the Western meanings. If either of these happens, we would have a mistaken and untrustworthy reconstruction. Therefore, it is imperative that one cultivate a sense of self-critique and self-understanding so that one's starting point and background understanding would remain or achieve a state of onto-hermeneutical equilibrium and consistency.[15]

4. Onto-Hermeneutical Interpretation as Truthful Interpretation

In the rational reconstruction of a Chinese term or view it is necessary that we explicate its meaning in full view of the philosophical view or conditions for the meaning of the term or the view. But it is not necessary for us to bring out the issue of the validity of the background understanding of onto-cosmology. But if we are not simply concerned with the meaning of the term or view, but the truth of the matter, that is, what the term is true of or what the view would represent in terms of the real world, we have to confront the truthfulness of the background understanding of the onto-cosmology and other related factors in order to have a direct understanding of the term or view so that we may represent from our own full understanding what the term or view is thought to represent in terms of truth and thus provide an interpretation of the term or the view.

Here I draw a basic distinction between rational reconstruction and onto-hermeneutical interpretation as a truthful interpretation. Rational reconstruction is an analytical exposition of the meaning of a term or a view independently of whether its intended reference is real or fictitious whereas an onto-hermeneutical interpretation is rational reconstruction or construction which is intended for being true of reality. We know that given a term or a view there could be many interpretations each of which is a rational reconstruction of the term or view because each is intended to explicate the meaning of the term or

15. It is in this sense that we may find Chad Hansen's *Daoist* reinterpretation of classical Chinese philosophy essentially misleading and he even ventures to view all Chinese uses of language and Chinese ways of thinking as reflections of the notion of mass-term derived from Quine. But in actuality this interpretation of both Chinese language and Chinese philosophy is derived from a singular lack of understanding of the Chinese language as a whole system as well as a singular lack of understanding of various Chinese philosophical schools. It only succeeds in making both Chinese language and Chinese philosophy foreign to a Chinese native speaker.

the view in question. But whether each is true is another question because truth points to the notion of reality and what we have come to know or come to understand in regard to reality. Hence, interpretation is a matter of giving meaning to the term or view against the understanding of reality. That is the reason why it is onto-hermeneutical whereby an interpretation or understanding of reality is thematized. It is not to assume that a certain set of propositions must be true nor to concern oneself with anything about truth apart from criteria of adequateness of analysis and explication of the truth conditions of a given term or view. In other words, we can see our proposed interpretation as a disguised truth claim concerning reality, not simply a rational statement concerning its content.

This distinction is important because it allows us to attribute new meaning to a given term and view which the author of the term or the view may not have seen. This is because it is always possible to develop new meanings for a new or rational use of a given term in light of the considerations of all things involved, particularly if we want to make interpretations according to new experiences and new needs so that our interpretation could be true of our world. In regard to interpretation of a text, Gadamer in fact points to the fact that we are removed from the origination of the text in time, and history has created a distance between the object of interpretation and us as interpreters. We have to understand the text under the influence of effective history, which amounts to saying that we are not free from whatever perspective of a given situatedness which would reflect the situatedenes with its vested historicity. This means that we must look to what constitutes truth or truth conditions for our understanding and evaluation of a given term or view, also granting that the perspective on truth and truth conditions may have to vary and change according to time. In this light new meanings will be brought out and old meanings will be reconsidered. A good example is how we consider or reconsider the meaning and significance of the view called Confucianism or for that matter the teaching of Confucius as embodied in the text of *the Analects*.

To narrow down our discussion, we can focus on the evolving concepts of *ren* (benevolence, human-heartedness, goodness, co-humanity) and *li* (rite, ritual, rule of propriety, etiquette form of norm). Even in Confucius's time, there could be different meanings for these two terms. But Confucius has to give a meaning to each of these terms which he feels and believes to reveal the truth of humanity and to promote the ideal harmony and dignity of the human person. He could, of course, identify the meaning of *ren* in the sense of care for people from a ruler's point of view as indicated in the *Shujing*. He could also identify the meaning of *li* in terms of what he knows about the Xia society, the Yin society, or the early Zhou society. But what he actually does is not to follow what the texts or records suggest, but to see to that these two terms would carry a meaning going beyond their historical contexts in virtue of his understanding of the human person. To be *ren* is simply to love people

and restrain one's self-interests and desires in order to restore and practice the social norm governing social order and harmony. On the other hand, to know *li* is to know how to place and establish oneself among people.

What is clear from *the Analects* is that Confucius does not take one single term by itself but considers the meanings of all things in a coherent system he has come to understand and appreciate. This coherent system is what he calls the *dao* which is threaded with oneness for him. This shows that the meaning of a term does not produce itself gratuitously but must come from a holistic totality of interrelated concepts or ideas which one has come to develop and embrace. When we come to reassess the philosophy of Confucius, we could reduce Confucius to a displaced feudal aristocrat who tries to restore the old political order in the quickly changing society of new bureaucrats and landlords. This familiar Marxist line may actually have been believed by most of the early Chinese scholars in the period of the Great Cultural Revolution during the '60s and even up to the '70s. But now we have a totally different story according to those who see Confucius as a humanist philosopher: the Confucian *ren* and *li* represent the inner core and outer form of what Confucius believes to be a moral person or a person who is devoted to preserve the best of humanity and who cares for the values of family and community and the achievements of human culture.

In either of the above two interpretations there is a belief factor, which motivates the interpretation and which supports the interpretation, and this motivation and support are no less than a vision of the truth resulting from the interpretation. This no doubt also holds in Confucius's own interpretation of *ren* and *li* which he has to believe to be more universally true than what is granted by the history of earlier eras. But if we wish to push for deeper ground for the truth claims inherent in these interpretations, we have to come to the world views and metaphysical beliefs of Confucius, and this no doubt leads to the major concern with Confucius's attention and interests in the onto-cosmological philosophy of the *Yijing*. We now know from newly discovered silk and bamboo manuscripts in 1972 and 1995 that Confucius did actually view the *Yijing* as a book of moral and metaphysical philosophy, reflecting both the way of heaven and the nature of human beings. In this fashion we come to an onto-hermeneutical interpretation of Confucius's ideas. What is onto-hermeneutical about this interpretation is that it brings out the question of the ultimate truth for Confucius which needs to be understood or interpreted in light of all his ideas and which must be also understood and interpreted as giving all relevant meanings to his ideas of *ren* and *li* and other virtues.

The upshot of the above discussion is this: we cannot escape from the question of truth or truth conditions in any meaningful form of interpretation, in other words, if we are to make a truthful interpretation rather than merely a rational reconstruction in a given context. The truth question is in essence the question of reality. This therefore means that we have to recognize that our understanding of reality is the underlying ground and source of the meaning

of the terms or views we are interpreting. Given this understanding, we have to ask how truth claims could be made so that what is claimed to be true can be shown to represent reality.

In this connection it is interesting to note that it is possible that we can believe some truth for the wrong reason and false evidence yet our belief may also turn out to be factually true. This is the lesson one may get from the so-called Gettier Problem.[16] The Gettier Problem challenges the analysis and account of knowledge as justified true belief in modern Western philosophy. It says that if A knows that *P*, then (1) *P* is true, (2) A believes that *P*, and (3) A is justified in believing *P*. But the justification A has for believing *P* may not be relevant, not to say sufficient or necessary, for establishing the truth of *P*. In other words, A may have his good reasons for believing that someone owns a Ford in his office but it may turn out that his reasons (he was told by a reliable person that Jones owns a Ford in his office) for such a belief is no basis for establishing *P* if Jones does not actually own a Ford but rather someone else in the office owns a Ford without A's knowing this. Hence, we may say that A has believed a true proposition which is not actually justified with the justification provided by A. Given this situation, do we call A's belief knowledge? If not, how are we to avoid the Gettier-type of problem in our asserting knowledge?

Of course, one may still call A's belief knowledge insofar as what he believes is true. But the issue is that we may believe many true propositions but we would not know that they are actually true from our justification. In other words we would not even know that they are true at all even though we believe that they are in fact true. The trouble as diagnosed by Gettier lies in the fact that our justification may not warrant or justify our belief and this means that we could have no reason or ground for deriving our knowledge because there is no essential link between reasons or evidence and the propositions which could happen to be true. Even though there are a few solutions for this trouble, there is no settled opinion on how to resolve the problem. There are two major current solutions: one, to add the requirement of "defeasability," which requires that justified true belief becomes knowledge if there is no other true proposition which would defeat the justification of the original proposition. But the trouble is regarding how do we know the "other proposition." A second solution is that a belief becomes knowledge if it will be sustained (not undermined) by all actual truths we have. But the trouble with this is how we come to know the collection of all actual truths. Both solutions would require that we have an independent way of knowing in a sense other than knowledge being true justified belief. As a consequence of this difficulty,

16. See Edmund Gettier's essay "Is Justified True Belief Knowledge?" *Analysis* 23 (1963): 121–23. For a brief discussion see Paul K. Moser, Dwayne H. Mulder, J. D. Trout, *The Theory of Knowledge: A Thematic Introduction* (Oxford: Oxford University Press, 1998), 94ff.

the causal theory of knowledge would require that the evidence must actually cause one's belief in a true proposition. Then again we may also query how an evidence-proposition would cause one's belief in the truth-proposition.

With these difficulties exposed, we may attack the problem from a different angle so that we may resolve the Gettier Problem without falling into infinite regress or begging the question. First, we should take a lesson from the pragmatic theory of truth which says that truth is that which works and has practical or actual consequences. What could make a proposition P true? The pragmatists say that it is our belief and practice regarding P that would verify (make true) the truth of the proposition. That might be the case if P deals with the human psychology of feeling and will. But for factual statements of the physical reality it is difficult to see how it works without first formulating P in light of our findings from our inquiry into the nature of the physical reality. Hence, for Charles Peirce scientific truths are also pragmatic truths in terms of a methodology of verification and confirmation. In this light, do we say that we cause the truth of P (and therefore we know that P) or the truth of P causes our belief in the truth of P (and hence we know that P)?[17] My answer is that we cannot say either to the exclusion of the other but that we can say both. Why? It is because in our inquiry into reality we come to formulate P as what we intend to put forth as truth and we also have to provide our best conditions for the verification or confirmation of P as truth. Hence, it is that we cause P to be P so that P would cause our belief in P; or we may put in another way: In emerging from our inquiry P causes us to believe P and our belief in P would of course cause us to make P true.

In making this proposal, I am quite aware of the complexity of scientific logic as developed by Peirce and also the controversies on the theory of confirmation initiated by Carnap and the theory of falsifiability initiated by Popper in the '30s to the '60s. We may even add Hempel's theory of explanation in terms of the covering-law model as a part of our background understanding of the process of scientific inquiry. It is clear that with proper analysis we can see that my proposal here would make good sense precisely and primarily due to the following observations: One, to develop scientific knowledge we need to apply our intellect in strategic ways to project organization, program scheduling, decision-making, evaluation, and improvement. Our ways of planning could themselves also be subject to scientific inquiry and thus become a second-order program organization. Two, on the other hand, there is no way that we may absolutely dictate to reality what we wish reality to be. There is at any time or any level of our knowledge system a reference which will not be thor-

17. D. M. Armstrong takes the view that some facts would cause our beliefs in the truth of these facts. But obviously it is not the case that all facts must cause true beliefs in them, otherwise we would know all truths. See his book *Belief, Truth and Knowledge* (London: Cambridge University Press, 1973). See also his paper "Perception and Belief," in Jonathan Dancy, ed., *Perceptual Knowledge* (Oxford: Oxford University Press, 1988), chap. 7.

oughly describable or governable by our description or theory.[18] In other words, there is always the brutality of an independent reality which resists our imposition and rebuffs our ideas. Yet this does not mean that the brutality of reality cannot be slowly framed and tamed into our conceptual schemes by our hard work in terms of adjusting our theorizing based on our observation.

With these two conditions said, it also becomes clear that there is no single proposition which could stand alone to claim truth, as any true proposition requires many other true propositions to be true so that it can be true by itself. It is obvious in regard to the subjective end in the form of the investigator or the personal knower, for he or she has to assume many conditions in order to conduct a fruitful inquiry or to acquire a plausible belief. Perhaps it takes him or her as a whole person with all his or her background training to bring himself or herself to be a qualified and successful inquirer. This of course means that there are an unlimited number of propositions which have to be true in order that we come to discover the truth of a single proposition.[19]

On the other end, it has become now a trite point that all our scientific propositions are intertwined and interrelated in the form of implication or presupposition in a framework of scientific understanding. Presently our scientific knowledge is primarily founded on basic sciences such as physics and chemistry. It is because of this foundation we are able to extend our knowledge of biological and social sciences. These disciplines of knowledge form an organic system with different assumptions which though different are interlinked by mutual rational support. The connectedness of our scientific knowledge prompts Quine to argue that our scientific knowledge forms a whole fabric which is totalistically confronted with the forum of sense perception. Quine's point is well taken, because there cannot be drawn any absolute demarcation as Plato did between knowledge and nonknowledge if they form a fabric of intertextuality.

Insofar as we can assign a truth value to a proposition on the assumption of other assignments of truth values to other propositions we can save the truth of one single proposition in an adjusted system of propositions. From this basic position, we have Quine's famous rejection of the distinction between analytic and synthetic truths. We also come to see his strong plea for a naturalized epistemology in which scientific knowledge should justify any other knowledge we care to have. According to Quine, our knowledge is to be preserved in our language and there is no knowledge if there is no language which organizes our knowledge. As our language also forms a holistic unity even though an open one, this adds weight to the proposition that our knowledge

18. In Davidson's anomalous monism even our mental predicates do not allow themselves to be described in physicalistic terms. See remarks made by Quine in his book *From Stimulus to Science* (Cambridge: Harvard University Press, 1995), 87–88.
19. The logic of discovery is difficult because an insightful discovery requires cultivation of an understanding which can only come from a long process of observation and thinking.

system is necessarily a holistic one. From this we may also come to the conclusion that there is not a single proposition which is to be true in the absence of any other propositions, which as a matter of fact are unlimited in number.

Given the above argument, we can now see how our true belief could be said to be caused by our efforts to inquire for the true belief and how our true belief can be said to cause our believing it to be true. There is a full onto-hermeneutical circle between our believing P to be true and the truth of P (P being true). If we take our knowledge-making as a holistic process and also take our knowledge as a holistic system, then there is also the closing of the onto-hermeneutical circle between knowing P and the truth of P, namely, that someone knows P implies holistically that P is true and that P being true also implies holistically that someone knows P. Because the truth conditions of a proposition are other propositions which we know to be true and similarly our knowing that P has the truth conditions which are other prepositions which are true. In this sense knowledge is not simply an isolated episode, but an event occurring in the process of knowledge-making or knowledge-system-making. In this process we can say that whenever truth occurs knowledge would occur and whenever knowledge occurs truth would occur. If we take truth to be a matter of discovering and understanding reality, then our knowledge-making is also world-making in which a holistic system of knowledge which represents the world would take place in a process of analysis, correlation, organization, and theorizing.

In taking this position we are able not only to overcome Gettier's Problem, we are also able to bring a Chinese philosophical view to the point. For Chinese philosophers it is an axiomatic dictum that knowledge must be accompanied by practice. This is known as the unity of knowledge and practice. But why this unity? The answer is that if we want to have genuine knowledge based on genuine evidence or reason, we need to put our knowledge to practice. It is obvious that moral knowledge needs moral practice to bring forth fruition and moral knowledge must realize itself in moral practice. There is a close affinity between the two. But for cognitive knowledge can we make the same argument? The answer is yes. Our knowledge of other people and the world depends on our experience of other people and the world. If we do not have these experiences, how do we know about other people and the world. Given a wide range of experiences and a long process of experiencing we can say that our experiences of other people and the world would justify our knowledge of them. Our reasons are our experiences which can be equally said to cause our knowledge because we could have numerous reliable experiences of other people and the world.

To generalize, whatever truth we have experienced would produce our knowledge of truth. There need not exist any gap between the truth of beliefs and the evidence for such beliefs. Of course, we must also recognize the contingency of any empirical truth and the inductive nature of our beliefs. But it is

important to bear in mind that the validity of knowledge has no escape from experience and reason. Here we want to add practice as a third factor from which knowledge has no escape, particularly regarding our moral and metaphysical truths. What we need to see is whether we have genuine and adequate experiences of other persons and the world. This need also applies to knowledge of oneself (*zhiji*). The pressure for correct and adequate experiences of the world, other people, and self, has in fact led the Confucians and Neo-Confucians to stress the importance of self-cultivation and self-reflection. In the process of self-cultivation we see how a model for moral and metaphysical knowledge can be developed.

For Confucius moral knowledge apparently starts with self-reflection and self-control. It can also be assumed that moral knowledge such as knowing the norm "Do not do to others what you would not want others to do to you" also requires wide observation of how people actually behave. With such a wide base of observation, self-reflection, and self-control, can we still doubt that what we thus know is only accidentally true if true at all and that we have no reason or cause to believe truth of the norm? I believe that even a moral skeptic can raise such a question, there is no reason why we must take the moral skeptic seriously. This is because one can easily see that in the case of Confucius the truth of this norm if it is true not only depends on the circumstances of the discovery and formulation of this norm by Confucius, but depends on how seriously we are prepared to practice it and thus to make it true.

The hidden objective of the norm is, of course, that I shall be fairly treated if I treat others fairly. One can testify to the effectiveness of this norm by working on the norm and thereby making it effective. In a sense all true moral principles are self-fulfilling and self-fulfillingly true if true. If one cannot make true a moral principle one believes to be true one would have to reformulate or rediscover another one so that it can become true by one's practice. It is in this sense that we may say that our moral truth causes us to believe its truth and our believing its truth makes the moral true.

Similarly, we can extend this principle to the metaphysical truth regarding the world and the relations between human beings and heaven, so that in matters concerning reality and truth in general one needs to practice what one believes to be true so that it can come to be true. On this point I think that we need to take both the *Da Xue* (the Great Learning) and the *Zhong Yong* (the Doctrine of the Mean) seriously at the same time, for it is only when we take them seriously at the same time that we are able to see how the subjective end of the human mind must work hard to meet the objective end of the world and reality and how the objective end of the world must be seen from a correct perspective so that it can be met by the subjective end for the maximum effectiveness of achieving understanding, enlightenment, and illumination, which would have moral significance for the life of the human person. As we shall see, it seems clear that the metaphysical truths we wish to have would always

have moral implications and one may even say that the motivation for seeking metaphysical truths is for moral practice. One can also say that the reason why we are seeking metaphysical truth is that we have the need for moral practice and moral decision making in terms of the metaphysical understanding. Hence, there is a built-in interdependence between moral truths and metaphysical truths.

Now in the *Da Xue* we read the following famous statement:

> In ancient times it was said those who wish to illuminate bright virtues in the world must first govern their states, those who wish to govern their states must first regulate their families, those who wish to regulate their families must first cultivate their persons, those who wish to cultivate their persons must first rectify their minds, those who wish to rectify their minds must first make sincere their intentions, those who wish to make sincere their intentions must extend their knowledge. The extension of knowledge consists in the investigation of things.

From this statement one sees many things. Not only does one propositional truth involve or give rise to another, but also there exists a mutual support among all these propositional truths in an order of progression. We see, too, that all these propositions need verification by individual conduct which involves human relationships and self-understanding. Specifically, the *Da Xue* puts down the *gewu zhizhi* (investigation of things for the purpose of extension of knowledge) as the very basis for moral practice and socio-political development. Even though we need not identify the knowledge in question with scientific knowledge of today, there is no reason why we may not see such knowledge as essentially knowledge which is both scientific and metaphysical in light of Zhu Xi's commentary in terms of the notion of *li* (principle, reason).

We see that Zhu Xi has made a rational reconstruction of the paradigm (*gewu zhizhi*) in terms of learning the *li* (reason and principle) in light of his metaphysics of *li* and *qi* (vital force and energy). As *li* can be understood both scientifically and metaphysically, the understanding of the *Da Xue* acquires both a scientific and a metaphysical significance. In this light we can further point out that as a metaphysical category *li* is no doubt holistic (as reflected in the motto "one principle and many manifestations *liyi fenshu*) and jibes with the Quinean holism of knowledge as well. Of course, there is still a difference between a manifestation theory of truth à la Zhu Xi on the one hand and the coherence theory of truth à la Quine on the other hand. There is no difficulty in arguing that the ontogenesis of coherence in groups of experiences is a specific way of manifesting the-one-in-the-many principle, whereas the dictum *liyi fenshu* can be understood as pointing to a normative state of ideal completion of all knowledge after empirical acquisition. But here my central point is on the relationship between scientific inquiry and moral psychology of self-discipline toward truth-inquiry.

The *Da Xue* seems to argue and suggest that it is knowledge that would prompt our sincerity of heart and purity of intentions (namely, intentions to achieve the highest form of good in the world community). Therefore, we may say that our evidence and good reason for having a moral intent can be given in the knowledge of the world we have. Metaphysically, this means that there is a unity of moral intent of self and epistemic or rational understanding of things so that achieving one would lead to the achieving of the other. Of course, for the Confucian the focus is the truthfulness of the moral intent which is then derived from our knowledge of the world or reality according to the *Da Xue*.

If we combine this insight or position with that of the *Zhong Yong* we see the explicit statement of mutual entailment of knowledge (as *ming*/ illumination) and moral intent (as *cheng*/sincerity). The *Zhong Yong* says, "If one's mind becomes illuminated from sincerity, this is the work of nature; if one's mind becomes sincere from illumination, this is due to the work of teaching. Being sincere, one's mind will become illuminated; being illuminated, one will become sincere." Here this articulation of the unity of knowledge and moral intent is so clear that we must say that it is not only that knowledge would bring out a moral intent to seek truth, it is also that the moral intent will bring knowledge. The possibility of the truth of this unity no doubt has to depend on the performance and practice of the individual persons involved.

For the purpose of assuring that one can reach this mutuality and unity of truth and moral intent, the *Zhong Yong* even has clearly mentioned its methodology of *boxue, shenwen, shengsi, mingbian, duxing* as a process of intensive practice and acting. It says:

> Learn wide, inquire hard, think carefully, distinguish clearly, and act honestly. If there is nothing not yet being learned, one should not stop until success; if there are questions not yet raised, one should not stop until one knows the answer; if there is a thought not yet thought of, one should not stop until one gets what one needs; if there is something not yet clarified, then one should not stop until one gains clarity; if there is something not yet practiced, one should not stop if one has not performed it to one's satisfaction.

This whole passage suggests a highly dynamic process of seeking knowledge in terms of practice and self-perfecting action in terms of knowledge. Hence, the unity of knowledge and moral intent becomes a normative requirement for the truthfulness of knowledge and genuineness of practice. This unity also testifies to the validity of the *Zhong Yong*'s focus on the "supreme sincerity" (*zhicheng*) as a mark and power of realization of truth.

There are several points that the *Zhong Yong* makes about the character of *cheng*. First, according to the *Zhong Yong* it is when one has *zhicheng* that one is able to fulfill one's nature, the nature of others, and the nature of all things

and thus to be creative and transformative like heaven and earth. This is because it is only when one has sincerity that one is motivated to seek truth and would not stop until one has found truth. Second, in persisting in *cheng*, one is able to penetrate the whole process of knowledge-making and world-making which the *Zhong Yong* refers to as the beginning and ending of things (*wuzhi zhongshi*). The link between what is experienced by the subject-mind will carry through the representation of the object-world. Third, in saying that if there is no sincerity there are no things (*bucheng buwu*), it is not to say that *zhicheng* actually creates all things, but rather that it is based on *zhicheng* that one is able to identify a right context for right identification of things.

From these three points, we see an open interaction between subject and object in the process of establishing correct knowledge and performing right action. This is also why the *Zhong Yong* regards the *cheng* as not just a quality of reality (the quality of reality as reality not as anything else), but as a process of applying or realizing *cheng* in engaging and understanding the world and things. Hence, the *Zhong Yong* is also capable of saying, "To be sincere is not simply to complete oneself, it is to complete things. To complete oneself is benevolence, to complete things is knowledge." This crucial passage pinpoints the key idea of knowledge: to know is based on one's sincerity to seek truth and one's persistence in sincerity to seek truth in a process of inquiry.

It is only in terms of this process one is able to reach genuine knowledge which is evidenced or even caused by one's sincerity. This is how sincerity brings out knowledge and knowledge will increase one's devotion to truth. This is how *cheng* as the beginning of knowledge and knowledge as the result of *cheng* is a virtue of one's nature. In such knowledge we shall achieve the way of combining or unifying the inner mind and the outer world. This is how the evidence becomes united with knowledge whether the evidence be sincerity and truth be the yield of knowledge or the evidence be knowledge and truth be moral goodness. We see the continuum and dynamic unity of knowledge and to evidence be a mark and criterion for truth or truthful understanding or truthful interpretation.

Now if we apply this insight or principle of unity of knowledge and practice to the founding of metaphysical truths, it is clear that the truthfulness of the metaphysical understanding must come from an intimate link of such understanding with deep experience and general practice of life. With this understanding the Gettier Problem is basically solved. It is solved because we come to see knowledge as a holistic and dynamic process of inquiry which unites both learning and reflection, both subject and object, both experience and prediction, both vision with knowledge, and thus both evidence and truth. There is no truth without evidence leading to the truth and there is no evidence without truth revealing evidence as part of its intrinsic validity.

With so much said about this vision of knowledge on both the moral and metaphysical levels in Chinese philosophy, it becomes clear that the moral and

metaphysical knowledge-making is precisely like the scientific knowledge-making in Quine. Even though I have no intention to pursue the similarity between the Confucian/Neo-Confucian theory of knowledge[20] and Quine's holistic system of scientific or naturalized knowledge, we have to conclude that both have stressed the importance of holistic vision, dynamic adjustment, and an achievable consistency in an open and organic system. In both the Gettier Problem would not arise.

It is interesting to note also that whereas Quine's holism is a scientific theory of scientific knowledge, whereas the *Da Xue* and the *Zhong Yong* have presented a holistic vision of moral knowledge and metaphysical knowledge. We see that they share the same structure of uniting evidence and truth in characterizing knowledge, even though they are different radically in their respective contents. They present the same model of understanding of knowledge and offer the same logic of holistically fusing experience and knowledge, part and whole, perception and theory. Specifically, despite their differences of subject matter, they present the same dynamic unity of evidence and truth, and envision a potentially infinite process of making adjustment and achieving unity. They also share in respectively contributing to the founding of a holistic system of describing reality or the world. Finally, they require a genuine beginning in seeking knowledge and truth as an enterprise of the human person.

Given these similarities between them, we are now in a position to explain why an onto-hermeneutical interpretation is a truthful interpretation and vice versa. First of all, we have shown that a truthful interpretation is a system or body of knowledge or belief which makes efforts to satisfy those conditions which the *Da Xue* and the *Zhong Yong* and Quine have satisfied. Secondly, we see that such an interpretation is onto-hermeneutical, because such an interpretation makes reference to the world on one end and reflects the experience of the human mind (whether in perception or in feeling or thinking) on the other. These two ends are related by the knowledge or belief constructed by the mind and the very act/ action in making reference to the world in a process of inquiry. Hence, the knowledge or belief is both a truthful interpretation in regard to the fact that it is the activity of understanding the world from the human mind, and also an onto-hermeneutical interpretation because it is an interpretation of the world for the mind and a representation of the human mind for the world in our understanding.

Such an understanding is itself onto-hermeneutical because it is always referential in that it involves construction of reference to things in the world whereas the world or reality of things has to be also understood in the interpretative framework. In this sense we can also refer to this truthful interpretation as onto-hermeneutical. By being onto-hermeneutical I mean also that knowledge and belief come from the constant interplay between the ontologi-

20. For Neo-Confucianism one should see Zhou Dunyi's *Tongshu*.

cal reference to the world and the interpretative activities of the mind. The above discussion of the *Da Xue-Zhong Yong* and Quine hence provides a solid illustration of the onto-hermeneutical thinking. By defining such thinking in terms of truthful interpretation we have come to bring out all major and salient points of onto-hermeneutical thinking. A reflection of such thinking is called "onto-hermeneutics."

As the *Da Xue* and the *Zhong Yong* can be further integrated to form a system in which moral and metaphysical knowledge are intimately related and mutually supportive, and as both the *Da Xue* and the *Zhong Yong* on one hand and Quine on the other hand share the same logic and methodology of truthful interpretation, we wish to ask the following significant onto-hermeneutical question: Could the Quinean system of scientific knowledge be incorporated in this integrative system to form a comprehensive philosophy of human understanding covering science, morality, and metaphysics as three dimensions or three levels?

I myself do not see real difficulty in recognizing the relevance of holistic science from the *Da Xue-Zhong Yong* point of view, because this point of view would argue that value-making of the human person would lead to knowledge-making and world-making through the work of realization of *cheng*. From the onto-hermeneutical point of view, such an interpretation would be even desirable because it would lead to truthful interpretation of reality as more fully corresponding to the activities of the human mind. It is, however, not clear whether the nominalistic and extensionalistic strains in Quine would ever accept or recognize anything beyond perception of sense and logic. In fact, for Quine moral and metaphysical beliefs and propositional attitudes should be explained as "things of mind" and, hence, as relations between people and sentences in a naturalized language framework of naturalized epistemology.[21] They can only exist or be preserved, therefore, in the overt language behaviors of people without revealing their contents. Yet mind does exist from one's mind's eye. The notion of truth or reality does not preclude its application to things of mind insofar as there is evidence uniting itself with the truth. As it cannot be denied that the same principle drives Quine to the formulation of a system of scientific knowledge drives the *Da Xue-Zhong Yong* to the presentation of a system of moral and metaphysical vision, there is no reason why the analytic methodology can not be applied to all these visions as an integrated whole to reveal a lively and perhaps lived world of truthful understanding on behalf of the human person.

Based on our analysis of both the *Da Xue-Zhong Yong* system and Quine's system as truthful interpretation in the above sense, we may reformulate and redefine our notion of truthful interpretation as onto-hermeneutical

21. See Quine's latest work *From Stimulus to Science* (Cambridge: Harvard University Press, 1995), chap. 7.

interpretation: An interpretation is onto-hermeneutical in the sense that it is a systematic understanding on any level of human mind which preserves unity of evidence and truth, experience and vision, part and whole. It is an interpretation which seeks truth as its goal and, hence, it can also be called truthful interpretation. It is clear from the above that no truthful interpretation will not intend to present or represent the world in a manner where there is wholeness, unity of evidence, and truth as well as unity of intent and reference.

In order to bring into focus the onto-hermeneutical insights from Chinese philosophy, I wish to point out that the ontological reference in a holistic interpretation of human experience need not be understood as individual entities or simply some unknown entity transcending all possible interpretative frameworks as often assumed in the traditional metaphysics of the West. Quine has made it clear that our ontology is what we are committed to and we can commit ourselves to entities by way of using or understanding our language, because it is with our language we are able to formulate a way of identifying what we believe there is. This leads to Quine's famous dictum: To be is to be the value of the quantificational variable of a proposition. As we value simplicity of our knowledge system, we need to simplify our ontology so that we may be able to verify or confirm what we believe. Hence, Quine is interested in developing a scientific language in which we may have as little or no commitment to a reality beyond our pragmatic and scientific verification. In this sense he has to be very restrictive of what the human mind wishes to know or what it can say it has experienced.

But in this regard, Quine may have gone too far to the point of defeating his scientific interest. I wish to offer the reason as follows: Quine has shown how we can come to make reference to things in the world as mental positings in his account of the ontogenesis of natural language. But he also shows and suggests that we can eliminate all our bound variables and therefore all our reference to things in the world. Theoretically, we could have a language which has no quantifiers and thence no reference to any entities. Such a language would be one of predicates as connected by logical symbols. A world as described by such a world would be a world of pure forms and phenomenal qualities. While we may be contented with the immediate verification of such a phenomenal world, it is world which would stifle our imagination to extend and explore because there are no things or entities for us to react to or to inquire into. It is a world in which there would be no room for our imagination and creative thinking. Besides such a world would be one in which it is also difficult to act as a person and establish norms of action. This would be too much a morally impoverished world. Hence, we cannot take ontology in this minimal sense and must reject the implicit phenomenology in the Quinean system of knowledge as untruthful interpretation.

On the other hand, ontology of our onto-hermeneutical interpretation needs to be understood as "*benti*" (original truth or substance), a concept which

refers to the ultimate reality which has given rise to our present experience of the world. As an ontology the *benti* is experienced and described in Chinese philosophy as a creative source from which all things arise and as a comprehensive system in which all things have their orderly places. It is furthermore a process of interaction in which all things are still in the making. In this sense *benti* is best represented as the *dao*. But as a general term it is conceived as having activities as well as a sustaining substance, as having a form as well as a function. In our analysis of the *Da Xue* and the *Zhong Yong* we can see that this notion of *benti* as experienced is much closer to our understanding of reality in a truthful interpretative system. This is perhaps because there is no external transcendence in the Chinese philosophy. The two or three onto-cosmological principles as mentioned above are subsumed under such a notion of *benti* because they serve also to define such a notion of reality as *benti*.

Finally, there is a very important dimension of our understanding of *benti*: *benti*, like original mind (*benxin*) or (*benxing*) in Mencius, is open to our present experience: it is the substance which we have experienced in our perception and thinking. But as reality in general we need to reflect on what we observe and continue to experience what we reflect so that we may draw our understanding of meaning and interpretation from such an experience of *benti*. This is the reason why we as human persons could become creative from drawing creativity from the *benti* as a creative source. This is also the reason why we can transcend historical bias or even history in our seeking for the truth.[22]

In addition to the notion of ontology as *benti*, it is also necessary to add that the onto-hermeneutical activity of interpretation is generally related to the user of a language for reference and presentation. This is also aptly expressed by the Chinese term *quanshi* (to explain and dissolve in language).

Recognizing the onto-hermeneutical interpretation apart from rational reconstruction, we are able to draw a natural conclusion concerning the understanding of Chinese philosophy. Chinese philosophy not only needs rational reconstruction or construction, it needs even more onto-hermeneutical interpretation or truthful interpretation because we need not only to understand Chinese philosophy but to live through Chinese philosophy for a comprehensive and holistic understanding of reality and truth.

In regard to interpretation in a form of language, Quine has proposed the principle of ontological relativity. This principle implies that our ontology is dependent on our language. Since we must translate one language into another by careful logic and semantics preserving truth and simplicity, we may come to have a language which does preserve logic and basic semantics but which may introduce other propositions by analytic hypothesizing, therefore these two ontologies need not be equivalent but must be relativized to

22. On this point we see clearly how onto-hermeneutics differs strongly from the philosophical hermeneutics of Gadamer.

each language. A good point resulting from this observation is that even though we have indeterminacy of meaning, incompatibility of two systems, and relativity of ontology, there is always the possibility of mapping one whole system into another so that we may hold that these two languages or systems are commensurable holistically even though not commensurable partially or atomistically.

5. Concluding Remarks:
Three Stages of Reconstruction and Interpretation

In the above I have discussed how contemporary analytic philosophy arose in the West but not in China. I have focussed on the phenomenon of the tradition of "methodological revolution" in the West. That such a tradition exists is exemplified by a series of innovations in methods of thinking in the history of Western philosophy. But there is no such tradition in Chinese philosophy. On the contrary, all methodological thinking is subsumed under a tradition of onto-cosmological thinking. In a sense the tradition of onto-cosmological is both ontological and cosmological on the one hand and methodological on the other, because the very onto-cosmological framework provides a perspective from which one would understand and evaluate things. It becomes a way of thinking from inside out, unlike the use of a method which is thinking from outside in. It is in this sense I speak of the onto-methodology of both Confucianism and Daoism. The introduction of analytic philosophy as a methodology for Chinese philosophy no doubt serves a double purpose: it serves to rationalize the substantive concepts and views in terms of modern logic and language analysis, but it also serves to clarify and provide critical reflections on the onto-methodological way of thinking in Chinese philosophy. But above all, as I pointed out, there is a practical need which justifies the analytic approach to Chinese philosophy because it meets the needs of precision, systematizing, organization, explicitness, and communicativeness in modern society and in the present-day lives of individuals.

However, I also point out the dangers involved in the development of analysis as a paradigm in modern Western analytic and scientific modes of thinking and discourse: such modes of thinking and discourse tend to lose sight of knowledge and understanding of the whole in favor of the interests of knowledge and understanding of the parts and may actually reduce our onto-cosmological understanding of the whole to our knowledge of the parts. This no doubt reflects the underlying bifurcational and dualistic way of thinking in the tradition of Western tradition. Even postmodern deconstructionism or nihilistic relativism can be seen as premised on the action-reaction mode of polaristic opposition (rather than polaristic continuum): Because of the ills brought on by the domination of modernity, let's eliminate modernity

altogether. Similarly, with the Nietzschean paradigm of the death of God, life is reduced to a state of pure technique devoid of vision.

It is in light of this danger in modern life at this stage of the development of the Western mode of thinking that, it is necessary to keep in mind that the analytic approach to Chinese philosophy is not to eliminate Chinese philosophy or its inherent tradition, but to bring its many insights, whether onto-cosmo-logical, onto-methodological, onto-hermeneutical, onto-ethical (onto-moral), or even onto-aesthetic, into focus for analytic understanding. It is to shed light on them so that they become the vitalizing forces for the further development of Chinese philosophy, for the fruitful dialogical exchange of the East and the West, a means of enrichment for the Western tradition, and for the evolution of a genuine world philosophy in which major traditions of human civilization will form a spring of living wisdom from which all people of the humankind will flourish and benefit in leading a life of well-being and self-fulfillment. Thus, the analytic approach to Chinese philosophy and the development of Chinese analytical philosophy should not be taken lightly: it has an onto-herme-neutical mission, the mission to interpret Chinese philosophy in light of both a universal reason and its tradition, in terms of its own spirit and the needs of the modern form of life.

It is in light of this understanding of the station of Chinese philosophy and the history and present state of analytic philosophy in the West that I make the distinction between "rational reconstruction in Chinese philosophy" and "onto-hermeneutical interpretation in Chinese philosophy." The former will focus on rational and analytic understanding of a Chinese term or view in the large framework of Chinese philosophy. The question of truth and truthfulness will not be its pivotal concern. There are many philosophers trained in the West who come to have knowledge of Chinese philosophy who may propose a rational reconstruction or construction of a Chinese philosophy. In fact, Chinese philosophy in the present-day West is primarily a matter of rational recon-struction and philosophical analysis of this concept or that view in Chinese philosophy. But in the case of onto-hermeneutical interpretation, we have to bring the question of truth or truth conditions into central focus.

We have to ask whether one who comes to understand Chinese philosophy and even does Chinese philosophy by way of rational reconstruction and philo-sophical analysis also sheds light on its truth conditions or its truthfulness. We have to ask under what conditions or from which perspective or using which criterion we speak of its truthfulness. In saying this it is not to say that there could not be critique or criticism of Chinese philosophy, it is to say that one must treat interpreting Chinese philosophy as a living form of thinking as one confronted with the question of truth and reality. In this sense one is not just working with Chinese philosophy qua Chinese philosophy but qua thinking of truth and being or reality. It is in this sense I explain the onto-hermeneutical

interpretation as truthful interpretation, just like any other kind of truthful interpretation.

Because of the importance of the distinction between rational reconstruction and onto-hermeneutical interpretation, we may now consider three stages for making an analytical approach to Chinese philosophy. These three stages of consideration can be described as onto-hermeneutical methodology in which the analytic thinking and the analytic discourse will be incorporated. It is a methodology which would require a preceding onto-hermeneutical vision and preunderstanding before analysis and rational reconstruction and then a suc-ceeding onto-hermeneutical reflection and postunderstanding after analysis and rational reconstruction. We need this postanalytic reflection because we need to evaluate our analysis and its result as a whole in order to gain more creative insights into truth and reality. Needless to say, this postanalytic reflec-tion is itself onto-hermeneutical in nature because it is to relate the analytic to the synthetic, to relate the parts to the whole.

We may first consider a preanalytic stage where we need a background onto-hermeneutical vision and preunderstanding for the purpose of knowing what to analyze for or what to explain or illuminate or even knowing how to analyze or explain or illuminate. We need a macroscopic guiding principle and a sense of relevant totality so that meaning of a part can be generated beyond the mere use of language. It is through this preunderstanding of a holistic context and background or even the grounding that a part from the whole can derive its meaning and significance. In fact this preanalytic preunderstanding is to relate the whole to the part so that logical and language analysis can be fruitfully performed.

In order to grasp a preunderstanding of the onto-hermeneutical vision in Chinese philosophy, one needs to do some comparative philosophy. Therefore, one might have to consult other systems of onto-hermeneutical systems in sorting out their problems and recognizing their strengths. It is clear that all major systems of philosophy in Western philosophy can provide one with many issues and many angles of consideration. But for useful illustration, I shall cite specifically Plato and Kant as relevant classical or neo-classical references. For the contemporary philosophy I would like to mention Whitehead and Heidegger. Why Plato and Kant? Why Whitehead and Heidegger? I mention Plato be-cause Plato offers the primary form of dualism in the West between reason and sense and between reality and appearance. Yet he has the merit of showing how sense corresponds to appearance and how reason corresponds to reality. In the case of Kant, Cartesian dualism seems to disappear and knowledge is secured within the capabilities of the transcendental ego. But in reality Kant has introduced another unbridgeable gap between phenomenon and noumenon (thing-in-itself). In contrast, Chinese philosophy does not see or create such Platonic or Kantian dualism from the very beginning and this brings out the onto-cosmological points very clearly.

In the twentieth century it is Whitehead who wants to build a speculative philosophy of organicism in order to resolve both Platonic and Kantian dualism. He has saved phenomena of change and developed modes of knowing and thinking as an interrelated whole. Unfortunately, he did not pay sufficient attention to the issue of self-understanding of the human person and thus one cannot see what a place the human person along with attendant values occupies in the conceptual scheme of actual occasions. On the other hand, in the case of Heidegger, although Heidegger has focussed on the inner world of human existence, little attention was given to society and the large universe and their relation to the human person. Given understanding of these philosophical systems one would find it easier to identify chief characteristics of the Chinese philosophical view and vision as embodied in the *Yijing*, Confucianism, Daoism, and Neo-Confucianism.

In the stage of actual analysis, apart from using logic and paying attention to use of language, one need specifically to make efforts to recognize three modes of analysis. The first mode is analysis in terms of use of language. Later Wittgenstein suggests that the meaning of a term is found in its legitimate use in correct contexts of a language. This provides a good beginning for analysis because one comes to know the meaning of a term in knowing its use. But this need not settle the philosophical question arising from knowing the meaning in this way. Confucius says: "Common people know how to use certain concepts without knowing these concepts." To know, one needs also to reflect, to observe and organize the outer observation with inner thoughts in finding a truth. Hence, one needs to go beyond merely knowing the rules or forms of use of a term. Yet there is no denial that use-of-language analysis also serves another purpose: it is capable of introducing logical distinctions otherwise unnoticed. We learn this merit from works of G. E. Moore, J. L. Austin, Gilbert Ryle, and P. F. Strawson. Another important insight from the Wittgensteinian analysis is that use of language reflects forms of life. In uncovering the forms of life by analyzing the use of language we may come to be aware of and appreciate the underlying onto-hermeneutical visions of a language or a community of people. In doing analysis in Chinese philosophy a semantic-textual (or semantic-cross-textual) analysis is often required and there are always advantages in observing the meaning-in-use principle.

The second mode of analysis is analysis in critique and theorization. To critique we need to know issues and problems; to theorize we need to know theories and take positions or develop viewpoints. Quine starts his philosophy of language by taking to task the issue of what there is and the "two dogmas" in modern and contemporary philosophy. He has also come to develop and take the position of extensionism in ontology and naturalization of knowledge. Following through these positions he has given a realistic and nonreductive empiricist analysis of the ontogenesis and morphogenesis of our language as a natural language. He has also made clear his reasons for taking such positions:

his belief in ontological simplicity and epistemological holism (or some form of "anomalous monism" à la Davidson). Can we apply the Quinean approach and the Quinean philosophy (as a theory and as a methodology) for analysis in Chinese philosophy? I have to answer in the positive, because in many aspects there is an overlapping of the Quinean positions and the general tone of Chinese philosophy, particularly in onto-cosmological or onto-hermeneutical matters.

I have discussed this affinity earlier in this essay. I have also touched on certain differences. One of these differences is that Quine has ignored or eliminated internal reflections as simply "things of mind" and failed to explore their onto-hermeneutical significance. In fact, if we do not have a sense of commitment in our mind and in our action, we could hardly speak of "ontological commitment" of a language. Can we say that our formulating an ontology of a language requires or depends on our prior commitment to the ontology? However, in a deep-seated sense Quine has held a mutual determination theory of truth and reality: where there is reality there is the convention of mind. This is specifically revealed in his proposed reduction and elimination of quantifiers. But this particular direction as I have pointed out is actually inconsistent with his naturalistic view on the ontogenesis of general terms and reference and his naturalized epistemology.

To propose Quine as a model for the analytic approach to the onto-hermeneutical issues is especially meaningful in that it combines both lessons in methodology of analysis and ontology of analysis. It enables us to bring more clarity and illumination to the organismic, contextualist, mutual-determinate, or sometimes indeterminate nature of Chinese philosophy couched in Chinese texts or Chinese language as a medium of expression. It is in this sense I treat Quine's philosophy of logic and language as part of the philosophical project of onto-hermeneutics, a project in working out an ontological (*benti*) reconstruction or interpretation for a given view as a truthful interpretation. But to complement Quine and counteract his special reductional tendencies, I would also like to suggest Husserl as a secondary model for analysis in Chinese philosophy. It seems clear to me that we would not be able to talk of a world-being (to translate the Chinese term *jingjie*) if we could not learn the Husserlian art of phenomenological *epoche* along with the Quinean technique of logical paraphrasing.

We come finally to the third mode of analysis which is logical formalization and formal argumentation. We have seen that we have to use logic and logical analysis in both the first and second modes of analysis. But in speaking of logical formalization, we have to explicitly bring forth the logical forms of a few sentences and the logical structures of a discourse. The purpose for doing so is to establish proof or demonstration of claimed truths or to reject formally a position because of its inherent logical inconsistency. One would not be able to do this formal argumentation without effort at an actual logical formalization. This is true of Russell's discovery of Russell's Paradox in regard to Frege's work

on the foundation of arithmetic. This is also true of Nagel's illumination of the Incompleteness Theorem of Goedel. In Chinese philosophy I have used logical formalization for validating Gongsun Long's argument for the thesis on all things being attributes.[23] Without such a formalization not only is there no clarity but also one would not see where one may have an issue of interpretation of meaning or reference.

In an analytic approach to Chinese philosophy we need not confine ourselves to a single mode of analysis. It is obvious that to yield maximum effectiveness in achieving clarity and relevance a mixture of the modes of analysis is often called for. Any limitation on the way a C or V is to be analyzed would be counterproductive and disastrous.

In reference to the postanalytic stage of reflection and reexamination I would like to mention briefly the relevance of pragmatic, historical, and systematic considerations. The consideration of actual and would-be pragmatic effects and consequences is important because it would relate the analytic results to a human context of belief, confirmation, and action. It would also provide an occasion to raise questions of valuation and normalization. In fact, a given analysis of moral concepts always has a pragmatic aspect in terms of which we may incorporate the analytic vision in the practical course of living and decision making. Regarding the historical significance, we have to relate our analysis to its historical precedents if any and explore its possible historicity in order to establish a link with the tradition or to show how it breaks off from the tradition and history. This is important because the analysis could mark out a new paradigm in thinking and stand out as a new insight into our understanding of truth and reality. We may cite G. E. Moore's refutation of idealism and Quine's rejection of the dogma of the analytic-synthetic distinction as examples of this point. Finally, we need to reflect on the systematic nature or aspect of the analysis. Oftentimes an analysis is ad hoc and lacks the depth to relate to a wider or deeper question or to disclose a wider or deeper insight into truth and reality. It is necessary, therefore, to further explore and examine our analysis both logically and onto-hermeneutically so that we would make it a lasting contribution.

23. See my essay co-authored with my student Swain, "Logic and Ontology of Kung-Sun Lung's *Chi-Wu-Lun*," *Philosophy East and West* 20, no. 2 (1970): 137–54.

Philosophical Analysis and Hermeneutics: Reflections on Methodology via an Examination of the Evolution of My Understanding of Chinese Philosophy

Shu-hsien Liu

As I have been widely recognized as a representative of Contemporary Neo-Confucianism, perhaps it would be instructive to review the evolution of my approaches to Chinese philosophy for about half a century from a methodological perspective.

I became a freshman majoring in philosophy at Taiwan University in 1951. Very quickly I realized that this was a new age of philosophy in which a great deal of emphasis was put on methodology. At that time the vogue was the kind of philosophical analysis promoted by the logical positivists. I was greatly impressed by this trend, and I believed that analytic skills were much needed to further develop Chinese philosophy, which is full of vague ideas. By the criteria of such philosophical analysis, however, only formal sciences such as logic, mathematics, and empirical sciences would have cognitive meaning, consequently there is very little with cognitive meaning in the Chinese tradition. Among the so-called three great philosophical traditions in the world, the Chinese had never developed anything like formal logic in the Greek tradition or the forms of syllogistic reasoning in the Indian tradition. Then even though the Chinese did make great contributions to science and civilization in the past, as Joseph Needham's studies have shown,[1] they had never been able to make the breakthrough to develop anything like modern science in the West which shows that knowledge is indeed power. Without any doubt there is much to be learned from the West. Actually there is very little choice on the part of the Chinese; just for the sake of survival, China had to quickly modernize itself, otherwise it would be worse than a colony as Dr. Sun Zhong-shan (Sun Yat-san) pointed out. As a matter of fact, even as late as the nineteen sixties,

1. Joseph Needham, *Science and Civilisation in China* (Cambridge: Cambridge University Press, 1954–).

Joseph Levenson still thought that Confucianism would be something like relics to be found only in the museums.[2] Today, however, very few scholars subscribe to such a view after the rise of Japan and the four mini-dragons, that is Korea, Taiwan, Hong Kong, and Singapore, that share a Confucian background. And some Western intellectuals challenge the hegemony of Enlightenment reason and dominance of Western values from a postmodernist perspective. There is, of course, no need to go into such discussions for our present purposes. Suffice it to say that even back in my school days, I took exception to the views of logical positivism for philosophical reasons, as the principle of verifiability is itself not verifiable.[3]

I found that there were other ways to study the problem of meanings such as Phenomenology, Pragmatism, and the later Wittgenstein.[4] Even more importantly, my teacher Thomé H. Fang initiated me into the philosophy of culture, and I discovered Ernst Cassirer, whose *Philosophy of Symbolic Forms* gave me great stimulation.[5] Cassirer was thoroughly familiar with the mainstream of Western philosophy. He studied the evolution of logic and science from Greek until modern times, and published volumes on epistemology from the Renaissance to the twentieth century. He found that the idea of substance has gradually been replaced by the idea of function,[6] but even the former should not be taken as the starting point, as it is already the result of a long evolutionary process. Before Greek philosophy, there was Greek mythology; and momentary gods, functional gods precede individual gods of polytheism. And symbols, in distinction to signs, are already in operation in myths and magic. According to Cassirer, besides science, there are other symbolic forms such as myth and religion, language, art, and history. They cannot be reduced to the same substance, so we must give up hope for a substantial unity. But a functional unity can be found, as we find symbols in use in all the symbolic, or the cultural, forms. History as a branch of humanities must not be reduced to science, as he told us explicitly that, "If we seek a general heading under which we are to subsume historical knowledge we may describe it not as a branch of physics but as a branch of semantics. . . . History is included in the field of hermeneutics, not in that of natural science."[7] It is interesting to note that Cassirer developed his own understanding of hermeneutics, which for me is a better option than

2. See Joseph R. Levenson, *Confucian China and the Modern Fate: A Trilogy*, vol. 3 (Berkeley: University of California Press, 1968).

3. See Shu-hsien Liu, *Yu-yi-xue yu zhen-li* [*Semantics and Truth*] (Taipei: Guang Wen, 1963).

4. See Shu-hsien Liu, *Xin-shi-dai zhe-xue de xin-nian yu fang-fa* [*New Philosophical Convictions and Methods in a Changing World*] (Taipei: Commercial Press, 1966).

5. Ernst Cassirer, *The Philosophy of Symbolic Forms*, 3 vols. (New Haven, Conn.: Yale University Press, 1953–1957).

6. See Ernst Cassirer, *Substance and Function* and *Einstein's Theory of Relativity*, translated by William Curtis Swabey and Mary Collins Swabey (Chicago: Open Court Pub. Co., 1923), *Determinism and Indeterminism in Modern Physics* (New Haven, Conn.: Yale University Press, 1956).

7. Ernst Cassirer, *An Essay on Man* (New Haven, Conn.: Yale University Press, 1944), 195.

that developed by Heidegger. As a Neo-Confucian philosopher I do not accept the Heideggerian ontology, even though I borrowed some of his insights to give a new interpretation of Wang Yang-ming's philosophy to be discussed later on. Cassirer's approach to the logic of the humanities is most helpful to me. He rejected some of the current views, as he said,

> Modern philosophers have often attempted to construct a special logic of history. Natural science, they have told us, is based upon a logic of universals, history upon a logic of individuals. Windelband declared the judgment of natural science to be nomothetic, those of history idiographic. The former gives us general laws; the latter describe particular facts. This distinction became the basis of Rickert's whole theory of historical knowledge. 'Empirical reality becomes nature, if we consider it with regard to the universal; it becomes history, if we consider it with regard to the particular.'
>
> But it is not possible to separate the two moments of universality and particularity in this abstract and artificial way. A judgment is always the synthetic unity of both moments; it contains an element of universality and of particularity. These elements are not mutually opposed; they imply and interpenetrate one another. 'Universality' is not a term which designates a certain field of thought; it is an expression of the very character, of the function of thought. Thought is always universal. . . .[8]

There is also the subsumption of the particular under the universal in the humanities, only it is conducted in a different manner. A concrete illustration is in order:

> In his *Civilization of the Renaissance* Burckhardt gave a classic portrait of 'the man of the Renaissance.' It contains features that are familiar to everyone. The man of the Renaissance possesses definite characteristics, which clearly distinguish him from the 'man of the Middle Ages.' He is characterized by his delight in the senses, his turning to nature, his being rooted in 'this side of existence,' his openness in behalf of the world of forms, his individualism, his paganism, his amoralism. Empirical research set out to find this Burckhardtian 'man of the Renaissance'; but it has not found him. No single historical individual can be cited who actually unites in himself all the traits that Burckhardt regards as elements constitutive of this image. . . .[9]

The reason is that universals in the humanities such as "man of the Renaissance" serve a different function from those in physical sciences such as "gold."

8. Ibid., 186.
9. Ernst Cassirer, *The Logic of the Humanities*, translated by Clarence Smith Howe (New Haven, Conn.: Yale University Press, 1961), 137.

Burckhardt could not have given his image of 'the man of the Renaissance' without relying upon an immense amount of factual material in support of it. The wealth of this material and its trustworthiness astonish us again and again as we study his work. But the kind of 'conspectus' he executes, the historical synthesis he gives, is wholly different from that of empirically acquired concepts of nature. If we wish to speak of 'abstraction' here it is that we are dealing with that process which Husserl characterized as '*ideirende* abstraction.' That the result of such an '*ideirende* abstraction' could ever be brought to coincide with any concrete case—this can neither be expected nor demanded. And 'subsumption' can never be taken here in the same sense in which we subsume a body given here and now, i.e., a piece of metal, under the concept 'gold,' after finding that it fulfils all the conditions of gold known to us. When we characterize Leonardo da Vinci and Aretino, Marsiglio Ficino and Machiavelli, Michaelangelo and Cesare Borgia as 'men of the Renaissance,' we do not mean to say that there is to be found in them a definite and inherently fixed distinguishing trait in which they all agree. We perceive them to be not only completely different, but even opposed. What we are asserting of them is that in spite of this opposition, perhaps just because of it, they stand to each other in a specific ideal connection: each in his own way is contributing to the making of what we call the 'spirit' of the Renaissance or the civilization of the Renaissance.[10]

Now I am ready to answer the question of whether the Chinese are capable of abstract thinking. Obviously the question is a loaded one which cannot have a satisfactory answer. It is a fact that the Chinese did not develop formal logic and empirical sciences like in the West, but this was based on their own choice not to separate form from content. That was why the kind of Western achievements could not have originated in China. However, the Chinese not only are capable of the *ideirende* abstraction that Cassirer referred to in the above, but also have developed a great humanities tradition the products of which are now considered to be treasures of the world.

There are certainly serious limitations of the traditional Chinese civilization. That is why it suffered frustration after frustration after the impact of the mighty West in the last couple of hundred years. Confucianism as the state ideology of the dynasties took all the blame, as the slogan during the New Culture Movement symbolized by May Fourth, 1919 was: "Down with the Confucian shop!"[11] After that Confucianism was no longer the mainstream of Chinese thought, which was eclipsed by Western thought, promoted by scholars such as Hu Shi. Finally Marxism was adopted as the state ideology by the People's Republic of China established in 1949 under the leadership of Mao Ze-dong.

10. Ibid., 186.

11. The May Fourth Movement in the narrower sense was a political movement initiated by student protest, it was later understood as a cultural movement with a much broader scope. For a deeper understanding of the movement, see Tse-tsung Chow, *The May Fourth Movement: Intellectual Revolution in Modern China* (Cambridge, Mass.: Harvard University Press, 1960).

But Confucianism was not dead yet, even though it was pushed to the sidelines. It was under such circumstances that there was the revival of spiritual Confucianism in the twentieth century. The first response to the challenges from the West came from Liang Shu-ming, today recognized as belonging to the first generation of contemporary Confucian philosophers.

A quick review of his thought is instructive for our purposes. In 1920 he began to give his public lectures series: Eastern and Western Cultures and their Philosophies.[12] His ideas may appear oversimplified from today's perspectives, but they were provocative and stimulating in those days. He found that the three great civilizations, namely, Western, Indian, and Chinese, have opted for three different directions of life. The guiding spirit of the Western culture is that the Will always strives forward. Characteristics of this culture are conquest of nature, scientific method, and democracy. The guiding spirit of the Chinese culture on the other hand is that the Will aims at achieving harmony and equilibrium. Characteristics of this culture are contentment, adjustment for the environment, and acceptance of authority. Such a culture would not invent steamships and trains or democracy. Finally, the guiding spirit of the Indian culture is that the Will looks backward. The only things it cares about is religious aspiration, liberation from worldly cares. The Western culture values material gratification, the Chinese society life, and the Indian transcendence. As a young man Liang was attracted by Buddhism and considered becoming a monk. But he changed his mind, as he felt that the development of both the Indian culture and the Chinese culture were premature, they should first go through a stage like the West. The conclusions he drew were as follows. As the Indian attitude looks backward, it must be totally excluded for the time being. The Western achievements must be taken over without any reservation, but its attitude to strive forward only must be changed, so that undesirable consequences of the Western civilization such as those exposed since the First World War can be avoided. Finally, the middle way of the Chinese culture, which looks both forward and backward, should be revived from a critical point of view. Confucius's strength lies in the fact that he finds resources in life itself, and both traditional shortcomings and modern diseases should be overcome in the future. Liang Shu-ming admitted that he was not a good scholar, but rather a thinker who wanted to put his ideas into action according to Chinese tradition, so he quit the academic life and gave up his post at Peking University. His thoughts are full of insights, but include plenty of wishful thinking as well. How would they measure up by Cassirer's philosophy of culture? In some respects the two approaches are compatible, in other respects seemingly contradictory. Further reflections are needed to deal with the issues before us.

12. Liang Shu-ming, *Dong-xi wen-hua ji qi zhe-xue* [*East-West Cultures and Their Philosophies*] (Shanghai: Commercial Press, 1922).

Let us now return to Cassirer. His approach is quite unique, as it is neither that of a historian, nor that of a philosopher, but rather something in between. He drew a lot of material from studies in different fields and showed great scholarship. But he was not content to just record things like a historian, and he also never just speculated in order to weave a system of philosophy in disregard of empirical data. In other words, he was not like an ant or a spider, but rather a bee as portrayed by Francis Bacon. He organized the rich data he collected and then certain forms emerged. Thus he was able to conclude that in the development of modern science, the idea of substance was gradually replaced by the idea of function. While scholars were puzzled by Einstein's theory of relativity and quantum mechanics, they served as further examples to show that the direction he pointed to was correct. Likewise in the broader area of culture, he found that at the dawn of human culture, language and myth were twins developing hand in hand. Then science emerged from language, and religion emerged from myth, along with art and history. These were the six symbolic forms that Cassirer studied, but they are not necessarily the only ones; for example, morality could be another one. Cassirer's philosophy is open-ended with a dynamic character. It points to a direction without being deterministic. Even though he gave us a portrayal of the evolutionary process of the development of human thought and human cultures, he never taught a linear progressive view of history. Our fortunes may go up or down depending on whether our creative and rational resources can function to bring us greater freedom, otherwise we can be victims of political myths such as Nazism which brought havoc to humankind during the Second World War.[13]

Cassirer's phenomenology may be characterized as a phenomenology of the spirit without the Absolute. It is by no means a closed system of philosophy like Hegel's, but rather an ongoing task. He drew freely from all cultures and never conducted comparative studies of cultures and philosophies like what Liang Shu-ming did. But there is nothing against the view that sees the mainstreams in Western, Chinese, and Indian cultures are science, morality, and religion respectively. But Cassirer did reject Spengler's deterministic philosophy of history which he took to be an astrology of history.[14] He would not disapprove of Liang's proposal for the Chinese to learn from the West first in order to expand the horizon of the Chinese culture, and finally to seek for spiritual liberation as taught by Buddhism first originated in India. The hidden message for Cassirer's portrayal of the evolution of human cultures is precisely to urge us to devote ourselves to be even more creative in order to find greater freedom in our lives at the present and in the future. And by implication it is also to urge us to fight against the dark forces that work to destroy the achieve-

13. Ernst Cassirer, *The Myth of the State* (New Haven, Conn.: Yale University Press, 1946), 277–98.
14. Ibid., 291.

ments of civilization. This is why his phenomenology always portrays an up-lifting movement, while actual development of history shows not only fluctuations but also crises. But he is confident that the direction he points to is correct, as he does not figure it out in his head, but bases it on rich empirical data. There are of course variations in conducting phenomenological description of the evolution of human cultures. For example, we can choose to portray also the fluctuations in the process. Seen from this perspective, Liang's observation that the development of the Chinese culture being precocious is indeed a precious insight. Furthermore, even though I would agree that the stage of rational, moral culture usually develops after that of myth and magic like Cassirer portrayed from a phenomenological perspective, I was still struck by the fact that, in the actual development of Chinese thought, it was after the emergence of the rational, moral culture of Pre-Qin Confucianism that the interest in myth and magic revived in the Han and Wei-Jin dynasties. Most of the material we have on ancient mythology postdates the works of Confucius and Mencius. Thus Cassirer's project needs to be expanded to deal with the Chinese situation.

Although I have great admiration for Cassirer, I must take exception to his views on the following two issues. Firstly, Cassirer's phenomenology of knowledge claims that science is the latest and by implication the highest achievement of human culture, the reason being that the high degree of abstraction seems to allow it to be further free from our concrete sense perceptions. This may be true as far as our knowledge is concerned, but it cannot be transferred to become the proper criterion to pass judgments on human cultures and for human life. My question is, can science serve as the ruling commitment of our life? For me, surely not! Liang's reflections touch upon this issue. For him, science is the beginning stage, followed by morality, and finally culminating in religion. We may not agree with Liang. Further debates and reflections are needed. But this issue cannot be settled by Cassirer's phenomenology. Secondly, another related issue is, there is without any doubt a philosophy of creativity implicit in his thought, but he seems to shy away from making it explicit. He is content with formulating his phenomenology of cultures, and leaving his readers to draw their own conclusions. This is unsatisfactory to me, as he cannot avoid telling us about his own presupposition, and readers may still draw rather different conclusions. Thus we have to look beyond Cassirer to formulate our own philosophies.[15]

After teaching several years at Donghai University, I went abroad to study at Southern Illinois University at Carbondale, and became the last Ph.D. student of Henry Nelson Wieman. I find great affinity with his thought, as he takes

15. Shu-hsien Liu, *Wen-hua-zhe-xue de shi-duan* [*An Introduction to the Philosophy of Culture*] (Taipei: Zhi-wen, 1970), 192–210. I wrote my master's thesis on Cassirer in 1958, which was later incorporated in this book. And I also translated Cassirer's *An Essay on Man* into Chinese: *Len-lun* (Taizhong: Donghai University Press, 1959).

"creative interchange" as his ruling commitment.[16] I also learned about Paul Tillich's definition of religion as "the ultimate concern" in distinction from other proximate concerns.[17] Such an approach does not take faith in god as a necessary condition for religion. Thus Buddhism, though atheistic, is recognized as a religion. Confucianism is a much more difficult problem. It is certainly not an organized religion, but it is the ultimate concern for its followers, and has unmistakable religious import. Tillich also made the important distinction between beliefs and faith. Beliefs are based on evidence: the more evidence one accumulates, the stronger the beliefs one would have. This pertains to the realm of probability, and this also explains why we can never reach absolute certainty in empirical sciences. But faith is a different matter. For example, faith in Christ and the myths and miracles associated with him is strongest, even though all the evidence appears to point to the opposite. Faith demands absolute commitment. The extreme case can be found in the declaration that "I believe because it is absurd" (*credo quia absurdum*), a statement attributed to Tertullian. Based on such a distinction, Tillich further distinguished between Jesusology and Christology. The former pertains to historical studies which study Jesus as a man, supposedly born through virgin birth by Mary who was married to Joseph, and all the legends surrounding him. Such studies may only help to establish higher or lower levels of probability, they cannot settle the issue of faith in Jesus as the Christ. The cross is a symbol, which means the end of one life here on earth is the beginning of another even more meaningful life of New Being. Such faith demands one's unconditional ultimate commitment, which goes beyond one's concern for science and history.[18] Tillich's theology of culture put emphasis on the transcendent dimension in answer to our ultimate concern, an issue not sufficiently dealt with in Cassirer's phenomenology of culture. And my interest gradually shifted from philosophy of culture to philosophy of religion, as I am keen to explicate the religious import of Confucian philosophy from a comparative perspective. In the meantime I also learned valuable insights from different forms of hermeneutics.[19] I find

16. Cf. Robert W. Bretall, ed., *The Empirical Theology of Henry Nelson Wieman* (New York: Macmillan, 1963), and also Shu-hsien Liu, "Henry Nelson Wieman and Chinese Philosophy," *American Theology & Philosophy* 12, no. 1 (Jan.1991): 49–61.

17. Paul Tillich, *Dynamics of Faith* (New York: Harper & Brothers, 1957), 1–4.

18. For general understanding of Tillich's theology, one must consult his *magnum opus*: Paul Tillich, *Systematic Theology*, 3 vols. (Chicago: University of Chicago Press, 1951, 1957, 1963). For the distinction between Jesus and the Christ, see vol. 2, 97–118. I wrote my dissertation: "A Critical Study of Paul Tillich's Methodological Presuppositions" in 1966. For my critique of Tillich's theology, see Shu-hsien Liu, "A Critique of Paul Tillich's Doctrine of God and Christology from an Oriental Perspective," in Charles Wei-hsun Fu and Gerhard E. Spiegler, eds., *Religious Issues and Interreligious Dialoques* (New York, Westport, Conn., and London: Greenwoord Press, 1989), 511–32.

19. Cf. Richard E. Palmer, *Hermeneutics* (Evanston, Il.: Northwestern University Press, 1969).

that even though we cannot directly apply these new tools to Chinese philos-
ophy, we can still certainly draw a great deal from them to capture the special
characteristics of Chinese philosophy, proceed further to find where it can
contribute to world philosophy, and then we can use the tools to form critiques
of both our own traditions and contemporary civilizations.

Since the early seventies I have published more than fifty articles in English
on Chinese philosophy in general and Confucian philosophy in particular, dis-
cussed issues concerning religious import, epistemology, ethics, time and
temporality, analogy and symbolism, humanity and nature, mind and reason,
creativity, freedom, value reconstruction, world peace, among others. After
occupying the chair of Chinese philosophy at The Chinese University of Hong
Kong in 1981, I published books on Zhu Xi and Huang Zong-xi in Chinese.
Recently I retired from CUHK and am doing pure research at Academia Sinica.
My book, *Understanding Confucian Philosophy: Classical and Sung-Ming*, was
published in 1998. Currently I am working on its sequel, *Contemporary Neo-
Confucian Philosophy*, and will compile a source book on the subject. My meth-
odology is a combination of philosophical analysis and hermeneutics, and the
subject matter is part philosophy and part intellectual history. As I firmly be-
lieve that method cannot be separated from doctrine, I would like to use five
concrete examples to show how I employed the methodology. The five cases I
will discuss are as follows:

(1) the religious import of Confucian philosophy[20]

(2) Zhu Xi's search for equilibrium and harmony[21]

(3) Wang Yang-ming's understanding of the "worlds" as meaning-
structures[22]

20. See Shu-hsien Liu, "The Religious Import of Confucian Philosophy: Its Traditional
Outlook and Contemporary Significance," *Philosophy East and West* 21, no. 2 (April 1971):
157–75. I have engaged in several Confucian-Christian dialogues since then. For example, the
First International Confucian-Christian Conference held in Hong Kong, 1988, the second one
in Berkeley, 1991, the third one in Boston, 1994, and the fourth one in Hong Kong again,
1998. All the papers I presented were published in journals or collection of essays.

21. Cf. Shu-hsien Liu, "On Chu Hsi's Search for Equilibrium and Harmony," in Shu-hsien
Liu and Robert Allinson, eds., *Harmony and Strife: Contemporary Perspectives East and West* (Hong
Kong: The Chinese University of Hong Kong Press, 1988), 249–70. I have been recognized as
a Zhu Xi specialist on the international level. In 1982 I was invited to present a paper: "The
Problem of Orthodoxy in Chu Hsi's Philosophy" at the International Conference on Zhu Xi
held in Honolulu, the collection of essays: *Chu Hsi and Neo-Confucianism* was published by
University of Hawaii Press in 1986. I was also asked to contribute items on Zhu Xi for *Encyclo-
pedia of Ethics* (Garland Pub., 1992), *The Cambridge Dictionary of Philosophy* (1995), and *A Com-
panion to the Philosophers* (Blackwell, 1999).

22. Cf. Shu-hsien Liu, "How Idealistic Is Wang Yang-ming?" *Journal of Chinese Philosophy*
10, no. 2 (June 1983): 147–68.

(4) the functional unity of four kinds of symbolism found in the *Yijing* and its philosophical implications[23]

(5) *li-yi-fen-shu* (one principle, many manifestations) and global ethic[24]

The first issue I want to discuss is the religious import of Confucian philosophy. As is well known, in the modern West religious faith and philosophical reason went separate ways. In the Chinese tradition we simply cannot find the equivalents of religion and philosophy in the Western sense. In fact even the Chinese terms for them: *zong-jiao* and *zhe-xue* are actually new terms coined by the Japanese by a novel combination of words and only later adopted by the Chinese. Thus it would be highly misleading for us to label Confucianism as either philosophy or religion. On the one hand it would be awkward to take it as a philosophy, as not only has Confucianism not developed a formal logic but also it has shown very little interest in argumentation or speculation like in Greek philosophy. And yet on the other hand it is also inappropriate to take it as a religion, as not only has it never shown any other-worldly sentiment like Christianity, but it is definitely not an organized religion, as it does not have a church organization. All too often Confucianism is understood in the West as teaching merely a secular ethics, or is taken to be just a conservative tradition to preserve a stable social order at all cost. If such should be the case, then it would really be a puzzle why missionary work was not successful in China, as it appears that a supernatural faith would seem to be such a perfect addition to a culture with attention only on secular ethics and social order. Here Paul Tillich's doctrine of religious faith as ultimate concern really helps. For Confucian followers, there is indeed something in the tradition that can calm one's mind and establish one's destiny (*an-xin-li-ming*); so when one's ultimate commitment is made, it would be realized that our Way is self-sufficient and that there is no longer the need to seek elsewhere. It is here we find that Confucianism has unmistakable philosophical and religious implications. As Confucianism offers deep reflections on both the world and life by way of personal realization in a conscious fashion, unless we understand philosophy in a narrow way, Confucianism then cannot but be said to be a great philosophical tradition. And, because such a philosophy can help a person to establish one's ultimate commitment, it certainly also has religious import. It is in such a way that the special characteristics of Confucianism are laid bare. These are exactly some of the important messages conveyed to us by

23. The problem was discussed in the presidential address I delivered at the Fifth International Conference in Chinese Philosophy organized by the International Society for Chinese Philosophy held at San Diego in July, 1987. See Shu-hsien Liu, "On the Functional Unity of the Four Dimensions of Thought in *the Book of Changes*," *Journal of Chinese Philosophy* 17, no. 3 (Sept. 1990): 359–85.

24. Cf. Shu-hsien Liu, "Reflections on World Peace through Peace among Religions," *Journal of Chinese Philosophy* 22, no. 2 (June 1995), 193–213.

the famous Contemporary Neo-Confucian Manifesto on Chinese Culture and the World delivered on New Year's day in 1958.[25] These Neo-Confucian scholars are determined to preserve the *Dao-tong* (the tradition of the Way) by giving brand new interpretations of *the xin-xing-zhi-xue* (learning of mind-heart and nature), but in the meantime also urge us to expand our horizon by further developing the *Xue-tong* (the tradition of learning) and the *Zheng-tong* (the tradition of politics) in order to incorporate science and democracy from the West.

The English term "Confucianism" is misleading, as Confucius did not start the whole trend, but rather inherited the system of rites (*li*) from the early Zhou period. But he did make great contributions by putting new wines into the old bottle, as he was the first to put emphasis on *ren*, variously translated into English as human-heartedness, humanity, and so on, as the spirit under-lying the practice of rituals and rites. Against popular beliefs in his time, he refused to make bargains with the spirits, and held a noncommittal attitude toward their existence. But he kept his faith in and felt awe before Heaven, which was worshipped as the supreme personal God by the Zhou people. There was a subtle change, however, as a new understanding of Heaven emerged: Heaven is understood by him to be the invisible creative power working inces-santly in the universe without making intervention in the natural course of events. Nevertheless it is the origin of values and norms, and serves as the example for sage-emperors Yao and Shun to govern by taking no [artificial] actions (*wu-wei*). It was reported in the *Analects* that Confucius claimed there is one thread in his doctrines. But he never said what it is, and his disciple Zeng Zi interpreted it to mean *zhong* (conscientiousness, true to oneself) and *shu* (altruism, regard for the others), two sides of the same coin. This view has been commonly accepted in posterity. Zeng Zi certainly was not wrong, but it appears that his interpretation has not been able to exhaust the meaning of this one thread. As Confucius urged us to learn from below and to reach up high, it was highly unlikely that he would only extend humanity on the social level, and be forgetful of its origin. As Heaven serves as the model for Yao and Shun, the acknowledged mentors for Confucius, to practice *wu-wei*, then Confucius followed their models to develop his political ideals. And he also followed the model of Heaven to work incessantly in a creative and silent fash-ion without the instruction of words. I venture to spell out the hidden mes-sage of Confucius's one thread: there is indeed the implicit faith in *tian-ren-he-yi* (Heaven and humanity in union) in his thought, even though the term had not yet been coined at that time. Thus, it is not correct to say that Confucius

25. "A Manifesto for a Reappraisal of Sinology and Reconstruction of Chinese Culture," in Carsun Chang, *The Development of Neo-Confucian Thought*, vol. 2 (New York: Bookman Associates, 1962), 455–83. The manifesto was drafted by Tang Jun-yi and was signed by Mou Zong-san, Xu Fu-kuan, and Carsun Chang after discussions and revisions. It has since been regarded as an important document in the study of the Contemporary Neo-Confucian movement.

taught merely a secular ethics without any religious aspiration toward the transcendent, as shown in his deep faith in Heaven.[26]

Mencius further developed the Confucian philosophy by making explicit what is only implicit in Confucius's thought. He urged us to develop to the utmost what is inherent in one's mind-heart in order to realize one's nature and to know Heaven. There is no need to depart from the human ways in order to comprehend messages from Heaven. The *Zhong-yong* or *The Doctrine of the Mean* taught the Confucian doctrine of trinity: Heaven, Earth, and Humanity, among the creatures only human beings are able to participate in the ways of Heaven and Earth. Then *Yijing*, or *The Book of Changes*, further developed a comprehensive philosophy of creativity and harmony. Such thought had later become the mainstream of Sung-Ming Neo-Confucian philosophy.[27] This type of thought is characterized by its understanding of immanent transcendence. The Way of Heaven is working everywhere in the universe, and hence is immanent, and yet it is not a thing, and cannot be grasped by the senses, and hence is transcendent. From a religious perspective, the ultimate commitment to the Confucian Way is in contrast to the Christian faith in a supreme personal God who created the world but is not part of the world, and hence is pure transcendence beyond the reach of the intellect. And then even though Confucius was honored in posterity as the most important sage, he was still regarded as just a human being, not like Jesus Christ, being the Son of God, associated with numerous supernatural miracles. As a philosophy, Confucian metaphysics taught that the Way is all-encompassing and dynamic, it must not be understood to mean the kind of static Eternal Being above the becoming process as taught by Plato and Aristotle in Greek philosophy.

The above discussions offer the first instance of a combination of philosophical analysis and hermeneutics to help us understand traditional Chinese philosophy from a comparative perspective. Philosophical analysis in terms of logical reasoning, argumentation, and speculation has not been valued in the Chinese tradition, as *Ming-jia*, the so-called Logical School or the School of Dialecticians, became extinct in the late Zhou period. And the Confucian Way cannot be established in terms of empirical generalization either. It can only be reached through personal realization, which is universal in the sense that it is usually achieved by following the examples of sages and worthies, but has absolutely nothing to do with revelations from supernatural sources. The language it employed is full of metaphors and analogies and lacked accuracy, but what was taught is certainly not beyond understanding. As philosophy stu-

26. To understand the spiritual roots of Confucianism, see the chapter on Confucius in Shu-hsien Liu, *Understanding Confucian Philosophy: Classical and Sung-Ming* (Westport, Conn.: Greenwood Press, 1998), hereafter cited as Liu, *Confucian Philosophy*.

27. See Liu, *Confucian Philosophy*, 81–90, 112–30.

dents received Western training today, we no longer think in the same way traditional Confucian scholars conducted their thinking. We love to think clearly and to have conceptual accuracy. But we still would not care to do analysis for its own sake. Through analysis we make distinctions between different ways of thinking and different levels of understanding. Here hermeneutics also comes into the scene, as analytic skills are employed to lay bare preunderstanding as much as possible, then merging of horizons may be expected in the future.

Now we need to proceed to further reflection on methodology to conduct the so-called comparative studies of philosophy. A common practice is to find certain major figures in the East and the West, such as Zhu Xi and Aristotle, compare their world and life views, analyze in great detail their metaphysical assertions, cosmological speculations, moral disciplines, and so on to ascertain significant similarities and differences in their opinions. Nothing appears to be wrong with such an approach, except that there is an important fact being overlooked. The underlying assumption is that the problematics for both philosophers are the same; in fact they are not. Consequently we inadvertently impose a framework commonly accepted by Western philosophy on Chinese philosophy. Yes indeed, as a great Chinese philosopher, Zhu Xi has a metaphysics, a cosmology, and an ethics. They are comparable to Aristotle in some ways. This is not where the problem lies. The trouble is that Zhu Xi simply does not think along these lines: establish metaphysics first, spell out its implications in cosmology, and then find applications in ethics. For Aristotle, what is most important is to establish a theory, pure contemplation comes first, pragmatic considerations are only of secondary importance. Anyone familiar with Zhu Xi's way of thinking knows, however, that such a Greek approach to philosophy would have no appeal to him in his search for the Way. A Neo-Confucian philosopher almost always starts with an existential concern about how to calm the mind-heart, and Zhu Xi was no exception. He drifted along the paths of Buddhism and Daoism, and finally followed the advice of his teacher Li Dong to return to the Confucian Way. But he still needed years of struggle to find his own equilibrium and harmony as intimated in *The Doctrine of the Mean*. First he had to have a penetrating understanding of his own mind-heart, truly realizing his own nature: only then was he able to construct a philosophy of his own, which was based on the guiding principles laid out by Cheng Yi. For him, the moral nature inherent in us is composed of *li* (principle), the physical nature is composed of *zhi* (material force), which is also the origin of *qing* (feelings and emotions). Thus he advocates a tripartite division of *xin* (mind-heart), *xing* (nature), and *qing*, and also a dualistic metaphysics of *li* and *zhi*. Finally he had to answer his critics by asserting that even withered things have their natures. Thus, for Zhu Xi, moral discipline comes first, and theoretical, metaphysical reflections follow at a later stage, as the cosmic order unfolds only after one has reached a deeper knowledge of the self. Underlying his thought is still the unshakable faith in *tian-ren-he-yi* as taught in *The Book of Changes*.

Thus, superficially we can certainly say that Zhu Xi taught an organic view of the universe seemingly similar to the one taught by Aristotle in the West and inherited by Thomas Aquinas in the medieval ages. But comparative studies of philosophy would remain skin deep, if we fail to understand the different problematics at work under different cultural backgrounds. There is no intention on my part to teach a deterministic philosophy of history like Oswald Spengler.[28] But different philosophies developed in different cultures do have special characteristics of their own which must not be overlooked by those who conduct comparative studies of philosophy.

Occasionally misunderstanding of problematics could have dire consequences. For example, Wang Yang-ming was often said to have taught a subjective idealism. In fact epistemology was never his concern, and solipsism was not his problem. On the contrary Wang was convinced that everyone is endowed with *liang-zhi* (innate knowledge), such thought was first proposed by Mencius and then was further developed into a comprehensive philosophy by Wang with moral and ontological implications. Wang's starting point was Zhu Xi's teachings, the basis for civil service examinations in his days. Zhu interpreted *ge-wu* in *The Great Learning* to mean "investigation of things." As Zhu Xi firmly believed in *li-yi-fen-shu* (one principle, many manifestations), investigation of the principles in things for him would eventually lead to enlightenment of the self. But Wang Yang-ming made a sharp distinction between moral knowledge and empirical knowledge; the accumulation of the latter would be no help for moral awakening in the self. Thus Wang also started with an existential concern, but came up with very different answers. Zhu and Wang may be said to have offered two variations of the Confucian Way. There are irresolvable differences between the two approaches, but they share the same goal: to follow the Way of sages and worthies. What drive them are not concerns for epistemological or cosmological issues, even though their teachings do have rich moral and ontological implications. Both are in the Song-Ming Neo-Confucian tradition which sees the correlation between *sheng* (creativity) as taught in the *Yijing* (*The Book of Changes*) and *ren* (humanity) as taught by Confucius and Mencius: creativity on the cosmic level finds resonance in the individual with humanity as one's nature. And Wang declared that, "The great man regards Heaven and Earth and the myriad things as one body. He regards the world as one family and the country as one person."[29] Obviously Wang had never doubted the existence of Heaven, Earth, and myriad things in the world, what concerned him most was how to extend his mind-heart of *ren* to all. There is the same faith in *tian-ren-he-yi* (Heaven and humanity in union). What has this got to do with an epistemological solipsism associated with the British empiricist philosopher George Berkeley?

28. For a critique of Spengler's philosophy of history, see n. 15, Shu-hsien Liu, *Wen-hua-zhe-xue de shi-duan* [*An Introduction to the Philosophy of Culture*], 76–98.

29. Quoted in Liu, *Confucian Philosophy*, 215.

It is interesting to note that Wang came up with a new understanding of the "worlds" when he tried to do self-discipline by following Mencius to preserve the night air, as he said,

> In a single day a person experiences the entire course of history. Only he does not realize it. At night when the air is pure and clear, with nothing to be seen or heard, and without any thought or activity, one's spirit is calm and his heart at peace. This is the *world* of Fu-xi. At dawn one's spirit is bright and his vital power clear, and he is in harmony and at peace. This is the *world* of Emperors Yao and Shun. In the morning one meets people according to ceremonies, and one's disposition is in proper order. This is the *world* of the Three Dynasties. In the afternoon one's spirit and power gradually become dull and one is confused and troubled by things coming and going. This is the *world* of Spring and Autumn and the Warring States periods. As it gradually gets dark, all things go to rest and sleep. The atmosphere becomes silent and desolate. This is the *world* in which all people disappear and all things come to an end. If a student has confidence in his innate knowledge and is not disturbed by the vital force, he can always remain a person in the *world* of Fu-xi or even better. (Italics are mine.)[30]

The "worlds" here are not just something out there, but rather meaning-structures resulting from the interaction between the subject and the object. Wang Yang-ming not only gave a phenomenological description of the "worlds" like Heidegger, but urged us to make an existential decision to remain in the world of Fu-xi. It is amazing that Wang could have given expressions to such thought some four hundred years ahead of our time.

We have already mentioned the *Yijing* (*The Book of Changes*) several times now. It is without any doubt an important classic in the Confucian tradition. But we have to face very different questions in dealing with the document. There is not a general consensus on what it is all about. Some say that it is a book of divination; others think that it contains a neat mathematical system; still others regard it as a great work in philosophy. One is doomed to failure trying to resolve conflicts of such a magnitude. I had groped for years without getting an answer. Then it suddenly dawned on me that perhaps generations after generations of scholars had asked the wrong question. It is simply impossible to reduce it to a single theme and find a substantial unity, as it could be all these and also none of them at the same time.

First of all there is the difference between the Text and the Commentaries. They were not products of the same time. No one can be sure who the authors were, as they were put together at a much later age after a long evolution of hundreds of years. Influenced by Ernst Cassirer, I proposed to try a different approach: instead of looking for a single theme, it would be much more fruitful

30. Ibid., 219–20.

to identify different layers of meaning in the classic. This new strategy works wonders, as I was able to find four different kinds of symbolism as follows:

(1) mystical symbolism

(2) natural/rational symbolism

(3) cosmological symbolism

(4) moral/metaphysical symbolism

Thus, even though it is impossible to reduce them to one another, they have shown a kind of functional unity that cannot fail to escape our notice. All these symbolisms appear to be manifestations of certain forms of *tian-ren-he-yi* in one way or another.

In mystical symbolism, we find that there appears to be a mystical correlation between humanity and Heaven. It is true that the Text of the *Yijing* could be understood as a book of divination. Symbols of trigrams and hexagrams are believed to have a kind of mystical connection with natural and human events in the world. We can of course choose to demythologize them to some extent, but total demythologization is impossible, as life itself is a profound mystery.

In natural/rational symbolism, we find that there appears to be an epistemic correlation between the subject and the object. Logical reasoning and empirical generalization appear to work together to increase our knowledge of the world of nature. There is indeed a mathematical system implicit in the classic, as Leibniz acknowledged that he was inspired by it to develop a binary arithmetic, which is taken to be the basis for computers today. And there have been claims that many inventions are due to the correct reading of natural symbolism therein.

In cosmological symbolism, a comprehensive cosmology of *tai-ji* (the Great Ultimate) and *yin-yang* has been developed in the Commentaries of the classic. The great Zhu Xi inherited its organic view of the universe, which has exerted profound influence on the Chinese mind for hundreds of years. Instead of conquest of nature, the Chinese have opted to live in harmony with nature.

And finally, in moral/metaphysical symbolism, the insights of a moral metaphysics are transmitted to posterity and have become the core of the Neo-Confucian tradition. Starting from one's mind-heart and nature, one realizes humanity in the depth of one's being and is able to partake in the creativity of Heaven. According to Professor Mou Zong-san, Kant can only formulate the metaphysics of morals, and take freedom of the will as a postulate of practical reason. But *liang-zhi* for Mencius as well as Wang Yang-ming is a presence.[31]

31. Mou inherited this view from his teacher Xiong Shi-li, see Shu-hsien Liu, "Postwar Neo-Confucian Philosophy: Its Development and Issues," *Religious Issues and Interreligious Dialogues*, see n. 18, 288–89.

For Song-Ming Neo-Confucian philosophers, the Principle is one while manifestations (principles) are many, and the dictum *li-yi-fen-shu* may be illustrated by the metaphor: the same moon shines over thousands of rivers. Cassirer's idea of functional unity certainly helps to provide novel creative interpretation for this dictum and enables us to realize its contemporary significance.

Only recently I have just completed a study on the formation of a philosophy of time and history through the *Yijing*.[32] I have chosen to discuss five aspects of the philosophy of time and history implicit in the *Yijing*:

(1) the idea of *yao-wei* (position of component lines)

(2) the idea of *shi-zhong* (timeliness)

(3) the interdependence between immanence and transcendence

(4) the interdependence between subjectivity and objectivity

(5) a dialectics without definite programs.

I chose to study the philosophical implications of the classic, as it has profoundly influenced the Chinese way of thinking. The idea of *yao-wei* implies the idea of *shi-wei* (time and position), which means that the Chinese take time and space as a continuum and refuse to separate the two. By the same token, they also refuse to separate fact and value, immanence and transcendence, subjectivity and objectivity. This is not the place for me to elaborate on these issues. But I do want to say more about the dialectics without definite programs implicit in the classic.

As the *Yijing* works on the principle of unity of opposites, in appearance such a dialectics may be compared to Hegelian or Marxist dialectics in the West. But I find substantial differences that mark Chinese dialectics off from Western dialectics. The former is much more fluid, and also open-ended in nature, while the latter follows much more strict rules, and has a definite end in view. For example, the Hegelian dialectics drives toward the realization of Absolute Spirit, and the Marxist turns it upside down and drives toward the realization of a Marxist utopia on earth. Perhaps both are inadvertently influenced by their Christian heritage that history drives toward a definite goal to face the Judgment Day. But the Chinese dialectics found in the *Yijing* is a dialectics without definite programs. It offers us a wisdom tradition, but not science as claimed by Hegel and Marx. It observes the rise and fall of empires and offers reasons to explain why such is the case. When leaders follow the guidance of the Way of Heaven to allow creative forces at work and individual natures fulfilled, then we have a peaceful and prosperous world. While tyrants

32. The paper was presented at the International Conference on the Notion of Time in Chinese Historical Thinking held from May 26 to 28, 2000 in Taipei.

and evil ministers work against the Way of Heaven and cause human miseries and natural disasters, their days are numbered and will be denounced by posterity. History has its high and low points, but it does not have a definite goal, let alone an end. The arrangement of the sixty-four hexagrams is indeed illuminating. Hexagram No. 63 is entitled: "Already-accomplished." This is, of course, not the end of the story, as Hexagram No. 64 is entitled: "Not-yet-accomplished." Apparently it is the end of one cycle in anticipation of a new cycle. Does the *Yijing* teach a cyclic philosophy then? Yes, and also no. As the arrangement of the hexagrams goes by circles, in that sense it appears to have taught a cyclic view. But the Chinese value the content much more than form, each cycle has new content and must not be seen as a mere repetition of the past or going by circles. Should we say spiral then? Yes and no again. When we learn from the past, certainly there are chances for us to scale new highs. In that sense there is a spiral movement upward. But there is no guarantee that history always moves toward a bright future. There could be downward movements, even destructive moments. But there is no need to despair; after the severe winter, another spring will be in the offing. And even if the present world order is destroyed, another world order will emerge in the future. So history is both predictable and beyond prediction. Anyhow it is not deterministic. Our wisdom or folly will determine whether it would go upward or downward, and it also pays for us to learn how to cope with both upward and downward movements, as they often turn to the opposite before we even realize it. To conclude, *yi* has been understood to have three meanings: *bian-yi* (change), *bu-yi* (no-change), and *zhou-yi* (comprehensive way of change) since the Han dynasty. It is by understanding the perspective of change and its opposite that we may have a comprehensive understanding of the way of change which would help us to act according to different times and circumstances accordingly. It seems to be a disadvantage for *yi* to be characterized as falling short of the ideal of a science. But such a "shortcoming" actually turns to its advantage: while the Hegelian and Marxist dialectics are later denounced as pseudo-sciences which are outdated products of the nineteenth century, *yi* still has attraction today not only for the Chinese, but for the whole world as well.

This brings us to the current situation. We do not intend to say that everything is just fine with the Chinese tradition. Focusing on the characteristics and strengths of this tradition does not mean that there are no serious limitations or even shortcomings in this tradition. For one thing, as has been pointed out by Liang Shu-ming, the development of Chinese culture appears to be too precocious. That explains why it has not been able to develop science and technology like in the West and enter into the modern age.[33] There is a lot to catch up with, and we are still in the process of modernizing ourselves. But

33. See Liang Shu-ming, *Zhong-kuo wen-hua yao-yi* [*Essentials of the Chinese Culture*] (Taipei: Cheng-zhong, 1963), 251-303.

after the two World Wars, and especially after the Korean War and the Vietnamese War, the mighty West, including even America, the only superpower in the world today, suddenly realized that history does not always proceed in a linear progressive way. Even though no one knows exactly what the term "postmodern" means, it appears that we are entering into a new age in consciousness. Now we find that the progress of science and the expansion of business do not always bring us positive results: the affluent society will not last forever, the resources on earth are very limited, and we still need to learn to live peacefully together. Under such circumstances various traditions are no longer seen as something just outdated, but rather as something we must try our best to preserve for the experiences and the wisdom. The Confucian tradition certainly has a great deal to offer. Today we are facing the strange situation that what is new could be really old, and what is old is truly new. One important development in recent years was that the Parliament of the World's Religions held in 1993 at Chicago issued the Declaration toward a Global Ethic subscribed to by virtually all the important religious groups and their representatives in the world.[34] This is almost like a miracle. As Confucianism is not an organized religion, and there was no Confucian scholar present in the parliament, no Confucian representative put a signature on the document. But a copy of the declaration was sent to me immediately after its publication, and my response was published in a volume that commemorated the fiftieth anniversary of the United Nations.[35]

In March 1997, the UNESCO (the United Nations Educational, Scientific and Cultural Organization) started its Universal Ethics Project. Twelve philosophers from different areas and traditions gathered in Paris in March to discuss the feasibility of drafting a Universal Ethics Declaration to be considered by the UN. I was the only one from the Far East and spoke from a Confucian perspective. Then in December about thirty philosophers from all over the world gathered in Naples in December to discuss related issues. The majority opinion was that it was still not the time and occasion to issue a declaration of such a nature. Even though it is somewhat a disappointment that a declaration with emphasis on responsibilities would not have a chance to be endorsed by the UN to supplement the Declaration on Human Rights at its Fiftieth Anniversary, the heated discussions and debates were a learning experience for all of us. And we had concentrated on methodological matters. Everyone agreed that should there be a document on Universal Ethics, a minimalist approach had to be adopted, as no philosophers would agree on a well-developed ethical theory. But just how minimal is the issue in question.

34. Hans Küng and Karl-Josef Kuschel, ed., *A Global Ethic: The Declaration of the Parliament of the World's Religions* (London: SCM Press, 1993), hereafter cited as Küng, *Global Ethic*.

35. Shu-hsien Liu, "Global Ethic—A Confucian Response," in Hans Küng, ed., *Yes to a Global Ethic* (London: SCM Press, 1996), 216–21.

It was under such circumstances that I offered my reflections on universal ethics from a contemporary Neo-Confucian perspective.[36] I find it impractical to follow an inductive approach by looking for common features of world ethics at the expense of differences. Either the goal cannot be accomplished, or what remains would be thin to the extent that it is practically meaningless. I believe one possible answer is by way of *li-yi-fen-shu*. On the level of manifestations there is no need to eliminate significant differences. For example, it is impossible to expect a Confucian scholar to agree with a Christian theologian on the understanding of God, the world, and human beings. But in every great religious tradition, there is the common concern for humanity, and also something like the Golden Rule. Each tradition must start from its own base and then reach out for the other traditions. In the Declaration of the Parliament of the World's Religions drafted by Küng and signed by representatives of other religions, four directives are listed as follows:

1. Commitment to a culture of non-violence and respect for life;

2. Commitment to a culture of solidarity and a just economic order;

3. Commitment to a culture of tolerance and a life of truthfulness;

4. Commitment to a culture of equal rights and partnership between men and women.[37]

Obviously these were based on a new interpretation of the four moral Commandments of the Biblical tradition. But they also coincide with the four basic precepts of Buddhism: do not kill, do not steal, do not commit adultery, and do not lie (the other precept: do not drink liquors). It has long been observed that these Buddhist precepts coincide with the Five Constant Virtues (*wu-chang*) of the Confucian tradition: *ren* (humanity), *yi* (righteousnes), *li* (propriety), *zhi* (wisdom), *xin* (trustworthiness). Admittedly, the doctrine of Three Bonds (*san-gang*) between the ruler and the minister, the father and the son, the husband and the wife promoted by political Confucianism since the Han dynasty is totally outmoded today. The emphasis on a one-way relationship resulting from the emphasis on loyalty, filial piety, and subservience actually deviates from the demand for rectification of names taught by Confucius and Mencius, which requires reciprocity among all parties.[38] But I see no reason why the Five Constant Virtues cannot be given a new interpretation like what

36. Shu-hsien Liu, "Reflections on Approaches to Universal Ethics from a Contemporary Neo-Confucian Perspective," presented at the Second Meeting of the UNESCO Universal Ethics project, held at Naples on December 1–4, 1997. The article is published in Leonald Swidler, ed., *For All Life: Toward a Universal Declaration of a Global Ethic* (Ashland, Oregon: White Cloud Press, 1999), 154–71.

37. Küng, *Global Ethic*, 24–36.

38. Liu, *Confucian Philosophy*, 108–9.

Küng did to the Commandments supposedly handed down by Moses. And *zhi* (wisdom), though not formulated as a directive, is implicit in Küng's approach, as he also advocates our commitment to Truth. Today's situation is, of course, totally different from the past. The world has turned into a global village with pluralistic traditions living as close neighbors. We just cannot afford to be hostile toward one another. Surely we cannot start with *li-yi* (One Principle) at the top, as we fully realize that no one individual or tradition can claim to possess the Truth, which cannot be fully captured by our concepts and expressions. We have no choice but to start from *fen-shu* (many manifestations) with the realization that each one of us has at best only a limited horizon, which has nevertheless a tendency to forever transcend itself. We are not happy with relativism, which is a self-defeating position. It seems advisable to endorse something that finds manifestations in practically all the religious traditions in the world, such as *humanum* (humanity) as well as creativity as our regulative principle and to seek a kind of functional unity as suggested by Cassirer. Nurtured in the Chinese tradition, I feel philosophers today tend to be arm-chaired academics with too much emphasis on scholarship and critical reflections without the sense of urgency and courage to face the problems of the real world. I would rather side with open-minded religious leaders to search for a way for us to live harmoniously together with one another and with the world. There is the urgent need to transform our consciousness, which happens to be emphasized by the Neo-Confucian tradition. Surely there is no need for us with very different backgrounds to agree on details. But we must concur that we each have to work hard to change our attitude so that, deep down in our consciousness, we really have the commitment to honor humanity within the self and others, and yearn for peace and harmony throughout the world. These may still appear to be empty words. But unless the fundamental attitude is changed, how can the enmity between, say the French and the Germans, ever be resolved? The same would apply to the situations in North Ireland, Palestine and Israel, India and Pakistan, Mainland China and Taiwan, and so on. We can still only follow Confucius's example just to work hard and hope for the best, which seems to be impossible at the present moment, with the realization that anything better we cannot do.

I have used five instances to show how a methodology which combines philosophical analysis and hermeneutics works to explicate meanings implicit in Chinese philosophy, to conduct comparative studies of philosophy, and to solve philosophical problems we have to face today. It appears to be pretentious for me to refer to my own works for illustration. But Chinese philosophy, especially the Confucian tradition, can never separate its messages from personal realization in the self. Of course, my ultimate commitment to Confucian spirituality does not exempt my views or claims from criticisms or controversies, they must be subject to rigorous examination from the perspective of solid scholarship. But I hope scholars may learn from both my findings and the

mistakes I committed in the process of searching for the meanings and truths of this tradition. Finally I must say that I do agree with the Western, especially the Socratic, tradition that takes philosophy as philosophizing, and believe that only through the merging of horizons may we open up the opportunities for the future of world philosophy.

The Import of Analysis in Classical China— A Pragmatic Appraisal

David L. Hall

1. Pragmatism, Historicism, Ethnocentrism

I will argue that the principal conditioning features characterizing a formal method of analysis were of only peripheral interest to those individuals most influential in the development of classical Chinese culture. As a consequence, one of the more important of the tools of intellectual inquiry within Anglo-European intellectual culture remained essentially unarticulated within the Chinese tradition. I wish to correlate this claim with another that asserts the effective absence in the classical tradition of the primary ontological construct grounding the method of physical analysis—namely, the model of the *atom*.[1]

Much of what I shall be saying, at least in its main outlines, will not be controversial to many comparativists. The principal contribution of my remarks is likely to be found in the comparative method I shall employ. A significant portion of this essay, therefore, will be given over to the discussion of methodological issues. These issues will be focused through a discussion of three perspectives presupposed by my comparative method—namely, *pragmatism, historicism,* and *ethnocentrism.*

For the pragmatist, ideas are to be understood *problematically* and *consequentially*—that is, from the perspective of the problems that generate them and the "consequences" that stamp them with meaning. To consider ideas detached from their generating problems and practical consequences is most *un*informative.

1. Many of the arguments of this work are discussed in greater detail in my previous works, principally *The Uncertain Phoenix—Adventures Toward a Post-Cultural Sensibility* (New York: Fordham University Press, 1982), *Eros and Irony—A Prelude to Philosophical Anarchism* (Albany, N.Y.: SUNY Press, 1982), *Richard Rorty—Prophet and Poet of the New Pragmatism* (Albany: SUNY Press, 1994), as well as in the following books written with Roger Ames: *Anticipating China—Thinking Through the Narratives of Chinese and Western Culture* (Albany, N.Y.: SUNY Press, 1996) and *Thinking From the Han—Self, Truth and Transcendence in China and the West* (Albany, N.Y.: SUNY Press, 1998). See also our articles on *"You/wu"* and *"Qi"* in the recently published *Routledge Encyclopedia of Philosophy* (London: Routledge, 1998).

Cultures and their languages are conditioned by "vagueness." Ideas, beliefs, and theories are objectively vague in the sense that they are open to rich and diverse interpretations.[2] Thus, even if we were to discover within the rich inventory of Chinese culture what appear to us to be all of the elements of an analytic method, we would not—merely on those grounds—be able to say that such a method in fact existed. For to detach an idea from its most important consequences is to separate it from its import. If we can't identify the problems that generated an idea or belief, which we are comparing to another, and some of the important consequences attaching to that idea, we are in no position to say that the ideas have the same *meaning*.[3]

My point is that it is perfectly possible for Western philosophers to rummage through classical Chinese texts and discover, for example, what appear to be ideas of conceptual and physical divisibility, discreteness, and atomicity. If, however, these ideas were not operationalized in a manner similar to their Western counterparts, it would make little pragmatic sense to say they were the same or similar ideas. It would make even less sense to say that their presence was an indication that the classical Chinese possessed an "analytic method."[4]

When Christoph Harbsmeier claims that "the question of whether rationality developed among the Chinese is entirely separate from the question whether the ways of speaking of the Chinese do or do not involve what *we can recognize* [my italics] as logical trains of thought,"[5] I take it he is making a pragmatic point. The fact that we (from the perspective of a culture importantly shaped by logical reasoning) can recognize elements of formal logical reasoning does not mean that the Chinese creators and interpreters of the language recognized those elements as such. The only way of seeing if that might be so is to look to the manner in which those elements were employed and the consequences of their employment.

I do not wish to overstate my case. The difficulties involved in the development of a formal analytic method in China may well be mitigated somewhat by recourse to "proto-" or "quasi-" analytic thinkers such as Gongsun Long and the later Mohists. Nonetheless, this easement may turn out to be not all that substantial since, absent the ontological assumptions that have supported the analytic methods in the West, there may not be an easy path from, for example, Mohist logical analysis to the full-fledged analytic method.

2. The technical sense of the term "vague" derives from C. S. Peirce.

3. Suppose a culture whose members placed what we recognize as wheels on their children's toys, but didn't employ them in any other fashion. (This has, in fact, been claimed of the ancient Mayans.) To say of that people that they had "the technology of the wheel" is simply an inaccurate statement.

4. Discussions of questions such as "Why no science in China?" or "Did the Chinese possess a concept or theory of 'truth'?" are all too often rendered banal by a formalist or intellectualist bias that leads to the intercultural comparisons of ideas detached from their problematic contexts.

5. Christoph Harbsmeier, *Science and Civilisation in China*, vol 7.1 *Language and Logic* (Cambridge: Cambridge University Press, 1998), 261.

One cannot, after all, simply paste atomistic assumptions on Mohist grammatical articulations in order to produce an analytic method.[6]

The pragmatic assumption that ideas are nothing more or less than the problems that generate them and the consequences that follow from them commits one to the perspective of radical historicism. Radical historicism is, in fact, a species of pragmatism that enjoins us to apply with rigorous consistency the principle that *praxis* precedes *theoria*. This is but to say that ideas originate as responses to problematic situations. Such responses are explanations, interpretations, technical resolutions, and so forth. Thus, intellectual operations are *transactions* that communicate between the problematic situation and the means of resolving it.

To the extent that significant problematic situations are appreciably distinct among alternative human societies, the intellectual inventories must themselves be expected to manifest important differences. Alternatively, important differences in intellectual inventories signal the likelihood of differences in the problematic situations from which the inventories arose.

The differing positions with regard to the method of analysis in the two cultures under consideration have led Western thinkers to err in either of two ways in their assessment of Chinese texts: Either (1) these texts are (chauvinistically) deemed "nonscientific" or "nonphilosophical" by analytic thinkers, or (2) their character and meaning are distorted by those in the Western tradition who otherwise appreciate these texts but who lack a developed (nonanalytic) vocabulary permitting coherent articulation of them.

Chinese translators and interpreters of Western texts are presented with a similar challenge: Without access to a formal analytic method, Western sources created and/or shaped by that method are often mistranslated and/or misconstrued. Cultural chauvinism operates from the Chinese side as well. Chinese criticisms of the "materialism" and "abstract individualism" of the West are predicated upon the implicit judgment that atomistic ontologies have dehumanizing social implications.

6. Even were we to claim that analytic method does not require ontological assumptions, the Mohists might not give as much support in the development of such a method as might be first thought. As we shall see, Western understandings of discreteness require the notion of disjunctive relations of "p" and "not-p"—theoretical reflections of the being/not-being (ontological) disjunction. The principal aim of the Mohist, however, was not the production of disjunctive propositions as a means of defending their truth or falsity. It was, as Angus Graham has argued (see his *Later Mohist Ethics, Science and Logic* [Hong Kong: The Chinese University Press, 1978] *passim*) to produce a discourse that was protected from the expression of incoherent or unproductive analogies. Many of the discussions found in later Mohist thought as expressed in *Names and Objects* comes close to what we in the West would recognize as rational analysis. But in Later Mohist philosophy, discourse, and logical argumentation remained distinct. Neither in the part of *Names and Objects* dedicated to discourse nor in that concerned with argumentation, is the Mohist interested in establishing logical forms. Without these forms, analysis in any strict sense is not possible. And, again, merely pasting the truth-functional, disjunctive logic onto Mohist "logic" would render that thought seriously incoherent.

There are many other complicating factors implicit in the apologetic context shaping the arguments of Chinese and Westerners with respect to the importance of analysis. One factor concerns the manner in which the meta-histories of the intellectual cultures of China and the Western World are themselves determined by the contrasting assessments of the notions of continuity and discreteness. The pronounced theoretic pluralism of the West contrasts dramatically with the far greater degree of intellectual commonality in China manifested in the Han Confucian synthesis, and in the subsequent history of Neo-Confucianism.

The plurality of ontologies in the West, expressed as self-contained semantic contexts, is itself a function of the application of the analytic bias at the meta-level. Subsequently, I will briefly discuss the four primary semantic contexts informing Anglo-European intellectual culture: Materialism, Formalism, Organic Naturalism, and Volitionalism. At this juncture, I merely wish to call attention to the fact that the discreteness and discontinuity of closed theoretical systems are rooted in the same analytic framework as are other expressions of the analytic bias—from the concept of the physical atom to the affirmation of individual autonomy in liberal democratic theory.

I would argue that Chinese intellectual culture, though it has clearly manifested a pluralist impulse at periods such as that of the Hundred Schools, is pressed by its principal historical dynamics to affirm the centrality of continuity. The familiar resort in Confucian and Daoist texts to vague and allusive language is expressive of the dominant strain of the classical Chinese cultural sensibility. Furthermore, the early submergence of analogues to the analytic, dialectical, and sophistic tendencies of thought represented by the Mohists, Hui Shih, Gongsun Long, and so forth, suggests that these proponents of a (qualified) discreteness were not addressing what came to be considered the most crucial of the problems advertising the cultural dominant of classical China.

The final presupposition of my comparative method I shall discuss is that of "ethnocentrism."[7] A pragmatic and historicist perspective entails the endorsement of a species of ethnocentrism requiring individuals to begin any act of understanding from where they concretely are—namely, from within the contexts of meanings and values expressed in their native cultural sensibility. This is an eminently sensible requirement unless one believes that cultural development possesses some transcendental character. Further, ethnocentrism is pernicious only if one refuses to appreciate alternative ethnocentrically grounded beliefs, to engage them in a responsible manner, and to be open to having one's beliefs broadened or transformed.

7. I have discussed the relations of ethnocentrism and comparative method in greater detail in my *Richard Rorty*, op. cit., 174–83. See Rorty's "On Ethnocentrism—A Reply to Clifford Geertz" in *Philosophical Papers*, vol. 2 (Cambridge: Cambridge University Press, 1990), 203–10.

Many Western intellectuals would be horrified by such a candid confession of ethnocentric bias as I have just made. But that response would itself be an ethnocentric one, predicated upon a belief in absolute principles, or universal canons of Reason, or a common human nature, or the necessity of shared cultural values, and so forth. *Universalism* is the fundamental expression of modern Western ethnocentrism. One of the happy consequences of Anglo-European engagements with the Non-Western world is that they have helped to influence a (admittedly fitful) transition away from the ethnocentric absolutism of Modernity and toward the pluralism of the so-called Postmodern Age.

An account of the character of theoretical engagements between China and the West may provide some insight into the importance of understanding ethnocentric bias.

First-generation interpretations of Classical Chinese thought by Anglo-Europeans presumed theological, philosophical, and scientific perspectives that supported universalist interpretations. In Asian/Western encounters, Western philosophers and theologians frequently employed abstract notions such as "God," "the Absolute, " "Mind," "Reason," and so forth, to interpret Chinese sensibilities. *Dao* was often rendered "God" or "the Absolute;" *xin* was translated as "Mind," and *li* as "Reason." The assumption was that these and many other metaphysical and cosmological categories—precisely because of their presumed metaphysical or cosmological status—applied always and everywhere.

A second stage of comparative thought, now in its initial stages, was born with the recognition on the part of some comparativists that such uncritically ethnocentric translations simply won't work. This recognition is in part driven by the discovery that, despite many commonalities, the Chinese were often concerned with quite different problems and challenges than were Anglo-Europeans during the important phases of their cultural development.

Recently, there has been a serious attempt on the part of some comparativists to search for alternative notions that better serve the ends of translation. This search proceeds, of course, within the readiest available resource—namely, one's own cultural experience. Ethnocentrism has not been transcended, but *deepened*. Research into one's own cultural milieu often highlights elements, in both the cultural past and present, that have been largely de-emphasized or ignored. It is these "unsown seeds" and "discarded scraps" that finally stimulate one to articulate more responsibly the otherness of an alien culture.

Comparative Asian/Western philosophy has begun, somewhat tentatively to be sure, to enter this second phase of intercultural comparison. Unfortunately, the promise of comparative Chinese/Western thought is threatened by the fact that the majority of Western sinologists are still working under the illusion that their expertise in Chinese language and culture equips them to translate classical Chinese texts into Western languages. But, in addi-

tion to some understanding of both the source and target languages, it is necessary that one have a grasp of the relevant technical vocabularies, as well. For example, the sinologist must either have philosophical training, or collaborate with one so trained, if he or she is to do justice to Chinese "philosophical" texts.[8]

2. Contrasting Problematics

I shall now briefly contrast the developments of Ancient Chinese and Greek cultures in terms of two contrasting problematics—two manners in which the character of thought is shaped at the most inclusive and pervasive levels.[9] This will set the stage for an assessment of the contrasting perspectives of these two cultures on notions allied to the method of philosophical analysis.

The Greek, and subsequent Anglo-European, cultures developed from a cosmogonic tradition that presumed the existence of a single-ordered world. Classical Chinese culture, on the other hand, did not presuppose a world having formal unity. A fundamental contrast, then, between Chinese and Western thought, reflected in the dominant strands of the two classical cultures, is that between worlds construed, on the one hand, as a Cosmos and, alternatively, as "the ten thousand things" (*wan wu*)."

In philosophical language, this contrast is an expression of the fact that Western thought had its origins in ontological questions while the classical Chinese tradition is primarily phenomenological in the sense that it accepts the world of experience unmediated by appeal to some presumed ontological ground. The organization of the phenomenological world is through correlative operations that relate by analogical classifications rather than by appeal to essences, categories, or natural kinds.

Presuming that the more primitive intuition, or more pervasive experience, is that of phenomenological process, change, and becoming, the Chinese tradition may be said to employ the *First* Problematic. The *Second* Problematic of the Western tradition is, as we shall see, associated with Being as unchanging ground.

8. My historicism—and ethnocentrism—run deep enough to lead me to problematize even the notion of the terms "philosophy" and "philosophical" in comparative contexts. In a real sense the term must be used advisedly with respect to Chinese thought. A blithe assumption that the Chinese have a "philosophical tradition" has led many who define "philosophy" in essentially Western terms to conclude that if the Chinese are doing philosophy, they are not doing it very well! For the purposes of our present discussion, the terms "philosophy" and "philosophical" must be operationalized along the following lines: I shall understand by "Chinese philosophical texts" any works whose translation into Western languages requires recourse to recognizably philosophical terminology.

9. The notion of First- and Second-Problematic thinking was first introduced in my *Eros and Irony*, op. cit. (114–23 and *passim*) as a means of contrasting the "one world"/"many worlds" cosmologies of the Ancient Greek philosophers. Subsequently Roger Ames and I have employed this distinction with some success in our collaborative works cited in footnote 1.

It is necessary to distinguish between a "problematic" and the specific "problems" occasioning the construction of the problematic. For these contrasting perspectives are certainly not *sui generis;* they arise within particular historical circumstances.

The First Problematic employs explanations accounting for the particularities of the phenomenal world. The Second Problematic provides rational or logical explanations of ontic and ontological characteristics. The different "problems" or challenges that generated these contrasting problematics are not easily discoverable. That is to say, it is not at all clear which of many possible cultural determinants may be responsible for shaping any given set of intellectual expressions. Though it is reasonably clear to most comparative thinkers that classical Western philosophy is dominated by notions of Being, substance, and permanence while Chinese thinkers are more interested in notions of becoming, process, and change, the specific character of the problems that led to these alternative priorities is not altogether clear.

We are in a better position to characterize some of the consequences of the contrasting problematics in terms of contrasting cultural formations than we are in discovering the fundamental problems leading to these problematics. Nonetheless, my argument may be somewhat more persuasive if I offer at least a *plausible* account of distinctive problems that occasioned the contrasting problematics of China and the Western world. This will involve me in a brief discussion of the contrast between Chinese and Anglo-European explanatory languages.

I wish to argue that the relative degree of ethnic and linguistic homogeneity during the period of preclassical China as opposed to the high degree of heterogeneity in the Ancient Hebraic, Greek, and Roman worlds was a significant factor in the development of the contrasting "technical" languages. Equitable interactions among different belief systems present problems of communication that occasion the use of highly abstract discourse. General or universal notions are stratagems for accommodation. General principles and categories sublate differences and disagreements at a lower level into agreement at a more abstract level.

Theoretical development in the classical Greek world was often a function of dialectical processes in which one theorist engaged another by attempting to create a more general vision. General concepts render theoretical conflict both inevitable and acceptable: Inevitable because of the very nature of dialectical interchange; acceptable because disagreement in theory may be distinguished from practical conflict. In China the relative degree of ethnic and linguistic homogeneity allowed intellectual leaders to be concerned with the construction of institutions that directly impinged upon the creation of social harmony. In fact, the Han dynasty victory of Confucianism was in part predicated upon a recognition that the ideological conflicts of the Hundred Schools were obstacles to realizing the way (*dao*) of social harmony.

It is often claimed that the Westerner looked beyond the concerns of this mundane world and went venturing after transcendent Truths while the Chinese, unconcerned with abstract truth, were obsessed with discovering the *dao*. There is some relevance to this claim, surely, but the simple contrast of Truth-Seekers and Way-Seekers masks the reality that both Westerners and Chinese were, and are, principally concerned with social harmony. It is just that the distinctive historical circumstances of the two cultures required rather different strategies to realize that harmony.[10]

The Western obsession with Truth is to be contrasted with an absence of any important speculations concerning the nature of truth among the Chinese. It is certainly not the case that the Chinese are unconcerned with "the fact of the matter;" it is just that they did not, as did we in the West, address second-order questions about whether the "fact" was "true."

The interest in formal logic in classical Greek philosophy led to a concern for the truth of nonfactual issues such as tautologies. The belief in the unreliability of sense experience occasioned by thinkers such as Parmenides, Zeno, and the subsequent Platonic tradition generated an Appearance/Reality distinction leading to questions about the "truth" of appearances. This belief in unreliability of appearances was ramified by the pluralism of interpretations. That pluralism was, as I have said, partly a result of ethnic and linguistic heterogeneity characterizing the ancient Greek world. The fact/fiction distinction, an aspect of the Appearance/Reality contrast, led to questions about the "truth" of art and poetry, and so forth.

Given such circumstances, the development of "theories" of Truth was inevitable. Indeed, once a Reality/Appearance distinction is made, Truth becomes easily construed as the conformation of the way things appear with the way things truly are.

The orthodoxy of the West is to be contrasted with the ortho-*praxy* of China in which common rituals (*li*) are substituted for common beliefs. Whatever the other reasons for the Western concern for truth, it is plausible to assume that the maintenance of orthodoxy—shared beliefs—can be an effective mechanism for insuring social harmony in a pluralistic society.

In the West, patterned from its beginnings by ethnic and linguistic heterogeneity, accession to abstract principles and doctrines could mask real ideological tensions, while the theory/practice dichotomy could insure that differences in theory would not always spill over into practice. For example, the idea of "God" as an absolute Being provided an object of belief and obedience that could mean many things to many different individuals and still guarantee at least a minimum of social consensus. In China, on the other hand, the relatively greater degree of ethnic and linguistic homogeneity supported the construction of common rituals requiring a minimum of conscious articulation. This,

10. See *Thinking From the Han*, op. cit., 103–7 for a more complete discussion of this point.

along with the ethnically grounded appeal to "Han identity" has served the Chinese as the means of maintaining social harmony to this present day.

My contention is that the first and second problematics, as they worked themselves out in the contrasting Chinese and Western traditions, help to account for some rather dramatic cultural contrasts. One ought expect that some understanding of these problematics would be helpful in efforts to translate the sensibility of each culture into the language of the other.

3. Discreteness and Atomicity in the Classical West

From the beginning, Western thinkers have been intoxicated by the idea of "Being." Metaphysical conceptions of Being are generally associated with the notion of *ground*. The relation of Being and beings then is thought to be that of indeterminate ground and determinate things. An allied notion is that of *permanence*. The ground of beings is unchanging, unalterable, noncorruptible. Change applies to the world of beings which themselves are understood in terms of the *imago* of permanence. The two principal notions allied with the concept of Being are, therefore, *ground* and *permanence*.

Of the four primary semantic contexts emergent in the Western world[11] — *formalism*, from Parmenides, Pythagoras, and Plato; *materialism*, from Leucippus and Democritus; *organic naturalism* from Aristotle, and *volitionalism* from the Sophists—each is generated from a question of the following sort: "What kinds of things are there?" The first three of these theoretical contexts express the dominant ontologies of Western thought. The Sophistic tradition is fundamentally *disontological*.

For Plato, there are ideas as mathematical patterns or forms; for Democritus, there are atoms swirling in empty space; for Aristotle, the world is comprised by organisms characterizable with respect to specific aims. For the disontological Sophists, the "world" is made up of human beliefs and judgments: "Man is the measure of all things, both of things that are that they are and of things that are not that they are not."[12]

The ontological tradition of classical Western thought is characterized by an Appearance/Reality contrast suggesting that the real constituents of the world serve to ground appearances, which are, as *mere appearances,* misleading and/or illusory. The ontological tradition of the Greek world is expressed in a number of theoretical manners, but there is a single characteristic shared by all varieties of ontology—namely, *Being* serves to ground the *beings* of the world.

In its function as ground, Being is the fundamental exemplification of *permanence*. That is, Being as ground is to be construed as *unchanging* and as

11. These Primary Semantic Contexts are discussed in some detail in *The Uncertain Phoenix,* op. cit., *passim,* and *Anticipating China,* op. cit., 102–4.

12. The Protagorean Principle.

at rest. The assumption of the dominant streams of ancient Greek ontological speculation is that changelessness and rest have priority over change and motion. The Greek preference for permanence and rest is best illustrated by appealing to the development of those mathematical and metaphysical speculations that led to the formalization of the idea of quantity. It is likewise the intuition of Being as unchanging, permanent, and at rest that allows for the construction of concepts, literal definitions, logical essences, natural kinds. In a world of process and change, classifications must be less formal—since reality is always outrunning concepts and categories.

The *locus classicus* for the understanding of being as permanent and unchanging comes from Parmenides. Parmenidean Being is one, eternal, and indivisible.

> But motionless in the limits of mighty bonds, it is without beginning or end, since coming into being and passing away have been driven far off, cast out by true belief. Remaining the same and in the same place, it lies in itself, and so abides firmly where it is. For strong Necessity holds it in the bonds of the limit which shuts it in on every side, because it is not right for what is to be incomplete. For it is not in need of anything, but not-being would stand in need of everything.[13]

Being has no beginning since Being cannot come into being either from nothing or from some other being. There is no nothing, nor is there any other being. Further, if there is only one indivisible Being, there can be no parts. Thus there are no elements that can move. And Being itself cannot move since motion requires space, or "nothing," to traverse.

The subsequent history of Parmenides's influence is in fact the history of Western philosophic speculation itself for, after Zeno's defense of Parmenides through the construction of his famous paradoxes of motion and change, every subsequent Greek thinker of any note constructed his philosophy in response to the Parmenidean challenge. We may see the direct influence of Parmenides and Zeno in the arguments of Empedocles and Anaxagoras defending pluralistic models of continuity, upon the Eternal Forms of Plato, and Aristotle's appeal to an Unmoved Mover.

Discreteness, defended by Plato through notions of mathematical pattern and logical definition, and by Aristotle through the functional articulation of distinctive ends defining separate organisms, was most dramatically affirmed by Leucippus and Democritus. These thinkers answered Zeno by positing "atoms" as physically indivisible (but mathematically divisible). For atoms to be distinct there must be something separating them. Thus the atomists asserted, in direct contradiction to Zeno, that there indeed was a Void. In addition,

13. Simplicius, *Phys.* 145.27 (DK 28 8, lines 34–36) in John M. Robinson, *Introduction to Early Greek Philosophy: The Chief Fragments and Ancient Testimony, with Connecting Commentary* (Boston: Houghton Mifflin, 1968).

Democritus defended motion by positing empty space through which atoms may move. Democritean atoms constitute myriad replicas of Parmenides's Being. Ironically enough, the foremost champion of continuity served as goad and inspiration for the principal founder of physical discreteness.

With the ad hoc construction of physical atoms, we arrive at the threshold of a fully articulated analytic method. Analysis is certainly conceivable without having recourse to physical atomism. Indeed, atomism presupposes the notion of conceptual analysis, but not vice versa. But the problems generating interest in analytic thinking within Western culture are principally associated with the at least implicit need for atomistic ontologies.

Both conceptual analysis and the presumption of physical atoms are occasioned by epistemological problems. Both Zeno's paradoxes and the Democritian atom were constructed to resolve problems associated with the unreliability of sense experience. And Zeno's conundrums were certainly not, as some have naively claimed, mere parlor recreations put to rest by Aristotle. As Bertrand Russell has argued, "Zeno's arguments, in some form, have afforded grounds for almost all the theories of space and time and infinity which have been constructed from his day to our own."[14] Infinity may be left to the logicians and mathematicians, but the nature of space and time are distinctly ontological issues. Thus it is most important to ally physical atomism and conceptual analysis in the full-fledged analytic method. Indeed, many of the most influential texts in Western philosophic and scientific literature must be understood as illustrations of such an alliance.

I shall conclude this section by summarizing certain of the assumptions grounding classical atomism:

1. Since, as Zeno's paradoxes of motion so cogently argue, appearances are not to be trusted, we must look for reality behind or beneath the appearances of everyday experience.

 1.1. If we are to meet Zeno's challenge, this search for the reality of things requires the conceptual exercise of breaking things down into discrete units (atoms) which must themselves be considered physically indivisible.

 1.2. The assertion that atoms are the final real things moves analysis beyond simply the conceptual realm to a method that, at least in principle, enjoins resort to physical analysis, as well.

2. Since atoms have no parts, they are permanent and unchanging.

 2.3. The Parmenidean opposition between Being and Not-being is, for the atomist, transformed into the opposition between permanence and change, or between being and becoming.

14. Cited in Wesley Salmon, *Zeno's Paradoxes* (New York: Bobbs-Merrill Co., Inc, 1970), 54.

2.11. Change and becoming are to be understood as the motions of permanent and unchanging things. That is, analysis breaks down complexes that are capable of becoming other complexes into things that do not become.

We are now in a position to look at the manner in which the classical Chinese contextualized the topics of discreteness and continuity. The primary value of making the following comparisons will be to point out some of the very real obstacles faced by the Chinese in developing a full-fledged analytic method. An implication of the discussion will be that there are, as well, real obstacles to Western efforts to deal responsibly with notions of change and becoming.

4. "Field" and "Focus" in Classical China

Our narrative of the transition from Parmenidean "Being" to Democritian "beings" is essentially a story of the effects of denying final reality to the world of human experience. For the ontological bias of the Second Problematic the Chinese substitute a distinctly phenomenological perspective. The disposition of the Chinese from the beginning to the present is highly inhospitable to fixed forms of asymmetrical relations such as is expressed by the relation of being and beings. The Chinese existential verb, *you*, "being," overlaps with the sense of "having" rather than the copula, and, therefore, *you*, "to be," means "to be present," "to be around," while *wu*, "not to be," means "not to be present, " "not to be around." This means that *wu* does not indicate strict opposition or contradiction, but *absence*. In classical Chinese philosophical discourse, the logical distinction between "not-p" and "non-p" is elided. Thus, the *you/wu* distinction suggests mere contrast in the sense of either the presence or absence of *x*, rather than an assertion of the existence or nonexistence of *x*.

Language that does not lead one to posit ontological difference between Being and beings, but only a difference between one being and another, suggests a decentered world whose centers and circumferences are always defined in an ad hoc manner. Such a world is not a Whole that can be divided into parts, nor are the beings discrete in any formal sense. The best model for understanding the Chinese "cosmos" is the "field/ focus" model. The ten thousand things are all potential foci in a pervasive field. Thus, in Chinese speculations, the relevant contrast is not between cosmological *whatness* and ontological *thatness*. Rather, it is a contrast between a given world construed from a singular perspective and the "cosmos" as the sum of all orders.

The Chinese understanding of the *you/wu* relationship has profound implications for the manner in which philosophic discourse is shaped throughout the Chinese tradition. Without recourse to the senses of Being associated with Western speculative philosophies, many of the beliefs deemed necessary conditions for philosophizing are simply not present. It may be plausibly argued

that the proper understanding of being in the Chinese tradition helps us to account for the fact that there is no real metaphysical tradition in China—if we mean by "metaphysics" anything like a general ontology (*ontologia generalis*) or a universal science of principles (*scientia universalis*). In fact, there is within the strictly Chinese philosophical tradition little interest in asking about what makes something real or why things exist.

In the absence of a sense of being as the ground of things, the act of understanding and articulating the sense of things—*daoli* (the grasp of the patternings [*li*] of *dao* [the ways of things])—cannot have ontic reference. The closest to our typical understanding of analytic reason is to be found in "seeking the *li*." *Wuli xue* in modern Chinese is "the investigation of the patterns of things and events"—what we term physics. Psychology is *xinli xue*—the investigation of the patterns of the heart-mind. In general, to be *he li*, to be "in accord with *li*," is to be reasonable or rational. There is no manner in which seeking the *li* could be called analysis in the sense of a search for the beings which constitute parts of a whole. One is not searching for "parts" but for *patterns*.

I have suggested that the apparent absence of an ontology of discrete objects or events in classical China is both a cause and a consequence of the absence of a copulative sense of "to be" in philosophical speculations. In the Western tradition, the notion of *Being* standing behind the beings of the world entails a Reality/Appearance distinction leading to the belief in essences and/ or natural kinds, to the development of univocal concepts, logical (connotative and denotative) definitions, and so forth. Commonsense intuitions of discrete things, which obviously exist in both classical Western and Chinese cultures, can't be precisely expressed without these motivations and means of developing formal definitions. Thus, in classical China—as opposed to the classical Western tradition in which discreteness and atomicity are important philosophical notions—continuity appears to rule over any sense of discreteness.

In the absence of a Western understanding of *Being*, one cannot expect to find what has come to be called, after Derrida, a "language of presence" in which Being in the form of essence is made present through the beings of the world. Another way of saying this is that there will be no Appearance/Reality distinction. The result will be that the world as it is humanly encountered, the phenomenal world, will be understood as the way things are. This world will be a world of process and change—a world of becoming rather than being. Such a world will be intuited in terms of continuity rather than discreteness. It will be a *field* focused by the items comprising it.

In China, the term most descriptive of the fundamental character of such a world is *qi*—a term that, at least since the Han cosmologists, has designated the fluid field of change that constitutes "the ten thousand things." *Qi* has been rendered rather awkwardly as matter/energy" or "psychophysical stuff." Perhaps the most appropriate translation, one that advertises the notion of continuity, is "energizing field." In the earlier texts, before the notion came to

be adapted to the speculative constructions of the Han "cosmologists," *qi* had a meaning close to that of the Greek *pneuma*—namely, "breath," or "animating fluid."

The reason for the problematic status of *qi* for the Westerner may be illustrated by the alternative careers of the notions of *qi* and *pneuma,* and their cognates in Chinese and Western cultures. Briefly, Western categories came to be associated with cosmological interpretations built up from discrete "parts," while *qi* and its related terms presuppose general notions of continuity. Thus, the tripartite soul developed by Plato is built up from Homeric understandings of alternative interpretations of the individual as living *(psyche)*, perceiving *(noos)*, and feeling *(thymos)*. These Homeric notions which Plato expressed in terms of thinking *(logistikon)*, acting *(thymoeides),* and feeling *(epithymetikon)* acknowledged a separation between the rational and nonrational aspects of the person, the latter coming to be identified with the material body. The majority of subsequent interpretations of the vital and spiritual character of things had to struggle with a physical/spiritual dichotomy. Thus, the animating principle was largely distinguishable from the animated things.

In China the animating fluid is conceptualized in terms of an *energy field*. This field not only pervades all things, but in some sense is the means or process of the constitution of all things. That is to say, there are no separable "things" to be animated; there is only the *qi* as field and its focal manifestations. During the period of the Han "cosmologists," the notions of *yin* and *yang* came to be used to characterize the dynamics of the transformations that constituted the field of *qi*.[15]

The energizing field, as the reality of things, precludes the existence of forms, or ideas, or categories, or principles, that presuppose "natural kinds." Thus, discriminations in the field of *qi* are made in terms of observed and conventionalized classifications associated with diurnal and seasonal changes, directions, colors, bodily functions, and so forth. Processes associated with these correlative classifications are then charted in accordance with the rhythms of the *yang* and *yin*—or *activity* and *receptivity.*

Qi does not serve as a *ground* of the appearance of the phenomenal world. *Qi* is the actual field focused by the things of the world. There is no ontological distinction between the field and its foci. Thus, the field/focus model contains no hint of an Appearance/Reality distinction. This is not surprising since, as

15. *Qi* is not necessarily the most primitive fundament. In the *Huainanzi*, we read: "The Way began in *xu* ("the tenuous") and transparent; the tenuous and transparent generated Space and Time; Space and Time generated *qi*." See A. C. Graham's discussion of this text in his *Studies in Chinese Philosophy and Philosophical Literature* (Albany, N.Y.: SUNY Press, 1990). According to Graham, *Xu* is to be understood as "the absence of shaped things." Some interpreters have compared its role to that of the primordial Chaos as emptiness—"the dark formless void" of Western cosmogonies. But it should be clear that "the absence of shaped things" does not entail a Void in the sense of "Not-being."

Jean Paul Redding has cogently argued,[16] the suspicion of sense experience that helped to generate the Reality/Appearance distinction in the classical West simply did not find expression among prominent Chinese thinkers of the classical period.

The dominance of the concept of being as *unchanging ground* has had serious consequences for the manner in which we in the West have been able to conceive motion, change, and becoming.[17] The centrality of the intuition of process and becoming in the Chinese tradition was equally influential. The disinterest in construing permanence in terms of discrete substances, essential features, natural kinds, and so forth has characterized Chinese thought since its inception.

In sum, the Western tradition was not disposed to think change while the Chinese tradition lacked interest in ontological permanence. This statement expresses much concerning the greatness and the limitations of each culture.

There was a time when the above paragraph might have served as the conclusion of an essay such as this one. That time has passed. Philosophical thought in both China and the Western world must be revised and supplemented sufficiently to allow for serious conversations between two cultures whose historical narratives have been distinctive enough to have created rather dramatically different intellectual and institutional expressions. Two ethnocentric peoples must reach within their own cultural resources for modes of understanding and expression that will allow them to reach outward toward one another with greater success.

16. Jean-Paul Redding, "Words for Atoms, Atoms for Words—Comparative Considerations on the Origins of Atomism in Ancient Greece and the Absence of Atomism in Ancient China," *passim* (unpublished paper, delivered at the conference on "Thinking Through Comparisons: Ancient Greece and China," University of Oregon, May 28-30, 1998).

17. One dramatic consequence of our having privileged the notion of *ontological ground* in the Western tradition is illustrated by the fact that one must turn to the "Dictionary Supplement" to the 1971 edition of the *Oxford English Dictionary* to find the initial entry of the word, "creativity." The OED entry contains three illustrations of the use of the term. One is from a literary critic (1875) and the other two are drawn from the writings of A. N. Whitehead (1926). Our Western disinterest in giving a proper name to processes yielding the spontaneous production of novelty is telling indeed. It is hardly an exaggeration to say that Whitehead's thinking, along with the twentieth-century "process" tradition allied with and partially emergent from it, has led to the introduction of an essentially *new* idea into the Western philosophical tradition— one that has been seriously misinterpreted by Western thinkers still dependent upon the ontological assumptions of the Second Problematic. Interestingly, the concept of "creativity" is currently being defended and elaborated by appeal to Chinese understandings of process, change, and becoming. In the Chinese philosophical inventory one finds terms such as *qi* (energizing field), *ziran* (spontaneous arising), *yi* (changing) which are most helpful in providing interpretations of our newly emergent concept of "creativity." For a wonderful example of an appeal to Chinese thought to defend process understandings of creativity against substantialist misconstruals, see John Berthrong's *Concerning Creativity—A Comparison of Chu Hsi, Whitehead, and Neville* (Albany, N.Y.: SUNY Press, 1998). That we in the West need help from China in understanding "creativity" is no more surprising to me than that the Chinese will need some assistance from us in developing a formal analytic method.

Chinese Philosophy and Semiotics

You-zheng Li

The term "Chinese Philosophy" (CP) is used for a modern discipline about ancient Chinese philosophy established during the twentieth century by modern Chinese philosophers and foreign sinological scholars through comparative studies of the Chinese humanistic classics and Western philosophy. At present, its composition and role is generally recognized not only in sinology but also in general philosophy. This discipline has become one of the pedagogical and academic professions in current academia, maintaining its established scholarly institutions and programs which, as in other disciplines, have created their own technical criteria and aims for scholarly activities. From a professional point of view, any questions concerning the CP can be raised and solved within its currently fixed academic framework. Nevertheless, the CP has recently aroused wider attention outside its professional field, and its intellectual value has been explored from some new angles beyond the conventional scope of discussion current in its own disciplinary framework. This paper attempts to reevaluate the intellectual potential of the CP from a semiotic perspective.

The current scholarship of the CP roughly consists of three major parts: the ontologico-metaphysical, the life-philosophical, and the ethical. Compared with their Western counterparts, the epistemological, scientific, and aesthetic sections of the CP seem relatively less inspiring. In the CP, more attention has been paid to the ontological-metaphysical aspects shaped by traditional Daoist and Buddhist philosophical speculations. This first part seems to be more easily communicated with, or more similar to, its Western counterpart, but the semantic-rhetoric divergence between the Chinese and Western philosophical traditions makes effective mutual communication really difficult. The second part draws upon philosophy and literature alike. But the Chinese life-philosophical texts sound more literary than philosophical. This literary Chinese life-philosophy has aroused wide interest among those Western readers who are not familiar with professional philosophy of any kind. The third part—Chinese ethics—has received the most attention from Western ethics scholars, who may find the Chinese ethical experience can be quite well appreciated from an empirical and realistic point of view, although its philosophizing seems less elaborated, compared with the Western.

A complete understanding of the CP is far from being a mere philosophical discussion; in fact it involves different aspects such as semantic organizations, social/scholarly institutions, scholars' motivations, intellectual condition of the audience, cultural structures, politico-historical contexts, and the traditional academic functions in Chinese history. Therefore, precisely speaking, "Chinese Philosophy" is not yet a really well-organized discipline within the current academic world. As is commonly said in China, "philosophy, history, and literature belong to one family." Moreover, the classifications of academic learning in Chinese and Western traditions are essentially divergent.[1] An adequate compositional comparison between Western and Chinese philosophies needs to include reference to the central epistemological structure of modern academic systems.

1. Chinese-Western Comparative Philosophical Studies

Reviewing the development of philosophy in China during this century, we find most Chinese philosophers have exhibited more interest in Western philosophy than in Chinese philosophy. If the term "Chinese philosophy" refers to all philosophical studies in China today, it will cover much more content than the CP, which is defined as a special modern discipline about ancient Chinese philosophy. The CP has indeed played an important role in modern studies of the traditional Chinese humanities at home and in Sinology, or Chinese studies, in the West. With different reasons and motives these two fields of the CP studies have communicated with each other closely for the past twenty years, and both are scholarly related to a new discipline—comparative philosophy. In a narrow sense, the modern content of the CP has been established with reference to the Western philosophical model. In a wider sense, however, following the development of Chinese-Western comparative studies, the theoretical part of the CP has always been reorganized with respect to its Western counterpart. Furthermore, both fields of the CP studies have been recently involved in the wider academic interaction with other scholarly branches as well.

On the whole, Chinese-Western comparative studies, including the philosophical ones, have been established on the traditional Western scholarly model,

1. Julia Ching pointed out, "One discovers Huang Tsung-hsi's inconsistencies, his moving from philosophical statements to classical allusions to polemical discussions, usually without any warning to the reader." See Tsung-hsi Huang, *The Records of Ming Scholars*, ed. by Julia Ching (Honolulu: University of Hawaii Press, 1987), 34. This shortcoming of Huang in philosophical composition is in fact a general tendency among many traditional Chinese "philosophers," including the theoretically more elaborated Song scholars—they were obviously weaker in logical construction. Another obvious shortcoming in their philosophical discourse is a fragmentary mode of thinking and writing which is represented by Zhu Xi's commentary style in his theoretical discourse. Like other Chinese philosophers, Zhu finished hardly any systematic writings.

especially its scientific part. That means that most Chinese scholars engaged in the field have already accepted the Western philosophical discipline to approach their own cultural heritage. In the Chinese intellectual history of the twentieth century there have been two divergent directions in studying the traditional Chinese cultural/academic history: the linguistico-historically directed (*yu-shi-pai*) and the philosophically or metaphysically directed (*xuan-xue-pai*) approaches. In essence, the linguistic-historical school involves not only the related special subjects in Chinese classics but also its methodology. For the traditional Chinese textual criticism (*kao-ju-xue*) seems to be in accord with the scientific spirit. Therefore, concerning the modern methodology in the CP, there has emerged a double confrontation in this comparative field: that between the scientific and the metaphysical, and that between the Chinese and the Western metaphysical. In a broader sense, the situation also exists in the present Chinese studies in the West; most sinological studies belong to the former type.

Chinese-Western comparative philosophy in the narrow sense thus has formed a special field involving more complicated backgrounds. This special field or discipline of comparative philosophy was first presented by the earlier New Confucianist philosophers of this century. Precisely speaking, we should not call those earlier studies genuine comparative research, for the involved comparative work consisted only of the reorganizing or reediting of the Chinese philosophical materials in terms of the Western terminological and disciplinary systems. More serious comparative studies were made later by the Chinese philosophers who belonged to the second generation of that school. Its typical trait was expressed in the tendency of combining the Western philosophy-disciplinary model and the Chinese metaphysical-ontological subject matter in a comparative framework. When the Chinese philosophers of the third generation of the school and others with a similar tendency have gotten trained and taught in the West, Hong Kong, and Taiwan, the comparative work has been internationally spread, making the new discipline of the CP further redefined in the West. The comparative studies, on the other hand, are still faced with the double confrontation: that between the Chinese and Western philosophical approaches and that between the Western-philosophical and Western interdisciplinary directions. With respect to the latest stage of these comparative philosophical studies, the difficulty could be made less severe if we can selectively deal with the content of the CP out of a practical purpose. Or, if we only consider how to promote our educational or academic programs according to the currently feasible standards, the actual situation itself can provide the workable criteria for increasing academic benefits of any kind by any acceptable means. The current volume does not belong to this kind of practical effort. Instead, we intend to reconsider the CP problems from a theoretical point of view in terms of the entire present-day humanistic-scholarly situation.

The contemporary efforts towards reinterpreting the traditional Chinese philosophy, either in China or in the West, is an attempt to reorganize the traditional Chinese philosophical history in terms of the Western academic framework, that is, to rearrange and reorder the original Chinese thoughts following the Western academic models. Thus, the reorganized Chinese philosophical textual materials may function as a sketchy representation of the related Western philosophical part. A typical example was presented by Mou Zong-san who, in reference to the Kantian conceptual system, still insists on the original Chinese way of reasoning.[2] For example, he put the Kantian and the Chinese parts into three stages of ethical reasoning—the intelligent, metaphysical, and humanist intuitive stages, attempting to find the similar metaphysical efforts in the Song ethical philosophy. For the most part, however, he only arranged different discussions of Chinese and Western philosophies in the same textual work, without forming a genuinely theoretical dialogue between the two. Nevertheless, Mou clearly maintained that "the bridge of the Chinese-Western philosophical communication should be based on Kantian philosophy."[3] Chinese and Western philosophies, in his opinion, tend to be in harmonious relationship.[4] This kind of work appears as a comparative theoretical analysis of the two philosophical systems, but in fact it is a mere coexistence of two separate demonstrative discourses in the same textual body. Talking about Song Neo-Confucianist philosophers, Wing-tsit Chan said, "The important thing to note now is that they put the whole Confucian system on a metaphysical foundation and a rational basis."[5] As a result, this development of Neo-Confucianism of the Song seems to provide an apparent reason for modern scholars to interpret the CP in terms of Western philosophy. In this way, if one finds something in Chinese texts metaphysically attractive, that might be mainly due to the general acceptance of the Western metaphysical model, which is indeed logically more persuasive. But, as a matter a fact, the metaphysical part of the CP is far from being logically commensurable with its Western counterpart. It is implied that what we obtain through reading such comparative discourse is basically similar to what we read purely in the original Chinese contexts; the added Western interpretations do not substantially increase our understanding of the related Chinese discourse, although there are certainly some instructive results helpful to our understanding of the original works. This is because the modern Chinese scholar with scientific common sense has a higher capability of performing the analyzing and synthesizing processes

2. Cf., Mou Zong-san, *Xin-ti yu xing-ti* [*Substance of Mind and Substance of Human Nature*] (Taipei: Cheng Zhong Book Co., 1991), 115–17.

3. Mou, 1985, xiv.

4. Ibid.

5. Chu Hsi and Lü Tsu-chien, *Reflection on Things at Hand*, trans. and noted by Wing-tsit Chan (New York: Columbia University Press, 1967), xviii.

which could more clearly represent the structure and function of the original discourse. The point, however, is that this kind of comparative study does not increase or enrich our philosophical understanding or spiritual inspiration.

A similar thing seems to happen as well to those Chinese historians who employ modern scientific knowledge to reorganize traditional Chinese historiographic discourse. However, the achievements of modern Chinese historians are more positive for the following reason. They keep a critical attitude to their scholarly object and purport to explore more scientifically the nature of the original discourse without sharing its original ideological stance. In contrast, the New-Confucianist philosophers closely share the same ideological position of the traditional Chinese philosophy. What they have pursued is not something scientifically represented; instead, they try to ascertain and strengthen the original values and modes of thinking in the classical texts by means of comparative analytical methods. The fact is that the two procedures of scientific analysis and spiritual reformulation are essentially divergent in nature. The two do not necessarily support each other, either logically or emotionally, despite a textual coexistence of different argumentative discourses. Thus, on the one hand, Western philosophy does not need any additional theoretical support from Chinese metaphysics; on the other hand, Chinese philosophy does not need the logical or aesthetic backing from its Western counterpart, primarily because these two sets of discourses belong to different academic institutional systems. For various reasons, a modern Chinese or sinological mind can accept the two different philosophical systems at the same time, while what is added to the comparative discourse is only the historical message of alien philosophical experience for the modern mind. As regards Chinese philosophy, it keeps its traditional intellectual autonomy consisting of various levels such as the linguistic, logical, aesthetic, social, political, and historical ones. Its "meaning" involves different semantic and intellectual layers; and it can only produce its spiritual inspiration or realize its values adequately within its own traditional cultural context, historically or in imagination.

Comparative work between Chinese and Western philosophies is basically a development in the scientific era or, precisely speaking, a result of a spiritual confrontation between the scientific and the traditional-Chinese cultural trends. In general, Chinese-Western comparative philosophy is confronted with a three-level difficulty, that is the scientific, philosophical, and spiritual levels. All three aspects involve our present task of evaluating the significance of Chinese philosophy in modern social and intellectual contexts. The meaning, function, and value of any philosophical tradition are determined in its own cultural, social, intellectual, and academic contexts. Unlike traditional Chinese learning, Western humanistic thought is essentially consistent with the modern scientific world. There has been a basic intellectual continuity between ancient, modern, and contemporary thought and scholarship in Western history. For the Chinese,

however, there has been an absolute "epistemological break" between its tradition and its modernity. We need a special hermeneutics, rather than a mere literally comparative "short-circuit," to deal with this cognitional gap. And semiotics is just one of the effective approaches to handle the epistemological breaks caused by different cultural patterns.

2. Chinese Character Semantics

Divergence of Chinese and Western academic classifying systems in connection to their mentality patterns, linguistic systems, and cultural traditions have produced different semantic organizations for their respective academic discourses. From Locke to Saussure it has been well known that the stable links between the referent, idea, meaning, sound, and name guarantee a constant semantic connection between the signified and the signifier. The innate linkage between meaning and sound naturally limits the number of semes of a word. The uniqueness of Chinese culture and its philosophy is fundamentally expressed in its linguistic and semantic organizations, namely its character-centric writing system. This system leads to a radical difference from the Western languages and cultural expressions: the form of writing is prior to that of sound and meaning. A single written unit (character) can correspond to several or numerous sounds and their related meanings in an irregular way. One character with its pictoriographic origin could keep an imagistic constancy because of the stability of the sketchy structure of basic strokes of a character. Such an independent written entity surviving across history becomes a "sign" which can carry different meanings associated with different sounds in its various contexts. One written character is not the representative of one idea or concept alone; instead it can be the sign for different ideas. This structure of one visual sign versus multiple meanings is obviously different from the Western pattern of sound–concept correspondence. Thus a character can be used by different people to refer to different things and to signify different meanings in a quite flexibly associative way. Comparing those different meanings of the same character we could say there are different uses of the same sign, but not that one conceptual unit or category presents different varieties of a certain meaning or a certain "philosophical category."

Consider, for instance, Tang Jun-yi's discussion in his account of Chinese history of philosophical concepts. The category "*dao*" or "*li*" (the principle) does not involve some single categorical set but rather merely involves different uses of the same character. Those signified meanings and represented objects do not stand in a logical relationship to each other; there is an etymological flexibility in its historical formation of the character. The so-called Chinese-Western philosophical-categorical comparison will be faced with the same problem. Chinese philosophical concepts exist neither in a logical hierarchy nor in semantic consistency. In fact, we can seldom trace a specific character-

word back to a conceptual lineage. Tang obviously confuses the pragmatic uses of the character *dao* with the implied meanings when he interprets the different meanings of the same character or word as being logically linked to each other. The category *dao* seems to develop in different stages, such as those expressing "fortune of heaven, virtue, heart, ritual, *dao* of heaven, *dao* of earth, *dao* of human and the *dao*."[6] In fact, the word *dao* is taken by him to be the designation of a general concept like "principle," "truth," or "philosophy." The general term itself thus becomes a universal, possibly connected to different theoretical systems according to pragmatic convenience or habit.

But, as a matter of fact, the term *dao* is only a character which can be used in different ways. First, the meaning of a concept represented by a written sign is not simply implicit in that sign; any meaning is the combinational result of the sign and its linguistic/cultural context. It is a resultant effect of interaction between the character and one or several of its possible contexts. The situation becomes even more complex with respect to the structure of the character-meaning. According to modern semantics there is a division between denotational and connotational aspects of the meaning. The connotational system of Chinese is much more complicated than the Western ones because of its much higher associative flexibility. The total meaning of a character in a concrete contextual hierarchy can be both multiply and heterogeneously defined, containing a flexible combination of different denotational and connotational elements. That means, when fixed by a single or a complex context, one character can present not only one or several definite senses, it presents a meaning-hierarchy consisting of different semic qualities which play different roles in the signifying processes. And that Chinese semantics is characterized by its richer connotational potential means that, when an abstract concept is signified by a character in a concrete context, there could be also several other connotated meanings functioning at the emotional, volitional, rhetorical, and other layers. All of these meanings represented or aroused by a single sign can function simultaneously with different reserves of meaning-effect. A qualified reader of Chinese can assimilate all the related meaning-complex of a character or a sentence containing that character through his or her accumulated reading practice. Unlike the Western logic-centered conceptual organization, Chinese philosophical terms carry many other semantic aspects besides the logical one. If one applies a Western logical-directed classifying system to interpret Chinese philosophical concepts, the nonlogical parts of the total meaning will be easily— almost unavoidably—excluded or neglected. If we follow such a logical procedure we can certainly get a more clearly defined conceptual organization, but at the same time we will lose many other related meaningful elements. The fact is that, in the mode of Chinese philosophizing, all sorts of meaningful

6. Tang Jun-yi, *Zhong-guo zhe-xue yuan-lun* [*On the Principle of Chinese Philosophy*], vol.1, (Taipei: Xue Sheng Book Co., 1976), 10.

elements work together in various changeable semantic networks, producing multiply synthetic semantic effects.

Modern Chinese philosophers have tried to reorganize and reformulate the traditional Chinese philosophical discourse, attempting to give it an effective role in modern social and academic communication. As a result, what they attempt to do amounts to disconnecting the semanticly synthetic texts from their original historical-cultural contexts. The disconnecting process occurs in two respects: the significational and the contextual ones. There are several kinds of significational institutions in Chinese philosophic discourse, including the verbal, conceptual, disciplinary, and cultural. The last one is by no means the least important in forming the meaning effect of Chinese philosophic discourse. Modern scholars of comparative philosophy would say that they will never neglect the alien semantic organization and the related cultural contexts in their reinterpreting activity. For those qualified comparativist scholars, what they do in their scholarship may be only the creation of a double reading process. On the one hand, they form a singly realized process of comparative reading of different texts. On the other hand, they employ the implicitly parallel strategies of reading the compared texts in terms of both Chinese and Western cultural and academic codes. This so-called comparative study is in essence only a co-presentation of the two different sets of academic rules. They are qualified in reading both, but not necessarily qualified in establishing the rational linkage between the two. Or, they get in the habit of maintaining a parallel reading of different textual systems in the same psychological process. In other words, there is still an absence of an effective theoretical dialogue between the Chinese historical and the Western modern discourses during this single-psychological but double-logical process. For the two logical systems cannot really support or be interconnected with each other at the theoretical level, particularly the parts concerning rhetorical and pragmatic semantic elements which are more closely rooted in the respective cultural contexts.

In one of my earlier essays about the character-centrism of Chinese semantics, I explained how modern Chinese can exactly maintain the Western scientific-conceptual system through systematically changing a single-character concept system to a double-character one. If one character A contains one set of dictionary-semes (a, b, c, . . .) and another one B a different set (a', b', c', . . .), then their semantic intersection as a two-character concept C formed by connecting the two characters A and B can greatly decrease the related number of semes involved.[7] Prior to any contextual semantic limitation, the two-character concept-system has already systematically restricted and fixed the semantic organization of Chinese words. This transition from the earlier single-character concept system to the modern two-character one had accompanied an earlier

7. Cf., You-zheng Li, "On the semic structure of traditional Chinese Philosophical words," *Shi-xue li-lun yan-jiu* [Historiography Quarterly] (March 1997): 127.

period of modernization of Chinese intellectual life. A two-character concept brings about the intersection of the two seme-sets, and accordingly the number of semes of the resultant set can be reasonably decreased; its dictionary meaning can be more effectively restricted and defined. The two-character concept system thus provides modern Chinese thinking with a more effective vocabulary tool without changing its original character-writing stratum. That stratum can continue to function as the basic semantic tool for effective reading of traditional texts consisting of single-character concepts.

The single-character concept system based on the Chinese written-character system has established a special argumentative rhetoric characterized by its multi-semic-layer vocabulary and signification. Besides the logical layer, that is, there are also emotional, volitional and aesthetic ones simultaneously converging on the same character-word. The single-character word containing a rich set of semes can be used to convey multiply synthetic semic compounds with the logical one as central in the argumentative genre. However, the argumentative communication in ancient texts is related to a synthetically formed semantics. That allows the argumentative genre to convey extra meaning effects of the nonargumentative layers as well. The Chinese philosophical genre typical of this kind thus implicates a more complicated meaning effect than its Western counterpart. As a verbal carrier of logical ideas, Chinese philosophical discourse incorporates a weaker inferential power but has a richer emotional and volitional stimulating power than the Western philosophical discourse. Or, the two "philosophical" discourse systems function in quite different ways even with respect to their dictionary-semantic organizations. This divergence becomes more obvious when different aspects of the academic and cultural backgrounds are involved. When Chinese philosophical discourse is reformulated according to the stricter logical standards used in Western philosophy, the other important semantic layers will probably lose effect or at least be seriously suppressed. In the extreme case, some of the CP texts reorganized in terms of the Western semantic and disciplinary institutions might look like "fish trying to survive on the land."

That is why modern Chinese scholars can much more precisely translate Western theoretical texts into Chinese than the ancient Chinese scholars translated Indian Buddhist texts into Chinese. With respect to our present topic, it is primarily a comparison between the ancient Chinese and Western scholarly semantic systems. Mou Zong-san and Tang Jun-yi may pay close attention to both types of conceptual system, maintaining the effective reading of the original Chinese texts and their semantic details. Trained in both traditional Chinese and modern scholarship, they are qualified to delicately grasp both the rhetorical charms of the original Chinese philosophical texts and Western logic. Nevertheless, what they have really accomplished in their comparative work is not something organically synthesized, but rather only a direct confrontation of the two different logical and rhetoric traditions. That certainly

provides a convenient way for us to perceive the similarity and divergence of the two systems in our comparative studies. What they have succeeded in doing, which some of their followers have failed to do, is exactly the effective reading of rhetoric expressions of the Chinese original philosophical texts rooted in Chinese historical contexts which themselves contribute a pragmatic strength to Chinese ethical scholarship. While attempting to give a Western logical backing to the Chinese ethical reasoning, they can still keep a separate focus on the original rhetorical components. The straightforward co-presentation of the two ethical expressions might increase the rhetorical enrichment of comparative discourse but not its logical strength.

A more serious problem confronts the comparativist scholars who read the Chinese texts mainly through a prior logical filter, taking as primary a Western-centrist framework. In such reading, the Chinese text becomes a sketchily simplified sign system conveying quasi-Western philosophical ideas lightly colored with Chinese rhetoric. Furthermore, what they can gain through this semantically selective way of reading the alien texts must be inferior to the Western counterpart, which would be characterized by its much stronger logical strength. What is neglected by such a reading of Chinese philosophy could be just its strongest points. A similar problem could occur with a Chinese way of reading Chinese philosophical texts in modern Chinese or Western languages. The typical case is the translation of philosophical works from Chinese to Western languages. In that case, the semantic loss involved is not caused by translators' inadequate understanding of the original texts. Well schooled in both languages, they are still unable to attain a complete translation because of the natural barriers of the two semantic organizations. It is interesting to note that, for those qualified translators, there is no difficulty for them to appreciate every detail of the original texts in the translated ones, because the latter just becomes an equivalent index of sign systems for the original. In other words, the translation becomes a reminder of the original one for the qualified reader of Chinese who has access to the original cultural context. Nevertheless, for those readers who are not expert at Chinese, the translated texts convey only a partial message of the original. Or, more precisely speaking, some quite important emotional and volitional elements will disappear or at least be seriously weakened in the translated texts. It will be especially the case when the texts contain more ontological and metaphysical content.

If so, how can we adequately realize intellectual exchange despite the unqualified reading caused first of all by the two semantic barriers: The linguistic-semantic and the disciplinary-constitutive ones? Qualified reading can only exist within specialized circles which are organized according to professional requirements. Efficient reading is thus based on preconceived disciplinary restrictions which will not help comparative studies to attain a higher intellectual level. We will return to this problem again later. By the way, the discussion above serves not merely to indicate the existence of a parallel reading process

involving the two kinds of philosophical texts. From a professional point of view, any multicultural interaction in comparative reading is useful. Our question is a broader one: how can we substantially increase the scientific worth of Chinese-Western comparative philosophical scholarship beyond the current pedagogical-professional routines?

3. Imagistically Rooted Concepts

The comparative-philosophical barriers can be more clearly disclosed through examining the divergent conceptual organizations of the two philosophies, the different structures of the two humanistic scholarships. Aristotle's system of categories is foundational for Western thought, and has contributed to a logic-directed tendency of the Western philosophical and scholarly tradition. Its basic conceptual system incorporates both conceptual and empirical rationality as organizing notions in philosophical discourse. It was this philosophical tradition which eventually led to the establishment of Western sciences. Moreover, this original rationalist mentality has in fact determined the logical direction for organization of linguistic, ethical, metaphysical, scientific, artistic, historical, and even socio-political thought. In contrast, with an interpersonal moral pragmatics as its intellectual direction, the original Chinese mentality manifested a much weaker capability for organizing texts logically. This is the main reason why the ancient Chinese did not attain a higher level of scientific reasoning. Similarly, in their quasi-philosophical discourse Chinese did not attempt a systematic construction of their verbal arguments, let alone a strictly logical one. Lacking in a stronger logical tradition, Chinese philosophical discourse is obviously weaker in establishing the criteria for conceptual definition, rules of logical and causal inference, and the hierarchy of categories. Basically, the absence in a strict conceptual hierarchy in the Chinese philosophical discourse explains this weak point.

In this section I do not intend to explore all the reasons for this absence. Instead, I wish to focus on one of its technical aspects: the pictographic origins of the CP philosophical words and their special semantic function, their "concrete abstraction." Despite the earlier pictographic origins of character-words, the linguistic development in China made the pictographic traits gradually decrease. The character-words that express more general ideas can function effectively; namely, a "concrete or imagistic-visual substratum" can play the role of the abstract concept. The point here is not to emphasize the imagistic origin of abstract Chinese concepts, but rather to emphasize the independent status of the single-character concepts in forming meanings and meaningful associations. On the one hand, the first-rank categorical concepts in *The Book of Changes* have different imagistic traces. On the other hand, the concepts carried by those separate imagistic characters do not define each other or relate to each other in a specifically logical or rational way. Their "logic" or operative

roles are "given" artificially by the designers of the system. In Daoist metaphysics, the same is true of the major concepts. For example, the original visual images of those main concepts like *dao* (way), *tian* (heaven), or *ren* (humanity) limit or specify their correspondent concepts by imagistic associations. Furthermore, those concepts do not have logical connections at the physical or psychological level. In fact, each single-character concept contains a history of its notional development, the history of the uses of that character. All its historically emerging notions can play their role in any communication, with different actual effects in constituting the meaning in concrete contexts. Different effective semes of one word in any specific context can interact with each other to form a definite meaning-complex appearing through actual reading. When an abstract word works together with other related conceptual words in a specific context, the meaningful network will become further complicated. Unlike the Aristotelian categorical system whose elements relate to each other logically, either at a notional or at a practical level, the CP has only different sets of uses of the concepts embodied in the characters used. (When the two-character words appear in modern time this associative flexibility is effectively restricted.)

In light of this background, we can understand why we should not regard those ancient philosophical words as notional entities containing their own innate or fixed meaning.[8] They are only to be pragmatically used in different contexts. *Dao* and *tian* become the top categories in the CP by virtue of their imaginative wealth as metaphors derived from the visual superiority of their image: the guiding index and the spatial height. When those words obtain their logical roles through habitual usage, the added meanings, however, are given in an arbitrary way. In principle, I think, any imagistic origins and the related words can play the same meaningful roles if their rhetoric effects can be expected. The category *tian* as a verbal medium can thus be used to carry different semic sets with its original imaginative association; the last factor can play a different semantic role in different intellectual and cultural contexts. Accordingly, the imagistic elements and related other semic ones can be synthetically used in a flexible way. Among the Confucian texts, original Daoist texts, and later Neo-Confucianist texts, the same character (not the same "conceptual category") *tian* can carry different notional implications. Even when it played a more metaphysical role in the Song texts, there was still a lack of logical relations between different key concepts such as *dao*, *xing* (human nature), *li* (principle), *li* (ritual), *ren*, *yi* (justice), and so forth. All of those concepts play their respective roles directly or intuitively with respect to their practical contexts. But where are the logical links between them within related theoretical systems? They cooperate with, or support, each other in practical

8. See the different opinions in Mou, op. cit., vol 1, (1991), 246, 254, 302.

experience emerging from human nature and real life, rather than in a logical hierarchy of the sort we know in Western philosophy.

However, we may say that both the merits and demerits can be drawn from this same mental tendency. As an indication of the pragmatic potential, by the way, those imagistic-rooted concepts can play a multiple, rather than single, function in intellectual communication.[9]

Shu-hsien Liu said, "*ren* is Confucius' ultimate commitment as well as that one thread that runs through all his doctrine."[10] The phrase "one thread that runs through" vividly indicates the recognition of a Chinese imagistic-rooted concept. Unlike the general term *dao,* which functions as the first-rank category in all contexts, *ren* functions on different semantic levels and aspects. It is an "index" which refers to different meaningful qualities in different contexts. Now the key question is whether the two argumentative systems can complement each other as comparative scholars have wished. My answer is quite conditional, because the two philosophical systems work in different academic frameworks, or precisely, in different contexts of semantic, conceptual, and disciplinary organizations. The complete meanings of the two philosophical discourse systems depend on their own respective academic contexts. The impression of the possible conplementarity of the two systems is caused by the psychological and pedagogical training of the comparative scholars, as we pointed out before. Nevertheless, the recognition of this fact is not necessarily negative; it may facilitate another active aspect of comparative communication, a possibility upon which we will elaborate further later. But for now let us discuss in more detail the semantic role of disciplinary institutions in philosophical communication.

4. The Semantic Aspect of Chinese Academic Disciplines

The meaning of humanistic discourse is deeply determined by the operative institutions of the related academic systems, as well as by the socio-cultural-historical conditions. Now let us turn to the semantic factors formed by the special academic programs, among which the most important one is the disciplinary system as the classifying pattern for organizing subject matters and their related methods. In the Aristotelian philosophy, as well known, an initial five-fold division of scholarship consisted of the logical, metaphysical, socio-practical, natural-scientific, and aesthetic-historical aspects of human intellectual experience respectively. The academic classificatory model was continu-

9. See You-zheng Li, *The Structure of the Chinese Ethical Archetype* (Frankfurt: Peter Lang, 1997), 191–201.

10. See Wing-tsit Chan, ed., *Chu Hsi and Neo-Confucianism* (Honolulu: University of Hawaii Press, 1986), 444.

ously refined and readjusted until mediaeval times, while its initial principle remained little changed. The division of subject matters, research techniques, pedagogical programs, and the academic aims have accorded with one another in the Western disciplinary network. Compared to this academic tradition, the Chinese scholarly activities were much more practical and less rationalistic in character, leading to quite different intellectual and social consequences in their cultural development.

Concerning the formation of intellectual activities in Chinese history, there are several academic-pragmatic systems working as parts of the operative framework of scholarly production. In general, the constitution of the meaning of intellectual units basically depends on the aforementioned tripartite institutionalization: the linguistic-semantic, conceptual-semantic, and the disciplinary-semantic. Compared with the Western type, there was much less rigorous classification among the traditional disciplines in ancient China. The initial historical record of academic classification emerging in the Han dynasty indicates an obviously practical character. The initial scholarly classification finished in the Han, called the "*Qi Lue*" (Seven Classes of Books), is a half-conceptual and half-bibliographic schematic on the basis of the book-compiling practice. The classifying principle was indeed related to the intellectual categories, for the so-called "books" were the results of compiling fragmentary articles on the basis of certain divisions within the philosophical, poetical, medical, engineering, and divinational-numerical writings. The way of classification was nevertheless based on the classifying tendency of practical common sense, not on academic-rational requirements. The first section of *Liu-Yi (the Six Arts)*, which was later called the "*Jing*" (Classics), is characteristic of a Chinese synthetically pragmatic mentality. This class of books covers all ideologically important, historically original, and earlier officially compiled books connected to various subjects such as philosophy, history, literature, ethics, linguistics, and divination. First, the class or division itself consists of so-called six subclasses which overlapped with other classes. Second, those books in this class were official educational textbooks used in various states or provinces since the pre-Qin time. Although there were great conflicts and wars among the political regimes, those historically official books were accepted by all of them as the *basic state-authoritative books*. Third, those basic classics are also historical books in the sense that they were historical records of the past official events and thoughts of China. It is interesting to note that the philosophical content of this basic class of books is really sparse. Therefore the traditional Chinese classic books are not philosophical but historical in nature. Or, more precisely, the basic Chinese classics in Chinese intellectual history are pragmatic, synthetic and ideological in composition and function. Considering the basic purpose of the Chinese academic classics and their sociopolitical circumstances, the weakness of the logical pursuit in ancient China seems naturally understandable.

Following the development of classification based on practical requirements in the editing and publishing practice after the Han, the above book-classifying patterns were further elaborated during the period of the Jin-Sui dynasties. Finally, there was a more fixed pattern called the "*Jing, Shi, Zi, Ji*" (Four Section Book Classification).[11] Rather than being classified consistently according to the intellectual subject matter, they followed diversely mixed criteria such as the ideological utility, official and honorary grades (the class *Jing*, or Classics), the substantial content (the *Shi*, or History), and the identity of authors (offices or private individuals). Philosophical texts were more frequently included in the second class according to a strange criterion: they were works by individual writers who were engaged in various specialties such as the philosophical, ethical, divisional, medical, literary, agricultural, and strategical, or anything made by named writers. Compared with the Western tradition, the most characteristic trait of ancient Chinese scholarship does not lie in the poverty of the philosophical content (in some sense), but in the lack of theoretical impulse in connection with humanistic learning. In other words, there was a weaker inclination in early Chinese academic life for reflecting upon and examining intellectual practice and experience. However, as late as in the Former Han, the scholarship of the emerging academy was not based on any theoretical reflection but rather on practical interests or on philological and ideological requirements.

The initial classification of books based on synthetic intellectual/bibliographic criteria laid a foundation for the development of book-classifying principles over the next two thousand years in China. This historical constancy reflects a stability in Chinese thinking characterized by its practical tendency. The academic-operative, bibliographic, and professional standards were mixed together in shaping ancient Chinese academic institutions. This more ideological and less intellectual tendency in the classification system of Chinese texts and thoughts has provided Chinese scholars with an authoritatively fixed framework for organizing their way of thinking and scholarly practice. The philosophical content in a modern or Western sense is mixed in intellectual and historical texts. It functions with the elements of other related intellectual categories within definite social and cultural contexts.

After the more logical categorization of Western academic culture was introduced into China, initially through early Japanese influence, Chinese awareness of scientific classification of subject matter was immediately sharpened, just like what we have seen in the recent history of Chinese scientific development

11. Based on the original classifying system and the later development of the classifying theory and practice about Chinese texts made by Liu Xie in the Qi Dynasty, there formed a general criterion of the half-bibliographic and half-conceptual nature leading to the establishment of this book classification system.

during the same period. Since then the Western definition of philosophical disciplines has become the generally accepted model in Chinese intellectual life. Following the Western classifying system, modern Chinese scholars began to reorganize an ancient Chinese "philosophical" discipline. In practice, people are inclined to use the more precisely defined Western standards to redescribe the Chinese counterparts. Modern Chinese comparative theology has been most subject to this tendency.

Stanislaus Lokuang offers a typical example in this regard. In comparing Zhu Xi's philosophy to Western mediaeval metaphysics, he employs a set of Western philosophical terms and model as a comparative framework, although the basic divergence of the two theoretical systems, particularly marked in respect to general terms like *Being, mind, nature,* and *principle*, makes the relevant comparison between the two less meaningful. This disciplinary blending occurs in both the Chinese and Chinese-Western comparative fields through using the same set of terms regardless of their respective cultural and historical distinction. Thus, we find comments like the following: "Zhu Xi's theory of metaphysical structure combined substance and morality, and connected ethics and ontology. . . . its ethics are the continuation of ontology. Its ethics and ontology are mutually connected."[12]

Such straightforward comparative philosophical studies perpetuate a basic self-contradiction about the identity of the CP itself. What significant parts should be selected to be put in this discipline from the related traditional Chinese material? According to the stricter Western standard, not so much material in Chinese philosophy could be accepted as exactly philosophical in nature. That is why, until now, the mainstream of Western philosophy has not taken much of interest in the CP. This fact does not have much to do with language problems, because many philosophical classics have already been translated into Western languages. Even following a flexible or extended standard, they are not easy to accommodate within the modern discipline of philosophy. It is obvious that so-called Chinese philosophy is quite miscellaneous in composition, containing elements from such different fields as the metaphysical, ethical, historical, political, and literary. First of all, there exists a problem of classification of academic disciplines involving both modern (Western) and traditional Chinese classifying systems. This is also a typical semiotic problem with respect to the conceptual and analytical-procedural classifications. Chinese-Western comparative philosophy is first of all a comparative analysis of the two different academic disciplinary systems. The problems associated with the meaning, function, and evaluation of different philosophical discourses can only be precisely and comprehensively defined within the related disciplinary systems. Even the obviously philosophical part functions within a certain system or in interaction with other related disciplines in the same system. It is

12. Wing-tsit Chan, ed., op. cit. (1986), 76.

difficult for us to put the philosophical parts of system A into system B and keep its original meaning and function. The pragmatic character of academic institutions has limited the scientific potential of those disciplines. The different fields in ancient Chinese intellectual practice do not function as a logically organized scholarly system. The more practical fields such as history and literature can retain clearer identities. However, in the more theoretical intellectual practices such as philosophy, linguistics, natural and social sciences, aesthetics (as more systematic description and analysis of the aesthetic experience), and logic, the disciplines or sets of scholarly procedures have not yet been truly established. Although all of those theoretical elements are present in the texts, they are organized in a less systematic way. The lack of separate theoretical disciplines indeed indicates a weaker point of the ancient Chinese logical mentality.

An adequate understanding of the CP as a modern discipline addressing traditional materials is innately linked to the traditional Chinese academic structure which is itself deeply rooted in the traditional Chinese sociopolitical system.[13] Reflecting on this problem today, we can recognize the necessity to further expand our problematic to a more general level: the formation of disciplines and its ideological background. As I have argued elsewhere,[14] the academic hierarchy itself becomes a structural reason for the stability of conservative scholarly directions. If a modern academic ideology involves several social aspects, the traditional Chinese academic ideology has concentrated more on its political mechanism. Since Chinese scholarship has been closely linked to its socio-political background, the relationship of Chinese metaphysics and Chinese politics will be a very important scholarly subject for inquiry.

5. The Semiotic Approach to Comparative Philosophy

The above explanation for the lower priority given in ancient Chinese thought to scientific rationality nevertheless has considerable pragmatic-rationalist potential from a semiotic point of view. The semiotic approach helps explore the multiple rational typology in connection with various connotational possibilities in signification and communication. Let me repeat that there are, in brief, four kinds of structural difficulty with analyzing the CP through comparative methodology: the linguistic-semantic, conceptual-definitional, disciplinary-institutional, and the historico-culture-contextual. These communicative

13. See You-zheng Li, *The Constitution of Han-Academic Ideology* (Frankfurt: Peter Lang, 1997), 58-66.

14. See You-zheng Li, "On Institutional Restriction of Academic Disciplines," in Gerald F. Carr and Lihua Zhang, eds., *Interdigitations: Essays for Irmengard Rauch* (New York:. Peter Lang, 1999), 427.

barriers exist between different academic traditions. The situation will become further complicated when we consider the current epistemological challenge offered by the changed situation concerning the humanities in general since the 1960s. There is a more complex question related to the current debate between philosophy as a strong traditionally rooted discipline and interdisciplinary epistemology as a new general type of theorization. In other words, the aforementioned difficulty in Chinese-Western comparative philosophy can be reconsidered from a larger intellectual perspective. It seems paradoxical that our problematic concerning the CP therefore gains intellectual significance.

In my opinion, the term *semiotics* today applies to a general research orientation which is primarily characterized by its strong interdisciplinary strategy. It involves various disciplines; but it does not center on any single traditionally established discipline. That means that it can draw upon numerous theoretical tools from various disciplines to constitute a new methodological framework; it can selectively apply theoretical elements from different disciplines to their various specific scientific projects. Furthermore, it deals with various semantic levels ranging from the linguistic, communicative, pragmatic, expressive, and rhetorical, rather than being limited to referring to perceptible or realist objects. Such a multi-semantic-layered semiotics can provide comparative scholars with the theoretical tools to more precisely analyze divergent cultural manifestations. Broadly, semiotics as a "universal semantics" in my interpretation can treat two different semantic dimensions: the linguistic and the disciplinary ones. What would be a "semantics" of disciplines then? According to our above discussion we know that the totality of a discourse involves various levels, including the related academic institutional ones, which are also determinative forces influencing the constitution of meaning. It is clear that both semantic analyses will be closely connected with the problematics of Chinese cultural history.

In general, there are three heterogeneous origins of modern semiotic theories: the Saussurian, Peircian, and the Husserlian, involving the linguistic, pragmatic, and psychological dimensions respectively. The diversity of modern semiotics stemming from its different sources presents a considerable technical difficulty in grasping its entire range. But for the study of multicultural theories, the three perspectives are all important and relevant, and the study certainly presents a theoretical challenge for scholars trained and specialized in any single discipline, including the philosophical. On the other hand, although there are different disciplinary origins of semiotic theory; the mostly relevant one remains the philosophical. If there exists a close relationship between semiotics and philosophy, there will be an even closer relationship between semiotics and comparative philosophy, including the CP, which is quite miscellaneous compared with its Western counterpart.

Despite containing a great number of philosophical elements, semiotic theory is characterized not by what it employs but by how, why, and in which

contexts it does so. The semiotic approach, in contrast with a philosophically centered one, has nothing to do with philosophical knowledge but rather with the traditional way of employing that knowledge. That is, it offers a way to operate within the discipline of philosophy which is defined by its fixed operative preconditions, procedures, and theoretical function. According to recent developments of semiotic theory in an expanded semantic sense, operational contexts play a very important role in constituting the entire meaning of any sign system. The disciplinary framework is the innermost circle of the related contextual network for signification and communication of any verbal texts. When the structure of the latter is more complicated and ambiguous, contextual analysis becomes more necessary. This is where one can find some serious problems with some approaches in Chinese-Western comparative philosophy. The new focus in the area of semiotics takes even the contextual network of semiotic practice itself into consideration. That means, the semiotic approach should pay attention even to its own operative conditions, internal and external, taking precautions against any semiotic dogmatism caused by the proposed procedural rigidity of a discipline, including any mechanistic definition of semiotics itself.

Semiotics as the general designation of an interdisciplinary/cross-cultural approach also involves a strategic shift of academic attitude breaking up the geographico-historical distinction of cultural traditions. Until now academic events and their scholarly results have actually emerged in definite sites and dates, originators of scholarship being associated with the related geographical names. The increase in international communication makes such geographical specification less meaningful when most cultural messages can be shared and employed by people everywhere in the world in a similar way, just as we have seen in present-day science. The CP, despite its rich historical lading, can provide more internationally commensurable and acceptable methods for the common academic tasks of the global culture. It should no longer be monopolized by native Chinese because it will no longer "belong" to them only. The same can already be said about Greek/Roman thought. The epistemological and axiological problems of Chinese-Western comparative philosophy will follow the same tendency, although a member of one culture can be more able to specialize in some technical aspects owing to his particular background. For example, Chinese are better at understanding the implications of their linguistic rhetoric and historical contexts but not necessarily better than non-Chinese at understanding some intellectual aspects of the CP when the nature of the latter are more connected to some modern disciplines, such as linguistics, anthropology, sociology, and political science. The same can be said about Western philosophy. Its philological scholarship is certainly better mastered by some Western specialists, but some intellectual aspects of Greek philosophy could be better understood even by some non-Western scholars if they were more familiar with other modern humanistic methodologies. For that

reason philological specialists can no longer maintain that they are authorities on everything in their own specialized fields, even if they have better memorized all the texts of Aristotle or of the Five Classes. The philological and scientific approaches to understanding the same texts are related to different epistemological-strategical levels, which may be connected to other disciplines. Or, more simply, the same subject matter can be treated by different methods formed in different disciplines and their different combinations.

That situation can be compared to what we talk about when we describe Sinology or the CP as a historically shaped discipline. In fact, humanistic scholars today are faced with the task of systematically reorganizing the structure of humanistic scholarship. Thus, although, in the conventional field of comparative philosophy, the identities of the compared traditional philosophies remain unchanged, the first task, from a semiotic point of view, should be to anatomize those academic bodies formed by history. This requires a double process called "breakthrough/interfusion": that between elements of the compared historical schools within the discipline; and that between that discipline and other disciplines. As we are using the term, a "discipline" consists of subject matters and methods alike, with the latter more determinative to its identity. On the other hand, the semiotic tendency will strengthen the process of reorganizing the methodological network across different historical and geographic cultural areas, further blurring the boundaries of various cultural traditions. Accordingly, a semiotic dialogue will promote the process of the international redescription of historical-cultural-academic topographies. To attain this goal, the Chinese part should be first reformulated in modern semiotic terms in order to make that discourse more commensurable with the Western one.[15]

6. Chinese Philosophy
Seen from a Semiotic Perspective

Understanding Chinese philosophy involves semiotic problems. Divergence and similarity between Chinese and Western philosophies is naturally related to the nature of the former which cannot be sufficiently clarified by using only the framework of the latter. The pre-scientific, synthetic nature of Chinese thought, the premodern disciplinary basis of Western thought, the modern Western interdisciplinary tendency, and contemporary new interdisciplinary/cross-cultural scientific directions in the world have contributed to forming an expanded context for redefining the identity of Chinese philosophical history. Our present inquiry urges us to confront a more fundamental problem of our time: What is the nature and function of philosophy as a discipline today? Although we cannot go into details here, taking that question as reference

15. See You-zheng Li, *Epistemological Problems of the Comparative Humanities* (Frankfurt: Peter Lang, 1997), 197–99.

point is nevertheless helpful for us to more relevantly define and evaluate Chinese philosophy.

The semiotic and thus interdisciplinary approach implies an intellectually "revolutionary" tendency to reorganize the preconditions and operative procedures of doing research. These involve a scholarly operative strategy with respect to epistemological and methodological conditions. As a matter of fact, the semiotic strategy functions on the margins between the disciplinary and cross-disciplinary, or between the specialized and cross-specialized (comparative). Furthermore, the semiotic tendency recently arising in Chinese-Western comparative studies evidences the importance of strengthening the general analytical tendency originating in ancient Greece, but also shows that the analytical or the traditionally rational patterns in intellectual productions should be expanded and pluralized. The involvement of the non-Western materials and practices in comparative studies will certainly push this development forward. On the other hand, the dialogue between the CP and semiotics is beneficial to both in various ways. First, the synthetic content of the CP can be more suitably treated by the interdisciplinary approaches of semiotics. Second, the interdisciplinary approach to the CP can more creatively stimulate cross-cultural scholarship which is itself interdisciplinary in nature.

Concerning the term "interdisciplinary," we should first point out that any single discipline unavoidably contains interdisciplinary elements; second, any particular interdisciplinary program is liable to further development into a new discipline, by acquiring a fixed set of scholarly preconditions and operational patterns. Similarly, any comparative approach in a field can become later a certain discipline with fixed operative steps. The essence of semiotics lies in overcoming or avoiding any kind of dogmatic formalism, scientific or rhetorical, keeping constant focus on its efficiency in rationally solving problems. To this end, we first should build up a set of relevant problematics, and then arrange a group of related methods collected from various disciplinary systems. For this purpose we have to get rid of professional routines which are more closely connected with academic utility and scholarly custom than with intellectual progress and theoretical ideals. The spirit of semiotics is therefore also expressed in transcending intellectual and scholarly interests determined by current academic and pedagogical market mechanisms. Unlike fashionable academic games shaped in present-day commercialized society, the semiotic quest for logical certainty and practical efficiency is closer to the classical ethos, both ancient Greek and pre-Qin Chinese.

7. Chinese Philosophy and Current Ethical Scholarship

The CP as a modern discipline involves different parts of Chinese intellectual history, some of which cannot easily be commensurated with the traditional

Western philosophical topics. On the other hand, recent epistemological developments are serving to divide Western philosophy itself into different thematic parts connected with other related disciplines. For example, some traditional branches of philosophy like aesthetics and philosophy of history have been largely transformed into the new disciplinary fields of artistic/literary theory and historical theory. Philosophy of language shares a number of important subjects with linguistic theory, while the latter has also created a number of new subjects which do not have counterparts in the former. Similar disorganizing processes can be observed in many other sociocultural areas such as politics, economics, and sociology. Philosophy today can no longer claim to be the single or central theoretical foundation for other academic branches.

This is especially true of ethical scholarship, which is the very center of the CP. It is well known that Western philosophy also originated in its ethical reflection. Ethical thought has played an important role in history, getting more and more logical elaboration as metaphysics became more sophisticated. Thus the later evolution of Western ethics has been closely linked with the ever-expanding Western metaphysical and ontological scholarship,with the Christian theological development further strengthening this metaphysical tendency. Accordingly, a metaphysical fundamentalism has disconnected Western ethics more and more from its empirical and positivist sources. In general, ethical thought has a strong empirical relevance in history, especially in Chinese ethical pragmatics. Moreover, the interdisciplinary and cross-cultural approaches today can further disclose a similar inconsistency between the metaphysical and empirical aspects in Chinese ethical thought. For example, the pre-Qin ethical empiricism and its Song-metaphysical elaboration present a sharp contrast in the style of ethical reasoning. From the interdisciplinary perspective, speculative elaboration based on metaphysical fundamentalism and pragmatic efficiency based on the humanist empirical positivism belong to different epistemological levels. On the other hand, between different cultural academic systems there are different degrees of logical subtlety and positivist efficiency. Western logic is much superior to the Chinese one; but each has its different advantageous and disadvantageous aspects with respect to efficiency of their ethical reasoning. Concerning the empirical aspect of ethical thought, the Western type manifests a much higher socio-empirically positivist efficiency, while the Chinese type expresses a much stronger motivationally positivist technique. Thus, comparison and complementarity between the two intellectual traditions first require the choice of the relevant epistemological and pragmatico-operative criteria in order to more beneficially promote efficiency of ethical scholarship of mankind.

The present examination of Chinese-Western comparative philosophy is therefore able to be seen as just one aspect of a more crucial problem about the nature of the discipline of ethics as such, a topic which has been traditionally full of epistemological controversy. In this respect, Chinese philosophy, or its

main focus — Chinese ethics — can provide an illuminating typical example for the current international discussion on ethics. Keeping a reasonable distance from the Chinese and Western metaphysical frameworks, Chinese philosophy as a whole can become a useful source for present-day comparative studies, especially cross-cultural ethical studies.

Modern comparative philosophy has brought about a general recognition that Western metaphysics, with its much higher logical elaboration, becomes a theoretical backing for the weaker Chinese metaphysical tradition in a special sense. Both share a metaphysical-semantic multivalence, creating a richer rhetoric potential for creative speculation; and also, Western metaphysics has firmly established itself in modern pedagogical systems world-widely. The modern disciplinary system based on the current professional system has become the *de facto* framework for comparative metaphysical scholarship, which thus does not need to focus on the genuine relationship of ethical scholarship and metaphysical rationality. This tendency is no doubt directly related to the progress of theoretical and political ethics.

Thus, in light of the former explanations, let us revisit our original question or formulate it more precisely: what contribution the CP can make to Western philosophy today? Or, what is the major value of Chinese philosophy in the current humanities? We attempt to repeat now that comparative philosophical studies do not need to be limited to certain related existing academic disciplines such as the philosophical, sinological, or philological-historiographical. All of those fields are certainly the important disciplines rooted in the present educational system, each with its own routine system of programs. But how to classify the content of the CP and how to analyze its respective composition in the specifically designed projects are also related to the chosen perspectives and methods in connection with other disciplines and their combinations in the scope of entire social and human sciences. Free from the fixed criteria set by the conventional disciplinary network, the CP, after reorganization, can increase or enrich its intellectual contribution to several other scholarly aspects of international and domestic academic fields. On the one hand, the initial reorganization of Chinese intellectual materials in terms of Western philosophical system can certainly benefit both sides by promoting the mutual understanding. But the Western philosophical system also manifests its own scholarly limitation because of the profound academic-cultural divergence of the two philosophical traditions. We should not uncritically accept the standards used in the traditional Western logic-centrist philosophy to measure the quasi-correspondent parts in the Chinese one, except in some specific topics. The result would be a form of cultural reductionism which acknowledges only the already-known without being open to profiting from those element in the Chinese tradition which are not directly commensurable with the Western traditional manifestations.

For example, Western metaphysics and ontology, being highly autonomous because of their strong logical and theological background, do not need

any theoretical support from non-Western philosophies which are historically weaker in those respects. But there are indeed parts of Chinese philosophy which can be very useful for improving the ethical aspects of the Western philosophical tradition, if the ethics is dissociated from its traditional reliance on the metaphysical framework, which after all serves diverse functions, including nonacademic ones. For example, the original "nonphilosophical" or "empirical" ethics of ancient China can be made more useful through epistemologically separating its metaphysical and ethical components. Julia Ching said, "In Kantian terms, Mencius offers an empirical ground for morality: That of moral feeling, based on human nature and its spontaneous, even instinctive choice of the good in moments of crisis calling for altruism."[16] According to Ching, this empirical stance should be overcome on the basis of a more effective metaphysical foundation. From the modern semiotic perspective, however, we can have a different view of what counts as theoretical strength. For instance, if we achieve an interdisciplinary deconstruction of the metaphysical fundamentalism in Western ethics, the more genuine nature of ethical scholarship can be further clarified. Confucian thought as the first important Chinese ethics is a typical example.[17] Furthermore, recognition of the empirical value of Confucian ethics can promote a deeper reflection on the empiricist and positivist traditions of Western ethics which have been undermined or weakened by various ontological and metaphysical speculations across history.

Another example is the synthetic manifestations of Chinese thought, which consists of philosophical, historical, literary, and artistic elements and procedures. This specific intellectual composition could provide a more suitable historical source for examining politico-ideological elements which function in the scholarly and social realities. Understanding the existence and role of these elements can further help us expand our understanding of the true mechanism of political-ethical reality and scholarship in history. Such strategic perspective can be easily obtained, but only if we avoid the Western philosophical or metaphysical centrism which was actually adopted by Mou, Tang, and some of their followers. The depth and utility of any scholarly operations should be measured by *suitable* or *relevant* theoretical procedures, rather than by the use of any kind of technically elaborated devices. We can do this best by keeping a distance from the traditional philosophical systems. Their conceptually technical programs have too long a history, leading them to preserve all of their historical accumulations in their operations without being responsive to the changeable social and intellectual reality.

In short, the answer to the question of what value Chinese philosophy has in the current humanities will involve a larger range of questions, including

16. Chan, 1986, 278.
17. See You-zheng Li, *The Structure of the Chinese Ethical Archetype* (Frankfurt: Peter Lang, 1997), xxix – xxxii.

the reexamination of the discipline of philosophy itself. On the other hand, besides its historical autonomy, there is also a modern academic-institutional autonomy determined by several other factors, some of which are nonscholarly. From such a larger perspective, our present question is not only about how to improve the CP through the Western methods, but also the reverse, about the CP's possible contribution to Western philosophy, after our comparative methodology of ethics is improved. Its significance will also go beyond the cross-cultural comparative field, reaching the discipline of ethics itself. Chinese philosophy might provide a chance to reexamine the structure of Western ethical scholarship now; or, more precisely, the Western-centrist ethical tradition needs to be replaced by a cross-cultural theoretical framework of ethical scholarship.

Comparative studies of Chinese and Western philosophies have become more and more significant today, because they involve the promotion of the two disciplines not only in their professional routines, but also in confronting the current great challenge of interdisciplinary/cross-cultural reorientation of comparative humanities, including philosophy. Our issue is therefore only one aspect of that larger problematic, the function of the traditional philosophical discipline and its relationship to comparative cultural history. The topic itself has a double significance: as part of the question of the relationship between philosophy and ethics and as part of interdisciplinary multicultural studies. Without treating problems in the larger intellectual context can we hardly achieve satisfaction in our traditionally specialized scholarly enterprises.

The situation raises another considerable challenge from the trans-disciplinary perspective. Particularly in Chinese-Western comparative cultural studies, a multiple-disciplinary perspective becomes increasingly desirable. From a Confucian point of view, which is a rather different perspective than the current professionally competitive utilitarianism, any new scholarly direction should be welcomed if it can offer greater scientific progress itself, regardless of any professional benefits or privilege officially confirmed by the academic market game. Now, following the rapid progress of current comparative scholarship, one hundred years of history of comparative philosophical studies based on both Western sinological and Chinese nationalist scholarship has come to its end.

The semiotic approach, including its comparative branch, definitely belongs to the analytical tradition based on principles of rationality, clarity, precision, and efficiency in demonstrative process. It is the recent semiotic version of this Western rationalist tradition that brings us a more promising perspective to deal with Chinese-Western comparative philosophy. Its further development at the cross-cultural level also extends its rational and operative scope to more effectively cover intercultural fields. The result, as we explained earlier in the paper, is collaboratively caused by interdisciplinary methodological innovation for the past decades. The double strategic innovation helps advance the

research on traditional Chinese thoughts, scholarship, and culture; especially its ethical thought can play a more creative role in the present new intellectual and scholarly context. As one of the most significant intellectual experiences of humankind, Chinese ethical tradition can be profitably involved in the collaborative reconstruction of the new ethics for the world. The original structure of Chinese ethics and its related unique historical experience before the intrusion of institutionalized philosophical methodology provide modern ethical inquiry with an originally instructive and illuminating working model for promoting ethical and politico-ethical science.[18]

18. Thanks to Mary Rorty for improving the English of this article.

CHINESE PHILOSOPHY AND
PHILOSOPHICAL ANALYSIS (II):
TEST CASES

Metaphysical and Moral Transcendence in Chinese Thought

Chad Hansen

1. Introduction

At the beginning of this century, Christian missionaries dominated the "Silk Road" to Chinese thought. We learned by trial and error—trying to put Chinese thought in one or another framework from the West. Seeming success or failure fueled the perennial debates about the deep differences between the two traditions. A surface worry was whether Chinese thought was atheistic. Did it have a "God" concept? A deeper worry was whether Chinese thought had any forms of transcendence. "God" was a paradigm. God transcends nature—he/she embodies the supernatural.

A closely related issue is whether Chinese thought has dualisms. I treat these as related because I take it that any claim about the absence of philosophical dualisms is not merely a claim about the absence of distinctions. (Clearly, Chinese thought is filled with the latter.)

Robert Brandom proposes the following account of a dualism. "A distinction becomes a dualism when its components are distinguished in terms that makes their characteristic relations to one another ultimately unintelligible."[1] How God can cause the world ("all that is the case") without being part of it is a paradox. How mind can affect body and vice versa still bedevils dualist philosophers of mind. Thus, both are dualisms in Brandom's sense and fully merit being regarded as doctrines of a transcendent reality.

We may, following Brandom, take a term to be transcendent when it is a component of a distinction that is dualistic, that is, when the account of the two elements or realms are such that their interaction is deeply problematic and particularly when the pair of terms is fundamental to their arena of knowledge. The natural/supernatural distinction, accordingly, marks a kind of transcendence. To claim that some Chinese term, e.g., 天 *tian*^nature:sky is not

1. Robert B. Brandom, *Making it Explicit* (Cambridge: Harvard University Press, 1994), 615.

transcendent in Chinese thought is to claim that its interaction with 地 *di*^{earth} is
not deeply problematic in Chinese thought.

We can also formulate the mind-body dualism in terms of "transcendence"—
the mind transcends the body. We, in denying that Chinese thought has a
mind-body dualism, would essentially be claiming that they did not have a
pair of concepts that motivated the familiar Cartesian difficulties about how
they interact. The 心 *xin*^{heart-mind} does not seem to transcend the body in a simi-
lar way in Chinese thought.

We tend to express transcendence or dualism in a "metaphysical" language
of "realms." However, Western transcendent dualisms also underlie Western
epistemology and ethics. The concept of reason lies at or near the core of the
most prominent Western dualisms. God embodies reason. Plato's transcen-
dent rational world was the source of being and value (truth, beauty, and the
good). We see it in Wittgenstein's and Sellar's distinction between the "space
of reasons" and the "space of (natural) law."

Nietzsche notoriously targets reason as the core postulate of the Indo-
European philosophical religion. I have argued that a core difference between
Chinese and Indo-European thought is the absence of the concept of reason
and have sided with those analyses that deny religious-metaphysical and mind-
body dualism.[2]

Norms and facts, in various guises, constitute another core dualism. It sur-
faces in many forms, is-ought, fact-value, descriptive-prescriptive, and moral-
ity-science. We may say norms transcend facts. This is the transcendent dual-
ism I want to address. I will argue that although it lacks the familiar forms of
metaphysical, psychological, and epistemic transcendence, Chinese thought
does have a version of moral transcendence. It does not require the familiar
Western rationalist, mind/body metaphysical and epistemological framework.

Moral transcendence in Chinese thought emerges in the Daoist contrast
between 道 *dao*^{guide} and 天 *tian*^{nature:sky}. 天 *Tian*^{nature:sky} represents the realm of
constant nature—the closest counterpart in that context to the "space of
(natural) law." The claim that no 道 *dao*^{guide} that can function as a 道 *dao*^{guide} is
constant emerges from an analysis that rejects grounding guidance (norms,
values, morality, and so on) in nature. As I read this development in Chinese
thought it is reminiscent of two famous modern Western philosophical slogans:

2. In their co-authored books *Thinking through Confucius* (Albany: State University of New
York Press, 1987) and *Anticipating China: Thinking through the Narratives of Chinese and West-
ern Culture* (Albany: State University of New York Press, 1995), Hall and Ames stand out as
strong opponents of attributing traditional Western dualisms to Chinese thought. "Partly be-
cause there was no functional equivalent of Parmenides or Zeno effectively present in the Chi-
nese tradition, classical culture in China developed without these hard and fast dualisms" (Hall
and Ames, 1995:32). In my discussion in this paper, I focus mainly on moral norms in re-
sponse to Roetz. However, I agree with Hall and Ames (1987) that aesthetic norms are inti-
mately intertwined in almost all Chinese thinking about norms in general.

"The meaning of the world lies outside the world"[3] and "There is no fact-of-the-matter about what a word means."[4]

Heiner Roetz and Benjamin Schwartz take me either to have denied or to be committed to denying the possibility of this kind of transcendence.[5] In giving "naturalist" interpretations to Chinese thought (interpretations that deny that Chinese thought is characterized by dualistic transcendence) Heiner Roetz argues that a "pragmatic" approach demeans Chinese thought.[6]

I shall analyze Roetz's own justification of moral transcendence briefly but not to deny its conclusion. What I will object to is the assumption that to achieve a notion of the autonomy of norms or morality, Chinese must have had some transcendent "capacity" or some access to a transcendent realm (that is, epistemic or metaphysical transcendence). In particular, I do not think we need any of the Kantian or Kohlbergian apparatus that Roetz deploys to license attributing moral transcendence to ancient Chinese thinkers. In effect, I will treat norm transcendence as the foundational one.

Western thought arrives at norm transcendence from a religious direction. I will briefly acknowledge and outline that development, then present my narrative interpretation of the alternative route classical Chinese thought took. Its distinctive route shows how a naturalistic, social, pragmatic outlook can lead to a unique conception of moral transcendence. Roetz is right that I do not see the transcendence in individualist (or psychological) terms but in logical or semantic ones. But I do see it as a kind of autonomy—as the claim that

3. Ludwig Wittgenstein, *Tractatus Logico-Philosophicus* (London: Routledge & Kegan Paul, 1961).

4. W. V. O. Quine, *Word and Object* (Cambridge: MIT Press, 1960).

5. Cf., Roetz, "Validity in Zhou Thought, On Chad Hansen and the Pragmatic Turn in Sinology," in H. Lenk and G. Paul, eds. *Epistemological Issues in Classical Chinese Philosophy* (Albany: State University of New York Press, 1993a), 70. Roetz seems to suggest both—that my method and/or assumptions commit me to such a denial and that I do in fact draw such a conclusion. His formulation of the claim, however, focuses more on individualism, freedom, and personal dignity. Schwartz seems to worry mainly that my method is "deterministic."

6. Cf., Roetz (1993a). Though I focus on Roetz and similar themes in Schwartz because of their common appeal to Jaspers's "Axial Age" theory, the underlying "orientalist" complaint is that Western interpretation (interpretation using some Western method) distorts Chinese thought. This familiar theme elides the distinction between the method by which we do cross-cultural interpretation and the content of our interpretive theories. I shall focus on mainly the question of content here. Despite its obstinate familiarity, I have seen no sound argument in Roetz or Schwartz showing that a "linguistic" theory of interpretation (an interpretive methodology that highlights the norms of use enshrined in social linguistic practice) must lead to demeaning any culture. Remember that heuristic methods come in many rival versions. We may argue that any particular version leads to unjustified conclusions about content, but the generalization to all available Western theories of meaning survives mainly because Sinology is a "methodologically polyglot" field. The plethora of methods from anthropology, literary studies, philosophy, religion, and so forth has tended to keep Sinology from serious methodological development. Here, I shall mainly address Roetz's and Schwartz's objections to the interpretive theories that attribute naturalistic views to Chinese thinkers, and mainly dismiss their objections to naturalistic methods.

norms are irreducible to any natural constancy. That is how I would read the claim that *dao* is more important than *tian*.

Finally, I will argue that the ancient Chinese theorists who do rely on claims to have special capacities of transcendence (epistemological) or access to a transcendent realm (ontological) to justify their moral insights are essentially dogmatic and authoritarian. Their position is philosophically naive in classical Chinese terms because it is obviously vulnerable to arguments presented by Chinese naturalists. Encouraging interpreters to foreground these thinkers in an attempt to vouchsafe the claim that Chinese are capable of "transcendent thought" is what, from a philosophical perspective, demeans Chinese thought. Further, it uncritically presupposes the traditional Western elaboration of moral transcendence in terms of the kind of ontological or epistemological dualisms which modern Western thinkers (and their ancient Chinese counterparts) have good reason to doubt.

We can fit Roetz into our Nietzschean framework by noting how he frames the issue in the terms of Nietzsche's old nemesis, Hegel. Roetz focuses on Hegel's treatment of China "under the heading of 'nature religion,' the antipode to 'religion of freedom.'"[7] He quotes Hegel's characterization: "the heaven of the Chinese is not a world that forms an independent realm above the earth. On the contrary, everything is upon earth." Roetz comments that "This world immanence of religion for Hegel is merely a symptom of a general subjectlessness."[8]

The latter "complaint" grounds Roetz's assumption that any claims about deep differences between ancient Chinese philosophical psychology[9] and Western methodological and ethical individualism imply an agreement with the Hegelian attitude about the value of Chinese thought. Roetz suggests that interpretive denials that Chinese thinkers had doctrines characteristic of Western rationalist individualism imply that Chinese are incapable of the moral "transcendence." Such interpretations implicitly commit one to the view that Chinese thinkers lack a crucial ethical insight. They cannot conceptualize a transcendent moral reality. This, in turn, commits the interpreters to denying that Chinese thinkers can have a moral theory: "I have surveyed interpretations which contrast Chinese ethics against 'Western' conceptions and consign it on the level of heteronomy. Strictly speaking, the purport of these interpretations is that there is no ethics as ethics (rather than: as politics, as cosmology, or as

7. Roetz, *Confucian Ethics of the Axial Age: A Reconstruction under the Aspect of the Breakthrough Toward Postconventional Thinking* (Buffalo: SUNY Series in Chinese Philosophy and Culture, 1993b), 19.

8. Roetz, 1993b:19.

9. Notice that this is a claim about the theoretical commitments ancient Chinese thinkers had about human psychology, not about the ways in which Chinese psychology differs from Western psychology. Running these together sometimes makes Roetz's accusations seem unintentionally personal. Those he identifies as in the tradition of Hegel not only demean Chinese philosophy, but also demean the mental and moral capacity of Chinese people as a race.

both together) in the first place."[10] Although Roetz introduces the issue through
a Hegelian analysis, he seems to disagree with Hegel that a conception of
reason "reveals itself" in a historical tradition—preferring the Kantian "meta-
physical" or "epistemological" posture. Of course, Hegel, like Kant, is a realist
about reason which is what makes his denial that Chinese thinking "achieved
rational self-consciousness" a demeaning claim. From a Nietzschean perspec-
tive, not falling into the delusion of that ancient priestcraft would be to their
credit!

Roetz is not alone in worrying about finding transcendence in Chinese
thought. Benjamin Schwartz expresses a related worry here.

> The main assault against the significance of human consciousness in human affairs
> thus comes not so much from "materialistic" metaphysics as from those social and
> psychological disciplines which crave the presumed mastery and apodictic certainty
> of the natural sciences. . . . Hence the scandalous notion that the deliberations or
> reflections of individuals or groups may influence their own behavior or the
> behavior of others or the even more scandalous proposition that the truth-seeking
> claims of such individuals must be treated as seriously as the truth-seeking claims
> of the social scientist himself is simply unthinkable. . . . Hegel lived at a historic
> point when World Reason was about to become fully actualized in history and he
> was the voice of that Reason . . . if we ascribe to ourselves the capacity to concern
> ourselves with the validity of the ideas we espouse, despite our lack of a privileged
> vantage point, we have no way of totally denying this precarious capacity to
> others. . . . On the contrary we must first take most seriously the degree to which
> adherents believe in the truth of the symbolic systems to which they adhere. . . .[11]

Schwartz here targets "naturalistic interpretive method" more than he does
the attribution of naturalistic theories to Chinese thinkers. This leads him, like
Roetz, to search for an explanatory "heuristic" to justify treating Chinese
thinkers as capable of transcendent (concerned with validity/truth) concerns.
And this worry introduces his approving recitation of the Jaspers concept of
an axial age—to which Roetz also appeals.

I think the worry is misplaced. A naturalistic method might easily attribute
a commitment to a transcendent reality to one thinker and not to another.[12] I
take it a naturalistic interpreter could attribute a transcendental theory to Plato.
Nothing in a naturalistic interpretive method blocks one from agreeing with
Schwartz that ancient Chinese thinkers "concern[ed] [them]selves with the

10. Roetz, 1993b:22.
11. Schwartz, "The Age of Transcendence," *Daedalus* 104, no. 2 (1985): 4–7.
12. Clearly, what content an interpreter attributes to a text surely is a function of both the
method and the actual structure of the text. Some methods may be more likely to attribute
nontranscendent content to their interpretive targets but that should be shown by a detailed
analysis of the method.

validity of ideas" and "believe[d] in the truth" of their doctrines. Postulating a nontranscendent content to Confucius's thought is saying that he took the grounds supporting that conclusion as good grounds and that he was sincere in espousing them. We can put these points without attributing to Confucius a concept of "validity," "belief," or "truth." Using a naturalistic method[13] to argue that this was Confucius's view would not commit us to finding that no Chinese thinker had transcendent or dualistic doctrines—any more than it would force us to deny that Western thinkers did.

A naturalistic (scientific or pragmatic) interpretative method, on the contrary, would normally commit itself to the view that Chinese thinkers drew inferences correctly, that is, they engaged in valid reasoning. However, it would not need to conclude (given the texts) that any philosopher knew or used the concepts central to the Western rationalist tradition. Any plausible interpretation would treat thinkers as normally committed to (i.e., as believing) the assertions they make.

To believe is to believe true. One can believe (i.e., believe true) without having or using either the concept of "belief" or "truth." On the other hand, to believe that you believe, to have the occurrent, explicit belief that my beliefs are true, normally requires both concepts. To credit them with a doctrine dealing with "validity" or "belief" or "truth" is to credit them with the concepts. An interpretation that credits Chinese thinkers with valid reasoning and sincere belief in their doctrines need not conclude that Chinese thinkers had concepts of or doctrines about "belief" and "truth."

I shall, accordingly, continue to rely on a naturalistic interpretive method to focus on the question of transcendental content. Does denying that Chinese thinkers had doctrines of metaphysical, religious, linguistic, or epistemological transcendence "doom" them to some "failure" in moral theory? I will approach this issue by showing how we can assume that those arguing against finding doctrines of metaphysical transcendence or dualism are right and then showing how moral transcendence still could develop.

First, let us set aside some other distracting ancillary worries. The issue is not whether Chinese are like Europeans either in having free will, or a capacity to transcend their historical perspective, or for moral maturity. We may leave aside the perennial philosophical questions: whether individuals of either culture really have free will, a capacity for absolute transcendence, or full moral

13. For a detailed presentation of my method, see Hansen, *A Daoist Theory of Chinese Thought* (New York: Oxford University Press, 1992), introduction. Although I characterize it here as naturalistic (in the mode of naturalized epistemology) and earlier as analogous to a "scientific theory," I follow the Wittgenstein, Sellars, and pragmatic tradition in viewing meaning as a normative category. I emphasize theory to contrast my view that meaning is a theoretical construct with those who treat it as empirical—who claim to "see" meanings. Vaguely, the meaning of a term is the usage norms enshrined in a society's linguistic practice. Despite the sociological starting point, meaning is, as Brandom (1994) emphasizes, "normative all the way down."

responsibility. Let us just stipulate that whatever is true of thinkers in one culture is true of thinkers in the other. We need lay no claim to the special capacity that so worries Schwartz—that we are uniquely able to lever ourselves out of history.

Second, the intellectual/moral capacities of people are not dependent on their doctrines about the psychology, ethics, or nature that may dominate their culture. One may believe that one is unfree and still be free and vice versa. One may believe that there is no such thing as moral responsibility and still have moral responsibilities. One may believe that her thought has liberated her from the gravitational force of history, and she would still be caught in it.

The only issue here is whether one can have a commitment to a naturalistic (or pragmatic, or nondualistic, . . .) conception of reality and still have a philosophically credible commitment to a "transcendent" ethical stance. Let us first survey an account of how metaphysical and moral transcendence are linked in Western thought. The account motivates Roetz's worry because plausibly the two were causally linked in the West.

2. Metaphysical Transcendence

It is easy to take Indo-European notions of transcendence as rooted in dualistic metaphysical doctrines. The most enduring and familiar popular dualism is religious supernaturalism. The most deeply-seated philosophical dualism is mind-body dualism.[14] Both have no doubt had impacts on the development of moral thought. Mind-body dualism is intertwined with claims about reason, emotion, and experience as well as introducing a formal contrast in kinds of substance—mind and body.

Plato turns Socrates's concern with the soul[15] into a philosophical system built around a transcendent reality to which we had access by virtue of our intellectual (rational) character.[16] It was a realm of "meaning objects" which conferred reality and value on the things in this "world." Historically, Western culture wove Plato's world with the Judeo-Christian, supernatural, creator-God of to yield the world view of Christian Europe. The distinctive element is

14. Nondualistic "descendants" of the classical forms of these doctrines may retain a vestigial distinctions but without the strong "transcendence" theme. For example, they may opt for some modern version of supervenience or a Wittgensteinian notion of different language games with different concepts of truth.

15. It may well be that only intellectualized versions of theological systems are fully transcendent in this philosophical sense. Popular beliefs may treat the soul as having spatial-temporal location, a kind of corporeality and so on. Pre-philosophical polytheism may also be broadly naturalistic—the gods have a physical location, are limited by laws (though not necessarily all of ours) and so forth. These "naturalistic" gods may interact with the empirical world because they are literally natural occupants of it.

16. Nietzsche's invective against the "self-hate" implicit in this conception of our "debased" natural state blames it squarely on Socrates. See especially his *Twilight of the Idols*.

the linking of value/meaning to reason/mind and the implicit rejection of values grounded in mere feeling or historical experience. This is the core framework around which the Kant-Hegel-Nietzsche dialogue develops.

I will say little more here about this complex of transcendent metaphysical and psychological notions. I assume, for purposes of argument, that those who are critical of the identification of 天 *tian*[nature:sky] with Europe's transcendental God are right. For purposes of argument, let us stipulate that 天 *tian*[nature:sky] is a component of the world, not outside of it and that its interaction with *di*[earth] and society is a natural interactions. I also assume that other core psychological (epistemological) concepts such as 心 *xin*[heart-mind] are naturalistic, that is, their interactions with other parts of nature, while perhaps not perfectly understood, are natural. That is, we also stipulate that Chinese thinking lacked the mind-body dualism characteristic of modern (Descartes to Kant) Western thought.

I do not dispute the traditional story of the importance of these transcendent notions in the development of Western notions of morality and individualism. At least for purposes of this argument, I accept that Platonic and religious doctrines of transcendence did importantly influence the development of Western notions of objective scientific and moral truth as well as Western versions of ethical individualism. All I shall argue is that they are not necessary to any transcendental ethical conception.

Thus, I limit my focus to Roetz's conceptual question. "Can we understand a philosophical tradition in a 'naturalistic' way and still credit it with a full-fledged conception of morality?"[17] Roetz appeals to Kohlberg's theories of moral development to justify his "heuristic of enlightenment." He emphasizes the postconventional stages which he describes as follows:

> Level C. Postconventional Level
>
> Stage 4½. The stage of "anything goes," the phase of youthful protest. What is the right is a question of arbitrary subjective decision. This stage is characterized by a radical rejection of the alienated conventionalism of Level B and the recourse to the naive pleasure principle of Level A. Instead of new normative rules, this stage proclaims a provocative "beyond good and evil." It is "postconventional but not yet principled."[18]

17. It is unclear to me how strongly Roetz is committed to the view that a capacity for transcendence will produce metaphysical transcendence as well. His attack on Hegel suggested that failure to attribute transcendental religious doctrines to classical Chinese thinkers "doomed" them to lack a "real" ethics. However, in a later disavowing paragraph he says: "Specifically religious transcendence seems neither to be a necessary condition for an objectifying and detached attitude towards the world nor does it necessarily imply such an attitude" (Roetz, 1993b:22). He does not make clear if he intends the disavowal to include other forms of metaphysical or epistemological transcendence or how this concession should be read alongside his attack on Hegel.

18. Roetz, 1993b:20.

Stage 5. The utilitarian, relativistic social contract orientation. What is right is not predetermined, like on Level B. by the existing institutions and social conditions. It is first of all a matter of personal, relative values and opinions. Beyond this it is defined in terms of standards that have been agreed upon by free and equal individuals and that can be changed by regulated procedures.

Stage 6. The universal ethical principle orientation: The right is what is in accordance with abstract, consistent, and universally valid principles. It is based on the autonomous decision of conscience.

In response to "relativists" of various stripes who have attacked Kohlberg's theories as ethnocentric, Roetz avers that the stages are demonstrably invariant across cultures. This is to frame the issue as whether or how Chinese people differ from Western people as regards their capacities for autonomous moral thought. However, the naturalist should assume that we are essentially alike in our adult moral capacities.[19] The interesting question should only be if Kohlberg's description of ideally mature moral sensibility is scientifically accurate or if its characterization relies on moral concepts used only in Western culture.[20] Critics find Kohlberg's statement of the final stage is suspiciously Kantian. The related question is whether all cultures must paint the same picture or have the same theory about what our shared moral capacities are? We may share a human nature and still differ in how we conceive or theorize what that human nature is. The critics' worry was that Kohlberg's description of the developmental phases was theory-laden. He used Western individualist and rationalistic concepts in interpreting his data.

Roetz also joins Schwartz in drawing support from Jaspers's theory of an Axial Age, a heuristic of "enlightenment": "This universalistic approach implies working with the expectation to find a spectrum of normative ideas in China similar to that of our own tradition."[21]

I find this dual strategy puzzling. Supposedly, the Axial Age approach does not signify a physiologically-based, evolutionary "breakthrough" in which human brains became for the first time capable of a higher "level" of mature moral capacity. What is alleged must be that it marks a change in cultural

19. While some evidence suggests that our basic mental capacity is affected by learning language, most such accounts suggest that all human languages have a comparable complexity and richness. See Steven Pinker, *The Language Instinct* (New York: HarperCollins Publishers Inc., 1994), 32–39.

20. An interesting question is whether our languages give us different but equally complex capacities at thinking certain kinds of thoughts—in the way different computer languages are better for different applications. One language may be as rich and expressive as another, and still have different strengths and tendencies. If this is what Roetz intends to deny through Kohlberg, then it would take a good deal more argument. It would appear to rest on the same issue we are addressing here—whether human languages must have the same concepts to count as fully rich, expressive human languages.

21. Roetz, 1993b:23.

attitudes toward morality and our moral conception of our natures. The appeal
also suggests that not all cultures must have had such breakthroughs in insight
even though their members have the requisite physiologically based moral
capacities. So the Axial Age and the Kohlbergian heuristics seem in conflict.

Schwartz's use of Jaspers's idea does not have the same drawback because
he is arguing on a much more temporal plane. Since these grand traditions
started at the same time we may suspect that all had parallel Axial Age
breakthroughs. The weakness is that we still have to show through an inter-
pretive argument that they did not and that the breakthrough took the form
of the familiar Western transcendental concerns. Hence Roetz's strategy of
combining it with the more "universal" of Kohlberg.

Metaphysical and Moral Transcendence

Roetz's conception of moral transcendence is usually expressed as individual-
ist moral autonomy. I will be agreeing with him that the classical thinkers had
a conception moral autonomy but not necessarily that it was individualistic. I
think otherwise our conceptions of moral autonomy are similar. We agree that
Chinese conceptions of morality are conceptions of something that transcends
society—in the sense that a whole society could be wrong about what is moral.
As I say, I agree with Roetz (and presumably Schwartz[22]) that Chinese think-
ers had conceptions of transcendent morality (道 *dao*[guide]) but:

(a) that this conclusion is consistent with denying they had other "ratio-
 nalist" transcendent dualisms (epistemological and metaphysica) and

(b) that nothing in interpretive arguments that rely on analyzing shared
 language and assumptions of thinkers from a period bars us from
 seeing this feature of their ethical thought.

This means that we need only show how a full conception of moral auton-
omy (but not necessarily individualist moral autonomy) can develop from a
different set of shared assumptions using different concepts and language. Let
us start by looking at how Western conceptions of individualist moral tran-
scendence are related to other Western dualisms.

One way religious and metaphysical doctrines of transcendence influence
theories of human moral personality and theories of the transcendent status of
morality is via "wide reflective equilibrium."[23] Moral reasoning and discourse
develop in ways that are broadly coherent with our conception of human
psychology and the "world." In this way, we can explain naturalistically how

22. Schwartz worries that my alleged "linguistic determinism" prevents me from allowing
this. I have denied that my account is deterministic in the way Schwartz thinks (Hansen 1992:
Introduction).

23. See discussion in Margaret Holmgren, "The Wide And Narrow Of Reflective
Equilibrium," *Canadian Journal of Philosophy* 19, no. 1 (1989): 43.

Western concepts of "mind," "reason," and "God" led to the emergence of the deontological individualist conception of moral transcendence in the West. A transcendent God grounds a conception of morality according to which "the (social) world" might be misguided about what is correct. It provides a law-giver for an absolute or transcendent morality—a morality that even transcends our nature. "God" underwrites a conception of morality according to which human nature might be bad. Reason can also serve this role, as can a Platonic dualism that postulates a transcendent world of value—the Form of the Good.

Kant's Formulation

Roetz's and Kohlberg's formulations are familiar adaptations of the Kantian conception of moral autonomy. Our conception of ourselves as moral agents is a conception of reasoning as free from "heteronomy." That is, our choices do not depend on prior desires or inclinations. By virtue of our reason, we are always capable of formulating the question "should I follow this desire/inclination or not? In conceiving of ourselves as "rational beings" we understand ourselves as free from the causal nexus when we are morally responsible. Our freedom is presupposed in our notion of truly moral choice.

Famously, Kant links his version of moral transcendence to an apparently epistemological and metaphysical dualism: the distinction between noumenon and phenomenon.[24] The Noumenal "world" is the realm of freedom. The mind "contributes" conceptual structure to the phenomenal realm. Thus, Kant argues, we must think of ourselves as rooted in the noumenally "free" when we are making moral choices. Kant's conclusion reflects the deep distinction between descriptive and prescriptive functions of language or intellect. When we are making choices, we are not predicting or explaining our behavior, but choosing it.

We also see the core of Kant's line of reasoning reflected in the G. E. Moore's account of the naturalistic fallacy. For any naturalistic description P of "good" or "right" we can ask "is P good?" or "is P right?" The capacity to ask this question points to the kind of moral transcendence that frees us relative to any existing account of morality we hold. Nothing in our nature or socialization is ipso facto right.

24. This "two-worlds" interpretation of Kant is, of course, widely doubted among Kant scholars today. See the discussion in Michael Friedman, "Exorcising the Philosophical Tradition: Comments on John McDowell's Mind and World," *Philosophical Review* 105, no. 4 (1996): 427–68. Modern interpretations of Kant often take a pragmatic line. They detach its moral insights from its transcendental metaphysical trappings. These pragmatic treatments take the noumenal component of our practical reasoning as signaling at most a different "conceptual scheme," rather than a different "world." To approach issues from the point of view of a decision-maker is to employ a fundamentally different way of using language from approaching the world as a descriptive scientist. It would not then require thinking of decision-making as transcendent nor rest on some nonnatural metaphysics.

3. Is Western Moral Transcendence Kantian?

Alan Donagan characterizes the "commonsense" Western morality as a "Pauline"[25] morality and treats Kant as an inheritor of a common conception shared by Platonic and Christian moral traditions. Many Western philosophers have questioned aspects of the Western commonsense moral conception. The dominant counter-tradition in the West is the Heraclitean, then utilitarian, and eventually the "pragmatic" trends in Western thought. A pragmatic view explains transcendence via a kind of social evolution. A society's moral principles of moral discourse develop and evolve through something like wide reflective equilibrium. It does not require a transcendent epistemic capacity of humans as a biological species. A pragmatist is free to hold that any society that has succeeded over a long period must have a moral system with the complexity necessary for this kind of self-reflective moral transcendence. He need not hold that they must all evolve along the same path or to the same autonomous result (that is, one based on reason).

The issue, then, is not whether the orthodox "Pauline" view or the "pragmatic" view of our "human" nature is correct. Many Western theorists have found these alternative analyses of morality can cogently replace the traditional Pauline or Kantian appeal to epistemic or metaphysical reasons for doctrines of moral transcendence. The question is whether a non-Pauline version of a pragmatic morality could have arisen in ancient China. If it could, then we need not presuppose that qua competent thinkers, they implicitly subscribe to our Pauline moral metaphysics or epistemology.

The Pragmatic Version: Compatibalism

The less "orthodox" Western thinkers, from Existentialists to classical and modern pragmatists, mind-body identity theorists, and so on insist that we do not have to postulate a deep split in reality to account for moral reflection and decision. We simply bear in mind that universal natural rationality (that contributed by language and the empirical/natural mind, and so on) works in two natural contexts—the theoretical and the practical.[26] It is one thing to recognize descriptively that my values are a product of my past training and history. It is quite another to make decisions about what to do. When I do the latter, I decide that something is right to do simpliciter, not that it is (descriptively) right from my point of view. That is, I do not implicitly or explicitly relativize

25. Cf., Alan Donagan, *The Theory of Morality* (Chicago: University of Chicago Press, 1977). Donagan's name for this moral conception reminds us, again, of Nietzsche's view that Paul, not Christ, is responsible for the "anti-nature" element in Western Christianity.

26. Even allowing a fundamental split between theoretical and practical offends the spirit of pragmatism. Pragmatism would ground the theoretical in its normative features. But the split does not involve any claim of metaphysical transcendence or fundamental dualism.

the practical judgments I make to my perspective even when I accept that my perspective has a social-historical, causal ancestry.

The Pauline/pragmatist split in Western ethical links up with the venerable freedom vs. determinism issue. Kantian "purists" insist that when we make decisions or act voluntarily our "awareness" of freedom forces us to reject the scientific picture of ourselves in the world as incomplete. The alternative is to reject our moral self-image as decision makers. In outline, this is because freedom (moral responsibility) and universal causation are incompatible. The Pragmatic thinkers are more inclined to accept "compatibalism" or "soft determinism." We are indeed natural creatures, subject to universal causation and scientific laws yet we are free in every way that matters.

Tautologically, we are not free in the sense that our actions are uncaused or inexplicable by a theoretically possible social science. That kind of freedom, as compatibalists from Hume to Dennett have argued, is "not worth having."[27] Compatibilists would argue that contra-causal freedom is not only not important, its randomness even makes it unappealing. I want to think that my actions are causally linked to my character and past choices and that they do exhibit a kind of consistency.

We can make a similar point about transcendence. It is hardly more comfort or self-affirmation to view my moral views as transcendent in the sense of being dictated by some transcendent reality than as being dictated by society. Still, I do want my values to be social at least in the sense that to affirm them is to affirm them as applying to everyone and as important to our shared communal lives. What is "worth having" is autonomy from the social determination of value that is still realistically grounded in my social relations. No special worth comes from exchanging transcendent God-dictation for worldly-dictation.

Roetz, of course, is not alone in finding pragmatic accounts unsatisfying. I do not mean to suggest the philosophical issue is settled in favor of naturalism. Roetz draws attention to what are still important and controversial philosophical issues. The "transcendental" conception has able defenders. Thomas Nagel formulates a version of modern resistance to naturalist compromises and similarly advocates a metaphysical-epistemological ground of moral and logical transcendence.

> My own opinion is that there is such a thing, or category of thought, as reason, and that it applies in both theory and practice, in the formation not only of beliefs but of desires, intentions, and decisions as well. This is not to say that reason is a single thing in every case, only that certain decisive aspects of our thought about such very different matters can all be regarded as instances of it by virtue of their

27. I borrow this phraseology from the title of Daniel Dennett, *Elbow Room: The Varieties of Free Will Worth Wanting* (Cambridge: MIT Press, 1984).

generality and their position in the hierarchy of justification and criticism. I shall refer to this as the rationalist position.[28]

Now I find [Peirce's] declarations not only eloquent but entirely congenial; but they have a radically antireductionist and realist tendency quite out of keeping with present fashion. And they are alarmingly Platonist in that they maintain that the project of pure inquiry is sustained by our "inward sympathy" with nature, on which we draw in forming, hypotheses that can then be tested against the facts. Something similar must be true of reason itself, which according to Peirce has nothing to do with "how we think." If we can reason, it is because our thoughts can obey the order of the logical relations among propositions so here again we depend on a Platonic harmony.

The reason I call this view alarming is that it is hard to know what world picture to associate it with, and difficult to avoid the suspicion that the picture will be religious, or quasi religious. Rationalism has always had a more religious flavor than empiricism. Even without God, the idea of a natural sympathy between the deepest truths of nature and the deepest layers of the human mind, which can be exploited to allow gradual development of a truer and truer conception of reality, makes us more at home in the universe than is secularly comfortable. The thought that the relation between mind and the world is something fundamental makes many people in this day and age nervous. I believe this is one manifestation of a fear of religion which has large and often pernicious consequences for modern intellectual life.[29]

Nagel's valid point is that we do not qualify or relativize our "commonsense" moral (as well as logical) judgments to context. When we justify them, we do not qualify or relativize our reasons either. Nagel finds this difficulty in all forms of relativism emerges when they try to explain reason naturalistically. Such projects, he argues, threatens to end in vacuity or self-contradiction. A reasoned argument for the naturalistic "reduction" of reason undermines itself.[30] It says that its own reasoning is merely a cultural prejudice. But a cultural prejudice is that which one may reasonably ignore. So, Nagel suggests, we cannot ultimately avoid a notion of a transcendent reason and truth. Moral autonomy because it is rooted in the notions of thought and reason, must lead us to a more complex world view than "naturalists" could accept. Thus, he hints, we cannot escape Platonism.

A naturalist could observe that Classical Chinese thinkers did not have obvious access to the crucial concepts and theories behind Nagel's reasoning

28. Thomas Nagel, *The Last Word* (New York: Oxford University Press, 1997), 6.

29. Nagel, op. cit., 129–30.

30. Naturalists would agree that a naturalistic account of reason is indeed a challenge, but it is premature to decide that it is impossible. Nagel is targeting one particularly interesting and successful attempt by Robert Nozick in Nozick, *The Nature of Rationality* (Princeton: Princeton University Press, 1993).

here. First, Chinese thought has a different sense of the religiosity in which nature itself (rather than its transcendent creator) is an object of religious awe. Secondly, as I have argued at length elsewhere,[31] it does not have the crucial Platonic concepts: reason, the mental (thought as content), logic, the belief-desire psychology, and the explanation of action via "practical reason." I have also suggested that other mainstays of the Kantian picture of human agency contrast with the shared view of most Classical Chinese thinkers. These include the notion of "metaphysical" free will and moral responsibility.

If we accepted Nagel's intuition, would it be enough to conclude that Classical Chinese thinkers must have viewed things as Kant, Nagel, Kohlberg, and Roetz do? Hardly, since it is demonstrably not enough to conclude that all Western thinkers all view things this way! Nagel may disagree with naturalists of the Western tradition from Heraclitus to Hegel, but he does not thereby denigrate them or deny their moral integrity. He certainly does not show that it is impossible to interpret them naturalistically. So his argument may give him a reason to disagree with Chinese thinkers, but not to disagree with an interpretation that attributed naturalist or pragmatic views to all of them.

If the transcendental rationalists are right, all it proves is that rational thinkers should postulate some "spooky" transcendent reality. The issue is not who is right about the philosophical issue, but whether a pragmatic approach adopted in a historical society can underwrite that society's development of a conception of moral transcendence. Can Chinese thinkers be moral objectivists while not merely eschewing, but completely lacking counterparts of the familiar Western ancillary notions of metaphysical, epistemological, or religious transcendence? Let us look at a way of interpreting the ancient Chinese dialectic that would suggest that they can.

4. Chinese Religious Naturalism

Roetz acknowledges that we should check whether attributing Kantian insights to Chinese thinkers is confirmed by the texts. However, he suggests that the combination of Kohlberg's empirical research and Jaspers's Axial Age hypothesis gives interpreters a prima facia reason to expect a range of concepts and doctrines similar to ours. Accepting these hypotheses considerations should affect the initial plausibility of interpretations. Other things being equal, we should prefer the former interpretative choice that attributes transcendent insights to a thinker to one that attributes "naturalistic" insights. Kohlberg and Jaspers should give us reason to expect that some thinkers, simply because they are reflective, are committed to a counterpart of transcendent reason, transcendent truth, and the transcendent autonomy of moral agents.

A naturalist methodology would prefer to look for reasons in background

31. See Hansen, 1992.

beliefs and modes of discourse for ways of explicating transcendent insights. The question is whether an ethical conception can be explained within a naturalistic method that assumes a naturalistic surrounding world view. Is there a "wide reflective equilibrium" route from Chinese naturalism to a full morality?

I would join Roetz in distinguishing my views from those of Henry Rosemont who traces his argument to Fingarette's discussion of "A Way Without a Crossroads." Rosemont suggests that we should resist of Classical Chinese philosophers as having the concept of morality at all since they lack our concept of individual moral choice. I doubt, however, that Roetz's arguments can rule out the Rosemont-Fingarette interpretation in principle.[32]

However, a naturalistic interpretation might resist the Rosemont-Fingarette line in the way it resists Roetz's insistence on Axial Age and Kohlbergian arguments. It relies too much on a Kantian conception of morality and moral choice. Kantians, in turn, regard compatibilists as "revising" our ordinary notions of "free will" and "responsibility." However, it is harder to argue that compatibilists and naturalists have revised our notions of "choice" and "morality." Kantians may argue that utilitarianism is the wrong moral theory, but the attempt to argue that by definition it is not a moral theory is a classic example of analytic philosophy gone wrong. The attempt to import substantive moral doctrines into the analysis of the meaning of terms supported by conceptual legislation/enforcement seldom resolves any serious philosophical issues.

The question, of course, is what definition of "morality" we should use to address the questions posed in their different ways by both Rosemont and Roetz. I propose to focus on Roetz's issue: transcendence. A real morality should be distinguished from mores. Another way of labeling the distinction is critical or rational morality and contrasted with positive morality. That is, the concept of morality implicitly postulates a distinction between itself and de facto social beliefs about morality. We find this crucially transcendent feature of morality in the awareness that a whole society could be wrong about what morality requires. Thus, the concept of morality is inherently a concept that could motivate a society to moral reform, that is, reform not merely of their practices, but of their widely shared moral attitudes themselves.

Beyond such transcendence, I choose to treat morality as an essentially disputed concept. That is, all more particular characterizations are subject to meaningful challenge. The challenges could take the form highlighted by G. E. Moore in naturalistic definitions of "the good." For any proposed naturalistic

32. I actually tend to find it quite plausible for the main thinker with which Rosemont and Fingarette are concerned — Confucius himself. However, I would be more inclined to count this as showing that Confucius was not yet a philosopher. I find it far less plausible to deny that the Mohists, Mencius, Xunzi, and the Daoists had no concept of (moral) choice. Paradoxically, from my naturalist point of view, Rosemont and Roetz share a failing: I believe both rely too much on controversial aspects of a Kantian account of what counts as a morality.

characterization, X, one could, without misusing the term, ask "must morality be X?" Thus, while I will not argue that Rosemont and Fingarette's individualist characterization of morality is wrong, it would take much more argument to show that it is the minimal acceptable conception of morality. One who rejects the Kantian elements of the conception is not obviously misusing the term "moral."[33]

We can, however, happily stipulate that the Western historical philosophical tradition typically explicates this transcendent character of morality using concepts like "reason," "individual autonomy," "free choice," and other concepts focusing on the individual agent. For our purposes, however, transcendence itself is the issue, not these particular ways of explaining it. Autonomy is crucial—but the autonomy of morality, not of individuals. Morality must be a concept that floats free from social constraint; a real concept of morality is one that can motivate moral reform of society from the inside.

5. The Evolution of Moral Reason

The denial that Chinese ethical thinkers operated with a concept of transcendental reason would seem less "demeaning" if we bear in mind the currently beleaguered state of its shaky Platonic foundations. Western thinkers have been "deflating" reason for long enough to make this theme a familiar one. Nagel's targets include Hume, Wittgenstein, W. V. O. Quine, Hilary Putnam, Bernard Williams, and Richard Rorty. He even criticizes Kant himself (since Kant relegated reason to the phenomenal world and denied it a place in "things-in-themselves").

Recent "naturalistic" writers on ethics have formulated interesting revisions of the notion of reason as applied to morality. Besides Williams, they include Blackburn's "quasi-objectivism" in morality, Gibbard's "norm-expressive" interpretation of moral reasoning, and Nozick's decision theoretical account of the "Nature of Rationality."[34] These naturalistic accounts share a common theme. We can understand reason as a set of natural norms enshrined in complex evolutionary and social discourse practices as norms of commitment, entitlement, and inference. The social norms include epistemic norms of justification which create the possibility of self-criticism and correction.

Now we can construe moral transcendence as a norm of justification of

33. The issue is complicated, though, by the whole issue of the boundary between meaning and belief. We may come to regard the outcome of any argument along these lines as settling the meaning of the term. The important point is that the conception is appropriately disputable in philosophy. We may understand the basis of the dispute to rest on the difficulty of determining the meaning rather than as a theoretical issue that goes beyond meaning.

34. See Simon Blackburn, *Spreading The Word: Groundings in the Philosophy of Language* (Oxford: Clarendon Press, 1984), Alan Gibbard, "Norms, Discussion, and Ritual: Evolutionary Puzzles," *Ethics* (1990): 787–802 and *Wise Choices, Apt Feelings: A Theory of Normative Judgment* (New York: Oxford University Press, 1990), and Nozick, op. cit. (1993).

moral norms that disallows direct appeal to the existence of a traditional practice. The community's practices of moral discourse can enshrine such a rule. It does so when such appeals are validly rejected by other community members. Social facts, may in some sense, explain these norms, but the norms so explained forbid ultimate normative appeal to the mere fact of social acceptance. Justification or warrant always depends on appeal to a norm—not to a bald fact. That norm, in turn, would normally be one we accept, but the fact of our accepting it, does not justify it and it is implicitly open to further normative challenge. Justifying each successive norm we appeal to in reasoning always requires deriving it from other norms.

Thus, a nonmetaphysical notion of objectivity is fully available within a social conception of normative discourse without postulating a faculty of human reason. The pragmatic view never requires the theoretician to assume she has some epistemic access to a transcendent truth or an ultimate insight into the normative question. We can generate all the autonomy worth having within a scheme of epistemic and ethical norms enshrined in social practices that have this norm-objectivist character. Such a conventional scheme can generate the familiar complexity and autonomy of real versus merely conventional truths.

Thus, we accept Nagel's worry that we cannot escape from an infinite chain of appeals to any "given" social view. We agree that we can question any socially shared attitude. When we accept the doubt, we may appeal to some other shared attitude, but we do not appeal to it qua shared attitude, we appeal to it qua justifying norm. So the naturalist cum pluralist need not accept any wording by transcendentalists that appends "mere" to the social norm to which she appeals. We need not treat the norms as irrational "prejudices" as long as we accept a quasi-objective social norm. We can claim that logically we rely on a norm. Trivially, if we appeal to a norm, we have access to and acknowledge a commitment to that norm. Still, we nowhere rely logically on the fact of our commitment to that norm. We trivially regard our commitments as "true" (or would if we had or used that concept) and as important (not "mere").

Given this richer pragmatic conception of social norms, we may wonder in what sense Nagel's or Roetz's "real" justification differs from justification simpliciter. Presumably, real justification would start from the top down—from some a priori, rational insight into an ultimate, categorical principle, a "real" moral truth. We would use some noninferential (rational?) access to a transcendental first premise to build a real justification to the chain of norms.

The truth of the first premise and our epistemic access to it would be "spooky" or religious. Thus this transcendental perspective is typically also absolutist. Pluralists would find the residual Platonism in this account no more convincing in morality than in mathematics. We do not have to claim that we have to have some immediate, intuitive "real" grasp of "infinity" to understand mathematical induction. It is enough that we understand a recursive procedure.

6. The Chinese Case

Let us now turn to the question of how Chinese thinkers from the classical period dealt with these metaethical issues. Unavoidably, my brief survey will make contentious interpretive claims. Methodologically, as well, I have agreed to assume an interpretation on which they accepted neither Indo-European mental (epistemological) nor metaphysical transcendence. I will assume they had no access to the conceptual structure familiar in Western discussions of "reason," "beliefs," "truth," and so forth.[35] My goal is to show that they can be interpreted as achieving moral transcendence, a moral transcendence that matters, while still interpreting their metaphysics, epistemology, and philosophy of psychology as nontranscendent.

Again, I will rely on my naturalistic interpretive methodology—eschewing appeal to Axial Age or allegations of pan-human capacities for such thought (beyond those necessary to explain their ability to acquire a full human language). If, given their language, terms of analysis, and background beliefs, they can still formulate an acceptable pragmatic counterpart of moral transcendence, then we will defuse the alleged need to project our transcendental dualisms on Chinese thinkers. We will not have to credit them with Western or Kantian insights or epistemic access, qua rational beings, to a Western conception of moral transcendence. Relying on a naturalistic interpretive approach, we can explain fully moral doctrines as arising from naturalistic metaphysical and epistemic views.

To start, let us contrast Platonic and Chinese baseline ethical models. Confucian moral and political theory did (as Hall and Ames and Rosemont claim) emphasize the historical embeddedness of moral reflection. Some of their resulting doctrines may be deficient in ways that Nagel correctly diagnoses. Others in the Chinese tradition, however, clearly seem sufficiently reflective and subtle to resist the errors. Thus, the natural growth of reflective enlightenment can explain the emergence of the kind of moral transcendence worth having.

Confucian Embeddedness

Let us accept arguendo that the early school of Confucius approximates an extreme model of historicist embeddedness—to the point that Confucius, notoriously, denies being anything but a transmitter. His 道 *dao*^guide approximates Williams's ideal type of hyper-traditionalism.[36] That is, the correct thing to do is follow tradition somewhat uncritically.[37] To the degree that a practical

35. I defend these interpretive postures in Hansen, op. cit. (1992).

36. Cf., Bernard Williams, *Ethics and the Limits of Philosophy* (Cambridge: Harvard University Press, 1985).

37. This embeddedness survives in the "Asian Values" resistance to rational or critical assessment and reform of traditional political attitudes. This is a form of the Rosemont-Fingarette hypothesis.

religious community does not make the distinction between conventional and right (between *li*rites and *yi*morality) one may justifiably suspect they lack a fully realized understanding of any concept that would count as a translation of "morality."[38]

The *Analects* still nicely illustrates, Nagel's point, however. The traditionalists are[39] pulled in an objectivist (Mencius) direction by the very kind of question Nagel says all "embedded" systems must face. While accepting the traditional as right, the Confucian still assumes some "really" correct answer to the question, "how should we follow the traditional 禮 *li*ritual?" They do not assume that however society historically happens to follow the *li* is the correct way to do so.

This objectivist worry lies behind the Confucian doctrine of 正名 *zheng-ming*$^{rectify\ names}$. Any attempt to appeal to tradition in correcting how we apply the names (words) of the 禮 *li*ritual in guiding our action begs the question. It is our way of using them that has been called into doubt. So a traditionalist morality must either be utterly quietistic or assume the possibility of moral reform. I have argued[40] that the way out explored in the *Analects* takes a step towards the Mencian solution—introducing some intuitive access to the objectively right interpretive answer: 仁 *ren*humanity.[41] If early Confucianism ever was radically traditionalist, its traditionalism was already destabilized by considerations raised in the *Analects* and the roots of the orthodox intuitionism of mature Confucianism were already present.[42]

Mohist Transcendence

The Mohists make generalizing Rosemont's case beyond early Confucianism difficult. Mohists so clearly formulate the contrast of convention or 禮 *li*ritual and morality using the concept of 義 *yi*morality that it is hard to avoid the view that 義 *yi*morality is our requisite "quasi-transcendent" notion. It shows that norms governing its use forbid deriving judgments about what is 義 *yi*morality from what is traditional practice. Furthermore, the *Mozi* gives us a glimpse at the

38. The most common translation of 義 *yi*morality is 'righteousness'. This makes it sound like a purely religious concept. My argument for resisting this traditional translation draws mainly on Mozi's use of the concept, not Confucius's. I assume, however, that it is common currency between the two rival schools and that the norms of its use are in force for Confucius as well as for Mozi.

39. I argue for this at length in my (1992), cited in note 13.

40. Ibid.

41. Roetz would argue that this shows the Confucians had individual access to the autonomous, transcendental morality. That requires acknowledging their claims of special access and I don't see what reason we have to do that. They surely don't give a Kantian or rationalist account of how the access works.

42. For a different but related account of the relation between 仁 *ren*humanity and 禮 *li*ritual, see Kwong-loi Shun, "*Jen* and *Li* in *The Analects*" *Philosophy East and West* 44, no. 3 (1993): 457–79.

workings of the Chinese functional replacement for Kantian choice — the notion of a 辩 *bian*distinction dispute based on 是 *shi*this:right and 非 *fei*not this: wrong.

> People up North in the land of Kai-shu have a conventional moral practice that when the first son is born, they tear him apart and eat him. They teach that it will make the other sons stronger. Their elders and teachers and superiors all support this tradition and no one has ever doubted it. They have practiced it for years, but can we say that it is the *dao* 道 of *ren*benevolence 仁 and *yi*morality 義 ?[43]

Mozi did appeal to a "reality" for some of his arguments in favor of transcending social 禮 *li*ritual. It was 天 *tian*nature:sky. 天 *tian*nature:sky was the author of the moral standard, utility, to which Mozi appeals in his moral reform. Mozi stressed that 天 *tian*nature:sky was universal, not bounded in the ways cultures, states, and societies were. It was "constant" where cultures and conventions could change. These claims do not entail that 天 *tian*nature:sky is the Chinese name for the Western God, Elohim. Nor does it conflict with the assumption that 天 *tian*nature:sky is a part of nature.[44] It essentially gave a "naturalistic" basis for the moral norm of maximizing utility. It grounded a conception of a natural value as opposed to a social one, but not necessarily of a transcendent, supernatural, or spooky value.[45]

In fact, the *Mozi*'s use of *tian*'s standard approximates the use pragmatists make of nature in their arguments for extracting norms from nature and social practices. Mozi did not find how the standard worked by revelation or by hearing a booming voice command it or seeing a finger of fire write it. He derived it from observations about how 天 *tian*nature:sky operated in practice. He was appealing to a version of the argument from design but not to prove a religious theory of a transcendent creator of the world. He did not use it against

43. The *Mozi*, "Moderation in Funerals" (See alternatative translation in Burton Watson tr., *Mo Tzui: Basic Writings* (New York: Columbia University Press, 1963), 75). Roetz (1993b: 2) highlights this same passage in initiating his claims about moral transcendence. Given his declared intention to defend Confucian Ethics, the fact that he has to go to Confucius's main philosophical opponent to find a clear statement that an "insight into the difference between the normatively valid and the merely current is characteristic of the consciousness of the Chinese 'axial age'" certainly gives Rosemont and Fingarette room for their analysis of Early Confucianism's failure to take this difference on board in their moral theory.

44. Standard accounts of 天 *tian*nature:sky trace its evolution from an anthropomorphic deity to a nature concept. If it was anthropomorphic, that grounds an analogy to the Christian God, but is not enough to imply transcendence. The Greek gods were anthropomorphic, but, arguably, they were on this world — on a particular mountain. Similarly, I would argue that the Mormon God, who lives on a planet near a star called 'Kolob' somewhere close to the center of the Milky Way and is subject to physical laws, is anthropomorphic, but not, in the traditional Christian sense, transcendent. The doctrine of "mandate of heaven" uses of *tian*nature:sky also suggests a single-world context. *Tian*'s "intervention" in support of revolutions did have a moral basis, but was typically operated via natural processes.

45. Traditional interpretations assume Mozi's 天 *tian*nature:sky is a form of religious supernaturalism. I argue against that view in Hansen (1992).

the background of such a religious view about creation. He argued directly for a natural guiding norm. He held this principle to be available to us via "objective" measurement in nature—not as a "rational" or religious intuition (intuition) that operates situationally.

Mozi did appeal to a contrast between the constancy of nature and the variability of social conventions. He took the issue to be "What kind of moral insight was constant in the sense that I was common to all societies and times, applied in all circumstances and so forth?" Despite the familiarity to Westerners of the use of similar arguments in transcendent contexts, this fact gives us no reason to suspect that Mozi thought that achieving such constancy required transcending the natural world or that we must have one Kantian foot in some transcendent reality.

Mozi, on this naturalistic interpretation, retains a kind of embeddedness— namely, that of the classical Utilitarian. It is a fact that natural kinds value maximizing utility. In Roetz's Kantian terminology, Mozi is still "locked in heteronomy."[46] Mohism takes the ultimate standard as naturally given and accepts our embeddedness in the natural world. The ultimate norm is not a matter of a radically free decision or choice, but of measurement. The *Mozi*'s ultimate principle is subject to a naturalized version of the standard criticism of any divine command morality (that is, G. E. Moore's criticism of any naturalistic morality).

Mozi's utilitarianism differs from its Western counterparts in other interesting ways that bear on the transcendence issue. His measure of utility is not mental, private, or subjective. The subject of the moral autonomy his argument vouchsafes is not the individual. He seemingly shares the Confucian notion that a *dao* is a social guide. As a moral reformer, he questions what social *dao* we (the society) ought to use in guiding our behavior. Then he urges we make a social choice to follow a path of moral reform that will naturally result in the individuals in society following a different path from the one they now follow. The locus of the autonomy necessary for conceiving of moral reform is not placed in individuals, but in the normative or guiding discourse (道 *dao*[guide]) itself.

The *Mozi*'s replacement for Confucius's traditional, authoritarian 正名 *zheng-ming*[rectify names] is also naturalistic. His model of standards for settling questions of *shi-fei*[this-not this] 是非 are the craftsman's operational measurement tools. We do not rely on an intuition (implicitly suggesting that our moral intuitions are themselves embedded in historical traditions and share their lack of constancy) or on reason. Measurement is not a Platonic absolute, but an oper-

46. One may speculate that this was part of Mencius's point in accusing Mohists of having two bases. Mencius does not, to say the very least, explain this charge but the context allows us to speculate that he might have had something like this in mind (along with a plethora of other possibilities). See *Mencius* 3A:2 and the discussions in Kwong-loi Shun, *Mencius and Early Chinese Thought* (Stanford: Stanford University Press, 1997).

ation in the natural world. It is highly reliable,[47] inter-subjective, but pragmatic (rather than abstract "ethical") interpretation of society's guiding discourse.

Mohist focus on standards introduces a key mechanism for quasi-objectivity. By broaching the idea that we can use one distinction (利 *li*[benefit] 害 *hai*[harm]) to fix another distinction (是 *shi*[this:right] 非 *fei*[not this: wrong]), the Mohists start a process of recursive justification. Mohists themselves stop at the next level, failing to ask the Daoist question, why one should follow the standard of 天 *tian*[nature:sky]. Like any other divine command theories, their position formally falls short of full moral autonomy—but note that it would even if 天 *tian*[nature:sky] were a supernatural transcendent deity.

The *Mozi* does pass close to a nature-embedded version of what Indo-European philosophers call "reason" but without the crucial formal content of the notion of a valid form of a proof (a sequence of sentences). Mozi observes that no one can resist his words. He also uses something like testing for coherence in his criticism of Confucian partiality. However, he does this without ever revealing any impulse to identify a human intellectual faculty with the capacity for logical or practical inference or the ability to recognize and accept sound arguments. Here is an example of Mozi's close brush with "rationality."

> Suppose here is a broad plain, a vast wilderness and a man is buckling on his armor and donning his helmet to set out for the field of battle, where the fortunes of life and death are unknown; or he is setting out in his lord's name upon a distant mission to *Ba* or *Yue*, *Qi* or *Jing*, and his return is uncertain. Now let us ask, to whom would he entrust the support of his parents and the care of his wife and children? Would it be to the universal minded man, or to the partial man? It seems to me that on occasions like these, there are no fools in the world. Though one may disapprove of universality himself, he would surely think it best to entrust his family to the universal-minded man. Thus, people condemn universality in words but adopt it in practice, and word and deed belie each other. I cannot understand how the men of the world can hear about this doctrine of universality and still criticize it![48]

Mencian Transcendence

The *Mencius* formulates a response to Mozi's transcultural arguments against traditionalist Confucianism.[49] Mozi forces the Confucian response into a moral

47. Mozi's formulation reminds us that it is not transcendentally reliable. "Although the unskilled may fail to be as accurate, they nevertheless get much better results if they follow these standards in the work which they do." E. R. Hughes, tr., *The Spirit of Chinese Philosophy* (London: Routledge & Kegan Paul, 1947).

48. *Mozi* 16.

49. I should make this as a logical rather than textual claim. It may well be that the various writers of the *Mencius* were more involved with debates within Confucian schools and merely

posture that mirrors that of the Mohist. The *Mencius* takes on board Mozi's transcultural conceptions of 仁 *ren*[humanity] and 義 *yi*[morality] as well as the Mohist notions on 是 *shi*[this:right] 非 *fei*[not this: wrong] in its famous doctrine of the "four hearts." Standard accounts of Mencius make him sound Kantian in his opposition to any utilitarian morality. Further, his metaethics highlights a "universal" source of moral insight—again 天 *tian*[nature:sky]. The access to this objective morality, however, is not Kantian reason but an arguably natural 心 *xin*[heart-mind]. What the 心 *xin*[heart-mind] "intuits" is not a moral maxim or principle, but each particular, situational choice to "do this, not that." The inherent moral capacity of all humans consists in an articulated structure of natural moral dispositions to action in context. They must, however, be prior to conventions and social practices to stand up to Mohist challenge.

> In past generations, people did not bury their parents. When their parents died, they picked them out and put them in a hollow. On another day when they were passing by the foxes were eating them and the flies and maggots sucked away at their flesh. Their brows broke into a cold sweat and they averted their gaze. The sweat, in fact, was not for shame or approval of others, it was their inner heart-mind revealed on their external demeanors. They returned home, came back with baskets and shovels and covered them up. Burying them was sincere approval, and thus filial sons and benevolent people came to bury their parents—it became, in fact, necessary that we have this 道 *dao*[guide]. Xuzi told this to Yizhi. He contemplated a while and said, "He's treating it as 命 *ming*[mandate]."[50]

Of course, the society-transcending account of the four hearts is the well-known gambit in Mencius. However, some more interesting transcendence claims come in less noticed details of the text. This account, for example, parallels a "contextual" point Rawls make about his naturalized "reflective equilibrium." A conception of justice will be judged adequate when the practice of it naturally leads to a greater commitment and concern with it. It is naturally self-reinforcing (Rawls 1971:498). Mencius says:

> 仁 *ren*[humanity] 義 *yi*[morality] 禮 *li*[ritual] and wisdom are not something pushed on us from without. We inherently have them but just haven't thought them out. Thus they say: "If you try, you will get it; if you abandon it, you will lose it." Some double, some fivefold and some incalculably expand them. It's because we can never exhaust the ability. The Book of Poetry says: "Nature gives birth to all humans. If there is a thing, there is a rule. When people sustain the norm, they come to love their many virtues." Confucius said, "The writer of this poem certainly knew the 道

used its references to Mohism and Yangism as negative rhetorical examples in this intramural debate. Thanks to Dan Robins for this warning.
 50. *Mencius* 3A:5.

dao^{guide}. Therefore, wherever there is anything, there is a rule. When people sustain norms, they love their many virtues."⁵¹

Other sections almost sound like paraphrases of Kant's insistence that reason can question any natural desire or inclination.

> Mencius said, "The organs such as the eye and ear cannot think and are misled about the kinds of things there are. Thing-kinds intertwine with other thing-kinds, which lead them further astray. The function of the heart-mind is to think—if you think you will get it. If you don't think, you won't. This is what 天 *tian*^{nature:sky} has bestowed upon us. If you first establish the greater part, then the lesser parts cannot usurp their position. This is how you become a great person."⁵²

However, in the end, Mencius's position, like the Mohists', rests on 天 *tian*^{nature:sky}, that is, on accepting our nature as the given normative reality. In the spirit of Kant and Nagel, the Mohist move that undermined convention could be applied in the same way to human nature and the intuitive heart itself. We can always ask, "Should we not modify our natures?" In fact, the *Mozi* does implicitly pose this question.

> Let us take two rulers. Make one of them *zhi*^{grasp} *jian*^{universal} and the other grasp *bie*^{partial}. Then the *bie*^{partial} ruler's language will say, "How can I be as concerned about all my subjects' well-being as I am about my own? This radically conflicts with the reality of the world. People have no choice but to live on this earth—like galloping horses through a slit." Thus he retires and sees his people starve and does not feed them, they freeze and he does not clothe them, are ill and he does not nourish them, die and he does not bury them. The *bie* ruler's words are like this and his actions the same. The *jian*^{universal} ruler's language is different as is his action. He says, "I have heard that, concerning the kingdom, an enlightened ruler puts the well being of the populace before his own. He only then counts as an enlightened ruler." Accordingly he retires and sees his people starve and feeds them, they freeze and he clothes them, are ill and he nourishes them, die and he buries them. The *jian* ruler's words are like this and his actions the same.⁵³
>
> Within less than a single generation, people can be changed. They will seek to affiliate themselves with those above them.⁵⁴

The later Mohists, like Zhuangzi, reject the appeal to human nature as ultimate. Mencians actually seems to acknowledge the "objectifying" doubt to

51. *Mencius* 6A:6.
52. Ibid., 6A:15
53. *Mozi* 26/16/35–41.
54. Ibid., 27/16/74.

which Nagel alludes. The text exhibits various strategies to argue for the authority of the innate 心 *xin*^heart-mind. These, however, all fall to the "open" question. The heart-mind is what distinguishes us from animals. (So why should we make ourselves different from animals?) The heart-mind is an organ of the body like a finger. (So why should we favor it over other organs?) The heart-mind is our "higher" selves. (Why should we want to identify with our higher self?) Recognition that these lines of argument all require would be the crucial textual evidence that Chinese thinkers achieved full "pragmatic" transcendence. I submit that Zhuangzi's criticism of Mencius does exactly this.

Daoist Transcendence: Standards Regress

I interpret Daoism as a metareflection on social *dao*'s. It is transcendent in the traditional sense that it sets up an opposition of 天 *tian*^nature:sky and 道 *dao*^norms: guide. Daoism is pragmatically transcendent but distinctly un-Kantian. Daoism implicitly accepts the dominant naturalism and social focus characteristic of other Chinese thinkers. The result is a qualified skeptical attitude toward morality. The skepticism implicitly treats as possible or conceivable that something "really moral" may conflict with both our natural and our social attitudes and judgments. However, it does not claim some "spooky" access to that moral insight—it is skeptical rather than dogmatic transcendence.

There are two ways to explain a Kantian insight about transcendent judgments arising from awareness of different perspectives. One is to have a direct intuition that something must be really right. The other is to note that the different perspectives disagree and dispute in a common language. They take each other to be making un-relativized judgments about the subject of the dispute and therefore as being in conflict. The Kantian insight can take a purely skeptical form. We understand the transcendental point when we wonder if either alternative is right or if there is any real right. The skeptical transcendence does not postulate or presuppose a right answer. It arises merely from taking on board that there are other perspectives that conflict with our own. It does not start by assuming that one of us is right, but that (at least) one of us is wrong.

The *Zhuangzi*'s approach to the Ru-Mo debate best exemplifies this autonomous but pragmatic transcendence. In their disagreement, as he analyzes it, each is presupposing its own system of standards for linguistic assertion and spinning out moral schemes that fit that standard. However, the *Zhuangzi* denies that we have any way to get wholly outside these historical systems of standards to know which is correct. You can't get a *shi-fei*^this-not this 是非 out of the 心 *xin*^heart-mind without having it "grown" in.

> Suppose you and I have had an argument. If you have beaten me instead of my
> beating you, then are you necessarily right and am I necessarily wrong? If I have

beaten you instead of your beating me, then am I necessarily right and are you necessarily wrong? Is one of us right and the other wrong? Are both of us right or are both of us wrong? If you and I don't know the answer, then other people are bound to be even more in the dark. Whom shall we get to decide what is right? Shall we get someone who agrees with you to decide? But if he already agrees with you, how can he decide fairly? Shall we get someone who agrees with me? But if he already agrees with me, how can he decide? Shall we get someone who disagrees with both of us? But if he already disagrees with both of us, how can he decide? Shall we get someone who agrees with both of us? But if he already agrees with both of us, how can he decide? Obviously, then, neither you nor I nor anyone else can know the answer. Shall we wait for still another person?

Suppose we use the standard of 利 *li* benefit 害 *hai* harm or tradition or some alternative. Given that choice, we still have to choose how to interpret that standard. What standard shall we draw on for that? As soon as we formulate it, we can raise the same series of questions again. The *Zhuangzi*'s moral transcendence arises from the awareness that we can raise such questions recursively. It does not (pace mystical interpretations) presuppose any supernatural epistemic access to an absolute or transcendent reality. The capacity to see that our community's linguistic conventions allow recursive or reflective application and thus allow us to raise self-correcting questions again and again. This does not require that we start by postulating an intuition into a real moral truth or an ultimate answer.

The base of Zhuangzi's move to moral transcendence was the recursive use of Mozi's original question about tradition. Once that question is "in the tradition" it can be reapplied to any proposed reform standard. Moral transcendence can thus emerge naturally within a conventional linguistic *dao*. Zhuangzi's response to Mencius exhibits his philosophical virtuosity in tracing the pragmatic transcendent move against all of Mencius's attempts to defend his attempt to rest moral judgment on human nature.

"Without an Other there is no Self, without Self no choosing one thing rather than another."

This is somewhere near it, but we do not know in whose service they are being employed. It seems that there is something genuinely in command, and that the only trouble is we cannot find a sign of it. That as "Way" it can be walked is true enough, but we do not see its shape; it has identity but no shape. Of the hundred joints, nine openings, six viscera all present and complete, which should I recognise as more kin to me than another? Are you people pleased with them all? Rather, you have a favourite organ among them. On your assumption, does it have the rest of them as its vassals and concubines? Are its vassals and concubines inadequate to rule each other? Isn't it rather that they take turns as each other's

lord and vassals? Or rather than that, they have a genuine lord present in them. If
we seek without success to grasp what its identity might be that never either adds
to nor detracts from its genuineness. . . . Once we have received the completed
body we are aware of it all the time we await extinction. Is it not sad how we and
other things go on stroking or jostling each other, in a race ahead like a gallop
which nothing can stop? How can we fail to regret that we labour all our lives
without seeing success, wear ourselves out with toil in ignorance of where we
shall end? What use is it for man to say that he will not die, since when the body
dissolves the heart dissolves with it? How can we not call this our supreme regret?
Is man's life really as stupid as this? Or is it that I am the only stupid one, and there
are others not so stupid? But if you go by the completed heart and take it as your
authority, who is without such an authority? Why should it be only the man who
knows how things alternate and whose heart approves its own judgements who
has such an authority? The fool has one just as he has. For there to be That's it,
that's not' before they are formed in the heart would be to "go to Yueh today and
have arrived yesterday." This would be crediting with existence what has no
existence; and if you do that even the daemonic Yu could not understand you,
and how can you expect to be understood by me?[55]

The author of chapter 2 revisits this regression theme repeatedly, for
example, in his regress about "beginnings" and his comments about the regress
of indexicality in 是 *shi*[this:right] and 非 *fei*[not this: wrong], birth and dying, knowledge
and ignorance, and so on. I take it his points are familiar enough not to require
repeating here.

7. Transcendent Intuitionism

I could close my case there. However, I do not mean to deny that no develop-
ment satisfies Roetz's search for a concept of "real" transcendence. I do not
deny, that is, that some philosophers claim to have found a spooky or super-
natural method of transcending their limited social perspectives. The *Xunzi*,
for example, echoes many Mencian themes about the 心 *xin*[heart-mind] but adds
formulations of its own that suggest an in principle capacity for full moral
transcendence. The *Xunzi* seemingly echoes Zhuangzi's observation about how
language and background guide our moral judgments. Hence, his transcen-
dent passages more clearly satisfy the Kantian criteria. On common (and
plausible) interpretations, the judgment method includes steps that pointedly
"bracket" the distorting effects of natural emotions and social or conventional
attitudes. "How do people know 道 *dao*[guide]? By the 心 *xin*[heart-mind]. How does
the 心 *xin*[heart-mind] know 道 *dao*[guide]? By being empty, unified and still."[56]

55. *Zhuangzi*, ch. 2 (Graham tr.)
56. *Xunzi*, ch. 21.

We should not treat this theme as the triumph of Chinese philosophy in the *Xunzi* because it so obviously begs the question against Zhuangzi's skeptical regress. If I were "empty" of norms of assessment, lacked any distinctions, and was not motivated to anything, how could I be understood to make any judgment at all? Zhuangzi does not deny that there is a "point of view of the universe;" he denies that it has any content—that is says anything.

In any case, this line of reasoning in the *Xunzi* conflicts with another line that reflects a more intellectually responsible, pragmatic response to Zhuangzi. According to this approach, the correct social 道 *dao*guide is one reached in history and "verified" by its past success in harmonizing guidance with the facticity of human "nature" and the real environment. The theme is not explicitly evolutionary,[57] but clearly invites such elaboration. The alternative elaboration of these historical themes is to attribute to the Sage Kings alone the transcendent capacity indicated and treat the historical element as mere confirmation of their transcendent wisdom.

A more convincingly transcendent, but less sophisticated, route to this conclusion follows the traditional interpretation of Daoism. On this orthodox reading, Daoism is close to Mencius. It portrays Daoism as an intuitive, anti-rational transcendentalism[58] (Graham 1989:176). One achieves transcendence through mystical access to a transcendent metaphysical absolute: the *Dao*. The *Dao* transcends and creates the world (reminding us of the transcendent God-role in Western religions). Mystically "grounding oneself" in that transcendent *Dao*, one can claim to leverage oneself out of the limited context of ordinary humans and natural animals.

Zhuangzi's refutation of Mencius, cited above, clearly simultaneously rebuts this intuitionist position.[59] However, I agree that many manifestations of this line of thought can be found in ancient Chinese texts and they are offered in apparent response to this skeptical challenge of the *Zhuangzi*. Recently, following Graham,[60] many have focused on key chapters of the *Guanzi* ("*Nei Ye*" and "*Xin Shu*") which propose techniques for cultivating a special "transcendent" epistemic state that allows one to see the whole where ordinary people can only see from a perspective. These techniques are more esoteric than is Xunzi's. They may have included meditation, breath control, and so on. They would not strike us as being as akin to rationality as Xunzi's approach.

57. It assumes, that is, that the Sage Kings were initially right in their formulation of Confucian norms—either by luck or by virtue of their insight into the issues. The test of rightness is the subsequent success in producing a social organization that provides for people's livelihood. But Xunzi gives little hint that conventions are an evolving adaptation of moral discourse shaped by those real conditions. Thanks to David Nivison, private conversation, for this warning.

58. Angus Graham, *Disputers of the Tao: Philosophic Argument in Ancient China* (La Salle, IL: Open Court, 1989).

59. See Hansen (1992): 277–90.

60. A. C. Graham, *Studies in Chinese Philosophy and Philosophical Literature* (Albany: State University of New York Press, 1990).

 This development would confirm Roetz's hypothesis that the Chinese "en-
lightenment" classical tradition have a notion of absolute moral transcendence
from the perspectival effects of social discourse. However, we can explain the
emergence of this notion in a naturalistic, developmental "hermeneutic." It
emerges reflectively within a set of background beliefs about the priority of
social discourse and the essentially social nature of human beings. Furthermore,
It does not require that we credit the reflective thinkers with a successful intui-
tive grasp of the Kantian apparatus of individual rational autonomy. In fact,
despite this theme, none of them seem to develop or rely on the apparatus of
a common rationality. They continue to assume that nonexceptional humans
are indeed limited by their natures and their shared historical social discourse.
Only the rare authoritative person can cultivate the mystical transcendent
breakthrough. This is a bald appeal to special pleading on the part of the "au-
thority" claiming to have achieved a heart-mind "breakthrough."

 As presented, it requires the proponents' abject failure to appreciate sound
philosophical points made in the *Zhuangzi*. It still fails to give the necessary
transcendence for the same reason that G. E. Moore's attempt to solve the
"open question" puzzle by postulating an unanalyzable property of goodness
fails. The nonnatural property can be appreciated, Moore argued, by a moral
intuition. However, even if we grant the obscure metaphysics and the self-
congratulatory epistemology that "makes us wiser than other men," we can
still ask Bertrand Russell's question. Once we intuit this simple, unanalyzable
property, why should we value it? Russell's worry would apply even if the
property were not natural. Making an intuition into a metaphysically tran-
scendent moral reality doesn't solve the philosophical problem to which
Zhuangzi's reflections draw attention. If we were autonomous in the Kantian
sense, we should still wonder why we should follow or conform to the tran-
scendent *dao*? My worry, here, is that the development that most satisfies Roetz's
criteria, is demonstrably less reflective and careful philosophically than the more
skeptical, pragmatic version. It is sheer dogmatism.

 Getting access to that transcendent *dao* by some special insight does not
solve the philosophical problems posed in classical China. Knowing that
Mencius or Xunzi claim some special discipline that generates judgments that
conform to this particular *dao* still leaves an autonomous reasoner free to ask,
"Why should I accept the conclusions of this cultivated judgment?" (This is
the worry Zhuangzi raises in his argument about our making a distinction
between the fool and the sage). If the judgment of this special or esoteric ca-
pacity judgment turned out to be one that overwhelmed our capacity to ask
this autonomous question, it would hardly solve the problem. On the contrary,
it would look like a reason to avoid using that technique on the ground that it
would destroy my critical abilities. (That is on the same grounds we refuse to
take reality-distorting drugs.) The vaunted process of cultivation looks from
Zhuangzi's point of view as if it were intended to undermine the capacity for

the moral transcendence that matters, rather than to enhance it.

Our shared goal of crediting Chinese thinkers with philosophical abilities thus inclines me to resist emphasizing these dogmatic and arrogant claims to some superior moral insight. In any case, they could hardly count as warranted on Kohlbergian grounds since it would amount to saying (with Xunzi) that all other moral philosophers are ethical children and only the gentlemen in my school of Confucianism are fully mature moralists. Understanding their transcendence as the skeptical kind is giving them more credit for philosophical acumen than is accepting these claims to cultivate a special supernatural access to moral truth.

The conclusion, interestingly enough, is that for moral purposes, at least, the assertion of a metaphysical ground is (1) not required for the kind of transcendence "worth having" and (2) incapable of providing it even when assumed. It is neither necessary nor sufficient. Pragmatic moral transcendence is what matters—and all that matters. Chinese thinkers clearly had that.

Self and Self-Cultivation in Early Confucian Thought

Kwong-loi Shun

I

In contemporary discussions of virtues, some authors have raised concerns about how an emphasis on virtues may lead to a misdirection of ethical attention. One kind of concern is that, in emphasizing the cultivation of virtues, one's attention is too other-directed. Virtue-terms are typically used in third-person descriptions rather than in first-person deliberation, and to aim at cultivating the virtues in oneself is to be concerned primarily with how others may describe oneself.[1] Another kind of concern is that, in emphasizing the virtues, one's attention is too self-directed. One is primarily concerned with maintaining one's self-image as a certain kind of person, or at least one shows a self-centeredness by putting more weight on one's own character than on others' well-being or character.[2] It is difficult to assess these observations in the abstract, and whether the concerns raised are genuine concerns depends on the kind of ethical thought under consideration. In what follows, I will consider early Confucian thought as an example of an ethical tradition that emphasizes cultivating one's character, and discuss whether such an emphasis leads to a misdirection of attention.

I will focus attention on a phenomenon which I will refer to as self-cultivation and which has been a main concern of Confucian thinkers. By self-cultivation, I mean the process of one's doing something to oneself to shape one's character, out of a reflexive concern with the kind of character that one has. Different views of self-cultivation have evolved in different branches of Confucian thought. What I will do is to focus attention on Mencius, who lived in the fourth century B.C. and whose teachings are recorded in the

1. Bernard Williams, *Ethics and the Limits of Philosophy* (Harvard University Press, 1985), 10–11.

2. The formulation in terms of self-image is in Edmund L. Pincoffs, *Quandaries and Virtues* (University Press of Kansas, 1986), 112–14. The formulation in terms of self-centeredness is in David Solomon, "Internal Objections to Virtue Ethics," in Peter A. French, Theodore E. Uehling, Jr., and Howard K. Wettstein, eds., *Midwest Studies in Philosophy*, vol. 13—*Ethical Theory: Character and Virtue* (University of Notre Dame Press, 1988), 431–36. Neither author endorses this kind of objection to an emphasis on virtues.

Mencius, a text composed of sayings by Mencius as well as dialogues between Mencius and his disciples, philosophical adversaries, and rulers or officials of certain states.[3] Several of Mencius's ideas can be traced to Confucius, who lived in the sixth to fifth century B.C. and whose teachings are recorded in the *Analects*, a text composed of sayings by Confucius and by his immediate disciples, as well as dialogues between Confucius and his disciples.[4] In addition to these two texts, I will also draw upon ideas in two early Confucian texts, the *Great Learning* and the *Centrality and Commonality*, the authorship of which is uncertain.[5] The four texts have been grouped together as the *Four Books* and regarded as the basic Confucian classics since the twelfth century A.D. Although there are other early Confucian texts that I will not consider, I will for convenience refer to the conception of self-cultivation that can be extracted from these four texts as the early Confucian conception.

To see whether the early Confucians' emphasis on self-cultivation leads to a misdirection of ethical attention, I will consider the way they viewed the self and its relation to others. I will argue that, from the early Confucian perspective, one's concern for oneself and one's concern for others are integrated in such a way that the emphasis on self-cultivation does not lead to the kind of misdirection of ethical attention that some have found problematic.[6]

II

Before I proceed, let us consider a remark that Herbert Fingarette makes in connection with the *Analects*:

> It is the commentator, rather than Confucius, who is tempted to generalize (Confucius's) teachings by focusing on the 'self' as an overarching or basic rubric, and summing it all up in terms of 'self-cultivation'. . . . Would Confucius himself have generalized on his own teachings, or summarized them, by taking the consummately cultivated self as his focal concept? The fact is, of course, that he did not.[7]

In taking the early Confucian conception of self-cultivation as my topic, it may appear that I am disagreeing with Fingarette's reading of the *Analects*.

3. All references are to D.C. Lau (trans.), *Mencius* (Penguin Books, 1970).

4. All references are to D.C. Lau (trans.), *The Analects of Confucius* (Penguin Books, 1979).

5. All references are to Wing-tsit Chan (trans. & comp.), *A Sourcebook in Chinese Philosophy* (Princeton University Press, 1963), chs. 4, 5; Chan translates the title of the second text as *Doctrine of the Mean*.

6. In my discussion, I will not engage in a close textual study but will assume interpretations of Confucius's and Mencius's thinking that I defend in my *Mencius and Early Chinese Thought* (Stanford University Press, 1997) and interpretations of ideas in the *Great Learning* and the *Centrality and Commonality* that I defend in my *The Development of Confucian-Mencian Thought* (in progress). Also, I have provided translations for key philosophical terms solely for convenience of exposition; the terms are discussed in the works just cited.

7. "The Problem of the Self in the *Analects*," *Philosophy East and West* 29 (1979): 130.

However, Fingarette's elaboration on his view elsewhere shows that, in saying that Confucius's teachings are not centered on cultivating the self, he is taking the notion of self to be associated with the idea of a "mysterious interior self" or "inner entity" with a "private ego and will" and with "individualistic, egoistic, particularistic grounds for action."[8] Since I will be speaking of the self in a way free from such associations, my presenting self-cultivation as a main concern of the Confucians, including Confucius himself, is not an expression of disagreement with Fingarette. Still, Fingarette's remark highlights the need to explain more clearly the notion of self that I ascribe to the early Confucians.[9]

Besides the use of first-person pronouns, the classical Chinese language has two characters with the meaning of "oneself." One (*"zi"*) is used in reflexive binomials referring to one's doing something connected with oneself, such as one's examining oneself or bringing disgrace upon oneself. The other (*"zhi"*) is used to talk about not just one's doing something connected with oneself, but also others doing something connected with oneself (such as others appreciating oneself), oneself doing something connected with others (such as oneself causing harm to others), or one's desiring or having something (such as a certain character) in oneself. The two characters differ in that the former emphasizes one's relation to oneself while the latter emphasizes oneself as contrasted with others. In addition, there is a third character (*"shen"*) which, when prefixed with the appropriate possessive pronoun, can be used to refer to oneself or one's own person.

These linguistic observations show that the early Chinese had a conception of the way one relates to oneself. Furthermore, in early Confucian texts, the characters just mentioned are often used to talk about one's examining oneself and one's cultivating oneself on the basis of such self-examination. So, the early Confucians also had a conception of one's being related to oneself in a self-reflective manner, with the capacity to reflect on and examine oneself and to bring about certain changes in oneself. In ascribing a notion of self to the early Confucians, I am ascribing to them a conception of persons with a capacity of this self-reflective kind.

This conception is not the conception of some "inner" or "private" entity, but has to do with the person as a whole, including the physical body. In fact, it is arguable that the early Confucians did not draw a sharp distinction between the mental and the physical. There is a character (*"xin"*), often translated as "heart" or "mind," which refers to the site of what we would characterize as cognitive and affective activities, such activities being located in the physical heart. There are also ways of referring to the physical body (*ti*) and its parts,

8. "Comment and Response," in Mary I. Bockover, ed., *Rules, Rituals and Responsibilities* (Open Court, 1991), 194–200.

9. Antonio S. Cua gives an elaborate discussion of the Confucian notion of self in the last section of "A Confucian Perspective on Self-Deception," presented at the East-West Center Symposium on Self and Deception (August 24–28, 1992).

such as the four limbs, as well as to the senses. In addition, another aspect of the person concerns the vital energies (*qi*) which fill and flow freely in the body and which are responsible for the emotions. Although there is a distinction between these aspects of a person, the different aspects are also viewed as mutually interacting. For example, the heart can come to focus itself in certain directions (*zhi*), and these directions of the heart, which include general aims in life as well as specific intentions, both shape the vital energies and depend on the vital energies for their execution. Conversely, the condition of the vital energies can affect these directions of the heart. Also, the vital energies that fill the body can be affected by what happens to the body, such as the tastes that the mouth takes in and the sounds that the ear hears; conversely, the vital energies can generate speech in the mouth and sight in the eyes. It follows from the interaction between the heart and the vital energies, and between the vital energies and the body, that the heart and the body are also intimately related. For example, the *Mencius* speaks of how the condition of the heart is manifested in the body, not just in action and speech, but in the face, the look of the eyes, the four limbs, and in one's physical bearing in general; indeed, it is only through self-cultivation that one can give complete fulfillment to the body.[10] So, for the early Confucians, the self is not some "inner" or "private" entity but comprises all these different but interacting aspects of the person, and self-cultivation is a matter of shaping one's whole person including the physical body.

III

What, then, is involved in self-cultivation? To explore the ways in which concern for the self and concern for others are integrated in early Confucian thought, let us first consider two ethical attributes highlighted in Mencius's thinking. One well-known idea of Mencius's is that human beings share certain spontaneous responses providing the starting point for cultivating four ethical attributes.[11] Two of these attributes, humaneness (*ren*) and righteousness (*yi*), are supposed to take as their starting point responses of commiseration and what I will tentatively refer to as responses of shame and aversion. Humaneness stresses having proper affective concern for other living things, while righteousness stresses a strictness with oneself, involving a commitment to right conduct. Both are related to certain traditional social distinctions and norms. For example, humaneness involves having a special concern for parents partly manifested in the observance of filial obligations associated with the parent-child distinction. Righteousness involves fulfilling obligations one has in vir-

10. *Mencius* 4A:15, 7A:21, 7A:38; cf. *Great Learning*, ch. 6.
11. *Mencius*, 2A:6.

tue of the social positions one occupies, such as being a parent or an official, as well as following certain ceremonial rules of conduct governing the interaction between people in various social contexts. According to Mencius, cultivating these attributes involves, at least in part, reflecting on and nourishing certain spontaneous responses pertaining to the heart.

These responses are responses to situations one has not expected to encounter, a point particularly highlighted in the example of one's response of commiseration upon suddenly seeing a young child on the verge of falling into a well.[12] Because one is caught unaware, the responses occur prior to a calculative attitude and so are not guided by ulterior motives; instead, they come directly from the heart and reveal something deep in the heart. Furthermore, one is supposed to see that this is the way one would react not via any empirical generalization about human beings, but by reflecting on one's own heart, often by imagining how oneself would respond if one confronts certain imaginary situations. That human beings share predispositions of this kind is often described as part of Mencius's view of human nature, and self-cultivation is a matter of developing one's nature in the sense of transforming oneself in the directions implicit in the predispositions of the heart.[13]

To illustrate how reflection on these responses reveals directions concerning how one should conduct or alter oneself, let us consider two examples. An example of a response of commiseration is found in a dialogue between Mencius and King Xuan of the state of Qi.[14] In an attempt to persuade the king to be more caring toward his people who were suffering under his harsh policies, Mencius reminded the king of a past incident in which, upon unexpectedly seeing an ox trembling with fear when being led to be killed for sacrifice, the king was moved by compassion and spared the ox. Commentators have given different accounts of how Mencius expected the appeal to the incident to help motivate the king to be more caring toward his people. At one extreme is the proposal that, even prior to the dialogue with Mencius, the king already had compassion for his people though it did not manifest itself in his policies due to the distortive influence of certain political ambitions. By reminding the king of his compassion for the ox, which the king himself described in terms of his seeing the ox as if it were an innocent person being led to the place of execution, Mencius helped to facilitate the manifestation of the king's compassion for the people.[15] At another extreme is the proposal that, though the king had no concern for the people to start with, the king could come to have compassion on his people after having been reminded of his compassion for

12. *Mencius*, 2A:6.
13. There have been controversies about whether "nature" is an appropriate translation of the relevant term ("*xing*") in the *Mencius*, an issue that I will not be able to address here.
14. *Mencius*, 1A:7.
15. This is the way some Neo-Confucians interpreted the passage.

the ox and the fact that his people were suffering just like the ox.[16] In between the two extremes are other possibilities. For example, one proposal is that the king already had some incipient but not full-fledged concern for his people to start with, and recognizing the similarity between the ox and the people in terms of suffering helped to crystallize this incipient concern, resulting in the king's being actually motivated to spare the people.[17] The nature of the text is such that it is difficult to adjudicate between these proposals, but whichever proposal we adopt, the example illustrates Mencius's view that, somehow, by reflecting on the way the heart is already disposed, one can come to see directions for altering one's conduct and dispositions.

An example of a response of shame and aversion is found in the context of criticizing certain forms of political behavior.[18] Mencius mentioned how, when one is given food in an abusive manner, one's immediate reaction is to reject the food even if one might be starving to death. That one would so react is supposed to lead one to a certain view of one's behavior in the political context. Just as it is shameful to accept food given with abuse, it is shameful to accept a gift or an office from someone in power who has failed to treat one in accordance with certain rules of propriety. In both cases, one should not submit to the abusive treatment even if one's life is at stake, and this realization will lead to a change in one's behavior in the political context.

In these two examples, the way one responds in one kind of context is supposed to reveal certain aspects of the way one should conduct oneself or be disposed in another kind of context, and part of the task of self-cultivation is to reshape one's life accordingly.[19] Mencius also commented on other aspects of the self-cultivation process. For example, while one should keep in mind and persist in the process, one should at the same time not be overeager and aim at results in a way that undermines one's efforts.[20] And by regularly acting in the appropriate way, one will come to take joy in so acting, and as a result the appropriate dispositions will grow.[21] I will return to these ideas later; for now, let us consider the attribute righteousness further and then return to the issue of how concern for the self and concern for others are integrated.

Earlier on, I expressed hesitation about the use of the word "shame" to characterize the responses that Mencius described. The word is a common

16. This interpretation is found in David S. Nivison, "Mencius and Motivation," *Journal of the American Academy of Religion*, thematic issues 47 (1980): 417–32, and also explored by myself in earlier writings.

17. This interpretation is in David B. Wong, "Is There a Distinction between Reason and Emotion in *Mencius*?" *Philosophy East and West* 41 (1991): 31–44.

18. *Mencius* 6A:10.

19. See *Mencius* 7A:17 and 7B:31. Both passages make the point that there are things that one does not desire (viz. harm coming to others) and would not do (viz. actions that one regards as shameful), and the task of self-cultivation is to extend such responses to other contexts.

20. *Mencius* 2A:2.

21. *Mencius* 4A:27.

translation of two characters, "*chi*" and "*xiu*," but the characters refer to attitudes that differ from shame in important ways. While aversion can be directed to anything that one dislikes and seeks to avoid or alter, *chi* is an attitude directed to things that reflect adversely on oneself. Typical objects of the attitude are things that cause disgrace, such as defeat in war or being subject to abusive treatment, as in the example of food given with abuse. However, the early Confucians also regarded as objects of *chi* things that are not necessarily disgraceful by ordinary social standards, such as one's having a reputation that goes beyond the way one actually is. For them, what is truly disgraceful is measured by certain ethical standards that need not coincide with ordinary social standards, though there can be overlaps. Now, although *chi* is like shame in presupposing certain standards to which one is seriously committed, it differs from shame in the following ways. Unlike shame which is a response to some past deed or occurrence that reflects adversely on oneself, *chi* can be directed to the future prospect of some such deed or occurrence, and it involves a resolve to distance oneself from such a situation. Even when directed to a past situation, it emphasizes the resolve to remedy the situation or to distance oneself from it, and does not have the connotation of one's dwelling on the past situation. Furthermore, although the attitude can be directed to the way one is treated in public, it is not associated with the thought of being seen or heard, and the reaction typically associated with it is not hiding or disappearing.[22] Instead, the thought associated with it is that one could be tainted by a certain situation, and the typical reaction is to remedy or distance oneself from that situation. Because of the more future-directed emphasis of *chi*, it is by comparison to shame less controversial that it has a largely constructive function.[23]

22. Though it is generally acknowledged that shame need not involve the actual or imagined presence of an audience, some have argued that the metaphor of an audience does capture an important aspect of shame. In *Pride, Shame and Guilt* (Oxford University Press, 1985), 65–67, Gabriele Taylor proposes that it captures a sophisticated type of self-consciousness, involving one's awareness of one's being in a position where one could be seen as fitting a description that is at discrepancy with one's own assumptions about oneself. In *Shame and Necessity* (University of California Press, 1993), ch. 4, Bernard Williams proposes that shame involves the thought of being seen by an internalized other which, though identifiable in ethical terms, is not just a screen for one's own ethical ideals but is the locus of some genuine social expectation. According to Williams, the basic experience connected with shame is that of being seen inappropriately, and the typical reaction is to hide or to disappear.

23. The extent to which shame is a constructive or destructive emotion has been an issue of controversy. Gabriele Taylor regards shame as an emotion of self-protection, protecting the self from corruption, and takes the capacity to feel shame to show that one has retained a sense of value—ibid., 79–81. By contrast, both Arnold Isenberg and John Kekes argue that shame is a largely destructive emotion, involving one's dwelling on and being pained by past failures, and serving to magnify weakness, distort judgment, and undermine self-confidence—see Arnold Isenberg, "Natural Pride and Natural Shame," in Amelie Oksenberg Rorty, ed., *Explaining Emotions* (University of California Press, 1980), 355–83, and John Kekes, "Shame and Moral Progress," in Peter A. French, Theodore E. Uehling, Jr., and Howard K. Wettstein, eds., *Midwest Studies in Philosophy*, vol. 13—*Ethical Theory: Character and Virtue* (University of Notre Dame Press, 1988), 282–96.

For these reasons, *chi* is perhaps more like the attitude of regarding something as contemptible or as below oneself than like the emotion of shame. The other character usually translated as shame, "*xiu*," is closely related to "*chi*," though one possible difference is that, while *chi* is focused more on the thing that taints oneself, *xiu* is focused more on the way the self is tainted by that thing. But, like *chi*, *xiu* can concern the future prospect of something's obtaining rather than something that has already obtained, and it has a more future-directed emphasis. While it is *xiu* that is mentioned along with aversion as a starting point for cultivating righteousness, Mencius also stressed the importance of *chi* in self-cultivation.[24]

That righteousness is linked to the kind of attitude just described shows that it is in part directed to the self—it involves a concern to distance oneself from situations that are below oneself, as measured by certain ethical standards to which one is committed. In fact, the character for righteousness (*yi*) was initially either a near relative of or derived from the character for "I" (*wo*), and it had the earlier meaning of a proper regard for oneself or a sense of honor. This feature of righteousness contrasts with humaneness, which emphasizes a proper affective concern for others. Although the two attributes have different emphases, they are closely related. Humaneness can lead to right conduct; for example, proper affective concern for one's parents may lead one to serve parents in ways that fulfill one's obligations. Furthermore, the affective concern that is part of humaneness has to be regulated by a commitment to right conduct for the person to be truly humane. In the example of King Xuan, though the king spared the ox which he saw, he also had an obligation to ensure that the sacrifice took place, and his way out was to order that a lamb which he had not seen be used instead. This way out of the situation Mencius described as the method of humaneness, showing that humaneness itself is regulated by righteousness. Conversely, acting out of righteousness is not incompatible with acting out of affective concern for others. One passage in the *Mencius* describes how King Wu, an early king of the Zhou dynasty, overthrew the last king of the Shang dynasty because the latter was corrupt and caused immense suffering to the people. While King Wu acted out of concern for the people, his act was also an act of righteousness as he was described as acting out of *chi*—he regarded it as below him that he should allow the suffering to continue when he was in a position to change things. So, although righteousness and humaneness emphasize different concerns, one more self-directed and one more other-directed, the two kinds of concerns are integrated in action and not exclusive of each other.

24. E.g., *Mencius* 7A:6, 7A:7; as Antonio S. Cua has noted in private communication, the difference between shame and *xiu* or *chi* can be traced to the different traditions of thought in which the concepts have their roots.

IV

There is another way in which the two kinds of concerns are integrated but, before discussing this, let us consider two other aspects of the early Confucian conception of self-cultivation—how it views others' response to oneself, and how it views external goods whose obtaining is not within one's control. Working within a tradition of thought that regarded a cultivated character as having an attractive and transformative force on others, the early Confucians took an unfavorable response from others as a likely indication of some shortcoming in oneself. Accordingly, if one gets an unfavorable response from others, one should examine oneself to see if one is deficient in some way.[25] However, while advocating a sensitivity to others' response, they were also opposed to gearing one's way of life to the approval of others. Confucius made it explicit that, in self-cultivation, one should be concerned not with others' appreciation of oneself but with one's own character and ability; according to him, learning should be "for one's own self" and not "for others."[26] And Mencius, elaborating on Confucius's ideas, criticized the village honest man whose way of life is geared to social opinion.[27] What the village honest man aims at is others' regarding him as good and, since he adjusts his way of life accordingly, it is difficult to find fault with him. His way of life appears good, everyone around him approves of him, and he himself is contented with his way of life. And yet he does not have a genuine concern for goodness; he has no aspiration to be like the ancient sages and he does not regard anything as below him. What he has attained is not genuine goodness, but at best certain semblances.

Turning to one's attitude toward external goods not within one's control, the early Confucians advocated one's not being swayed in one's purpose by such considerations and one's willingly accepting the consequences. In the face of adversities to oneself or the prospect of great profits, one is supposed not just to conform to what is right in one's behavior, but also to be free from any distortive influences that might potentially lead to a deviation from what is right. The heart should be 'unmoved' in that one is not subject to fear, uncertainty, or distortive influences of any kind in fact of adversities.[28] More positively, one should willingly accept such adversities, an attitude conveyed in the use of the character "*ming*." Though often translated as "fate" or "destiny," "*ming*" does not refer to some opaque force operative in human events that cannot be thwarted. Instead, it serves primarily to express a certain attitude toward occurrences that go against one's wishes and to which one attaches importance, an attitude that follows upon one's recognition of certain con-

25. E.g., *Mencius* 4A:4, 4B:28; as Joel J. Kupperman has noted in private communication, the early Confucians emphasized both fallibility in self-cultivation and ways of dealing with it.
26. *Analects* 14.24; cf. 1.1, 1.16, 4.14, 14.30, 15.19.
27. *Mencius* 7B:37; cf. *Analects* 13.21, 13.24, 17.13, 17.18.
28. *Mencius* 2A:2; cf. 3B:2, 7A:9.

straints on one's activities. The constraints may be causal in that the occur-
rences are actually not within one's control, such as the failure of one's political
endeavors or unexpected illness or death. The constraints may be normative in
that the occurrences are something one could alter but altering which would
involve improper conduct. Whichever is the case, having done what one could
within the limits of what is proper, one accepts the undesirable outcome in
that one will not engage in improper conduct to alter things and will not be
worried by the outcome.[29] In addition, one may resolve to redirect attention
to other pursuits, such as Confucius's turning his attention to teaching having
accepted the failure of his political mission.

The willing acceptance of adversities and absence of distortive influences
potentially leading one to deviate from what is proper requires a complete
orientation to the ethical, such an orientation being expressed by the notion
cheng which occurs in the *Mencius* and is highlighted in the *Great Learning* and
the *Centrality and Commonality*. "*Cheng*" has the connotation of being real
and complete. It refers to a state in which there is no discrepancy in oneself,
not just between the way one is and one's outward appearance and behavior,
but also within the heart itself. One may still have desires that go unsatisfied,
but such desires do not lead to any inclination that is at discrepancy with what
is proper. The idea of inclination is expressed by the character "*yi*," which is
highlighted in the *Great Learning* and often translated as "thought."[30] While a
thought can concern one's opinion or the meaning behind what one says, it
can also have to do with the thought of doing something or of something's
happening. Unlike desires which may be something that one just happens to
have (such as sensory desires), a thought is formed by the heart. On the other
hand, a thought can be just an incipient tendency of the heart that is in a less
focused state than the directions of the heart which comprise one's aims and
intentions. While a thought can be just a thought in favor of something without
one's actually deciding to act accordingly, the directions of the heart involve
one's actually deciding on certain courses of action.[31]

Cheng involves the absence of thoughts that are at discrepancy with the
ethical life. Thus, the *Great Learning* speaks of one's making one's thoughts
cheng, this involving one's watching over the minute and incipient tendencies
of the heart. The goal is to ensure that there is not a single thought opposed to
what is proper, not even a thought that could cause the slightest reluctance or
hesitation in doing what is proper. The *Centrality and Commonality* takes this

29. The idea that the cultivated person has no worries is in *Analects* 9.29, 12.4, 14.28, and
the attitude of willing acceptance is highlighted in *Mencius* 7A:1, 7A:2.
30. *Great Learning*, text and ch. 6; Chan translates "*cheng*" as "sincerity" and "*yi*" as "the
will."
31. Since a thought is formed in the heart and yet can fall short of full-fledged aims and
intentions, some Neo-Confucians characterized it as an incipient tendency of the heart that is in
transition from being nonexistent to being existent.

idea further, and describes *cheng* as a development of one's nature, an idea related to Mencius's view that self-cultivation is basically a development of one's own nature. Furthermore, it elaborates on the idea, also found in the *Analects* and the *Mencius*, that self-cultivation is ideally the basis of government.[32]

For the early Confucians, edicts and punishment are secondary measures; instead, the goal of government is to transform the people so that edicts and punishment can be dispensed with.[33] And the way to transform the people is to first cultivate oneself and let the transformative power of one's cultivated character take effect.[34] This does not mean that actual policies are not important, and both the *Analects* and the *Mencius* contain discussions of the details of government. But proper policies are themselves a manifestation of the cultivated character of those in power, and properly carrying out policies transmitted from the past also requires a cultivated character.[35] So, the ultimate basis for order in society lies with cultivating oneself.[36] The *Centrality and Commonality* elaborates on this idea in relation to *cheng*. It emphasizes that what is on the inside will eventually be manifested on the outside, and that it is only when one is fully *cheng* that one can have the transformative effect on others that provides the basis for order in society. Indeed, since the transformative effect on others is itself a natural outgrowth of one's cultivated character, a failure to transform others is an indication of a failure in one's own self-cultivation. Accordingly, one's concern for cultivating oneself cannot be separated from a concern for cultivating others; *cheng* involves not just developing one's nature but also developing others' nature.[37]

V

With the above discussion as background, let us return to the worries mentioned earlier about possible misdirection of ethical attention. Consider first the worry that an emphasis on cultivating the virtues may involve an excessive concern for others' opinion of oneself. The thought is that, since virtue-terms typically occur in third-person descriptions rather than in the content of the virtuous person's deliberations, the first-person exercise of cultivating the virtues in oneself involves one's being concerned primarily with the way others describe oneself. Now, the early Confucians did advocate a concern with humaneness and righteousness, or with one's becoming like the ancient sages. For example, Mencius spoke of a concern with one's becoming like the ancient sage king

32. *Centrality and Commonality*, chs. 1, 20–25.
33. *Analects* 2.3; cf. 12.17.
34. *Analects* 2.1, 12.19, 13.4, 13.13, 15.5; *Mencius* 4A:20, 7A:19.
35. *Mencius* 2A:6, 4A:1, 7B:5.
36. *Mencius* 4A:5, 4A:12, 7B:32; cf. *Great Learning*, text.
37. *Centrality and Commonality*, ch. 22; cf. *Analects* 6.30.

Shun, and also advocated humaneness and righteousness as something one should be concerned with throughout one's life.[38] This may lead to the worry that, in aiming at humaneness and righteousness or at becoming like Shun, one's primary concern is with one's being describable by others in a certain way or with acquiring the kind of stature that Shun has in others' eyes. If so, then this kind of concern does seem other-directed in a disturbing way, just like the village honest man's concern with pleasing others.

We have seen that, although the early Confucians did advocate a sensitivity to others' response, this is not because they regarded a concern with others' approval as the primary concern in self-cultivation. The reason is rather that, given their belief in the transformative power of a cultivated character, the way others respond to oneself is often a reliable indicator of the state of one's own character. Furthermore, Confucius's idea of learning "for one's own self" rather than "for others" and Mencius's criticism of the village honest man show that they would regard a concern with others' approval as misdirected. The question remains, though, as to how we reconcile this view of the early Confucians with their advocacy of a lifelong concern with humaneness and righteousness.

Part of the answer is that, even if we grant that humaneness and righteousness are often used by others as a third-person description of the humane and righteous person, a concern with these attributes need not be a concern with one's being describable by others in a certain way. Instead, it can be a concern with one's becoming like the kind of person that one would *oneself* describe in this way. That is, the third-person description in terms of humaneness and righteousness can be a description of others by oneself, rather than of oneself by others. Furthermore, in being concerned with becoming like the kind of person that one would oneself describe in this way, one's primary object of concern is not the description, but one's having a certain character which, as it happens, can be described in this way. Likewise, a concern to be like Shun can be a concern with one's character being like Shun's, rather than with one's having the kind of stature that Shun has in others' eyes.

This proposal can be supplemented with the following observation about the role humaneness and righteousness play in first-person deliberation. We have seen that, according to Mencius, constant reflection on oneself reveals certain directions concerning how one should conduct or alter oneself. Such directions are constantly revealed via self-reflection and, instead of specifying given endpoints that one aims at in self-cultivation, humaneness and righteousness serve more to highlight two different aspects of such directions. Although they are often used as third-person descriptions of individuals who have progressed in such directions, they can also be used in first-person deliberation to characterize the directions of change that one discovers via self-reflection. A

38. *Mencius* 4B:28; the reference to a concern with humaneness and righteousness is found in several passages.

concern with humaneness and righteousness is a concern to continue to transform oneself in such directions, and since such directions are continually revealed through self-reflection, this is a concern one should have throughout one's life.

Still, even if a concern with humaneness and righteousness need not be a concern with how others look at oneself, it is a concern with one's own character and this can lead to the other worry that such a concern may be too self-directed. This concern can be too self-directed in two ways—one may be concerned with preserving or promoting one's own self-image as a certain kind of person, or one may be making one's own character the ethically most important thing, more important than other-regarding considerations. These two forms of the worry are different. The first focuses on the way one is concerned with one's character, how it can take on a distortive form so that one's object of concern is one's image of oneself rather than one's character as such. The second focuses on the importance one attaches to one's own character, how one puts undue weight on one's character by comparison to other-regarding considerations.

In connection with the first form of the worry, I have already mentioned that a concern with humaneness and righteousness is a concern with continually transforming oneself in certain directions revealed through self-reflection. Just as such a concern need not be a concern with the way others' look at oneself, it need not be a concern with preserving or promoting one's self-image. However, the worry about a concern with self-image may arise with regard to the particular actions that one performs, in relation to both acts of humaneness and acts of righteousness. Let us therefore consider the two kinds of action in turn.

In the case of humaneness, let us take a helping action as example. Suppose one's thought in helping is that one should be doing the humane thing. If so, it seems that what one is concerned with is that one gives expression to one's humaneness, that one does what is humane, or that one preserves one's image of oneself as a humane person. Either way, it seems that there is indeed a misdirection of one's attention in acting.

It is unclear, though, that the early Confucians would advocate performing such acts with thoughts about one's own humaneness. For example, in the case of the child on the verge of falling into a well, one's compassionate response is described as a direct response to the imminent death of the child, not mediated by thoughts about one's own humaneness. It is true that, in cases in which one is not sufficiently moved by a concern for others to act, but acts out of a concern that one becomes the kind of person who would be so moved, one might act with the thought of doing the humane thing. Even so, one's acting with such a thought is itself a way of transforming oneself so that one will act out of a more direct concern for others. Such a transformation of motives is part of the point of Mencius's remark about how regularly acting in the direction of humaneness and righteousness will lead one to take joy in so acting,

which in turn will lead to the growth of the appropriate dispositions. One may, of course, be so preoccupied with one's own character that the transformation of motives does not take place. But this is presumably part of what Mencius was warning against in saying that one should not be overeager despite keeping in mind one's own self-cultivation; being preoccupied with the results can itself undermine one's efforts. So, it seems, even the early Confucians would agree that, ideally, actions for others' well-being should not be mediated by a concern with one's own humaneness.

Turning to righteousness, we have seen that it involves a concern to distance oneself from certain things that one regards as below oneself. In acting out of such a concern, it seems, one's primary concern is with avoiding smears on one's character, which is a self-directed kind of concern. Now, even if this is correct, it seems that this kind of self-directed concern need not be problematic for actions that do not, or at least do not directly, affect the well-being of others. For example, in the case of rejecting food given with abuse, there does not seem anything problematic in rejecting the food with the thought that to submit to such treatment is something below oneself. If there is something problematic about acting out of this kind of concern, it will have to do with acts that also affect the well-being of others.

Let us therefore consider an act of this kind, such as King Wu's overthrowing the corrupt last king of the Shang dynasty. In the description of this occurrence in the *Mencius*, there is a reference to *chi*, or regarding something as below oneself. Now, although King Wu's attitude was that he regarded it as below him that he, who was in a position to remedy the situation, should allow the people's suffering to continue, there are two ways in which he was also acting out of a concern that is not self-directed. First, what he regarded as below him is also something he would view with aversion if done by someone else in a comparable position. That is, although he reacted with *chi* because of his special relation to the situation, underlying this reaction is the more general attitude of aversion directed to the act, whether by himself or by others, of allowing avoidable suffering to continue. So, in acting out of *chi*, he was in part also acting out of a more general concern that an act of this kind did not take place. Second, his acting out of *chi* is not exclusive of his acting out of a genuine concern for the people. Presumably, it was because he had such concern that he regarded it as below him that the situation be allowed to continue. As long as this other-regarding concern also played a role in his action, his action did not seem to suffer from a misdirection of attention.

This last point assumes that a concern to avoid what is below oneself and a concern for others converge; but what if the two should come into conflict? This takes us to the second form of the worry about an excessive concern with oneself—the worry that one may attach too much weight to one's own character by comparison to other-regarding considerations. Indeed, Mencius himself had been accused of precisely this kind of self-centeredness. The *Mencius*

contains several examples of his refusing to see a ruler because he had not been summoned or treated in accordance with certain rules of propriety appropriate to his position. His critics made the point that, if only he had been willing to 'bend' himself a little and have audience with the ruler, he might have been able to effect desirable political changes and thereby help the people. By insisting on an adherence to rules of propriety, he was apparently putting more weight on preserving his sense of honor than on the well-being of the people.[39]

This is a serious charge, and Mencius's response was to draw on the early Confucian view about the transformative power of a cultivated character. The basis of order in society is the cultivated character of those in power, and what Mencius sought to accomplish in the political realm was to 'straighten' those in power. And straightening others depends on one's being straight oneself; there has never been a case of one's bending oneself and yet succeeding in straightening others.[40] So, according to Mencius, it is not possible to achieve the desired political changes by bending oneself. And, to the extent that the well-being of the people depends on a reform of the political order, there cannot be a conflict between a concern for one's character and a concern for others. The same point applies to the relation between one's character and the character of others. Given the belief that the transformative effect on others' character is a natural outgrowth of one's cultivating one's own character, there cannot be a conflict between a concern for one's character and a concern for others' character.

Having discussed how, from the early Confucian perspective, one's concern for the self and one's concern for others are integrated in such a way that a concern with self-cultivation need not involve a concern with the self of a problematic kind, let me conclude with a brief comment on the Confucians' response to their critics. The response appeals to an optimistic belief about the transformative power of a cultivated character; if the belief is true, then it is not possible for a concern with one's character to come into conflict with a concern for others. However, despite their appeal to this belief, at times it seems that the early Confucians also held views that might conflict with this belief.

For example, in discussing how unfavorable responses from others should lead one to engage in self-examination, Mencius considered the possibility of one's not detecting any deficiency in oneself despite getting an unfavorable response from another person.[41] His comment is that, in this case, this other person is not different from a lower animal, on which a cultivated character would not have a transformative effect. This comment, however, opens up the possibility that perhaps a cultivated character may not always have a transfor-

39. *Mencius* 3B:1; cf. 4A:17.
40. *Mencius* 3B:1, 5A:7; cf. *Analects* 12.22, 13.13.
41. *Mencius* 4B:28.

mative effect and so may not suffice as the basis for reforming the political order. And it seems that this possibility is implicitly acknowledged when the attitude of acceptance is directed to one's failure to bring about desirable political changes. If a cultivated character is sufficient for bringing about such changes, then, to the extent that self-cultivation is within one's control, the accomplishment of such changes should also be within one's control. And if this is the case, it would not have been appropriate to direct the attitude of acceptance to one's failure to bring about such changes. So, in directing this attitude to the failure of their own political mission, it seems that the early Confucians might have implicitly acknowledged that their belief about the transformative power of a cultivated character did not quite match the political realities of the times.

If this is correct, then there seems to be a tension between the early Confucians' belief about the transformative power of a cultivated character and their directing the attitude of acceptance to the failure of their own political mission. Furthermore, this tension could undermine their response to criticisms about their being overly self-righteous, to the extent of ignoring political opportunities that would have enabled them to accomplish desirable political changes. It is possible that the early Confucians had a way of resolving this tension, but this is a subject which I will not be able to address here.[42]

42. I am indebted to Antonio S. Cua, Joel J. Kupperman, and Ronald Suter for helpful comments on an earlier version of this paper, and to Antonio S. Cua for sharing with me a paper on related topics, "A Confucian Perspective on Self-Deception," presented at the East-West Center Symposium on Self and Deception (August 24–28, 1992). An earlier version of the paper was presented as a public lecture sponsored by the Philosophy Department of the Michigan State University at East Lansing (October 27, 1994), and I have benefitted from comments by the participants.

Three Dogmas of New Confucianism: A Perspective of Analytic Philosophy

Yiu-ming Fung

1. The Ultimate Concern of New Confucianism

There are at least three kinds of theses of "the unity of Heaven and humans" (天人合一) or "the united virtue of Heaven and humans" (天人合德) that have been in existence since pre-Qin China. The first kind is from *Zhuang Zi* 莊子, which is a thesis with emphasis on the organic harmony of all the things in the cosmos. The second one is from *Zhong-yong* 中庸, which concerns the relation of identity or creation of Heaven and human nature. The third one is from Dong Zhong-shu's 董仲舒 *Luxuriant Gems of the Spring and Autumn Annals* (春秋繁露), which emphasizes the correspondence between the human constitution and the numerical categories of Heaven. The first thesis, if it is claiming for some kind of spiritual vision or aesthetic projection, seems to be attractive and there seems to be no fallacy of inconsistency. The third thesis looks nonsensical, but it is not. Different from these two kinds, the second one is not only a thesis difficult to confirm or disconfirm, but it is also unintelligible for its counter-logicality and irrationality.

Most of the new Confucianists (including the Song-Ming and contemporary Confucianists) and Confucian scholars believe that "the unity of Heaven and humans" is their ultimate concern. If this concern were considered as a subjective faith only, it would have had no consequence to the problem of objective validity. However, the new Confucianists do think what they investigate is not merely something of subjective significance, but it is also related to the realms of ontological and cosmological realities. This is why the scholars inside and outside Confucianism often have the question of objective validity concerning the reality of this ultimate concern: the scholars pro Confucianism are supposed to confirm it while those con Confucianism are supposed to disconfirm it. It is certain that the confirmation or disconfirmation of "the unity of Heaven and humans" is as difficult as that of Christian "God," Buddhist "*Nirvana*," Daoist "*dao*," and so on. In what follows I am not going to

question the objective validity of the ultimate concern of new Confucianism; instead, I would like to question the logical and historical coherence of the thesis.

2. The Thesis of "Universalized Liang-Zhi"

According to the Song-Ming Neo-Confucianists as well as contemporary new Confucianists the Heaven in the conception of "the unity of Heaven and humans" is not identical with the natural world or the personal God, but with some metaphysical reality—the so-called "*ben-ti*" 本體 (Original Substance). On the transcendent level, the Original Substance can be called "*dao-ti*" 道體 or "*li-ti*" 理體; on the immanent level, it can also be named "*xin-ti*" 心體 or "*xing-ti*" 性體. As *tian* 天 (Heaven), *dao* (way), or *li* (principle), on the one hand, this Original Substance is the creative origin of all the things in the world, an onto-cosmological foundation of the phenomena. On the other hand, as *xin* (mind) or *xing* (nature), the same substance is also the origin of morality, a mentalistic foundation of moral behaviors. Cheng Ming-dao's 程明道 assertion of "*xin* is *tian*" (心即天) and Wang Yang-ming's 王陽明 "*xin* is *li*" (心即理) both point to this dual characteristic of the Original Substance. When Mou Zong-san 牟宗三 and other contemporary new Confucianists claim that the Original Substance is both transcendent and immanent (it can be called "transcendent immanence" or "immanent transcendence"), and that the moral order is identical with the cosmic order, they also have the same kind of commitment to this duality. However, we know that "transcendent" and "immanent" are logically contrary to each other. This is the reason why Plato asserts the transcendence of the *Idea* only, while Aristotle asserts the immanence of the *idea*. Since *xin* and *xing* are something embodied or exemplified into individual things, it is logically impossible to make a token-identity statement for the nonindividualized *tian*, *dao*, or *li* on the one hand, and the individualized *xin* or *xing* on the other hand. Even though the relation of the transcendent and the immanent is not token-identical, it does not mean that claiming for type-identity is possible. Because, it is obvious that the transcendent is very different from the immanent in that the latter has to be located in a spatial-temporal context while the former is absolutely free from it. Hence, when the Song-Ming and contemporary new Confucianists commit to this duality for describing their ultimate concern, they cannot escape from the trap of irrationality or logical inconsistency.

Zhu Xi's 朱熹 thesis of "*li* is one but its manifestations are many" and Wang Yang-ming's and Xiong Shi-li's 熊十力 thesis of "universalized *liang-zhi*" (普遍化的良知—cosmic mind with innate knowledge of the good) are two paradigm cases faced with this kind of theoretical difficulty.

In Zhu Xi's case, it is believed that, before the natural world and the myriad things in it came into being there was only *li* or *tai-ji* 太極 (Supreme Ultimate);

after the world and the humans came into existence, every individual person possesses the one *li*, and every separate thing also possesses the one *li*.[1] It is clear that the *li* in the first of these states is considered as transcendent and the second immanent. Although Zhu Xi believes that the transcendent *li* is one and the immanent *li*s are many, and that the one is identical with the many, the thesis was unintelligible even to his own disciples. One of them asked the following question: "You [Zhu Xi] said: '*li* is a single, concrete entity, and the myriad things partake of it as their substance. Hence, each of the myriad things possesses in it a Supreme Ultimate.' According to this theory, does the Supreme Ultimate not split up into parts?" Zhu Xi's answer is: "Fundamentally there is only one Supreme Ultimate, yet each of the myriad things has been endowed with it and each in itself possesses the Supreme Ultimate in its entirety. This is similar to the fact that there is only one moon in the sky but when its light is scattered upon rivers and lakes, it can be seen everywhere. It cannot be said that the moon has been split."[2] The conclusion is: "to say there are ten thousand entities is the same as to say there is one entity, and one is ten thousand."[3] It seems that Zhu Xi borrows from Buddhism an analogy as a conceptual scheme to deal with the problem. But, this analogy doesn't really work, because the needed similarity cannot be obtained. We know that even though the moon in the sky is, for the sake of argument, similar to the moon (reflections) in the rivers and lakes, i.e., there is a type-identity between them, they are not the same entity. In other words, there is no token-identity between them. What Zhu Xi wants to argue is that the transcendent (the one *tian-li* 天理) and the immanent (the ten thousand *xing-li* 性理) are one and the same entity. By the analogy he can only argue at most for the sameness in kind, but not the sameness of individuals. After all, Zhu Xi is unable to give us a coherent picture of his version of the doctrine of "the unity of Heaven and humans"—that "*li* is one but its manifestations are many."

Wang Yang-ming's and Xiong Shi-li's theories of "the unity of Heaven and humans" are in no better position; the difficulty they face is even more crucial. For Zhu Xi, *xin* is not identical with *li*, because *xin* is formed of *qi* 氣 (material force), though it is *xu* 虛 (vacuous) and *ling* 靈 (intelligent).[4] But for Wang Yang-ming and Xiong Shi-li, *xin* is not *qi* but *li*. The difference here can be put in this way: as something formed of *qi*, Zhu Xi's *xin* is an entity which can be individualized; as something identical with *li*, Wang Yang-ming's and Xiong Shi-li's *xin* has to have a transcendent status. What they claim for *xin* is not an individualized mind, but a universalized *liang-zhi*—a cosmic mind. We know that Lu Xiang-shan 陸象山 also asserts the identity of *xin* with *li*, but he defi-

1. *Zhu-zi yu-lei* 朱子語類 [*Classified Conversations of Zhu Xi*], 1 and 94.
2. Ibid., translation is from Wing-tsit Chan's *A Source Book in Chinese Philosophy* (Princeton: Princeton University Press, 1963), 638, with minor revision.
3. *Zhu-zi yu-lei*, 94.
4. Ibid., 5.

nitely rejects the idea that trees and stones may have *liang-zhi*.[5] Wang Yang-ming and Xiong Shi-li use the same slogan to tell a different story. They think that *liang-zhi* or the transcendent mind (of morality) is embodied in everything that we can find *liang-zhi* everywhere.

One of Wang Yang-ming's skeptical disciples asks his master a critical question: "Humans have *liang-zhi* because they have vacuity (*xu*) and intelligence (*ling*). As regards the nonsentient things such as plants, trees, tiles, and stones, do they have *liang-zhi* as well?" Wang Yang-ming gives a pantheism-like answer to his student: "Humans' *liang-zhi* is definitely the *liang-zhi* of plants, trees, tiles, and stones. If plants, trees, tiles, and stones lacked humans' *liang-zhi*, they would be unable to be plants, trees, tiles, and stones."[6] Wang Yang-ming's answer may be understood in three ways: (1) To be (even as plants, trees, tiles, and stones) is to be known or functioned by *liang-zhi*. (2) Without humans' *liang-zhi* as intentionality, the nonsentient things cannot be considered as intentional objects. (3) The universalized *liang-zhi* or cosmic mind is manifested or exemplified without difference in humans, other sentient beings, and the nonsentient things. The first interpretation appears to be like a moralized version of Berkeley's subjective idealism or some kind of solipsism. However, if we take Wang Yang-ming's idea of "nothing external to the mind" (心外無物) seriously, it is obvious his statement, "Before you look at these flowers, they and your mind both become quiescent; as you come to look at them, their colors at once show up clearly. From this you can know that they are not external to your mind,"[7] is not solipsistic. "Quiescent" (寂) does not mean "nothing" (無). In this context Wang Yang-ming is not rejecting the external world. The second interpretation seems to be more concordant with the idea of "nothing external to the mind." Under this interpretation, "quiescent" means a state that no intentional activity happens, and "clear[ly]" (明白) indicates the effect of intentional activity. Although the intentionality interpretation seems more reasonable in this context, it has two weaknesses: (1) If only humans could have *liang-zhi* and their intentional functions onto other things, the meaningful world opened up by *liang-zhi* would be a mere subjective vision or mental projection. No ontological claims for the objective validity of the external world can be made from these premises. (2) It is clear that what Wang Yang-ming's disciple asks presupposes that humans but not nonsentient things have vacuity and intelligence. Wang Yang-ming is required to explain the question why nonsentient things also have *liang-zhi* if they do not possess vacuity and intelligence. Hence, if Wang Yang-ming had answered the question based on the second interpretation, he would have been accused of being slippery. As we know, Wang Yang-ming is a responsible teacher, he would not use a slip-

5. *Lu Jiu-yuan ji* 陸九淵集 [*Collected Essays of Lu Jiu-yuan*], 11.
6. *Wang Yang-ming quan-shu* 王陽明全書 [*The Complete Works of Wang Yang-ming*], 3.
7. Ibid. Translation is from Wing-tsit Chan's *A Source Book in Chinese Philosophy*, 685, with minor revision.

pery strategy, and his idea of *"liang-zhi"* does not refer to individual minds which have the function of making subjective visions or mental projections only. In conclusion, the pantheism-like interpretation is much better than the other two interpretations.

If I am right that Wang Yang-ming's answer is pantheism-like, that is, one cosmic mind is manifested or exemplified everywhere, he is definitely not a true successor of Mencius 孟子 as he thought he was. Mencius defines *liang-zhi* as humans' moral and essential characteristic that other animals do not have, but Wang Yang-ming's *liang-zhi* is something shared by all the things in the world. Therefore, Mencius's distinction of humans and beasts is not compatible with Wang Yang-ming's idea of "universalized *liang-zhi.*"

This conflict is more critically reflected in Xiong Shi-li's version of "cosmic mind." Xiong thinks that the original mind is something embodied in one's body but not self-owned. Since what is embodied in one's body and in stones is the same cosmic mind, this mind is not in one's possession alone.[8] As to the question why nonsentient things are unable to transform or cultivate themselves to become ideal moral beings, the only explanation given by Xiong Shi-li is that there is such demarcation between humans and other things that humans' *qi-zhi* 氣質 (material force and natural disposition) is *qing-tong* 清通 (clear and transparent) while the *xing-ti* 形體 (body and form) of other things such as trees and stones are *bi-sai* 閉塞 (nontransparent) and *cu-ben* 粗笨 (coarse and clumsy) before they are transformed into human through evolution.[9] In other words, it is not the case that the same cosmic mind is embodied in stones with less power of transformation or cultivation than in humans. What determines the capacity of transformation or cultivation is *qi-zhi*. If we accept this kind of *qi-zhi* determinism, it will follow that the power of *liang-zhi* is not sufficient for self-transformation or self-cultivation; those who have second-rate *qi-zhi* would have no real freedom, nor responsibility, for their failure in self-transformation. To use an analogy, consider how the sun illuminates an area uniformly and evenly except in those places covered by clouds; likewise, the only differentiating factor in many manifestations of *liang-zhi* is whether the *qi-zhi* of someone or something is "cloudy" or not. In comparison to Wang Yang-ming, Xiong Shi-li diverts even farther from Confucius and Mencius.

Wang Yang-ming's and Xiong Shi-li's idea of "universalized *liang-zhi*" or "cosmic mind" is self-contradictory if it is understood in a pantheistic sense. It is impossible that the universalized *liang-zhi* is identical with any individual mind; in other words, it cannot be both transcendent and immanent. Suppose, for the sake of argument, there were no problem of contradiction, the idea of "universalized *liang-zhi*" would still be unable to play such roles as an indi-

8. Xiong Shi-li, *Xin wei-shi-lun* 新唯識論 [*New Doctrine of Consciousness-only*] (Beijing: Zhong-hua Book Company, 1985), 252.

9. Xiong Shi-li, *Qian-kun-yan* 乾坤衍 [*An Exposition of the Male and the Female Forces*] (Taipei: Student Book Company, 1976), 324, 328.

vidual mind or agent does, for only an individual mind or agent can have free choice and the sense of responsibility. In this regard, we can say that Wang and Xiong are not true successors of Confucius and Mencius.

3. The Thesis of "Paradoxicality"

From a rational point of view, all language use should observe the principles of logic and rationality. This is the last checking point of all the rational thinking. If we give up this checking point, everything goes as well. No matter how profound and interesting a theory is, there would be no demarcation between this theory and other irrational or antilogical theories (if they can be called "theories"). However, the contemporary new Confucianists do not think that antilogic or antirationality is a weakness of their doctrines; on the contrary, they emphasize that the language of their assertions belongs to some kind of "paradoxical language" which transcends logic and rational language. Although Xiong Shi-li's idea of "[the Original] Substance and its functions are not the same, nor are they different" (體用不一不二) and Mou Zong-san's and Tang Jun-yi's 唐君毅 idea of "transcendent immanence" or "immanent transcendence" seems self-contradictory, they maintain that these ideas are not really self-contradictory, but used as a kind of "temporary strategy/expediency measure" (方便説法/權法) to transcend the limit of the normal language. Their status and functions are like those of the paradoxical sayings in Buddhism and Daoism, such as "*samsara* is *Nirvana*" (生死即涅槃), "*prajñā* is not *prajñā*, that is *prajñā*" (般若非般若, 斯之謂般若), and "the creation without creating" (不生之生). Mou Zong-san calls this kind of sentences and phrases the "dialectical paradox" which is different from the "logical paradox."

It is not clear in what exact sense the contemporary new Confucianists say that their dialectical paradoxes or paradoxical language transcend logic and rational language. If dialectical paradoxes are not statements with cognitive function but some kind of *heuristic expressions* which can lead us to the vision of wisdom as Mou Zong-san describes,[10] they should not be understood as something transcending logic and rational language. If they are expressions of some kind of *private language* whose words have very special meaning that only the people who reach the enlightened state can understand, they should not be considered as transcending logic and rational language either. I do not think the contemporary new Confucianists are able to escape from this dilemma. In the former case, the so-called "dialectical paradox" is nothing but some kind of noncognitive use of language. A heuristic expression, which can lead us to the vision of wisdom, is definitely a speech act that can do something that a cognitive expression is unable to do. In this regard, we cannot say that it is tran-

10. Mou Zong-san, *Zhong-guo zhe-xue shi-jiu-jiang* 中國哲學十九講 [*Nineteen Lectures on Chinese Philosophy*] (Taipei: Student Book Company, 1983), 28.

scending logic and rational language just as we cannot say that ceremonial use of language is transcending logic and rational language. In the latter case, it is impossible for the so-called "private language" to have any confrontation with the public language of which rational language is a sub-language, because any confrontation has to presuppose that both sides can be understood as languages with public meaning. According to Donald Davidson's principle of charity, we cannot identify any similarity or difference between two languages without their sharing the maximum beliefs.[11] It follows that, whether in the former or the latter case, there is no real confrontation between the Western idea of "external transcendence" (transcendence in the sense of wholly other) and the Chinese idea of "internal transcendence" (immanent transcendence or transcendent immanence). The reason is that the Chinese words in this context are not used cognitively or with public sense.

The contemporary new Confucianists use the term "dialectical" like a magic word to go beyond the "logical." However, they never tell us what the meaning of "dialectical paradox" is except that it is not "logical paradox." We know that some of the speculative philosophers often use big terms without definition, but most of the analytic philosophers often check the related examples of the big terms. When the contemporary new Confucianists emphasize the significance and profoundness of their dialectical paradoxes without a clear description of what it is, we need to check their examples in order to see what they really mean. We may find out that there is, after all, no magic power in their language.

Except for some general descriptions of the Original Substance such as "transcendent immanence" or "immanent transcendence," very few examples of dialectical paradoxes in Confucianism are mentioned by the contemporary new Confucianists. They often borrow examples from Buddhism and Daoism. The paradigmatic example is the Buddhist comment on *prajñâ* (nonanalytic wisdom). According to Mou Zong-san's explanation, *prajñâ* cannot be explained and analyzed by any concepts. If someone tells us what *prajñâ* is, then *prajñâ* will become a concept and lead us to delusion, and the wisdom of *prajñâ* will never be shown. The dialectical paradox, "*prajñâ* is not *prajñâ*, that is *prajñâ*," to Mou, is not expressed in an analytical or discursive way, but in a negative way which is derived from an existential feeling of our mind or self. But why should *prajñâ* be expressed or exhibited in this way? Mou Zong-san's answer is that this expression indicates that the real *prajñâ* is something without properties and forms, it is nothingness, and the way this is expressed can remove our attachment and delusion.[12] In other words, this expression, like many *Zen* (*Chan*) Buddhist sayings, is a special speech act which can have an

11. Donald Davidson, *Inquiries into Truth and Interpretation* (Oxford: Clarendon Press, 1984), 27, 137.

12. Mou Zong-san, *Zhong-xi zhe-xue zhi hui-tong shi-si-jiang* 中西哲學之會通十四講 [*Fourteen Lectures on the Meeting of Chinese and Western Philosophies*] (Taipei: Student Book Company, 1990), 214; and Mou Zong-san, *Zhong-guo zhe-xue shi-jiu-jiang*, 356.

illocutionary force of removing attachment and delusion or a perlocutionary force of inviting such a removal. If the above explanation of this expression is right, there will be no magical sense in it, and we can rationally understand what it means and how it functions. The so-called "dialectical paradox" can be explained away!

The next famous example borrowed from Buddhism is "*samsara* is *Nirvana*" (transmigration is *Nirvana*). Mou Zong-san's view is that this expression is used to criticize the notion of the absolute separation of *samsara* and *Nirvana*.[13] Nevertheless, if the criticism is not a straw-man attack, both sides should have the same meaning of "*samsara*" and "*Nirvana*" and the word "is" has to have the connotation of "being inseparable." According to the Buddhist principle of "removing no *dharma* but its disease" (除病不除法), "*samsara* is *Nirvana*" means that "to arrive at the realm of *Nirvana* is not to remove the realm of *samsara*," because only the disease of *samsara* should be removed. Here is a rational interpretation of the meaning and an explanation of the function of the expression. Here we cannot find from the expression any magic powers transcending logic and rational language. Furthermore, we can confirm the nonparadoxical character of the expression through some of the analogies used by the contemporary new Confucianists. The relation of *samsara* and *Nirvana* has been compared by many Buddhist philosophers as a relation between the mud and the lotus flower growing out of the mud, or as that between ice and water. What these analogies say is that the lotus flower cannot be separated from impure mud and that ice and water are but different aspects of the same thing. The message provided by these analogies is clear enough for us to understand the original relation of *samsara* and *Nirvana*. In this case, there is nothing nonrational or irrational either.

The famous example of dialectical paradoxes in Daoism is "the creation without creating." "What is 'the creation without creating'?" Mou Zong-san said, "This is an expression to represent negatively the function of creation. Wang Bi's 王弼 interpretation is very good in its grasping the meaning of the expression. What the Daoists actually say about the activity of creation is that all things are self-creating and self-growing. But why do they still say '*Dao* creates them and *de* fosters them'? (道生之, 德畜之) And why do we say it has negative meaning? Here is wisdom with a dialectical process. Wang Bi interprets the expression as that '[people] do not prohibit the nature [of things] nor block up their origin' (不禁其性, 不塞其源). Then all things would be naturally growing by themselves."[14] What Mou Zong-san informs us from the above is again a discursive description of the Daoist idea of creation. There is

13. Mou Zong-san, *Zhi-di-zhi-jue yu zhong-guo zhe-xue* 智的直覺與中國哲學 [*Intellectual Intuition and Chinese Philosophy*] (Taipei: Commercial Press, 1971), 230.
14. Mou Zong-san, *Zhong-guo zhe-xue shi-jiu-jiang*, 106–7, 145.

no dialectical process, paradoxical power, or seeming contradiction in his explanation. How can it transcend logic and rational language?

Almost the only example offered by Mou Zong-san as a dialectical paradox in Confucianism is from the *Book of Odes* (尚書). Although the expression—"*Wu-you zuo-hao*; *wu-you zuo-wu*" 無有作好, 無有作惡—seems to be contradictory in that it tells us not to take a liking to something and at the same time not to take a disliking to something, it can be understood as a rational expression if we follow Mou Zong-san's explanation. His explanation is that this negative expression is not really used to reject a positive expression of "liking" and "disliking;" it is used to hint at a positive expression of them. It means that through this seemingly negative expression we can hint at a positive expression of "no artificial (or unnatural) act of liking and no artificial act of disliking."[15] Again, the so-called "dialectical paradox" is explained away.

As is well known, logic provides principles and rules for rational discourses. If we could demonstrate with "reasons" that some discourses transcend logic, the so-called "reasons" would not be "rational" in its proper sense. The more the contemporary new Confucianists use persuasive reasons to refute logical constraints on their special language, the more rational evidence there would be for us to refute their own thesis. In other words, they refute logical constraints consciously but self-refute their refutation unconsciously. The thesis of paradoxicality is doomed to fail in self-justification.

4. The Thesis of "Ineffability"

No matter how successful or unsuccessful the thesis of paradoxicality is, dialectical paradoxes are only strategies of speaking for the contemporary new Confucianists. They cannot touch the ultimate reality through these paradoxes, because the absolute truth is ineffable or unsayable in its ultimate sense. But why is it ineffable?

There are at least four reasons put forth by the contemporary new Confucianists to support their thesis of ineffability. The first, mentioned by Xiong Shi-li and others, is a longstanding one that says since the ultimate truth is profound, all-inclusive, and without limit, we are unable to use language to fully exhaust its meaning.[16] This is enticing particularly to those who are already attracted to the ideal of new Confucianism in general. As a matter of fact, it is not totally false if "ineffability" does not mean inexpressible in principle. Assuming that the thesis aims at showing empirical ineffability, we can say that it is not only true but also trivial and applicable to everything everywhere. If we

15. Ibid., 138–39, 141, 144.

16. Xiong Shi-li, *Du-jing shi-yao* 讀經示要 [*Instructions on Reading Cannons*], vol. 2 (Taipei: Guang-wen Book Company, 1970), 110–11.

take any descriptions seriously, it is obvious that nothing in the world can be all-inclusively and exhaustively described. Every description has to be based on some special interest and purpose with a particular perspective, each has to be focused on some aspect of the object being described. By definition no descriptions are all-inclusive, complete, and exhaustive. This is not the privilege or monopoly of the ultimate truth of Confucianism; that of Buddhism, Christianity, Hinduism, Judaism, Islam, and Daoism is also said to be ineffable. In fact a tree has this characteristic also. A tree can be described by an artist as something colorful and beautiful, by a scientist as something with certain biological and chemical properties, by a philosopher as something suggestive to understanding human life and the world, or by a carpenter as something useful for making furniture. Certainly we have no complete description that can be used to fully exhaust the meaning of the tree. The idea of being able to "fully exhaust" meaning is a myth or fantasy for the people who overrate or overstate the function of language.

The second reason often mentioned by the contemporary new Confucianists is that their ultimate truth is out of the limit of language in the sense that the truth as a practical activity cannot be replaced by speech. Tang Jun-yi thinks that this practical truth is the *greatest philosophy* which transcends all the sayable.[17] Mou Zong-san regards, with the same kind of confidence, this as a learning of life that is not equivalent to conceptual thinking.[18] Although they are right in considering Confucianism as a teaching inseparable from moral practice, they seem to confuse the concept of *"gong-fu"* 工夫 (moral practice) with *"gong-fu-lun"* 工夫論 (theory of moral practice). It is common sense that to drive or swim is different from knowing how to drive or swim and knowing what it is to drive or swim. It is also common sense that undergoing the latter two epistemological activities does not amount to doing the former. With the same reason, I do not worry that engaging in *gong-fu-lun* or the related conceptual thinking would harm the *gong-fu* or moral practice. However, I do worry that, without *gong-fu-lun* or the related conceptual thinking, whether the *gong-fu* or moral practice itself can get start at all. Few people will disagree with the general principle that not knowing how to swim suggests not going to swim alone. If someone tries to swim without the relevant epistemic equipment, the consequence could be very serious. Doing *gong-fu* while thinking that *gong-fu-lun* is a conceptual "demon" is dangerous as well.

The third reason to support the thesis of ineffability is shared by almost all the followers of the three teachings (三教) in traditional China: Confucianism, Buddhism, and Daoism. If we call the above two reasons *"not exhausting"* and *"not replacing,"* respectively, the third reason can be called *"not objectifying."*

17. Tang Jun-yi, *Zhe-xue gai-lun* 哲學概論 [*Introduction to Philosophy*], vol. 2 (Hong Kong: Meng-shi Education Foundation, 1961), 1219.
18. Mou Zong-san, *Zhong-guo zhe-xue shi-jiu-jiang*, 30–31.

Why cannot the ultimate truth of new Confucianism be objectified? Mou Zong-san's answer is that if we objectify *liang-zhi*, *liang-zhi* will not be seen by us. Because *liang-zhi* is an absolute subjectivity and the vision of "the unity of Heaven and humans" developed by *liang-zhi* is without the duality of subject and object, or of the knower and the known.[19] But this is not a good reason. We know that there is not one and only one vision of nonduality developed in philosophy and religion, if we do not objectify and conceptualize their ulti-mate realities or visions, how can we know whether there is any identity or difference between them and differentiate one from the others. If what the contemporary new Confucianists pursue or search for is not a mere mental projection but something with ontological and cosmological significance, they should observe the principle of individuality, that is, no entity without iden-tity and no identity without objectification and conceptualization. Even though someone wants to violate this principle, he or she can only justify his or her violation by basing it on the same principle. Hence, to emphasize the nonduality of the ultimate reality is to make a duality of the nonduality of the ultimate reality on the one hand and the duality of the nonultimate phenomena on the other. Any claim for nonduality and thus nonconceptualization is self-refuting. If the ultimate reality of new Confucianism is to be understood as something that cannot be objectified and conceptualized, it would become an "x" for which there is no description and stipulation. It is an absolute darkness and we are in a position of absolute ignorance!

In comparison to the first reason which is *empirically* "not exhausting," the fourth reason to support the thesis of ineffability is *logically* "not exhausting." This reason is provided by Fung Yu-lan 馮友蘭. He thinks that the ultimate concern of his new Confucianism is "the vision of Heaven and Earth" (天地境界) which is related to the greatest universe (大全). The greatest universe is composed of all the things, universal or particular, in all possible worlds, but it is logically impossible to describe it. From the premises that any description used to express the greatest universe is also an entity of the universe, and this new entity is not included in the greatest universe described, it follows that the original greatest universe under description is not really the greatest universe; it leaves out something. Hence, he thinks the argument is self-refuting.[20] Fung Yu-lan's argument can be elaborated in the following:

(1) The greatest universe is effable.

(2) If the greatest universe is effable, then the greatest universe (under description) is not the greatest universe.

19. Ibid.

20. Fung Yu-lan, *Xin yuan-dao* 新原道 [A New Treatise on the Way of Living], in *San-song-tang Quan-ji* 三松堂全集 [*The Complete Works of the Hall of Three Pines*], vol. 5 (Henan: Henan People's Press, 1986), 41–42.

(3) The greatest universe (under description) is not the greatest universe.

(4) The greatest universe is not effable (or is ineffable).

Let the individual constant "a" stand for "the greatest universe" and the predicate "F" for "is effable," the above argument can be formulated in a valid form as follows:

(1') Fa

(2') Fa\rightarrow~(a=a)

(3') ~(a=a)

(4') ~Fa

(3') is derived from (1') and (2') by the rule of *modus ponens*, and (4') is followed from (3') by the rule of *reductio ad absurdum*, therefore, it is a valid but self-refuting argument from (1') to (4'). However, the term "the greatest universe" used by Fung Yu-lan can have more than one interpretation. It seems to have an individual entity as its reference, but I think this is not the case. In reality it refers to some kind of totality which Georg Cantor, one of the founders of set theory, describes as "absolute infinite." He said, "A multiplicity can be such that the assumption that all its elements 'are together' leads to a contradiction, so that it is impossible to conceive of the multiplicity as a unity, as 'one finished thing'. Such multiplicities I call absolutely infinite or inconsistent multiplicities. As we can readily see, the 'totality of everything thinkable,' for example, is such a multiplicity."[21]

Fung Yu-lan's "the greatest universe" is similar to the concept of "unbound (or unlimited) totality" pursued by some philosophers in traditional theology. Both are not constructible through any effective procedure. If what is *conceived* cannot be *constructed*, it is highly probable that it is not an identifiable entity in any possible world: mathematical, physical, or metaphysical. In this regard, we should not use an individual constant to stand for an unconstructible entity. If we use Bertrand Russell's theory of definite descriptions, the story will be different. The above argument form can be reconstructed as follows:

(1") $(\exists x)\{[Gx \ \& \ (\forall y)(Gy \rightarrow y=x)] \ \& \ Fx\}$

(2") $(\exists x)\{[Gx \ \& \ (\forall y)(Gy \rightarrow y=x)] \ \& \ Fx\} \rightarrow \ \sim[(\iota x)Gx = (\iota x)Gx]$

(3") $\sim[(\iota x)Gx = (\iota x)Gx]$

(4") $(\exists x)\{[Gx \ \& \ (\forall y)(Gy \rightarrow y=x)] \ \& \ \sim Fx\}$

21. Georg Cantor, *Gesammelte Abhandlungen*, 443. This letter (to Dedekind) is translated by Stefan Bauer-Mengelberg in Jean van Heijenoort, ed., *From Frege to Gödel* (Cambridge, Mass.: Harvard University Press, 1967), 114.

Here the conclusion is (4″) but not

(5) $\sim (\exists x)\{[Gx \ \& \ (\forall y)(Gy \rightarrow y=x)] \ \& \ Fx\}$

If it were (5), the argument would be valid as the case from (1′) to (4′). From (1″) to (4″), the conclusion is not obtained through a valid argument. The obvious difference between (4″) and (5) is that the negation sign in (4″) is used as a *predicate negation* while that in (5) a *sentence negation*. Using the theory of definite descriptions to analyze the above sentences, we cannot consider (5) but (4″) as a form for the sentence "the greatest universe is *not* effable. " And (5) can be understood as a form for the sentence "it is *not* the case that the greatest universe is effable" or the sentence "it is not the case that there is something which is both the greatest universe and effable." On the one hand, the set of sentences from (1″) to (4″) understood as an argument form for sentences from (1) to (4) tells a different story from the set of sentences from (1′) to (4′). In this case, the argument or argument form is neither valid nor self-refuting. On the other hand, even though the set of sentences from (1″) to (5) is a valid and self-refuting argument, since sentence (5) has no commitment to the existence of the greatest universe as the case of sentence (4″), it is still unhelpful to Fung Yu-lan's thesis of ineffability.

Maybe there are other reasons to support the thesis of ineffability that we do not know, or more profound reasons are still awaiting discovery or disclosure. I agree it is a real possibility, but I also think the burden of proof is on the thesis holders. Very likely other forthcoming reasons are also self-refuting if not trivially true. We can elaborate an argument to "welcome" all the possible newcomers. Suppose any sentence "A" of the kind in favor of the thesis of ineffability has the form "K is ineffable" (for example, "*dao* is ineffable"), we have the following self-refuting but valid argument:

(i)	"A" is true	*assumption*
(ii)	"A" is true if and only if A	*disquotation*
(iii)	A	(i), (ii), *modus ponens*
(iv)	If A, then K (*dao*) cannot be described by any predicate	*definition*
(v)	K (*dao*) cannot be described by any predicate	(iii), (iv) *modus ponens*
(vi)	K (*dao*) cannot be described by the predicate 'is ineffable'	(v), *instance*
(vii)	If K (*dao*) cannot be described by the predicate 'is ineffable', then "A" is not true	(vi), *explanation*
(viii)	"A" is not true	(vi), (vii), *modus ponens*

If the above analysis is right, any thesis of ineffability is doomed to fail.

5. "Twin Philosophers":
Thought Experiment I

While the thesis of "universalized *liang-zhi*" exposes the new Confucianists'
intention of giving up the principle of individuality, the theses of paradoxicality
and ineffability have a hidden agenda. This agenda contains an item that
represents the new Confucianists' privilege of accessing to the ultimate reality.
This item is a peculiar, magical, and deep-rooted experience that can only be
obtained by someone who has been doing moral practice in a long and hard
time. Through a long-term practice, the new Confucianists think, one can reach
the realm of sacred inwardness and thus have inward confirmation of or inner
enlightenment about the ultimate reality. In comparison with the outward
confirmation or external verification of the physical phenomena in natural
sciences, they favor the inward confirmation for its infallibility, though the
former is actually more objective and ascertainable than the latter.

How can one affirm and justify what is inwardly confirmed is really the
ultimate reality? We think the guarantee must be rational and not arbitrary.
But there has never been any guarantee with objective validity that is not
outwardly confirmed. The new Confucianists and other philosophers with an
inclination to mysticism often make claim of the infallibility of their inwardly
confirmed experience without noticing that real experience does not mean
real substance. The following thought experiment—"twin philosophers"—is
designed for illustrating the unbridgeable gap between the subjective experi-
ence and the objective reality.

There are two twin philosophers in our possible world: one named "*Mi-
yin Dao-ren*" 密印道人 (The Daoist with Mystic Experience), the other named
"*Huan-si Zui-zhe*" 幻似醉哲 (The Drunken Philosopher with Magic Vision).
Through a long-term moral practice the Daoist reaches an inward confir-
mation of "the unity of Heaven and humans." He "knows," in the words of
Cheng Ming-dao, "The *xin* is just *tian*, to exhaust the *xin* is to know the *xing*,
and to know the *xing* is to know *tian*. We should ascertain the Original
Substance in this context, but not by searching outwardly."[22] In Mou Zong-
san's vein of expression, we can say that he "knows" that the Original Substance
is both transcendent and immanent on the basis of his private and inner
experience. But what is the ontological status of the content of his "knowing"?
Up to now no answer and explanation have been provided by the contem-
porary new Confucianists. We can try to do for them by singling out three
answers that are most plausible: (1) There is some kind of experiential content
which corresponds to the Original Substance; (2) The experiential content
itself is the Original Substance; (3) The mind of the experiential content is the

22. *Er-Cheng Quan-shu* 二程全書 [*The Complete Works of the Cheng Brothers*], 2A.

Original Substance. The first option is a *correspondence thesis* about the subjective content and the objective reality, the second an *identity thesis* about the subjective content and the objective reality, and the third an *identity thesis* about the subjective faculty (as entity or activity) and the objective reality. Since the correspondence thesis presupposes the duality of the subject and the object (it would make no sense to say that the absolute subjectivity still has self-knowledge without the duality), I do not think that the new Confucianists would like to accept it. They do have a proclivity for the identity thesis in general, such as "*xin* is *tian*" or "*xin* is *li*," but they usually neglect to specify the concrete meaning or content of the related terms. With respect to the objective side, the identity statement is undoubtedly related to the Original Reality (the transcendent); as to the subjective side, however, it is not clear what the mental item (the immanent) is. If it is the experiential content of the vision of "the unity of Heaven and humans," it pertains to option two. If it is the mind as a faculty (either entity or activity), it pertains to option three. With either of the two options, the new Confucianists seem able to establish their absolute subjectivity through the identity thesis. Nevertheless, allowing that there is really an absolute subjectivity, there still remains the question of how they know that they have the absolute subjectivity. It cannot be the absolute subjectivity itself that knows it, because the absolute subjectivity, by their account, is not a knowing self with knowing content under a dualistic scheme. If we accept, for argument's sake, the so-called "self-knowledge" of the absolute subjectivity, then new Confucianists who have the absolute subjectivity still cannot tell, through their "*inner mouths*," the same people, who speak up for their philosophy through their "*outer mouths*," anything. In other words, for the Daoist (with Mystic Experience—one of the twin philosophers) himself, there is no real communication between his absolute subjectivity and his ordinary knowing self. "*He*" (the absolute subjectivity) cannot tell him (the ordinary knowing self) anything, because it is logically impossible for "*He*" to tell him anything, period. If the above analysis is right, we can say that the Daoists (with Mystic Experience) and the new Confucianists must know their ultimate reality under a dualistic scheme, if they are able to know at all.

In the case of the Drunken Philosopher's experience, there is neither a long-term moral practice nor an inward confirmation. He obtains the experience similar to or the same as what the Daoist (with Mystic Experience) has after a drinking bout. He has no "inner eyes" to "see" the ultimate reality but is endowed with some magic imagination or vision for him to play with (玩弄光景). In the case of option one—the correspondence thesis, what he experiences would not correspond to the Original Substance. In the cases of options two and three—two kinds of identity theses, he seems able to reach the realm of absolute subjectivity and to escape the duality. But this is not so. My question

is: In what sense can we say what these twin philosophers obtain in experience are different? Is there any subjective factor we can mention to make the difference? No, because the only subjective factor that is relevant is the experience itself. Is there any objective factor, such as behaviors in the moral practice, that can be considered as a differential characteristic? None either, because this would be searching outwardly instead of inwardly which is contrary to Cheng Ming-dao's moral instruction. As is well-known that "*bian-hua qi-zhi*" 變化氣質 (transforming one's natural disposition through cultivation) is an important concept in Confucianism. But the moral transformation of behaviors is not a sufficient condition of the inward confirmation of the ultimate reality. We do find some examples of this kind of inference in new Confucianism and other religions as well. From the empirical evidence of behavior transformation to the transcendental judgment of ultimate reality, we can only obtain a transcendental argument that is logically unsound.[23] Hence, the idea of changing from an inner to an outer approach does not help the new Confucianists. It seems logically impossible to make the difference.

The thought experiment with the twin philosophers can be more challenging to the new Confucianists if we make some modifications. We may borrow Hilary Putnam's idea of "brains in a vat" to make our own version.[24] Imagine that the Daoist (with Mystic Experience) has been subjected to an operation by an evil scientist. His brain has been removed from his body and placed in a vat of nutrients which keeps the brain alive. The nerve endings have been connected to a super-scientific computer which causes the Daoist, whose brain it is, to have the illusion that everything is perfectly normal. There seem to be people, objects, the sky, and so on out there, and there seem to be the *xin*, *tian*, *li*, and he has experienced the unity of them; but in reality all he is experiencing is the result of electronic impulses traveling from the computer to the nerve endings. The computer is so clever that if the Daoist tries to raise his hand, the feedback from the computer will cause him to "see" and "feel" the hand being raised. Moreover, by varying the program, the evil scientist can cause him to "experience" (or hallucinate) any situation or environment the evil scientist wishes. He can also obliterate the memory of the brain operation, so that the victim (the Daoist) will seem to himself to have always been in this environment. In this case, it is possible that what is experienced by the *real Daoist* is the same as what is experienced by the *Daoist brain*. The Daoist brain can have the same kind of experience about "the unity of Heaven and humans"

23. A detailed argument for the unsoundness of transcendental arguments is given in my "Chao-yue Fen-xi yu Luo-ji Fen-xi" 超越分析與邏輯分析 ["Transcendental Analysis and Logical Analysis"], *Er-hu yue-kan* 鵝湖月刊 [*Legein Monthly*] 229 (July 1994): 8–20.

24. Hilary Putnam, *Reason, Truth and History* (London: Cambridge University Press, 1981), 5–6. This part of my story is borrowed from Putnam's thought experiment with minor modification.

and think that what he obtains by the experience is an absolute subjectivity. He can also have the experience that he has been doing moral practice for a long time with struggles against thousands of deaths and hundreds of calamities (千死百難). But in reality he has neither inward confirmation nor moral practice. Consider almost all the possibilities, we do not find any criterion that can be used to make the distinction between having and not having the confirmation of the ultimate reality.

To sum up, there is no effective criterion we can find to make the distinction between the Daoist's and the Drunken Philosopher's experience, or the real Daoist's and the Daoist brain's experience. The approach of inward confirmation is not acceptable unless the distinction can be made in advance.

6. "Dracula (The Alien)": Thought Experiment II

Suppose, for the sake of argument, that all my analyses and arguments in the previous sections are totally wrong, that what the new Confucianists inwardly confirm is really the ultimate reality which is also named "Original Substance," "absolute subjectivity," and "universalized *liang-zhi*." We can even agree that the vision or entity has the characteristics of being both transcendent and immanent, being paradoxical, and ineffable. But is this Confucianism, so transformed in a "genetic modification" by a moral metaphysics, acceptable?

The following thought experiment is designed as a debunking of the myth of the metaphysicalized Confucianism. It aims at demonstrating the theoretical and practical consequences of accepting the above ideal world provided by the new Confucianists. The conclusion is that it is too high a price for us to pay.

In the possible world of our thought experiment, there is a people-like kind of creature living on a planet far away from the Earth called "Planet Dracula." These aliens, called "Dumans" (德民) or "the people of Dracula" (德古來族人), can only survive by means of sucking the blood from some other living beings called "Djickens" (狄勤士). Although Dumans live like Dracula, they are an extraordinary species for having the perfect virtues. Most of them have reached the highest level of morality and entered into the vision of "the unity of Heaven and Dumans" through their inward confirmation, unlike human beings most of whom lack this moral and visional achievement. In other words, although the ideal of new Confucianism has not yet been realized on the Earth, it has been instantiated in the moral and spiritual lives of the Dumans. Being the *ren* people (仁者—people with the virtue of benevolence), they can consider all the things in their world as a unity, enter into the vision of nonduality, and understand everything in their world is an "end in itself." Five hundred years ago, there was a great philosopher on this planet whose name was "You'n'me Dracula" (德陽明). He wrote a masterpiece entitled

"Dracula's Questions on the Great Learning" (德古來大學問). At the very beginning of the essay, he says:[25]

> The Great Duman regards Heaven and Planet Dracula and the myriad things as a unity. He regards the world as one family and the country as one person. As to those who make a cleavage between objects and distinguish between the self and others, they are small Dumans. That the Great Duman can regard Heaven, Planet Dracula, and the myriad things as a unity is not because he deliberately wants to do so, but because it is natural to the benevolent nature of his mind that he do so. Forming a unity with Heaven, Planet Dracula, and the myriad things is not only true of the Great Duman. Even the mind of a small Duman is no different. Only he himself makes it small. Therefore, when he sees a child about to fall into a well, he cannot help a feeling of alarm and commiseration. This shows that his benevolence forms a unity with the child. It may be objected that the child belongs to the same species. Again, when he observes the pitiful cries and frightened appearance of birds and animals about to be slaughtered, he cannot help feeling an "inability to bear" their suffering. This shows that his benevolence forms a unity with birds and animals. It may be objected that birds and animals are sentient beings as he is. But when he sees plants broken and destroyed, he cannot help a feeling of pity. This shows that his benevolence forms a unity with plants. It may be said that plants are living things as he is. Yet even when he sees tiles and stones shattered and crushed, he cannot help a feeling of regret. This shows that his benevolence forms a unity with tiles and stones. This means that even the mind of a small Duman necessarily has the benevolence that forms a unity with all. Such a mind is rooted in his Heaven-endowed nature, and is naturally intelligent, clear, and not beclouded. For this reason it is called the "clear character."

Another great philosopher called "Silly Dracula" (德十力), following You'n'me Dracula's idea of "universalized *liang-zhi*," said in his "Dracula's New Doctrine of Consciousness-Only" (德古來新唯識論) that *liang-zhi* is a universal great life which is not self-owned by Dumans but manifested in all the things in the world whether sentient or nonsentient. But the reason why nonsentient things cannot be transformed into ideal beings such as the Duman Sages is that their material forces and natural dispositions are not so luminous and intelligent as Dumans'.[26]

As mentioned in the beginning of this section, the Dumans have their limitation. Although most of them spiritually transcend all the external constraints and enter into the realm of "the unity of Heaven and Dumans," they have to suck the blood from the Djickens' bodies just like human beings make meals of

25. Wing-tsit Chan, *A Source Book in Chinese Philosophy*, 659–60. This citation is from Chan's translation with minor modification.

26. Xiong Shi-li, *Qian-kun-yan*, 324, 328.

chickens. Here there seems to be a conflict: they should love everything, for their benevolence is able to form a unity with all the things in the world; but they are unable to love everything, for they have to suck the Djickens' blood for survival. How can the Duman new Confucianists solve the problem of this conflict? You'n'me Dracula gives us the following solution:[27]

> It is a natural principle that there should be things of greater and lesser importance. The body, for example, is a unity, but if we use the hands and feet to defend the head and eyes, does that mean that we belittle the importance of the hands and feet? It simply means we are in accord with this natural principle. Thus, though animals and plants are both to be loved, we nevertheless endure the fact that we make use of plants to nourish the animals. And though Dumans and animals such as Djickens or chickens are both to be loved, our minds nevertheless endure the fact that we butcher animals to feed our parents in life, to sacrifice to them after death, and to entertain guests. (In the same way) love is to be shown both to our close relatives and to the passersby on the road. Yet suppose there be but a single dish of (blood) food or bowl of (blood) soup, and that life or death depends upon whether it be gained or not. When it thus becomes impossible to fulfill (our love) in both cases, we then prefer to save our close relatives rather than the passersby. Our mind endures this, moreover, because, according to natural principle, it is proper that we should act in this way.

This solution presupposes a natural principle which functions like the principle of "ought implies can." This may not be the most favorable principle, but is certainly a necessary condition for the solution of moral conflicts. Hence, I agree with Confucianism that love should be extended by gradations, yet I do not think that this can help the idea of "the unity of Heaven and humans (or Dumans)." Why? Let us continue with the story.

Suppose that, unfortunately, it happens that all Djickens are inflicted with a fatal disease called "DAIDS" (德滋病毒), and so no fresh uncontaminated blood is available to the people of Dracula. In this critical time the only way of survival is to search for the same kind of blood from other planets. Luckily, after long space travel, some similar blood is found on a far away planet named "Earth." It is the blood of human beings that is similar to that of Djickens (actually they are the same species). It can be said that it is luck for Dumans, but not for humans. In this regard, all the living beings face two crucial questions: (1) Should Dumans suck human beings' blood for their own survival? (2) Do we (the human beings), who commit to the new Confucianism, deserve or agree to be victims? I think these two questions are critical for the new

27. Fung Yu-lan, *A History of Chinese Philosophy*, translated by Derk Bodde (Princeton: Princeton University Press, 1952), 612. It is cited from Bodde's translation with minor modification.

Confucianists; they are not easy to answer, because in this situation it is not *other* creatures such as Djickens but rather we who are the victims. In our actual world, according to You'n'me Dracula's and Wang Yang-ming's natural principle, we think that eating chickens for our meals is not committing a sin. For the same reason, in Dracula's possible world, we probably think that the Dumans' sucking of Djickens' blood is also not murder. Nevertheless, when we are put in the place of the victims, can we still accept this natural principle so that we agree to identify the Dumans' bloodsucking as rational? I believe no human beings, except for maybe a few new Confucianists, would welcome this idea though it is consistent with the cases in other possible worlds. It is obvious that there is a relevant isomorphism between these three possible worlds: chickens, Djickens, and human beings as victims, respectively. Based on this isomorphism, the same natural principle should be applied to the three possible worlds without discrimination. That we do not like to be the victims may be an emotional reaction, but it is not rational to reject this universal principle in one possible world while accepting it in others. In other words, the people on the Earth, who accept this principle, should not reject what Dumans do to us as irrational should they decide to take our blood, because You'n'me Dracula and Wang Yang-ming, or Silly Dracula and Xiong Shi-li, are talking about the same universal principle.

It may be objected that we are neither chickens nor Djickens. Human beings are different from other animals, therefore, Dumans should not take our lives. But Dumans would challenge us that "for us, there is no essential difference between human beings, chickens, and Djickens, maybe human beings' *qi-zhi* is more clear and intelligent than chickens', but they are similar to Djickens'." The Song-Ming Confucianists often mention the idea of "*tui*" 推 (push, extension, or inference) and emphasize that "human beings can push, other things cannot." (人能推, 物不能推) In this context, "*tui*" means to generalize a moral feeling of commiseration from oneself to other people and things in order to form a unity of oneself with others. Obviously, this concept refers to the function of *liang-zhi*. However, we should not neglect the idea that, according to Wang Yang-ming's and Xiong Shi-li's idea of "universalized *liang-zhi*," not only human beings but also all other things in the world have *liang-zhi*. Hence, the fact that "human beings can push, other things cannot" has to do with the problem of *qi-zhi*, that is, there is a difference in degree, not in essence. If I am right, the counter-argument based on the idea of "*tui*" is not only to reenforce the "poison" of *qi-zhi* determinism, but also to refute itself.

The question may be pursued further. We may allow the validity of the new Confucianists using the idea of "*tui*" to elaborate their argument, thus "*tui*" can be used as an essential characteristic for making a distinction between human beings and Dumans, on the one hand, and other animals, on the other. Can this justify the argument that Dumans should not take the lives of human

beings? I don't think so. I think that the Dumans have to take human beings' lives unless they decide to let themselves die out. If most Dumans who have succeeded in reaching the ideal of new Confucianism should decide not to take the lives of humans, even though the latter's performance with respect to moral practice is not satisfactory, the consequence would be the extinction of their species. Is this a rational choice? Why is the suicide of Dumans more rational and moral than the same sacrifice by human beings? We may revise the story slightly to accentuate the implications. Imagine that Dumans have to suck the blood of humans, and conversely, the latter need the blood of the former in order to save them from a fatal form of anemia. In this case, what should they do to each other or for each other? Should they commit suicide collectively? If it is the case, the consequence will be the scenario described by Song-Ming Confucianists as follows: "Heaven and Earth are hidden, and the moral gentlemen are concealed" (天地閉, 賢人隱). Is this a rational consequence derived from a moral choice? Can the new Confucianists instruct us how to escape from this predicament?

"Is there any way out?" My answer is: "No way!"

7. Conclusion

If I am right in any step, even not all, of my analyses and arguments in the previous sections, the ideal world designed by the Song-Ming and contemporary Confucianists will collapse. Actually, all three dogmas provided by the new Confucianists are not peculiar to Confucianism, they are also shared by other religious traditions. If everything they claim were true, there still remains the question of why the ultimate concern of Confucianism is more acceptable. If the new Confucianists appeal to their own inward confirmation of the ultimate concern, why cannot people with other religious wisdom do the same thing? The new Confucianists are not privileged to say they are on the right track.

The new Confucianists often claim that if the water is too clear, there will be no fishes (水清無魚). Is this a good reason to support the necessity of using paradoxical language or adopting the thesis of ineffability? Of course not! It is not persuasive in the sense that other religious traditions may have the same excuse, and in another sense that these two theses cannot be sustained for they are self-refuting or trivial. The thesis of "universalized *liang-zhi*" or "cosmic mind" is not only trapped in a theoretical inconsistency, but also deviates from the main concerns of Confucius and Mencius. We know that Confucius and Mencius emphasize the distinction between humans and beasts, but the new Confucianists' great plan for the universalization of morality necessitates the removal of the distinction. In this context, we cannot say that they are true successors of Confucius and Mencius.

After cleaning up the mud, there will be no "cosmic big fish" in the water, but this is a good environment to nourish healthy smaller fish. For Kant, humans can have no direct duties to any beings other than humans, all nonhuman beings have only instrumental values, and they cannot be treated as ends-in-themselves. But for the Kantian Confucianists, not only humans, but also plants, trees, tiles, and stones are members of the Kingdom of Ends (*Reich der Zwecke*). Why should we assume there is a "cosmic big fish" in order to support a pseudo kingdom?

A localized morality may be more adequate for our age.[28]

28. I would like to express my deep gratitude to my good friend and colleague Professor Karl Kao for his comments on the writing style and theoretical content of this paper.

PART FOUR

METHODOLOGICAL ISSUES
IN COMPARATIVE PHILOSOPHY

The Myth of Comparative Philosophy or the Comparative Philosophy *Malgré Lui*

<div style="float:right;border:1px solid;padding:10px">12</div>

Robert E. Allinson

Is there a difference between comparative philosophy and philosophy proper? As Robert Neville so aptly wrote in his foreword to my *Chuang-Tzu for Spiritual Transformation: An Analysis of the Inner Chapters,* "Early Christian thought, for instance, was comparative philosophy, combining Jewish, Zoroastrian and Greek traditions. Early modern philosophy arose from a comparative base of scholasticism and humanistic science."[1] The question is, can comparative philosophy exist as an enterprise distinct from any good philosophy? Was Laozi practicing comparative philosophy when he argued that morality only arose when the Great *dao* was forgotten? Was Aristotle practicing comparative philosophy when he envisioned his philosophy as a completion of what the pre-Socratics were attempting to accomplish but, without his unique contribution, were unable to accomplish?[2] Was Mencius practicing comparative philosophy when he expanded implicit notions of human nature to be found in such sayings attributed to Confucius as, "The Master said, 'Is benevolence really far away? No sooner do I desire it than it is here'"[3] and "The Master said, 'People are close to one another by nature. They diverge "as a result of repeated practice,'"[4] to explicit pronouncements on the goodness of human nature? Was Zhuangzi practicing comparative philosophy when he related the story of the madman criticizing Confucius both for his failing virtue and for his teaching of virtue? Was Kant practicing comparative philosophy when he constructed his philosophy as a mean between the extremes of Hume and Leibniz? Was Kant practicing comparative philosophy when he argued that one could not know, as the rationalists thought, things as they existed in themselves? Was Marx practic-

1. See Robert E. Allinson, *Chuang-Tzu for Spiritual Transformation: An Analysis of the Inner Chapters* (Albany: SUNY Press, 1989; sixth impression, 1996), 2.
2. See Robert E. Allinson, "An Overview of the Chinese Mind," in Robert E. Allinson, ed., *Understanding the Chinese Mind: The Philosophical Roots* (New York: Oxford University Press, 1989; 2000 tenth impression), 1–25.
3. *Analects,* (*Lun Yu*): VII, 30.
4. *Analects,* (*Lun Yu*): XVII, 2.

ing comparative philosophy when he applied Hegelian dialectic to economic systems? Was Marx practicing comparative philosophy when he argued that Hegel had turned philosophy upside down and he was turning Hegel on his head and thus putting philosophy back on its feet again? Was A. J. Ayer practicing comparative philosophy when he argued that metaphysics (of others) was nonsense? Analytic philosophy arose as a reaction to the excesses (so it thought) of nineteenth-century Absolute Idealism. The philosophy Russell studied at Cambridge was the philosophy of Bradley and other Cambridge neo-Hegelians. Thus was the long reign of analytic philosophy ushered in! In short, is it possible to find an example of philosophy, whether Eastern or Western, which does not make use of comparison, nay, this is far too mild a statement, which is not based on a key comparison or contrast as the source of its inspiration and consequent development? All philosophy arises in reaction either as a revolution against or as a completion to previous philosophy.

The moral of the above story is that it is quite impossible to carry out philosophy in a vacuum whether one has Western philosophy or Chinese philosophy in mind. All philosophy is comparative philosophy and in this sense the term is too wide to be very useful. In this regard, the notion of comparative philosophy, as a unique self-subsistent discipline in itself, is a myth. Philosophy always has been comparative philosophy. The phrase "comparative philosophy" is redundant. All philosophy must contain a comparative basis for its inspiration and as part of its data base.[5] The only real question left to decide is in what direction philosophy is to proceed.

Now, of course, since the different traditions of philosophy such as Western philosophy and Chinese philosophy have not always been very well known to each other, "comparative philosophy" such as it has been generally practiced, has been confined to comparative philosophy within each tradition perceived from within as a separate whole. Thus, the philosophy of *Zen* can be considered to have arisen as a comparative outgrowth of the philosophies of Mahayana Buddhism of India and Daoism of China.[6] But such a comparative outgrowth was confined to the comparison and consequent process of exclusion and inclusion of philosophies taken from the Eastern hemisphere.[7] Similarly, the

5. The argument of this chapter is a continuation and a further development of the argument presented in the author's introductory chapter, "An Overview of the Chinese Mind," Robert E. Allinson, ed., *Understanding the Chinese Mind: The Philosophical Roots* (New York: Oxford University Press, 1989, 2000 tenth impression), 1–25. That chapter argued that the idea that philosophy even from ancient times arose in splendid cultural isolation was a myth. Further, it was argued in that chapter that the Chinese and the Western ways of thinking did not reflect two alien and incommensurable mind-sets but rather reflected developments in different degrees of two tendencies of a common human mind and the purpose of *rapprochement* between these two tendencies was for the sake of integrating and broadening the human mind.

6. See Robert E. Allinson, "Daoism in the Light of *Zen*: An Exercise in Intercultural Hermeneutics," *Zen Buddhism Today* 6 (Kyoto: November 1988): 23–38.

7. See Robert E. Allinson, "The Buddhist Theory of Instantaneous Being: The *Ur*-Concept of Buddhism," *The Eastern Buddhist* 8, no. 1 (Kyoto, May 1975).

philosophy of St. Thomas was a comparative philosophy of religion and philosophy taken from the Western hemisphere, the religion of Christianity and the philosophy of Aristotle. The idea of a comparative philosophy of East and West is not any different from the idea of pure philosophy in the East or in the West. The only difference that arises is constituted by the inclusion of a wider data base. Thus, a global philosophy, which makes use of the developments from both Western and Chinese philosophy is no more a comparative philosophy than the previous philosophy of either the West or China. It is only a philosophy which includes as its inspiration and data base, the methodology and the conclusions of both Chinese and Western philosophy. (This is, of course, to speak in shorthand. The utilization of Western and Chinese philosophies as Others serves the needs and purposes of this volume and serves as an archetypical model. In point of fact, the Other could be another other, or a plurality of Others.)

"Comparative philosophy" such as it has been practiced is normally "comparative-inclusive," "comparative-exclusive," or a mixed type.[8] Examples of "comparative-inclusive" philosophy not usually recognized as such include the aforementioned example of Aristotle's famous reference to the pre-Socratics in his *Metaphysics* as anticipating but not quite formulating his idea of his four causes and the aforementioned example of Mencius's elaboration of Confucius's intimations of the goodness of human nature. Examples of "comparative-reactive" philosophy include the analytic philosophy of Russell as a reaction against his exposure to the Cambridge neo-Hegelians. Other famous examples of "comparative-reactive" philosophy include Kant's reaction to the rationalists and the empiricists and Zhuangzi's reaction to Confucian philosophy. A famous example of a mixture of a comparative inclusive and comparative exclusive philosophy is the aforementioned example of the *Zen* and the *Chan* Buddhist appropriation of and reaction to both original Indian Mahayana Buddhism and Chinese Daoism.[9]

Comparative exclusive philosophy, practiced as a discipline separate from philosophy proper can be classified into two streams.[10] One stream, represented

8. This set of types is not intended to be an exhaustive classification of types but it does represent a good starting point for investigation. For simplicity's sake one can overlook for the time being East-East or West-West comparative types as well as ahistorical or achronological comparisons such as Hegel's intriguing historical ordering in his *Phenomenology of Mind* of the Stoics preceding the Skeptics when in point of historical fact the temporal order is the reverse. The rearrangement served Hegel's purpose of showing an hermeneutic relationship and dialectical development between philosophies that, for Hegel, existed irrespective of the actual empirical order of the appearance of the philosophies. A further development of Hegel's ahistorical comparison is to be found in Robert E. Allinson, "Daoism in the Light of *Zen*: An Exercise in Intercultural Hermeneutics" and "The Buddhist Theory of Instantaneous Being: The *Ur*-Concept of Buddhism," op. cit.

9. See Robert E. Allinson, "Daoism in the Light of *Zen*: An Exercise in Intercultural Hermeneutics" and "The Buddhist Theory of Instantaneous Being: The *Ur*-Concept of Buddhism," op. cit.

10. This is not intended as an exhaustive classification of comparative inclusive philosophy

by the positive comparativist, searches for likenesses and unlikenesses between the two traditions but normally shows a preference for the likenesses. This stream, while searching for positive correlations, does not generally attempt to borrow from the content or the methodology of the other tradition or lend the content or the methodology of its own tradition to the other tradition. Generally speaking, the positive comparativist searches for analogues of Western concerns, issues, and methodology in Chinese philosophy. Normally, the positive comparativist does not first find issues, concerns, and methodologies in the Chinese tradition that are borrowed for use within the Western tradition.[11] The standpoint of the positive comparativist is a stand-alone standpoint in which parallel developments in each tradition may be noted, but normally there is no active expropriation of issues, concerns, or methods found originally in the other tradition and consequent alteration of methods in one's own tradition.

Another stream, represented by the negative-exclusionist comparativist (for future reference, for convenience's sake these types will be referred to as negative or positive comparativists), possesses the tendency to find that the traditions or the terms compared are incommensurable. This stream also remains intact within the secure boundaries of its own philosophical heritage. Negative comparativists are not completely negative since, irrespective of the internal inconsistency in approach this implies, generally consider that Western categories are useful in understanding the other tradition even though the other tradition remains alien to one's own.

Neither the positive nor the negative comparativist tends to self-consciously contribute to the systematic internal development of either philosophical tradition although the data of the positive comparativist sometimes is put to this use. Furthermore, the third territory of the construction of a philosophically mixed system is left undeveloped. Negative comparative philosophy practiced as a discipline separate from philosophy does not partake of the cultural

but only as an identification of two tendencies. There are also interpreters of cultural traditions who are not, strictly speaking, comparative philosophers since their interpretation, generally speaking, is only of the other culture, not of their own. One could argue that they are comparative philosophers, nevertheless, since they employ categories of their own culture to interpret the culture of the other, but this is still not comparative philosophy in its fullest sense. Extreme versions of this "interpretative" school of comparativists attempt to impose systematic theoretical constructions on the other culture and sometimes do violence to the other's natural cultures in their attempts to make the other culture fit into one or another of these preconceived frameworks. Such extreme impositions of theoretical schemes of one culture on the other reflect a kind of philosophical imperialism. Worse yet, the other cultures sometimes innocently take on these systematic framework explanations of their cultures as valid self-descriptions.

11. An example of attempting to find arguments that are different in the Chinese tradition which then can be utilized to enhance reasoning in the West can be found in Robert E. Allinson, "The Negative Formulation of the Golden Rule in Confucius," *Journal of Chinese Philosophy* 12, no. 3 (September 1985). Translated into Chinese in *History and Theory* 3 (Beijing, China: The Institute of World History, Chinese Academy of Social Sciences, September 1988): 92–97.

richnesses of another tradition nor does it impart its own cultural richnesses to the other tradition. In some examples, as mentioned above, negative comparativists do seem to discover tendencies in the other tradition which are similar to tendencies found in their own cultural tradition while insisting upon the incommensurability of the two traditions. In these cases, there is an overlap of this type with that of the interpretative school. This type of negative comparativist reinterprets the other culture through its own preexistent system and thus contributes something of its own culture to the interpretation. The danger is that some internal values of the other culture might be lost in the process. The work of the strict *ab extra* comparativist does not serve the cause of intercultural communication since the comparison which holds both traditions at arm's length from each other lacks the dynamic interplay and growth that is the result of a pluralistic cultural dynamic integration.

Now that the myth of comparative philosophy has been well deconstructed, where does the way lie ahead for the world philosopher? Several examples may suffice to point to some directions. In these examples, the approach utilized by the present, respective author is an integrative approach which tends to demonstrate the value of borrowing both content and methodology of the other tradition in order to enhance the development of a world tradition. While such an emphasis might appear to be one-sided, it is only offered as a preliminary account.

The first example with which one may commence is the case of moral philosophy. In moral philosophy, it will profit the world philosopher to consider including the methodologies of Chinese moral philosophers in constructing a moral philosophy for the future. Mencius's brilliant utilization of a thought experiment as a methodological principle for ethics is hereby proposed as a methodology that can enhance the development of moral reasoning in the West. For example, Mencius has provided a singular thought experiment to prove the universal existence of a moral feeling.[12] Whether or not one agrees with Mencius, it is undeniable that his intention is to show that there is a universal and necessary moral feeling. Mencius claims that all human beings will immediately and spontaneously feel a sense of alarm and compassion if they observe an infant about to fall into a well. Mencius's point is that every human being must imaginatively reconstruct this case to test the existence of her or his own moral feeling. If one were to advance the hypothesis that some people would not possess such a feeling, Mencius would either not count them as fully developed human beings and/or would point to his example of the Ox Mountain (to be discussed below). In his ethical argumentation, Mencius has

12. See Robert E. Allinson, "A Hermeneutic Reconstruction of the Child in the Well Example," *Journal of Chinese Philosophy* 19, no. 3 (September 1992): 297–308. Translated into Chinese in *The Journal of Fudan University*, Special Issue on "Confucianism for the Future," 1st ed., (Shanghai, China: Fudan University, April 1991): 107–17.

provided a singular thought experiment on the universal existence of a moral feeling.[13] With regard to Western philosophy, to the best of the knowledge of the present author, no such comparable thought experiment can be discovered in the literature. Whether or not one agrees with Mencius's test, the point is that it appears that no Western philosopher has considered making comparable use of a thought experiment in the area of ethics.[14] This is most surprising because test examples are made use of in epistemology. For example, one is reminded of Kant's famous use of a thought experiment which forms the entire second argument of his four arguments, or metaphysical expositions as he prefers to call them, for the *a priori* character of space in his *Critique of Pure Reason*. Regardless of whether one finds this argument valid, its methodological character as a thought experiment is obvious.[15]

Mencius proceeds to offer an argument as to why his theory that human nature is orginally good can find so few supporting historical examples. While Mencius does not explicitly articulate his "defense" of the absence of historical instantiations of good human nature either as a defense or in the terms so suggested here, nonetheless an interesting and very modern defense is offered in his famous Ox Mountain example.[16] Mencius's point, put in modern terms, is that conditioning alters the original tendencies. The cattle and the goats that feed on the original plants (the original goodness) represent the influence of external conditions. The axe that hews down the trees is a symbol, perhaps, of the encroachment of technology on the original nature of human beings. Whether or not one agrees with Mencius's defense is not important here. What cannot be denied is that Mencius has provided an argument, albeit in a metaphorical form but an argument nonetheless, for the countless counterexamples that can be pointed to as evidence that his theory is invalid.

His argument is one which, for Karl Popper, could not count as a valid

13. *Mencius*, Bk. II, Pt. I, Ch. 6.

14. For a fuller treatment of this topic, see Robert E. Allinson, "An Overview of the Chinese Mind," op. cit. In the case Plato's use of the ring of Gyges, there is a fundamental dissimilarity in the use of the example. In the case of the ring of Gyges, the question is, would a man be unethical if he wore the ring? There is no comparable test of ethical behavior. In the case of the Leontius, the example is also put to a different use. Leontius cannot tear his eyes away from dead bodies. Once again, the test is whether one can resist temptation, not whether one would necessarily feel a sense of compassion for fellow human beings. One could argue, however, that Mencius claims that one will feel the feeling of compassion whether or not one is observed by others and in a sense is thus wearing the ring of invisibility. But nonetheless the test is not one of resisting temptation. The test is whether one will feel a sense of compassion for an innocent child who is about to lose her or his life. Of course, one could argue that without accompanying behavior to attempt to save the child this is a meaningless ethic. But this is another matter and is discussed in Robert E. Allinson, *Space, Time and The Ethical Foundations*, op. cit.

15. For an elaboration as to a new interpretation and a new importance of Kant's arguments here, see Robert E. Allinson, *A Metaphysics for the Future*, Avebury Series in Philosophy (Aldershot: Ashgate, 2001) and Robert E. Allinson, *Space, Time and the Ethical Foundations*, op. cit.

16. *Mencius*, Bk. VI, Pt. I., Ch. VIII.

argument because, according to the nature of the argument, no counterexample could be found and thus it is a nonfalsifiable and therefore metaphysical and therefore invalid argument. But this would be to accept Popper's critique of metaphysics as a valid critique. According to Popper, Freud's psychoanalysis would also be a metaphysics. But is Freudian theory completely ineffective in its application to psychotherapy? On the contrary, with suitable modifications which are minor in nature, it still represents the most influential set of guiding principles to psychoanalytic and psychotherapeutic practice. Is it an example of comparative philosophy to criticize Mencius's metaphysical argument in defense of his ethics with the nonfalsifiability criterion of Karl Popper? No, it is no different from attempting to criticize any metaphysical argument (whether Western or Chinese) with the nonfalsifiability criterion of Karl Popper. It is only that the data base of philosophy has been extended to include Mencius within it.

What of epistemology? When one "compares" Plato's arguments for the impossibility of discerning if one is waking or dreaming with those of Descartes, it becomes evident that Plato's arguments are more sophisticated and are superior to those of Descartes. The Cartesian use of the criterion of coherence introduced in *Meditation* VI is vulnerable to Plato's argument in the *Theatetus*. For Plato argues that the criterion of coherence may be upheld by one in a dream state to be true of her or his dream state while she or he is dreaming. While Plato does not make this point explicitly, the implication of his argument is that all viewpoints including those applying to the validity of criteria may be ones introduced in either the waking or the dream state.[17] The notion that a dream is incoherent or less coherent than a waking experience is a notion that is introduced from the standpoint of the waking state. But during a dream state, the opposite argument may be introduced. The coherence criterion thus is not sufficient to demarcate the waking from the dream state. In that event, it is impossible to know at any moment whether or not one is dreaming. If this is the case, how is one to adjudicate between the claims of one in a waking state and one in a dream state? If it is to be objected that sleep and thus dreaming takes place during an eight-hour period and hence does not represent equal lengths, Plato would perhaps reply that such an observation obviously takes

17. ". . . and in fact, our time being equally divided between waking and sleeping, in each condition our mind strenuously contends that the convictions of the moment are certainly true; so that for equal times we affirm the reality of the one world and of the other and are just as confident of both." *Theatetus*, 158 B, C. It could be said, though Plato did not say this, that there is no need to choose which mental state represents reality, the waking state or the dream state. This could be the message of the *Zhuangzi*. If one is not forced to choose, it is possible to consider that both waking and dream states are related to each other in a complementary manner. Such a relationship is already betokened in art movements such as surrealism and in stream of consciousness writing. The psychotherapeutic techniques of Freud and Jung show a strong awareness of the need to recognize the complementary perspectives of waking and dream life in order to achieve a more healthy mental state.

place during the waking state which is then granted a preferential status. But during the dream state, no such inequality of length can be observed.

The argument of Zhuangzi extends even further. If one reads between the lines, in the butterfly's consciousness there is no length (or coherence) of the human's life and therefore the "length" or the "coherence" criterion is only a human critierion. To accept either criterion as valid is to accept the human state as valid. But this is the very question at issue. If one considers the arguments of Zhuangzi, it becomes evident that those of Zhuangzi exceed even those of Plato. Is this comparative philosophy? Or is it simply good epistemology?

One may extend one's "comparison" between Zhuangzi and Descartes even further. One can "compare" Zhuangzi's questioning of the "I" most favorably with that of Descartes. In several places within the seven authentic inner chapters of the *Zhuangzi*, Zhuangzi raises the question of whether or not he is dreaming. In the most famous case referred to above of the butterfly dream at the end of chapter 2, the *Qiwulun,* the classic reading of the butterfly dream story is that Zhuangzi has no way to tell if he is Zhuangzi who has dreamt of a butterfly or if he is a butterfly dreaming he is Zhuangzi.[18] In this reading of the butterfly dream, Zhuangzi offers no criterion whereby he can distinguish between his identity as Zhuangzi or a butterfly. He even entertains the possibility that his own philosophizing takes place during a dream. Descartes, on the other hand, in his *Meditation* VI, thinks that he has discovered a criterion, that of coherence, by which he can distinguish his waking life from his dream life. But for Zhuangzi, to paraphrase his argument, the criterion of coherence of a philosopher's may be part of a butterfly's (or a philosopher's) dream. Zhuangzi's philosophy ranks with Plato's in terms of its sophistication for Plato, too, argues that there is no means of claiming that our waking life represents reality. It is just that Zhuangzi adds an imaginative hypothesis to Plato's intellectual dilemma. Not only is it impossible to distinguish but such an impossibility may be a part of a butterfly's dream. The inclusions of Zhuangzi's "arguments" in considerations of Western—nay—global epistemology would represent an advance in epistemology proper.

Both Plato and Zhuangzi offer a more sophisticated solution than that of Descartes in this trilateral "comparison." Both ancients, one Greek and one Chinese, are more advanced than the temporally advanced Frenchman. (If one wished to include a more recent figure, one could add the viewpoint of Bertrand Russell to this mix but as a coherentist his approach does not significantly differ from that of the Descartes of *Meditation* VI.) Zhuangzi's butterfly illustration is a more colorful and in some ways a less cryptic way of making Plato's point. For both Plato and Zhuangzi, the Cartesian criterion of coherence begs

18. Robert E. Allinson, "The Concept of Harmony in Zhuangzi," in Robert E. Allinson and Shu-hsien Liu, eds., *Harmony and Strife: Contemporary Perspectives, East and West* (Chinese University Press, 1988), 169–83.

the question. If one cannot, from the standpoint of Plato and Zhuangzi, distinguish a waking state from a dream state, then one could be within a dream state when one considers that "waking" life is more coherent.

A third case. To consider the case of ethics once again, it is of interest to consider Plato's and Aristotle's positions with regard to the question of the original goodness of human beings and their consequent position with respect to the individual or the social self and "compare" these two topics with the treatment to be found in Confucius. It seems at first that Plato must consider that the human being is possessed of original goodness (though he, like Confucius, does not say this explicitly) since he argues that if one truly knows what is good for oneself, one will do what is good. If ignorance is the cause of evil, then the original nature must not be corrupted. This does not represent his complete argument for he also states that ethical action (or justice) cannot be located in the individual but must be found in the State.[19] This implies that the human being is social by nature. Where then is the individuality that supposedly forms the bedrock of the Western tradition? It seems that, for Plato, it is difficult if not impossible to discern the ethical self in the individual and in order to find the ethical self, or justice, one must turn to the State.

Earlier, fragments were offered that suggested that implicitly, at least, Confucius held that human nature was good. Can one at the same time find statements supportive of individuality in the writing attributed to Confucius? What of the statement that, "The Master said, 'What the superior man seeks, he seeks within himself, what the inferior man seeks, he seeks in others.'"[20] Where is the social self that supposedly forms the bedrock of the Chinese tradition? (This is not to say that one can find no statement supportive of a concern for society in Confucius. It is only to say that one can find statements which emphasize the importance of looking inwards and acting in conformance with one's individual principles.) What of when "The Master said, 'Cunning words, an ingratiating face and utter servility, these things . . . I find . . . shameful. To be friendly towards someone while concealing one's hostility . . . I . . . find it shameful.'"[21] Is this evidence of an encouraging of one to fit into society or is it an advocacy of standing up for one's own values in the face of

19. If one considers Plato's examples of the ring of Gyges and Leontius who was unable to tear his eyes away from the spectacle of dead bodies, one could argue that these represent indicators that human nature is not naturally good. (We must not forget that the example of the ring of Gyges forms part of Glaucon's argument and not part of Socrates's argument.) But these examples do not necessarily represent Plato's last word on the subject. These examples are susceptible to other interpretation such as they may be examples in which the individuals do not really know what is good or examples in which such problems would be obviated by a civil life such as one would find in the *Republic*. Or, as suggested in the body of the argument below, the examples might be covered by the Divine random dispersal of good traits. Plato's view is not easily discerned.

20. *Analects (Lun Yu)* XV, 21.

21. *Analects (Lun Yu)* V, 25.

possible social disapproval? Where is the vaunted Confucian social self? Is this comparative philosophy? Or, is this simply critical thinking or philosophizing?

Plato's position, is, of course, a many-sided one. In the *Meno,* Plato is led to the conclusion that empirically speaking, morality is Divinely dispensed by a sort of Divine lottery. While this is a position that Einstein would probably deplore, it seems to be more close to the theories of quantum physicists today. While Plato could appeal to the argument that whoever was an evildoer simply did not know fully what was the good, he does not always so appeal nor does he have to. For he has posited another solution here. Empirically speaking, there are all sorts of mixtures of good and evil out there. Plato is saying that Mencius and Xunzi and Gaozi are all right.[22] What exists is a mixture of types. Perhaps, for Plato, it is only the guardians who can be good in the end because only this tiny proportion of the population of the *Republic* live under communism and the bulk of the population live under capitalism.

Fundamentally, Plato thinks that the evil types that do exist will be mitigated by the construction of the ideal State. Those with empirical instantiations of the good natures will be preselected and properly educated to become rulers. They will also be provided with the lack of social incentives (axes, cattle, and sheep) to become greedy and power seeking. Plato's insistence on the details of a powerful social structure to ensure goodness are far more socialist—even communist when one considers the life style of the rulers, soldiers, and police force—than individualist. Is it a biased comparison to choose Plato? Are these not social insurances? Did not Aristotle also say that the human being who could live outside of a *polis* was a beast or a god? For Aristotle, a human being was a political (which includes social) animal. A human being, for Aristotle, outside of a *polis*, was an idiot. While Aristotle, like most Western ethical theorists, considers that human nature is evil, he also considers that the problems of ethics can only be properly and fully resolved by a correct social and political system, albeit a different one than the choice proposed by his master, Plato.

It is frequent that "comparative philosophy" compares two comparable philosophies and points to the similarities and the differences. It thus may be useful to revisit a more commonly utilized "comparative set": that of Zhuangzi and Nietzsche.[23] To forget the differences which are ones of programatic, temperament, tone, and fervor more than anything else, similarities are astonishing when one considers that the historical and cultural environments are so very different. Both philosophers are richly poetic, filled with sardonic insights, play with traditional philosophers, make use of animals, fools, and other social

22. For an attempt to sort out a solution to these puzzles, see Robert E. Allinson, "The Debate Between Mencius and Hsün-Tzu: Contemporary Applications," *Journal of Chinese Philosophy* 25, no. 1 (March 1998): 31–50.

23. See Robert E. Allinson, "Evaluation and Trans-Evaluation in Zhuangzi and Nietzsche," *Journal of Chinese Philosophy* 13, no. 4 (December 1986): 429–43. Abstracted in *Philosophical Index*, 1987 Cumulative Edition, vol. XXI, 326.

misfits to prove their cases, are brilliant *literati* and in content come very close in certain key respects. Both argue for transcending good and evil; both argue against traditional moral argumentation. In both cases, as this present author has argued in other places, neither philosopher is a relativist and while they eschew traditional moral argumentation, they both advocate a kind of moral transcendence which is not to a state of amorality or immorality but to a higher state of affirmation. But after all of this is pointed out, no matter how glorious the noticing, where does one go from there? One has successfully gathered two similar appearing trophies to place within one's intellectual museum to show off, perhaps, as cases of historical oddities. In the model of comparative philosophy, one is pleased with visiting one's mental museum and glancing back and forth at the acquired trophies to take note of their resemblances and their dissonances. But how does this contribute to acquiring a philosophical viewpoint? In the model suggested in only bare outlines in the course of this chapter, it may be said that the noticing of certain similarities between Zhuangzi and Nietzsche can serve other purposes. The noticing of similarities can draw cultures together. The noticing of similarities might provide evidence of the validity of a viewpoint when it can arise from such different cultures and from such different periods in history. The noticing of similarities can in the project of both Zhuangzi serve the cause of self-transformation, and in the case of Nietzsche, self-overcoming.[24] Both are models of self-transcendence. Noticing both is not for the purpose of sitting back and idly watching one's intellectual showcase. Noticing both is a reminder that the need for and the desire for self-transcendence is universal. Noticing both is a method of discovering more examples and arguments that induce the subject reader to alter herself or himself. That each culture can in turn produce a Zhuangzi and a Nietzsche is evidence that such thinking is universal and thus, in a way, provides a greater possibility for the validity of the standpoints that are advocated. Of course, the standpoints require the greater test of being ethically sound. But, if they meet this test and also inspire self-improvement, the fact that such "alien" cultures have produced such astonishing advocates of self-transformation is a fact that may motivate someone who feared that paradigms taken from her or his culture may be limited and parochial—who may have considered one of these viewpoints a culturally bound standpoint—to embark upon the great philosophical journey of self transcendence.

Examples could be multiplied but perhaps one final set of comparisons will suffice. Laozi argues that human nature is originally good and also provides a kind of State that seems to support his theoretical beginnings in that it is a State that is based upon minimalist intervention. Laozi appears to have a greater trust in the masses than Plato. Laozi, in short, is more democratic than Plato. Is this another case of slanting the examples by the choice of the anti-

24. Ibid.

Democrat of the West, Plato? But, Aristotle also favors the rule of the aristocratic wise. Laozi may not provide for an elected Ruler but the Ruler that exists is one who virtually does not rule but creates the impression—which is in a sense largely true—that the people do what is done, by themselves. Of course, it may be said that this reading of Laozi is biased and that notorious passages such as the refractory chapter 5 in the *Daodejing* are hereby ignored. But for such niceties, one may consult previous writings of the author.[25] Is it fair to base one's concept of Chinese political thought on the thought of Laozi? One need not. One may turn to the writings of Mencius to discover that two millennia before John Locke, Mencius wrote of the right of revolution. Is any of this comparative philosophy? Or, should it be said that it is all comparative philosophy and hence the term "comparative philosophy" applies so widely that it can hardly be very functional as a descriptive term since it does not point to a distinction between comparative philosophy and philosophy proper.

Where does one proceed from here? It may be apposite at this point to consider, if comparative philosophy is to be abandoned, at least as a term of description, and both Western and Chinese philosophy are to form the data base of the world philosopher, or should it be said, the philosopher today, as the phrase "world philosopher" is redundant, then what further benefit can be discovered from examining the data base of both Western and Chinese philosophy? Perhaps the most useful lesson that can be derived, apart from the individual lessons pointed to above, is the lesson that may be learned from the overall purpose of bringing Western and Chinese philosophy together to form a unified data base.

One would not include Chinese philosophy in one's data base (as a Western philosopher) only if one considered that philosophy should be conducted strictly within cultural limits (philosophical isolationism) which is a culturally provincial approach or that Chinese philosophy was an "alien philosophy" or not a philosophy at all. To put this in another way, if one abandons both the positive comparative stream, the one which, like a parlor magician, dazzles the audience by showing how two traditions are alike (and leaves both of them unchanged), or the negative comparative stream, that sets out to prove that the two traditions are incommensurable, one may be more tempted simply to expand one's friendly philosophical data base to include philosophers from other cultures. The notion of comparative philosophy is thereby reduced to a notion of a more inclusive history of philosophy.

Of course, the negative comparativist represents a greater danger. If comparative philosophy is conducted with a Kiplingesque bias of showing the

25. See Robert E. Allinson, "Moral Values and the Chinese Sage in the *Dao de Ching*," chap. 12, in Brian Carr, ed., *Morals and Society in Asian Philosophy,* Curzon Studies in Asian Philosophy (London: Curzon Press, 1996), 156–68. This was originally published in the special edition of *Asian Philosophy* 4, no. 2 (Autumn 1994): 127–36.

fundamental irreducibility of one system of thinking to another, then such a methodology precludes the possibility of a genuine world understanding. The Kiplingesque approach (however historically ungrounded) does not serve the cause of intercultural exchange. The danger of leaving the other as an alien other is that not only will it be unlikely that there will be mutual understanding, but that a justification for mutual conflict, as elaborated in the theory of Samuel P. Huntington, may result instead.[26]

If one gives up the Kiplinesque idea that one must always be alienated from the other and comparative philosophy can be better understood as integrative philosophy, then access to the data of the philosophies of other cultures can add to the data base of one's own culture. Western philosophy can grow with its adoption of the data base of Eastern philosophy and vice-versa. Also, if comparative philosophy—or in its more proper understanding—integrative philosophy, is enlisted in the service of intercultural dialogue, the possibility of enhancing intercultural understanding will be increased.

What is the purpose of widening the data base? Of course, it may be said that further insights will be gained that will shed light on either Western or Chinese philosophy taken as separate disciplines. But this would merely be to plunder the other's discipline as a pirate and to return to one's own without any thought of the construction of a common subject matter. It seems to the present author that the construction of a common subject matter which included a common methodology would be a more fruitful and a more ethical direction to take. Since the benefits of the construction of a common data base are evident, what would be the benefits of a common methodology? The benefits of a common methodology would be that intercultural dialogue would be enhanced and there would be thus a better access to and use made out of the data common to multiple cultures. For example, if each party to a dialogue were to enter the dialogue with a methodology in mind that the purpose of the dialogue was to enhance understanding and that to enhance understanding might require an alteration of one's viewpoint, the prospect of a mutual understanding would be increased. If, on the other hand, one entered an intercultural dialogue to prove that one's standpoint was "right," the prospect of mutual understanding would be decreased. If one entered into an intercultural dialogue with the concept that one's standpoint was superior and that one would listen to the other's standpoint so to become more tolerant of the other, again, the prospect of mutual understanding would be minimal. In fact, the notion of tolerating the other would be less likely to lead to any self-alteration since one would in one's toleration already be right. One would indulge the other in the sense of tolerating the other but one would not be inclined to alter one's own viewpoint. This would severely limit self-growth. Toleration

26. Samuel P. Huntington, *Foreign Affairs* (Summer 1993).

implies that the other's viewpoint is wrong and inferior and thus is not condu-
cive to an attitude of mutual respect. The concept of tolerance maintains the
idea that there is one coherent view and one primitive and alien view.

Consider the alternatives. What if one were, for a moment, to model the
attempt at East-West understanding after the attempts on the parts of certain
Western anthropologists, sociologists, or philosophers to understand so called
"primitive" cultures earlier in this century or even in earlier centuries? In his
fascinating lectures given at the *Collegium Phaenomenologican* in Italy in 1998,
Robert Bernasconi argued that Durkheim treats the primitive as childish or
abnormal white culture and thus in this sense speaks "down" to the "primitive."
This account might be classified as seeing the primitive as an earlier develop-
ment of or a deviation from the more mature civilization. Bernasconi went on
to say that Lévy-Bruhl, at least in his writings prior to his posthumous
notebooks, regards the "primitive" as possessing a different mentality, in this
case, for example, more affective. Bernasconi offered the following account: in
his *Primitive Mythology*, Lévy-Bruhl seems determined to maintain the exist-
ence of two different mentalities. The world of the primitive is untranslatable;
it does not use concepts. The route to understanding the primitive is through
mystic participation. Lévy-Bruhl sacrifices one of the mentalities, the logical,
to get at the prelogical. On the other hand, Durkheim's view in effect reduces
the "primitive" view to the civilized one. Lévy-Bruhl's view regards the "primi-
tive" as impenetrable from the standards of Western logic. In Lévy-Bruhl one
finds a questioning of the categories of Aristotle and Kant even though,
quixotically, Lévy-Bruhl is seen as representing Western civilization.

Bernasconi also referred to Merleau-Ponty. In his essay "Everywhere and
Nowhere" in *Signs*, in the section entitled, "The Orient and Philosophy,"
Merleau-Ponty, moving to the example of Chinese philosophy, suggests that
Oriental philosophers do not understand understanding. For Merleau-Ponty,
the Oriental philosophers are characterized by their failure to understand
themselves. For Merleau-Ponty, a culture is judged by its transparency, the
degree to which it understands itself and the other. He writes that Hegel in-
vented the idea of understanding the Orient by going beyond the Orient, by
including the Orient within Western understanding. The Orient then possesses
no unique value of its own; it serves only as an imperfect version of the West
to be superseded and replaced by the West.

Bernasconi discussed Hegel and Kant as well. Hegel considers the Orient
as representing a distant approximation of conceptual thought and thus as
inferior to it and destined to be surpassed by the West. Going back even further,
Kant, in his review of Herder, asks why the people of Tahiti even exist since
European thought will give the law to all humanity. It is only the case that if
there is historical progression, then Tahiti reassures us that there is development
in history. The primitive is part of the narrative since it shows the development

of humanity and thus makes sense of our lives. In this case, however, under-standing always serves the "developed" culture.

Or, one can even consider the reverse position. Bernasconi related that in his book, *Existence and Existents*, in the section, "Existence Without a World," Levinas criticizes the later Heidegger for promoting mystical thought as a return to barbarism. Levinas then invokes monotheism to combat the relativism of primitivism. This position now has come full circle to the position of the mis-sionaries whose goal was conversion, thus assuming that their point of view was the correct and universal one. Bernasconi's revealing account well illus-trates the view of the present author. In the opinion of the present author, one can tolerate although obviously never fully understand the alien other. Cultures are forever to be left asunder. Full understanding cannot take place because full understanding requires the alteration of one's own absolute standpoints. It is only in the very process of self-alteration and the adoption of the other's standpoint that one comes to fully understand the other. And, when this is mutual, the other, in adopting the viewpoints of its other, comes to under-stand its other as well. In the end, there are no longer two alien others but a single, pluralistic viewpoint which is made up of elements taken from each other's standpoint. Already this shows that one problem with the concept of tolerance is that it is only really interested in the self tolerating the other; it is not that interested in self-understanding and it is not that interested in the other tolerating—not to speak of understanding itself or its other. The will-ingness to alter one's premises is the key element to achieving an intercultural understanding. It is only from the standpoint of the other than one can truly understand oneself. One is reminded of Alexis de Tocqueville's *Democracy in America*, or Henry Miller's, *The Air-Conditioned Nightmare*. In the one case, Tocqueville was an original foreigner; in the other Henry Miller became one via living abroad in France for twenty years. But their books provided a mirror for America's self-understanding.

In an intercultural dialogue it is only when one realizes the limitations of one's original position that one can truly understand the other. But one can-not know oneself until or unless one goes out of oneself. One of the benefits of the intercultural dialogue is not only that one may come to know the other; but that one can come to know oneself. And one comes to know oneself, or, strictly speaking, one's previous self, only in the process of expanding beyond that self. The other is an essential element in self-understanding.

The concept of tolerance of the alien other is a preventative to self-understanding. Of course, one also benefits from the other's view of oneself. If both standpoints are not incommensurable alien others, one can learn a great deal about oneself from listening to (not merely tolerating) the other. In addition, as one leaves behind one's preconceptions of the other and one's lack of understanding of oneself, one can more truly understand the limitations of

the other. And this is, of course, a two-way street. In a fundamental sense, what is occurring in the intercultural dialogue is the abandonment of the concept of a random assortment of mutually opposing cultures and a development of a pluralistic world culture. Or, to make this point even stronger, what one is ultimately capable of accomplishing is the ability to transcend all cultural limitations and to perceive the universal values that are common to all cultures. Proper intercultural dialogue is the key to understanding the universal family of humanity.

This brings us back to the essential question. If we are to achieve an intercultural dialogue, then we must possess access to a mutually common data base. In order to gain access to a mutually common data base, it is essential that both parties (or all parties if more than two are involved) share a common methodology of integration. The key to successful intercultural dialogue is the adoption of a shared methodology of integration. Thus, the issue of the how to achieve a mutual methodology of intercultural hermeneutics looms large.

In order to begin an answer to this question of how to achieve a mutual methodology of intercultural hermeneutics, one which enables one to both expand one's data base and to enhance intercultural dialogue, we may consider two different methodologies of integrating philosophy, the methodologies of the Hegelian dialectical opposition and the methodologies of the Chinese *Yin/Yang* cooperation.[27] In the end, a complementary version of both the Hegelian and the *Yin/Yang* models of interaction will most likely serve best the cause of intercultural dialogue. The benefits of a proper intercultural dialogues are twofold. One can increase both one's understanding of oneself and the other.

Both approaches taken by themselves are superior to the "comparative approach" since this latter approach implies a static comparison of two philosophies placed side by side. In the Hegelian approach, two philosophies are perceived of as coming into a conflict. Thereafter, a resolution is derived via the dialectical process of *aufheben*. In *aufheben*, the two viewpoints are at first perceived as antagonistic to each other. Thus, in a sense, one may say that they come together, as it were, in a collision of opposites. (If there is no dialectic, the initial clash is fully definitive of the interaction in which case we have the outlook of Huntington and the doomsday view of the ultimate clash of cultures). In the dialectical collision, the resolution is first to jettison what is no longer relevant within the two opposing views and then to salvage what is of value. The final stage is to synthesize what is remaining of the two viewpoints so as to form a third viewpoint which contains something of the two previous viewpoints and yet also forms a new viewpoint of its own which transcends either of the previous viewpoints. The emphasis in the Hegelian model is on confrontation and destruction, preservation, and synthesis and

27. The idea of the dialectic originated with Fichte rather than Hegel but Hegel borrowed it and it became famous via his use of it and it has thereby been associated with his name.

the creation of something new. What is valuable in the Hegelian approach is that viewpoints must come into contact with each other in order for the process to begin. Thus, the Hegelian standpoint discourages isolationism of viewpoints. The emphasis in the Hegelian interactionism of viewpoints is on the transformation of each participating viewpoint with a view to creating a third standpoint which will then become the shared standpoint of the previously conflicting standpoints. Thus, the goal of the interaction is to create a shared standpoint for both interacting standpoints which is better than the standpoint that either severally possessed. There is the suggestion that the new standpoint will in time be supplanted by another standpoint via the mode of coming into contact with a different standpoint. The emphasis thus is on the process of transformation rather than on the particular viewpoints obtained in the course of the process. This emphasis on process enhances the prospect of constant and future interactionism in the hope of obtaining better and better resolutions which will improve the standpoints of the participating parties. The emphasis is not on the obtaining of the right or the final viewpoint or else this will defeat the notion of the continuous process of transformation and progress. Process is thus ultimate over substance or content. The point of the Hegelian dialectic is on the constant endeavor to improve one's viewpoint and thus, in the end, the motivation for coming into contact with other viewpoints is self-alteration.

In the *Yin/Yang* model of interaction, there is not so much motivation to go outwards to seek the other. The *Yin/Yang* model requires a Hegelian seeking starting point in order to possess more than an internal objective of self resolution. Granted such a starter, in the *Yin/Yang* model of two viewpoints coming into contact with each other, the motivation and the process of resolution are somewhat different. In the model of *Yin/Yang* interactionism, the two viewpoints replace one another in turn. This replacement is only temporary because the temporal model of the process is cyclical. On the other hand, it is not a complete replacement because the replaced viewpoint is always necessary and in fact is a constituting element of the replacing viewpoint. The replacing viewpoint always retains a portion of the replaced viewpoint so that the replacement is always a matter of degree. When the replacing viewpoint is in turn replaced by the previously replaced viewpoint, it, too, lingers behind in a matter of degree. No viewpoint totally replaces any other viewpoint so that the mixture is always a mixture of two viewpoints. The difference is only one of degree and not one of kind. In addition, the two viewpoints are not perceived as in conflict with each other but as being in collaboration with each other. Thus, the total viewpoint that one embraces at any moment is always a combination of both viewpoints. The only difference between one moment and another is that the combination will contain both viewpoints in different degrees of ascendancy and descendancy. Differing viewpoints are perceived of as needing each other in order to constitute a complete whole. The two viewpoints

collaborate, as it were, to produce the relevant standpoint which is perceived of as most suitable to a current situation. There is no idea of a linear or vertical progress. The model is a circle in which differing viewpoints replace each other in a succession. The motivation for the merging of viewpoints is the obtaining of a complete harmony of differing viewpoints. While self-alteration may be considered to be an overarching motivation, the self that is altered is a self that expands and contracts, so to speak, rather than changing itself altogether. Its opposing sides are not so much in conflict demanding a solution that is different than either one alone but rather are colleagues who rule in turn leaving the other as a shadow cabinet until such time as its services are desired. The model is thus one of collegial cooperation rather than self-alteration.

How then to reconcile the two differing integrating modalities? Should one utilize a Hegelian model of self-alteration or a *Yin/Yang* model of collegial interactionism to sort out how to structure the process of interaction? This question is indeed difficult to answer. Perhaps, a key to answering this question is to consider more closely an aspect of the *Yin/Yang* model of interactionism which has not yet been fully explored. This aspect is that the qualities of *Yin* and *Yang* are modeled after the feminine and the masculine principle. In the Hegelian dialectic, there is no such gender parallel. When *Yin* and *Yang* are in collaboration, there is the driving force of the attraction between opposites. This masculine and feminine aspect of *Yin* and *Yang* may perhaps offer a clue as to how to collate the Hegelian dialectic with the *Yin/Yang* model of interactionism. In *Yin* and *Yang*, one must balance the masculine and feminine sides to achieve a proper harmony. Depending upon the needs of the time, the *Yin* or the *Yang* may require more or less emphasis. Thus, the question of how to collate the Hegelian with the *Yin/Yang* models of interaction depends to a large extent *upon the needs of the time*. If the needs of the time are such that a greater harmony between differing viewpoints is desirable, the *Yin/Yang* model of interactionism may be preferable as a model to adopt over the Hegelian model of seeking self-alteration.

Of course, in a way, both viewpoints can be used together. In seeking a harmony between different viewpoints, it may be that in the end a new viewpoint will be selected which becomes a third viewpoint that both previous viewpoints subsequently share. On the other hand, if the needs of the time are such that a greater diversity of viewpoints is desirable, it may be that the Hegelian model of seeking self-alteration and new standpoints might become more desirable. (Even within the greater world, cultural pockets may display differences that suggest the need for different approaches.) However, as such new standpoints are adopted, the standpoints will become richer and richer in the sense that they contain more and more diverse elements which are retained from previous standpoints and as a result the new standpoint achieved might in turn require a *Yin/Yang* model of harmonizing its parts so as to achieve a greater stability. This in turn may break down and result in the need to reach

out to find new viewpoints once again. In truth, the *Yin/Yang* model of interactionism is no more static than the Hegelian model. Perhaps, in the end, a new model which contains both the Hegelian model of new standpoints and the *Yin/Yang* model of forces in harmony with each other, may emerge. This may appear to be a more Hegelian than a *Yin/Yang* resolution. On the other hand, this is not completely the case as while the new standpoint emphasis might be a Hegelian element, the constant need to harmonize the new viewpoint with its own incorporated parts would be a *Yin/Yang* element.

There is a second aspect of the *Yin/Yang* viewpoint which might prove very fruitful for the future. In the *Yin/Yang* perspective, the *Yin* and the *Yang* are complementary to each other. Whatever process is more emphasized at any point in history, the reconciliation of the parts with each other or the reaching out for the forging of a new viewpoint, both of these aspects must also be seen as complementary to each other in order for a complete picture to be formed. In this sense, it could also be said that the resolution to the question as to which model to utilize, *Yin/Yang* or Hegelian, is that it is both. One never really chooses one or the other; one always chooses both in a matter of degree. The question as to which to choose already assumes a Hegelian prejudice as if an absolute choice is to be made. The answer of both implies a *Yin/Yang* model of harmony rather than a Hegelian model of change. In this sense, it appears as if preference is given to the *Yin/Yang* model.

However, the element borrowed from the Hegelian model is the element that a third perspective is always sought in which the differing viewpoints can join and thus reconcile their differences. In a sense, the model of progress is incorporated in this integration of *Yin/Yang* and Hegelian viewpoints which is lacking in the *Yin/Yang* movement *simpliciter*. It may be said that an entirely new model has been constructed which is constituted by both approaches, which may be symbolized by a spiral that sometimes returns upon itself and sometimes moves upwards and sometimes moves downwards. While this may appear to be more of a Hegelian than a *Yin/Yang* resolution, it must be stressed that it is not always an upward movement but sometimes it is a downward movement that is required. Thus, progress is reconciled in some sense with harmony. It is not a circle since sometimes one must reach back to the past to discover inspiration for the future. The very question as to which aspect of the model is dominant is answered differently depending upon the needs of the time. And that is the aspect of the model that is complementary.

Where is all of this leading? What concrete example can be offered today of an insight taken from Western or Chinese philosophy that can be integrated so as to form a more continuous and harmonious union and which will also represent a new standpoint that may encourage or enhance the cause of human progress. There is one interesting example. In the world today one sees growing signs of moral degeneration. In this past century one saw many examples of the massacre of civilians. One may of course point to past centuries to find

abundant examples as well. But the point is, if the twentieth century was supposed to be such an example of intellectual, cultural progress, how can one account for the Nazi massacre of innocent Jews in such a calculated and premeditated fashion and with such horrifying and cruel methods? One must bear in mind that one and one half a million children made up the total of the six million massacred Jewish people. Given the percentage of the existing Jewish population of the world, this constituted over 90 percent of all Jews in the world. How could the Nanjing massacre have occurred? How can, in contemporary America, child murderers emerge which is a new event in history? How can, in turn, the not infrequent murder of school children occur? Is this not also another historical precedent? Can one consider this past century to have been a civilized century? It was a century in which literacy was at an historical high. If this past century was an example of high culture and high civilization, then perhaps Rousseau was correct. Civilization is the cause of the moral degeneration of man. Josef Mengele, a Doctor of Medicine, a lover of music and one who had studied Dante, was a most civilized man.

If one reaches back to the past and adopts a Confucian definition of culture, such a problem may be obviated. In the Confucian definition of a cultured person, a person is not considered cultured unless the person has achieved an ethical actualization. Morality is considered an indispensable attribute of culture. One cannot, by definition, be cultured, even if musically educated, if one has not achieved a moral personality. Thus, retrieving this Confucian definition is an enormous asset in sorting out a most vexing problem. Civilization is not necessarily a cause of barbarism, as Rousseau feared; civilization without its moral attribute may indeed be a cause of barbarism, but then civilization without its moral attribute cannot be considered civilization.

For example, Confucius makes a profound demarcation between humanity as the essential precondition or the *sine qua non* of a cultured person and religious practice or musical appreciation in *The Analects* (*Lun Yu*): "The Master said, 'What can a person do with the rites who is not benevolent? What can a person do with music who is not benevolent?'"[28] In this passage, Confucius states that a person who possesses no humanity can possess no meaningful relationship to religion or music. It is evident from this statement that humanity is something that can and in fact must be possessed as a separate trait from ritual observance and musical appreciation since it can and must be separated from ritual observance and musical interest. Since ritual observance may not be considered a *sine qua non* of culture nowadays, it will suffice to concentrate on Confucius's awareness of the fallacy of identifying an ethical life with a life of musical enjoyment. With a Confucian definition of culture, one who had not attained to morality would not be considered a cultured individual.

Mengele would not be a civilized man according to Confucius. Mengele

28. *Analects*, (*Lun Yu*): III, 3.

was a barbarian. Mozart is not enough to constitute civilization.[29] Civilization requires the attribute of morality. Such is the contribution of Confucius. This is an application of the doctrine of the rectification of names.[30] One can borrow a methodological principle from Chinese philosophy to solve a problem of Western—nay—world culture. Civilization can be restored to its ancient (Chinese) meaning which includes as a necessary component, a moral self. This ancient Chinese meaning may now be shared with the world as a whole such that civilization in name and deed can be returned to its true meaning.

Now, here is an example of how digging into the ancient philosophy of China one may discover an ancient truth which can be applied to bring an important corrective to the twenty-first century. In order to create civilization, moral education is required. Without moral education the prospect of repeating the barbarism of the previous century cannot be ruled out. Here is an example of how opening the West to China can create a benefit not only for the West but for the world as a whole. Indeed, it can also create a benefit for the East, for ironically, in its contact with the West, China is in danger of losing its own Confucian heritage.

The advantages of a complementary spiral model of East-West philosophical integration have been emphasized above. It is fascinating to consider that Niels Bohr, the discoverer of the complementarity principle in physics, learned of the concept of complementarity from his study of Chinese philosophy.[31] Up

29. One recalls the late Isaiah Berlin's statement, in his account of Tolstoi, that "We find the works of Mozart and Chopin beautiful only because Mozart and Chopin were themselves children of our decadent culture, and therefore their works speak to our diseased minds; but what right have we to infect others, to make them as corrupt as ourselves." See "Tolstoi and Enlightenment," in Henry Hardy and Aileen Kelly, eds., *Russian Thinkers* (Harmondsworth: Penguin Books, 1979), 255. It is entirely possible, though it is not clear from the essay, that Sir Isaiah, normally a most perspicacious thinker, was merely restating Tolstoi's view. Of course, it might be that Sir Isaiah's view (or Tolstoi's) would find support from the example of Josef Mengele, the worst of the death-camp doctors in Nazi Germany, who cruelly experimented on inmates. Perhaps, Sir Isaiah is agreeing with the point made by the present author, that music alone is not enough to constitute culture.

30. It is useful to consider Xunzi's description of *Zheng-ming* or the rectification of names. There is a need now, in the West, or, what is more properly a global region in which philosophy is to be carried out, to become aware of the existence of this essential philosophical activity of the rectification of names. See *Xunzi*, Book 22. To rectify a name, for Confucianism, was to return the name to its proper use, which meant, in accord with its ancient meaning. Of course, this activity meant more than simply using language correctly, since its major emphasis was on orienting persons to engage in appropriate activities.

31. There is considerable discussion as to whether Eastern philosophy influenced Bohr's discovery of complementarity in physics. In a private discussion with his son Hans at the Niels Bohr Institute in Copenhagen on 17 October 1995 the author was told that Bohr had read the *Daodejing* in a Danish translation. The idea of the complementarity of opposites is advanced in the *Daodejing*. (It is of course an integral part of the teachings of the *Yijing*). For further discussion, see Robert E. Allinson, "Complementarity as a Model for East-West Integrative Philosophy," *Journal of Chinese Philosophy* 25, no. 4 (December 1998): 505–17. For a fuller discussion of the relationship between Chinese philosophy and physics, see Robert C. Allinson, *Space, Time and the Ethical Foundations* (Aldershot: Ashgate, 2001).

until now, this discovery, which has proved immensely fruitful in physics, has been languishing as an idle historical relic in philosophy. It is time to consider that a principle which has had such a great success in physics can now be considered to be a prophet within its own discipline as well. The principle of complementarity emerged from the soft, ruminative discipline of ancient Chinese philosophy. It lived for a while in the borrowed clothing of the hard core Western science of physics. Now, having tested itself in the scientific arena, it once more can be borrowed back by the humanistic disciplines and utilized as a means to bridge not only between the two cultures of C. P. Snow but between Kipling's two cultures as well.

Integrative philosophers can look to the complementarity principle as a model for working with two viewpoints at once. Neither viewpoint need be considered to be ultimate but both in turn may take the center stage as its content proves to provide a helpful direction for humankind. At the moment, a suggestion has been made as to how to borrow an insight from ancient Chinese philosophy to sort out a most vexing intellectual problem today. One can be educated in culture and civilization providing education includes a moral education in addition to an intellectual, physical, and aesthetic education. This is not the last insight to be derived from an openness of both traditions, Chinese and Western, to each other. But it does display the advantages of openness and it therefore can serve as an incentive to shed the coils of a useless comparison of viewpoints and to engage in the active process of altering one's viewpoint so as to form a more humane and complete philosophical model for understanding and acting properly in the world today.

The ultimate lesson may be one that one must remain in a continuous state of openness to the other. If one adopts a standpoint that a complementary picture will provide the most fruitful results for mankind, then the prospect that a continuous openness can be achieved is enhanced. One need not regard the other as an alien other as the previous concrete examples have illustrated. The other is only another empirical instantiation of the self. There for the grace of G-d, go you or I. The self and the other are wedded in a *Yin/Yang* harmony such that the self becomes the other and the other becomes the self. *Yin/Yang* harmony is a model of collaboration, not one of conflict and competition. If cultures are perceived of as alien others destined for collisions and conflicts, then the outcome will most likely be a self-fulfilling, doomsday prophecy. If cultures are perceived of as brothers, the prospects of harmony in the family of man will be great indeed. In the *Analects*, in response to Ci-ma Niu's worry of having no brothers, Zi-xia reports that he has heard that "all within the Four Seas are his [the cultured person's] brothers."[32]

Has all of this proved to have been a deconstruction of the myth of comparative philosophy or has it proved to have been an exercise in comparative

32. *Analects*, (*Lun Yu*): XII, 5.

philosophy? Perhaps, it can be said that this chapter can be understood as a demythologing of comparative philosophy as a discipline distinct from pure philosophy and at the same time a reconstruction of comparative philosophy as an exercise in complementary, integrative philosophy. While philosophy proper need not be distinguished from complementary, integrative philosophy, the label of complementary, integrative philosophy does allude to the need to integrate philosophies rather than to hold them, as stand-alone philosophies, at a distance from each other. This is the advantage of the adoption of the methodological principle of complementary integration.

Saving the Phenomena: An Aristotelian Method in Comparative Philosophy

13

Ji-yuan Yu and Nicholas Bunnin

"Saving the Phenomena" was the method most commonly used by Aristotle in science, metaphysics, and ethics. In *Nicomachean Ethics* Vii.1, at the outset of his discussion on incontinence (or weakness of will, *akrasia*), Aristotle offered a general account of this method:

> We must, as in all other cases, set the phenomena (*phainomena*) before us and, after first discussing the difficulties (*aporiai*), go on to prove, if possible, the truth of all the reputable opinions (*eudoxa*) about these affections or, failing this, of the greater number and the most authoritative; for if we both resolve the difficulties and leave the reputable opinions undisturbed, we shall have proved the case sufficiently.[1]

Accordingly, Saving the Phenomena comprises the following procedures:

(1) establishing the phenomena

(2) analyzing the conflicts among these phenomena and the difficulties arising from them

(3) saving the truth contained in all the reputable opinions

The method of Saving the Phenomena is also called "Aristotle's dialectic" and is indeed derived from the dialectical practice of Socrates, who cross-examined one or more interlocutors about their beliefs and exposed the puzzles arising from these views. The difference is that for Socrates discussion often ended in *aporia* (no solution, literally, no way out), but for Aristotle the exposure of *aporiai* was only a preliminary step. He sought to solve these *aporiai* and to reach a stable and conclusive view by bringing to light the truth that these apparently conflicting *phenomena* or *eudoxa* contain. Hence, for Aristotle *aporiai* are difficulties or puzzles to be solved rather than problems which are beyond solution.

It is our belief that Saving the Phenomena is a method that can be usefully

1. *Nicomachean Ethics*, 1145b1–7.

extended to the area of comparative philosophy by treating as phenomena what is said or believed in different cultures or traditions. Given the willingness of Socrates in Plato's dialogues to discuss beliefs with "strangers" as well as those sharing the traditions of Athens and given the openness of Platonic doctrines to Persian influence, this should not be entirely surprising. This paper tries to show how such an extension is possible and what kinds of modifications are needed for the extension of method to be worthwhile. The first section discusses how theories or beliefs from different cultures or traditions can be grouped together as phenomena. The next three sections deal with the three steps of this method as they might be employed in comparative philosophy: (a) establishing comparable phenomena; (b) articulating the differences among phenomena; and (c) saving truth in the phenomena that are compared.

1. Phenomena and Different Traditions

The term *"phainomena"* (literally meaning what are present or evident) is derived from the verb *"phainesthai"* (to appear). It can be translated as "appearances," but this rendering can give rise to misunderstanding. The English word "appearances" is used mainly for observable facts or empirical evidence. A method that starts from "appearances" in this sense seems to lead inevitably to a Baconian picture in which conclusions about reality are drawn from what is empirically given. But the method of Saving the Phenomena differs from this. Instead of being the empirically given, *phainomena* are what people commonly say (*ta legomena*) and hence "common belief" might be a more appropriate translation. Due to this distinctive sense of phenomena, the method of Saving the Phenomena extends beyond the scope of empirical science to logic, metaphysics, and ethics.[2]

If phenomena are initially understood as common beliefs, we can follow Aristotle's link between phenomena and *eudoxa* (*eu*, good + *doxa*, opinion or belief, hence, reputable opinion). Aristotle defines *eudoxa* in this way: "Those opinions are reputable which are accepted by everyone or by the majority or by the wise—that is, by all, or by the majority, or by the most notable and

2. The ambiguity of the term *phainomena* in Aristotle is explored in G.E.L. Owen's seminal paper, "Tithenai ta phainomena," in Owen, *Logic, Science and Dialectic* (London: Duckworth, 1986), 239–52. Owen claims that although in certain scientific contexts (particularly in biology and meteorology), *phenomena* are empirical observations, in most of Aristotle's works, the term means the common conceptions or what is commonly said on the subject rather than the observed facts. Owen suggests on this ground that for Aristotle there is no sharp methodological distinction between science and philosophy. Martha Nussbaum argues further that *phenomena* in Aristotle has only a single use: "Instead of the sharp Baconian distinction between perception-data and communal belief, we find in Aristotle, as in his predecessors, a loose and inclusive notion of 'experience', or the way(s) a human observer sees or 'takes' the world, using his cognitive faculties (......). This, I suggest, is the meaning of Aristotle's talk of *phainomena*" (Nussbaum, *The Fragility of Goodness*, Cambridge: Cambridge University Press, 1986), 244–45.

reputable of them."[3] *Eudoxa* includes *phenomena* as common beliefs, but also includes views which are not commonly accepted but are held by a small number of wise people or even by a single wise person. For example, Socrates insisted that *akrasia* (incontinence) is impossible on the grounds that one cannot act against what one believes to be best. He held that people appear to act incontinently only by reason of their ignorance. As Aristotle saw, this view "contradicts the plain phenomena."[4] Most people believe that *akrasia* exists. Yet Aristotle included the Socratic view as one phenomenon about *akrasia* and, indeed, considered it to be the main phenomenon worthy of discussion. The main goal of Aristotle's discussion of *akrasia* was to reconcile the truth of Socrates's view with the truth of the plain phenomena. Strictly speaking, *phainomena* and *eudoxa* are not the same, because *eudoxa* includes more than *phainomena*, yet Aristotle did not always bother to distinguish them and frequently used the terms interchangeably. Thus, the method of Saving the Phenomena can also be called the method of Saving the *Eudoxa*.

The first step of Saving the Phenomena in Aristotle's normal practice requires that our inquiry starts from what is commonly believed or what is believed by the wise regarding a certain issue. He began the discussion of an issue by listing the views of his predecessors on the same subject. One does not have to read many pages of Aristotle to recognize this as a standard procedure. We can note not only that Aristotle began an investigation of a subject by collecting a variety of views, but that a characteristic virtue of his method was its respect for all the views that he examined.

Following Aristotle, the first step in applying Saving the Phenomena to comparative philosophy is to bring together what is said or believed in different philosophical traditions if these beliefs appear to share similar theoretical or practical concerns. Here, the phenomena collected are not from one's predecessors or contemporaries in one's own tradition, but are from a variety of different traditions. In comparative philosophy, Saving the Phenomena begins with respect for these diverse phenomena.

In a sense, this initial step in Saving the Phenomena seems to be nothing new, but is rather a normal practice in philosophy. To discuss a philosophical issue, we must pay attention to what others have said or are saying on the same issue. There is, however, a fundamental difference between Saving the Phenomena and the normal practice of collecting what other people are saying. The aim of Aristotle's method is to list different phenomena in order to preserve and reconcile the truth contained in each of them or in most of them.[5] In

3. *Topics*, 100b20–22.
4. *Nicomachean Ethics*, 1145b27.
5. It is worth mentioning that Kant followed this reconciling aspect of Saving the Phenomena in much of his critical philosophy, as did Wittgenstein in his treatment of solipsism in the *Tractatus*.

contrast, much current philosophical discussion identifies opposing views in order to reject them and to establish the superiority of one's own position. In Saving the Phenomena, the combative and cooperative aspects of dialogue are in better balance.

In comparative philosophy, the proposed initial act of drawing together phenomena from different traditions can encounter vehement objections. Comparative philosophy is *comparative* because it involves different philosophical traditions that developed in relative isolation from one another, in particular because it involves comparisons between the traditions of the West and the historically discrete traditions of India, China, or Africa. To compare different systems within the Western tradition (or more accurately within the complex array of different Western traditions) is a normal philosophical practice, but it is never called comparative philosophy. The assumption seems to be that direct and indirect relations or interactions among Western doctrines, however different in aim or content, legitimate the collection of phenomena within the West. Yet because comparative philosophy brings together traditions which have not interacted or have not interacted very intimately in their development, comparative philosophy does not explore existing or potential natural dialogues, but imposes the form of dialogue where the pragmatically necessary conditions of discussion do not obtain.

More specifically, two objections can be raised for our proposal to extend the scope of the phenomena collected to reputable opinions drawn from humankind as a whole and to view differences across cultures or traditions as differences among phenomena. First, how can we determine that phenomena from different traditions are commensurable? Second, how do we know that phenomena drawn from different traditions concern the same issue? We deal with the second objection in the next section, but now focus on the first objection.

It has been an influential position that differences arising from different traditions are irreducibile. Let us turn, for example, to Alasdair MacIntyre's claim that Aristotelian virtue ethics and Confucian theory of virtue are incommensurable:

> [E]very major theory of the virtues has internal to it, to some significant degree, its own philosophical psychology and its own philosophical politics and sociology. These dictate for the adherents of each such theory how the relevant empirical findings concerning human life are to be construed, classified, and characterized. There is just no neutral and independent method of characterising those materials in a way sufficient to provide the type of adjudication between competing theories of the virtues which I had once hoped to provide and to which some others still aspire.[6]

6. Alasdair MacIntyre, "Incommensurablity, Truth, and the Conversation between Confucians and Aristotelians About the Virtues," in Eliot Deutsch, ed., *Culture and Modernity* (Honolulu: University of Hawaii Press, 1991), 105.

Although MacIntyre does not talk about the Saving the Phenomena method, he presents a profound challenge to the possibility of extending this method to views and theories from different cultures and traditions. If rationality must be embedded in and shaped by different traditions and views from different traditions are based on different forms of rationality, a comparison of their validity is impossible, and there are no objective standards by which to assess them. If views are incommensurable, we cannot judge them in order to establish which is true and which is false. For MacIntyre, comparative philosophy would be impossible, because the very condition that makes it comparative would undermine the possibility of comparison leading to adjudication between phenomena.

In sketching a response to MacIntyre, we seek to provide an Aristotelian justification for extending the scope of phenomena to different cultures or traditions. We believe that this extension can be grounded in common human experience and common human rationality. Furthermore, the goal of Saving the Phenomena in comparative philosophy is not to determine that one phenomenon is true and the other false but to find the truth in all or most phenomena.

It should be noted that for Aristotle himself *ta eudoxa* is simply "the reputable opinion" and *ta phenomena* are simply "the things said." He did not talk of the reputable opinion *in this tradition* or the things said *in this culture*. Although there is no doubt that his theory is characterized by Greek language, culture, and traditions, Aristotle was concerned with human nature as such rather than with the culture and traditions of ancient Greece alone. Hence, although Aristotle did not address the issue of interpretation across cultures, there is no reason to believe that he would object to extending Saving the Phenomena to "what is said" in different cultures.

Aristotle was fully aware of the multiplicity of cultures or social customs and their differences (for example, Book II of the *Politics*). But he also maintained that beyond differences in culture, human beings share certain feelings. "We may see even in our travels how near and dear every man is to every other."[7] More important, he claimed that rationality is the universal human function or characteristic activity that distinguishes human beings from other animals.[8] Across cultural boundaries, there is the rationality that comprises the essence of being human. Whatever further account of it may be possible or necessary, this universal rationality is a fundamental natural capacity that characterizes human being as human being. The *Metaphysics* opens with the sentence: "Human by nature desires to know." We have the ability to know because we are rational.

Common human experience and rationality can justify our attempt to extend

7. *Nicomachean Ethics* 1155a20–7.
8. Ibid, I 7, 1098a3–77.

the scope of phenomena to views that come from different cultures or traditions.[9] As humans, we have various common desires, feelings, and needs. Different cultures constitute different forms of expression of these common features. However different they are, cultures enable individuals to live together by shaping and setting limits to the expression of these desires, feelings, and needs. Cultural differences are important, but they are not absolute barriers to communication. Rather they are different specifications of our common humanity.

Philosophy is understood as the reflection of human experience. Philosophy at its most profound is not restricted to the particular expressions of human experience, but leads from these particular expressions to an appreciation of human experience as such. Aristotle distinguished between practical rationality and theoretical rationality. Whereas the exercise of practical rationality is culturally-embedded, theoretical rationality or intellect is not: "not only is intellect the best thing in us, but the objects of intellect are the best of knowable objects."[10] Theoretical rationality enables us to recognize truth that is universal for human being. In this light, philosophies in different traditions are reflections of a common theoretical rationality upon common human experience. They are attempts to understand a common humanity, and to solve common human problems. Here are the grounds on which we can draw together philosophical views from different cultures and traditions and thus establish the possibility of comparative philosophy.

Seen in this way, cultural differences are not inevitably opaque. On the contrary, precisely because there are cultural differences, we need to compare views from different cultures in order to achieve a perspicuous understanding of our common humanity.

In a sense, to deny the possibility of comparative philosophy is to reject the universality of metaphysical claims. Metaphysics is traditionally regarded as being a universal rational enterprise. If we reject absolutely the commensurability of "what is said" in cultural differences and traditions, we have to accept the consequence that metaphysics is also culturally bound.

We also respond to MacIntyre's position by providing an Aristotelian

9. Several scholars take the common human experience as the basis for cross-cultural comparison. For instance, Schwartz says: "The faith which must animate an enterprise such as this is the faith that comparative thought, reaching across the barriers of language, history, culture and Foucault's 'discourse', is possible. It is a faith that assumes a common world of human experience" (B. Schwartz, *The World of Thought in Ancient China* (Cambridge: Harvard University Press, 1985), 13). This point is most sophistically argued by Nussbaum in her "Nonrelative virtues: An Aristotelian Approach" (*Midwest Studies in Philosophy* 13 (1988): 32–53). She maintains: "We do not have a bedrock of completely uninterpreted 'given' data, but we do have nuclei of experience around which the constructions of different societies proceeds. . . . There is just human life as it is lived. But in life as it is lived, we do find a family of experiences, clustering around certain foci, which can provide reasonable starting points for cross-cultural reflection" (ibid., 49).
10. *Nicomachean Ethics*, 1177a20–21.

account of the aims of Saving the Phenomena. The ultimate goal of the method is not to establish that of all the phenomena on a given issue there is one that is the winner regarding truth. On the contrary, Saving the Phenomena seeks to conserve the truth that these various phenomena contain by showing that each phenomenon is neither completely wrong nor completely right. On Aristotle's account, the view that emerges from the method "will be most in harmony with the phenomena; and both the contradictory statements will in the end stand, if what is said is true in one sense but untrue in another."[11] Similarly, we believe that in comparative philosophy, an adjudication between claims from different cultures is not the goal.

Aristotle's attitude regarding phenomena is related to his belief that where there is dispute, truth is unlikely to be held only by one phenomenon. Aristotle realized that the discovery of truth is by no means the business of one person or one group, but needs to be a collective human endeavor:

> The investigation of truth is in one way hard, and in another easy. An indication of this is found in the fact that no one is able to attain the truth adequately, while, on the other hand, no one fails entirely, but every one says something truth about the nature of things, and while individually they contribute little or nothing to the truth, by the union of all a considerable amount is amassed. Therefore, since the truth seems to be like the proverbial door, which no one can fail to hit, in this way it is easy, but in fact that we can have a whole and not the particular part we aim at shows the difficulty of it.[12]

Phenomena are worth collecting because there is truth in them. The goal of the method is not to establish that one phenomenon is prior to others in respect of truth, but to bring to light the elements of truth contained in a variety of apparently conflicting *phenomena* and *eudoxa*. The significant point here is that everyone is a member of truth-seeking and truth-contributing community. In Aristotle's account of the phenomena that he collected about happiness (*eudaimonia*) or human good, he wrote: "Some of these views have been held by many men and men of old, others by a few persons; and it is not probable that either of these should be entirely mistaken, but rather that they should be right in at least some one respect or even in most respects."[13] Each of a conflicting array of phenomena cannot be completely right, but each might be partly right. A view would be rejected by Aristotle if it contradicted all the phenomena or was incompatible with universally endorsed beliefs.[14]

Saving the Phenomena contrasts with the philosophical method practiced

11. *Eudemian Ethics*, 1235b15–77.
12. *Metaphysics* 993a28–993b7.
13. Ibid.,1098b27–9.
14. *Topics* 160b17–22; *Physics* 196a13–7, 254a7–70; *On Generation and Corruption*, 315a4–5; *De Anima*, 418b20–26; *Nicomachean Ethics*, 1096a1–2, 1173a–4.

by Parmenides and Plato. For Parmenides, phenomena such as perceptions
and beliefs cannot lead to truth, and the only road to truth is the road of being
and rational argumentation. Plato distinguished between two worlds and
claimed that whereas the world of ideas is stable and the real object of truth
and knowledge, the sensible world is transient and the object of opinion. Both
Parmenides and Plato contrasted *doxa* (opinion or belief) and knowledge and
held that *doxa* conceals truth (in Greek, *aletheia*: *a*, not + *letheia*, cover, literally,
what is uncovered). Seeking of the truth is to bring out what is the case from
concealment. [15]

 Aristotle did not think that *doxa* conceals the truth. In adopting the method
of Saving the Phenomena, he presupposes that the truth must be contained in
doxai held by all, by the majority or by the wise. Accordingly, to locate the
truth we must start with *doxa* or phenomena, that is with what appears clearly
to us. In the pursuit of knowledge, Aristotle believed that we must proceed
from what is knowable to us to what is knowable to nature:

> The natural way of doing this is to start from the things which are more knowable
> and clear to us and proceed towards those which are clearer and more knowable to
> nature; for the same things are not knowable relatively to us and knowable with-
> out qualification. So we must follow this method and advance from what is more
> obscure by nature, but clearer to us, towards what is clearer and more knowable
> by nature.[16]

Because phenomena are precisely what is evident to us, they are the starting
points of an inquiry and the locus in which truth can be found. Following this,
we compare "what is said" in different cultures or traditions because their phe-
nomena must have elements of truth in them as well. This truth is simply
human truth, rather than truth relative to this or that culture. This holds how-
ever partial that truth and however difficult it is to disentangle it from the
culture in which its expression is embedded.

 How could Aristotle be so confident that there were elements of truth in
phenomena or *eudoxa*? In *Eudemian Ethics*, I, 6, he began with a summary of
Saving the Phenomena: "About all these matters we must try to get conviction
by arguments, using the phenomena as evidence and illustration. It would be
best that all men should clearly concur with what we are going to say, but if
that is unattainable, then that all should in some way at least concur."[17] Imme-

 15. As Nussbaum nicely puts: "The Platonist encourages us to neglect this work by giving
us the idea that philosophy is a worthwhile enterprises only if it takes us away from the 'cave'
and up into the sunlight, . . . Aristotle, answering them, promises to work within and to defend
a method that is thoroughly committed to the data of human experience and accepts these as its
limits" ("The Fragility of Goodness," 1986, 245).
 16. *Physics*, 184a17–21. Cf. *Metaphysics* 1029b3–72; *De Anima*, 413a11–76; *Nicomachean
Ethics*, 11216b33–9.
 17. *Eudemian Ethics*, 1216b26–30.

diately afterwards, we read: "And this if converted they will do, for every man has some contribution to make to the truth." This sentence apparently serves as an explanation of why there is truth in phenomena. In another place, Aristotle said: "It may also be noted that men have a sufficient natural instinct for what is true, and usually do arrive at the truth. Hence the man who makes a good guess at truth is likely to make a good guess at what is reputable."[18]

Based on these remarks, we think that for Aristotle there is truth in phenomena because human beings have natural instinct or natural ability to hit the truth. The ways in which human beings live and act guarantee that there is something true in phenomena, because they contribute to human survival and development. This pragmatic and naturalistic consideration is the ultimate ground of the method of Saving the Phenomena.

If this is right, bringing together phenomena from different cultures or traditions enables us to increase the scope of a union of truth-seeking communities and to provide a broader basis for our own truth-seeking. We will appreciate the richness of human experience by bringing together phenomena from whatever philosophical corner of the world we find them. The goal of comparative philosophy is not a competition among candidates for a single truth, but a realization of a joint human effort to find and reconcile the various and partial truths expressed in phenomena. The goal of philosophy is not to establish absolutely correct knowledge from a humanly impossible standpoint, but to understand things better from a standpoint that is humanly constructed from the resources provided by initially given phenomena.[19]

Saving the Phenomena also allows us to dispute the often-heard prejudice that allegedly philosophical traditions outside the West are not serious philosophizing. If we consider treating "what are said" in the non-Western traditions as phenomena, this prejudice amounts to saying that only Western phenomena contain truth, whereas non-Western phenomena do not. This is contrary to the spirit of Saving the Phenomena. The extension of the method to the phenomena of other traditions places these phenomena on equal footing with phenomena from the West. If we treat phenomena from different traditions in the way that Aristotle treated the phenomena of his predecessors, we have treated them fairly.

Finally in this regard, we have accepted for the sake of argument a simplified picture of mutual intelligibility and commensurability in the Western tradition and ruptures and breaks between Western and non-Western traditions. In fact, all of the problems which are posed for comparative philosophy arise within the complex of traditions in Western philosophy. Western philosophers

18. *Rhetoric*, 1355a15–77.
19. Endorsing the impossibility of an ideal standpoint does not force us to support a Nietzschean claim for the perspectival nature of all possible representations. We can recognize nonperspectical representations as a guiding ideal that we cannot realize or as an ideal that we can realize a Peircean consensus through Saving the Phenomena.

have differed radically in fundamental aims, assumptions, problems, methods, theories, vocabularies, doctrines, and self-understanding as philosophers. The very real problems of understanding and assessing phenomena drawn from non-Western traditions can all be found within the West as well. Complexities of intellectual topography may preclude a single standpoint from which all phenomena can be clearly seen and judged, but this is as much a problem for Western philosophy as it is for comparative philosophy.

2. Establishing Comparable Phenomena

We proceed to deal with the second objection to the extension of the method of Saving the Phenomena to comparative philosophy. How do we know that phenomena drawn from different traditions concern the same issue? How should such issues be identified and characterized?

When Aristotle used the method, all the phenomena drawn together were definitely about the same issue. If indeterminacy of meaning and reference is overcome by the embedding of language in shared practice, how can we be certain that phenomena are about the same issue where the phenomena are drawn from traditions among which there has been no or little interaction? If these phenomena turn out not to be about the same issue, but are treated by Saving the Phenomena as if they were about the same issue, the application of the method to comparative philosophy would be fatally flawed.

This is precisely the problem arising from what G.E.R. Lloyd calls "piecemeal approach" in comparative philosophy: "the attempt to make direct comparisons between individual theories and concepts *across* cultures *as if* they were addressed to the *same* issue."[20] Lloyd vehemently criticizes the piecemeal approach:

> It is clearly not possible, without courting disaster, to proceed to a comparison and contrast between individual theories or concepts seriatim in China and Greece *as if* they were addressing the same questions. . . . Thus we cannot start from the Greek side, let us say, by identifying some particularly prominent theory or concept and then asking what the Chinese equivalent is—as if it is a foregone conclusion that there will be any such equivalent.[21]

20. G.E.R. Lloyd, *Adversaries and Authorities* (Cambridge: Cambridge University Press, 1996), 3.

21. Lloyd, ibid., 1996, 5. We may compare Lloyd's rejection of the piecemeal approach in comparative philosophy with Kant's rejection of what might be called a piecemeal approach in philosophy. Kant argued that unless he solved all of the problems of philosophy, he could not claim to have solved any one of them. He thought that traditional logic provided the key to determining the scope of philosophy that the order and relationship among philosophical problems. We can reject this key, but still argue in favor of dealing with problems in their wider connections rather than with each on its own.

A careful reading shows that in this passage Lloyd is attacking two different attitudes rather than one. The first target is an attitude which simply takes individual theories or concepts in China and Greece to be addressing the same issue. Presumably, these individual theories or concepts exist and have apparent, if profoundly misleading, similarities. The second target is an attitude which starts from a theory or concept in one tradition and searches for an equivalent in another. The theory or concept is prominent in one tradition, but does not seem to be present in other traditions, at least not explicitly. We are not presently concerned with cases of this sort in which it would be necessary to carve out a counterpart in another tradition and thereby to "create" the phenomena ascribed to that tradition, rather than "save" existing phenomena according to the method of Saving the Phenomena. For this reason, we shall concentrate on the first target and consider whether Lloyd's objection to it undermines the extension of Saving the Phenomena to comparative philosophy.

We agree with Lloyd's criticism of the piecemeal approach, but want to point out that employing Saving the Phenomena in comparative philosophy is fundamentally different from this piecemeal approach.

The first step of Saving the Phenomena in comparative philosophy does not assume that seemingly similar phenomena are dealing with the same issue and on this basis group them for consideration. Rather, Saving the Phenomena questions precisely whether seemingly similar phenomena are indeed about the same issues. In the application of Saving the Phenomena to comparative philosophy, the first step is far more complicated than it is in Aristotle's own method. The phenomena that Aristotle listed were intended by their authors to be about the same issue. In comparative study, because phenomena are drawn together from different cultures and traditions that provide their own special contexts, it would be wrong to assume that apparently similar phenomena are views of the same subject or that each is an exact counterpart of phenomena in another culture. To make comparison possible, we must first determine whether seemingly similar phenomena are indeed phenomena concerning the same sort of theoretical and practical issues. No presupposition is allowed here. [22]

Establishing that phenomena are comparable is the crucial first step in comparative study. It takes serious effort to determine this point. If seemingly similar views differ too much in the issues they concern, there is no reason to pursue a comparison between them. If a comparative philosopher mistakenly takes different cases to be the same or similar, his or her study will not serve much purpose. A comparison is exciting only if the phenomena that are con-

22. At this point, we might be urged to employ the approach of hermeneutics. In our view, Saving the Phenomena provides a methodological context in which the problems of hermeneutics arise. We shall have to see in later work how well defined the boundary between Saving the Phenomena and hermeneutics turns out to be.

sidered turn out after examination to concern the same set of philosophical issues. Even if phenomena do not deal with the same issue, they might be about different aspects of the same issue. These relations might be too vague for philosophers who demand identity of issue for comparative philosophy to proceed, but we have successful experience in Western philosophy in dealing with similar imprecision. In any case, apparently comparable phenomena raise questions and invite study, rather than being the naïve basis for piecemeal comparison.

The difference between a piecemeal approach and our method of Saving the Phenomena in comparative philosophy can be illustrated through Lloyd own example, namely the comparative study of the concept of nature in Ancient Greece and Ancient China. The piecemeal approach will proceed on the assumption that "there is a single concept of nature towards which both Greeks and Chinese were somehow struggling." Lloyd argues that "It would introduce massive distortions in the interpretation of both Greek and Chinese science if we took it that the work of ancient investigators was targeted at that goal."[23]

What Lloyd has criticized is precisely what Saving the Phenomena seeks to avoid. If we study the concept of nature in Ancient Greece and Ancient China by using the method of Saving the Phenomena, we will first notice that there is no single conception of nature (Greek, *phusis*). Nowadays we use "nature" to mean the universe or our natural environment. In Greek, this is called *kosmos*, which is close to what in Chinese is called *tian* (heaven). The term "*phusis*" has many senses. In *Metaphysics* 5, chapter 4, for example, Aristotle listed the following five senses:

(a) the genesis of growing things

(b) the primary immanent element in a thing

(c) the source from which the primary movement in each natural object is present in it in virtue of its own essence

(d) the primary matter of which any non-natural object consists or out of which it is made

(e) the substance of natural objects

In Ancient Chinese philosophy, these senses are assumed by different terms. For instance, (a) and (e) are similar to *xing* (commonly translated as nature). *Zi ran* (literally, self-so) is also translated as nature and is similar to (c). The sense (d) is related to *stoicheia* (element) and corresponds to the theory of five phases in Chinese philosophy. In view of all these phenomena, it is impractical to have a general comparison. Instead, we would compare one sense of *phusis*

23. Lloyd, op. cit., 1996, 7.

in ancient Greece with the term that assumes a counterpart role in ancient China and proceeding step by step from there we would seek to establish sensible relations between Greek and Chinese terms and their senses.[24]

To establish comparable phenomena, we must avoid imposing the concepts and theories of one side on the other. Such imposition would result in assimilating the issues addressed by concepts and theories on one side to the issues addressed by the concepts and theories on the other side. By revising and unifying the phenomena in this way, the original meaning of the assimilated terms would be distorted and opportunities for insight would be lost. Practically speaking, in our formulation of the problems to consider we should seek to avoid imposing Western concepts and theories on alternative traditions, because imposition in the opposite direction rarely occurs. We should begin by following what each side sees itself as doing and by clarifying the issue in terms of that side's own categories and logic. This requires us to place the views of each side in an appropriate context in terms of which initial discussion is conducted. It also requires us to take into consideration the history and tradition of a philosophical concept or issue within its own tradition. Chad Hansen's position in *A Daoist Theory of Chinese Thought* exemplifies our point. Hansen criticizes the standard interpretation of the classics of Chinese philosophy for attributing "the conceptual structure of a Western theory of mind and language to Confucian writers. This results from the translation paradigm that tempts us to regard English as fixing the possible meaning structure of Chinese."[25] In contrast, he argues that whereas language in Western philosophy is primarily representational, in Chinese philosophy it is a social practice and its basic function is guiding action. Whereas the Western theory of mind is expressed in terms of ideas and beliefs, the Chinese theory of mind is expressed in terms of dispositions.

24. Lloyd describes his own alternative method as follows: "One suggestion that may be thought to emerge from my anti-piecemeal reflections is that we should not begin with a comparison between the answers or results: we should ask first what the questions were to which the answers were thought to be the right answers. I have insisted that we cannot assume that the theories or concepts were addressed to the same questions. So it follows that we must problematize the questions" (1996, 9). We disagree with him on the grounds that one will not able to problematise the questions if one does not establish the comparable phenomena first. One cannot brush aside "what is said" in the available texts to locate the questions. As Lloyd himself anticipates, one objection to his method is that "that inquiry is, in any case, going to have to be all too speculative" (1996, 10). To this objection, he says: "the only response is to rest one's case on the result obtained. It is a question of how well the job can be done, how speculative, how far removed from the direct textual evidence, one has to be, how suggestive or fruitful the results appear to be, for example in relating together previously unconnected areas or aspects of ancient investigations" (1996, 11). In fact, to start from what is said in the texts of each side is the best way to stop any speculation or simplified generations and to lay down a solid basis on which to begin. It also fits perfectly in spirit with Aristotle's instructions on how to proceed: from what is evident to us to what is known in nature.

25. Chad Hansen, *A Daoist Theory of Chinese Thought* (New York: Oxford University Press, 1992), 7.

Our emphasis on the importance of the self-understanding of a culture or tradition in the first stage of Saving the Phenomena does not imply that there is a transparency and coherence in that culture or tradition. There can be vagueness, contradictions, gaps, distortions, misunderstandings, incoherence, nonsense, and textual corruption. Also, cultures and traditions can take wrong turns and lose as well as gain from internal criticism and interpretation. We do not propose to eliminate external criticism in comparative philosophy, but to reserve it for a later stage.

3. Articulating Differences

For Aristotle, once the phenomena were established, the next step was to set out the *aporiai*, that is the difficulties and contradictions that are presented to us by the phenomena. These *aporiai* reflect disagreements, tensions, and ambivalences among the various sides of the debate. Aristotle viewed these difficulties as knots that need to be untied, and said: "for those who wish to get clear of difficulties it is advantageous to state the difficulties well; for the subsequent free play of thought implies the solution of the previous difficulties."[26] In philosophy, these difficulties are conceptual rather than empirical.

In comparative philosophy, once the phenomena from different cultures or traditions are shown to be concerned with similar theoretical and practical problems, we proceed to show why each phenomenon answers the question and look at the question from the perspective of each phenomenon and its tradition, that is we work out their similarities and differences. This step demands careful textual analysis to present the logical structure of the views and to highlight the strengths and weaknesses of each. This step forms the bulk of a comparative study.

In analyzing the logic and rationality of each phenomenon, the initial presentation should be a descriptive construction based on the perspective and logic of the proponents of the view. Each expository move at this stage should be closely supported by textual evidence. The translation of a given term, argument, or theory should seek to approximate the original meaning. In making sense of the development of a phenomenon, the analysis should place texts in the context of their own philosophical environment. We should guard against arbitrarily applying our own logical model to infer what a phenomenon from a different tradition should or should not say.[27]

26. *Metaphysics*, 995a27–9.
27. Of course, since each comparative philosopher has his or her own background and standpoint, it might be humanly impractical to be purely neutral in analyzing and comparing cross-cultural phenomena. Even Aristotle was not completely immune to partiality, as H. Cherniss found regarding Aristotle's discussion of the pre-Socratic philosophers and of Plato (see, Cherniss, *Aristotle's Criticism of Presocratic Philosophy*, Baltimore: John Hopkins University Press, 1935; and *Aristotle's Criticism of Plato ad the Academy*, Baltimore: John Hopkins University Press, 1944). Yet we must be aware of our limitations and do our best to overcome them.

Nowadays, each phenomenon that is examined according to the method of Saving the Phenomena is likely to be surrounded by a rich array of existing exploratory and critical scholarship. One cannot presume that a phenomenon is itself uncontroversial. A view or theory might be interpreted according to various and even contradictory understandings. The understanding of a text matures through being tested by controversies over interpretation. A serious comparative study cannot simply draw together Western and non-Western phenomena, as if the understanding of any phenomenon were unanimous. Before we start to compare phenomena, we have to express our interpretation of them to the extent that the scholarly community on both sides judges that its side is treated in a superficial way.

In comparison, we see similarities and differences, convergences and divergences. The similarities and convergences are worth showing and are often suggestive, yet as many comparative philosophers would agree, difference is more interesting than similarity. Even if phenomena from different cultures or traditions identify precisely the same questions and provide virtually the same answers to them, each side must retain its distinct perspective colored by its cultural environment. Because Saving the Phenomena begins to show its significance for comparative philosophy in the articulation of differences among comparable phenomena, it is no surprise that the majority of current comparative studies focus on setting out differences. Many comparative philosophers simply understand the point of their study to be setting out differences.

We should respect the value that they see in their work. First, through articulating differences, we can seek to avoid intercultural misunderstanding and to dispel crude, simplified and distorted representations of other traditions. Once at least some differences are explicit, we will understand the other culture from its own initial perspective and on its own terms rather than solely in terms of our conceptual framework. Figuring out the real basis of differences will help us to appreciate what is compelling in the other tradition. For example, because Western philosophers tend to understand Chinese philosophy from the standpoint of Western scientific rationality, the peculiar sensibility of Chinese philosophy is often missed or reduced to mere decorative quaintness. In recent years, David Hall and Roger Ames have painstakingly sought in a series of collaborative works to elaborate fundamental differences between Chinese and Western philosophy and have contributed significantly to the understanding of Chinese culture on its own terms. In their own words, "our comparative efforts have constituted attempts to raise to the level of consciousness, those habitual attitudes and assumptions that preclude Western thinkers from understanding China on its own terms, and to offer, quite tentatively, some revised categories that may permit a richer understanding."[28]

Secondly, articulating differences among comparable phenomena provides

28. Hall and Ames, *Thinking from the Han* (Albany: SUNY Press, 1998), p. xi.

a variety of perspectives from which to view the same theoretical and practical problems. Phenomena from different cultures—because they are from different cultures—provide contrasting perspectives, contrasting modes of thought, and contrasting arguments. In such circumstances, we can identify alternatives in approach and ways of thought and reach the terrain on which comparative philosophy becomes philosophically exciting. Hall and Ames say: "we hold that it is precisely this recognition of significant differences that provides an opportunity for mutual enrichment by suggesting alternative responses to problems that resist satisfactory resolution within a single culture."[29] In the first section, we argued that cultural difference is not a barrier to philosophical communication across cultural boundaries. We should further say that it is precisely the existence of cultural differences that gives comparative philosophy its vocation.

Third, articulating differences helps to bring out the often elusive presuppositions of a concept, theory, or whole tradition. It is a commonplace that philosophy is a self-reflective discipline that constantly seeks to clarify its own underlying assumptions. Comparative philosophy has much to contribute to the self-reflective aspect of philosophy. Axioms cannot be proven within a deductive system for which they are axioms, and by analogy the extent to which a philosophical system is shaped by its underlying cultural assumptions is difficult to determine solely through discussion within that culture. In contrast, comparison of phenomena from different cultures or traditions, by tracing the development of alternative perspectives can bring to light the gaps, limitations, and biases of each side. This will certainly deepen the understanding of one's own philosophical tradition, change one's horizon, and help to explore the foundations of philosophizing. As Lloyd says:

> The best way of disabusing ourselves of those assumptions is by using all the considerable resources available for the investigation of other ways of doing things. . . . The only way we have of even beginning to test the strengths and weakness of any of these or other explanatory schemata, or of seeing which aspects correlate with which, is by resolutely looking across the borders at our colleagues on the other side—that is, across the institutionalised walls that our universities have created as barriers between our specializations.[30]

Comparative philosophy cannot provide an absolutely independent standpoint to question the basic foundations of our own philosophical activity and to explore the otherwise unexamined presuppositions of our culture, but it can provide a relatively independent standpoint through the disciplined cultivation of other traditions. Comparative studies can enrich philosophical discussion

29. Hall and Ames, *Thinking through Confucius* (Albany: SUNY Press), 5.
30. Lloyd, op.cit. 1996, 19.

and help philosophy to transcend cultural boundaries to reach humanly universal insights regarding nature and truth.

In Aristotle's theory of friendship, a real friend is regarded as a second self, and a mirror to reflect and perfect oneself. As Aristotle says:

> When we wish to see our own face, we do so by looking into the mirror, in the same way when we wish to know ourselves we can obtain that knowledge by looking at our friend. For the friend is, as we assert, a second self. If, then, it is pleasant to know oneself, and it is not possible to know this without having some one else for a friend, the self-sufficing man will require friendship in order to know himself.[31]

Comparable phenomena from different cultures or traditions are like friends. Each should view the other as a mirror in order really to know itself.

4. Saving the Truth in Comparable Phenomena

Through articulated differences, comparative philosophy can prove itself to be a significant undertaking. Many scholars believe that this is the most important aspect of what comparative philosophy can contribute to our intellectual life. Some scholars even claim that clarifying differences from a neutral standpoint is the feature that constitutes comparative philosophy. As R. Panikkar suggests: "The contemporary concept of comparative philosophy pretends to be an autonomous discipline. It claims thematically to compare two, or more, or all philosophical views and give them a fair treatment without—at least ideally—necessarily subscribing to any of them." [32] Taken this way, comparative philosophy is a second-order study, a meta-philosophy dealing with the philosophy of different cultures and traditions. It is not about reality or truth itself, but is concerned with different historical bodies of philosophical thought. Can Saving the Phenomena lead us to expect more of comparative philosophy?

For the method of Saving the Phenomena in Aristotle, setting out an array of difficulties is only a middle step that leads towards a result which "puts an end to difficulties and contradictions" by showing how each phenomenon is true in one way but wrong in another and preserving the truth the phenomena contain.[33] The explication of difficulties locates the knots that need untying, but the goal of the method is to provide a *lusis* that loosens these knots. At the end of the inquiry one is supposed to say, "Herein lies the solution of all the difficulties raised and the conclusion of the investigation upon which we are

31. *Magna Moralia*, 1213a2–26.
32. Raimundo Panikkar, "What is Comparative Philosophy Comparing?," in James Larson and Eliot Deutsch, eds., *Interpreting Across Boundaries* (Princeton: Princeton University Press, 1988), 118.
33. *Eudemian Ethics*, 1235b12–7.

engaged."[34] Aristotle is neither a pluralist nor a relativist. He has a realist assumption that there is final truth to be attained and he wants to know something by nature, but he holds that this final truth can be uncovered in part in each of the phenomena rather than being completely contained in one of them.

Aristotle believed that a philosophical discussion should adjust or modify "what is said" by all sides of a debate. Having laid out the tensions and ambiguities among the phenomena, we draw distinctions and thereby redefine the issue under investigation. After our faithful representation of the phenomena, we can determine a new position that differs from the initial phenomena but preserves the partial truths that each contains. In this way, we can make philosophical progress and achieve objective truth, or what is known by nature. Aristotle claimed that "dialectic is a process of criticism wherein lies the path to the principles of all inquiries."[35] Dialectical engagement among alternative theories leads to truth.

Aristotle's discussion of *akrasia* illustrates what he meant. The ordinary view, or what most people believe, is that incontinence is possible, that a person can act against his best judgment.[36] Indeed, most of us have experience of incontinence. The problem is to explain how it is possible. Contrary to this ordinary view, Socrates denied that a man can knowingly not to do what is best: "for it would be strange . . . if when knowledge was in a man something else could master it and drag it about like a slave" (*Nicomachean Ethics* 1145b23–4). If a man apparently acts against his knowledge of what to do, it must be because he in fact lacks this knowledge and is ignorant of what is best. Having set out the tension or puzzle, Aristotle did not reject Socrates's view because it was implausible. Rather, he distinguished various senses in which one can have knowledge or understanding. For instance, one can potentially possess knowledge even though one is not actually using it at present (1146b31–5); one can know, but be prevented from exercising one's knowledge because one possesses strong anger or appetites (1147b9–77); or one can be like an actor who, judging from the lines he speaks, appears to know something but who has not learned enough to know what he is talking about (1147a19–24). The result is that the ordinary view—that one can know what to do and yet act badly—is not completely right, and Socrates's view—that a man cannot act against what he knows to be best—is not completely wrong (1147b13–77). If each side qualifies the sense of knowledge in terms of degrees and kinds of potentiality and actuality, their respective positions turn out to be compatible.

In line with this example, we claim that for Saving the Phenomena, articulating differences is a significant part in comparative philosophy, but is not its final goal. At the middle stage, comparative philosophy is a sort of meta-

34. *Physics*, 253a31–3.
35. *Topics*, 101b3–4.
36. *Nicomachean Ethics* 1145b12–21.

philosophy. This is by all means already not a trivial achievement, but that does not exhaust its importance. In its final stage, Saving the Phenomena goes beyond a mere historical study. By being concerned with truth and reality, it is a first-order study: philosophy in its own right. In seeking truth, we can be helped by having access to the perspectives of different traditions, because things can then show up more clearly than when they are seen from the perspective of one tradition alone. Yet according to Saving the Phenomena it would be more significant and rewarding to show how each perspective could be modified to achieve a new theory that can save and reconcile the partial truths contained in the phenomena of different traditions. In spite of the difficulties, these different perspectives might complement one another to form a comprehensive whole, or they might reveal different aspects of the same idea. In moving to its final stage, comparative philosophy changes its status from being a historical study to being an active part of constructive philosophical discussion.

Before we close, we should mention an objection that Aristotle's method of Saving the Phenomena cannot reach objective truth. If we start from what is said in phenomena and seek to save the truth that they contain, the result that we achieve seems to be no more than a coherent version of these initial beliefs, yet coherence does not guarantee objectivity and truth, because it is possible that all of these initial beliefs might be false. Two Aristotelian points can be made in response to this objection. First, Aristotle himself would not be bothered by this objection, because underlying Saving the Phenomena is his firm belief in human nature and our experience of its capacity to hit the target. We must proceed from what is evident to us to what is known by nature, and this is why the dialectical engagement of alternative theories can lead to truth. We can remind ourselves of a passage already cited: "It may also be noted that men have a sufficient natural instinct for what is true, and usually do arrive at the truth. Hence the man who makes a good guess at truth is likely to make a good guess at what is reputable."[37]

Secondly, when we talk of "saving" the phenomena, saving does not simply bring out what is already there; rather, saving is a process of reworking and creating. Most of Aristotle's conclusions established through Saving the Phenomena were neither a restatement of the phenomena nor merely a minor alteration of the phenomena. His conclusions were far from common views and were genuinely new theories. Thus, between the starting point of the method in gathering phenomena and its potentially original outcome stands the figure of the creative philosopher. The philosopher needs to convert an obscure, conflict-ridden, and ambiguous understanding of an issue into a clear and grasp which advances beyond initial understanding. Aristotle saw the importance of gathering and listing the views of his predecessors and contemporaries,

37. *Rhetoric*, 1355a15–77.

but he was not shy in recognizing his creativity if he thought that his insights did not benefit from the views of others.[38] Hence, when Aristotle relied on the method of Saving the Phenomena, we have reason to believe that he sincerely thought two things: that his own theories benefited from examining and reconciling the phenomena and that where phenomena existed the method was the most effective way to achieve the goals of a study. If we believe that Aristotle was not merely a synthesizer or historian, we should not believe that history and synthesis is the best that Saving the Phenomena can achieve. It is up to the practitioner of Saving the Phenomena rather than to the method itself whether the result of its use is merely a coherent version of initial beliefs or a creative theory with a claim to objectivity and truth. But even if Saving the Phenomena is not sufficient for achieving our philosophical goals, it might be necessary to reach them.

What this means for comparative philosophy is that Saving the Phenomena can lead comparative philosophy beyond a meta-philosophical history of philosophical ideas drawn from different cultures and traditions and achieve more than mere descriptive results. After the stage of faithful representation of concepts, theories, and their presuppositions from the perspective of the traditions which produced the phenomena, comparative philosophy can be creative philosophy in its own right. If it is premature to claim that comparative philosophy is already creative, Saving the Phenomena shows that it can legitimately claim creativity for its future and that we can legitimately nurture it in that direction. Realizing this future, of course, calls on the creative originality of comparative philosophers.[39]

38. For instance, in talking about his discoveries in logic: "of the present inquiry, . . . it was not the case that part of the work had been thoroughly done before, while part had not. Nothing existed at all. . . . If, then, it seems to you after inspection that, such being the situation as it existed at the start, our investigation is in a satisfactory condition compared with the other inquiries that have been developed by tradition, there must remain for all of you, our students, the task of extending to us your pardon for the shortcomings of the inquiry, and for the discoveries thereof your warm thanks" (*Sophistical Refutations*, 183b34–784b8).

39. We wish to thank Reinhard Dussell and Bo Mou for their helpful comments on an earlier version of this paper.

Mencius and Augustine on Evil: A Test Case for Comparative Philosophy

Bryan W. Van Norden

Mencius was a Confucian philosopher of the fourth century B.C.E.* His teachings are known to us today through an eponymous collection of his sayings, and his dialogues and debates with rulers, rival philosophers, and disciples. Augustine was a Christian saint and philosopher of the fourth and fifth centuries C.E., who left behind a number of texts in a variety of genres. Mencius and Augustine are among the greatest and most influential thinkers in their respective traditions. Neither knew of the other, or even had any inkling that another major intellectual tradition existed far beyond the boundaries of what was, to them, "the world."[1]

This essay is an exercise in comparative philosophy, taking as a test case Mencius's and Augustine's explanations of human wrongdoing. I take comparative philosophy to be concerned both with understanding what is distinctive about two thinkers or traditions, and with trying to determine whether there are any respects in which one thinker or tradition might provide a philosophical "challenge" to another. (I hope it will become more clear over the course of my essay what forms such a "challenge" might take.) We shall see that the differences between Mencius and Augustine are very great. Indeed, we might think that a *comparison* between them, in any substantive sense of that term, is impossible.

I shall begin by outlining and applying the comparative philosophical methodology of Alasdair MacIntyre, because I think he has said much that is illuminating on this topic. However, I shall present some evidence against MacIntyre's view on one key point. MacIntyre argues that there are some intellectual traditions which are "incommensurable." I certainly cannot prove in the space of

* I am indebted to Giovanna Borradori, Herman Cappelen, Jennifer Church, Jesse Kalin, Michael McCarthy, Mitchel Miller, Uma Narayan, and Xianglong Zhang for helpful comments on an earlier draft of this essay.

1. There have probably been contacts between Indo-Europeans and Chinese since the second millennium B.C.E. (See J. P. Mallory and Victor H. Mair, *The Tarim Mummies: Ancient China and the Mystery of the Earliest Peoples from the West* [Thames & Hudson, 2000].) However, Mencius would not have known of either Platonism or Christianity (the major influences on Augustine), and the Roman Empire did not know about Confucianism.

one paper that there exist no two traditions that are incommensurable. However, the views of Mencius and Augustine represent two extremely different intellectual traditions. One might expect that their views would prove to be incommensurable if any do. I hope to show that the philosophies of Mencius and Augustine can not only be substantially compared, but can also challenge one another philosophically in a manner that is more direct than MacIntyre's methodology allows. In particular, I shall try to show that in his *Confessions* Augustine's narrative of his adolescent theft of some pears cannot be accounted for by Mencius's philosophical psychology.

1. MacIntyre's View in Brief

MacIntyre holds that "[l]ogical incompatibility *and* incommensurability may both be present" between the claims or theses of two competing traditions.[2] Logical incompatibility requires that "two communities . . . are able to agree in identifying one and the same subject matter as that identified, characterized, and evaluated in their two rival systems and are able to recognize that the applicability of certain of the concepts in the one scheme of belief precludes certain concepts in the other scheme from having application. . . ."[3] Incommensurability, as MacIntyre uses the term, obtains when "no or insufficient common standards are available by which to judge between the rival standpoints."[4] One of the implications of incommensurability is that adherents of rival intellectual traditions cannot fruitfully engage in *direct* argument with one another, because "there is no set of independent standards of rational justification by appeal to which the issues between contending traditions can be decided."[5]

MacIntyre also holds that not all languages are intertranslatable. One set of such cases involves

> those situations in which the task of translation is from the language of one community whose language-in-use is expresssive of and presupposes a particular system of well-defined beliefs into the different language of another such community with beliefs which in some key areas are strongly incompatible with those of the first community.[6]

In understanding MacIntyre's claim about translatability, it is important to keep in mind both what he means by "translation" and the relationship he sees

2. Alasdair MacIntyre, *Whose Justice? Which Rationality?* (Notre Dame: University of Notre Dame Press, 1988), 351 (emphasis in original).
3. *Whose Justice? Which Rationality?*, 380.
4. *Whose Justice? Which Rationality?*, 351.
5. *Whose Justice? Which Rationality?*, 351.
6. *Whose Justice? Which Rationality?*, 379.

between language and beliefs. MacIntyre is not denying that it is possible for a speaker of any given natural language to *learn* any other natural language. Nor is MacIntyre denying that it is possible to *modify* an existing language so that it comes to have expressive resources that had previously only existed in some other language. In fact, MacIntyre writes that

> when Greek philosophy came to be written in Latin, those who continued the Greek tradition of philosophical enquiry had to be able to recognize . . . the previous singularly unphilosophical character of Latin, thus acknowledging the extraordinary achievement of those who like Cicero both translated from Greek and neologized Latin, so that it acquired new resources.[7]

However, MacIntyre argues that, if we attempt to translate between linguistic communities whose languages presuppose mutually incompatible beliefs, there will be cases in which translation by "same-saying and paraphrase" will fail.[8] MacIntyre gives the example of an ode by Horace that, if we tried to translate it out of Latin and into first-century B.C.E. Hebrew, would result in a statement that was "at once false and blasphemous; the Hebrew explanation of the Roman conception of a god could only have been in terms of an idolatrous regard for evil spirits."[9] One might object to MacIntyre at this point that one *could* translate from Latin into Hebrew; however, the corresponding sentences in Latin and Hebrew would be deemed to be *true* by Horace and *false* by the Jews in question. MacIntyre would respond, I think, that Horace's conception of the gods simply has no conceptual place in the worldview of the Jewish community in question. Yahweh could not be anything like Jupiter, much less the deified Roman emperors. Consequently, the Jews in question could not even express what Horace was trying to express in order to disagree with it. (I shall offer additional examples of untranslatability below.)

Surprisingly, MacIntyre holds that the combination of logical incompatibility, untranslatability, and incommensurability does not entail relativism. One reason for this is that two competing traditions can write narratives of one another and attempt to show through these narratives how the other tradition's problems are insoluble from within that tradition, but can be both diagnosed and circumvented from within the first tradition. If a narrative achieves this condition, those who have learned to be "bilingual" in the two traditions can come to recognize this fact.[10]

7. *Whose Justice? Which Rationality?*, 372. See Augustine's comments in *The City of God* XII. 2 on the Latin neologism "*essentia.*"

8. *Whose Justice? Which Rationality?*, 379.

9. *Whose Justice? Which Rationality?*, 380.

10. Interestingly, the 1958 "Neo-Confucian Manifesto" by Mou Zong-san, Xu Fu-kuan, Zhang Jun-mai, and Tang Jun-yi is such a narrative, written prior to and independently of MacIntyre's work. It attempts to give narratives of both "the Western" and the Chinese traditions,

It is important to recognize that, according to MacIntyre, such comparisons must take the *indirect* form of competing narratives. If two traditions are incommensurable, a person in one tradition cannot, while still occupying a position in only her own tradition, pose an objection to a person in another tradition that can present a genuine challenge. MacIntyre holds that one can only mount a genuine challenge to another incommensurable tradition through the kind of competing narratives I referred to above.

2. MacIntyre's Methodology Illustrated

The philosophies of Mencius and Augustine might seem to provide an illustration of the combination of logical incompatibility, incommensurability, and mutual untranslatability of which MacIntyre speaks. Logical incompatibility seems clearly to be present. Consider, for example, the issue of human sexuality. Augustine favors celibacy for those who are able to maintain it and become "eunuchs for love of the kingdom of heaven."[11] Mencius, in contrast, says that "For a man and a woman to dwell together in one home is the greatest of human relations" (5A2),[12] and that "[t]here are three ways of being a bad son. The most serious is to have no heir."[13] Indeed, one suspects that Mencius's attitude toward sexuality and reproduction was closer to that of Augustine's father (whom Augustine criticizes): one day at the public baths, Augustine's father "saw the signs of active virility coming to life in [Augustine] and this was enough to make him relish the thought of having grandchildren."[14]

It might seem that there could not be untranslatability between the languages of Augustine and Mencius. After all, Augustine wrote in Latin, and the writings of Mencius *have* been translated into Latin (by Jesuits, no less!).[15]

and to show how the West must come to incorporate certain features of Chinese culture. The Manifesto is a fascinating and revealing document. However, I submit that it is vitiated by its reliance upon oversimplified and monistic conceptions of both "Western culture" and the Confucian tradition. (For a critique of the Manifesto, see Philip J. Ivanhoe, "On the Metaphysical Foundations of Neo- and New Confucianism," *Journal of Chinese Philosophy* 22 [1995]: 81–89.)

11. Augustine, *Confessions*, R.S. Pine-Coffin, trans. (New York: Penguin Books, 1961), II. 2, 44, citing Matthew 19:12. Augustine also cites the Apostle Paul freely on this point. Here and elsewhere Augustine's debt to earlier texts and thinkers (both Christian and Pagan, especially Platonist) is evident. It would take us too far away from my main purpose in this paper to trace Augustine's influences, but we should keep in mind that they are many (as are his distinctive innovations).

12. Unless otherwise noted, all translations from the *Mencius* are from Philip J. Ivanhoe and Bryan W. Van Norden, eds., *Readings in Classical Chinese Philosophy* (New York: Seven Bridges Press, 2001). An "*" indicates that the passage is translated by Van Norden, but is not included in *Readings*. Reference is to the standard sectioning of the *Mencius*.

13. *Mencius* 4A26. D.C. Lau, trans., *Mencius* (New York: Penguin Books, 1970), in loc.

14. *Confessions* II.2 (Pine-Coffin, 45).

15. *Confucius Sinarum Philosophus* (first published C.E. 1687) includes selections from the *Four Books*, including the *Mencius*. (For a discussion of this translation and its influence, see Lionel Jensen, *Manufacturing Confucianism* [Durham: Duke University Press, 1997], 121 ff.) Additional Latin translations may be found in Stanislaus Julien, *Meng Tseu, vel Mencium* (Paris:

However, it is not clear that such renderings count as genuine translation. Consider the Classical Chinese term *tian* 天, which is standardly rendered as "Heaven" in English, and as *caelum* in Latin. There *is* some basis for this translation, since *tian* can refer to the sky, which is also a legitimate meaning for "Heaven" or *caelum*. However, *tian* often refers to a sort of higher power, which is responsible for implanting an ethical sense in humans, and for managing some of the things that we might describe as "fate." On this basis, it might seem more appropriate to translate *tian* as "God" or *Deus*. However, many of the characteristics that are central to Augustine's conception of God are either absent or significantly less prominent in Mencius's conception of *tian*. For example, Mencius would never have conceived of *tian* as "eternal" in the precise way that Augustine conceives of God as eternal (that is, as existing outside of time). Furthermore, Mencius's *tian* seems less personal than Augustine's God. One cannot imagine Mencius crying out to *tian* in the manner that Augustine (or Job) cries out to God.[16] Clearly, there is no possibility of translation as "same-saying" between Augustine's Latin and Mencius's Chinese.

This is not to deny, of course, that one can *explain*, using the resources of Latin, Mencius's conception of *tian*. One can do this in Latin, just as one can do it in English. (And it is worth reminding ourselves that we have no real translation of *tian* into English either.) But it seems to me that it is one thing to *explain* to someone, using the resources of a particular language, the use of a term from another language, and quite a different thing to translate a term from the latter into the former. To translate, I submit, there must be either a term or a commonly used phrase in the home language onto which the term in the target language can be mapped. This might seem like an arbitrarily narrow conception of "translation." However, if we introduce a neologism or a new expression into a language, we are expanding the conceptual possibilities that are, practically speaking, available to speakers of that language.

Working in the other direction, from Latin into Chinese, we can also see untranslatability. Augustine is clearly a figure for whom the notion of "being," and of degrees of being are central. As we know, the Indo-European traditions link notions of existence, predication, and truth through forms of the verb "to be." However, A.C. Graham has pointed out that, in Classical Chinese, existence, predication, and truth are not linked through some common word

1824–1829), and Seraphin Couvreur, *Ouvres de Meng Tzeu* (1895). (The latter has a Latin translation in addition to the French.) MacIntyre would be quick to point out, though, that Mencius's writings were never translated into *Augustine's* Latin, and, on his view, "there can be no such language as English-as-such or Hebrew-as-such or Latin-as-such. There are not even, it must seem, such languages as classical Latin or early modern Irish. There is only Latin-as-written-and-spoken-in-the-Rome-of-Cicero and Irish-as-written-and-spoken-in-sixteenth-century-Ulster." (*Whose Justice? Which Rationality?*, 373)

16. *Mencius* 5A1 might seem to present a counterexample, though.

or grammatical structure, and that this has implications for the two metaphysical traditions.[17] Here it is especially clear that explanation is possible, but not translation. Consider for example, Exodus 3:14, a passage especially important to Augustine. Moses asks God what His name is, and He responds (in a translation of Augustine's Latin), "I am the God who is," or (in one contemporary English translation), "I am who I am."[18] This statement is evocative for anyone, I think, because of its ellusive meaning. However, for Augustine this Scriptural statement about God takes on special meaning, because he saw connections between it and Platonistic notions of being and eternity.[19] Even in modern Chinese, though, there is no way to express the line from Exodus. The closest one can come is to use a form of the verb *you* 有 which means "to have," and to leave off the subject of the verb. Thus, one modern Chinese translation of Exodus 3:14 gives, 上帝對摩西說，我是自有永有的. [20] It is not possible to literally translate this into English (any more than the Chinese is a literal translation from the Hebrew), but a close (although inelegant) version would be "God to *Moshe* said, 'I am-a-sort-of-thing which it has naturally and has forever.'"[21] If we translate more idiomatically, we get, "God said to Moses, 'I am something that exists naturally and forever.'" Ironically, part of the problem here is that the Chinese and the back-translated English are less paradoxical and much easier to understand than the original Hebrew! All the mystery of God's statement to Moses is lost in translation. In the Classical Chinese of Mencius's era, Exodus 3:14 would probably come out as something like 天對摩西曰, 有我. Literally, "Heaven said to *Moshe*, 'It has me,'" or idiomatically, "Heaven said to *Moshe*, 'I exist.'" That Heaven "exists" would seem true, but not a profound or challenging statement. Even worse, Mencius would interpret the exchange between Moses and God in terms of his own concept of Heaven, and Mencius thinks that Heaven "does not speak." Consequently, he would regard the story as a barbarian superstition.

Is there incommensurability between the philosophies of Mencius and Augustine? It might seem, at first, that there clearly is. Ironically, an issue on which they agreed seems to provide a basis for incommensurability: the power and role of human reason and dialectic. The views of Mencius and Augustine on this topic are subtle. Even those who know either Mencius or Augustine well sometimes caricature his position. But I would argue that both of them saw an important role for dialectic (in a broad sense of that term), but also

17. A.C. Graham, "'Being' in Western Philosophy Compared with *Shih/fei* 是非 and *Yu/wu* 有無 in Chinese Philosophy," in Graham, *Studies in Chinese Philosophy and Philosophical Literature* (Albany: SUNY Press, 1990), 322–59.

18. *Confessions* VII.10 (p. 147). English translation of Exodus is the New International Version.

19. Cf. *The City of God* XII.2.

20. 聖經 (Hong Kong: Hong Kong Bible Society, 1984).

21. There is nothing in the Chinese corresponding to the word "it" in the translation, but we need a "dummy pronoun" to fill out the grammar in English.

thought that human reason, by itself, was incapable of discovering or demonstrating the most important truths.

Mencius clearly was well acquainted with the dialectical techniques of his era, and sometimes shows a powerful command of rational argumentative techniques such as reductio ad absurdum.[22] However, Mencius also announced that he was not "fond of disputation" (3B9). Furthermore, his failures in attempting to persuade rulers to adopt a policy of "benevolent government" seem to have suggested to him that human virtue and wisdom are influenced by one's environment (6A9), as well as factors involving fate (1B16) and inscrutable human commitments (6A15).[23]

For his own part, Augustine began his career as a well trained and powerful rhetorician, and his capacity to argue forcefully and rationally is clear throughout his work. However, he was also fond of a quotation attributed to the prophet Isaiah: "Unless you believe, you will not understand."[24] That understanding requires belief follows from Augusine's distinctive psychology: he holds that the human will makes a choice between a commitment to God and a commitment to this world, and that this choice influences one's beliefs and the operations of one's reason.[25] (There is, I think, a nontrivial similarity between Augustine's view here, and Thomas Kuhn's view of how commitment to a paradigm influences one's perception of and reasoning about the world.) Consequently, although Augustine recognizes the value of human reason, he also thinks that "for those who seek to learn great and hidden truths authority alone opens the door."[26]

In acknowledging the limits of reason, Mencius and Augustine have more in common with one another than with rationalists like Descartes. However, this similarity means that neither is likely to expect to be able to convince the other. Augustine accepts the Bible as authoritative, saying that its "divine authority puts it above the literature of all other people and brings under its sway every type of human genius. . . ."[27] Furthermore, Augustine accepts as authori-

22. His exchange with Chen Xiang in 3A4 and with Gaozi in 6A3 are both worthy of Socrates.

23. Some scholars have gone as far as to argue that Mencius has no real interest or confidence in rational argumentation whatsoever, and that what are apparently rational arguments in his text are actually purely rhetorical efforts to gain financial support for the ritual activities that he (and other Confucians) regard as actually important. See, for example, Robert Eno, *The Confucian Creation of Heaven* (Albany: SUNY Press, 1990). For what I think is an insightful critique of Eno's claim, see the review by Kwong-loi Shun, *Harvard Journal of Asiatic Studies* 52, no. 2 (December 1992): 739–56.

24. *On Free Choice of the Will* I.2 and II.2. This phrase is found in the Septuagint version of Isaiah 7:9, but it is actually a mistranslation. The Vulgate gets the translation right, and Augustine did not read Greek, so he is presumably following some pre-Vulgate Latin translation.

25. Cf. *Whose Justice? Which Rationality?*, 156. More on Augustine's notion of the will below.

26. Augustine, *On Order* II.9.26–27, cited in Vernon J. Bourke, ed., *The Essential Augustine*, 2nd ed. (Indianapolis: Hackett Publishing, 1974), 26

27. Gerald G. Walsh, S.J., et al., trans., *The City of God* (Garden City, NY: Image Books, 1958), XI.1, 205.

tative the interpretive traditions of the Fathers of the Catholic Church. Mencius, in contrast, accepted neither of these, and *did* accept as authoritative the texts known as the *Odes* and the *Documents*, and the teachings of the ancient sages of China, especially Confucius.[28] In particular, Mencius endorsed the claim that "Since humans were first born there has never been another like" Confucius (2A2). Consequently, Augustine would probably dismiss Mencius as a pagan, while Mencius would dismiss Augustine as a "twittering . . . barbarian" (3A4*).

Despite these reasons to expect incommensurability to obtain between the philosophies of Mencius and Augustine, I shall argue that there is a basis for a substantial dialogue between the two philosophies. In order to make this case, however, I need to say more about what the views of each were.

3. Augustine's World View in Brief

According to Augustine, God is the entity that is most real, has the most being, and is most perfect. Everything else in existence is created and preserved by God. Created entities *share in* God's being and perfection, but in differing degrees (and none matches God's reality or perfection):

> Among all things which somehow exist and which can be distinguished from God who made them, those that live are ranked higher than those that do not. . . . In that order of living things, the sentient are superior to the non-sentient, for example, animals to trees. Among sentient beings, the intelligent are higher than the non-intelligent, as with men and cattle. Among the intelligent, the immortal are superior to the mortal, as angels to men.[29]

Broadly speaking, there are two classes of entities, the material and the immaterial, and the immaterial have a higher degree of being and perfection than the material. Thus, it is the possession of an immaterial soul that makes humans more real and perfect than inanimate objects. However, even a rock shares, to a minor degree, in the goodness and perfection of God.

Humans are created by God "in His image," not in the sense that human physical bodies resemble God's body, but in the sense that humans have souls which are endowed with reason and with a will. So what is the will (*voluntas*)? Most broadly speaking, the will is something internal to a person's psychology that is distinct from both simple beliefs and simple desires. The nature and functions of the will are subject to debate, but the will as a third aspect of human psychology is commonly thought to at least shape, and possibly

28. Mencius's faith in the *Documents* is not unconditional, though. See *Mencius* 7B3.

29. *The City of God*, XI.16, 223. See Arthur Lovejoy, *The Great Chain of Being* (Cambridge: Harvard University Press, 1936) for the antecedents and later developments of the metaphysical view Augustine espouses here.

override, one's other beliefs and desires. Some scholars hold that Augustine himself is responsible for discovering (or inventing) the notion of human will.[30] One might dispute this claim, but it seems plausible that "we find no earlier parallels for [Augustine's] pervasive and explicit appeal to the will."[31] Furthermore, it seems likely that Augustine introduces a distinctively "voluntarist" conception of the will.[32] According to a voluntarist like Augustine, the choice of the will is undetermined by any recognition of the goodness of the objects of its choices. In other words, the will does not decide to pursue something *because* it recognizes that it is good; rather, the will decides to pursue something, and—because of that—a person sees value in the object of her choice.

Being endowed with will gives each human an immense dignity and value. However, the presence of will also creates a danger, because the will can be oriented either toward God or toward the material world. This orientation is fundamental, determining many other aspects of one's psychology. As I mentioned earlier, human reason does not operate independently of human desire and volition, since the orientation of the will determines how one interprets the world. In addition, until one's will is oriented toward God, genuine virtue is impossible. Thus, pagans can only be motivated by such things as the desire for worldly fame.[33] Furthermore, since the "fall of Adam," human souls have carried the imperfection of original sin, which impedes the operation of the will. Original sin makes it impossible for humans to make a commitment to God without the assistance of God in the form of divine Grace. Thus, humans can no longer choose freely to orient themselves toward God without divine assistance.

In addition to giving humans reason and a will, God also creates humans so that they can only ultimately find their happiness in God. Humans sense this, and have an inchoate feeling of love for God. Thus, Augustine writes,

> Man is one of your creatures, Lord, and his instinct is to praise you. . . . since he is a part of your creation, he wishes to praise you. The thought of you stirs him so deeply that he cannot be content unless he praises you, because you made us for yourself and our hearts find no peace until they rest in you.[34]

Indeed, one way of reading Augustine's *Confessions* is as a love story—boy is alienated from God by original sin, boy seeks God, boy finds God and is finally happy.

30. The classic defense of this claim is Albrecht Dihle's *The Theory of Will in Classical Antiquity* (Berkeley: University of California Press, 1982). MacIntyre agrees with this assessment.
31. Terence Irwin, "Who Discovered the Will?" in James E. Tomberlin, ed., *Philosophical Perspective*, vol. 6: *Ethics* (Atascadero, CA: Ridgeview Publishing Company, 1992), 455.
32. Irwin, 468. (Irwin does not explicitly endorse this second hypothesis himself.)
33. See *The City of God* V.20 and XIX.25.
34. *Confessions* I.1, 21.

The gap between humans and God is so great—both because of the metaphysical difference in their beings, and because of original sin—that God must find some way of overcoming it. This he does by incarnating his "only begotten son," Jesus.[35] Through incarnation, Jesus bridges the gap between God and humans. By being crucified even though he had never sinned, Jesus atones for the sins of humans, including original sin.[36]

4. Mencius's World View in Brief

The world view of Confucians like Mencius is, like that of Augustine, hierarchical. However, this hierarchy is not expressed in terms of degrees of being, nor does Mencius recognize any radical division in reality between the material and the immaterial realms. Mencius's world view has been described as "organismic."[37] This metaphor is helpful *if* we think of it as referring to a world view in which the elements of the universe are potentially parts of a harmonious whole, like the parts of a well functioning organism. Obviously, some parts of an organism will be more important than others, or will have a guiding function. The brain should tell the hand what to do. But the divisions among the parts are in no case categorical metaphysical divisions.

Cosmologically, the highest place in the hierarchy is occupied by Heaven. Heaven sometimes seems to have some anthropomorphic characteristics. Thus, Mencius approvingly quotes the *Documents* when it says that "Heaven sees as my people see; Heaven hears as my people hear" (5A5*). However, Mencius does not address or talk about Heaven in the way one talks to the personal God of the Old or New Testaments.

Heaven endows humans with innate but incipient virtuous inclinations. Mencius refers to these inclinations, using a carefully chosen metaphor, as "sprouts."[38] Our virtuous inclinations seem to be like sprouts in the following

35. The relationship between Jesus and God is subtle. Jesus *is* the son of God, but not in the way that Hercules is supposed to have been the son of Zeus. The belief that Jesus came into existence *after* God was condemned as the Arian heresy.

36. Christian theologians have long debated the precise significance of Jesus's sacrifice. Contrast the views of St. Anselm (who holds that Jesus's death is reparation to God for the offense of human sin) and Peter Abelard (who holds that Jesus's death is a demonstration of God's love for us). For excerpts from some of the relevant texts, see Alister E. McGrath, ed., *The Christian Theology Reader* (New York: Blackwell, 1995), 182 ff.

37. Similar points have been stressed by David Hall and Roger Ames. See, for example, their *Anticipating China* (Albany: SUNY Press, 1995) and *Thinking from the Han* (Albany: SUNY Press, 1998). However, on the basis of these observations, Hall and Ames go on to assimilate Confucians to postmodernists. This seems to me to be a simple non sequitur. See my review of *Thinking from the Han* in *Pacific Affairs* 73, no. 2 (Summer 2000): 288–89.

38. I shall have occasion in explicating Mencius to cite the insightful commentary of Zhu Xi (C.E. 1130–1200). However, my interpretation of Mencius is importantly different from that of Neo-Confucians and the so-called New Confucians. For example, the Chinese word *duan* 端, which I would translate "sprout," is glossed by Zhu Xi as *xu* 緒 ("tip" or "endpoint," see *Sishu jizhu* 四書集注 2A6). I think that Zhu Xi is led to this interpretation because he has a metaphysical orientation very different from that of Mencius. For more on Zhu Xi and the

respects. Sprouts have a natural course of development that, given a proper environment, culminates in becoming a mature example of a particular kind of thing. However, sprouts are only the first stage of the mature entity, and do not have all the characteristics of the fully developed form. Nonetheless, sprouts are active. They respond to conditions in their environment.

We can illustrate these features with the sprout of the virtue of benevolence. In what is perhaps the most famous passage in the *Mencius*, our philosopher asks us to consider the following thought-experiment:

> Suppose someone suddenly saw a child about to fall into a well: everyone in such a situation would have a feeling of alarm and compassion—not because one sought to get in good with the child's parents, not because one wanted fame among their neighbors and friends, and not because one would dislike the sound of the child's cries.
>
> From this we can see that if one is without the heart of compassion, one is not a human. (2A6)

Mencius goes on to say in this passage that "The heart of compassion is the sprout of benevolence."[39] Although having this sprout is a defining mark of being a human, most humans have not fully developed it. This is well illustrated in a conversation Mencius has with a king who had spared an ox he had seen being led to slaughter because he felt sorry for it (1A7). Mencius says, "In the present case your kindness is sufficient to reach birds and beasts, but benefits do not reach the commoners." The king must thus "extend" his kindness from the cases in which his sprout of benevolence manifests itself to other cases in which his sprout does not currently manifest itself, although it should: "Hence, if one extends one's kindness, it will be sufficient to care for all within the Four Seas. If one does not extend one's kindness, one will lack the wherewithall to care for one's wife and children."[40]

When it has grown to maturity, a plant takes a particular form. Sprouts of millet do not mature into corn. Likewise, Mencius holds that the sprout of benevolence, when it grows to maturity, manifests itself in a particular way: in

development of Neo-Confucianism, see Philip J. Ivanhoe, *Confucian Moral Self Cultivation*, rev. ed. (Indianapolis: Hackett Publishing, 2000).

39. See below for more on what Mencius means by "heart."
40. For discussions of "extension" and of *Mencius* 1A7, see David S. Nivison, "Motivation and Moral Action in Mencius," in Nivison, *The Ways of Confucianism* (Chicago: Open Court, 1996), 91–119; Kwong-loi Shun, "Moral Reasons in Confucian Ethics," *Journal of Chinese Philosophy* 16 (September/December 1989): 317–43; Bryan W. Van Norden, "Kwong-loi Shun on Moral Reasons in Mencius," *Journal of Chinese Philosophy* 18, no. 4 (December 1991): 353–70; David Wong, "Is There a Distinction between Reason and Emotion in Mencius?" *Philosophy East and West* 41, no. 1 (January 1991): 31–44; Craig Ihara, "David Wong on Emotions in Mencius," *Philosophy East and West* 41, no. 1 (January 1991): 45–54; Philip J. Ivanhoe, "Confucian Self-Cultivation and Mengzi's notion of Extension," in Liu Xiusheng and Philip J. Ivanhoe, eds., *Essays on Mencius' Moral Philosophy* (Indianapolis, IN: Hackett Publishing Company, 2001).

greater concern for one's own kin than for strangers. This view of benevolence is in sharp contrast to the contemporary philosophical movement known as "Mohism," which claimed that benevolence required treating everyone with universal love. However, Mencius argued that such universal love was a violation of one's natural (and Heaven-given) instincts (3A5).

In 2A6, Mencius also uses another one of his key technical terms, "heart" (*xin* 心). His use of this term is complex, but systematic. In its "focal meaning," *xin* refers to the psychological faculty that thinks and feels emotions.[41] By metonymy, the term refers to the emotions that faculty manifests. And by synechdoche, the term can refer to any one of the four aspects (almost like sub-faculties) of the *xin* that manifest the emotions and attitudes characteristic of Mencius's four cardinal virtues. Thus, when Mencius says that "The heart of compassion is the sprout of benevolence,"[42] we might paraphrase this as, "The emotion of compassion is a manifestation of our incipient tendency toward benevolence."

Benevolence is one of four cardinal virtues that Mencius thinks we all have innately but incipiently: Benevolence, righteousness, wisdom, and propriety. "Righteousness" is manifested in one's disdain to perform or accept certain shameful forms of behavior (6A10).[43] "Wisdom" is manifested in understanding and being committed to benevolence (4A27), and in making good judgments about the likely consequences of actions, and the character of others (5A9). "Propriety" is hard to distinguish from righteousness, but it is connected with expressing deference and respect toward others through ritual forms.[44]

The presence of the sprouts of these virtues is what leads Mencius to claim that human nature is good. As he says in 6A6, "As for what they genuinely are, they can become good. This is what I mean by calling their natures good. As for their becoming not good, this is not the fault of their potential." But if human nature is good, and if Heaven has implanted in us incipient tendencies toward virtue, why do so many people do so many evil things?

41. On the notion of a "focal meaning," see Lee H. Yearley, *Mencius and Aquinas: Theories of Virtue and Conceptions of Courage* (Albany: SUNY Press, 1990), 190–95. The focal meaning of a term need not be the same as its original meaning. Historically, the term *xin* 心 seems to have originally referred to the heart as a physical organ.

42. I take "heart" here to refer to an emotion, and I take it that the sentence is not asserting a strict identity. (Compare the following English phrase one might use in explaining how a computer works: "This window is the mail program.") My interpretation here is close to that of Zhu Xi: "One traces back from the manifestations of the emotions and then one can see what the nature is fundamentally like." (*Sishu jizhu*, in loc.) See also my comment on the use of "heart" in 6A6 (below, n. 46).

43. On righteousness, see Bryan W. Van Norden, "The Emotion of Shame and the Virtue of Righteousness," in David Wong and Kwong-loi Shun, eds., *Confucian Ethics: A Comparative Study of Self, Autonomy and Community* (New York: Cambridge University Press, forthcoming).

44. On propriety, see Bryan W. Van Norden, "Yearley on Mencius," *Journal of Religious Ethics* 21, no. 2 (Fall 1993): 369–76.

5. Mencius on Evil

Mencius clearly acknowledges the significance of environment in influencing one's moral development. In illustrating this point, Mencius once again makes good use of his sprout metaphor:

> In years of plenty, most young men are gentle; in years of poverty, most young men are cruel. It is not that the potential that Heaven confers on them varies like this. They are like this because of that by which their hearts are sunk and drowned.
>
> Consider barley. Sow the seeds and cover them. The soil is the same and the time of planting is also the same. They grow rapidly, and by the time of the summer solstice they have all ripened. Although there are some differences, these are due to the richness of the soil, and to unevenness in the rain and in human effort. (6A7)

Mencius also notes that it is possible for one's good nature to be almost destroyed by a bad environment, as he illustrates with the metaphor of "Ox Mountain":

> The trees of Ox Mountain were once beautiful. But because it bordered on a large state, hatchets and axes besieged it. Could it remain verdant? Due to the rest it got during the day or night, and the moisture of rain and dew, it was not that there were no sprouts or shoots growing there. But oxen and sheep then came and grazed on them. Hence, it was as if it were barren. People, seeing it barren, believed that there had never been any timber there. Could this be the nature of the mountain?!
>
> When we consider what is present in people, could they truly lack the hearts of benevolence and righteousness?! That by which they discard their good heart is simply like the hatchets and axes in relation to the trees. (6A8)

Mencius is *not* an environmental determinist, though. There is a role for human agency in becoming (or failing to become) good. Mencius has a complex and nuanced view on human ethical cultivation and self-cultivation. Among the resources for cultivation he identifies are certain classic texts, wise teachers, and the companionship of other virtuous people (5B8). However, for the purpose of contrasting Mencius with Augustine on the issue of why humans do (or do not) become good, the key text is *Mencius* 6A15, which I here quote in full:

> Gongduzi asked, "We are the same in being humans. Yet some become great humans and some become petty humans. Why?"
>
> Mencius said, "Those who follow their greater part become great humans. Those who follow their petty part become petty humans."

Gongduzi said, "We are the same in being humans. Why is it that some follow their greater part and some follow their petty part?"

Mencius said, "It is not the office of the ears and eyes to concentrate, and they are misled by things. Things interact with things and simply lead them along. But the office of the heart is to concentrate. If it concentrates then it will get [Virtue]. If it does not concentrate, then it will not get it. This is what Heaven has given us. If one first takes one's stand on what is greater, then what is lesser will not be able to snatch it away. This is how to become a great person."

"Ears and eyes" is synecdoche for our various sense organs and their associated desires. These desires are "automatic," in the sense that, when we are confronted with an appropriate object for one of our desires, our desire is activated, and we are drawn to the object of that desire. Mencius expresses this in 6A15 by saying that our senses are thing-like in their propensity to be "simply led along" by other things. He makes a similar point elsewhere (7B24) by saying that our sensual desires are "mandated."

Since Mencius says that the sensual desires "mislead" us, it is tempting to assume that he thinks they are evil, or at least that their satisfaction does not play a significant role in the best kind of human life. However, it is clear from other passages that this is not Mencius's view. For example, in 1B5 he tells a king that his fondnesses for wealth and sex are no impediment to being a great ruler, because the sage kings of old also had such desires; the only difference is that the sages made sure that their own subjects were able to satisfy their desires for wealth and sex too. Consequently, Mencius's view seems to be that sensual desires are a less significant part of our nature, but nonetheless a part of it that will function in a fully flourishing life.

The "greater," or more important, part of our nature is the part that includes the virtuous inclinations. There is a certain extent to which these reactions are "automatic" too. Thus, we spontaneously feel "alarm and compassion" at the sight of a child about to fall into a well; we feel a sense of disdain when asked to cheat (3B1) or accept a handout given with contempt (6A10). However, our innate virtuous reactions are only incipient. They need to be "extended" and "filled out," so that we come to have virtuous reactions in every appropriate situation, and not just in some paradigmatic cases. This extension is *not* automatic. Extension is achieved through ethical cultivation. One of the factors in such cultivation is "concentration."

The Chinese word that I have rendered as "concentration" is *si* 思. *Si* has several related meanings. It can, for example, mean "to think longingly of," as it does in the very first of the *Odes*, where a noble longs for (*si*) his bride. Arthur Waley observes of the term that it often refers to

a process that is only a short remove from concrete observation. Never is there any suggestion of a long interior process of cogitation or ratiocination, in which

a whole series of thoughts are evolved one out of the other, producing on the physical plane a headache and on the intellectual, an abstract theory. We must think of [*si*] rather as a fixing of the attention. . . .[45]

For Mencius, one of the objects of this "fixing of the attention" is one's innate ethical inclinations. As he tells us in 6A6,

> The heart of compassion is benevolence. The heart of disdain is righteousness. The heart of respect is propriety. The heart of approval and disapproval is wisdom.[46] Benevolence, righteousness, propriety, and wisdom are not welded to us externally. We inherently have them. It is simply that we do not concentrate upon them.

Given that one meaning of *si* is "to think longingly of," we can assume that to *si* our "hearts" of virtue is to be aware of them, to think well of them, and to wish for them to flourish. And Mencius does say in 4A27, in what I take to be a reference to the sprouts, "If one delights in them then they grow. If they grow then how can they be stopped?"

We are now in a position to see how the sensual desires "mislead" us. When we are offered a chance to satisfy some of our sensual desires, we are automatically drawn to this opportunity. The desire is not in itself wrong. What *is* wrong is to attempt to satisfy sensual desires when doing so violates the demands of ethics. Thus, it is wrong to twist one's brother's arm to get food, or climb over your neighbor's wall and sieze his maiden daughter to get a wife (6B10). But a person often, when offered things that satisfy one's sensual desires, simply doesn't "notice propriety and righteousness and accepts them" (6A10). Evil actions, then, are the result of a failure to actively cultivate the "greater part of oneself" (that is, one's ethical inclinations), so that it intervenes to prevent acting on sensual desires (that is, the lesser part of oneself), in those cases where doing so is unethical.

Are there any other "lesser desires" besides the sensual ones that Mencius adverts to in 6A15? In 6A17*, he writes that, "The desire to be exalted is a universal feeling among humans." This desire apparently can be a lesser desire, but it can also become a greater desire, depending upon its object, for Mencius goes on to say that, "Everyone has within oneself what is exalted. It is simply that one never concentrates upon it. That which other people exalt is not what

45. Arthur Waley, trans., *The Analects of Confucius* (New York: Vintage Books, 1938), 45.
46. This seems importantly different from 2A6, in which Mencius says that the heart of compassion is the *sprout* of benevolence, the heart of disdain is the *sprout* of righteousness, and so on. However, I think Zhu Xi is basically correct in suggesting that the difference in wording merely reflects a difference in emphasis: "In the former passage, [Mencius] says that these four are the sprouts of benevolence, righteousness, propriety, and wisdom, but here he does not say 'sprout.' In the former passage he wants us to extend them. Here he traces back directly from their function in order to make evident their fundamental substance. Hence, there is a difference in the expressions" (*Sishu jizhu*, in loc.).

is most exalted. Those whom Zhao Meng exalts, Zhao Meng can debase." In other words, what is truly exalted is one's own ethical inclinations, which do not depend on the vagaries of human popularity.

Does Mencius have a conception of will? One reason for suspecting that he does *not* have a conception of will is that there is no word in Classical Chinese corresponding to will (or *voluntas*). This claim might seem surprising to those used to most English translations of the *Mencius*, which render the Chinese word *zhi* 志 as "will."[47] However, there is no hint in the *Mencius* that *zhi* is some faculty distinct from the "heart" that determines the orientation of one's psychology. For example, *zhi* is never described in the *Mencius* (or, to the best of my knowledge, in *any* early Chinese text) as influencing or affecting the *xin*. Rather, the *zhi* seems to be simply the heart itself "in motion," as it were, toward some particular object.[48] Consequently, I prefer to translate *zhi* as "intention" or "resolution" (when it is used nominally), or "to set one's heart on," or "to be intent upon" (when it is used verbally). But if *zhi* is simply the heart's "intention" to do something, then it cannot perform the function that the will is supposed to perform: to explain the orientation of one's desires and perceptions.

Nonetheless, there is some reason to think that, whether he has a word for it or not, Mencius believes that humans have a capacity to orient their desires and perceptions. We can see this by carefully considering the implications of passages such as 6A15. Mencius thinks that our sensual desires are automatically drawn to their appropriate objects, but that our engaging in "concentration" (or our not engaging in concentration) is not automatic. Concentration upon our virtuous inclinations has the effect of strengthening those inclinations. Thus, engaging in concentration has an effect quite similar to what Augustine would describe as an act of will. Finally, Mencius stresses that humans are *capable* of acting virtuously. It seems likely that his motive in stressing this is to encourage them to elect to use the capacity for concentration that they have. In support of this, notice that, in 7A3, Mencius quotes his own statement in 6A6 about our capacity for virtue, "If one seeks, one will get it; if one abandons it, one will lose it," and comments, "[i]n this case, seeking helps in getting, because the seeking is in oneself" (7A3). So it seems that electing to use the capacity for concentration is within human control. We may conclude, then, that Mencius believes that humans have something internal to their psychology that chooses (at least partially) the content and strength of their desires, beliefs, and the focus of their concentration.

47. See, e.g., James Legge, trans., *The Works of Mencius*, reprint (New York: Dover Books, 1970); D.C. Lau, trans., *Mencius*, op. cit.; David Hinton, trans., *Mencius* (Washington: Counterpoint, 1998).

48. Needless to say, the Mencian "heart" cannot perform the role of the Augustinean will either. The Augustinean will is something that would determine the general orientation of the desires, perceptions, and emotions that Mencius attributes to the heart.

6. Augustine on Evil

Augustine writes that the problem of why humans do evil is a "question that worried me greatly when I was still young, a question that wore me out, drove me into the company of heretics, and knocked me flat on my face."[49] The "heretics" to whom Augustine refers are the Manicheans, who claimed that good and evil are two equally real forces, battling for control of the universe.[50] Augustine was presumably attracted to this doctrine because its teaching expressed vividly his own feeling of the evil that humans must overcome. However, the reality of evil is difficult to reconcile with the existence of a God who is all good, all knowing, all powerful, and creator of all that exists. Consequently, Augustine became convinced that "evil has no positive nature; what we call evil is merely the lack of something that is good."[51] Insofar as anything is real, it is good. God is both fully real and fully good. His creations are good insofar as they participate in the reality of God, but are imperfect because no creation can participate fully in the reality of the creator. Humans become sources of evil when they turn their wills away from that which is fully real, God, toward that which is less real, His creations. There is something of a mystery about this, though. Why do humans turn away from God, who is, after all, their creator and the only ultimately satisfying object of their love? Part of the answer has to do with the Fall. When Adam and Eve sinned, they corrupted human nature. Consequently, sensual desires distract us from God in ways that they did not for Adam and Eve. Nonetheless, we are left with at least two questions. Why did Adam and Eve violate God's command? And why did the fallen angels, who are not subject to physical desire, also violate God's command? Although he does not "flag" it as such, Augustine's answer to these questions grows out of his reflections on his own sinfulness as an adolescent.

In Book II of his *Confessions*, Augustine writes that "[t]here was a pear-tree near our vineyard, loaded with fruit that was attractive neither to look at nor to taste. Late one night a band of ruffians, myself included, went off to shake down the fruit and carry it away. . . ." What might seem, to most of us, to be an unremarkable incident of teenage naughtiness becomes, for someone as reflective as Augustine, an occasion for gaining greater insight. Augustine asks why people do evil, and observes that

> The eye is attracted by beautiful objects, by gold and silver and all such things. There is great pleasure, too, in feeling something agreeable to the touch, and material things have various qualities to please each of the other senses. Again, it is

49. Augustine, *On Free Choice of the Will*, Thomas Williams, trans. (Indianapolis: Hackett Publishing, 1993), I.2, 3.

50. For an excellent discussion of Manicheanism and Augustine's relationship with it, see Peter Brown, *Augustine of Hippo* (Berkeley: University of California, 1967), chap. 5.

51. *The City of God*, XI.9, 217.

gratifying to be held in esteem by other men and to have the power of giving them
orders and gaining the mastery over them. . . . Friendship among men, too, is a
delightful bond, uniting many souls in one. . . .

 When there is an inquiry to discover why a crime has been committed, normally
no one is satisfied until it has been shown that the motive might have been either
the desire of gaining, or the fear of losing, one of those good things which I said
were of the lowest order. . . . A man commits murder and we ask the reason. He
did it because he wanted his victim's wife or estates for himself, or so that he
might live on the proceeds of robbery, or because he was afraid that the other
might defraud him of something, or because he had been wronged and was burn-
ing for revenge.[52]

So, normally, people do evil in order to get some worldly good. Augustine
regards this as a terrible error, for the goods of this world are paltry in com-
parison with the goods of God, which one forfeits by doing evil; however,
such actions seem at least *comprehensible*, because they aim at some good.

 So far, Augustine's account of the origin of human evil seems very close to
that of Mencius. We desire things, typically the objects of our various senses,
and we do evil in order to get these things. Augustine even says some things
that sound quite similar to Mencius's doctrine of the sprouts, for he speaks of
"the law that is written in men's hearts and cannot be erased however sinful
they are. For no thief can bear that another thief should steal from him, even if
he is rich and the other is driven to it by want."[53] There are important differ-
ences between the metaphor of a "law written in men's hearts" and that of a
sprout of virtue, but the example of a thief objecting to having something
stolen from him could easily have been used by Mencius as an illustration of
the sprout of righteousness.[54] Consequently, we might expect Augustine to
develop an account of human evil that emphasizes focusing attention on our
innate moral sense, so that our sensual desires cannot mislead us into doing
what is wrong to satisfy them.

52. *Confessions* II.5, 48.
53. *Confessions* II.4, 47. Augustine is obviously influenced here by the Apostle Paul (Romans
2:14–15), but the example is his own. One might object that the reaction of a thief does not
show the presence of actual *moral* reactions; instead, a thief would object to having something
stolen from him only because it would be a loss of his goods. However, I think Augustine
would say that a thief's *outrage* at being stolen from is different from the *sadness* and *frustration*
he would feel if he lost something through simple bad luck (e.g., his house burning down), and
that this reaction is not only an indication of an innate moral sense, but also of the fact that
humans are made both by God and for God. (A similar indication of the fact that humans are
made by and for God is the love humans feel that [whether they know it or not] can only be
satisfied by God.)
54. Indeed, the sixteenth-century Neo-Confucian follower of Mencius, Wang Yangming,
illustrates the existence of the sprouts by stating that even a thief will blush if you call him a
"thief" to his face.

However, Augustine's account cannot be this similar to that of Mencius for at least two reasons. First, as we saw above, Augustine holds that, as a result of original sin, humans cannot choose to do good through the power of their own will. The belief that humans can achieve their own greatest good (which for Augustine would be the beatific vision of God) through their own agency is the heresy of Pelagianism, a doctrine which Augustine fought energetically. Thus, had he known of him, Augustine might have described Mencius's doctrine as a kind of "pagan Pelagianism."

Furthermore, the simple account of human evil that we gave above does not seem to apply to the theft that Augustine and his companions engaged in:

> It is true that the pears which we stole had beauty, because they were created by you, the good God, who are the most beautiful of all beings and the Creator of all things, the supreme Good and my own true Good. But it was not the pears that my unhappy soul desired. I had plenty of my own, better than those, and I only picked them so that I might steal. For no sooner had I picked them than I threw them away, and tasted nothing in them but my own sin, which I relished and enjoyed. If any part of one of those pears passed my lips, it was the sin that gave it flavour.[55]

Augustine asks, "Could I enjoy doing wrong for no other reason than that it was wrong?"[56] It seems that the answer must be, Yes, since Augustine stole the pears without being hungry, and was not attracted by the pears' taste or beauty. But this is especially puzzling to Augustine, since he does not regard evil as an entity: "I loved nothing in it except the thieving, though I cannot truly speak of that as a 'thing' that I could love. . . ."[57] How can one be drawn to something that does not exist?

Augustine struggles to understand his motivation in the remainder of Book II of the *Confessions*, and the result seems aporetic. Indeed, Augustine thinks that there is a sort of mystery about why a will chooses evil: "What 'makes' the will evil is, in reality, an 'unmaking,' a desertion from God. The very defection is deficient—in the sense of having no cause."[58] Furthermore, "[t]rying to discover causes of such deficiencies . . . is like trying to see darkness or hear

55. *Confessions* II.6, 49.
56. *Confessions* II.6, 50. Cf. the remarks of the narrator in Poe's "The Black Cat," who says that he hung his cat from a tree "*because* I knew that it had loved me, and *because* I felt it had given me no reason of offence;—hung it *because* I knew that in so doing I was committing a sin—a deadly sin that would so jeopardize my immortal soul as to place it—if such a thing were possible—even beyond the reach of the infinite mercy of the Most Merciful and Most Terrible God." (Poe, *Poetry and Tales* [New York: Library of America, 1984], 599–600 [emphasis in original].)
57. *Confessions* II.8, 51.
58. *The City of God* XII.9, 256.

silence."⁵⁹ Nonetheless, Augustine does not regard the evil choice of a will as completely arbitrary.⁶⁰

> All who desert you and set themselves up against you merely copy you in a perverse way. . . .
>
> What was it, then, that pleased me in that act of theft? Which of my Lord's powers did I imitate in a perverse and wicked way? Since I had no real power to break his law, was it that I enjoyed at least the pretence of doing so, like a prisoner who creates for himself the illusion of liberty by doing something wrong, when he has no fear of punishment, under a feeble hallucination of power?⁶¹

I take Augustine's point to be the following. The free exercise of human will is a good. Indeed, to freely exercise the will is to act like God. Even without the Grace of God, humans recognize this, at least inchoately. Humans also recognize that, at least in some sense, freedom involves acting without any constraint that is alien to them. Consequently, acting in violation of moral law *appears* to be an expression of perfect freedom, since it shows contempt for a standard that *seems* to be external to oneself.⁶² Thus, part of the reason for Augustine's sin was that it gave him a God-like sense of freedom to intentionally violate morality.

A second factor in this sinning was the companionship of others: "By myself I would not have committed that robbery. It was not the takings that attracted me but the raid itself, and yet to do it by myself would have been no fun and I should not have done it."⁶³ It is significant, I think, that the two factors Augustine identifies as relevant for his sinning (companionship in sin, and a desire to be like God) correspond to the sins of Adam and Eve. In *The City of God*, Augustine writes that Adam "sinned knowingly and deliberately," in part because he "refused to be separated from his partner [Eve] even in a union of sin."⁶⁴ Recall also that the serpent tells Eve, "you will be like God," if she and Adam eat of "the tree of the knowledge of good and evil."⁶⁵ We see now, if we did not before, that Augustine's explanation of his own theft of

59. *The City of God* XII.7, 254.

60. Augustine might be comfortable with saying that, while there is no *efficient* cause of a will choosing evil, there is a *final* cause. However, this final cause does not necessitate the act of will, and it is, furthermore, an erroneous choice of the will, since it chooses a lesser good over a greater.

61. *Confessions* II.6, 50.

62. Of the five sentences preceding this note, Augustine would say that the first four are (properly interpreted) correct. However, Augustine thinks that the fifth sentence expresses crucial misperceptions. The human will can only really be free with the help of divine Grace. Furthermore, since humans are created to love and obey God, obedience to the divine commandments is not alien to them.

63. *Confessions* II.9, 52.

64. *The City of God* XIV.11, 307.

65. Genesis 3:3 and 2:17, respectively (Bible, New International Version).

those pears helps to explain why Adam and Eve sinned in the Garden of Eden. In addition, the desire to be like God was a motivation for the fallen angels who rejected Him.

7. Mencius and Augustine in Dialogue

So far, it might seem that we have two interestingly different, but self-contained, world views. Perhaps incommensurability, as MacIntyre describes it, obtains between them. However, it seems that there are some important standards in common between Mencius and Augustine. For example, each hopes to account in some way for human wrongdoing. (Perhaps any world view concerned with ethics must offer some such account, at least implicitly.) Furthermore, Augustine's account of his theft, and large parts of his description of his psychological state (including his claims about what his motivation was *not*) would be perfectly comprehensible to Mencius from within his own conceptual scheme. Consequently, it is possible for an Augustinean to challenge a Mencian to explain why Augustine stole the pears. Can Mencius explain Augustine's theft using the resources of his own philosophical psychology?

The basic account of human evil that Mencius gives in 6A15 seems inadequate to explain Augustine's theft: Augustine did not steal the pears out of any sensual desire that overwhelmed his virtuous inclinations—because he really did not want to eat the pears anyway. Mencius may have the *beginnings* of an explanation, though, in his discussion of the universal human desire to be exalted or esteemed, for Augustine says that

> among my companions I was ashamed to be less dissolute than they were. For I heard them bragging of their depravity, and the greater the sin the more they gloried in it, so that I took pleasure in the same vices not only for the enjoyment of what I did, but also for the applause I won.
>
> I gave in more and more to vice simply in order not to be despised. If I had not sinned enough to rival other sinners, I used to pretend that I had done things I had not done at all, because I was afraid that innocence would be taken for cowardice and chastity for weakness.[66]

Although he does not make it a central part of his explanation of human evil, Mencius does acknowledge (in 6A17, as I discussed above) that humans desire to be "exalted" or "esteemed," and that this desire is potentially dangerous ethically. Thus, Mencius can partially explain Augustine's theft by his desire to be esteemed by his peers. However, this is only the *beginning* of an explanation, for it leaves open the question of *why* it was the case that "the greater the sin the more [Augustine's companions] gloried in it." Why, in other words, did

66. *Confessions* II.3, 46.

Augustine and his companions esteem those who seemingly did evil just because it was evil?

Augustine's psychology gives him a way of answering this question; as we saw, he thinks that we imitate the freedom of God, in a perverse way, by intentional action against the good. Why can't Mencius simply *add* Augustine's explanation to his own repertoire of explanations for human evil? One impediment is that Augustine's explanation appeals to God, an entity which has no place in Mencius's world view. But this is not, I think, a deep objection. Although Augustine's formulation invokes God, the *kind* of explanation he offers does not depend on the existence of a god. For what is really central to Augustine's explanation is the notion of human will. Augustine sees that humans can will to be god-like, in the sense of exercising their will without any external constraint, and that this can become a source of evil. And willing to be *god-like* in exercising one's will in this way does not depend on there actually being a god. Thus, Augustine's explanation can be adapted and then adopted by those who are not theists.

We also saw earlier that Mencius seems to need to appeal to something like the capacity to exercise the will to explain why one does (or does not) engage in concentration. So why can't Mencius (or a neo-Mencian) simply make explicit the role in Mencius's thought of something like the Augustinean conception of will, and then use that conception to explain actions like those of Augustine when he stole the pears? The answer is that Mencius, although he has some implicit conception of the will, does not attribute to the exercise of the will the sort of role and importance that Augustine attributes to it.

For Augustine, the presence of a will is what distinguishes God, angels, and humans from other kinds of creatures. Indeed, the will is part of what gives humans such great intrinsic value and dignity. Furthermore, the free exercise of the will is part of the highest good for humans. Given the importance of the free exercise of the will, and given the fact that humans at least inchoately recognize this importance, Augustine can explain acts like his own youthful theft as (misguided) efforts to exercise the will free of all constraints.

In distinction from Augustine, there is no hint in Mencius that the possession and exercise of this faculty is of immense value. (This is a reason why Mencius does not have a term for "will.") Mencius *does* think that there is something humans possess which gives them great intrinsic value, and distinguishes them from the "birds and beasts." However, this "greater part" of human nature is the virtuous inclinations themselves, not the capacity to choose to engage them (or not). Consequently, there seems to be no obvious place in Mencius's world view for a desire to exercise one's will (per se) without constraint.

Augustine takes a major step down a distinctively Western ethical path. There are, of course, other ways to proceed down the path Augustine began, but to take that first great step is to start heading toward a world view very

different from that of Confucianism. Augustine's path is one of choices, freedom, and authenticity. In contrast, Confucianism has been described, rightly to my mind, as "a Way without a crossroads."[67] It may be possible to somehow synthesize Mencian Confucianism with an Augustinean conception of the will, but doing so would require a genius as great as that of the "Dumb Ox" who synthesized Augustineanism and Aristotelianism in the thirteenth century.

8. Conclusion

The world views of Augustine and Mencius provide a good illustration of the sort of logical incompatibility and untranslatability that MacIntyre discusses. Furthermore, their differences seem so great that we might expect them to be incommensurable. (Indeed, we might think that there will be incommensurability between Mencius and Augustine if there is such incommensurability anywhere.) However, I hope to have shown that Augustine's narrative of his youthful theft of some pears presents a serious, and direct, challenge to Mencius's explanation of human evil.

Why? Mencius and Augustine both attempt to give an explanation for human wrongdoing. Mencius can understand, from within his own world view, *that* Augustine acted in a certain way in his youth, and Mencius would agree that the action in question was wrong. However, Mencius cannot, using the resources of his own philosophical psychology, explain *why* Augustine so acted.[68] Augustine, in contrast, *can* explain his own actions, using his notion of human will. Consequently, even in a case in which the world views are as radically different as those of Mencius and Augustine, we find a common standard that allows us to judge the superiority of one world view on at least one point.

This does not entail, of course, that the Augustinean tradition has "defeated" the Mencian tradition. (As Kuhn taught us, one anomaly does not bring a paradigm to its knees.) It may be that the Mencian tradition has advantages that recommend it over the Augustinean tradition, all things considered. It may also be, for all I have shown in this paper, that the Mencian and Augustinean traditions are genuinely incommensurable on so many other topics that we cannot adjudicate between the traditions overall. And even if the Mencian tradition is shown to have serious shortcomings in comparison with the Augustinean tradition, this should not by any means be taken to imply that there is nothing of value in Mencius's world view, or that an Augustinean cannot learn much by reading the *Mencius*. However, I hope to have shown

67. Herbert Fingarette, *Confucius—the Secular as Sacred* (New York: Harper & Row, 1972), 18 ff.

68. Cf. Melville's Billy Budd, who is speechless when confronted with the malevolence of Claggart ("Billy Budd," section 20).

that, on this particular topic, we can be warranted in deriving a conclusion based on a direct dialogue, despite the immense differences between the traditions.

This has only been one test case. Even if I am right about this one comparison, there may be other cases in which there is genuine incommensurability of the kind MacIntyre describes. However, I submit that a case study like this one provides some hope that there may be enough in common even among seemingly quite disparate world views and traditions to allow for significant rational dialogue.[69]

69. Martha C. Nussbaum and Lee H. Yearley have also argued independently that, despite the genuine and significant differences among world views, there is enough in common for rational dialogues. See Nussbaum, "Non-Relative Virtues: An Aristotelian Approach," in Peter French et al., eds., *Midwest Studies in Philosophy*, vol. XIII (Notre Dame: University of Notre Dame Press, 1988), 32–53, and Yearley, *Mencius and Aquinas*, op. cit. Furthermore, anthropologist Donald Brown has called for a reevaluation of the reigning anthropological paradigm, which he claims has overlooked the evidence for genuine human universals. See his *Human Universals* (New York: McGraw Hill, 1991).

An Analysis of the Structure of Philosophical Methodology— in View of Comparative Philosophy

Bo Mou

One fundamental methodological issue in comparative philosophy is *how* to look at apparent differences and similarities in those distinct, either seemingly competing or seemingly allied, methodological approaches in different philosophical traditions or even within the same tradition. This methodological issue in conducting comparative studies demands a metaphilosophical understanding of the structure of philosophical methodology, especially the status and functions of various dimensions of a methodological approach and their relations. The purpose of this essay is to contribute to constructive comparative studies of Chinese and Western philosophies by focusing on methodology. The methodological concern in this paper is dual: I am concerned with *how* to look at distinct *methodological approaches*. That is, I am concerned with the identity and structure of philosophical methodology; and, in so doing, I am thus concerned with a metaphilosophical understanding of a variety of ways of taking methodological approaches in philosophical pursuits.

For the aforementioned purpose, in this essay, I present an analysis of the structure of philosophical methodology in terms of a metaphilosophical framework. The main points which I endeavor to make are these. (1) Generally speaking, there are three functionally distinct but somehow closely related dimensions of a methodological approach, namely, the perspective dimension, the guiding-principle dimension, and the instrumental dimension. (2) Given that a methodological perspective has its due metaphysical basis to be explained, one's reflective activity *per se* of taking that perspective alone as one's working perspective is philosophically innocent on its own and constructive by virtue of its contribution to a complete account. (3) There is a distinction between adequate and inadequate methodological guiding principles, and the latter would result in the inadequate application of a methodological perspective. (4) In comparative studies, both for the sake of evaluating a methodological approach and for the sake of constructively taking a certain methodological approach to an object of study, one crucial evaluative reference point is whether or not the guiding-principle dimension of the methodological approach is

adequate rather than whether or not its methodological perspective alone is taken as working perspective. (5) There is no absolutely superior methodological perspective in the senses to be explained. (6) With adequate guiding principles in place, there are alternative ways, instead of one exclusive way, of adopting a certain perspective (simplex or complex), among seemingly competing methodological perspectives, as working perspective in our philosophical pursuit.

My strategy in the following discussion is this. I first give a preliminary characterization of various dimensions of philosophical methodology. I then examine the perspective dimension, the guiding-principle dimension, and the instrumental dimension of philosophical methodology respectively. In so doing, for the sake of illustrating the points to be made and for the sake of their relevance to the theme of the volume, I give brief case analyses of two seemingly competing methodological approaches, namely, Socrates's being-concerned approach in the Western analytic tradition and Confucius's becoming-concerned approach in the Chinese tradition. Finally, I sketch several prospective ways in which one would take one or more methodological perspectives as one's working perspective(s) with an adequate methodological guiding principle in place.

1. Preliminary Characterization:
A Variety of Dimensions of Philosophical Methodology

In this section, I suggest a preliminary classification of three dimensions of philosophical methodology. The term "philosophical methodology," or "philosophical method," is both ambiguous and vague. It is ambiguous, because it might be used to mean one of three things: a methodological perspective which is intended to point to a certain aspect of an object of study, a methodological instrument to implement a certain perspective, or a methodological guiding principle which is presupposed by the agent in guiding or regulating how to apply a certain methodological perspective. The term is also vague, because it is often used to mean the aforementioned several things simultaneously without elaborating their differences. When the term "(philosophical) methodology" is prefixed with a certain specification, it seems to be often the case that ambiguousness and vagueness of "methodology" or "method" would pass onto the resulting label. For example, by the same token, "analytic methodology" has been used to signify various things: a type of analytic perspective, a variety of instrumental analytic methods, or some methodological guiding principle(s) that is (are) presupposed by the agent in regulating her application of her analytic perspective. What is preliminarily needed now is to clarify the meaning of "philosophical methodology" or "philosophical method" and to provide a clear classification of various things that would be normally covered by the term "philosophical methodology" in its clarified sense.

By the term "philosophical method" I mean a variety of ways that are concerned with, and respond to, the question of how to approach an object under reflective examination in philosophical pursuit. A variety of methodological ways can be classified into three distinct but somehow closely related categories to be explained: (1) the methodological perspective, (2) the methodological guiding principle, and (3) the methodological instrument. Considering that a more or less complete methodological approach, explicitly or implicitly, consists of all those three methodological ways due to their close connections, I identify the three methodological ways in terms of three dimensions of the methodological approach: the perspective dimension, the guiding-principle dimension, and the instrumental dimension. In other words, they constitute three dimensions (if any) of a methodological approach in philosophical practice. Throughout this work, I use the term "philosophical methodology" as a collective noun to denote a variety of methodological approaches in philosophical pursuit, such as the being-concerned methodological approach in the Western analytic tradition and the becoming-concerned methodological approach in the Chinese philosophical tradition, both of which will be explained below through their respective presentations in Socrates's and Confucius's methodological approaches to characterizing reflectively important things. Thus, when talking about, say, the perspective dimension of philosophical methodology, I mean a variety of methodological perspectives of various methodological approaches; the same holds for my talking about the guiding-principle dimension or the instrumental dimension of philosophical methodology

It is clear that in so doing I take a holistic metaphilosophical attitude towards the relation among various methodological components of a certain methodological approach as well as towards the structural connection in various dimensions among various methodological approaches. Nevertheless, when presenting this three-dimensional framework of philosophical methodology, I do not take it for granted that any methodological way which has ever been historically taken was actually presented in its agents' mind indiscriminately as an inclusive methodological approach which manifestly reveals all three dimensions. The point is that whether or not an agent who consciously takes a certain (category of) methodological way, also consciously or reflectively ponders how the way is related to other dimensions or categories of methodological way, the methodological way in question is either conceptually or historically possibly related to other categories of methodological way. In this sense and to this extent, I consciously present a philosophical method in the context of, and in terms of, the three dimensions of philosophical methodology, even if it was not historically proposed by its actual agents in that way. Moreover, in the context of this anthology concerning comparative philosophy, the three-dimensional framework of philosophical methodology is especially relevant: in comparative studies, what are reflectively examined are often those

more or less inclusive or self-contained methodological approaches which explicitly go with their three-dimensional structure. The point would become clearer when my elaboration is given in the subsequent discussion.

Now let me give a schematic characterization of various dimensions of philosophical methodology, which will be further explained in the subsequent sections. The three methodological ways are specified as follows.

(1.1) A way to approach an object of philosophical study is a *methodological perspective*, or a perspective-simplex, in the perspective dimension of philosophical methodology when (i) the way responds to how to approach the object, (ii) the way is intended to point to a certain aspect (or facet or layer) of the object and to explain the aspect in terms of the characteristics of that aspect rather than some other aspect, and (iii) the way provides a starting point for that study with a minimal metaphysical commitment that there *is* that aspect of the object.

If the minimal metaphysical commitment is true in the sense that the object does go with that aspect, the methodological perspective is considered as one with its *due metaphysical basis* in dealing with the object and thus as *relevant* in regard to that object. Otherwise, the methodological perspective is considered to be without due metaphysical basis in dealing with the object and thus as *irrelevant* in regard to that object.

(1.2) A way to approach an object of philosophical study is a *methodological guiding principle* concerning a certain methodological perspective when (i) the way responds to how to approach the object, (ii) the way is, or should be, presupposed by the agent who takes the perspective, and (iii) the way is, or should be, used to guide or regulate how the perspective would be applied and evaluated.

(1.3) A way to approach an object of philosophical study is a *methodological instrument* concerning a certain methodological perspective when (i) the way responds to how to approach the object; and (ii) the way is an instrument which is used as means to implement the methodological perspective.

Under this three-dimensional classification framework, various ways involved in how to approach an object of philosophical study would be classified into the three methodological dimensions, depending upon their nature, status, and functions to be further explained. Before a further explanation is given in the subsequent discussion, let me use a simple metaphor to illustrate the distinction made here. Suppose that a person intends to approach her destination, say, a house (the object of study). She then takes a certain path (a methodological perspective) to approach the house, believing that the path leads to (one side or one door of) the house. In so doing, she holds a certain instrument in her hand (a methodological instrument) to clear her path, say, a hatchet if the path is overgrown with brambles or a snow shovel if the path is heavily covered with snow. She also goes with a certain idea in her mind (a methodological guiding principle) that explains why she takes that path and

guides her to have some understanding, adequate or inadequate, of the relation of that path to other paths (other methodological perspectives), if any, to the house.

In the following, I will examine the perspective dimension, the guiding-principle dimension, and the instrumental dimension of philosophical methodology and their mutual relations. There is some reason for arranging my examination of them in that order, which I will explain at the beginning of the next section immediately below. In my discussion, considering the theme of this anthology, I will illustrate the points of my general theoretical explanation primarily through two seemingly competing methodological approaches which are representative and influential in Western and Chinese philosophies respectively, namely, Socrates's being-concerned approach as presented in earlier Platonic dialogues and Confucius's becoming-concerned approach as suggested in the *Analects*.

2. The Perspective Dimension

Examining the perspective dimension of philosophical methodology occupies a central position in this writing for several reasons. First, one central concern of this work is to explain the nature, status, and function of a methodological perspective in the background of the three-dimensional metaphilosophical framework of philosophical methodology. Second, the perspective dimension of a methodological approach serves as a pivot on which the whole approach would turn to such an extent: given a certain methodological perspective, some instrumental methods are used as means to implement the methodological perspective, and a certain guiding principle is presupposed, explicitly or implicitly, by the agent in regulating how to apply and evaluate that perspective. Third, as I will explain later, the criterion for adequacy of a methodological principle in the guiding-principle dimension is characterized in terms of its relation to methodological perspectives. Fourth, for the sake of convenience of presentation, the perspective dimension of a methodological approach is like a point of tangency at which the presentation of the methodological approach could be made conveniently.

2.1. Illustration: Two Seemingly Competing Methodological Perspectives

Before a general theoretical examination of the perspective dimension is given, for the sake of heuristics and illustration, let us briefly consider two seemingly competing methodological approaches in Western and Chinese philosophical traditions. One of them is Socrates's representative methodological approach as suggested in some earlier Platonic dialogues; the other is Confucius's representative methodological approach to characterizing those important things

in one's moral life like *ren* (humanity) and *xiao* (filial piety) as revealed in the *Analects*.

Socrates's distinct methodological approach which he consciously and systematically pursues in some earlier Platonic dialogues is called "*elenkhos*" in Greek, more usually written as "*elenchus*," literally meaning "refutation."[1] The manifest level or layer of the *elenchus* approach clearly reveals itself through the dialogue between Socrates and Euthyphro on the latter's four definitions of piety presented in the *Euthyphro* (5a–15d).[2]

When Socrates applies his *elenchus* methodological approach, the object approached through the method could be anything that deserves reflective examination. It is known that, with Socrates's primary concern with the issues of human life and human society, the typical objects under his reflective examination are those like piety (in the *Euthyphro*), justice (in the *Republic*), and virtue or human excellence in general (in the *Meno*). What kind of things does Socrates intend to pursue in regard to those objects, besides those more fundamental purposes among his guiding principles to be discussed below? The form of the typical Socratic question partially reveals this. Socrates's typical question concerning an object under reflective examination is "What is the F-ness?": the F-ness is supposed to be the one and only universal that is true of all and only F-things, as shown in the *Euthyphro*[3]; and it is supposed that the F-ness can be captured by any rational mind through intersubjective rationality and to be articulated in definite terms of language, as shown in the *Meno*.[4] Though there are various aspects or layers of any object, what Socrates is concerned with is the aspect of the object that is stable and invariable (stably and invariably existing in all F-things), unchangeable, definite, and thus intersubjectively accessible by any rational mind. For convenience, I use a blanket term, "the being-aspect," to cover those characteristics of the object, or to stand for the aspect of the object that is identified in terms of the aforemen-

1. The *elenchus* approach can be seen most clearly in such short dialogues as *Laches* (to define bravery) and the *Euthyphro* (to define piety); but it is also used in book 1 of the *Republic*, the first part of *Meno*, *Protagoras* and *Gorgias*. The presentation in the *Euthyphro* of such a methodological approach is usually considered as the most neat, concise, and representative, especially in connection with its perspective and instrumental dimensions. Two notes. First, some guiding principles of the *elenchus* approach, as revealed in another important early Platonic dialogue, the *Apology*, are not directly concerned with methodological consideration—how to approach an object of study—but involve the purposes of the method. Second, Socrates might also use some other methodological approach in the earlier Platonic dialogues. What I focus on here is Socrates's *elenchus* methodological approach whose manifest aspect or instrumental dimension is what I call his "universal-definitional method" later, which is clearly illustrated in such a dialogue as the *Euthyphro*.
2. Assuming that the general philosophy readers here are familiar with the aforementioned manifest layer of Socrates's *elenchus* methodological approach, for the sake of space, I will not go over this aspect of his method step by step.
3. See the *Euthyphro*, 5c-d.
4. In the *Meno*, under Socrates's guidance, even a slave boy without much education can infer what Socrates has inferred through the boy's own rationality.

tioned characteristics.[5] It is the being-aspect of the object to which the perspective dimension of Socrates's methodological approach is intended to point. In other words, Socrates's methodological perspective is directed towards the stable, unchangeable, and definite aspect of the object under investigation. (Accordingly, the kind of knowledge that Socrates seeks through his method is also considered as stable, definite, and publicly accessible without appealing to any party's unequal or privileged intelligibility but intersubjective rationality; it could be achieved via rational argument; it could be clearly and coherently expressed in terms of definition. In other words, the kind of knowledge Socrates pursues through his *elenchus* methodological approach takes certainty and exactness as its characteristic hallmarks among others.) I thus call "the being-concerned perspective" the methodological perspective that is intended to point to the being-aspect of the object. Considering some general methodological features of Western philosophy in the analytic tradition which have been strongly influenced by Socrates's methodological perspective, and also partially for the sake of convenience, I might as well call the methodological perspective involved in Socrates's approach (a token of) "analytic perspective" (as a type) in its broad sense.

The other sample methodological perspective to be considered, in contrast to Socrates's being-concerned one, is Confucius's becoming-concerned perspective in his methodological approach to characterizing those things like *ren* (tentatively glossed as "humanity") as revealed in the *Analects*. As far as the perspective dimension of Confucius's methodological approach is concerned, some characteristic features of it are suggested in, say, 4.3, 6.28, 12.1, 12.22 and 13.19, which were intended to characterize the fundamental virtue *ren*. No matter how the meaning of *ren* is paraphrased in the contexts of those passages,[6] one thing is certain: though his different disciples asked about the same virtue *ren*, Confucius gave his quite different answers in connection with different situations, depending on the inquirers' different degrees of understanding, or even the inquirers' different temperaments. The virtue *ren* allows for divergent manifestations. Once one has captured the spirit of *ren* in such a holistic and situational way, one would be able to find out what one should do in a given situation. Because each concrete situation is somewhat different from another, it seems that the best one can do is to give characterizations of

5. For, though having been taken as a trademark term in ontological study in the history of Western philosophy, the term "being," when in contrast to the term "becoming," is intended to denote the stable, definite, unchanging aspect or layer of existing things. A prominent example of using the term "being" in this sense is Parmenides's case. Actually, the two characteristic uses of "being" are somehow closely connected with each other in some philosophers' minds: because the stable, definite, unchanging aspect of an object is considered to be its defining aspect which reveals its essence, the metaphysical study of being as existence is considered essentially the study of being as the stable, definite, and unchanging.

6. For a good paraphrase of the meanings of *ren* in those contexts, see Shu-hsien Liu, *Understanding Confucian Philosophy* (Greenwood Press, 1998), 17–18.

concrete situations as manifestations of the virtue *ren*. In this way, one may learn from these examples and realize the dynamic character of *ren* in one's own life. It is clear that, from Confucius's point of view, all those different manifestations of the virtue *ren* are relevant—furthermore, all of them reveal the genuine character of *ren*. What Confucius is concerned with in the *Analects* seems to be the dynamic, ever-changing, concrete characteristics of the objects under examination; all those characteristics are intrinsically connected with various situations in which the object reveals itself. I use a blanket term, "the becoming-aspect," to cover the aforementioned characteristics of the object because all of them essentially involve dynamic change or becoming.[7] I call "the becoming-concerned perspective" the methodological perspective which is intended to point to the becoming-aspect. It is clear that, to understand the becoming-aspect of the object, one needs to take a holistic or correlative perspective which endeavors to correlate various points in the concrete course of becoming process so as to capture the object as a whole. For this reason, one might as well call the perspective "the correlative perspective."[8] In this way, in contrast to the typical Socratic question, "What is the F-ness (the universal that is supposed to be true of all and only F-things)?," the typical question that Confucius intends to answer seems to be "Where is the *dao* of F-things?"[9] or "How does the *dao* reveal itself in a specific concrete situation?"[10]

7. There is another reason that I use the term—the reason is related to the conventional reason that the term "the being-aspect" is used to highlight those characteristics with which Socrates was concerned: "being" and "becoming" are sometimes used in contrast to each other to respectively highlight the stable, definite, and unchanging aspect of an object, on the one hand, and its dynamic, indefinite, and changing aspect, on the other hand.

8. The term "correlative" is sometimes used to characterize something more substantial than a methodological *perspective*, such as a certain metaphysical or cosmological view that considers the becoming-aspect of the universe as its primary or defining character. Cf., David Hall and Roger Ames, *Anticipating China: Thinking through the Narratives of Chinese and Western Culture* (Albany, N.Y.: SUNY Press, 1995), xix–xx, etc. Based upon my previous specification of the meaning of the term "perspective" and the distinction between the perspective and the guiding-principle dimensions of a methodological approach, the term "correlative perspective" as used here amounts to neither a correlative guiding principle nor a correlative cosmology.

9. A. C. Graham has contrasted different crucial questions for the Western and Chinese philosophers: the crucial question for all of the classical Chinese philosophers "is not the Western philosopher's 'What is the truth?' but 'Where is the Way?'" See A. C. Graham: *Disputers of the Tao* (La Salle, Ill.: Open Court, 1989), 3.

10. One might ask one question: Didn't Confucius's disciples ask Confucius about *ren* or ask him "What is *ren*?"? If they did, then, since the form of such questions seem the same as the typical Socratic question "What is the F-ness?," didn't Confucius fail to answer what his students really asked? Note that, in Greek or English, a typical common noun is a count noun like "person" or "horse" which, assisted with its plural forms, is supposed to denote countable separate individuals: one person, or five horses. For each count noun, there is a separate term like "horseness" or "piousness" which is supposed to denote one universal property, the F-ness, shared by all horses or all pious things. However, generally speaking, a Chinese common noun is arguably a collective noun. Unlike an abstract noun like "horseness" or "piousness," a collective noun is not supposed to designate one single object like the F-ness, which is exactly shared by all and only F-things, but some mereological whole of individual F-things. In this aspect, the difference in noun structure between Chinese ideographic language and Western phonetic

2.2. *A Metaphilosophical Examination*

With the two sample methodological perspectives in view, let me give a further characterization and clarification of the perspective dimension of methodological approach.

A methodological perspective, as characterized in section 1.1, is a way to approach an object of study which is intended to point to a certain aspect of the object and to explain the aspect in terms of the characteristics of that aspect rather than some other aspect. This characterization certainly needs further explanation. First, as far as the metaphysical nature of an object of study is concerned, the metaphilosophical commitment or implication of a methodological perspective *per se* in this connection, conceptually speaking, is minimal in the following several senses. (i) An object of study is not necessarily some ontological object in some standard sense like a chair or a tree but an object in the following minimal metaphysical sense: what counts as such an object can be anything that could emerge as, or be objectified into, a thing under reflective examination. The object in question might be the universe or a chair in ontological study, or virtue, piety, and the relation between the individual and the collective in ethical study, or anything that deserves reflective examination. (ii) Indeed, there is one basic metaphilosophical presupposition in the current metaphilosophical interpretative framework of philosophical methodology: in many cases, there are various aspects or facets or layers of an object of study which are somehow co-present in the object. For example, a person, as an object of philosophical study, has her moral aspect as she is a moral agent, her aesthetic aspect as she is regarded as the object of aesthetic appreciation, her mathematical aspect as she is a measurable physical body, and so on. Nevertheless, this metaphilosophical metaphysical commitment is minimal in this sense: such a commitment makes no further ontological characterization of what really exists or further metaphysical elaboration of the nature and structure of the object or its other metaphysical implications. (iii) A methodological perspective itself does not have the following extravagant metaphysical implication: an object of study must be materially as well as logically prior to the perspective. It might well be the case that an object of study is merely logically prior to a methodological perspective, which is intended to point to a certain aspect of the former, and that the methodological perspective itself might somehow participate in the construction of the object, as in the Kantian

languages like Greek and English seems to bear on the difference in metaphysical orientation and ontological insight between Chinese and Western philosophies. For a detailed discussion of the issue, see my "The Structure of Chinese Language and Ontological Insights: A Collective-Noun Hypothesis," *Philosophy East and West* 49, no. 1 (1999): 45–62. The point here is this: when one asks for *ren* (humanity) or *xiao* (filial piety), or, in direct speech, "What is *ren*?" or "What is *xiao* (being pious)?," the use of those Chinese characters themselves does not necessarily commit the user to a single F-ness; rather, it might denote a whole of individual or concrete things.

case or in the case of some mathematical objects. A methodological perspective characterized this way does not commit to the implication of subjective relativism in the sense to be explained in the seventh point.

Second, I call the methodological perspective specified in section 1.1 a "perspective-simplex." It might be the case that, being guided by a certain methodological guiding principle, one agent simultaneously takes several perspectives which are intended to look respectively to a number of aspects of an object of study in a more or less comprehensive way; this approach would result in a sort of perspective-complex which is eventually based upon the perspective-simplexes involved. A distinction between a perspective-simplex and a perspective-complex is thus due: a perspective-simplex is one methodological perspective which is intended to point to one aspect of the object, while a perspective-complex is a combination which somehow integrates two or more perspective simplexes into one—such a way of taking the methodological perspective will be examined in the last section. Below, unless otherwise specified, by "perspective" I mean a methodological perspective-simplex.

Third, the term "perspective" in ordinary language is sometimes used in a more substantial fashion. In this essay, I make a distinction between a methodological perspective and a substantial perspective, though both are connected in a certain way. A substantial perspective starts with a certain methodological perspective but is more substantial than the latter in that it says something about the object beyond the aforementioned minimal metaphysical commitment which a methodological perspective makes. The use of the term "perspective" in such a substantive sense is compatible with the term used in its methodological sense. A substantial perspective would start with a certain methodological perspective, although different substantial perspectives could develop from the same methodological perspective and might be inconsistent with each other especially when they result from some inconsistent guiding assumptions which are intended to guide the application of the methodological perspective. For example, as a matter of fact, there are distinct substantial being-concerned perspectives or points of view which develop from the same methodological starting point, that is, the being-concerned methodological perspective. Among them, at one extreme, is the Parmenides-style metaphysical view in ancient Greece, while there are many far more moderate substantial views as evidenced in contemporary analytic philosophy.

Fourth, to say that one takes a certain methodological perspective to look to some aspect of an object of study does not imply that the aspect to which a certain perspective points is the only aspect which one examines when taking that perspective. Rather, one who takes that perspective could attempt to explain some other aspect(s) from that perspective, specifically, in terms of the characteristics of the aspect to which that perspective is intended to point. Note that looking to, and examining, a certain aspect of an object of study is only one necessary condition for taking the methodological perspective that is

intended to point to the aspect of the object; another important feature of taking the methodological perspective in question is to examine the aspect in terms of the characteristics of the aspect rather than some other aspect. For example, one who takes the being-concerned perspective might intend to examine and explain the becoming-aspect; this fact itself is certainly not sufficient to show that one takes the becoming-concerned perspective. Rather, when one intends to partially or completely explain the becoming-aspect in terms of the (characteristics of) being-aspect, one is taking the being-concerned perspective. For instance, in the history of Western philosophy, since Zeno put forward his famous paradoxes, many philosophers in the analytic tradition have tried to solve the problem. Bertrand Russell's approach is a good example in this regard, for he tried to explain the becoming or changing aspect and Zeno's paradoxes (eventually) in terms of the being-aspect.[11]

Fifth, when taking a certain methodological perspective in reflective examination of an object, one's minimal metaphysical commitment might be wrong: the object of study might turn out to go without the aspect to which the perspective is intended to point. In this case, the methodological perspective is considered as one without its due metaphysical basis in dealing with that object and thus as irrelevant in regard to the object.

Sixth, however, if a methodological perspective is relevant, that is, with its due metaphysical basis, in regard to an object of study, one's reflective activity *per se* of taking that methodological perspective alone as one's working perspective to look at the object is *philosophically innocent*, whether or not one consciously takes some other relevant perspective as one's working perspective. For convenience, in that sense, it is said that (taking) a relevant methodological perspective *per se* is philosophically innocent. By "(being) philosophically innocent" I mean not violating but going along with the purpose of philosophy as worthy reflective activity to contribute to the understanding of an object of study. One might object: if an object of study has other co-present aspects to which other relevant perspectives are expected to point, wouldn't one's taking that methodological perspective alone as one's working perspective be one-sided or even result in distortion of one's understanding the object? It is important to note the distinction between the perspective dimension and the guiding-principle dimension of a methodological approach. The point is that the merit, status, and function of a methodological perspective *per se* can be evaluated independently of certain methodological guiding principles which the agent might presuppose in her actual application of the perspective. Taking a certain methodological perspective as a working perspective implies neither that one loses sight of other genuine aspects of the object nor that one ignores

11. Cf., B. Russell, *Principles of Mathematics* (Cambridge University Press, 1903), sections 332, 447; 350–51. Also see Graham Priest's discussion of Russell's view in his *In Contradiction* (Martinus Nijhoff, 1987), 215–19.

or rejects other relevant perspectives in one's background thinking. What is crucial is whether one's taking a certain methodological perspective is regulated by an adequate guiding principle or by an inadequate one. When one's application of a relevant methodological perspective as part of one's reflective practice is guided by some adequate guiding principle and leads to, or contributes to, (adequate) understanding of the object of study, one's application of that perspective would be philosophically constructive. In contrast, when one's application of a relevant perspective is guided by some inadequate guiding principle and fails to contribute to adequate understanding of the object of study but leads to some mistaken consequence, one's application of that perspective would be philosophically nonconstructive. But, even so, there is nothing wrong with the perspective *per se* which is still philosophically innocent; what is wrong in that situation is the inadequate guiding principle, using it to regulate application of the perspective, and one's nonconstructive application of the perspective. I will discuss the guiding-principle dimension of methodology in more detail in the next section.

Seventh, saying that the reflective activity of taking a relevant methodological perspective is philosophically innocent, does not amount to endorsing subjective relativism, which might be presented in terms saying that any "perspective" can go. The philosophical innocence of taking a relevant methodological perspective is intrinsically connected with some genuine aspect of an object of study. It might be the case that an object of study is merely logically prior to a relevant methodological perspective and that the perspective somehow participates in the construction of the object—such as the case of some mathematical objects. However, once an object of study is given and once the identity of the genuine aspect(s) of the object is thus determined, it is not the case that any "perspective" can go. To this extent a relevant methodological perspective is considered to be minimally objective. Indeed, while relativism allows subscription to some *subjective* identity criterion for the status of a perspective in the sense that a perspective might point to something subjective merely in any agent's mind without being intended to point to some genuine aspect of the object, what is resorted to here is some *objective* identity criterion for the status of a methodological perspective in the sense that a relevant perspective is considered to go with its due metaphysical basis concerning the object of study, as explained before.

Eighth, given the distinction between the methodological and substantial perspectives specified in the preceding third point, to say that the reflective activity *per se* of taking a relevant methodological perspective is philosophically innocent does not amount to saying that taking any substantial perspective which develops from that methodological perspective is philosophically innocent. For, although a methodological perspective *per se* is philosophically innocent in the aforementioned sense, a substantial perspective developing from the methodological perspective might well be mistaken, either because

the substantial perspective might give some inadequate characterization of the aspect, to which the methodological perspective is intended to point, or because the substantial perspective is developed under the guidance of some inadequate methodological guiding principle.

Ninth, no single one methodological perspective or perspective-simplex itself is the perspective *par excellence* (that is, the best without equal). All of the relevant methodological perspectives concerning an object of study are not only philosophically innocent and constructive but also philosophically equal in the following senses: (i) No one methodological perspective is philosophically absolutely superior or inferior; and (ii) all of the relevant methodological perspectives are equally necessary in a complete account of an object of study. Only relative to a certain purpose or situation can one say that one perspective is relatively more adequate or applicable.

One might object that, among various genuine aspects of an object of study, some of them are more important or vital than others (say, the "essence" aspect over the "nonessence" aspect, or the becoming-aspect over the being-aspect, or the being-aspect over the becoming-aspect); if so, why aren't those methodological perspectives that point to some more important aspects more significant than others or even absolutely superior? This objection takes two things for granted: (i) There are aspects of the object that are absolutely more important than its other aspects; (ii) the magnitude itself of one aspect of the object would justify the absolutely superior status of the perspective-simplex that points to that aspect. Both assumptions, however, are doubtful.

Let me first consider the first assumption. In this connection, I would like to emphasize two things. First, at least as far as those aspects that are intrinsically indispensable and interdependent (such as the being-aspect and the becoming-aspect of many natural objects) are concerned, one cannot say which aspect is absolutely superior or absolutely more essential than the other. If this is right, one cannot say which perspective, say, between the being-concerned perspective and the becoming-concerned perspective, enjoys an absolutely superior status. Second, for many an object under reflective examination, the issue of which aspect(s) of the object is(are) more important than others depends upon the identity condition of the object; and the identity condition of an object, in many cases, is not absolute but is localized when a certain perspective is taken; there is no absolute criterion by which some aspect(s) is (are) judged to be more important than others. For example, between a philosopher who studies ethics and looks to the moral aspect of a person and a philosopher who studies the issue of mind-body and looks to the physical-physiological aspect of the person, one cannot say that the former aspect is more important than the latter aspect, or vice versa. Note that this position is fundamentally different from relativism. The latter subscribes to some *subjective* identity criterion in the sense that the identity condition involved is eventually something subjective merely in the agent's mind, while the former resorts to some *objective*

identity criterion in the sense that the identity condition involved is eventually something possessed by the object itself.

Now let us move onto the second assumption. For the sake of argument, let us assume that a certain aspect is more important than others or even that the aspect is absolutely important. Can we say that a perspective which looks to that aspect would be absolutely superior? The magnitude of a methodological perspective that points to a certain aspect of an object under an agent's examination is not determined by the magnitude of that aspect of the object. Rather, the issue depends at least partially upon the agent's purpose and the nature of her reflective project. For example, even among a group of philosophers who agree upon which aspect of an object of study is more important than some others but who have different agendas so as to focus on some different aspects of the object, it seems inadequate to say that the perspective which looks to that accepted most important aspect is more significant than those other perspectives which point respectively to those other aspects. The case is like that in scientific studies: one might argue that the numeral aspect of things is the most important aspect in regard to (natural) science; however, it seems to be inadequate to say that the mathematical perspective taken by mathematicians that looks to the numeral aspect is more important than the physical perspective taken by physicists or more important than the chemical perspective taken by chemists, even if all those mathematicians, physicists, and chemists agree that the numeral aspect of things under their studies is the most important aspect.

Now it is clear that a relevant methodological perspective *per se* should be conflated neither with its certain actual (adequate or inadequate) applications which are regulated by various methodological guiding principles presupposed by its agents, nor with those guiding principles. For relevancy of a methodological perspective itself is determined by its due metaphysical basis if any rather than by the nature of its historically related guiding principles that have ever been presupposed by the agents to regulate its applications. Consider, for example, Socrates's being-concerned perspective and Confucius's becoming-concerned perspective as identified before. Their reflective activities *per se* of taking their respective methodological perspectives would be philosophically innocent if the objects under their reflective examination do have those aspects to which the two perspectives are intended to point (that is, when the perspectives go with their due metaphysical bases or when they are relevant); their applications of their methodological perspectives would be philosophically constructive when they are regulated by some adequate guiding principles as well as when those methodological perspectives go with their due metaphysical bases.

Indeed, to say that a methodological perspective *per se* is philosophically innocent and that no methodological perspective is absolutely superior amounts to saying neither that any use of a philosophically innocent perspective would be philosophically adequate nor that no methodological perspective is more suitable relative to a certain purpose. I suggest that a methodological perspec-

tive is *minimally adequately used* or *applied* when (i) the perspective is relevant or has its due metaphysical foundation; (ii) the application of the perspective is compatible with the application of other philosophically innocent methodological perspectives, and (iii) the perspective is not used with some inadequate or philosophically overloaded guiding assumption(s). That means that an adequate use of a certain methodological perspective in philosophical practice intrinsically demands a certain adequate guiding assumption.

3. The Guiding-Principle Dimension

In contrast to the distinction between relevant and irrelevant methodological perspectives in the perspective dimension, in the guiding-principle dimension, there is a distinction between philosophically adequate and inadequate methodological guiding principles regarding relevant methodological perspectives. The minimal condition for adequacy of a relevant methodological guiding principle concerning a methodological perspective, as indicated at the end of the last section, lies in its being compatible with the application of other relevant philosophical perspectives. Below, by "adequate methodological guiding assumption" I mean a *minimally* adequate one.

Typically, an inadequate methodological guiding principle presents itself as philosophically overloading, or metaphysically inflating, a methodological perspective, MP, which it regulates in one or both of the following ways. (1) In its guidance of how to apply the perspective, the guiding principle metaphysically overloads MP by positively attributing to MP the agent's favored metaphysical import that goes beyond the minimal metaphysical commitment of MP and makes MP become incoherent with other relevant perspectives. (2) The guiding principle metaphysically overloads another seemingly competing but relevant methodological perspective, MP*, by attributing to MP* some negative, or the agent's unfavored, metaphysical import of MP* that goes beyond the minimal metaphysical commitment of MP* and makes MP* become incoherent with MP. Through (1) or (2) or both, the guiding principle metaphysically overloads itself to become incompatible with (the adequate application of) other relevant and philosophically innocent perspectives that are relevant to the object of study. In this sense, to overcome an inadequate methodological guiding principle, one needs to deflate its metaphysical oversupplies in the preceding two connections.

In this way, when one claims to criticize a methodological approach as a whole, one might actually criticize some part(s) of its guiding-principle dimension which turns out to be inadequate. In this case, the difficulty is not with one's criticism of the part(s) of the guiding-principle dimension involved, but with one's conflating distinct dimensions of philosophical methodology and with one's inflating or overloading the methodological perspective with some undue metaphysical imports.

Note that "some part(s) of the guiding-principle dimension" needs more explanation. At this point another distinction is due, namely, the distinction between the descriptive and prescriptive portions in the guiding-principle dimension of a methodological approach. The descriptive portion consists of all those methodological guiding assumptions, *adequate* or *inadequate*, that have ever been presupposed by philosophers in guiding their applications of that methodological perspective.[12] On the other hand, its prescriptive portion consists only of those adequate guiding assumptions, which either have been actually presupposed by philosophers in regulating their applications of that perspective or have yet to be figured out, for the sake of future adequate application of the methodological perspective. So, at any given occasion, the descriptive portion is a close set of methodological guiding assumptions which traces back to the past, while the prescriptive portion is an open set of adequate guiding assumptions which faces toward the future. One can see that the classifications resulting from the two distinctions do not coincide: a guiding assumption might be both in the descriptive portion and the prescriptive portion if it is adequate and was actually presupposed by some philosopher before, while a guiding assumption cannot be both adequate and inadequate in regard to a certain methodological perspective.

With the distinction between the adequate and inadequate guiding principles and the distinction between the descriptive and prescriptive portions of the guiding-assumption dimension specified above, several points can be made. First, it should be clear that, when examining a certain methodological approach, one might need to distinguish its various dimensions which invite distinct, rather than indiscriminate, treatments. One might need to make clear which dimension or which components in that dimension one is really talking about. One might disagree about, or argue against, say, some components in the descriptive portion of the guiding-principle dimension of a methodological approach. Nevertheless, one needs to be cautious about not rendering various parts of the guiding-principle dimension of a methodological approach indiscriminately as adequate or inadequate; one needs to be cautious about

12. Moreover, given a methodological guiding principle that is presupposed by one in guiding one's application of a certain methodological perspective, that does not mean that the guiding principle must be presupposed in one's whole philosophical system, if any, but that, relative to the methodological perspective, it is presupposed. It might be the case that the guiding principle itself results from some philosophical argument and justification in one's philosophical doctrine as a whole, even if the doctrine might develop from the same methodological perspective. Consider Parmenides's case. Parmenides takes a being-concerned methodological perspective; he is known as the first philosopher in the Western philosophical tradition to consciously employ the method of deductive reasoning. The guiding principle which he presupposes in guiding his being-concerned methodological perspective is an assumption to the effect that the being-aspect of the universe is its only genuine aspect while the coming-into-being, changing, and plurality cannot be. However, this assumed guiding principle itself, in his whole philosophy, is derived from his a priori first principle: that which is, is and cannot not-be; that which is not, is not and cannot be.

not throwing away the baby while pouring out unwanted water, in Hegel's words.

Second, a certain inadequate methodological guiding principle, if any, of a methodological approach should not be considered as a defining component—much less the exclusive defining component—of that methodological approach. For it seems to be true that, historically speaking, the perspective dimension of a methodological approach has been connected with various guiding principles in the (descriptive portion of) the guiding-principle dimension, adequate or inadequate. Moreover, due to their oversupplying the metaphysical import for the guided perspective, and due to their failing to do justice to other relevant perspectives, those inadequate guiding principles hinder rather than promote the healthy development of the guided methodological perspective and thus the whole methodological approach. For those considerations, there seems to be no intrinsic reason to characterize the methodological approach in terms of those inadequate guiding principles.

Third, as suggested above, some inadequate methodological guiding principles have been presupposed merely by some of those who take a certain methodological perspective; to those philosophers who have taken this methodological perspective but do not hold those inadequate methodological guiding principles, it would be both unfair and mistaken to characterize the nature of their methodological perspective in terms of the metaphysical import of those inadequate methodological guiding principles which they have not held.

In the following, to illustrate some of the preceding points made in this section, let us look at the two sample methodological approaches with regard to their respective methodological guiding principles, which I try to hypothetically identify.

While examining the perspective dimension of Socrates's methodological approach, one is certainly right when recognizing that there seem to be some more basic methodological guiding principles in Socrates's background thinking which guide how he applies his being-concerned perspective.[13] For the sake of heuristics, I hypothetically and tentatively identify four methodological guiding principles in Socrates's background thinking in connection with his *elenchus* approach, though it seems that most of them are not explicitly given in the text. (1) With his being-concerned perspective in mind, Socrates seems to presuppose not merely that there is the being aspect of an object under his

13. There are also other guiding principles that are not directly related to regulating his methodological perspective. Two primary guiding principles of such a kind are there. (1) The starting point of Socrates's *elenchus* methodological approach is his strong conviction to the effect that one cannot uncritically accept opinions about philosophically important matters. The same point is also characteristically rephrased in terms of pursuing objective truth in Socrates's case. (2) Another goal of Socrates's *elenchus* is to know and improve oneself in regard to both parties in dialogue.

examination but also that the being-aspect is the only genuine aspect which reveals or constitutes the essence of the object and on which one needs to turn for the sake of having the genuine understanding of the object. (2) Socrates also seems to presuppose that the genuine knowledge, or the primary dimension of knowledge, of the object is that of the F-ness. For example, one cannot have genuine knowledge of a virtue like bravery or piety unless one can give a rationally defensible general account of the F-ness of the virtue. (3) Socrates seems to assume that the only reliable means to achieve systematic knowledge of the F-ness is our intersubjective cognitive rationality which is possessed even by a slave boy's mind. For the F-ness as something stable, definite, and unchangeable in all and only F-things should be something that can be repeatedly, definitely, and intersubjectively accessible, and human capacity to make such access is supposed to be human intersubjective cognitive rationality. (4) It seems that Socrates thus presupposes that the only eligible question in seeking such kind of knowledge is "What is the F-ness?" question.

There are several necessary notes. First, Socrates seems to be less explicit about these methodological guiding principles; I would like to emphasize the hypothetical character of my identification of these methodological guiding principles. Indeed, all those guiding principles involve evaluations of the being-concerned perspective or its metaphysical basis. As emphasized before, the mere fact that one takes a certain methodological perspective alone as a working perspective does not necessarily mean that one holds a certain guiding principle that would reject another relevant perspective that does not serve as one's current working perspective. The preceding identification of those guiding principles is based upon my understanding of the relevant textual contexts in which Socrates's *elenchus* methodological approach appears. The adequacy of this understanding hinges partially on which image of Socrates is being talked about here; and it is well known that the latter issue is a controversial one which I do not intend to pursue in this essay.[14] Second, in a completely historical account, a more extensive textual analysis concerning Socrates's background thinking needs to be explicitly provided; but here such a historical account is not pretended to be given. Rather, as an illustration of some of the theoretic points, I focus more on the structure of his *elenchus* methodological approach and its perspective dimension and instrumental dimensions to be discussed. These considerations render my identification of these methodological guiding principles hypothetical in character. Third, though identifying those guiding principles, I do not intend to evaluate their adequacy in this writing. For the adequacy of, say, the aforementioned first guiding principle depends upon the metaphysical nature of those objects under Socrates's examination; nevertheless, a metaphysical investigation of the metaphysical nature of an object of study goes beyond the scope of this essay.

14. See Sarah Kofman, *Socrates: Fictions of a Philosopher* , trans. by Catherine Porter (Cornell University Press, 1998).

Now let us consider the guiding-principle dimension of Confucius's methodological approach. Some interesting questions emerge when we think about Confucius's becoming-concerned perspective: Why does he take such a methodological perspective rather than others (such as Socrates's being-concerned perspective)? What in Confucius's mind would guide his applications of his becoming-concerned methodological perspective? All these point to the guiding-principle dimension of Confucius's methodological approach. One traditional explanation is this: in contrast to the theoretical consideration of his Western contemporary like Socrates, Confucius is primarily concerned with practical issues or practical ethics and therefore he is less interested in pursuing systematic principles or he simply does not have coherent thought in this regard at the reflective level. Although it is true that Confucius has his practical concern, it is important to note that there is also more or less reflective methodological consideration in Confucius's background thinking in this aspect. Can we say that it is because Confucius's thought in this connection is not overall coherent and systematic in that he fails to make any attempt to give a Socratic definition of the virtue *ren*? The consideration of why Confucius does not give a Socratic definition of an object, say, *ren*, under his examination seems to be that he emphasizes a holistic understanding of *ren* which is intrinsically connected with concrete situations but hard to exhaust through a once-and-for-all definite definition. As Confucius takes Yao's example in 8:19 to suggest, such a fundamental virtue is boundless so that it cannot be defined in finite language once and for all. Confucius takes the virtue *ren* essentially not as something static and definite but as a dynamic, ever-changing, and concrete process or something that cannot be given a definite definition in terms of some fixed formulation. Indeed, it is one long-standing orientation in traditional Chinese philosophy to the effect that the essence of *dao* or the eternal *dao* cannot be exhausted in a finite way, as given by a definite definition in limited language, because the eternal *dao* lies in its dynamic changing process. Though quite different in their respective substantial approaches, Confucianism and philosophical Daoism are kindred in spirit in this methodological regard to some extent. The point has been captured in the opening passage in the *Daodejing*: "The *dao* can be talked about or reached in language, but the *dao* that has been characterized in language is not identical with, or does not exhausted, the eternal *dao*." There are two closely related points here: on the one hand, the genuine *dao* can be reached and characterized in language, as Confucius does in the above citations and Laozi does in the *Daodejing*; however, on the other hand, neither any of those currently available characterizations alone nor even all of them together can exhaust the eternal *dao*, due to its open-ended character in its ever-changing developing process.[15] It seems that, when taking a becoming-

15. For a more detailed discussion of the issue, see my "Ultimate Concerns and Language Engagement: A Re-Examination of the Opening Message of the *Daodejing*," *Journal of Chinese Philosophy* 27, no. 4 (December 2000): 429–39.

concerned perspective as his primary methodological perspective, Confucius presupposes that the becoming-aspect of things is not merely a genuine aspect but the primary aspect of the object under consideration. Confucius thus does not intend to provide Socratic definitions of various virtues but characterize them through their revealations in various concrete situations in the course of its everlasting changing and developing process. As in the case of the characterization of Socrates's guiding principles, the aforementioned methodological guiding principles are also identified hypothetically for the sake of heuristics, I would leave the reader to think about whether or not they are fairly assigned to Confucius, based upon textual evidence and upon a holistic understanding of his methodological approach.

4. The Instrumental Dimension

In this section, I examine the instrumental dimension of philosophical methodology by pondering on two issues: one is that of the relation between the perspective and instrumental dimensions; the other is the issue of philosophical neutrality of an instrumental method. Let me first say something about my aim and strategy in this section.

 As specified in section 1.3, an instrumental method in the instrumental dimension of a methodological approach concerning an object of study is characterized as a way to approach the object and as a way that is used as means to implement the methodological perspective of the methodological approach. Indeed, there is a close connection between the perspective and instrumental dimensions of a methodological approach. For an instrumental method serves a certain purpose when it is consciously figured out or designed; and such a purpose is typically framed by a certain methodological perspective, to be illustrated by the cases of the instrumental dimensions of Socrates's and Confucius's methodological approaches. But it is an issue how closely an instrumental method is connected with its related methodological perspective. There are a series of relevant questions in this connection, including the following: Is an instrumental method exclusively determined by its related methodological perspective? Should an instrumental method be applicable when another methodological perspective is taken, whether or not the former was historically connected with its related methodological perspective? To what extent could an instrumental method be considered philosophically neutral? It seems that it is hard to give too general answers to those questions because the unique characteristics of many instrumental methods tend to resist any indiscriminate treatment. What are expected might be these: On the one hand, one needs to realize that there is a close connection between an instrumental method and its historically related methodological perspective; on the other hand, one needs to be encouraged to carefully examine individual cases without a preset stereo-

type in this regard. For these considerations, my aim in this section is quite moderate and limited. First, I intend to examine the close connections between the being-concerned perspective and its (historically) related instrumental method and between the becoming-concerned perspective and its (historically) related instrumental method. My strategy for this is to make such an examination through looking at Socrates's and Confucius's cases. Considering that Socrates's instrumental method and Confucius's instrumental method used to implement their respective methodological perspectives are representative and influential in the Western analytic tradition and the Chinese tradition, I render such an examination worthy. Second, considering the theme of this volume, I focus on the issue of philosophical neutrality of many instrumental resources of the analytic methodological approach.

The set of cross-examination steps and involved apparatus and techniques, as illustrated in the *Euthyphro*, constitute the instrumental dimension of Socrates's methodological approach, which is considered part of the manifest layer of Socrates's *elenchus* methodological approach. I call the instrumental dimension of Socrates's approach "universal-definitional method" on the basis of its following characteristics. (1) This kind of instrumental method emphasizes deductive reasoning and aims at systematic principles. (2) It is intended to help the interlocutor herself to *infer* what Socrates has inferred and what anyone with normal intersubjective intelligence could infer. (3) The participants in this kind of cross-examination dialogues are considered to be intellectually equal with respect to the capacity of reasoning and capturing those publicly accessible aspects of the object under examination; there would be thus a common ground in this connection to carry out the conversation. A good example is Socrates's analysis of Euthyphro's fourth definition (from 14b-c through 15b). When Euthyphro gives his definition to the effect that piety is prayer and sacrifice, Socrates infers with such a characteristic: at each step, Socrates either asks Euthyphro to give his own answer or makes sure if Euthyphro agrees when Socrates himself makes inference. Indeed, in Socrates's cross-examination, those basic principles of deductive reasoning like the principle of noncontradiction and the law of identity are strictly observed. It is not hard to see that the instrumental dimension of Socrates's *elenchus* approach is intended to implement Socrates' methodological perspective examined above. For those aforementioned instrumental components are considered to be instrumental in capturing the being-aspect of the object under examination and achieving certainty of knowledge.

In contrast, to implement his becoming-concerned methodological perspective, Confucius adopts a kind of instrumental method which might as well be called "holistic-situational method." Confucius's holistic-situational method has the following features. (1) It emphasizes analogous reasoning. When seeing connections between phenomena that may seem unconnected at

first sight, analogous reasoning is eventually based on a correlative and holistic perspective to look at the nature of things and their connections.[16] (2) It seeks generality through appealing to an exemplary model. In Western philosophical tradition, generality is considered to be captured in terms of systematic principles and articulate definitions in language. Nevertheless, in contrast to Socrates's approach, it seems that Confucius seeks neither a systematic principle given in language that decrees what is morally right nor articulate definitions of the key moral concepts in terms of necessary and sufficient conditions. Nevertheless, that does not amount to saying that Confucius is not concerned with generalization. as Hall and Ames point out, the exemplary model of sagehood somehow serves as the functional equivalent of a general principle: "Through analogizing, [exemplary] models [of sagehood] come to do much of the work we expect from concepts by providing generalizations capable of organizing particular situations."[17] (3) The analogous reasoning in Confucius's methodological approach is not used in isolation but, for its adequate and effective use, closely connected with some substantial expectations for the agent's understanding or wisdom that does not result merely from inter-subjective rationality as a universal human capacity but from a certain kind of personal cultivation and reflective efforts. Confucius does not consider as an eligible dialogue-participant the one who is not eager to learn and anxious to give an explanation oneself. The point is that Confucius's holistic-situational method requires a participant to have some personal experience and cultivated wisdom so as to understand the points of his teachings. (4) In contrast to Socrates's approach to help the interlocutor herself *infer* what Socrates *has inferred*, Confucius, when replying to his disciples' questions, endeavors to help them *see* what Confucius *has seen*. In other words, in his dialogues, what Confucius tries to resort to is not merely intersubjective rationality (whether it is a capacity or more substantial built-in ideas) but some insights, intuitions, or wisdom whose availability typically needs personal cultivation and reflective efforts rather than merely intellectual rationality through deductive inference.

One can see from the preceding two cases that there are close connections between those instrumental methods and their related methodological perspec-

16. For example, as 6:28 shows, Confucius takes the analogous approach in his version of the Golden Rule as the method of putting *ren* (humanity) into practice. When being asked if there is a single word that can be taken as a guide to conduct moral cultivation throughout one's life, Confucius said, "It is *shu*: Do not treat others the way you don't want to be treated (by others or by yourself)." One can see from 6:28 and 8:19 that Confucius highlights this kind of analogous thinking at least as one important aspect of his ethical thought that runs as a methodological thread guiding one's moral cultivation. In 8:19, Confucius characteristically appeals to the ancient sage as exemplary model to illustrate the point of a certain virtue in concrete situations. Confucius even takes the ability to make suitable analogous reasoning as prerequisite for conducting enlightening dialogues (as shown in 7:8) or even as a criterion of moral excellence when analogous reasoning is concerned with moral judgments (as shown in 5:9).

17. Hall and Ames, *Anticipating China*, 198. A further interesting question is exactly how such an exemplary model can do that, which I intend to answer in another writing.

tives. Now a related issue is that of philosophical neutrality of the instrumental method, that is, whether or not, or to what extent, those in the instrumental dimension of a methodological approach is philosophically neutral. The reason that this issue is related to the issue addressed above is this. If the connection between an instrumental method and its (historically) related methodological perspective is so close that the instrumental method is exclusively determined by, and serves merely, that perspective, the instrumental method would be restricted-to-the-perspective and have no room for serving, and being compatible with, other relevant perspectives. Also note that the issue of philosophical neutrality in connection with the instrumental dimension is somewhat different from that of philosophical innocence in connection with the perspective dimension. The latter is about whether a method itself violates or goes along with the spirit or purpose of philosophy as reflective activity, while the former is about whether or not a method could be applied to any token of philosophy as a type of reflective activity.

There seems to be no simple answer "yes" or "no" to the issue of whether or not an instrumental method is philosophically neutral. For that depends primarily upon what kind or type of reflective activity "philosophy" is used to mean. It is important to note the distinction between a type of reflective inquiries as intersubjective intellectual inquiries with theoretical concern, on the one hand, and a type of reflective activities as endeavors in thought with practical concerns or aiming to deliver specifically personal experience, on the other hand. There exists the distinction, not merely a second-order conceptual one, no matter how an agent conducts the two types of reflective activities in her philosophical practice. The former type focuses on knowing-that and is intended at least partially for intersubjective communication and peers' scrutiny and criticism, while the latter type focuses on knowing-how and resorts to some personal feeling or experience. The nature and purpose of philosophy as a type of intersubjective reflective inquiries into the object of study require careful arguments, clarity of concepts used, and coherent language expressions, and it is sensitive to reflective progress.[18] Because many resources in the in-

18. One might question the identity conditions of the so-called clarity, rigor, or coherence. It is true that Plato, Aristotle, Hegel, Russell, Wittgenstein, James, Heidegger, and so on have quite diverse or even contradictory understandings of them. The points to note are these. First, what is highlighted here is the distinction between two types of philosophical reflective activities; and all the philosophers who are engaged in the first type of reflective inquiries intend, or aim at, careful argument, coherent explanation, and so forth, no matter how they identify them, in contrast to those in the second type who simply don't have such intentions. Second, in a community of philosophers (or reflective-activities-participants), there are some bottom-line cases or minimal expectations in regard to the identity conditions of what count as careful argument, reflective progress, clarity, and coherence of a conceptual or theoretic system, etc.; they constitute a set of more or less quasi-academic norms established or accepted by the community at a certain time for the sake of its own healthy development, no matter what individual (contemporary or subsequent) philosophers would say. A full explanation of this matter of fact involves the complex relation between thought and language in connection with the level of

strumental dimension of the analytic methodological approach in its broad sense, as illustrated by some of Socrates's instrumental methods, are developed exactly for the sake of conducting careful arguments and clarifying concepts, they would be *philosophically* neutral in regard to any token of philosophy as a type of the intersubjective intellectual inquiries aforementioned, if they can be used as instruments to facilitate careful arguments, clarity of concepts, and coherent language presentation in such philosophical inquiries. It is not hard to see that philosophy as a type of intersubjective intellectual inquiries is somehow related to the being-concerned methodological perspective as illustrated by its Socratic version discussed before.

One might object that intellectual inquiry is not restricted to the reflective intellectual inquiry that resorts to intersubjective rationality and might refer to some other kind of intellectual inquiry which might resort to paradoxical remarks to capture the point. One might illustrate the point by citing some seemingly paradoxical utterances in Heidergger's and Sartre's intellectual works which are used to deliver their points. In such cases, it seems that, instead of intersubjective rationality, what is resorted to is either some special personal experience/emotion or some kind of cultivated rationality, if any, that appears to go beyond what a current stock of conventional public-language resources could capture. Nevertheless, one question is worth raising: as far as those ideas and thoughts that are considered to be subject to reflective examination are concerned, even though they might as well be delivered, to some extent, in paradoxical and intentionally vague utterances, and even though the objects about which they are uttered are inconsistent in character, couldn't they be expressed through one's theory in a nonparadoxical but coherent way and in a sophisticated language? Indeed, what is at issue here is not whether or not the object itself of study could be paradoxical or inconsistent in character but how to provide a best explanation of it in theoretical inquiries of the first type. Whether one's answer is eventually positive or negative, two things seem to be certain: (1) as far as a variety of philosophical activities as first type of intersubjective reflective intellectual inquiries are concerned, many instrumental resources that have been thus far worked out for the sake of careful arguments and sophistication of concepts are *philosophically* neutral and could significantly contribute to our understanding of the object of study; (2) many of the instrumental methods in analytic methodology are among such instrumental resources.[19]

reflective sophistication of the community and its language-use habit—a topic that goes beyond the scope of this writing.

19. It is worth mentioning that some serious efforts have already been made to explain, say, certain central ideas of some Continental philosophers, such as Hegel and Nietzsche, in terms of clear but sophisticated analytic language—some of those efforts seem to be quite successful. For example, in his *In Contradiction* (Martinus Nijhoff, 1987), Graham Priest presents and elaborates some central points of Hegel's dialectics on contradiction in a rigor language of logic. (Also see his "What is So Bad About Contradiction?" *The Journal of Philosophy* [1998]: 410–26.) One example in recent Nietzsche scholarship is John Richardson's *Nietzsche's System* (Oxford University Press, 1996).

5. Alternative Ways
of Taking Methodological Perspectives

If, as explained before, the reflective activity *per se* of taking a relevant method-ological perspective in dealing with an object of study is philosophically innocent, and if whether or not a methodological perspective could be adequately applied largely depends upon whether or not a suitable guiding principle would be available in the agent's background thinking, one interesting issue that is directly relevant, and significant, to the common philosophical enterprise in our times is how a variety of relevant methodological perspectives could be complementary to each other and how they could be connected with some adequate guiding principle in our reflective activities. In the following, I propose four alternative types of taking relevant methodological perspectives as working perspective in a more or less sketchy way. These four alternative types are neither pretended to exhaust all the possible ways nor claimed to be no precedents. For example, both Socrates's case and Confucius's case might turn out to fall under one or other type. Also note that the metaphilosophical examination to be suggested in this section is merely programmatic and has yet to be further elaborated.

As explained before, one's reflective practice itself of taking a single relevant methodological perspective as a working perspective is philosophically innocent or even is philosophically expected based upon the purpose of such an examination; on the other hand, it might also be subject to the danger of inadequate application when it is regulated by some inadequate guiding principle. What is crucial, as suggested above, is to have some adequate methodological guiding principle in place. There are two basic types of methodological guiding principles. One acknowledges the role of other alleged (relevant or irrelevant) perspectives and includes them in the agent's background thinking concerning the object under examination; I call this type of guiding principle an "inclusive guiding principle." What is in contrast to the inclusive guiding principle is the exclusive guiding principle which disclaims the role of other perspectives as irrelevant and excludes them from one's background thinking concerning the object under examination. Accordingly, there are two ways to take a single methodological perspective: one way is to take a single perspective as a working perspective with an *inclusive* guiding principle, while the other is to take a single perspective as a working perspective with an *exclusive* guiding principle.

When taking a single methodological perspective as a working perspective, which type of methodological guiding principle should be assumed by the agent? That really depends upon the metaphysical nature of the object of study. If the object does have aspects other than the one to which the single working perspective points, one needs to assume an inclusive guiding principle which acknowledges the role of other relevant perspectives that point to the other aspects of the object and includes them in one's background thinking concerning the object. However, if the aspect to which the single working perspective

points is the exclusive defining aspect of the object, an exclusive guiding principle would be adequate because it does justice to the genuine metaphysical nature of the object without invoking irrelevant perspectives and some extravagant metaphysical presupposition. For a similar reason, in the former case, an exclusive guiding principle is inadequate, while, in the latter case, an inclusive guiding principle is inadequate, though what often happens in philosophical pursuit is that one takes an exclusive guiding principle for granted when an inclusive guiding principle should be assumed.

Now, if various co-present aspects, say, both the being-aspect and the becoming-aspect, are genuine aspects of an object under examination, and if one's purpose is to have a more complete look at various aspects of the object in a more comprehensive project, there would be two other ways of adopting methodological perspectives, both of which intrinsically require the agent to assume an inclusive guiding principle. One way is to combine two or more methodological perspective-simplexes (say, the being-concerned perspective and the becoming-concerned perspective) into a perspective-complex from which one takes, say, both the being-concerned perspective and the becoming-concerned perspective to look at the being and becoming aspects of the object simultaneously. I call this type of approach "taking a perspective-complex as a working perspective with an inclusive guiding principle." For example, for the sake of achieving a more complete account, one could simultaneously take Socrates's and Confucius's methodological perspectives to characterize, say, the virtue of (filial) piety if such an object of study does have its being-aspect and becoming-aspect. Another way is to alternately take different relevant methodological perspectives as working perspectives within a project. For example, one can first totally take a Socratic approach and then totally take a Confucian approach in an alternate way so as to achieve a more comprehensive understanding of the object of study within the same project. I call this type of approach "taking alternate perspectives as working perspectives with an inclusive guiding principle."[20] In sum, as for how methodological perspective(s) would be taken as working perspective(s), there seem to be at least the following four types of approaches that could be legitimately taken.

(1) *A single perspective with an inclusive guiding principle* (in the case of the co-presence of multiple aspects of the object): One takes a single one perspective as a working perspective and goes with some guiding principle which (i) acknowledges the role of the other relevant perspective(s) that point to the other co-present aspect(s) and (ii) includes them in one's background thinking concerning the object under examination.

20. This type of approach presupposes that the agent has a coherent inclusive guiding principle which regulates applications of alternate perspectives. Nevertheless, it is possible that, when taking different perspectives in different stages of the project at different times, the agent might have different or competing guiding principles.

(2) *A single perspective with an exclusive guiding principle* (in the case of an exclusive defining aspect of the object): One takes a single perspective as a working perspective and goes with some guiding principle which correctly disclaims the role of other perspectives as irrelevant and excludes them in one's background thinking concerning the object under examination.

(3) *A perspective-complex with an inclusive guiding principle*: One takes multiple relevant perspectives simultaneously as a working perspective-complex so as to have a more complete account within one project and goes with an inclusive guiding principle.

(4) *Alternate perspectives with an inclusive guiding principle*: One takes different but relevant perspectives alternately as a working perspectives within one project and goes with an inclusive guiding principle.

As for exactly which type of approach is most suitable, the issue is surely sensitive to the purpose of the project at hand. What is crucial for the validity of the project is to have an adequate guiding principle in place, based upon suitable understanding of the metaphysical nature of the object under examination, which does justice to co-present aspects, if any, of the object and the corresponding relevant methodological perspectives.

6. Summary

For the sake of constructively conducting comparative studies of Chinese and Western philosophies in connection with philosophical methodology, this essay has endeavored to achieve a metaphilosophical understanding of the structure of philosophical methodology, especially the status and functions of various dimensions of a methodological approach and their relations. The methodological concern in this paper is dual: *how* to look at distinct *methodological approaches*.

I have given an analysis of the structure of philosophical methodology in terms of a three-dimensional metaphilosophical framework. In so doing, partially for the sake of their relevance to the central theme of this anthology, I have taken Socrates's being-concerned and Confucius's becoming-concerned approaches as sample methodological approaches to illustrate the points.

The main points which I have endeavored to make are these. (1) Generally speaking, there are three functionally distinct but somehow closely related dimensions of a methodological approach, namely, the perspective dimension, the guiding-principle dimension, and the instrumental dimension. (2) Given that a methodological perspective has its due metaphysical basis in dealing with an object of study, one's reflective activity *per se* of taking that perspective alone as a working perspective is philosophically innocent. (3) There is a distinction between the adequate and inadequate methodological guiding principles,

and the latter results in inadequate application of a philosophically innocent methodological perspective. (4) In comparative studies, both for the sake of evaluating a methodological approach and for the sake of constructively taking a certain methodological approach to an object of study, one crucial evaluative reference point is whether or not the guiding-principle dimension of the methodological approach is adequate rather than whether or not its methodological perspective alone is taken as a working perspective. (5) There is no absolutely superior methodological perspective in the explained sense. (6) With certain adequate guiding principles in place, there are alternative adequate ways of taking seemingly competing methodological perspectives in a philosophical pursuit.[21]

21. I would like to thank Lin-he Han, Douglas Heenslee, Thomas Leddy, You-zheng Li, and Xiang-long Zhang, for helpful comments and criticism of early versions of this essay or stimulating discussions of some relevant issues from which I benefit much.

Contributors

ALLINSON, ROBERT E., is Professor in the Department of Philosophy of the Chinese University of Hong Kong. He is the author or editor of seven books and one hundred and sixty academic papers including *Space, Time and the Ethical Foundations* and *A Metaphysics for the Future* (Aldershot: Ashgate, 2000), *Understanding the Chinese Mind: The Philosophical Roots* (ed.) (New York: Oxford University Press, 1989, tenth impression, 2000); *Chuang-Tzu for Spiritual Transformation: An Analysis of the Inner Chapters* (SUNY Press, 1989, sixth impression 1996); and *Harmony and Strife: Contemporary Perspectives, East and West* (co-edited with Shu-hsien Liu) (Hong Kong: Chinese University Press, 1988). His works have been translated into Chinese, Japanese, French, German, and Italian. He serves on eight Editorial Boards of international journals including *The Journal of Chinese Philosophy* (US) and *Asian Philosophy* (UK). He has been Visiting Professor at Beijing University and Fudan University and has been Visiting Fellow at Yale University, an Associate Member of Balliol College of Oxford University and Senior Associate Member of St. Antony's College of Oxford University. He was invited by Joseph Needham to be a Fellow at the Needham Research Institute in Cambridge University.

BUNNIN, NICHOLAS, is Director of the Philosophy Project at the Institute for Chinese Studies, University of Oxford, UK, and Chairman of the British Committee of the Philosophy Summer School in China: China British Australia. He obtained an A.B. *summa cum laude* at Harvard College and a D.Phil. at Corpus Christi College, University of Oxford, where he was a Rhodes Scholar. He previously taught at the University of Glasgow and the University of Essex. Dr. Bunnin co-edited the *Blackwell Companion to Philosophy* with Eric Tsui-James and compiled the *Dictionary of Western Philosophy: English-Chinese* with Jiyuan Yu. He is currently co-editing the *Blackwell Guide to Contemporary Chinese Philosophy* with Chung-ying Cheng.

CHENG, CHUNG-YING, is Professor of Philosophy at the University of Hawaii at Manoa. He received his B.A. degree from National Taiwan University (1955) and his Ph.D. degree from Harvard University (1964). Cheng is the founder and honorary President of the International Society for Chinese Philosophy

and the International Society for the *Yijing (I Ching)*; he is also the Editor-in-Chief of *The Journal of Chinese Philosophy*. He is the author of many articles and books on Chinese philosophy and comparative philosophy, including *Peirce's and Lewis's Theories of Induction* (1969), *Modernization and Universalization of Chinese Culture* (1988, in Chinese), *New Dimensions of Confucian and New-Confucian Philosophy* (1991), and *Knowledge and Value* (1996, in Chinese).

FUNG, YIU-MING, teaches philosophy at the Hong Kong University of Sciences and Philosophy. He received his Ph.D. degree in Philosophy from the Chinese University of Hong Kong in 1984. Fung has held various research or teaching appointments at the Institute of East Asian Philosophies in Singapore, the Department of Philosophy at the Chinese University of Hong Kong, the Institute of History and the Department of Chinese Literature and Linguistics at National Tsing Hua University in Taiwan, the Sun Yat-Sen Institute of Social Sciences and Philosophy at Academic Sinica in Taiwan. Fung is the author of *The Methodological Problems of Chinese Philosophy* (1989, in Chinese), *Chinese Philosophy in the Ancient Period*, 4 volumes (1992, in Chinese), and *Kung-Sun Lung Tzu: A Perspective of Analytic Philosophy* (1999, in Chinese). He is also the editor of and contributor to the following two collections: *Collected Essays in Analytic Philosophy and the Philosophy of Science* and *Collected Essays in Analytic Philosophy and the Philosophy of Science* (1990 and 1995, in Chinese).

HALL, DAVID L., is Professor of Philosophy at the University of Texas at El Paso. He has degrees from Texas Western College (B.A.), Chicago Theological Seminary (B.D., *summa cum laude*), and Yale University (Ph.D.). He has written several books on the philosophy of culture (*The Civilization of Experience, The Uncertain Phoenix, Eros and Irony*), a book on Richard Rorty, and a philosophical novel (*The Arimaspian Eye*). He has collaborated with Roger Ames on three books dealing with classical China: *Thinking through Confucius, Anticipating China*, and *Thinking from the Han* (Albany: SUNY Press, 1987, 1995, and 1998). The two have recently published a book on modern China entitled *The Democracy of the Dead* (Open Court, 1999) and are collaborating on a translation and philosophical interpretation of the *Zongyong*. His current solo projects include two books, *Peace in Action: America's Broken Promise*, and a collection of fictionalized travel essays entitled *The Sydney Explorer: Notes of a Bookish Traveler*.

HANSEN, CHAD, is Chair Professor of Chinese philosophy at the University of Hong Kong. He first went to Hong Kong in 1961 and has lived in Asia (Hong Kong, Taiwan, and Japan) for fifteen years of his adult life. He got his B.A. at the University of Utah in 1960 (Philosophy and Political Science) and his M.A. and Ph.D. (Philosophy) at the University of Michigan (1972) working with Don Munro. His dissertation, *Ancient Chinese Theories of Language*,

examined theories of the Later Mohists and School of Names. He attended the "Stanford" (Inter-University Program) School of Mandarin in Taipei in 1969 and did dissertation research at the Universities Service Center in Hong Kong, where he studied at New Asia College under Tang Junyi and Mou Zhongshan. He has taught in philosophy departments at the universities of Pittsburgh, Michigan, Stanford, Vermont, UCLA, Hawaii, and Hong Kong. He was selected as University Scholar at the University of Vermont in 1992. He has published over sixty scholarly articles and two books on Chinese thought focusing on theory of language and mind in China and the impact of those theories on the moral and political thought of the ancient period (*Language and Logic in Ancient China* [Michigan, 1972] and *A Daoist Theory of Chinese Thought* [Oxford, 1992]).

LI, YOUZHENG, is a Senior Fellow Emeritus at the Institute of Philosophy, the Chinese Academy of Social Sciences and a member of the Executive Committee of the International Association for Semiotic Studies. He had become a self-taught Chinese philosopher during Mao's period and has been engaged in comparative epistemological and methodological inquiries, specializing in phenomenology, hermeneutics, structuralism, and pragmatism. For the past two decades he has received various visiting appointments at the philosophy departments of the University of Princeton, Columbia University, Munich University, Berlin University, Bochum University, Paris University, Hong Kong University, Tokyo University, and Taiwan University. During his research tenure at Bochum from 1989 to 1997, he published three books on comparative philosophy, *The Constitution of Han-Academic Ideology*, *The Structure of the Chinese Ethical Archetype*, and *Epistemological Problems of the Comparative Humanities* (Peter Lang, 1997). He is the author of the following Chinese books: *Introduction to Theoretical Semiotics*, *Structure and Meaning*, *Ethical Crisis: On Contemporary German and French Ethics*, and *Ethics of Desire: Freud and Lacan*. He is also the translator of several contemporary Western philosophy classics by Husserl, Rorty, Ricoeur, Levi-Strauss, and Barthes.

LIU, SHU-HSIEN, is now a Research Fellow (specially invited Chair) at the Institute of Chinese Literature and Philosophy, Academia Sinica, Taipei. He received his B.A. (1955) and M.A. (1958) degrees from Taiwan University, and Ph.D. in Philosophy (1966) from Southern Illinois University at Carbondale. He taught at Tunghai University from 1958 to 1964 as a lecturer and an associate professor. After earning his advanced degree he taught at SIU-C as an assistant professor and an associate professor, getting promoted to full professor in 1974. In 1971, he taught at New Asia College and the Chinese University of Hong Kong. He taught as Chair Professor in Philosophy at CUHK from 1981 to 1999. He has published more than twenty books in Chinese, including studies on Chu Hsi (1982) and Huang Tsung-hsi (1986),

and also more than fifty articles in English. More recent publications include *Contemporary Chinese Philosophy: Problems and Characters*, 2 vols. (1996) in Chinese and *Understanding Confucian Philosophy: Classical and Sung-Ming* (1998) in English.

MORTON, ADAM, is Professor of Philosophy at the University of Bristol, U.K. He received his Ph.D. degree in Philosophy from Princeton University. He is the author of four books: *Frames of Mind* (Oxford University Press, 1980), *Disasters and Dilemmas* (Basil Blackwell, 1991), *Philosophy in Practice* (Basil Blackwell, 1995), and *A Guide through the Theory of Knowledge* (2nd edition, Blackwell 1997). He has recently finished in draft the book *Folk Psychology as Ethics*. His recent articles on the philosophy of mind, the philosophy of language, and epistemology include "Where Demonstratives Meet Vagueness: Possible Languages" (*Proceedings of the Aristotelian Society*, Autumn 98), "Mathematics as Language," in Morton and Stich, eds., *Benacerraf and his Critics*, "Folk Psychology is Not a Predictive Device" (*Mind*, Jan. 96), "Game Theory and Knowledge by Stimulation" (*Ratio*, 94), and "Mathematical Models: Questions of Trustworthiness" (*British Journal for the Philosophy of Science*, 93). He is presently trying to finish a book on moral aspects of folk psychology and writing a series of papers on the connections between action-directed and belief-directed rationality.

MOU, BO, is Assistant Professor of Philosophy at San Jose State University in California. After receiving his B.S. in Mathematics, he studied philosophy at Beijing University, the Graduate School of the Chinese Academy of Social Sciences (M.A.), and the University of Rochester (M.A. and Ph.D. in Philosophy). He has held research, teaching, or visiting appointments respectively at the Institute of Philosophy of CASS, the University of Rochester, Le Moyne College, and the University of California at Berkeley. His recent English publications on the philosophy of language, metaphysics, Chinese philosophy, and comparative philosophy include: "An Analysis of the Semantic Structure of the Hexagram in the *Yijing*" (*The Journal of Chinese Philosophy*, 1998); "The Structure of the Chinese Language and Ontological Insights" (*Philosophy East and West*, 1999); "Tarski, Quine, and the 'Disquotation' Scheme (T)" (*The Southern Journal of Philosophy*, 2000); "A Metaphilosophical Analysis of the Core Idea of Deflationism" (*Metaphilosophy*, 2000); "Ultimate Concerns and Language Engagement: A Re-Examination of the Opening Message of the *Daodejing*" (*The Journal of Chinese Philosophy*, 2000); and "The Enumerative Character of Tarski's Definition of Truth and Its General Character in a Tarskian System" (*Synthese*, 2001).

NEVILLE, ROBERT CUMMINGS, is Professor of Philosophy, Religion, and Theology at Boston University, and is Dean of its School of Theology. He is

past president of the International Society for Chinese Philosophy, the American Academy of Religion, and the Metaphysical Society of America, and was Director of the Comparative Religious Ideas Projects at Boston University. He is the author of many articles and sixteen books, among which are *The Tao and the Daimon* (1982), *The Puritan Smile* (1987), *Behind the Masks of God* (1991, translated into Chinese), *Normative Cultures* (1985), and *Boston Confucianism* (2000), all relevant to his essay in the present volume.

RESCHER, NICHOLAS, is University Professor of Philosophy at the University of Pittsburgh where he served for many years as Director of the Center for Philosophy of Science. A former president of the American Philosophical Association, he is an honorary member of Corpus Christi College, Oxford. He has been elected to membership in the European Academy of Arts and Sciences (Academia Europaea), the Institut International de Philosophie, and several other learned academies. Having held visiting lectureships at Oxford, Constance, Salamanca, Munich, and Marburg, Rescher has received five honorary degrees from universities on three continents. Author of more than eighty works ranging over many areas of philosophy, he was awarded the Alexander von Humboldt Prize for Humanistic Scholarship in 1984. Some of Dr. Rescher's representative works are: *The Coherence Theory of Truth* (1973), *Methodological Pragmatism* (1977), *Scientific Progress* (1978), *The Strife of Systems* (1985), *Predicting the Future* (1998), and *Realistic Pragmatism* (1999).

SHUN, KWONG-LOI, is Professor of Philosophy at the University of California at Berkeley. He received his B.A. in Mathematics and Philosophy from the University of Hong Kong (1975), B.A. in Philosophy from the University of London (1978), M.Phil. from UHK (1978), B.Phil. from Oxford University (1982), and Ph.D. in Philosophy from Stanford University (1986). Shun is the author of *Mencius and Early Chinese Thought* (Stanford, 1997). He has published many articles on moral philosophy, Chinese philosophy, comparative philosophy, and philosophy of religion, including "Review of Robert Eno *The Confucian Creation of Heaven: Philosophy and the Defence of Ritual Mastery*" (*Harvard Journal of Asiatic Studies* 53, 1992); "*Jen* and *Li* in the *Analects*" (*Philosophy East and West* 43, 1993); "Review of Heiner Roetz *Confucian Ethics in the Axial Age*" (*Journal of Chinese Philosophy* 22, 1995); "Ideal Motivations and Reflective Understanding" (*American Philosophy Quarterly* 33, 1996); and "Mencius on *Jen-hsing*" (*Philosophy East and West* 20, 1997). He has also contributed to many entries on Chinese philosophy in several philosophy encyclopedias.

TONG, LIK KUEN, is Professor of Philosophy at Fairfield University in Connecticut. He received his B.S. from New York University and his Ph.D. from the New School for Social Research. He is the founder and director of the International Institute for Field-Being at Fairfield University and the

Honorary Chief Editor of *Field and Being: The Fusion of Chinese and Non-Chinese Philosophies* (Beijing). A former president of the International Society for Chinese Philosophy, he has been its Executive Director and Chair of the Executive Committee since 1990. His major publications include *Between Chou I and Whitehead: An Introduction to the Philosophy of Field-Being* (1989), *Context and Reality: A Critical Interpretation of Whitehead's Philosophy of Organism* (1998), *Relativity and Relatedness: Collected Essays* (1999), and numerous articles on Field-Being thought and Chinese and comparative philosophy.

VAN NORDEN, BRYAN W., is Assistant Professor in the Philosophy Department and in the Asian Studies Program at Vassar College in New York. He has a B.A. in Philosophy from the University of Pennsylvania (1985) and a Ph.D. in Philosophy from Stanford University (1991). He has published extensively on early Chinese philosophy, including "Mengzi and Xunzi: Two Views of Human Agency," in T. C. Kline and Philip J. Ivanhoe, eds., *Virtue, Nature, and Moral Agency in the* Xunzi (Indianapolis: Hackett, 2000) and "Competing Interpretations of the Inner Chapters of the *Zhuangzi*" (*Philosophy East and West* 46, no. 2 [1996]). In addition, he is editor and a contributor to *Confucius and the* Analects: *New Essays* (New York: Oxford University Press, forthcoming), and has contributed a partial translation of the *Mengzi (Mencius)* to *Readings in Early Chinese Philosophy* (New York: Seven Bridges Press, forthcoming). His website is at < faculty.Vassar.edu/~brvannor/>.

YU, JIYUAN, is Assistant Professor of Philosophy at the State University of New York at Buffalo. He received his Ph.D. in Philosophy at Guelph University (1994). He held a post-doctoral research post at the University of Oxford. His main areas of interest are Greek philosophy and Greek-Chinese comparative philosophy. His recent English publications include: "Two Conceptions of Hylomorphism in *Metaphysics ZH*" (*Oxford Studies in Ancient Philosophy*, 1997); "Virtue: Aristotle and Confucius" (*Philosophy East and West*, 1998); "The Language of Being: Between Aristotle and Chinese Philosophy" (*International Philosophy Quarterly*, 1999); "The Moral Self and the Perfect Self in Aristotle and Mencius" (*Journal of Chinese Philosophy*, 2000); "Justice in the *Republic*: An Evolving Paradox" (*History of Philosophy Quarterly*, 2000); "Aristotle on *Eudaimonia*: After Plato's Philosophical-King" (*History of Philosophical Quarterly*, 2001). He and Nicolas Bunnin co-authored the *Dictionary of Western Philosophy: English-Chinese* (Beijing: People's Press, 2000). Currently he is co-editing with Jorge J. E. Gracia a volume entitled *Rationality and Happiness: From the Ancients to the Earlier Medievals*.

Index

The English translations of non-English terms (primarily Chinese ones) are given either following the relevant authors' paraphrases in certain contexts or merely tentatively for the sake of heuristics—especially when the concepts for which many of them stand are under reflective scrutiny in this volume.

372 *Index*

autonomy, 210, 213
Ayer, A. J., 29, 29n, 270

becoming, 64–65, 69–70, 80, 161–65
being, 59, 65, 81–82, 91, 161–64
Bergson, Henri Louis, 68, 101
Berkeley, George, 20, 34, 144, 248
Berlin, Isaiah, 289
Bernasconi, Robert, 282–83
Berthrong, John, 37n, 167n
bian-hua 變化 (change; transformation), 94
Blackburn, Simon, 213
Boer, John F., 30n
Bohr, Niels, 289
Bradley, F. H., 13, 18, 19, 270
Brahman (Ultimate Reality; Universal Principle of Nature), 63
Brandom, Robert, 8n, 197, 202n
Bretall, Robert W., 138n
Buchler, Justus, 27
Buddhism, 34, 36, 41, 65, 97, 135–36, 138, 143, 150, 247, 251–54
 Chan 禪 / Zen, 108, 251, 270–71
 Indian, 177
 Mahayana (The Great Vehicle), 271
Bunnin, Nicholas, xx, 365, 370

Cahoone, Lawrence E., 27–28, 38
Cantor, Georg, 256
Carnap, Rudolf, 89–90, 113
Cartesianism, 66, 122. *See also* Descartes
Cassier, Ernst, xix, 132–38, 145, 151
Chan, Wing-tsit 陳榮捷, 28, 172, 181n, 184n, 192n, 247n–48n, 262n
Chang, Carsun. *See* Zhang Jun-mai
change, 94, 165
cheng 誠 (sincerity; truthfulness), 96, 118–19, 121, 238–39
Cheng, Chung-yin 成中英, xviii, 92n, 93n, 97n, 107n, 129n, 365
Cheng, Ming-dao 程明道, 246, 258, 260
Cheng Yi 程頤, 143
Cherniss, H., 306n
chi 恥 (shame), 235–36
Chinese philosophy, xvi, xviii, xix, 27–
 30, 39–44, 91–129, 131–52,
 153–67, 169–94
 and analytic methodology, 39–44
 and semiotics, 169–94
 onto-methodological nature of, 92–98
 rational reconstruction of, 125. *See* rational
Ching, Julia 秦家懿, 170n, 192
Chow, Tse-tsung, 134n
Christianity, 28, 35, 138, 147, 269, 271, 313n
Chun-Qiu-Fan-Lu 《春秋繁露》 (*Luxuriant Germs of the Spring and Autumn*), 245
coherence, 7, 9–15, 276
Collins, Randall, 29, 35n
common sense, 53, 67
commensurability, 298, 301. *See also* incommensurability
communication, 53, 90, 92
comparative:
 humanities, 193
 philosophy, xx, 87, 269–91, 293–312, 313–36, 337–64
 studies of Chinese and Western philosophies, xx, 157, 170–74, 182–94
compatibalism, 209, 212. *See also* soft determinism
complementarity, 286–90
Confucianism 儒家, xviii, 28, 35, 35n, 41, 93–98, 108, 110, 116, 120, 124, 127, 132, 135, 138–51, 156, 159, 192–93, 216, 218–19, 227, 245, 254, 271, 278, 288–90, 296, 305, 313n, 335
 contemporary, 245–65
 early, xix, 229–44
 Neo-, xix, 30, 34, 36, 41, 96, 108, 116, 120, 120n, 127, 131, 141–47, 141n, 150–51, 171–73, 233n, 238n, 245–65, 322n–23n, 330n
 Qing dynasty, 34
Confucius (Kongzi) 孔子, xx, 35, 36, 41–42, 93–94, 110, 116, 127, 144, 150–51, 202, 212n, 216n,